THE RAINBOW BRIDGE

THE RAINBOW BRIDGE

RAINBOWS IN ART, MYTH, AND SCIENCE

RAYMOND L. LEE, JR., AND ALISTAIR B. FRASER

The Pennsylvania State University Press, University Park, Pennsylvania
SPIE Press, Bellingham, Washington

Library of Congress Cataloging-in-Publication Data

Lee, Raymond L. 1952–
 The rainbow bridge : rainbows in art, myth, and science / Raymond L. Lee, Jr. and Alistair B. Fraser.
 p. cm.
 Includes bibliographical references and index.
 ISBN 0-271-01977-8 (cloth : alk. paper)
 1. Rainbow. 2. Rainbow in art. 3. Rainbow—Mythology. I. Fraser, Alistair B. II. Title.
QC976.R2L44 2001
551.56'7—dc21 99-39847
 CIP

Copyright © 2001 Raymond L. Lee, Jr., and Alistair B. Fraser
All rights reserved
Printed in China
Published by
The Pennsylvania State University Press,
University Park, PA 16802-1003
in cooperation with
SPIE Press,
Bellingham, WA 98225

It is the policy of The Pennsylvania State University Press to use acid-free paper for the first printing of all clothbound books. Publications on uncoated stock satisfy the minimum requirements of American National Standard for Information Sciences—Permanence of Paper for Printed Library Materials, ANSI Z39.48-1992.

CONTENTS

(ix) Preface

(xiii) Acknowledgments

ONE (2) The Bridge to the Gods

TWO (34) Emblem and Enigma

THREE (68) The Grand Ethereal Bow

FOUR (100) Optics and the Daughter of Wonder

FIVE (136) Unweave a Rainbow

SIX (168) Beyond the Medieval Rainbow

SEVEN (206) Color the Rainbow to Suit Yourself

EIGHT (242) What Are "All the Colors of the Rainbow"?

NINE (274) The End of the Bow

TEN (300) Sell It with a Rainbow

(321) Appendix

(327) Notes

(367) Bibliography

(383) Index

TO OUR FAMILIES

PREFACE

Who among us has not admired the majestic beauty of a rainbow arching silently across a storm's wake? Vivid and compelling, this image recalls childhood memories, venerable folklore, and perhaps some half-remembered science lessons. Yet except for such fleeting, transcendent moments, the rainbow seems an unlikely candidate for emboldening, terrorizing, and fascinating our species. Nevertheless, across the millennia the rainbow has been venerated as god and goddess, feared as demon and pestilence, trusted as battle omen, and used as an optical proving ground. The rainbow image is woven into the fabric of both our past and present, but its very familiarity today renders it nearly invisible. For all of us, a fresh look at the rainbow seems well worthwhile, especially given that the bow spans some modern divides between the arts and sciences.

Because almost every society has considered the rainbow its private preserve, not surprisingly the bow has assumed many guises. The optimism that we associate with the rainbow is hardly universal. For example,

> What, then, in optics is most difficult of demonstration? Is it not, perhaps, the explanation of the form, size, and color of the rainbow, seeing that there enters into its production a consideration of the entire field of optics, namely, vision, light, reflection, and transparent bodies, concerning which many have written; but no one has as yet given a satisfactory explanation?
>
> Francesco Maurolico, "Problems in the Field of Optics and the Rainbow" (1567)

the ancient Greeks named the rainbow Iris, and she became the bearer of the gods' often dread messages of war and retribution. Some societies see the rainbow as an ominous serpent arching across the sky, while others imagine it to be a tangible bridge between the gods and humanity. In Judeo-Christian culture, this literalism has been reworked so that the rainbow is a symbolic bridge to the divine, a sign of God's covenant. We too will use the rainbow as a bridge, but this time as a link among the disparate perceptions that artists, scientists, and mythmakers have of the natural world.

Throughout history, the rainbow is seen primarily as a symbol—whether of peace, covenant, or divine sanction—rather than as a part of nature. As a symbol, rather than a natural phenomenon, the rainbow can depart quite radically from nature. Advertising art can satisfy (or create) our collective desire for emblems, and in so doing, it has absorbed the rainbow along with many other aspects of nature. As an object of fantasy, the rainbow in advertising can take on any appearance, freely mixing its colors or consorting with mermaids and unicorns. Our myths remain as vigorous as our science.

Francesco Maurolico's sixteenth-century rainbow theory is an apt metaphor for the bow itself, an incomplete image that tantalizes with alternating brilliance and obscurity. Yet whatever his faults as a student of the rainbow, Maurolico poses exactly the right question above. The rainbow spans all the optical world that he knew and much of ours. In fact, from antiquity to the nineteenth century, the rainbow played a vital role in both inspiring and testing new ideas about the physical world. Although today we understand the rainbow's underlying optics fairly well, its subtle variability in nature has yet to be fully explained. Many of Maurolico's questions have been answered to date, but certainly not all. How do we address them?

To begin with, our chapters are organized thematically and, where useful, chronologically within those themes. For example, Chapter 1 gives an overview of rainbow mythology from across the world, while Chapters 2 and 3 outline the rainbow's history in art. The rainbow's scientific history from Aristotle to Isaac Newton is discussed in Chapters 4–6, while Chapter 7

considers its influence on color theory in Western science and the arts. In Chapters 8 and 9, we look at some of the natural rainbow's subtler features and how they influenced optical theory after Newton. Chapter 10 examines the rainbow's status today, whether in advertising, the fine arts, or the sciences. Within each chapter, we illustrate the rainbow's complex story with historical or scientific sketches that are devoted to particular persons or ideas. In each of these sketches we relate some feature of the natural rainbow to its human reflection, whether written or painted. From Chapter 7 onward, we add to these sketches our own rainbow research whenever this helps explain the bow's history, mythology, or optics. For ready reference, the Appendix summarizes some basic rainbow features and explanations that the main text describes in more detail.

Because we believe that bridges can be built between different cultural visions of the rainbow, we offer vignettes on rainbow paintings in most chapters, including those nominally devoted to rainbow optics. Our goal here is not to cast artists in the role of scientists, but rather to emphasize the shared problems of observation that the two groups face—and how they often arrive at very different answers. (We can easily imagine that art historians writing this book might add some scientific sidebars to their chiefly historical tale.) Just as the two ends of a real bridge may arise from very different bases, so too the rainbow bridge may span very different perceptions of the same rainbow feature. Similarly, we know that some historians of science may question our labeling as "errors" the now-rejected features of rainbow theories from earlier centuries. In fact, identifying our predecessors' errors is not present-day scientific chauvinism, for we keenly appreciate that scientific ideas always evolve within (and are shaped by) particular cultural contexts. Furthermore, many older theories have some quite plausible features. However, their very plausibility can mislead readers newly versed in modern rainbow theory, so we offer some guideposts along the way. Perhaps rainbow bridges can help span modern academic divides.

Our book is intentionally eclectic—we are offering an illustrated survey of the rainbow's place in science, mythology, and art, not an exhaustive monograph on one of those themes. For

such specialist treatments, we recommend Carl B. Boyer's *The Rainbow* or Paul D. Schweizer's recent paper "John Constable, Rainbow Science, and English Color Theory" (complete citations are in the Bibliography). Rather than attempt to follow every twist and bend of the rainbow's course through history, we instead want to traverse bridges between the various roles that the rainbow has played. As scientists, teachers, and devotees of the rainbow, we will consider it high praise indeed if we inspire readers to look at the rainbow anew.

<div style="text-align: right">

Raymond L. Lee, Jr.
Owings, Maryland

Alistair B. Fraser
Lemont, Pennsylvania

</div>

CREDITS

Title page illustrations center and right are details from Figures 4-13 and 8-8, respectively.

Chapter opening illustrations: Chapter 1, from Fig. 1-12; Chapter 2, from Fig. 2-6; Chapter 3, from Fig. 3-7. Chapter 4, from Fig. 4-6; Chapter 5, from Fig. 5-1; Chapter 6, from Figs. 6-1, 6-2, 6-3, 6-4, 6-11; Chapter 7, from Fig. 7-17; Chapter 8, from Fig. 8-3; Chapter 9 from Fig. 9-21; Chapter 10, from Fig. 10-30.

The following graphics are by Raymond L. Lee, Jr.: Figs. 4-1, 4-3, 4-4, 5-2, 5-3, 5-4 (after Alhazen 1989, vol. 2, p. xlvii), 6-5, 6-6, 6-7, 6-8, 6-9, 7-5, 7-6, 7-7, 7-10, 7-11, 7-12, 7-13, 7-14, 7-15 (after Goldstein 1980, plate 4-1), 7-16 (after Sekuler and Blake 1985, color plate 10), 7-18, 7-19 (after Mollon and Sharpe 1983, p. 72), 7-22, 7-23, 7-24, 7-25, 8-6, 8-7, 8-9, 8-11, 8-12, 8-13, 8-14, 8-15, 8-16, 8-17, 8-18, 8-19, 8-20, 8-21, 8-22, 8-23, 9-3, 9-4, 9-7, 9-8, 9-9, 9-11 (after Walker 1977, p. 144), 9-12, 9-13, 10-29.

The following photographs are by Raymond L. Lee, Jr.: Figs. 4-10, 7-4, 10-1, 10-12, 10-14, 10-18, 10-22, 10-23, 10-28.

The following photographs are by Alistair B. Fraser: Figs. 4-14, 4-15, 4-16, 5-1, 7-20, 7-21, 8-1, 8-3, 8-5, 8-8, 9-6, 10-2, 10-3, 10-4, 10-5, 10-6, 10-7, 10-8, 10-9, 10-10, 10-11, 10-13, 10-16, 10-17, 10-19, 10-20, 10-21, 10-26.

ACKNOWLEDGMENTS

While the author's lonely garret and the light of a guttering taper at midnight are not complete fictions, few writers of history can honestly say that their work is a solitary act. As a writer on the science and history of the rainbow, I am no exception. In many ways, I have simply patiently gleaned facts and assembled intriguing puzzles, propelled forward in a quest for more insights. Obviously neither I nor Alistair Fraser have made the rainbow's colors or its history. Instead, we have tried to bring together the fragments of that story in a way that has been instructive for us and, we hope, for our readers. Along the way, I have had a great deal of help.

At the U.S. Naval Academy, I want to thank the staff of Nimitz Library for their assistance, in particular librarians Barbara Yoakum, Barbara Breeden, and Catherine Dixon. Very special thanks are owed to Florene Todd of the Nimitz Interlibrary Loan department, who resourcefully fielded all my myriad loan requests, no matter how esoteric. Without the skilled, cheerful assistance of Ms. Todd and her colleagues, I could not have written parts of this book. Other professionals were also helpful in my trek through some rather obscure book stacks, including Penn State Rare Books librarians Sandra K. Stelts and the late Charles Mann. In particular, Ms. Stelts alerted me to the wonderful rainbow imagery of Antonio Verrio's Heaven Room mural (Fig. 3-1). Carolyn Wilson of the Albany Institute of History and Art generously sent me some hard-to-find materials on Jasper Francis Cropsey's *Dawn of Morning, Lake George* (Fig. 9-10).

A book as wide-ranging as this requires the assistance of a diverse group of people. Wayne H. Millan provided careful translations of numerous difficult Latin passages, including Chapter 4's first-ever English translation of Alexander of Aphrodisias's question about the

rainbow feature that bears his name. My wife, Nancy A. Mace, brought her considerable scholarly talents to bear on this project, translating several Latin and Italian passages for me and more than once saving me from serious howlers. In the Naval Academy's Oceanography Department, Alan E. Strong gave me invaluable support in the form of the high-speed computer needed to calculate Fig. 10-29's map of Mie-theory rainbow colors. Michael E. Churma and Joan M. Osenbach separately made valuable research and bibliographic contributions to several chapters.

I have not had the pleasure of meeting all who contributed to my efforts. These people include Dominique Collon of the British Museum's Department of West Asian Antiquities, James R. Fleming of Colby College's Department of Science and Technology Studies, Charles Jones of the University of Chicago's Oriental Institute Research Archives, Alex Kidson and Jeff Dawe of Liverpool's National Museums and Galleries on Merseyside, David C. Lindberg of the University of Wisconsin at Madison, Gloria S. Merker of Rutgers University's Classical and Modern Languages Department, Scott B. Noegel of Cornell University's Department of Near Eastern Studies, George Siscoe of Boston University, Robert Vergnieux of the University of Bordeaux's Service Informatique et Recherche en Archéologie, Robert M. Whiting of the University of Helsinki's Department of Asian and African Studies, Stephen Wildman of the Birmingham Museums and Art Gallery, and Andrew T. Young of San Diego State University's Department of Astronomy.

Kenneth Sassen of the University of Utah's Meteorology Department generously provided me with an original color slide of Fig. 1-9's rainbow pictograph. Similarly, Jacques Livet of Paris made available to me a splendid photograph of Fig. 1-7's Meryra relief. John Rosenfield, Professor Emeritus in Harvard University's Fine Arts Department, gave me advance copies of his catalog entries on Soga Shōhaku's *Mount Fuji and Miho no Matsubara* (Fig. 3-2), while its owners, John and Kimiko Powers of Carbondale, Colorado, kindly gave permission to reproduce it. I am indebted to Luke Taylor, Senior Curator at the National Museum of Australia, Canberra City, for background information on and a color slide of Lofty Nabarrdayal's *Yingarna the Rainbow*

Serpent (Fig. 1-14). Similar thanks are owed to Paul S. C. Taçon, Senior Research Scientist at the Australian Museum, Sydney, for Fig. 1-13's Rainbow Serpent photograph. Of course, any errors made in using the materials provided by these thoughtful correspondents are entirely mine. To those whose names I have inadvertently omitted, I can only offer the harried author's excuse of forgetfulness.

Kind and long-suffering moral support has come from my family—Nancy A. Mace, John M. Bowen, and Edgar Mace Lee. Although Edgar's specialty is long, therapeutic walks with me, he himself hopes to publish one day, perhaps in the canine sciences. To my parents, Virginia and Raymond Lee, I offer the most profound thanks and love for their steadfast encouragement. My intellectual forebears are Martin Kemp and the late Carl Boyer, whose groundbreaking monographs on the histories of artistic color theory and of the rainbow, respectively, inspired me to tackle this difficult task. Without question, this book would not exist were it not for the intellectual stimulus provided by my mentor and valued colleague, Alistair B. Fraser. Under the management of Ronald C. Taylor and Roddy R. Rogers, the U.S. National Science Foundation's Physical Meteorology Program has generously funded much of my scientific research on the rainbow (and other atmospheric optical phenomena) in four separate grants during the past fifteen years. Finally, no author can say that he has a book until he has a superb editor, a job admirably filled by my patient colleague at Penn State Press, Sanford G. Thatcher. To all these friends, family, and colleagues I offer my heartfelt thanks.

Raymond L. Lee, Jr.

THE RAINBOW BRIDGE

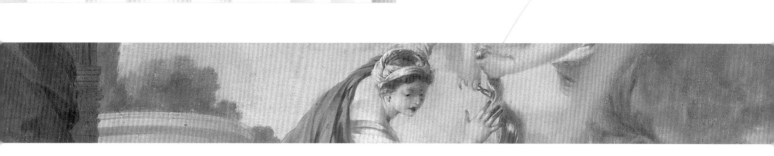

Whatever the culture or continent, our species' earliest rainbow is the rainbow of the imagination. Because these bows color all their successors, we begin our journey with a look at the rainbows of myth, legend, and folktale. From the Occident to the Orient comes a dizzying array of imagined rainbows. Whether as bridge, messenger, archer's bow, or serpent, the rainbow has been pressed into symbolic service for millennia. The Judeo-Christian rainbow's symbolism of peace and covenant is hardly universal, and in many cultures the rainbow is an evil presence— often one too dangerous even to point at. Forearmed with an explorer's eclectic tastes, we can begin our ascent over the world's rainbows.

ONE

THE BRIDGE TO THE GODS

Like stepping through the looking glass, climbing the rainbow is childhood's impossible dream. While Lewis Carroll's Alice enters a fantasy world through the looking glass,[2] George MacDonald's Mossy and Tangle leave this one by ascending the rainbow. As delightful as their rainbow vision is, using the rainbow as a colorful path to the land of the dead might seem macabre.

But need it be? In Constantino Brumidi's (1805–80) *Apotheosis of George Washington* (Fig. 1-1), America's founding father wears an expression more placid than portentous as he is propelled heavenward on a rainbow. Certainly there is no hint of the shroud among these friends and foes of the republic as Washington lords over them enroute to deification. Instead, judging by the tumult beneath his rainbow seat, Washington is headed toward an afterlife that promises to be very active politically. Surrounded by thirteen

> They climbed out of the earth; and, still climbing, rose above it. They were in the rainbow. Far abroad, over ocean and land, they could see through its transparent walls the earth beneath their feet. Stairs beside stairs wound up together, and beautiful beings of all ages climbed along with them. They knew that they were going up to the country whence the shadows fall.[1]
>
> George MacDonald,
> *The Golden Key* (1867)

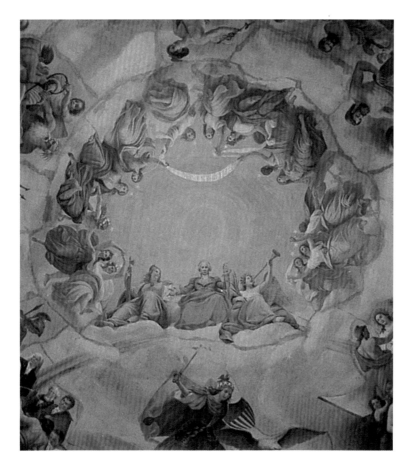

FIG. 1-1

Constantino Brumidi, *Apotheosis of George Washington*, 1866. Capitol Rotunda, Washington, D.C. (photo: Courtesy Architect of the Capitol)

maidens, one for each of the republic's original states, Washington serenely supervises an armed Liberty beneath him as she tramples out the powers of kings and tyrants. Encircling the rainbow are groups of heroic figures industriously attending to war, agriculture, art and science, commerce, mechanics, and the maritime trades.[3]

Rainbows at the Dawn of History: Babylonia and Beyond

As a bridge to the heavens, then, the rainbow can apparently function in many different ways. Whether as the delicately transparent path of *The Golden Key* or the emphatically solid Judgment Seat of Brumidi's *Apotheosis*, the rainbow is bent to many ends. Yet were the Victorians the first to take the rainbow heavenward? Far from it. They were simply the inheritors of a long tradition of exploiting the rainbow's powerful visual symbolism. To get a flavor of that symbolism's origins, we consider several known or presumed examples of ancient rainbows. We begin with ancient Mesopotamia and a cycle of epic poems that grew up around the real and mythic exploits of a Sumerian king who is himself part fact and myth—Gilgamesh.[4]

The Gilgamesh epic likely originated before 2000 B.C., and it has been painstakingly assembled over the last 150 years from cuneiform records that literally are fragmentary.[5] This

scattered collection of partially preserved sources reveals that the epic took on many names and forms in antiquity. One Victorian translation of an ancient Gilgamesh variant is Leonidas Hamilton's *Epic of Ishtar and Izdubar*.[6] King Izdubar of Uruk, this epic's hero, visits the Temple of Samas with his war council to seek the gods' blessings on an imminent battle with his enemy Khumbaba. When the god of the atmosphere Bel tells Izdubar that "sixty gods thy will commands / To crush Khumbaba's hands," the king is jubilant. He emerges from the temple to revel in the splendor of the Samas precinct:

> Grand temples piled on temples upward glide,
> A mass of colors like the rainbow hues,
> Thus proudly rise from breezy avenues.
> The brazen gates lead to the temple's side,
> The stairs ascend and up the stages glide.
> The basement painted of the darkest blue
> Is passed by steps ascending till we view
> From them the second stage of orange hue
> And crimson third! from thence a glorious view—
> A thousand turrets far beneath, is spread
> O'er lofty walls, and fields, and grassy mead.[7]

Like Mossy and Tangle, Izdubar admires the architecture of the rainbow colors climbing skyward. But for Izdubar, the rainbow colors at Samas are linked to divine sanction for war, not to a search for immortality. The link to immortality comes later in the epic, when Izdubar reaches the garden of the gods and sees the "glistening colors of the rainbow rise" in the fountain of life beside Elam's Tree of Immortality.[8] Images pairing sacred trees and vase-fountains appear early in Mesopotamia, as indicated by an eighteenth-century B.C. mural from ancient Syria (Fig. 1-2) that marks a ceremony from the reign of King Zimrilim of Mari (1779–1761 B.C.).[9]

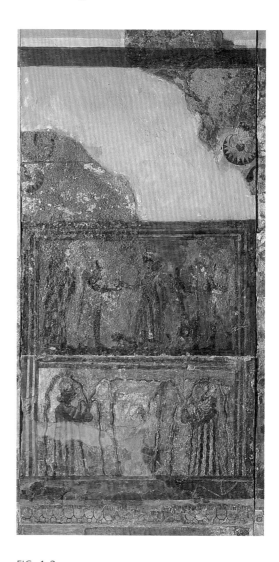

FIG. 1-2

Mirror-image figures hold vases from which issue streams that water ceremonial or sacred trees. Palace of King Zimrilim at Mari, Syria, c. 1775 B.C. Louvre, Paris (photo: Courtesy Photographie Giraudon, Paris)

Yet we do not need to turn to Victorian translations of epic poetry to find portentous Babylonian rainbows. Sumerian and Babylonian astronomers kept diaries of astronomical and meteorological phenomena that, while highly formulaic in their wording, nonetheless record some remarkable events. In the reign of the Babylonian king Šamaššumukin (reigned 667–648 B.C.), astronomers made the following reports during a single fortnight in 651 B.C. "Three ra[inbows,] one in the west, one between north and west, and one in the north, were seen" on the

fifteenth day of one month. Twelve days later "a rainbow whose brightness was very great stretched in the east," and the next afternoon "a very red rainbow stretched in the east."[10]

If, like the mythic Izdubar, the real Šamaššumukin had been looking for battle portents, he should have consulted his astronomers. On the same day they saw the bright rainbow, they recorded: "[In] Hiritu in the province of Sippar the troops of Babylonia and of Assyria fou[ght with each] other, and the troops of Babylonia withdrew and were heavily defeated."[11] Three years later, Šamaššumukin's battles were over. After enduring a lengthy siege, he surrendered in Babylon to the Assyrian troops of his brother Ashurbanipal (reigned 668–627 B.C.).[12] As the legendary Sardanapalus, Šamaššumukin supposedly capitulated by defiantly immolating his palace, his concubines, his treasures, and himself.[13]

A Mesopotamian myth about an even greater calamity may also feature the rainbow. As part of the Gilgamesh epic, Gilgamesh seeks eternal life from his forebear Utnapishtim, an immortal whose tales of surviving a catastrophic flood recur in Noah's biblical story.[14] Utnapishtim tells Gilgamesh how he built an ark, survived a storm of seven days, and rode the Deluge waters for a week. Like Noah, Utnapishtim makes his ark fast to a mountain, releases a dove and a raven (as well as a swallow) to see whether the waters have receded, and finally offers a sacrifice on finding that they have. While the gods "gathered like flies over the sacrifice," Utnapishtim recalls, "Then, at last, Ishtar also came, she lifted her necklace with the jewels of heaven that once Anu had made to please her. 'O you gods here present, by the lapis lazuli round my neck I shall remember these days as I remember the jewels of my throat; these last days I shall not forget. Let all the gods gather round the sacrifice, except Enlil. He shall not approach this offering, for without reflection he brought the flood; he consigned my people to destruction.'"[15]

The Akkadians of northern Babylonia venerated Ishtar (the Sumerians' Inana) as a goddess of lust and war, and she was also regarded as goddess of the planet Venus. Yet a temperate strain occasionally surfaces in her generally wanton nature; in one Gilgamesh episode, Ishtar transplants a sacred tree in Uruk (if only for her own use later).[16] Her dual nature is plainly evident above, for her compassion after the Flood's destruction is tempered by the fact that both she and the storm god Enlil had advocated it earlier.[17] Some writers have claimed that Ishtar's colorful necklace is the rainbow.[18] At the very least, there are striking parallels with the later account in Genesis of a destructive and compassionate God who offers the rainbow as a promise:

> And God said, This is the token of the covenant which I make between me and you and every living creature that is with you, for perpetual generations:
> I do set my bow in the cloud, and it shall be for a token of a covenant between me and the earth.
> And it shall come to pass, when I bring a cloud over the earth, that the bow shall be seen in the cloud:
> And I will remember my covenant, which is between me and you and every living creature of all flesh; and the waters shall no more become a flood to destroy all flesh.[19]

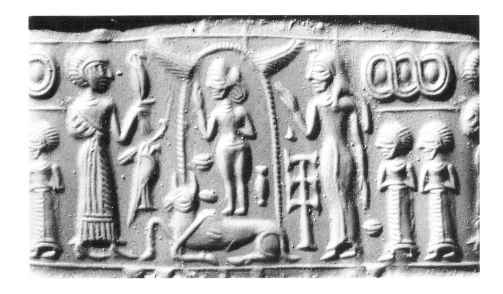

FIG. 1-3

Syrian rain goddess above a bull, cult animal of the Amorite storm god Adad (Sumerian Enlil). The winged gate around her may represent the rainbow. Cylinder seal, c. 1750–1650 B.C. The British Museum, London

For those raised in Judeo-Christian culture, this linking of the rainbow with divine promises of peace and compassion seems almost self-evident. However, God's heavenly bow of peace was once joined with (and may have originated in) the archer's bow of war.[20] Such imagery occurs in the fourteenth-century mystery play *Noah's Flood* (one of the English Chester Plays), where God's speech in Genesis is changed to merge the celestial and earthly bows:

> The stringe is torned towardes you
> and towardes me is bente the bowe,
> that such wedder shall never show;
> and this behett [promise] I thee.[21]

God not only turns His weapon of the deluge away from humanity, but also directs it toward Himself in a foreshadowing of Christ's sacrifice.[22] The immediate literary source of this stretched-out heavenly bow may be an even more elaborate metaphor from the allegorical work *Pèlerinage de la vie humaine* (Pilgrimage of the Life of Man, 1330) by the Cistercian Guillaume de Deguileville. In it, the female figure of Mercy humbly persuades "the myghty kyng celestial":

> I made hym drawe of the [bow's] corde,
> and, for sygnes of concorde,
> Sette it in the heven alofte;
> and (as men may se ful ofte)
> In tookne of pes, and not of wrak,
> that, of his mercyable lawe,
> he may not the bowe drawe,
> whan of mercy (as it is knowe)
> toward hym-self he drough the bowe.[23]

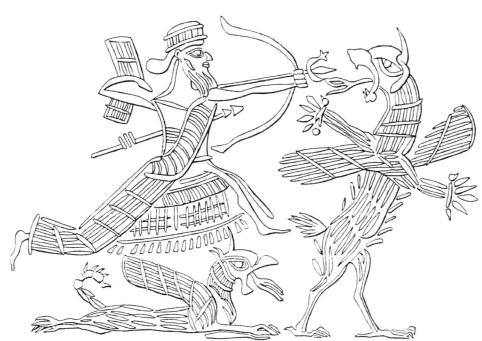

FIG. 1-4
Adad or Enlil's son Ninurta draws down on a leonine bird-monster. Representation of cylinder seal, 8th–5th century B.C., in The British Museum, London. Reprinted from Jeremy Black and Anthony Green, *Gods, Demons and Symbols of Ancient Mesopotamia: An Illustrated Dictionary,* illustrations by Tessa Rickards, Copyright ©1992. By permission of the University of Texas Press. Courtesy of The Trustees of the British Museum © 1992

Suggestions of heavenly archer's bows greatly predate these medieval examples. Throughout Babylonian astronomical records, rainbows are referred to as "stretching" in some compass direction.[24] Although we cannot be certain, this probably indicates that the rainbow's semicircular arc was identified with the archer's stretched bow. Figures 1-3 and 1-4 indicate how such an association may have evolved in Mesopotamia, where we see deities' life-giving (Fig. 1-3) and warlike attributes (Fig. 1-4) linked to bows of heaven and war.[25] In Fig. 1-4 the Sumerian god Ninurta is, like Ishtar, a deity with various aspects: a warrior god who defends Sumer against its enemies, Ninurta is also a farmer god.[26] Especially interesting to us is that the bow-wielding Ninurta's crown was described as the rainbow.[27] Similarly, the Hindu myths of the Rigveda (c. 1500–1200 B.C.) tell how Indra, the god of thunder and war, uses the rainbow as the "bow of Indra" to kill the Asura Vṛtra, a primordial demon-serpent.[28] Just as Indra shot arrows of lightning to slay Vṛtra, so Tiermes, the Scandinavian Lapps' thunder god, would later use the rainbow to fire arrows at evil spirits.[29]

In Book 17 of the *Iliad*, the poet Homer (fl. c. 850 B.C.) has the supreme god Zeus send Athena to encourage the embattled Danaäns (Greeks). Athena wraps herself "in a lurid cloud, like the cloud about a rainbow which Zeus stretches across the sky to be a portent of war."[30] In similar fashion, the Greek poet Aeschrion (fl. c. 300 B.C.)[31] simultaneously invokes the warrior's bow and the rainbow goddess when he says: "The iris shone out, the fair bow of the sky."[32] Another Greek pairing of war and the rainbow can be seen in Fig. 1-5, which combines scenes from Books 22 and 23 of the *Iliad*. Iris, goddess of the rainbow and messenger of the gods, summons the Winds to ignite the pyre of Patroclus, Achilles' warrior comrade who was killed by Hector in the Trojan War.

Archers' Bows and Rainbows in Egyptian Antiquity

Similar visions of death and the bow already existed in ancient Egyptian texts. From the *Book of Gates* (c. 1650 B.C.) comes a description of the great sun god Re's retinue (Fig. 1-6): "Of the double bow it is said: This is the MEḤEN serpent of the uraei, which strideth through the Ṭuat. The two bows are stretched out, and they bear up on themselves him of the Two-Faces [of Horus and Seth] in his mystery which [appertaineth] to them. They lead the way for Rā in the horizon of the east of heaven, and they pass on into the heights of heaven in his train."[33]

The Tuat (or Duat) is the underworld that the dead Re traverses every night in order to be reborn in the eastern sky.[34] The uraei are stylized cobras worn as part of an Egyptian ruler's headdress, and they simultaneously protect the wearer and symbolize pharaonic power.[35] Although the serpent-god Mehen usually surrounds Re in his coils to shield him from evil, he also guides Re on his perilous nightly voyages through the Duat.[36] (In Fig. 1-6, Mehen appears in hidden form in a human body.) A god of Upper Egypt, Seth is sometimes given power over wind and storms, and he also protects Re during his underworld journeys.[37]

Seth's nemesis is Horus, either in the form of his nephew Horus, son of Osiris, or Horus the Elder, Lord of Lower Egypt.[38] Real political struggles between Lower and Upper Egypt were reflected in the changing relationships of the mythological Horus and Seth, who may either symbolically bind together the Two Lands[39] or battle implacably for them.[40] So the gods'

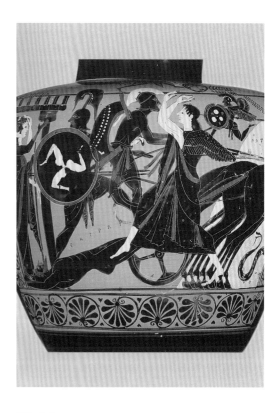

FIG. 1-5

Iris (arms uplifted) runs toward Achilles (bearing a shield) as he drags the body of Hector past Patroclus's tomb. Antiope Group (attributed), Attic black-figure hydria, c. 520–510 B.C. Museum of Fine Arts, Boston. William Francis Warden Fund

unification as Horus-Seth has overtones of conflict subordinated to the greater good—protecting the supreme god Re from the underworld's dangers.

In the *Book of Gates* hieroglyphs, Mehen literally is supported by a "double bow" in the form of two upturned archer's bows. Thus the hieroglyphs are not literal pictograms for a double rainbow, nor can we expect meteorological rainbows to "lead the way" for the sun, in the sense that they cannot appear near the sun. Of course, if we interpret this phrase to mean that the bows merely herald the sun's passage, then it can be reconciled with the late-afternoon appearance of rainbows in the eastern sky.[41] (See the Appendix's "A Field Guide to the Rainbow" for a summary of the natural rainbow's features.) One obvious objection to our speculation is that solar rainbows cannot be seen in the tenth hour of the night, the setting of this *Book of Gates* passage. So why suggest that its double bow might be a rainbow?

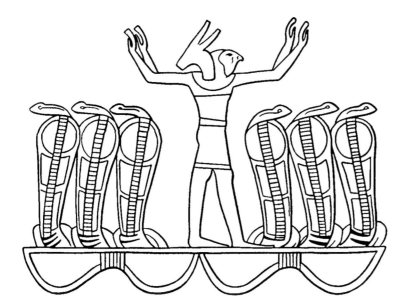

FIG. 1-6
Wearing the heads of Horus and Seth, an avatar of the coiled serpent-god Mehen stands atop double bows in the Tenth Division of the Duat, *Book of Gates*, c. 1650 B.C. (From Alexandre Piankoff, *The Tomb of Ramesses VI, Part I: Texts*, p. 209. Copyright © 1954 by Princeton University Press. Reprinted by permission of Princeton University Press.)

First, many cultures associate the rainbow with a gigantic sky serpent, and the double bow here is paired with the "Meḥen serpent of the uraei." Second, as in the later Babylonian astronomical observations, these bows are described as "stretched out." Finally, the notion that rainbows "bear up on themselves" a divine being is a persistent one, as Fig. 1-1 suggests. Obviously we cannot use folkloric or textual arguments to prove that the *Book of Gates* passage describes a double rainbow. Yet as we will see shortly, in numerous cultures the rainbow is invoked ambiguously and by proxy, rather than unambiguously and directly.[42] Furthermore, meteorological accuracy is seldom an important criterion in making rainbow images, so we should not automatically exclude the *Book of Gates* passage as a veiled rainbow reference. It remains a tantalizing possibility.

Figure 1-7 shows us another possible rainbow from ancient Egypt: a tomb relief from Tell el-Amarna, about 190 miles south of Cairo, and it dates from the reign of Amenhotep IV (or Akhenaton; reigned 1353–1336 B.C.). Between about 1348 B.C. and his death, Akhenaton used the site as his new but short-lived royal capital. Akhenaton's virgin city was tangible evidence of his radical religious conversion to a monotheism based on the sun-disk god Aton.[43] The artistic style of Akhenaton's reign was equally radical, reaching unprecedented levels of naturalism and of frankness in royal portraiture (although the latter tendency was partly caricature).

This interest in nature is evident in Fig. 1-7, where we see rays radiating from Aton and ending as hands, one of which holds the ankh, a hieroglyph signifying "life." Although this relief is from the tomb of the high priest Meryra, Aton's rays are reserved for Akhenaton and his queen Nefertiti, who appear beneath Aton here. While Aton reliefs are found throughout the Amarna tombs, the unusual feature of this one is the series of painted arcs that cross Aton's rays. Four distinct groups of these arcs are evident, and they often overlap each other. Traces of blue and red pigment remain on individual arcs, suggesting the rainbow's color banding.

Might these arcs have been meant to signify the rainbow? Obviously the rainbow consists

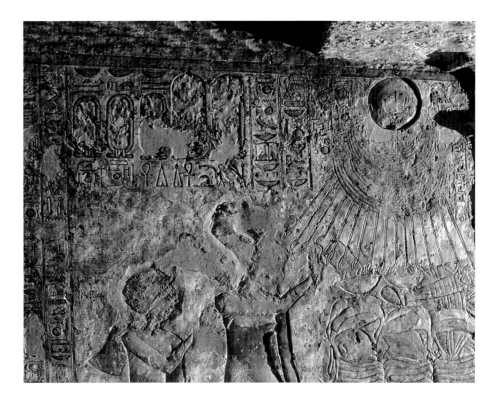

FIG. 1-7
Akhenaton's royal family makes offerings to the sun disk Aton, whose rays end as hands, one of which offers the sign of life. Overlying these rays are arcs that may represent halos or rainbows. Relief from tomb of Meryra, Tell el-Amarna, Egypt, c. 1340 B.C. (J. E. Livet Editions, Paris)

of colored bands that are centered around the sun (although on the opposite side of the sky), and on that basis alone we could call this an ancient Egyptian rainbow. Furthermore, to pair ankhs with rainbows is entirely natural, especially given the association of life-giving waters and the rainbow seen in older Near Eastern images.[44] Finally, as we see in Fig. 1-1, rainbows are often a sign of divinity, in this case Aton and Akhenaton. From a strictly naturalistic standpoint, however, there are some problems with our identification.

If the arcs are rainbows, they have been turned upside down (at least for normal rainbow viewing conditions; the Appendix describes how to see the rainbow's lower half). No such inversion of nature is necessary if we instead describe the arcs as halos, whose lower parts are often visible.[45] Second, unlike the rainbow, halos *do* appear near the sun. Of course, the fact that the circular arcs are not strictly concentric with one another or with the sun might disqualify them from being either halos *or* rainbows, but that level of literalism seems extreme—one might as well criticize the unnatural number of arcs in the relief. Finally, the color order of the arcs is not literally the rainbow color order, although discerning patterns among the faded pigments is difficult at best.

In 1903, British Egyptologist Norman Davies (1865–1941) said of this relief: "With remarkable fidelity to nature, [the rays] stream forth from under the encircling clouds, bright with the colours of the setting sun. The hues and forms of the clouds are in fact the same as those employed in the ⌒ hieroglyph to represent the rising sun, but in reverse position."[46] In other

words, Davies proposes that the arcs are semicircular clouds illuminated by sunset's colorful sunbeams. One problem with this explanation is that the irregular shapes of clouds resemble the precise circular arcs in the relief very little.

According to Davies's colleague Francis Llewellyn Griffith (1862–1934), the ⌒ hieroglyph contains blue, green, and red arcs.[47] While a red arc is consistent with Davies's explanation, blue and green arcs are more difficult to reconcile with sunset colors. Furthermore, Griffith translates ⌒ not as Davies's "rising sun" but as "royal crown" or "to appear in glory." Based on linguistic arguments, Griffith briefly allows that ⌒ *could* be a rainbow, and he notes that the sign's "fifth and cresting band, sometimes marked with radiating lines, does not extend to the diameter."[48] We shall see later that radiating sunbeams and a variant on ⌒'s truncated arc are both common rainbow features (see Figs. 4-6 and 9-2, respectively).

Clearly we can enmesh ourselves in interminable meteorological and pictographic arguments about the true nature of Fig. 1-7's colorful arcs. As is true for most ancient images that suggest the rainbow, if there is no contemporary identification, then we can never be certain what was intended. However, the available symbolic and visual evidence suggests that rainbows (or halos) may well have graced Meryra's tomb for millennia.

Scarce as Egyptian Rainbows

Ancient Egyptian rainbows are not only problematic but also quite scarce. Years of our own searching have produced little more than the examples above. Egyptologists with whom we have talked believe either that no rainbows exist in Egyptian art and writing or that rainbows are represented by proxies such as the archer's bow. As meteorologists, we are inclined toward the latter possibility because it seems more consistent with the images that we have seen and with what we know of ancient weather. Furthermore, for rainbows to have gone unseen and unrecorded across nearly three millennia of Egyptian history is difficult to believe. Finally, there is the matter of rain in ancient Egypt.

"Never" is a word applied judiciously to any region's weather, but the belief that rain never fell in pharaonic Egypt (thus ruling out rainbows) is as widespread as it is unlikely. To a casual observer, photographs of Egypt's deserts may suggest that rain never occurs there, but modern weather records show that rain and thunder, while not plentiful, are nonetheless facts of Egyptian life.[49] Rare storms and rainfall are documented in numerous explorers' accounts of nineteenth-century Egypt.[50] In 1646, English writer and physician Thomas Browne (1605–82) firmly noted about Egypt: "[the fact] that great showers do sometimes fall upon that Region, beside the Assertion of many Writers, we can confirm from honourable and ocular testimony, and that not many years past, it rained in Grand Cairo divers days together."[51] But what about rain in the Egyptian climate of, say, 2,500 years ago?

The fiction that Egypt is devoid of rain dates from at least the time of the Greek writer Herodotus (c. 484–430/20 B.C.), whose influential *Histories* frame the events and background of

the Greco-Persian wars (499–479 B.C.).[52] In Book 2 of the *Histories*, Herodotus contentiously discusses explanations of the Nile's annual floods, rejecting some arguments as absurd and others as plausible. Although he had traveled throughout much of Egypt, he clearly overstates the case against one possible source of the Nile's waters. Writing about countries along the Nile's course, including Egypt, he dismissively says that "the country is ever without rain and frost."[53] That a Greek traveler in Persian Egypt might have been offered such a remarkable weather tale is not surprising, especially if the drought-stricken locals were "ever without" sight of rain. Further muddying Herodotus's Egyptian interviews is his reliance on occasionally unscrupulous or incompetent Greek-speaking interpreters.[54]

However, linguistic evidence of rain's existence in ancient Egypt seems unambiguous. One authoritative Egyptological dictionary notes that cold and storms were far from unusual in antiquity and that Egyptian itself has literal and metaphorical terms for rain's various forms.[55] Similarly, another dictionary of Middle Egyptian (c. 2200–c. 1600 B.C.) has entries for both "cloudiness" and "rain."[56] Whatever its origins, the rainless Egypt of Herodotus is a fiction that has endured. The ancient Egyptians themselves had a variety of opinions about rain. For example, a prayer to Aton from Akhenaton's Amarna may seem to support Herodotus: "You have caused all the far distant countries to live, / For you have set a Nile in heaven, / That it might (bring) rain for them."[57] Of course, saying that foreign rain's Egyptian source is a heavenly river is quite different from Herodotus's claim that rain never fell in Egypt. As archaeologist Barbara Bell notes of Middle Kingdom art (1938–c. 1600 B.C.), "representations of flora and fauna . . . indicate rainfall conditions indistinguishable from the modern aridity,"[58] meaning that rainfall then was scanty but present.

In contrast to the implied message from Amarna, a temple inscription at Edfu places rain and storms squarely within Egyptian cosmology. The inscription describes the powers of Heru-behutet (or Horus Behdety), one of the many forms of Horus who fights with Seth.[59] As British Egyptologist E. A. Wallis Budge describes the inscription, Heru-behutet is a god who "dispels darkness and night, and drives away clouds, rain, and storms [that is, Seth]."[60] From the Egyptian *Book of the Dead*, the deceased appeals to the god of the moon and of learning, Thoth,[61] whom he joins in an unusual and ominous role: "I am he who sendeth forth terror into the powers of rain and thunder. . . . I have made to flourish my knife along with the knife which is in the hand of Thoth in the powers of rain and thunder."[62] Even more direct is a 1996 B.C. rock inscription from Wadi Hammamat, east of the present-day Nile town of Qift: "The wonder was repeated, rain fell. The highland was made a lake."[63]

Not only the dead, but also the quick, seemed to be familiar with rain in pharaonic Egypt. Many years after its initial closing, an opened Twelfth Dynasty tomb at Beni Hasan near Tell el-Amarna[64] proved to be an irresistible draw for some ancient Egyptians. Like awestruck modern tourists, they felt compelled to leave graffiti behind. Confused about whose memorial he was in, one of these men (probably a scribe) nonetheless was eloquent about what he had seen. Speaking of himself, he said: "He found it like heaven in its interior with the sun shining in it; {and he said,

'May heaven rain fresh myrrh} and sprinkle incense upon this temple of that Khufu, true of voice.'"[65] Our scribe had mistaken the governor Khnumhotep II's tomb (c. 1838 B.C.) for a temple of the grand Fourth Dynasty (c. 2575–c. 2465 B.C.) king Khufu, builder of Giza's Great Pyramid. Yet in this mistake of identity our ancient scribe suggests something of how rain, offerings, and the divine pharaoh were linked.

In addition to its written records, Egypt's architecture also strongly suggests that its ancient inhabitants could have seen rainbows. Waterspouts and other drainage devices appear in several pyramid precincts, one of which (c. 2480 B.C.) dates from Egypt's Old Kingdom.[66] Some of the waterspouts are quite large, suggesting that Egyptian builders anticipated the need to handle runoff from heavy downpours. Finally, the Nile itself would often have been a source of rainbows. At each of its six cataracts, sunlit water spray would have been a persistent feature where the river was at its most dramatic. Considering the Nile's central importance in Egyptian economic and religious life, plus the fact that its cataracts span some 800 miles of the river's length, the silence of ancient Egypt on the rainbow is all the more puzzling.

Tassili-n-Ajjer: A Rainbow in the Desert?

Fifteen hundred miles from and thousands of years before our scribe's visit to Beni Hasan, another African seems to have described rain on stone. In present-day southern Algeria, scattered collections of open-air pictographs are found on the high desert plateau called Tassili-n-Ajjer.[67] Today Tassili is a forbidding moonscape dominated by massifs, wadis, and weathered sandstone monoliths, but in the Neolithic era of several thousand years ago, it was a savanna that enjoyed a Mediterranean climate conducive to both herding and cultivation. The evidence for this favorable ancient climate comes not only from the herdsmen and animals of Tassili's rock paintings, but also from ancient pollen samples.[68]

Little known to Europeans until the early twentieth century,[69] the Tassili pictographs have become the subject of international archaeological study and since 1972 have formed the core of Algeria's Tassili National Park.[70] Figure 1-8 shows one of the park's most elegant pictographs: a horned running woman who may be a dancer or a goddess. Much of her body is covered with white dots that suggest scarifications, and she wears a fringed loincloth and arm bands.[71] She is rendered in the Round Head or archaic style, which places her among Tassili's oldest pictographs.[72] Around her are figures from a later Tassili style, and beneath her is a smaller archaic-style woman framed by the feature that interests us most—a banded arch resembling a rainbow.

Henri Lhote, one of the first archaeologists to see this pictograph, simply described these bands in 1959 as "an arch," presumably meaning a geologic feature such as a cave opening or rock shelter.[73] A more dramatic natural arch, such as Utah's remarkable sandstone Rainbow Bridge,[74] does not seem to exist anywhere nearby. Yet barring the unlikely existence of a constructed arch, might not Fig. 1-8's arch represent a rainbow? Several of the pictograph's features support this idea.

FIG. 1-8

Running or dancing woman, archaic style pictograph. Inaouanrhat site near Djanet, Algeria, fifth to sixth millennium B.C. (From Henri Lhote, *The Search for the Tassili Frescoes: The Story of the Prehistoric Rock-Paintings of the Sahara* [Librairie Arthaud, 1959]. Used with permission.)

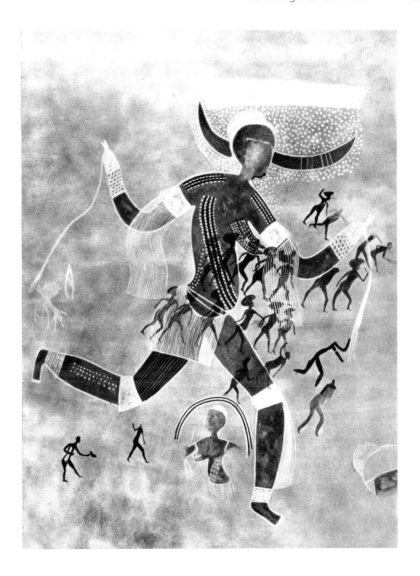

First, the running woman's stippling is most likely scarification. However, stippling would later be used in the Near East[75] and in Greece[76] to suggest divine rain. Thus the dots at the top of Fig. 1-8 may be either "a cloud of grain falling from a wheat field," as Lhote suggests,[77] or a cloud of life-giving water drops. Second, the wavy lines hanging from the woman's arms and waist are reminiscent not only of decorative fringes but also of the rain bundles seen in Mesopotamian cylinder seals.[78] We need not choose between these identifications; they may have coexisted for the ancient Tassilians. Third, the banding of Fig. 1-8's arch is one of the few distinctive features common to most ancient rainbows. For example, some aboriginal rainbow pictographs from the western United States (Fig. 1-9) share the banding and oblong shape seen in Fig. 1-8, and their resemblance to it is both striking and unexpected.[79] Great differences of time and place presumably rule out any cultural connection between Figs. 1-8 and 1-9, yet those very differences arouse curiosity about what common visual or artistic experience might have led to such remarkably similar rainbow shapes in ancient Africa and pre-Columbian America.[80]

16 — THE RAINBOW BRIDGE

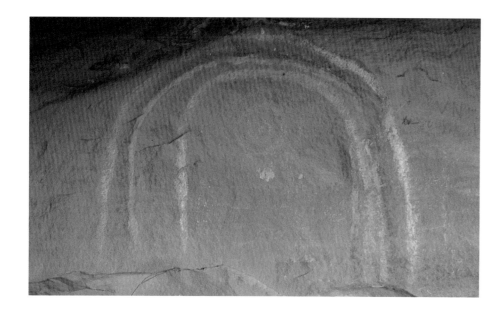

FIG. 1-9

Multicolored rainbow pictograph, Fremont culture. Red Hole Wash, central Utah, c. A.D. 400–1300 (photo: Kenneth Sassen, University of Utah)

Unlike ancient Egypt, Neolithic Tassili does not pose any vexing questions about whether its climate permitted rainbows. Although Tassili's rainfall was not prodigious, there seems little doubt that it was routine. Can we say with certainty that Fig. 1-8's arch is a rainbow? No, but several features suggest that it may well be, and if so, it is one of our oldest rainbow images. With the civilizations of Mesopotamia and Egypt millennia in the future, Neolithic pastoralists invested spiritual and artistic energy in depicting the portentous bow of the heavens.

Alcmene, the Rainbow, and the Meddlings of Zeus

As we noted above, stippling is sometimes used in ancient art to indicate rain. Figure 1-10 not only gives us a splendid example of this, but it also tells an intriguing story of the rainbow and divine lust. Unusual for ancient Greek bell-kraters (or wine jars), Fig. 1-10 is signed by its creator, the Paestan-school painter Python (fl. 330 B.C.).[81] Python has carefully labeled the principals of this crowded scene, including Zeus (upper left), Amphitryon (lower right), Antenor (lower left), Eos (goddess of dawn, upper right), and Alcmene (center, on log pyre).[82]

Alcmene is the hapless mother of Heracles (or Hercules), the superhuman hero of Greco-Roman mythology. Why is she hapless? As frequently occurs in Greek mythology, Alcmene's troubles begin with revenge. During King Electryon's reign at Mycenae, a vicious power struggle left Alcmene as the sole survivor among Electryon's children. After Electryon's nephew Amphitryon inadvertently killed the king, Alcmene refused to let Amphitryon consummate their marriage (which Electryon had arranged) until he had slain her brothers' killers. Amphitryon dutifully set sail on this mission of vengeance, but in his absence the ever-resourceful Zeus assumed his form and visited Alcmene. Zeus masquerading as Amphitryon assured Alcmene that her brothers' deaths had been avenged. The deception worked, and Alcmene unwittingly slept with Zeus for a single

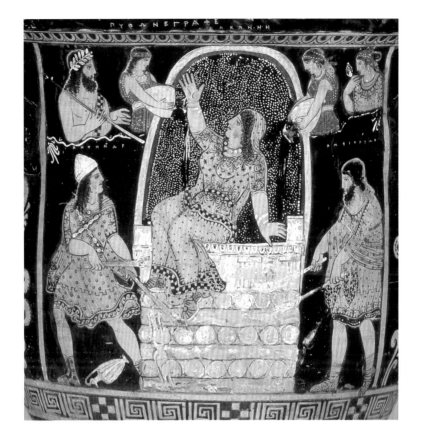

FIG. 1-10
Python, Alcmene saved from the pyre by Zeus. Red-figure bell-krater, c. 330 B.C. The British Museum, London

night, which he miraculously turned into three. Heracles was the offspring of this fraud by Zeus.[83]

The real Amphitryon returned that same night with a story of success that must have sounded oddly repetitious to Alcmene. Presumably, she innocently greeted her cuckolded husband and told him about a heroic wedding night that was news to him. Python shows us the near-fatal consequence for her. Although Amphitryon and Alcmene would shortly conceive Heracles' twin brother Iphicles, Alcmene's future seems doubtful indeed in Python's krater. Amphitryon, now filled with his own thoughts of vengeance, has chased Alcmene to an altar where she seeks refuge and before which stands a log pyre. Amphitryon and his companion Antenor hold torches to the pyre, prepared to destroy Alcmene for her infidelity.

In her extremity, Alcmene throws up her arm and appeals to Zeus for salvation, unaware that he is the author of her troubles. Whether to save Alcmene or the unborn Heracles, Zeus intercedes by calling forth a storm to extinguish the pyre's flames. Three stylized lightning bolts (resembling upturned vases) have already been hurled and lie near the pyre's base. More important for Alcmene, Zeus's life-giving rains also have begun to descend, poured from hydria by two of the rainmaking Hyades.[84] A cloud of stippled raindrops surrounds the streams of water. Framing Alcmene at her moment of salvation is this rain's natural accompaniment, the arch of the rainbow. Although scholar Arthur Cook speculated in 1940 that this "appears to be the earliest naturalistic representation of a rainbow in ancient art,"[85] we now believe that it has

predecessors. Like its similarly shaped aboriginal cousins (Figs. 1-8 and 1-9), Alcmene's oblong rainbow probably is fused with a purely mythological figure, in this case Iris.

Alcmene's rainbow serves the same function as some rainbows in images and texts from the ancient Near East—it is a sign of a covenant (no matter how expedient) and of a deity's intervention (no matter how ironic or self-serving). The rainbow is Alcmene's personal bridge to the divine, a symbolism that is used repeatedly in art of the West and the East (see Chapters 2 and 3). Before we embark on that survey, however, we want to explore the rainbow's many other mythological uses around the world. We begin by examining Iris, the best-known rainbow deity of the ancient West.

Iris: At the Service of the Gods

In the Greek pantheon, the antiquity of Iris is as great as her importance is small. In some genealogies, Iris was only two generations removed from Gaea, the disk of the earth. Greeks viewed Gaea as their "broad-bosomed Mother Earth."[86] That Gaea's granddaughter should personify the rainbow, companion of the life-giving rain, is not surprising. However, Iris's immediate family was less agreeable than her ancestry might suggest. Daughter of the gods Electra and Thaumas, fair Iris had the four loathsome Harpies as sisters, vile-looking and vile-smelling birds with women's heads.[87] A child of better fortune, Iris wears the rainbow's colors and flies about on golden wings in her duties as messenger. Often she carries a caduceus to distinguish her from other minor winged goddesses such as Nike or the Harpies.[88] Figure 1-11 shows a winged Iris with her caduceus, one of several Iris types represented in antiquity. In the fifth century B.C., Iris was deemed important enough to merit separate sculptures on a pediment and metope of the Parthenon.[89]

Despite her appearance on the Parthenon, however, Iris was a distinctly minor deity. Her only cult appears to have been limited to the Aegean island of Hecate near Delos.[90] Although Iris occasionally originated messages, usually she was merely a mouthpiece for the gods, in particular Hera (Roman Juno).[91] One eighteenth-century account of Iris says that she "attended so close upon *Juno* that she never left her and, *Callimachus* [c. 305–240 B.C.] tells us, that when she wanted Rest she leaned against the Throne of that Goddess."[92]

Iris carried messages from god to god and from gods to mortals, frequently serving Zeus in the latter capacity. For example, Iris the messenger appears in nine of the *Iliad*'s twenty-four books (see Fig. 1-5). As befits a divine messenger, her speed is that of the winds, whom she sometimes follows.[93] Yet her messages were seldom of peace or good fortune—usually she told of battle, death, or the gods' counsels.

Iris's role was not always so passive. She sometimes drew water from the sea to prime the clouds with rain, thus reversing the cause and effect we see in Fig. 1-10. Whenever Zeus was vexed by quarreling or lying gods, he dispatched Iris to fill a golden jug with water from the holy River Styx, and he then made the gods swear their most binding oath by it. Gods were ill-advised to break this oath, for the punishment was one year "wrapped in a malignant coma" and nine

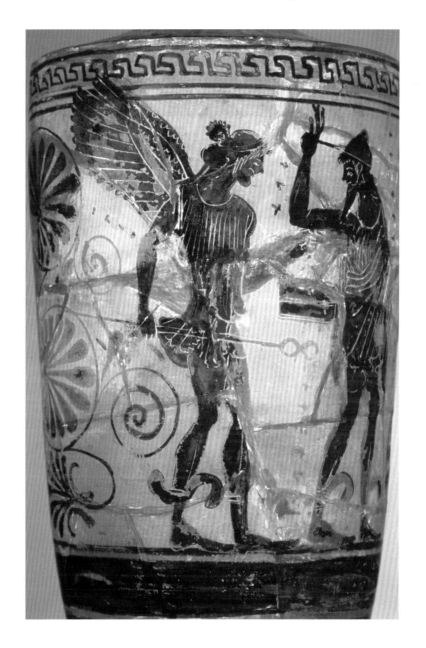

FIG. 1-11

Diosphos Painter, a winged Iris holds a caduceus in her right hand and faces her male counterpart, the messenger Hermes. Black-figure lekythos, c. 495–480 B.C. University Museums, University of Mississippi (photo: Maria Daniels/Perseus Project, courtesy of the University Museums, University of Mississippi Cultural Center)

years' banishment from Olympus.[94] Perhaps Iris's most somber task was to separate the souls of dying women from their bodies by cutting their hair, her most famous client being Carthage's Queen Dido in the *Aeneid* of Virgil (70–19 B.C.).[95]

Figure 1-12 depicts the fatal aftermath of Aeneas's abrupt departure from Carthage. Dido, despairing at her lover's abandonment, has thrust Aeneas's sword into her breast as his ships disappear in the distance. Juno takes pity on her death agony and dispatches Iris: "So therefore Iris, saffron-winged, sparkling like dew and trailing a thousand colours as she caught the light of the sun, flew down across the sky. She hovered over Dido's head: 'By command I take this lock as an offering to Pluto; and I release you from the body which was yours.' Speaking so, she held out

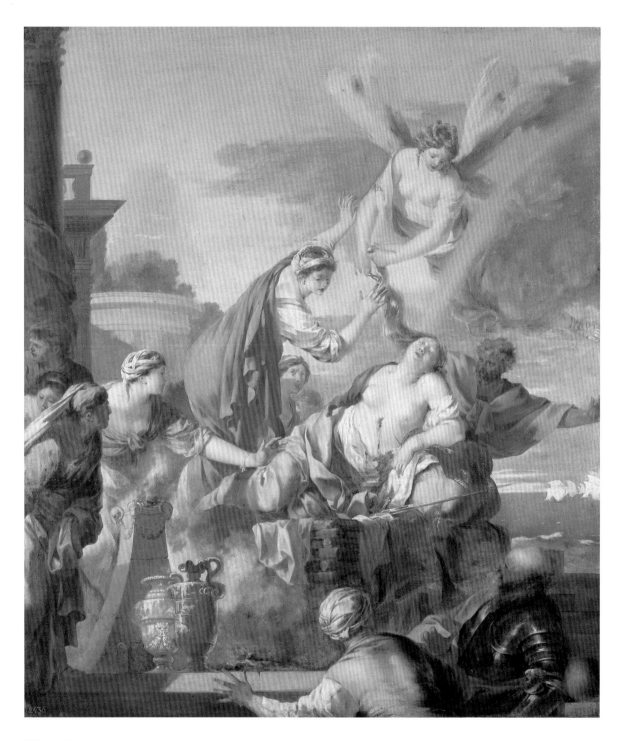

FIG. 1-12
Sebastien Bourdon (1616–71), *The Death of Dido*, c. 1640. The State Hermitage Museum, St. Petersburg

a hand and cut the lock. At once, all the warmth fell away, and the life passed into the moving air."[96]

Iris appears here both as goddess and as rainbow, a pairing seen again in Fig. 7-2. Dido's sister and her attendants react with understandable shock to the gory scene that Virgil describes. Yet the woman with upraised arms (probably Dido's sister) tries only halfheartedly to stay Iris from her lethal but merciful act. Iris and the rainbow are the agents that let Dido complete her last wish: "Now my wraith shall pass in state to the world below."[97] Once again, the rainbow serves as a bridge from this world to the next.

Iris as the iris

Whatever Iris's duties in antiquity, we now tend to think of her as the goddess of the rainbow. Yet in Greek and Roman literature, her rainbow attributes tended to be less important than her ever-changing role as herald. Homer employs her as a messenger throughout the *Iliad*, yet Hermes completely replaces her in the *Odyssey*. Virgil's Iris has responsibilities never hinted at by Homer. For Ovid (43 B.C.–A.D. 17), Iris rouses the god Sleep in his cavern, whereupon he dispatches his son Morpheus to enter Alcyone's dreams, take the form of her husband Ceyx (king of Trachis), and tell her that Ceyx has drowned at sea.[98]

But what of Iris as the iris or the rainbow itself? In 1878 William E. Gladstone, the once and future prime minister of England, wrote a lengthy article on Homer's treatment of Iris. Although much of Gladstone's article is now dated, one of his conclusions still seems valid. Speculating on Homer's literally colorless presentation of Iris, Gladstone says: "Evidently Iris the messenger is a personification from Iris the rainbow. And I find, as a general rule, that when Homer has to present an Olympian personage, who stands in some relation to a particular phenomenon or power of Nature, he carefully holds back, as far as may be, the signs of the connection."[99] That the ancients should simultaneously anthropomorphize *and* denature natural phenomena is certainly consistent.

Like many other gods, Iris was continually redefined in antiquity, and eventually the rainbow merely became her transient pathway, appearing and disappearing at her command.[100] The sudden appearance and disappearance of the natural rainbow's bright colors obviously helps explain the emphasis throughout antiquity on Iris's speed and brilliance. Similarly, the apparently huge size of a rainbow seen in distant rain (see Appendix) makes the notion of a bridge to heaven's heights easily understandable. Yet before Aristotle (384–322 B.C.), few Greek writers resisted the fashion for describing the rainbow anthropomorphically. Xenophanes (c. 560–c. 478 B.C.) was a poet and natural philosopher who did resist, and with considerable energy. In his surviving *Fragments*, he firmly notes: "And she whom they call Iris, this too is by nature a cloud, purple, red and greenish-yellow to behold"[101] —a description on which Aristotle himself would later elaborate.

Linguistically, Iris is still very much alive. Whether as the iris flower, the iris of the eye,[102] or the colorful iridescence of pearls and soap bubbles, the association of Iris with color and sight

continues to the present. The iris lineage is plainly evident in languages other than English. In medieval and Renaissance Latin, numerous writers on the rainbow entitled their works *De iride* (On the Rainbow),[103] and in fact "iris" remained a common scientific term for the rainbow into the eighteenth century.[104] In vernacular speech, variations on the rainbow "iris" still exist in Italian, Spanish, and Portuguese.[105]

Now we step outside Western and Near Eastern antiquity to see how other cultures have explained the rainbow. As was true in our research on commercial images of the rainbow (Chapter 10), any initial conceit we had about assembling an exhaustive list of rainbow myths eventually succumbed to reality—we stopped counting at 150 myths. Faced with this embarrassment of riches, here we offer only an overview of these rainbow myths' common threads, plus some of their more interesting loose ends.

Australia: Rainbow Serpents and the Dreaming

One of the commonest depictions of the rainbow is as a snake. In cultures ranging from Australia to Estonia, rainbows are seen as gigantic, often malevolent, serpents who inhabit the sky or ground. (Although we usually describe rainbow myths in the present tense, remember that any particular myth may no longer be extant.) While both the rainbow arc and snakes are curved and thin, the obvious similarities end there. Why then is this association so common?

English anthropologist A. R. Radcliffe-Brown has speculated that the Australian Rainbow Serpent is "the most important representation of the creative and destructive power of nature, principally in connection with rain and water."[106] In Australia's Arnhem Land, the paired creative and destructive powers of the Rainbow Serpent may stem from the chaos of coastal flooding that accompanied the end of the last ice age.[107] Aborigines' fear of and respect for the rainbow are seen in many other cultures, and it mirrors similarly mixed emotions about serpents. So it seems natural that these two morphologically and emotionally similar forms should often be joined together in myth.

Yet we should not be too literal in our interpretation of the Rainbow Serpent. As the Romanian-American scholar Mircea Eliade has noted: "The Rainbow Snake is no more a rainbow than a snake. The 'natural' meteorologic[al] phenomenon and the 'natural' reptilian species are religiously valuable because they are related to a religious structure, that of the Rainbow Snake."[108] Most important, the Australian Rainbow Serpent is a mythic being of the Dreaming, the legendary Aboriginal time that began with the world's creation and that has no end. People, animals, and eternal beings like the Rainbow Serpent are all part of the Dreaming, and everyday life is affected by the Dreaming's immortals.[109] Figure 1-13 shows an ancient Aboriginal pictograph of a Rainbow Serpent, and the oldest of these paintings are now believed to date from about 4000 B.C.[110]

Aborigines in fact hold a wide range of Rainbow Serpent beliefs, and the serpents themselves bear many different names across the continent. Aborigines near the Pennefather River, North Queensland, label both the rainbow and its serpent as Andrénjinyi, a vividly colored snake who ends the rains sent by their enemies.[111] For opposite meteorological results, the Yualai

FIG. 1-13
"Yam style" Rainbow Serpent pictograph. Western Arnhem Land, Northern Territory, Australia, c. 4000–2000 B.C. (photo: Paul S. C. Taçon, Australian Museum, Sydney)

of New South Wales paint on posts the sign of their Rainbow Serpent, *Kurreah*. However, *Kurreah* has a darker side, lying in wait for humans in deep waterholes so that it can swallow them whole.[112] Throughout Australia, shamans and rainmakers share in the Rainbow Serpent's powers, which they control with prismatic quartz crystals and iridescent pearl shells.[113] One example of this shared power comes from medicine men in western Australia's Kimberly region, who ascend to heaven on Ungud, the Rainbow Serpent.[114] Alone among all people, shamans can see the Rainbow Serpent and suffer no harm when they enter its pools.[115] In New South Wales, the Wirajuri say that shamans follow a thunderstorm's rainbow to its end in a waterhole. The shaman dives to find the Wāwi, a serpent-like creature who lives there and who schools him in new ceremonial songs that he takes back to his people. Like the rainbow, the Wāwi's size can change from tiny to enormous.[116]

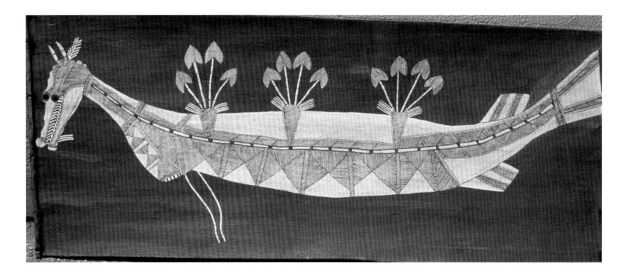

FIG. 1-14

Lofty Nabarrdayal, *Yingarna the Rainbow Serpent*, 1982. Bark painting, Oenpelli, Australia (photo: Luke Taylor, National Museum of Australia; reproduced by permission of Injalak Arts and Crafts Association, Gunbalanya, Australia)

In western Arnhem Land, the Kunwinjku honor a primordial Rainbow Serpent called Yingarna (Fig. 1-14). Like most Rainbow Serpents, Yingarna is the Kunwinjku's original creator being, and they describe her as the "mother one," a role reminiscent of the Greek Gaea.[117] Nominally female, Yingarna has androgynous qualities that are matched by those of her first-born son, Ngalyod. As we shall see shortly, the rainbow's ambivalent sexuality is common in Australia and elsewhere. Yingarna's very form is confused, as in Fig. 1-14, where she combines elements of snake, fish, crocodile, catfish, emu, and kangaroo.[118] This amorphousness tells knowledgeable Kunwinjku that Yingarna has great powers of transformation.[119]

During the Australian dry season, Ngalyod retreats to deep waterholes, another common theme in Australian Rainbow Serpent myths. He sucks up water during the dry season and expels it as rain during the wet season. Like the Greek Iris, Ngalyod helps to ensure the fertility of the land by creating rain, especially the monsoons. When the Kunwinjku see a rainbow in a rain shower, they say that Ngalyod is standing up into the sky.[120] Yet like the rains, Ngalyod can destroy as well as nurture. He can punish Kunwinjku who unintentionally damage his sacred sites by loosing blindness and disease on them and their people. Kunwinjku shamans can control this destructive force in their healings. In a more fundamental way, the Aborigines' rainbow *is* humanity, because it causes the "energy" and "breath" that gives people life.[121]

Serpents of the Sky and Earth: Rainbow Snakes Worldwide

Among the peoples of the southern Pacific, Australia's Aborigines are not alone in ascribing great powers to a rainbow snake. For the Feranmin of Papua New Guinea, an alien being called Magalim lives in the bush.[122] Magalim has power over many destructive natural forces, includ-

ing thunderstorms and earthquakes, and he assumes myriad forms while maintaining an essential spiritual indivisibility. Magalim resembles a python but, like the Aboriginal Rainbow Serpent, is of huge size. Magalim takes the rainbow *wepal* as his sign, and his skin has the rainbow's shimmering colors. Real snakes encountered by the Feranmin may share Magalim's properties such as his skin's iridescence.[123]

A Feranmin myth tells how snakes were once given the ability to become immortal by repeatedly shedding their skins, but the myth concludes that snakes soon lost their grasp on immortality and that humans never acquired it. Thus the two creatures forever remind one another of their mutual mortality. Many Feranmin resist the original myth's conclusion and believe that most snakes cannot die until they first see a person. As anthropologist Robert Brumbaugh notes, "Snakes show man the potential for immortality, while men show snakes the reality of death."[124] As in Australia, the rainbow serpent is humanity's link with the immortal.

Like myths of Australia's Kunwinjku, Estonian folklore also casts the rainbow snake as a giver of rain. After the Estonian rainbow serpent sucks up water from rivers, seas, and lakes, it sprinkles the water back to earth as rain. Just as Yingarna's zoology is jumbled, the Estonian serpent is confusingly given an ox's head.[125] But because rainbows often are seen after a storm, they may also be given the opposite power of ending the rain. As was true for the Pennefather Aborigines, the Toba Indians of the Argentine Chaco have a rainbow serpent who stops the rain. Unlike the Pennefather serpent, the Toba rainbow Wosa'k appears only when he is angry at humans.[126] For the Luhya of western Kenya, the rainbow's ability to stop rain depends on cooperation between the sexes. The Luhya hold that God created a male rainbow (primary rainbow; see Appendix) and a female (secondary) rainbow. The narrow male rainbow cannot by itself stop rain, but if it is followed by the wider female rainbow, then the rain ends.[127] Meteorologically, this sequence makes some sense because the fainter secondary rainbow will become visible *after* the primary rainbow and closer to a passing shower's end.

In eastern Nigeria, the Igbo people also link death, the rainbow, and serpents. For Igbo artists, the rainbow *egurugru* is represented as a double-headed python, and Igbo folklore says that it was not always large enough to fill the sky. Only after feeding for years in a river did *egurugru* reach its present enormous size.[128] While the rainbow's presence may be either good or evil, the "falling of a rainbow" (probably the rainbow's end seeming to touch the earth) is ominous indeed. When a rainbow falls, an important Igbo man will soon die, and the place of the falling (the rainbow's end) marks the unfortunate's location.[129] In Malaysia, seeing just the rainbow's end by itself in the western sky signals the impending death of a raja.[130] The notion that a rainbow marks the location of a divinity or a person of high birth is widespread: in separate myths, the Hawaiian chiefess Hoamakeikekula and a chief's son, Ho'oka'aka'aikapaka, can be tracked by following the rainbows that attend them.[131]

Dan Ayido Hwedo, the rainbow serpent of Benin's Dahomey, had much more momentous tasks. Encircling the world, Dan bites his own tail to bring together the world's disparate parts, and he also builds its mountains with his excrement.[132] For Zaire's Luba, the rainbow *nkongolo* takes its form from two snakes copulating in the sky.[133] Nkongolo, a legendary man of the Luba

genesis story, is infamous for his cruelty, and a related Luba term combines meanings for "dragon," "rainbow," and "mythic serpent that digs rivers and eats people."[134]

In Native American legend a great snake lives in Niagara Falls, an idea perhaps suggested by the rainbows seen year-round in the waterfalls' spray.[135] The Shoshoni of the American West viewed the sky as an ice dome against which an enormous rainbow serpent rubs its back. Ice falling from the dome produces snow in winter and rain in summer, once again making the rainbow a source of life-giving rains.[136]

Perhaps the most famous mythic serpent of the Americas is Quetzalcóatl, the Feathered Serpent of the Mexican Teotihuacáns, Toltecs, and Aztecs (spanning, in sequence, the third through sixteenth centuries A.D.). Quetzalcóatl's name stems from the iridescent quetzal bird, whose long green tail feathers symbolized vegetation, and *coatl* ("snake"). In his earliest forms, Quetzalcóatl seems to have been a vegetation deity, and he was associated with the rain god Tlaloc.[137] Thus one of the colorful Quetzalcóatl's earliest guises may have been as a rainbow serpent.[138]

Pestilential and Medicinal Rainbows

Odd as it may seem, the rainbow is viewed not only as a giver of life but also as a spreader of disease and injury. While Australian Aborigines believe that a powerful nature spirit such as the Rainbow Serpent can inflict damage, the rainbow by itself is not usually dangerous. Other peoples' views of the natural rainbow are less charitable.

For the Semang of Malaysia the rainbow is a huge python that infects any earth it touches. Because these sites are dangerously unhealthy, the Semang are ill-advised to live nearby. Another aboriginal Malay people, the Senoi, know that walking beneath a rainbow leads to a fatal fever.[139] Similar ideas on rainbow-borne disease occur across the Java Sea in Australia. During Australia's colonization, Aborigines near Melbourne called the European-introduced smallpox the "scale of Mindi," their Rainbow Serpent. In the 1840s, Aborigines grew excited by the prospect that Mindi's coming would mean death by smallpox for the Europeans.[140] Natal's Zulu people view the rainbow with emotions no less mixed. They acknowledge its importance as "the Queen's Bow" or one of the roof supports in the Queen of Heaven's house.[141] Yet they also fear it as a disease source. A Zulu named Utshintsha tells of being chased from his garden by a rainbow and concludes: "Men say: 'The rainbow is a disease. If it rests on a man, something will happen to him.' So, then, after the rainbow drove me from the garden, my body became as it is now, that is, it was affected with swellings."[142]

Malignant rainbows are found in the Americas as well. Like the Zulus, ancient Peruvians (c. 1400 B.C.) claimed that a rainbow entering a person's body causes grave illness. However, they allowed that anyone sickened by a rainbow "will be cured if he unravels a ball of yarn made of seven colors," presumably undoing the rainbow colors' bad works.[143] Sometimes the rainbow protects rather than afflicts. A Fang holy man in Gabon tells an unscrupulous villager who kept a piece of a rainbow that it is to be used to guard against sorcery.[144] In Colombia, the former Chibcha tribe honored Chuchaviva as the rainbow goddess who aided people stricken with fever

and women in labor—nicely reversing the negative effects of the Senoi's pestilential rainbow.[145] Ix Chel, Mayan goddess of medicine and women's patron deity,[146] has also been identified as goddess of the rainbow.[147] In the latter role, she added to Chuchaviva's good works by bringing rains, making women fertile, *and* guarding them during childbirth. In German mythology, the rainbow is the source of golden water bowls that can cure children's fevers and ease women's labor pains.[148]

Sex and the Single (or Double) Rainbow

Sometimes the rainbow causes, rather than safeguards, childbirth. A creation myth from the ancient Acoma pueblo in New Mexico recounts the dawning awareness of the first two humans, the sisters Ia'tik and Nao'tsiti. Frustrated by her unseen father's prohibition against having children, Nao'tsiti encountered a snake whose ready counsel was "Go to the rainbow; he will show you." "Soon afterward," the myth holds, "Nao'tsiti was sitting alone on a rock when it rained. It was so hot that the rain cracked on the ground, and she lay on her back to receive the drops. As the water dripped into her, the rainbow did his work and she conceived without knowing it."[149] A similar impregnation feat is possible for Cuichi Supai, rainbow deity of Ecuador's Indians.[150]

Such rainbow virility seems to be the exception rather than the rule, however. For the Panare Indians of Venezuela, the rainbow shares a reversed, or biologically unproductive, sexuality along with the moon, sun, and Milky Way.[151] Not strictly homosexual, this "reversed" sexuality simply means to the Panare that the rainbow does not participate in reproduction.

The sexuality of Australia's Rainbow Serpent can be ambiguous (for example, Yingarna and Ngalyod), a characteristic not at all unusual for primeval creation beings. For other Aborigines, the Rainbow Serpent may be either bisexual or female.[152] Sometimes the rainbow's colors determine its sex, as we saw in the Luhya story of the primary and secondary rainbows. Ancient Chinese beliefs agree with this sex separation, making the brighter primary rainbow male and the darker secondary bow female.[153] Another example of rainbow gender comes from a Navaho man who describes the primary rainbow as female and the rarer white rainbow (or cloudbow; see Appendix and Chapter 8) as male.[154]

In some folklore, the rainbow's most prominent sexual trait is its ability to change people's gender. For Bohemian girls younger than seven years old, passing beneath the rainbow is a transsexual experience.[155] Hungarians are less restrictive and believe that sex changes happen to anyone who passes through the arch.[156] Serbian, French, and Albanian folklore all give the rainbow transsexual power over humans (and sometimes animals).[157] Two Ohioans recently offered different accounts of rainbow-driven sex changes.[158] The Chinese *I Ching* (twelfth century B.C.) hints at the sexual mutability of the rainbow when it says "The rainbow is the combination of yin and yang," the complementary female and male opposites contained in all life.[159] The seemingly strange optics of real rainbows probably prompts such beliefs (see Chapter 4, "The Inescapable [and Unapproachable] Bow").

Several cultures describe the rainbow as a bride, perhaps as a way of signifying physical

dependence or nascent sexuality. For example, the Iroquois guardian of heaven is Hino the Thunderer, and he takes the rainbow as his bride.[160] Among the Berber tribes of North Africa, the rainbow is variously known as the "bride of the rain" or the "bride of the sky." Berbers and Arabs in North Africa's Maghreb region echo this idea in their rainmaking ceremonies. A wooden spoon is dressed to resemble a bride and then carried amid rainmaking chants delivered at local priests' tombs.[161] A similar image of the rainbow comes from the Arabic poet Ibn ar-Rumi (d. c. A.D. 896), who describes it as a maiden clad in colorful layered robes, each robe shorter than the one beneath it.[162] Occasionally the rainbow's marital role is reversed, as in Tierra del Fuego where the Yámana call the rainbow the husband of the moon.[163]

Pointing at the Rainbow: The Near-Universal Taboo

You may not have thought about the dangers of pointing at the rainbow, but rest assured that much of humanity has. In places as widely separated as Hungary, China, Mexico, and Gabon, pointing (or even looking) at a rainbow is a foolhardy act. Hungarian folk belief says that a person's finger will wither after pointing at the rainbow, a grim prophecy surpassed by the Chinese text that promises immediate ulceration of the offending hand.[164] A Chontal-speaking Mexican recalled: "My father tells me that when the rainbow appears it is not good to point with the finger because it breaks the machete."[165] The Fang of Gabon are even more cautious and may forbid children either to bathe in rainwater or to look at the rainbow.[166] Sumu Indians of Honduras and Nicaragua hide their children in huts to protect them from looking or pointing at the rainbow.[167] The dire and occasionally lethal consequences of pointing at the rainbow have been recorded in more than a dozen other locales. Getting jaundice, losing an eye, being struck by lightning, or simply disappearing are among the unsavory aftermaths of rainbow pointing.[168]

Why should this seemingly innocuous act cause such widespread fear? First, the rainbow's powerful (and not always benign) symbolism earns it a special respect that often borders on fear. Second, prohibitions against pointing with a finger (especially the forefinger) at people and things are found from ancient Babylonia to the modern West.[169] Certainly anyone foolish enough to curse a deity or spirit implicitly by pointing at it should expect horrific payment in kind. So if we combine a child's natural instinct to point at the bright, colorful rainbow with an adult's finger-pointing taboo, dire warnings are the predictable result.

But many folk beliefs go beyond merely avoiding the rainbow's spiritual power—they try to manipulate it. Zambia's Ila are cautious enough to point at the rainbow with a pestle when they want to make it disappear.[170] In "breaking the rainbow," Slavic children linked hands or fingers, separately or individually, and then strained to break the link and thus make the rainbow disappear.[171] Children in Staffordshire, England, attempted to do the same by crossing a pair of sticks or straws on the ground and placing a stone or two atop them, the goal being literally to cross out any rainbow they saw.[172] These rituals are doubly safe—participants simultaneously rid themselves of the rainbow's unwanted effects and observe the taboo against pointing a finger at

it. In the same spirit, a rainmaking formula from suburban Moscow calls for catching a frog, tying its leg to a ladder rung, and putting "a sickle above it so that it makes a rainbow over it."[173] The frog's cries will supposedly cause rain.

What is the purpose of these rainbow rituals? A. B. Strachov argues that it is very simple: to stop unwanted rain or to cause needed rain, all the while avoiding the dangers of rainbow pointing.[174] Because the rainbow's existence requires sunlit rain, the rainbow can be used as a short-term weather forecasting tool. So if the various rainbow rituals are applied with some foreknowledge, they appear to work and thus seem all the more credible. Consider a simple and familiar rainbow forecast from American and European weather folklore:

Rainbow in the morning, sailors take warning;
Rainbow at night, sailors' delight.[175]

Throughout much of North America and Europe, weather systems tend to move from west to east. Because the rainbow is seen opposite the sun, a morning rainbow means that rain is falling to the observer's west and thus is likely to arrive soon ("sailors take warning"). Conversely, a late-afternoon rainbow ("night" here obviously is poetic, not literal) means that rain is to the east and thus is receding from the observer.[176] Because many rainstorms occur in the afternoon, the rainbow is often (and quite fittingly) taken as a sign of fair weather to come.[177]

In agrarian (or even recently urbanized) communities, too much or too little rain has consequences far more serious than mere inconvenience. Even if rainfall is adequate, its timing can help or hinder plant growth and harvest. Thus the belief that one can control rainfall by ordering the rainbow to appear or disappear makes rainbow rituals and rhymes seem worthwhile.

Rainbow Beasts, Demons, Odds, and Ends

As the story of Iris indicates, one of the rainbow's oldest mythic tasks is to charge clouds with rainwater. To do this, the Greek Iris drafts water from oceans, lakes, and rivers. She is far from alone—the image of the rainbow "sucking up water" is spread across many cultures. In his *Georgics* (37–30 B.C.), Virgil casually notes that "a great rainbow drinks."[178] Hungarians[179] and Estonians make the rainbow draw up water, while Siberia's Ostiaks call the rainbow "The thunder drinks water."[180] In western Africa, the Ewe peoples believe the rainbow Anyiewo is a huge serpent that spans the sky when it is thirsty so it can drink from the opposite side of the world.[181] Nigeria's Yoruba reverse this flow as their great rainbow serpent comes from beneath the earth to drink the sky's water.[182] On the Malay Peninsula, the drinking rainbow may take the form of a snake or the entrails and head of a horse or bullock.[183]

Rainbows apparently need to dine as well as drink, and few myths make them out to be dainty eaters. Among the Masai of Tanzania and Kenya, the rainbow's diet includes whole cattle. For Kenya's Kikuyu, the rainbow Mukunga Mbura is even less finicky, as evidenced by the cattle

and people it disgorged from a cut on its little finger.[184] In Washington, Makah Indians lived uneasily with a rapacious rainbow spirit that seized passersby with strong talons and that was associated with the thunderbird, itself a cause of rain and lightning.[185] Equally vicious was the rainbow snake-fish *Takkan* of Australia's Kabi, which could shatter mountains and slaughter people if the mood suited.[186] Even Zulus who were not afraid of rainbow diseases might avoid bathing in large pools where a rainbow could eat them in its occasional lair.[187]

The rainbow can arrange to have people swallowed even if it has no interest in eating them itself. Argentina's Toba and Pilagá Indians tell how a group trying to kill Rainbow suddenly found themselves its prey. Having been smoked out from his cave, Rainbow suddenly turned on his pursuers, "stuck out his tongue, and the men sank under the ground on the very spot where they stood."[188] Rainbow treated a second party to the same earth-swallowing treatment and then made plants grow where his tormentors had stood. In a similar story from Tanzania, a livestock-hungry Chaga man prayed for cattle at an especially auspicious place: the rainbow's end. His prayers unanswered after many days, he angrily slashed the rainbow in two with his sword. Although half the rainbow rose into the sky, the other half sank into the ground and left a huge hole. Hapless souls who descended into this hole at first found a very agreeable country beneath the earth. Unfortunately they soon were pursued by subterranean lions, and the lions' growls were the only sound that greeted a second group of would-be settlers.[189] In these two ominous tales, the rainbow once again serves as a bridge to another world.

The Ewe fear that their great serpent Anyiewo, heralded by his rainbow reflection in the clouds, will instantly devour any person that he touches. Between rainstorms, Anyiewo lives in an anthill, and so anthills share the rainbow's dread reputation.[190] A remarkably similar fusing of "anthills" (properly speaking, termite mounds), serpents, and the rainbow comes from India. There thousands of termite mounds are worshiped as the home of a serpent who guards a treasure. This serpent is often fearsome indeed, described as spitting fire and creating the rainbow from a jewel in its head. Whatever their other sectarian differences, India's Buddhists, Hindus, and Muslims share a common set of stories that joins earth mounds, serpents, rainbows, and treasure.[191]

Americans[192] and Europeans may fancy themselves originators of the belief that golden treasure lies at the end of the rainbow,[193] but they clearly have competition. While Africa's Ewe fear the appetite of their ravenous rainbow serpent, they prize places where Anyiewo touches the earth, for there the serpent leaves behind rare and desirable beads.[194] The Ewe's Dahomey neighbors similarly believe that the rainbow's ends leave behind prized decorative beads—or more lucratively, buried gold.[195]

At first glance, some animistic rainbow myths seem inexplicable. We might accept with aplomb associations of the rainbow with birds[196] or fish.[197] Yet when the Yakuts and Buryats of Siberia describe the rainbow as "the urine of the she-fox" and the Kirgiz of Central Asia call it "the old woman's sheep halter,"[198] bafflement is entirely understandable. However, a little puzzling and some background helps explain these two mysteries. We know that the rainbow is a colorful arc, so might not unsqueamish Siberians identify it as a graceful, colorful arc of urine?

As for the sheep halter, the Kirgiz story tells of a man whose two wives quarreled constantly. Cursed by her mother-in-law, the older wife escaped to the sky with her sons and cattle, and since then the rainbow has been her sheep tether.[199]

Not all mythic rainbows are so tangible. Sumu Indians may simply refer to the rainbow as *walasa aniwe*, "the devil is vexed."[200] Guyanese believed that the rainbow *yolok* was a disease-bearing evil spirit.[201] In a Chinese folktale, rainbows contain the souls of two star-crossed lovers, the man Hsienpo and the woman Yingt'ai. The tale concludes that if the lovers "ever want to be together, undisturbed and unseen, so that no one on earth can see them or even talk about them, they wait until it is raining and the clouds are hiding the sky. The red in the rainbow is Hsienpo, and the blue is Yingt'ai."[202] For ancient Akkadians, a star called Rainbow graced the constellation we know as Andromeda.[203] For Buddhists, the rainbow represents the highest state achievable before attaining Nirvāna, where individual desire and consciousness are extinguished.[204] Initiates into the Fang religion Bwiti have a similarly transcendent experience when they arrive at the rainbow's center, for there they can see both the entire circle of the rainbow and of the earth, signaling the success of their vision.[205] In fact, the rainbow seems to be a bridge to the divine as often as it is a serpent.

Rainbow Bridges of Every Stripe

Imagining the rainbow to be an enormous celestial bridge is merely a fancy for us, but it is an image taken quite seriously in many cultures. Occasionally rainbow bridges are literal, not metaphorical. In ancient China, elegant arched "rainbow" bridges spanned streams too wide or swift for conventional pier bridges. If the rainbow is eternal, rainbow bridges are not far behind. One dated to A.D. 1207 still bears traffic, and records of Chinese cantilever bridges predate this by a millennium.[206] Naturally, present-day rainbow spans can bear more traffic than their ancient predecessors, as the Rainbow Bridges over the Niagara River and Tokyo Bay attest.[207]

We have already seen that the rainbow is a kind of celestial girder in the Zulu story of the Queen of Heaven's house. Similar beliefs come from Navaho and Hawaiian mythology. In the Navaho creation story, a pair of rainbows crossed like rafters at the zenith of a proto-world so small that the "heads and feet of the rainbows almost touched the men's heads."[208] By the miraculous intervention of the man Atseatsine and the woman Atseatsan, the sky and the sun are partly lifted to their proper places. Atseatsine's technique, although not entirely successful, is simplicity itself: "I have the sunbeams; I have a crystal from which I can light the sunbeams, and I have the rainbow; with these three I can raise the sun."[209] The rainbow forms a more modest support for Malanaikuaheahea, beautiful wife of the mythical Hawaiian seer Makali'i, for whom "the sun shone at her back and the rainbow was as though it were her footstool."[210] We shall encounter this image again, for the rainbow as a divine support is a persistent feature of Christian painting through the sixteenth century (see Chapter 2).

In Japanese mythology, the male and female creator beings Izanagi and Izanami descended on the Floating Bridge of Heaven to create land from the ocean of chaos. Izanagi thrust his

bejeweled spear into the primordial soup below the bridge and stirred it. When he withdrew his spear, drops falling from it coagulated into an island-pillar, upon which Izanagi and Izanami begot many nature gods and gods of the Japanese islands.[211] Often the Floating Bridge is taken to be the rainbow, meaning that the creation of Japan and its culture ultimately depends on the bow.[212] In Cambodia, Khmer kings built artificial mountains that include shrines whose doorway arches represent the rainbow bridge connecting earth and heaven. For the Buginese and the Makasarese of Indonesia's Celebes Island, the son of a sky god was dispatched to earth on the rainbow so that he could prepare the world for human habitation.[213] More prosaically, a belief of southern Gabon is that human ancestors arrived on the earth by walking down a rainbow.[214]

The rainbow bridge is a means of ascent as well as descent. When Aphrodite is wounded in battle during the Trojan War, Iris takes the tenderhearted goddess of love to the "heights of Olympos, safe at home" and to the arms of her consoling mother.[215] Hawaiian legend tells of Kaha'i, who ascends "by the path of the rainbow" to the world above in order to find his missing father, the East Maui chief Hema. Hema's eyes were gouged out during a foreign expedition, and now Kaha'i's brother Alihi fares no better as he climbs the rainbow with Kaha'i in search of Hema—Alihi too is blinded, this time by the horizon sky.[216] Variations on this grisly rainbow tale seldom require that Kaha'i find his father alive, just that he find his eyes. Among Native Americans, the Carolinas' Catawba and Alaska's Tlingit simply call the rainbow the "dead people's road."[217] In Australia's Forrest River region, an initiate into Aboriginal shamanism undergoes an imagined death and resurrection that include his master straddling the rainbow and pulling both of them up into the sky. When the master nears the top of the rainbow, he prepares the candidate for resurrection by first hurling him to his death in the sky.[218] Siberia's Buryats also have shamans ascending to the sky spirit-world via the rainbow, which they symbolize with a pair of red and blue ribbons tied to a ceremonial birch tree.[219]

Like the Forrest River Aborigines, the Chumash of coastal California tell of falling from a rainbow bridge. In Chumash mythology, Sky Snake brought fire to their ancestors on Santa Cruz Island. His wife, the earth goddess Hutash, grew annoyed with the noisy, rapidly growing Chumash populace, so she built a rainbow bridge across which they could walk to the uncrowded mainland. As islanders made the perilous trek across the high bridge, some grew dizzy and fell toward the sea. Because Hutash did not want her people to drown, she turned these luckless ones into dolphins, who remain the Chumash's friends and brothers.[220] The souls of German and Austrian sinners fare more poorly than the Chumash—when they fall from their rainbow bridge, they will be burned up in the rainbow's fiery red band. However, much like *The Golden Key*'s Tangle and Mossy, children and the forgiven will be led safely to heaven by guardian angels.[221]

Not all trips on rainbow bridges are one-way. In Hopi legend, mortal children of the divine Sun routinely travel the rainbow between this world and their father's sky-house.[222] Sometimes the rainbow bridge is more coveted than used. From New England's Abnaki Indian confederation comes the story of Ball-Carrier, a boy ensnared by an old witch whose magic ball always returned to her wigwam when a child chased it. She dispatched Ball-Carrier to find and steal the

gold of Sunlight and Rainbow's magic bridge, both of which were in a distant giant's lodge. Transformations and adventures alike await Ball-Carrier, but ultimately he succeeds and returns home with his prizes.[223] As we have seen in the story of Alcmene, the rainbow arch can carry deliverance. In the Chibcha flood legend from Colombia, the inundation was punishment for offense that the people had given to the god Chibchachum. They appealed to their divine folk hero Bochica for salvation, who appeared on a rainbow and, by striking the mountains with a staff, drained away the waters.[224]

In Western mythology, the most celebrated rainbow bridge of all is Bifrost, the span connecting Earth with Asgard, home of the Norse gods. Bifrost is described in the thirteenth-century Icelandic books called the *Eddas*. In one of the *Eddas*, the Swedish king Gylfi visits Asgard and converses with the Norse gods about their world's origins, events, and eventual end. This Doom or Twilight of the Gods, the Ragnarök (the German Götterdämmerung), is preceded by ruthless winters and moral dissolution, and its climax comes when the giants and demons who are the gods' enemies attack Asgard over Bifrost. Yet Asgard is always prey to attacks, so Bifrost is guarded by Heimdall, the most astounding of sentries. Heimdall scarcely sleeps, is able to see 300 miles day or night, and can hear grass and wool growing.[225] At the Ragnarök, Heimdall sounds his horn Gjallar to alert the gods one last time for their valiant but doomed struggle. As that struggle destroys the Norse gods and their world, Heimdall and his mortal enemy Loki kill each other, and Bifrost is smashed into a thousand pieces under the invaders' weight.

Of Bifrost itself, we know that this rainbow bridge is of three colors—its red being a fire that wards off the giants,[226] its vivid green symbolizing the gods' vain hopes for Asgard's successful defense.[227] Although the gods use Bifrost in their daily travels to Earth (Midgard), where they sit in judgment of men, living mortals cannot travel on it. The only men who can hope for that privilege are those killed in battle. As we are about to see, this notion that only the valorous or virtuous (see the German/Austrian soul bridge above) could aspire to the rainbow bridge's deliverance is an idea repeated often in Christian painting.

The myriad rainbow bridges and myths built by the world's peoples clearly tell us more about human hopes and fears than they do about nature's rainbow. The stories recounted above variously contradict and support one another. That should not surprise us, for the anthropomorphic view of nature, an extremely volatile one shaped by accidents of environment and culture, seems to be the oldest human impulse. However, the growth of a consistent, externalized view of the rainbow develops concurrently with (and sometimes overlaps) this inconsistent, internalized rainbow mythology. It is to those intertwining twin threads that we now turn. We do so by looking at the evolution of artistic and scientific visions of the rainbow, primarily in the Western world.

Imagined, emblematic rainbows have long thrived in the art of the Christian West. Yet these painted rainbows could not deny their pagan and Near Eastern origins any more than the faith itself. As our trek through Europe's Christian centuries shows, both symbolism and science inform its artists' rainbows. In fact, a renewed interest in representation sometimes yielded painted rainbows that were more natural than their scientific contemporaries. Paired with this artistic naturalism, however, was a continued reliance on the rainbow as sign and symbol. Often quite complex, this rainbow symbolism still has resonance for us today. So our journey toward the rainbow's modern image now takes us to the roots of modern European science and art.

TWO

EMBLEM AND ENIGMA

French cleric and scholar Nicole Oresme (c. 1325–82) wrote for a world whose outlook we can scarcely imagine. His speculation that the rainbow is not just a sign of divine covenant, but also an earthly analogue of the celestial body of Christ, may seem strange indeed to us. Stranger still is Oresme's speculation that, because the secondary rainbow "contains" the primary rainbow, "we could possibly say that the body of the glorious Virgin Mary, which contained the body of Christ, is, as it were, the second rainbow."[2]

Yet Oresme was simply offering a particular example of a general church belief voiced a century earlier by the Dominican theologian Thomas Aquinas (1224/25–1274; canonized 1323). In his *Summa contra gentiles*, Thomas clearly outlined a world view in which reason and observation were inadequate but necessary tools: "our intellect's knowledge, according to the mode of the present life, originates from the senses: so that

> . . . and I ask why God could not have the entire body of Christ and each of His members present throughout every part of this heaven in the same way that the colors of the rainbow are situated in every part of a cloud, except that Christ's body would be everywhere the same, even according to number. And thus will He show Himself, and each holy body, wherever it may be, will see Him face to face in His own shape, just as we have shown in the case of the changeable rainbow which we can see here below.[1]
>
> Nicole Oresme,
> *Le Livre du ciel et du monde*
> (Book on the sky and the world, 1370-77)

things which are not objects of sense cannot be comprehended by the human intellect, except in so far as knowledge of them is gathered from sensibles. Now sensibles cannot lead our intellect to see in them what God is, because they are effects unequal to the power of their cause. And yet our intellect is led by sensibles to the divine knowledge so as to know about God that He is, and other such truths."[3]

For Thomas, the limitations of human senses and reason meant that knowledge of the natural world, while pragmatically useful, was of secondary importance. Of primary importance was divine knowledge, which was free from human error and for which natural knowledge was a prerequisite.[4] Such a doctrine is essentially Platonic in its separation of mutable, sensible appearances from the immutable and invisible reality underlying them.[5]

While Christian philosophy is far more complex than a gloss on Plato, one of its earliest and most consistent features is this subservient (and sometimes irrelevant) role that the senses play in understanding the divine. Consider an example that closely parallels Oresme's discussion of the rainbow, the twelfth-century doctrine of transubstantiation. In the Roman Catholic celebration of the Eucharist, the sacramental wine and bread are held to have been miraculously transformed into the "substance" of Christ's blood and body, even though the "accidents" of their sensible appearance are unchanged. Thus the vitally important reality of the Eucharist remains invisible, yet sight allows the faithful to appreciate its immanent divinity.

Perceptual dualism of this sort allows Oresme to seamlessly mix the optical and religious explanations of rainbows within the same text.[6] He certainly was not the first Christian scholar to do so. Isidore, Archbishop of Seville (c. 560–636; canonized 1598), included the rainbow among his voluminous writings. Saint Isidore's encyclopedia *Etymologies* remained a standard reference into the Middle Ages, and his opinions on the rainbow in *De natura rerum* (On the Nature of Things) also carried great authority. After offering a fanciful etymology for "iris" in the *Etymologies*, Isidore gives it an equally fanciful physical basis both there[7] and in *De natura rerum*.

Isidore claims that the rainbow's shape derives from the brightness of the circular sun reflected by light-colored clouds, thus paraphrasing Aristotle's explanation of the rainbow.[8] However, Isidore's description of rainbow colors sharply diverges from Aristotle. Isidore proposes that the rainbow has four colors, a number based on antiquity's four elements of earth, water, fire, and air. Isidore believes that water gives purple to the bow, the sky contributes fiery colors, air contributes white, and earth gives the bow blackness.[9] Although Isidore's arguments by analogy may seem absurd to us, he at least mimics ancient science by constructing a rational framework to explain a natural phenomenon.

The real break with naturalism comes when Isidore cites the opinions of others on the colors of the rainbow: its purple is a reminder that the impious once drowned in the Flood's waters, and its reds foretell the immolation of the damned in Hell's fires.[10] A century later, England's Venerable Bede (672/73–735; canonized 1899) repeated in his *De natura rerum* much of Isidore's explanation of the rainbow, adding to it the enduring superstition that no rainbow would be seen in the forty years before the world's end.[11] Rabanus Maurus (c. 780–856),

FIG. 2-1

Noah (head upturned) and his sons receiving God's covenant, sixth century A.D. *Vienna Genesis* (Ms. Theol. graec. 31, folio III, p. 5). Österreichische Nationalbibliothek, Porträtsammlung, Vienna

a Benedictine scholar and Archbishop of Mainz, would write in his *De arcu coelesti* (On the Rainbow) that the rainbow's red and blue were caused by fire and water, respectively, and that their presence indicated the world's end would come by fire rather than flood.[12]

In 1646, Thomas Browne derided such convolutions in his *Pseudodoxia epidemica; or, Enquiries into Very many received Tenets, and commonly presumed truths*: "And Christian conceits do seem to strain as high, while from the irradiation of the Sun upon a cloud, they apprehend the mysterie of the Sun of Righteousness in the obscurity of flesh; by the colours green and red, the two destructions of the world by fire and water; or by the colours of blood and water, the mysteries of Baptism, and the holy Eucharist."[13] The fervor of Browne's polemic suggests the entrenched nature of the superstitions against which he railed. Even Browne must have found his task daunting, for he was struggling against a millennium of cherished Christian beliefs about the rainbow.

The *Vienna Genesis* and a Byzantine Rainbow

What ancient mythologists had begun with the goddess Iris, the church fathers and their followers serenely continued with their explanations of the meteorological iris—the rainbow simultaneously served the conflicting ends of natural explanation and myth. It is little wonder, then, that the rainbow's image in the Christian West long reflected these dual roles. We can see the origins of those roles in one of the earliest surviving examples of the rainbow in Christian art, an illumination from a sixth-century codex known as the *Vienna Genesis* (Fig. 2-1).

Comprised of vellum parchment sheets folded and stitched together between hard covers (often wood or leather), early codices such as the *Vienna Genesis* solved a practical bookmaking problem. Although illuminated manuscripts in the form of papyrus rolls date from second-millennium B.C. Egypt, these rolls had distinct limitations. Rolls were unwieldy for long manuscripts, whether made of papyrus or, by Hellenistic times, vellum.[14] Furthermore, any surface pigments in roll illuminations would have cracked with repeated handling.[15] By stacking sheets and thereby eliminating their constant warping, codices made lengthy, vividly colored books practical.

No less remarkable than the vividness of the *Vienna Genesis* illuminations is the accident of their survival—only one other illuminated Greek Old Testament predating the seventh century still exists.[16] Such manuscripts are rare in part because of the Iconoclastic Controversy of the eighth and ninth centuries. Icons, or images of holy figures and events, had acquired cult followings in some parts of the Roman Empire by the seventh century. The Controversy was provoked when the Byzantine emperor Leo III (c. 675/80–741) decried the use of icons in 726. Iconoclasts cited the prohibition against graven images in the Book of Exodus and warned of unholy idolatry. Icons and those who venerated and produced them suffered during seesaw doctrinal battles that tilted back and forth for over a century.[17] Ultimately, Byzantine iconophile rulers prevailed, but not before priceless manuscripts and icons were lost.[18]

If manuscripts like the *Vienna Genesis* faced hostility after their creation, neither were they universally welcomed beforehand. Saint Jerome (c. 347–419/20), influential ascetic and translator of the Vulgate Bible, remarked pointedly that such sumptuous books were a useless luxury. In a letter written in 384 to one of his spiritual charges, the young noblewoman Eustochium, Jerome ardently defends the difficult virtues of virginity. After decrying the vanity of women who maintain large wardrobes, Jerome takes on the excesses of too-elegant manuscripts: "Parchments are dyed purple, gold is melted for lettering, manuscripts are decked with jewels: and Christ lies at their door naked and dying."[19]

Jerome would undoubtedly be pleased that time (and oxidation) have long since reduced the extravagant purple vellum and silver lettering of the *Vienna Genesis* to humbler shades of brown and black, respectively. It is human hands, though, that have further reduced the manuscript from nearly one hundred pages to forty-eight.[20] Such selective vandalism is probably not the result of iconoclastic fervor, which would be more inclined to destroy all the offending illuminations. Instead, the plundering of this iconographic treasure trove, probably early in its existence, may simply be a perverse measure of the esteem in which it was held.

In Fig. 2-1 we see Noah and his sons encircled by a tricolor rainbow that heralds the divine covenant after the Flood. Because the accompanying Greek text fixes the scene unambiguously (Genesis 9:8–15), the peace symbolism of God's outstretched hand may seem redundant.[21] Surprisingly, this disembodied arm may have more to do with Jewish conventions of illustration than any explicitly Christian ideas. First, several of the illuminations in the *Vienna Genesis* lay out a story whose time line progresses from right to left, the same direction in which Hebrew

text is read (and opposite that of Greek text). Second, several figures in the manuscript's illuminations appear to have specifically Jewish, not Christian, origins.[22] Unlike contemporary Jewish art, explicit depictions of God's form were seldom discouraged in pre-Iconoclastic Christian art. Thus the disembodied arm of God may indicate that Fig. 2-1 is based partly on Jewish, rather than Christian, models.

Whatever its sources, Fig. 2-1 is unusual among the *Vienna Genesis* miniatures because it shows only a single scene, rather than a narrative sequence of scenes.[23] Despite the obvious drama and energy of Fig. 2-1's momentous episode, its figures may seem oddly static to us, their emotions only hinted at by an impossibly upturned head or awkwardly lifted hand.[24] These seemingly artless poses stand in sharp contrast to the languid naturalism of Zeus and Eros in Fig. 4-8, which is Fig. 2-1's closest predecessor among our rainbow paintings. Evidence suggests that both the *Vienna Genesis* and its archetype were illuminated in Palestine or Syria.[25] Why the great stylistic shift between first-century Italy and the sixth-century Near East?

At the most basic level, Figs. 2-1 and 4-8 come from completely different world views. The worldly polytheism of Fig. 4-8's bourgeois Herculaneum could not be more removed from the otherworldly monotheism of Fig. 2-1's ascetic Near East. Sixth-century illuminators were probably familiar with some conventions of classical illusionism, because traces of it appear in the *Vienna Genesis* and other early manuscripts. Yet few of these artists would have shared the Roman taste for painting as a window on a particular mythological moment. Rather, Early Christian and Byzantine artists strove to create images of eternal divine truths untarnished by the corruptible world around them.[26] As the preeminent iconophile Saint John of Damascus (c. 675–749) wrote, "images are a source of profit, help, and salvation for us all, since they make things so obviously manifest, enabling us to perceive hidden things."[27] That artists aided faith by creating visually sumptuous illuminations shows how contradictions arose within presumably ascetic Christianity, contradictions that Jerome (among others) pointedly denounced.

What remnants of classical art appear in Fig. 2-1? Elongated white clouds are scattered throughout a sky whose color gradation[28] hints at the naturalism of some Roman landscapes.[29] The figures stand firmly on the ground, however loosely connected it is to the vague background space. Two of Noah's sons appear to stand in an awkward *contrapposto*, or counterpoise, although their stance evokes little of Greek and Roman sculpture's gracefulness.[30] Distinctly unclassical is the semicircular disk of blue sky from which God's arm emerges, a device that may emphasize the separation of the worldly and divine that is central to Christian belief. This heavenly semicircle appears elsewhere in the *Vienna Genesis*, yet it does not accompany God's disembodied hand in some comparable scenes in Jewish art.[31] Thus while elements of classical naturalism often occur in Early Christian and Byzantine miniature painting such as the *Vienna Genesis*, these elements tend to be more copied than comprehended.[32]

What of the rainbow itself in Fig. 2-1? After examining the *Vienna Genesis* in the late nineteenth century, von Hartel and Wickhoff described that rainbow as shading from blue-green, green, white, and finally to various reds.[33] Such subtleties are difficult to discern in Fig. 2-1,

FIG. 2-2

Saint Luke in glory. *Gospel Book of Otto III* (Codices Latini Monacenses 4453), 998–1001. Bayerische Staatsbibliothek, Munich

where only white, red, and greens are evident, yet we cannot rule out von Hartel's and Wickhoff's wider color range. (Pigments used in illumination are less prone to marked color shifts than the manuscript's silver letters and dyed vellum.) If the colors here are limited to greens, white, and red, then they approximately match those of Fig. 4-8, although neither color sequence is natural. The colors of both works only partly match Aristotle's tricolor bow of green, red, and purple. Yet the shared red and green hint at a common heritage of classical rainbow colors, such as that seen in a rainbow mosaic from second-century B.C. Pergamum.[34]

Figure 2-1 is not the only Byzantine image to include a colorful rainbow. Historian Liz James cites an icon, another manuscript, and several mosaics that incorporate multihued rainbows. Although these works disagree on the range of rainbow colors, scenes of Noah and the Covenant consistently feature red and green in their bows.[35] Contemporary Byzantine documents describe the rainbow as having three colors—red, green, and a "dark-colored" purplish hue.[36] Thus early in the Christian era both art and literature often agreed with Aristotle on the rainbow's colors, especially with his belief that all colors ultimately derive from mixtures of

black and white. However, this veiled nod to the rainbow's classical past eventually disappeared from Christian iconography, even as the rainbow itself remained part of art's common currency.

Saint Luke in Celestial Glory: An Ottonian Rainbow Seat

One hallmark of Byzantine art is its rendering of the human figure: large eyes stare out from elongated bodies, themselves arranged hierarchically and often posed frontally. Other characteristic features include placing primary figures as far forward as possible and overlapping figures of secondary importance.[37] Perhaps surprisingly, these formulas do not necessarily drain figures of emotion; instead, they formalize and categorize emotion.[38] The powerful emotional appeal of the Byzantine style exerted itself soon after Constantine the Great (Constantine I; c. 285–337) dedicated his Roman imperial capital in Constantinople (formerly Byzantium) in 330. Despite the ensuing religious separation of the empire into Western (Roman) and Eastern (Orthodox) parts, the eastern Byzantine style strongly influenced figural art in the West for centuries.[39]

Our next rainbow image, Fig. 2-2, gives us a much stronger flavor of the Byzantine style.[40] Naturally, the transmission of artistic style often follows a complex path whose direction changes with local and individual tastes. That is what we see in Fig. 2-2, an illumination from a Gospel book of the German king Otto III (980–1002). The Evangelist Luke faces us and stares with visionary intensity as he holds aloft a remarkable constellation of figure-laden clouds.[41]

Where Byzantine art offers emotional tension or understated pathos, this Germanic image fairly bristles with religious energy. Luke's Gospel rests in his lap as he sits on a double rainbow, but little else about him suggests repose. One of the cloud roundels that he emphatically thrusts heavenward contains Luke's symbol, the winged ox. Above the ox, King David fixes his gaze on us and is surrounded by the prophets Ezekiel, Nahum, Habakkuk, and Sophonias.[42] Angels, seemingly wind-blown, flank these Old Testament figures, and forked blasts of light radiate from the clouds themselves. Within the confines of early medieval painting, a more energetic vision of Luke's fairly sedate life is difficult to imagine. In what context did Fig. 2-2 arise?

The reigns of the Ottos (Ottos I and II were Otto III's grandfather and father) not only defined the embryonic German state but also gave it its first distinctive artistic style, Ottonian art. With varying degrees of fervor and effectiveness, the Ottos sought to build a Germanic successor to the empire of the Frankish king Charlemagne (742–814). Because Pope Leo III (d. 816) sought a political counterbalance to the unified church and state of Byzantium, the devout and ruthless Charlemagne had been a natural choice for elevation to Emperor of the West.[43] Although Charlemagne's rule as emperor was short-lived (800–14), its political and artistic consequences were not. Charlemagne is often described as the first Holy Roman Emperor, a title (and, in principle, a state) that endured in Central Europe into the nineteenth century. Charlemagne's determination to recreate not only the Roman Empire's political, but also its cultural, glory[44] led to state patronage of the arts. In bookmaking, the resulting Carolingian style yielded both Carolingian minuscule, the forerunner of our modern Roman alphabet, and

manuscript illuminations that range from serenely classical to expressively local styles.[45]

The fervent Ottonian scene in Fig. 2-2 recalls the expressive Carolingian style. This is no accident, for both politically and artistically the Ottos sought to revive the real and imagined glories of Charlemagne, including his pairing of papal and imperial power under one crown. Beginning with Otto I's 936 coronation as king of the East Frankish remnant of Charlemagne's empire, the Ottos shared Charlemagne's military zeal, and conquest expanded their kingdom considerably. Like Charlemagne, the Ottos were crowned as Emperors of the Roman West, and their reigns included routine communication with—and occasional rescues of—the pope. By one account, Otto III, the owner of the *Gospel Book*, was so enamored with Charlemagne that he opened Charlemagne's tomb at Aachen, removed a gold cross from the corpse's neck, and then wore it himself.[46]

Yet Otto's tastes were far from provincial. His mother Theophanu was a Byzantine princess, which meant that Otto was well acquainted with the art and culture of Byzantium. The influence of her aesthetic tastes at court would not have been negligible, for she served as her son's regent for several years. Otto himself was an emotional, high-strung young man when he was crowned Holy Roman Emperor in 996.[47] Otto's temperament is evident in the story of Johannes Philagathos (d. c. 1013), the antipope John XVI. For his part in the unseating of Pope Gregory V (972–99), Otto and Gregory had Philagathos blinded and his face mutilated. Otto's sense of guilt was not soothed by subsequent meetings with Saint Nilus of Rossano (c. 905–1005), an aged ascetic and friend of Philagathos. Nilus told Otto that instead of an imperial monastery he required of Otto a chance to save his sinful soul. At this rebuke from a man of peerless faith, Otto burst into tears and handed Nilus his crown, sign of the church's sanction.[48]

This emotionalism is evident in the *Gospel Book* in such miniatures as "Christ weeps over Jerusalem" and "The repentant Mary Magdalen."[49] In general, of course, the connection between a patron's temperament and his artists' styles is moot. However, Otto's *Gospel Book* was probably intended for the emperor's personal use, so some of its images may well have been created to suit his taste.[50] If Fig. 2-2 is any indication, not all the images in the *Gospel Book* were easy viewing for Otto. In spirit, at least, Saint Luke's stern visage more resembles the hardheaded Nilus than the often nervous Otto.

Most vestiges of the natural world have been expunged from Fig. 2-2. A Byzantine gold ground replaces the cloud-bedecked sky of Fig. 2-1, and the rainbows have become monochrome arcs of white, gray, and black. Elsewhere in the *Gospel Book*, stylized tree trunks sprout pileus-shaped leaf canopies.[51] Carolingian art's traces of classical illusionism are either unknown to or unused by this Ottonian artist, who instead envelops us in a world of formal symbolism. The real import of Fig. 2-2 is spelled out in its Latin inscription, which translates as "From the source of the fathers the ox brings forth a flow of water for the lambs."[52] In other words, Luke the ox draws the water of understanding from its Old Testament source for God's human flock.[53] No other legend for a devout Holy Roman Emperor's New Testament could be more apt.

Yet Luke's pose is more apocalyptic than scholarly. While Fig. 2-2 emphasizes the textual

unity of the Bible's Testaments, the immediate visual metaphor is the New Testament's Christ in Majesty, which itself has Old Testament analogues.[54] Christ in Majesty is usually seated on a rainbow or two as He passes final judgment on humanity. No Bible passage exactly matches the endlessly varied images of Christ in Majesty (or those of its variant, the Last Judgment).[55] Nevertheless, the Apocalypse (or Revelation) of Saint John is the most likely source for these images, for in it we find the following visionary account:

> And immediately I was in the spirit: and behold there was a throne set in heaven, and upon the throne one sitting.
> And he that sat, was to the sight like the jasper and the sardine stone; and there was a rainbow round about the throne, in sight like unto an emerald.[56]

Already firmly established by Otto's time, Last Judgment images would be repeated in literally hundreds of paintings in the coming centuries. Sometimes Christ's arched seat is the zodiac, as in the *Triumph of the Church* fresco by Andrea da Firenze (fl. c. 1343–77) in Florence's Santa Maria Novella.[57] More often the seat is either a vivid rainbow or a nearly monochrome echo of one. For such Byzantine-influenced images as Figs. 2-1 and 2-2, historian Liz James makes a distinction between multihued "naturalistic" rainbows and "non-naturalistic" bows of one or two colors. She concludes that "the colours of non-naturalistic rainbows are either red, or blue, with the addition of gold and silver, and omitting entirely the colours in the green area of the spectrum."[58] Figures 2-1 and 2-2 certainly support this idea. Like James, we have found that bicolor rainbows are usually reserved for images of Christ in Majesty, while multihued bows are commoner in Noah scenes.

What might be the sources of such rainbow color distinctions? As James notes, early biblical exegesis often emphasized the rainbow's brilliance[59] rather than its colors.[60] As such, the rainbow is a worldly sign of God's divine brilliance. In the early tenth century, the bishop Arethas of Caesarea (b. c. 850) held that the divine, monochromatic rainbow bears the same name as the worldly, multihued one, to remind humanity that faith's unity is the result of the disunited multitude joining together spiritually.[61] Based on this and other evidence, James concludes that in the early church "the rainbow is not a manifestation of [a] physical phenomenon, nor a part of the Old Testament covenant between God and men, . . . but a manifestation of divine light reflecting the glory of Christ and seen particularly in holy visions [for example, Ezekiel 1:28], a further indication of the unworldly nature of these rainbows."[62] Clearly by Oresme's day the distinction between the rainbow's brightness and its colors was less important, but in earlier centuries, artists probably had sound iconographic reasons for avoiding naturalism in apocalyptic rainbows.

Rainbow Variations in the *Last Judgment:* Giotto and Memling

Another element of the Christ in Majesty formula is the mandorla, the almond-shaped shield of divine light that surrounds the seated or standing Lord. Religious and artistic usage of the analo-

gous terms "glory," "aureole," "nimbus," and "mandorla" has been so varied and confused that any modern distinctions probably differ from those that Byzantine artists and their successors made.[63] As a matter of convenience, we use "mandorla" to indicate any circular or almond-shaped shield that appears behind a biblical personage's entire body.

In Fig. 2-2, Luke's mandorla is of several greens and, like many others, supports a rainbow seat. Sometimes the mandorla itself is painted in rainbow colors, suggesting that artists' understanding of the iconography of the mandorla and rainbow was quite fluid. One example among many is a sixteenth-century Ukranian panel painting of the Transfiguration that transforms the nearly monochrome mandorla into a circle of five colors surrounding Christ.[64] In fact, the artistic popularity of Christ in Majesty guaranteed the image both a long life and endless variations, with the divine light of its mandorla and rainbow often being hard to distinguish. (Atmospheric halos and coronas[65] presumably also inspired numerous examples of the mandorla and its kin.)[66]

Figure 2-3 shows us a medieval Italian fresco that vividly illustrates this seamless integration of arched rainbow seat and round mandorla. Its author is Giotto di Bondone (c. 1267–1337), a Florentine painter celebrated by his contemporaries[67] and later revered by the artist and writer Giorgio Vasari (1511–74) as having "revived the modern and good style of painting."[68] Some of this Renaissance enthusiasm for Giotto's innovative, naturalistic rendering of the human figure reads like hyperbole to us. Yet no less an artist than Leonardo da Vinci (1452–1519) said of Giotto that "after much study he not only surpassed the masters of his own time but all those of many preceding centuries. After him art again declined, because all were imitating paintings already done."[69]

Much of the perfervid reaction to Giotto stems from the passionate rejection of Byzantine art's unnaturalism by later writers.[70] Even though Carolingian and Ottonian artists had altered details of the early Byzantine style, they rarely strayed outside its essential pictorial conventions. Two centuries after Otto III, Romanesque artists began to make tentative forays into painting secular nature in such miniatures as a *Spring Landscape* that accompanies the worldly lyrics of the thirteenth-century manuscript *Carmina Burana*.[71] Yet the fantastic plant forms and two-dimensional topography of *Spring Landscape* were far removed from the realistic landscape elements and figures that would emerge within a few generations.

One source of Giotto's remarkable break with the Byzantine and Romanesque past was likely his familiarity with the sculpture of Nicola (c. 1220–78/84) and Giovanni Pisano (c. 1250–after 1314). This father and son separately created highly sculptural pulpits and ornamentation for Pisa and Siena cathedrals that were remarkable confluences of classical naturalism and Gothic animation.[72] Also influential in Giotto's development were the classical illusionism of the Roman painter Pietro Cavallini (c. 1250–c. 1330) and the Gothic style of Nicola Pisano's assistant Arnolfo di Cambio (c. 1245–1302).[73] Cultural as well as personal influences shaped Giotto's style. The rapidly growing wealth and power of Italy's trading centers guaranteed that private donors and religious orders alike acquired the taste and means for a religious art more worldly than the severe Byzantine style. Among these donors was Enrico degli Scrovegni of Padua, a wealthy merchant who attempted to atone financially and spiritually for his father's unbridled

FIG. 2-3

Giotto di Bondone, *Last Judgment*, 1305–6. Arena Chapel, Padua (photo: Courtesy Scrovegni Chapel, Padua, Italy)

usury by building a palace and small chapel on the former site of a Roman arena.[74] Consecrated in 1305, Scrovegni's Arena Chapel shortly became the stage for Giotto's remarkable fresco cycle that includes Fig. 2-3's *Last Judgment*.

In this *Last Judgment*, Giotto's deft modeling of the human form is no less remarkable than his subtle coloring of the scene's rainbow-like mandorla.[75] Here for the first time we see rainbow colors painted not just as discrete stripes but as imperceptibly merging regions of color.[76] Giotto's near-naturalistic ordering of rainbow colors is also novel, with red and orange on the mandorla's exterior and blue on its interior.[77] Only a single band of white—itself subtly blended with surrounding colors—betrays an allegiance to earlier unnatural canons of rainbow coloration. By contrast, Christ's rainbow seat is restricted to blue and white, but its patterns and color gradations are the same as those of the encircling mandorla. The verisimilitude of Giotto's

rainbow may not be accidental. Although we do not know if Giotto studied the natural rainbow, his Arena Chapel frescoes do make clear his interest in another celestial spectacular—Halley's comet.[78]

In 1301 the comet swept past the earth in a vivid display whose details appear to be captured in the Arena Chapel's *Adoration of the Magi*.[79] Instead of the traditional Star of Bethlehem, Giotto has placed Halley's comet above the divine manger, perhaps in response to a contemporary legend that seems to identify the Star as a comet.[80] Giotto's comet is both detailed and astronomically accurate, featuring a realistic coma and tail that agree with descriptions of Halley's comet. This level of realism is far different from that found in earlier schematized representations of comets.[81] Does Giotto's unprecedented interest in a spectacular comet assure us that he took a similar interest in rainbows? Obviously it does not, even if artists in later centuries did make the comet and rainbow a literally ominous pair.[82] Nevertheless, the Arena Chapel's breakthrough representations of a realistic rainbow and comet certainly do not argue against Giotto studying the natural rainbow.

Whatever their archetypes, Giotto's *Last Judgment* rainbow and circular mandorla should not be confused with their natural cousins.[83] Several layers of illusion and allusion are used in their construction. First, as is true throughout Giotto's art, the sunlight and shadow of the real world are absent here—only Christ's divine light gives rise to the Last Judgment's rainbow.[84] Second, although Fig. 2-3 is done entirely in fresco, its rainbow and mandorla are painted to resemble a curious, scaly mosaic. On closer inspection, the individual "scales" reveal themselves to be imitations of feathers. Finally, these "feathers" visually echo those in the wings of the *Last Judgment*'s angels, while scripturally they echo the Book of Psalms:[85]

> He shall say to the Lord: Thou art my protector, and my refuge: my God, in him will I trust.
> For he hath delivered me from the snare of the hunters: and from the sharp word.
> He will overshadow thee with his shoulders: and under his wings thou shalt trust.
> His truth shall compass thee with a shield: thou shalt not be afraid of the terror of the night.[86]

To make the mandorla's role even clearer, Giotto parts with convention and depicts a geyser of flame erupting from its lower right. Diverging into four rivers of fire, the flames sweep away but do not consume the luckless damned, carrying them toward their grim appointments with energetic devils.[87] As divine shield of the saved and scourge of the damned, surely this rainbow mandorla would give pause to all but the most worldly medieval viewer. Like the feathered mandorla, one other feature in Fig. 2-3 emphasizes how the divine is immanent in the everyday world. Above the heavenly audience, two angels peel back the blue of the heavens to disclose the gates of Paradise.[88] Drawn from Apocalypse 6:14,[89] the didactic purpose of this image seems to be a graphic reminder that on Judgment Day even the familiar blue sky will have its true, supernatural purpose revealed.

In Fig. 2-3, Saint Luke's regnant ox from Fig. 2-2 humbly joins emblems of the other Evan-

gelists in supporting Christ's rainbow seat. Changed too is the impenetrable severity of Luke's gaze, replaced by Christ's expression of gentle reverie, a look that more closely resembles the languid naturalism of the reclining Zeus in Fig. 4-8. Yet Giotto is not showing viewers a reverie here; instead he is reminding them of the stark fate that awaits the unrepentant. Giotto's vision of the Last Judgment is simultaneously more approachable and more formidable than its predecessors—its carefully observed half-size human forms[90] are arrayed throughout a work that is more than 30 feet tall.[91] As is true of his lifelike heavenly host, Giotto's naturalistic rainbow circle may have been meant to provoke an immediate, tangible sense of the spiritual among his medieval audience. Giotto's powerful (and popular) illusionism in the Arena Chapel seems at once to support the long-standing church bias against the senses and to invite his viewers to revel in their enjoyment.

In the wake of Giotto's landmark achievements, imitators and innovators alike sought to exploit the new mimetic power of painting. Naturally, the centuries-old Byzantine style was not displaced everywhere, and in slowly evolving form it would prevail for centuries in the Orthodox East. Yet throughout much of Italy, the transformation of painting was so rapid that the Byzantine style of Giotto's putative teacher Cimabue (c. 1251–1302) was within a few years "banished to the villages, where it lingered only a decade or so."[92] In the century following Giotto's death, illusionistic elements increasingly intruded into the painting of northern and southern Europe.

The Italian Gothic traditions of painstaking draftsmanship and vivid coloration were paired in the fifteenth century with an explicit geometric mapping between three-dimensional landscape and its two-dimensional representation. This remarkable system of *linear perspective* is one of the earliest and most enduring achievements of Renaissance art, and it would dominate Western painting for centuries.[93] But not all developments in illusionism were occurring in southern Europe. One crucible of northern painting was Flanders, a medieval remnant of Charlemagne's empire that included parts of present-day France, Belgium, and Holland. By the fifteenth century, Flanders was an international trading and financial center sufficiently important that the port city of Bruges had a permanent branch of the powerful Medici Bank of Florence.[94] In addition to Italian banking, Bruges attracted much business from the Hanseatic League, a looseknit mutual-protection and trade confederation based in Germany. As we shall see, an odd confluence of Medici money, Hanseatic piracy, and Flemish Late Gothic painting leads us to our next rainbow painting, the *Last Judgment* (Fig. 2-4) by Hans Memling (c. 1430–94).

Although the importance of Bruges as a commercial and financial center had declined by the time Memling's *Last Judgment* was completed, the city was still prosperous, and its wealthier citizens craved fashionable, albeit locally produced, art.[95] Flemish art had been transformed in the fifteenth century by the accomplishments of such native painters as Robert Campin (c. 1378–1444), Jan van Eyck (c. 1395–1441), and Rogier van der Weyden (c. 1399–1464). German by birth,[96] Memling by the 1460s was thoroughly familiar with (if not actually tutored in) the Flemish style.[97] He found the Flemish artistic and patronage climate so promising that in 1465

FIG. 2-4

Hans Memling, *Last Judgment*, central panel, triptych interior, c. 1467. Muzeum Narodowe, Gdańsk, Poland (photo: Art Resource, New York)

he purchased a Bruges citizenship and remained there, busy and well paid, for the rest of his life.[98]

The rise of a bourgeois Flemish art market did not diminish the importance of religious subject matter or ecclesiastical patrons, and thus the total demand for paintings increased. But what caused the combination of local success and international fame for Flemish painting?[99] Just as fourteenth-century Italians had revolutionized painted space with vivid colors and stage-like architecture, so the artists of fifteenth-century Flanders achieved success with their own technical and stylistic innovations. Their technical advance would prove as permanent as it was disarmingly simple. Medieval panel painting had relied on dilute egg yolk as a binder for its pigments, and the resulting colors were both opaque and highly saturated.[100] The new Flemish painting used linseed oil as a binder instead. While oil paints were known, their past use had been quite limited. Technically, oils offered a range of opacities and color gradations that were difficult to achieve with tempera paints. Stylistically, painters exploited this greater subtlety of

color and brightness to create works in which the play of natural light is, for the first time, a central feature.

For example, pictorial depth could now be suggested not only by perspective foreshortening (for example, Campin's *Merode Altarpiece*, c. 1425)[101] but also by painting subtle changes in atmospheric transparency.[102] When we scrutinize a distant horizon on a clear day, not all portions of the scene are equally distinct. Even with perfect vision, no one sees distant objects with the same clarity as those nearby, and it is the atmosphere itself that causes this gradual degrading of landscape detail. Both brightness and color distinctions decrease with distance because the atmosphere scatters more and more sunlight toward our eyes as we look at increasingly distant objects. Almost no light reaches us directly from the most distant objects; instead, we see sunlight scattered by the intervening air. Although twentieth-century scientists have analyzed this *airlight* phenomenon quantitatively,[103] artists and natural philosophers first described it qualitatively in antiquity.[104] Writing about Hellenistic art, Philostratus the Lemnian (b. c. A.D. 190) noted that, unlike sculpture, contemporary painting "knows chestnut and red and yellow hair, and the colour of garments and of armour, chambers too and houses and groves and mountains and springs and the air that envelops them all."[105] In his *Optica*, the Alexandrian astronomer and geographer Ptolemy (fl. A.D. 127–45) clearly described the effects, if not the causes, of airlight.[106]

Artists' term for airlight is *aerial* or *atmospheric perspective* (as opposed to linear perspective). By reducing distant landscape features to indistinct grayish or pastel-blue outlines, artists can effectively reproduce our outdoor visual experience. Just as airlight changes with weather and time of day, so too has painters' rendering of its effects on atmospheric transparency.[107] In Fig. 2-4, Memling displays his mastery of aerial perspective by rendering the distant mountains in a blue-gray. Convincing as well is the way in which this supernatural Judgment Day sky faithfully mimics the color and brightness gradations of the natural one.[108] Although the dark upper sky makes the scene nominally a nighttime one,[109] its landscape and horizon have a distinctly daytime appearance. In fact, our initial reaction to Memling's work is that we have glanced through a window into a real landscape, no matter how surreal its details.

The naturalistic shadows hinted at in Giotto's *Last Judgment* are now unambiguous, even if their apparent cause is still Christ's divine light instead of the sun. If we do not marvel at the shading of Memling's painted world, it is because such realism seems almost photographic to us. To fifteenth-century viewers, however, this degree of verisimilitude must at first have been startling indeed.[110] Yet by Memling's day such technical skill was no longer innovative. Any master painter would have been expected to be proficient at constructing illusionistic yet suitably recondite sacred landscapes. That Memling succeeded in doing so is suggested by the heartfelt, if hyperbolic, opinion penned by a Bruges cleric on Memling's death that he was "held to have been the most skilful and most excellent painter of the whole Christian world."[111] Since then, Memling's reputation has waxed and waned with historical fashion, and decades have separated major twentieth-century exhibitions of his works.[112]

Although peopled by bodies that reflect medieval conventions of beauty, Memling's *Last Judgment* nonetheless reaches out to us with a frightening immediacy. The dead arise from their graves all around the Archangel Michael, who weighs them in his scales of judgment. The head of the reverent and fortunate fellow in the lower pan is believed to be that of Tommaso Portinari (c. 1428–1501), a manager and schemer within the Bruges branch of the Medici Bank. Portinari first conspired to force out his predecessor at the Medici Bank and then may have appropriated Memling's *Last Judgment* from him.[113] Whoever ultimately owned the work in Bruges, Portinari's portrait clearly was added as an afterthought, even if it was an auspiciously located one.[114] The intrigues endured by the *Last Judgment* on land were surpassed by those it encountered at sea— shipped in 1473 from Bruges and destined for Florence, it was seized almost immediately by a Hanseatic League privateer and taken to Gdańsk.[115] Despite the best efforts of Portinari and the Burgundian court (Flanders' nominal rulers), Memling's *Last Judgment* never left Poland.[116]

Looming above this earthly chicanery is a Christ who sits more emphatically than ever on His rainbow perch. So solid is this rainbow that His mantle falls in elaborate folds over its arc. Surrounded by symbols of His Passion, this blessing Christ holds court over a scene whose energy is far greater than His detached expression suggests. Like his Flemish predecessor Rogier van der Weyden,[117] Memling has made the Judgment rainbow a central, inescapable fact of the scene. Gone is the rainbow seat's subservient role to the aureole or mandorla, which it all but replaces in Fig. 2-4. The rainbow dominates this space in both color and composition, for it clearly divides the serene elect on the left from the frantic damned on the right.

The naturalism of Memling's rainbow is unprecedented in several ways. As with other natural elements in this unnatural scene, religious foreknowledge is no longer required to read the arc as a rainbow. The color order is entirely plausible, as is the airlight-induced fading of the rainbow's bright colors near the horizon.[118] Intriguing too is the fading of the bow's innermost arc near the horizon—a disappearance that occurs near the bases of some natural rainbows.[119] Our reaction to Fig. 2-4's rainbow is as immediate and as visceral as our reading of the scene's iconography is measured and intellectual. What Memling knew about natural rainbows is a mystery, yet judging by the realism of his *Last Judgment* rainbow and that of another (*St. John the Evangelist on Patmos*, 1479),[120] he may well have scrutinized rainbows in nature.

Memling is unlikely to have relied on current scientific thinking to arrive at his rainbows. As an artist, he would have had little professional incentive to pursue natural philosophy, even if the more radical Florentines had presumed in the early fifteenth century to place painting among Plato's liberal arts.[121] As a practical matter, Memling's Flemish ecclesiastical and lay patrons were unlikely to view him as anything more than a skilled master craftsman. Even if Memling had a scientific bent, he would have encountered another difficulty. Although new theories of the rainbow had emerged in the preceding two centuries, their claims were conflicting and their dissemination was uncertain. Aristotle remained the dominant figure, as evidenced by the several books of *Questions* that Oresme and his learned University of Paris colleagues wrote on *Meteorologica*.[122] On the seemingly simple matter of choosing rainbow colors, Memling faced a

medieval smorgasbord: three, four, five, seven, and an indefinite number of colors had all been offered.[123] The number of Memling's rainbow colors (with careful scrutiny, approximately six) in his *Last Judgment* is less remarkable than their naturalistic blending.

Memling's *Last Judgment* rainbow does depart from nature in one significant way. No less impossible than it is visually compelling, his Judgment rainbow forcefully swoops forward from its base at the horizon to Christ's seat in the foreground.[124] Like many later artists, Memling apparently (and understandably) assumes that the rainbow is bound by the rules of aerial *and* linear perspective, just as any other landscape element is. But because the rainbow is an image rather than an object, it cannot display any perspective foreshortening, regardless of the viewer's position. Thus the rules of linear perspective applicable to objects do not apply to the rainbow, a distinction that many artists have either overlooked or simply rejected. While Fig. 2-4 is our first rainbow image with illusionism sophisticated enough to pose this problem, it is far from the last. However, we should not take the rainbow's curious placement to mean that Memling was not concerned with optical geometry. For example, Memling's modeling of the reflections of objects in Saint Michael's curved breastplate is both detailed and optically accurate.[125] Only his rainbow departs from the optical rules of the everyday world, whether intentionally or not.

Heaven's Fading Rainbow: Albrecht Dürer's *Adoration of the Trinity* and *Melencolia I*

Hans Memling represents one strain of the final great flowering of Flemish Gothic painting. As idiosyncratic as it was illusionistic, Memling's art was more borrowed from than adopted wholesale.[126] Yet the insularity of fifteenth-century Northern art had been more a matter of taste than a lack of access to Italian models. Indeed, Memling's fellow countryman Albrecht Dürer (1471–1528) achieved international fame early in the sixteenth century with his seemingly effortless melding of Italian and German styles. Dürer's father was a master goldsmith who understandably expected young Albrecht to take up his trade. However, Albrecht's evident talent as a draftsman persuaded the reluctant elder Dürer to apprentice him in 1486 to his Nuremberg neighbor, the painter Michael Wolgemut (1434–1519). In Wolgemut's workshop, Dürer not only learned the painter's trade but also was exposed to the relatively new techniques of drypoint and woodcut.[127]

Dürer's early fascination with the expressive possibilities of these media, as well as engraving, gave him both widespread popular appeal and a steady income. His eclectic artistic tastes sprang from several sources, including the German Gothic pioneer of drypoint known as the Housebook Master (fl. 1450–70) and the Colmar engraver and painter Martin Schongauer (1445/50–1491).[128] After his apprenticeship, Dürer traveled for several years as a journeyman (perhaps visiting the Netherlands and Hans Memling's Bruges workshop),[129] gaining experience and inspiration as he did so. Unlike most of his contemporaries, however, Dürer traveled abroad even after returning to his hometown. In 1494 he made the first of two trips to Italy, an artistic quest partly inspired by his close friendship with the Nuremberg patrician and humanist Willibald

Pirckheimer (1470–1530).[130]

Unlike Memling, Dürer aspired to and was accepted by Pirckheimer and the intellectual elite of his day, sharing with them an enthusiasm for the new humanist ideals of Italian Renaissance thought and art. For Dürer, the ascent of painting from the mechanical to the liberal arts was not a presumption, but a right earned by painters' embrace of the mathematics of perspective and proportion.[131] Yet despite his love of Italy and Italian art, Dürer retained an essentially Germanic outlook: he journeyed from but never abandoned his native Nuremberg, nor did he abandon Northern painting's penchant for favoring realism above flattery.[132] The complexity of Dürer's world view is suggested by the fact that his great enthusiasm for Martin Luther and the Reformation's antipapist demagoguery[133] was combined with lifelong membership in the Catholic Church and continued association with its prelates.[134]

At the height of his career, Dürer contracted in 1508 to execute an altarpiece painting for the Nuremberg metal merchant Matthäus Landauer. With intentions somewhat more altruistic than Florence's Enrico Scrovegni, Landauer had established both a chapel and a hostel for destitute elderly artisans.[135] Like most donors, Landauer nevertheless hoped to secure divine favor with his gifts, so we can well imagine his delight when Dürer delivered the magnificent *Adoration of the Trinity* in 1511 (Fig. 2-5).[136] Although the subject of the *Adoration* seems superficially similar to that of Memling's *Last Judgment*, the paintings record two quite different moments.

For many years, the presumed subject of the *Adoration of the Trinity* was Heaven after the Last Judgment, in which laity and ecclesiastics alike join the heavenly host in celebrating the culmination of Saint Augustine's (354–430) *City of God*.[137] Certainly the serene hierarchy of Fig. 2-5 suggests a moment of divine tranquillity far different from the Last Judgment's frantic day of reckoning. Iconographically, the figures of the Trinity are arranged around the Throne of Mercy, rather than Christ's Throne of Judgment,[138] which makes a post-Apocalypse setting plausible. However, art historian Carolyn Carty argues persuasively that numerous other iconographic details fix Fig. 2-5 as a divine celebration of the Eucharist.[139]

The pallid double rainbow of the Mercy Seat bears little resemblance to Memling's or Giotto's vivid *Last Judgment* bows. Only a narrow reddish stripe on the outside of God's rainbow seat suggests the natural rainbow, and His rainbow footstool is little more than a semi-transparent white arc. Compared to the vividly colored clothes of the heavenly and earthly elect, the rainbows in Fig. 2-5 are wan indeed. Despite their ghostly coloration, though, they retain all the solidity seen in Fig. 2-4's rainbow. Here as there, divine robes fold over the rainbow's curve, and now a lower rainbow is solid enough to serve as God's footrest. What rationale might there be for this combination of unnatural rainbow solidity and coloring?

The unnaturalism of Dürer's rainbow likely stems from his compositional decisions. If Dürer had given his Mercy Seat rainbow vivid colors, it would compete visually with the central figures of Father and Son in Fig. 2-5. At the same time, Dürer's peopling of an illusionistic heaven required a visually (if not physically) plausible seat for that heaven's central figures. Another indication that Dürer has bent meteorology to his illusionistic needs is the V-shaped cloud bank

FIG. 2-5

Albrecht Dürer, *Adoration of the Trinity*, 1511. Courtesy Kunsthistorisches Museum, Vienna

that flanks the Trinity. Although the cloudscape just above the earth is physically believable, the V-shaped cloudscape higher up is not. Thus Dürer has used unnatural clouds as a kind of divine buttress for his equally unnatural rainbows. His pictorial achievement here is that, at first glance, the realistic terrestrial sphere blends seamlessly with the unrealistic heavenly one. Only on closer scrutiny do the inconsistencies become obvious.

Perhaps Dürer's Mercy Seat rainbow is pastel because he deemed its brightness more important than its colors, as was true in some Byzantine and early medieval rainbows.[140] However, this notion poses several problems. First, we do not know whether Dürer knew of or believed in these centuries-old distinctions between bicolor and multihued rainbows. Second, the rainbow in Fig. 2-5 is scarcely brighter than its background, so its brightness is no more striking than its colors. Further evidence that Dürer does not intend the Throne of Mercy's rainbow to outshine the Trinity is that God's robes cast shadows on the lower rainbow! Although Dürer is the first of our rainbow artists to leave an extensive written record, he seems not to have commented on the rainbow.[141] We do know that Dürer was keenly interested in the mathematics of linear perspective and human proportions[142] and that he occasionally produced meticulous watercolor studies of flora and fauna,[143] but the implications of these interests for his rainbows are moot.

A decade before beginning the *Adoration of the Trinity*, Dürer had made rainbows a

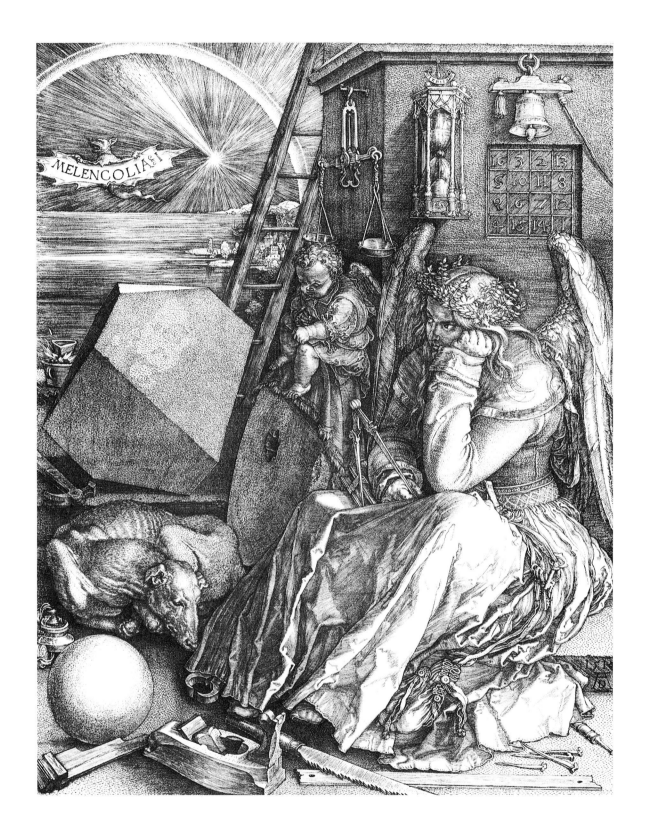

FIG. 2-6
Albrecht Dürer, *Melencolia I*, 1514. Brooklyn Museum of Art, New York, Gift of Mrs. Horace Havemeyer

central feature in another influential work. Published in 1498, Dürer's woodcut series *The Apocalypse* had quickly gained international fame because it made inexpensive, religiously compelling images available to a wide audience. In addition, Dürer had for the first time accompanied Revelation's often impenetrable text with scenes that were visually coherent and easily understood. Numerological fears about the year 1500 and real fears of plague combined to give the fifteen fantastic images of *The Apocalypse* special resonance for Dürer's contemporaries.[144] Although not as well known as the series' *Four Horsemen* woodcut, Dürer's first *Apocalypse* image is no less powerful. In it, God appears to John the Evangelist on Patmos while He is enthroned on a double rainbow. On this seat, God holds seven stars in His hand, is surrounded by seven golden candlesticks, and confronts John with his apocalyptic book.[145] Dürer has merged Revelation scenes to create this image, and he gives the rainbow a visual prominence that is only barely hinted at in John's text.

What might Dürer's *Apocalypse* rainbow tell us about that of the *Adoration*? At most, we can say that Dürer believed the Trinitarian imagery in Fig. 2-5 required a small, muted rainbow compared to that of John's vision. More likely is simply that a pair of large, vividly colored rainbows would only have cluttered the already complex and colorful composition. Dürer's real concession to tradition may have been including any rainbows at all. In fact, Dürer's perfunctory use of the rainbow as a sacred accompaniment in the *Adoration* seems more interesting than does his rainbow's lack of verisimilitude.

Dürer returned to the rainbow in 1514 in his enigmatic engraving *Melencolia I* (Fig. 2-6). Relentlessly and hopefully plumbed by scholars of every stripe, this small work seems to have spawned a different interpretive theory with each new analysis.[146] These theories tend to suffer the fate of courtroom arguments: each sounds definitive and eminently reasonable until the next one is aired. As an example of the stumbling blocks involved, consider Konrad Hoffmann's claim that "*Melencolia* represents Dürer's exhortation against contemporary fear of a new flood."[147] While a rainbow does arch over waterside buildings in the background, are we witnessing a biblical inundation or simply viewing a tranquil seaside town? Similar ambiguities dog *Melencolia*'s rainbow and comet, which may be either good or evil omens depending on the author's taste.[148] If the rainbow appears as a sign of hope, then its pairing with a melancholic winged genius seems incongruous indeed. (Of course, Dürer's point might be that the creative personality's melancholy is unmoved by *any* sign of hope.)[149] However, rather than enter deeper into the morass of *Melencolia* interpretations,[150] we ask instead whether this work has any significance for Dürer's earlier rainbow in the *Adoration of the Trinity*.

In both works, the rainbow is clearly one piece of a complex iconographic puzzle rather than a purely natural feature. But note that Dürer makes the outside of his *Melencolia* rainbow darker than the inside—a subtle bit of realism that is superfluous to any purely symbolic reading. When the rainbow's symbolism is important, Dürer displays the bow prominently (for example, the Patmos *Apocalypse* and *Melencolia I*). On the other hand, when the iconography of a scene does not require the rainbow (for example, the *Adoration of the Trinity*), Dürer apparently

relegates it to the status of a minor prop.[151] In fact, within a generation of Dürer's death, artists' use of the rainbow as a support for Father or Son declined rapidly. This decline is partly due to the increasing artistic energy devoted to pagan and secular images, yet it also reflects the passing from fashion of a powerful, centuries-old pairing of Christ and the rainbow.

Although Dürer seems to have regarded the rainbow with professional reserve, not all his countrymen did. Swept up in a Reformation fervor that combined Lutheran biblicism and hostility to the oppressive tax and labor demands of their lords, thousands of German peasants in 1524–25 attacked symbols of the despised old order: monasteries, castles, and some cities (including Dürer's Nuremberg).[152] Although poorly armed, the organized peasant armies posed a serious threat to patricians, abbots, and townspeople alike. (The peasants found some support among city dwellers who were no better off than they.) Brutal suppression of the revolt inevitably followed, and in its waning days the radical Reform theologian Thomas Müntzer (c. 1490–1525) urged one peasant army into battle against seemingly hopeless odds. Opposed by the nobility's cavalry and artillery, the ragtag peasant force boasted only two potent weapons: Müntzer's unflinching belief in the power of the Holy Spirit[153] and a rainbow-emblazoned banner.[154] Neither would prove much use.

When a rainbow glowed in the sky just before battle, Müntzer had all the inspirational ammunition he needed to counter his opponents' offer of amnesty. As one sixteenth-century chronicler recounts Müntzer's impassioned speech to his troops:

> For albeit we are not well fournished wyth weapons and other thynges necessarye for our owne defence, yet shall this engine of heaven and earth be chaunged rather than God shal forsake vs. . . . Beholde, se you not howe mercyfull a God we haue: behold a signe & token of his euerlastying good wyll towardes vs, lift up your eies and see the Reinebow in the skie: for seeing we have the same painted in our enseigne, God declareth plainely by the similitude that he sheweth vs on highe, that he wyll aide vs in battell, and distroye the Tyranntes.[155]

Predictably, the only force destroyed that day was Müntzer's pathetic army, and its chief rainbow warrior was himself executed days later. As the English writer Thomas Nashe (1567–c. 1601) grimly noted, the antipapist peasants "were all kild, & none escapt, no, not so much as one to tell the tale of the rainebow."[156] Even in Dürer's day, only the unlettered would believe so naively in the rainbow's divine powers.

Maarten van Heemskerck and a Pagan Rainbow

If Albrecht Dürer drank from the well of Italian Renaissance art, other Northern artists plunged into it. Several years after Dürer's death, the Dutch painter Maarten van Heemskerck (1498–1574) set out from Haarlem to immerse himself in the Italian style that was to dominate much of his oeuvre. His pilgrimage would be far from the last. As historian Francis Russell notes, in

Dürer's wake "the artist's journey to Italy would become a tradition, then a commonplace, [and] finally a persisting cliché."[157] To be sure, Heemskerck's talent and the timing of his stay in Rome combined to yield something quite different from mere artistic clichés. One likely impetus for Heemskerck's journey was his study in the atelier of a fellow Netherlander recently returned from Italy, Jan van Scorel (1495–1562).[158] Scorel had lived at the heart of the Roman High Renaissance, briefly serving as director of the antiquities collection and maintaining a Vatican studio under the papacy of Utrecht-born Adrian VI (1459–1523).[159]

When Heemskerck arrived in Rome in 1532, he stepped into an artistic world in flux. Three central figures of the Roman High Renaissance were either in vigorous mid-career (Michelangelo Buonarroti, 1475–1564) or fresh in living memory (Raffaello Sanzio or Raphael [1483–1520] and Leonardo da Vinci).[160] Michelangelo's monumental biblical fresco cycle on the Sistine Chapel ceiling was a mere two decades old, and within a few years, in 1536, he began his ambitious *Last Judgment* on the chapel's altar wall.[161] At the same time, a new generation of central Italian artists was struggling to find direction amid the splendid, if daunting, achievements of its predecessors. For some, the artistic solution was a self-consciously distorted or "mannered" approach to figural drawing and composition. The *Descent from the Cross* (1521) by Rosso Fiorentino (1495–1540) and the *Madonna with the Long Neck* (1534–40) by Parmigianino (1503–40) vividly illustrate the artistic distance traveled from the harmonious monumentality of Raphael's *School of Athens* (1510–11).[162] No longer paramount are the High Renaissance ideals of humanity ennobled by reason and inspired by God, nature, or antiquity. Instead, Mannerist painters treated these subjects as starting points for their own bravura, and often idiosyncratic, solutions of formal problems in color and composition.[163] As a working definition, we can say that sixteenth-century mannerism valued artificiality above illusionism and elegant historical quotation above naturalism.[164] However, Mannerist and High Renaissance painters alike flourished in the Central Italy of Heemskerck's Roman stay.[165]

Although scholars have long debated the presumed virtues and vices of the Mannerist style,[166] there is no doubt that Central Italian painting underwent a profound change in the years surrounding Heemskerck's visit to Rome. One fairly late stimulus for this change was the 1527 Sack of Rome, an orgy of looting and destruction by troops of Charles V (1500–58), the Holy Roman Emperor. Goaded by a threatening alliance between the Medici pope Clement VII (1478–1534) and France's Francis I (1494–1547), Charles unleashed his mercenaries against Clement's defenseless Rome. (Clement himself was imprisoned but eventually escaped.) During their destructive swath, Charles's troops pillaged countless public and private buildings in Rome, destroying many artworks in the process.[167] In the wake of this trauma to the city's cultural life, Rome was ripe for new artistic outlooks, including Mannerism's later extremes. The common belief that the pagan tastes of the Medici popes and the corrupt church had made Rome ripe for punishment[168] certainly would not have discouraged the Mannerist retreat from High Renaissance worldliness.[169] Even Clement's eventual return to Rome and his military triumph over a newly independent Florence could not quell the Reformation flood tide outside Italy[170]

or artistic ferment within it.

Heemskerck has been described as a Dutch Mannerist who also borrowed from Raphael and Michelangelo. Yet recent scholarship has stressed that Heemskerck was not merely a devotee of the Roman High Maniera, which combined Mannerist formalism with a taste for subjects from earlier Renaissance art and antiquity.[171] For example, during his time in Rome, Heemskerck assiduously sketched ruins with a precision that has made these drawings valuable as archaeological records.[172] In a 1604 biographical sketch, the Dutch painter and writer Carel van Mander (1548–1606) approvingly noted of Heemskerck's Roman stay: "He did not sleep away his time nor did he spend it in company of the Netherlanders with drinking and the like, but made drawings of many things, antiques as well as works by Michelangelo; furthermore many ruins, ornaments, and decorative details from antiquity such as are seen in great quantities in that city which is comparable to a painter's academy."[173]

After his return from Rome (c. 1537),[174] Heemskerck worked from Haarlem for the rest of his life, painting Italianate portraits of patrician burghers,[175] Roman gods,[176] and biblical figures[177] alike. Although Heemskerck's taste for Italian High Maniera modeling and composition dominates his later work, his figures sometimes take on a very Northern frankness and fleshiness.[178] Heemskerck was a prolific painter, yet for many years his reputation rested on his even more voluminous output of drawings and print designs.[179] Engravings after Heemskerck, reprints of these engravings, and copies of the reprints eventually numbered in the hundreds, and numerous seventeenth-century artists (including Rembrandt [1606-69]) noted Heemskerck print books in their libraries.[180] Given that mass-produced images were no longer rare, what accounts for the extraordinary longevity of Heemskerck's print designs? To a large extent, it was Heemskerck's fascination with antique themes in general[181] and Roman ruins in particular[182] that guaranteed him popularity far beyond his lifetime. We can see much of the power (and peculiarity) in Heemskerck's vision of Roman antiquity in our next rainbow painting, his *Panoramic Landscape with the Abduction of Helen* (Fig. 2-7).

A strange brew of Homeric literature, archaeology, and mythology swirls within the world of this vast painting (some 5 feet by 12 feet). As if from an aerie, we look down on a fantastic city that is an amalgam of Heemskerck's painstaking observations of contemporary Rome and his garbled understanding of the Seven Wonders of the Ancient World.[183] Yet this bravura catalog of real and imagined antiquity is but a backdrop for the painting's central scene, the legendary abduction of Helen, wife of Sparta's king Menelaus. Helen's abductor is the Trojan prince Paris, and his rash act was the proximate cause of the Trojan War described in Homer's *Iliad*.

Atop a rearing horse in the left foreground, Paris urges Helen and her mount on toward a waiting Trojan ship. Trojan soldiers and servants hurry toward the water, laden with booty from the city. One likely commissioner of the painting, Alessandro de' Medici of Florence (1510/11–1537),[184] might have found this pillage to be an unpleasant reminder of Medici Rome's recent sack. However, other aspects of the Homeric legend would have been more agreeable to Alessandro. Because Renaissance viewers often read Helen's abduction as a marriage, and because Paris was

FIG. 2-7

Maarten van Heemskerck, *Panoramic Landscape with the Abduction of Helen*, 1535. The Walters Art Gallery, Baltimore

also called Alexander, Heemskerck's painting may well have been a grandiose celebration of the Florentine Alessandro's 1536 marriage to Margaret of Austria (1522–86).[185]

The naked man who carries off a golden statue of Venus (the Roman goddess of love) holding an apple would have signaled learned viewers that they were witnessing the aftermath of the Judgment of Paris.[186] On the anchored galleon's mainsail, Heemskerck reinforces this subtle signal by explicitly depicting the Judgment.[187] Greek legend tells how Zeus tricked the unwitting Paris into selecting the fairest of the goddesses Hera, Athena, and Aphrodite (the Roman version's deities are Jupiter, Juno, Minerva, and Venus). This contest of divine vanity was disguised from Paris, who believed that he was simply choosing the most desirable of the three goddesses' bribes to him. Rejecting Juno's and Minerva's offerings of power and glory, Paris accepted Venus's promise that she would help him seduce the world's most beautiful woman, Helen of Sparta (and later Troy).[188]

Behind Paris and Helen unfolds an imposing urban landscape within which are set statues and monuments of Rome that Heemskerck undoubtedly knew.[189] For good measure, Heemskerck has also added some of antiquity's Seven Wonders, including the Colossus of Rhodes (astride the harbor mouth in the right background) and perhaps the Hanging Gardens of Babylon (the walled garden in the middle distance). Although both of these structures were long destroyed by the sixteenth century, Heemskerck's depiction of them is no more fantastic than that of the diminutive Pyramids.[190] Scholars have long speculated whether the remaining Wonders can be identified in Fig. 2-7.[191] For our purposes, we need only note that Heemskerck's medieval sources[192] and self-evident imagination almost certainly made his rendering of the Wonders fanciful (and thus difficult to identify) rather than archaeological.[193]

Scattered among the grandeur are signs of decay—Heemskerck's artful ruins everywhere shadow the pristine beauty of intact ancient buildings. Heemskerck might have made such a juxtaposition for bizarre Roman Maniera effect, or perhaps as a typically Netherlandish foreshadowing of the inevitable doom of antiquity[194] (and of the illicit lovers).[195] If Fig. 2-7 does indeed fete a Medici marriage, Heemskerck would have been ill-advised to present the powerful bridegroom with a paean to doom and decay.[196] But Heemskerck's burgeoning interest in Roman antiquity could easily have married Rome's ruins and their Renaissance reincarnation as a glorious confluence of ancient and modern accomplishment. As historian Richard Turner notes, Heemskerck offers us a specific instance of the widespread Renaissance dualism in which coexisted "the science of archaeology on the one hand and nostalgia for a distant civilization on the other."[197] Even though the juxtaposition of ruined and reconstructed ancient architecture looks incongruous to us, it might not have appeared so to either Heemskerck or his patron.

In fact, Heemskerck offers up a blend of two fashionable sixteenth-century painting genres: history painting and world landscape. History painting, with its emphasis on the human figure in historical, mythological, or allegorical scenes, had long been viewed as far superior to mere landscape delineation.[198] Yet by the sixteenth century, the skill of Netherlanders in rendering a particular kind of historical landscape was admired even in Italy, home to a much different tradition of landscape art.[199] The Netherlandish world (or cosmic) landscape[200] had several distinctive traits: multiple viewpoints within a single work; upward-tilted ground planes seen from great heights; and detailed, meticulously rendered panoramas that seem to encompass a "substantial segment of the earth itself."[201] Clearly Heemskerck's landscape tour de force brings us this encyclopedic view of an imaginary world,[202] while at the same time its foreground offers a suitably dramatic mythological episode.

Note how Venus's temple and the ground beneath Paris seem to be tilted toward us more than the intervening shore is tilted. In fact, if we scrutinize the various building sites in Fig. 2-7, we find that Heemskerck's city has either very unusual topography or a contrived perspective. In a sense, Heemskerck is offering us a hybrid of a ground-level view and a map,[203] a device still used occasionally in cartography. Thus we simultaneously have the vague sensation of standing in the landscape and looking down on it. Heemskerck found this kind of tilted, cluttered cityscape so agreeable that he revisited it in at least two later works.[204] Heemskerck also adheres closely to contemporary Netherlandish formulas for representing the spatial progression of landscape colors (that is, airlight).[205] Beginning with a foreground dominated by browns, Heemskerck gives the middle distance a greenish cast and finally renders the distant (and fantastic) mountains in blues. Typical of Netherlandish world landscape, the bluish airlight does not diminish the visibility of the background features, but rather seems to isolate them with an icy clarity.

From Heemskerck's minutely observed background emerges what appears to be an immense rainbow spanning mountains and sea in grander fashion than even the Colossus at the harbor mouth. Even though this rainbow is meteorologically impossible,[206] that is unlikely to have troubled Heemskerck as he constructed his fantasy landscape. Nevertheless, one realistic

touch in Heemskerck's rainbow is that its top disappears where clouds and rain are in shadow.[207] Consistent with Heemskerck's airlight color scheme, although not with nature, the rainbow's colors are a dull pastel yellow and brown that blend almost imperceptibly with the icy blues of the surrounding clouds. Nonetheless, as an evocation of natural grandeur commensurate with the foreground's momentous events, Heemskerck's rainbow is clearly a success.

In understandably perfunctory asides, writers have variously described this rainbow as the accompaniment to either an approaching[208] or a departing storm[209] or a bad omen similar to the foreground snake and burning ships,[210] or a natural wonder comparable to the Seven Wonders.[211] Clearly one should not exaggerate these disagreements among widely separated authors briefly discussing a minor landscape detail. Nevertheless, their divergent interpretations suggest that not only artists but also historians readily use the rainbow as a mutable emblem. We can add to this catalog of contradictory interpretations. In an episode from the *Iliad*'s Book 3, Iris visits Helen disguised as her sister-in-law. Iris finds Helen (then in Troy) "weaving a great web of purple stuff, double size; and embroidering in it pictures of the battles of that war which two armies were waging for her sake."[212] We may be tempted to connect Iris, Helen, and her pictures with the rainbow, heroine, and destroyed ships of Fig. 2-7. But both the time and place—Helen is not yet in Troy—argue against our reading. As in earlier paintings, rainbows are best read cautiously in the absence of specific documentary evidence. What Heemskerck had in mind for the rainbow we can only imagine, but he clearly did not find the earth-spanning rainbow out of place in the vastness of his pagan world landscape.

The *Rainbow Portrait* of Queen Elizabeth I: An Enigmatic Emblem

In contrast to the sumptuous *Abduction of Helen*, our next rainbow painting at first seems spartan indeed (Fig. 2-8). Yet closer scrutiny of this portrait of England's Elizabeth I (1533–1603; reigned 1558–1603) reveals an ever-unraveling skein of allegory. As Frances Yates has observed, "Every detail in this picture is significant,"[213] even if that significance is not immediately obvious. For example, any casual reading of the *Rainbow Portrait* will be arrested by its two strangest features—Elizabeth's cloak adorned with eyes, ears, and mouths, and the diminutive rainbow that she holds. Explaining these mysterious features first requires that we examine the elaborate allegorical world of Elizabethan portraiture.

The most elementary of the mysteries in Fig. 2-8 is that we cannot be completely certain who painted this unsigned work. Various continental artists have been suggested, but the picture's style implies that the French expatriate painter Isaac Oliver (c. 1556–1617) is its creator.[214] Like Heemskerck in Italy, Oliver would have found favor in England for the novelty and ability of his work, especially his flattering miniatures of royalty and nobility.[215]

Indeed, the *Rainbow Portrait* has long been praised as royal portraiture[216] and was probably admired in Tudor times. The reasons for viewers' admiration have undoubtedly changed over the years. For example, even allowing for some uncertainty in its dating,[217] one puzzlement

FIG. 2-8

Isaac Oliver, *The Rainbow Portrait of Queen Elizabeth I*, c. 1603. Hatfield House, Hatfield, England (photo: Courtesy The Marquess of Salisbury)

is that this portrait cannot be a literal record of the nearly seventy-year-old Elizabeth's features.[218] Yet this "mask of youth" would not have been regarded as a sham by Elizabethan viewers, who readily separated the realities of an aging Queen from her idealized representation as an eternally youthful ruler.[219] Elizabeth's perpetual youthfulness was much more than ritual compliment. It reflected the widespread and unshakable belief that her reign had brought a "flower-decked springtime of the golden age"[220] to England. This Elizabethan belief sprang from an intertwining of contemporary events and classical mythology.

Although Elizabeth's notable successes at sea[221] were paired with a more mixed record at home,[222] she nonetheless succeeded in fostering a fervent personality cult. London crowds viewing Elizabeth's effigy in her funeral train sent up a lamentation such "as the like hath not been seen or known in the memory of man."[223] Several years before Elizabeth's death, characters in the Thomas Dekker (1572–1632) play *Old Fortunatus* opened a performance with the following royal paean: "Some call her Pandora: some Gloriana: some Cynthia: some Belphoebe: some Astraea: all by several names to express several loves: Yet all those names make but one celestial

body, as all those loves meet to create but one soul. I am of her own country, and we adore her by the name of Eliza."[224]

If such adulatory comparisons of Elizabeth to the Greco-Roman goddesses of the moon (Cynthia or Belphoebe)[225] and the dawn (Astraea)[226] seem farfetched to us, they would have been second nature to cognoscenti in Renaissance England.[227] Astraea, like Iris, had taken on diverse forms and duties over time. In Ovid's *Metamorphoses*, the virgin Astraea is the last of the immortals of the Golden Age to flee the ravaged earth in the fallen Age of Iron.[228] The Greeks had also identified Astraea as the goddess of innocence and purity,[229] and so Ovid conceives of her as Justice. According to other authors, Astraea fled to the constellation Virgo when she quit the earth. Thus Elizabethans could identify Astraea with Virgo as the emblem of virginal Justice.[230] Without a trace of irony, they also linked Astraea with Venus, the Roman goddess of love.[231] However, these opposites are paired in Virgil's *Aeneid*, where Venus appears as a maiden of the chaste moon goddess Diana,[232] sometimes also called Cynthia.[233] That Elizabeth should be given attributes not only of the mutable Astraea but also of other mythological goddesses suggests something of her followers' love of multilayered symbolism.

The Elizabethans were not the first to entertain the conceit that their country had entered a new golden age, a reincarnation of Ovid's perpetual springtime of effortless plenty.[234] In his fourth *Eclogue*, Virgil describes a yet-unborn sovereign "beneath whom the iron brood shall first begin to fail and the golden age to arise in all the world."[235] Virgil later portrayed Caesar Augustus (63 B.C.–A.D. 14) as such a ruler in the *Aeneid*,[236] and the Roman poet Marcus Minilius (fl. early first century A.D.) describes a virgin named Erigone (or Virgo) who will govern a new golden age.[237] Especially interesting for us is the Elizabethan description of Astraea's return to earth as a descent from heaven,[238] an image that may suggest a rainbow path. Thus from these classical antecedents Elizabethan readers could easily have imagined their own just virgin to be reigning over the rebirth of the Golden Age.

Christian exegesis of Virgil's *Eclogue* was also significant for Tudor England. Writers ranging from the Emperor Constantine I to Saint Augustine and Dante Alighieri (1265–1321) had helped establish the idea that Virgil's returning virginal ruler was either the Virgin Mary or Christ himself.[239] This messianic reading of Virgil took on some novel overtones by Elizabeth's day. As leader of a supposedly pure, Protestant alternative to the degraded Catholic Church, Elizabeth was seen by Protestants as the agent of a new golden age in English religion.[240] Thus the same Virgo-Astraea association that made Elizabeth the sovereign of a just English state also made her the temporal head of God's one true Church. Another aspect of this complex mix of pagan mythology and Christian power was the Tudor interpretation of the divine right of kings.[241] Just as Elizabeth was not accountable to any political body, so too did she exercise absolute authority over the Church of England (whose direction she tried to set, with varying degrees of success). Yet Elizabeth's authority (like that of the tearful Otto III) directly depended on divine sanction, and while she might try to redefine this sanction, she could not openly abrogate it. Publicly, Elizabeth's deference to and dependence on God's authority was complete: "For myself,

I was never so much enticed with the glorious name of a king or royal authority of a queen as delighted that God hath made me this instrument to maintain His truth and glory."[242] We shall see shortly what implications the Queen's religious rights and responsibilities have for the *Rainbow Portrait*.

Elizabeth's subjects portrayed her not only as a source of virginal purity but also as its analogue, heavenly light. An anonymous poet simultaneously grieves over Elizabeth's death and reviles Catholic Spain by comparing Elizabeth with two celestial lights:

> Righteous *Astraea* from the earth is banish't.
> And from our sight the morning star is vanish't
> Which did to us a radiant light remaine,
> But was a comet to the eye of *Spaine*:
> From whose chaste beames so bright a beautie shin'de,
> That all their whorish eyes were stricken blinde.[243]

Dramatist George Peele (c. 1556–96) more prosaically but no less passionately describes the Queen as "England's Astraea, Albion's shining sun."[244] In his poem *Cynthia* (1595), Richard Barnfield (1574–1627) is even more effusive when he compares Elizabeth with the moon and sun:

> Thus, sacred Virgin, Muse of chastitie,
> This difference is betwixt the Moone and thee:
> Shee shines by Night; but thou by Day do'st shine:
> Shee monthly changeth; thou dost nere decline:
> Yet neither Sun, nor Moone, thou canst be named,
> Because thy light hath both their beauties shamed.[245]

Comparing a monarch to the sun (or other heavenly light) was not unique to Tudor England. Monarchs from Egypt's Akhenaton[246] to France's Louis XIV (1638–1715) have allied themselves in ritual and name with the sun's divine light. The unusual feature of Elizabeth's divinity cult is that, while much of it was orchestrated, its enthusiastic equating of her with the sun seems spontaneous.

Elizabeth's image as a creature of light was given perhaps its most polished form in the *Hymnes of Astraea in Acrosticke Verse* (1599) by the lawyer and poet John Davies (1569–1626).[247] In his twenty-six Astraea acrostics, Davies repeatedly spells out ELISABETHA REGINA at the beginnings of lines. One of several references to Elizabeth's light occurs in the sixth acrostic:

> **R**oyal Astraea makes our day
> **E**ternal with her beams, nor may
> **G**ross darkness overcome her;
> **I** now perceive why some do write
> **N**o country hath so short a night
> **A**s England hath in summer.[248]

Davies's other possible connections with the *Rainbow Portrait* are found in his compositions for two royal entertainments in the last year of Elizabeth's reign. Davies composed several poems for a royal fete given at the Middlesex country house of Harefield in August 1602. This lavish, lighthearted affair spanned several days and included numerous readings and gifts for Elizabeth.[249] One of the most unusual gifts was a rainbow-colored robe specifically intended to evoke the image of Iris. In a Davies poem that accompanied the robe's presentation, Saint Swithin (c. 800–62)[250] stoutly denies responsibility for the weekend's rainy weather and instead blames Iris:

But this he saith that to his feaste
commeth Iris an vnbidden guest
in her moist roabe of collers gay
and [when] she cometh she euer staies
for the space of fortie daies
and more or lesse raines euery day
.

Hee gently first bidds Iris goe
vnto the Antipodes below
but shee for that more sullen grew
when hee saw that with angry looke
from her, her rayneie roabes he tooke
which heere he doth presente to y[o]u[251]

This rainbow robe is not just poetic fancy; a contemporary correspondent describes the gift as "the Gowne of Raynbows very Riche embradrid."[252] (A heart-shaped jewel that appears on Elizabeth's left sleeve may also have had its origins at the Harefield fete.) Elizabeth holds, rather than wears, the rainbow, yet beneath her cloak and underneath her rainbow her dress bears the rain-watered wildflowers of England's Astraean spring.[253]

Within six months another occasional piece by Davies was presented before the Queen, this time at the London house of Robert Cecil (1563–1612), Elizabeth's secretary of state and later First Earl of Salisbury.[254] In his "A Contention between a Wife, a Widowe, and a Maide for Precedence at an Offringe," Davies has those three types of womanhood debate who has first right of offering to Astraea.[255] The costume Elizabeth is wearing and the costumes worn at Davies's "Contention" performance may well have a common source: a 1581 book of costume designs by Jean-Jacques Boissard (1528–1602).[256] In particular, Elizabeth's unusual headdress resembles that of Boissard's figure of a Thessalonian bride, although Oliver has added a crown and a crescent jewel to his design. These two jeweled additions emphasize Elizabeth's Astraean role as the virgin sovereign,[257] while the Queen's loose-hanging curls follow Elizabethan custom for a bride's coiffure.[258] Historian Mary Erler also sees dress similarities between another Boissard costume illustration (this one of a Roman bride) and Fig. 2-8, and she notes how similar the poses of all three figures are.[259]

Specifically Christian interpretations of the *Rainbow Portrait* are also possible. René Graziani describes how the Queen's loose ringlets in Fig. 2-8 were rare both in her portraiture and public appearances, and he proposes that Elizabeth is shown here as a virginal bride.[260] Just as nuns are brides of Christ, so too Elizabeth as head of the Church of England might be seen as His bride in Fig. 2-8.[261] As such, then, Elizabeth modestly offers us God's rainbow covenant as a sign of divine protection[262] (and perhaps of her divine right to rule). A further parallel between Davies, Boissard, and Fig. 2-8 can be drawn from Saint Paul's praise of the Thessalonian church's steadfast resistance to persecution (c. A.D. 50),[263] a comparison that is not unfavorable to the ecclesiastically embattled Elizabeth. While simultaneous readings of Elizabeth as Astraea, Virgo, and the bride of Christ strain credibility,[264] they vividly illustrate the complex symbolic milieu within which the *Rainbow Portrait* arose.

Emblematic ambiguities abound in Fig. 2-8. First, several different iconographies have been offered for Elizabeth's mysterious orange cloak. The cloak's eyes, ears, and mouths may be observing and spreading Elizabeth's fame throughout the world,[265] symbolize the Queen's intelligencers (and her superiority to them),[266] or signify her clear comprehension of Christ's teachings as one favored by God.[267] Elizabeth's headdress poses a second problematic reading. The pale arc emerging from its top has been described both as an aigrette[268] and as an "overarching ray" of queenly light.[269] The latter interpretation clearly makes a direct visual parallel between the Queen and her rainbow. Third, the jeweled serpent on her sleeve may represent either Christ the Redeemer[270] or sublime Platonic wisdom drawn from the earth.[271] Finally, what can we make of the *Rainbow Portrait*'s central mystery, the rainbow itself?

Clearly the rainbow in Fig. 2-8 functions only as an elaborate symbol. At once tangibly graspable and intangibly transparent, this colorless arc bears little resemblance to its natural archetype. And that is as it should be, because the entire rationale for this portrait is a learned presentation of the Queen's multilayered masques. That Elizabeth can go beyond the possible—not only reach but also restrain the rainbow[272]—surely would have resonated well with an audience that already ascribed to her a near-divine stature. Elizabeth was not the only Renaissance leader to adopt the rainbow as an emblem. Working under Pope Paul III (1468–1549), Perino del Vaga (1500/1501–47) and his assistants added Paul's impresa of lilies (that is, irises)[273] and the rainbow among Raphael's *logge* frescoes in the Vatican palace.[274] The motto of Paul's impresa is "lily of justice,"[275] an evocation not only of Christian justice and forgiveness but also of the just virgin Astraea.[276] In a similar vein, Catherine de Médicis of France (1519–89; regent 1560–74) joined her rainbow emblem with the hopeful Greek motto "It brings light and serenity."[277] Given the Catholic-Huguenot strife that wracked her regency, Catherine's impresa was more wish than reality. Like the troubled Catherine's impresa, Elizabeth's rainbow emblem also bears a clarifying motto (possibly added after the picture's completion)[278] whose Latin translates as "No rainbow without the sun."[279] What do we make of this seemingly simple statement?

As with Fig. 2-8's other features, its motto suggests several kinds and levels of interpretation. At the most literal level, the motto is a perfectly acceptable statement of meteorological

fact: without sunlight, no rainbow can appear. A more sophisticated reading is that Elizabeth personifies the rainbow's required sunlight of temporal power, divine grace, or of a dawning golden age. Whether its source is Isaac Oliver or a later, long-vexed iconographer, the motto is certainly meant to provide some clue about the rainbow's odd presence here. Yet even with this rather ambiguous help, Fig. 2-8's rainbow has been described variously as an emblem of peace, worldly power, or divine protection.[280] Of course, another tack is also justifiable. Perhaps trying to unearth the artist's original intent for the rainbow is as pointless as it is difficult. Even if Oliver envisioned a different rainbow symbolism than we do, are we in fact misreading the bow? Oliver's Elizabethan delight in visual and verbal puzzles might well make him content that we have worked hard to unravel the mysteries of the *Rainbow Portrait*, even if we do not ultimately solve them all.

The Painted Rainbow Points Forward—and Back

As Fig. 2-8 indicates, at the outset of the seventeenth century the rainbow continued to serve its traditional roles as herald of God's Noachian covenant and as token of an idealized antiquity. Yet chinks were beginning to appear in this portentous facade. While the rainbow continued sporadically to be revered as a bridge to the distant past and an imagined future, artists increasingly portrayed it as incidental visual filler (Fig. 3-1), an impressive landscape component (Fig. 4-12), or an object of scientific curiosity (Fig. 3-5). With the end of Elizabeth's reign, the rainbow of legend would seldom seem as important as that of the vibrant, colorful present.

By the close of the seventeenth century, the outlines of modern rainbow theory had been clearly sketched in Europe. In both the East and West, some artists and writers greeted these scientific developments with enthusiasm, or at least curiosity. But the future would be marked by a growing tension between artistic and scientific images of the rainbow. Some artists regarded the rainbow's optics as irrelevant to their ends, while others strove to accommodate the latest scientific theories. From the eighteenth century onward, both the language and practice of art reflect this growing divide between the observed and imagined rainbows. Ultimately, even artists who admired rainbow science would find that its needs were no longer theirs—the rainbow bridge had vanished.

THREE

THE GRAND ETHEREAL BOW

In the rainbow's long history, the sunny scientism of Scottish poet James Thomson (1700–48) is a rare moment indeed. Thomson's awe of the groundbreaking rainbow theory of Isaac Newton (1643–1727) was neither universally shared nor especially long-lived. Yet in the third decade of the eighteenth century, Thomson could foresee only a serene confluence of the scientist's and artist's interests. So seamless is this merging for Thomson that, as one recent anthology puts it, he "draws no sharp line between description on the one hand and scientific and philosophical exposition on the other."[2] Although this line was firmly drawn in the decades after his death, Thomson's delight in natural description remained a fixture of British art long after Newton's science was declared its enemy.

Already evident in Thomson's fluid verse, however, is the stark difference in outlook that would separate later science and art. While Thomson drew

> Meantime, refracted from yon
> eastern cloud,
> Bestriding earth, the grand ethereal bow
> Shoots up immense; and every hue unfolds,
> In fair proportion running from the red
> To where the violet fades into the sky.
> Here, awful Newton, the dissolving clouds
> Form, fronting on the sun, thy
> showery prism;
> And to the sage-instructed eye unfold
> The various twine of light, by thee disclosed
> From the white mingling maze.[1]
>
> James Thomson,
> *Spring* (1728), from *The Seasons*

inspiration from his reading of Newton's science, he assiduously reworked it into forms that Newton likely would have found remarkable. For example, in the year of Newton's death Thomson wrote a 209-line paean entitled *A Poem Sacred to the Memory of Sir Isaac Newton* that contains the following memorable passage: "Even now the setting sun and shifting clouds, / . . . declare / How just, how beauteous the refractive law."[3] Newton's attempts to describe the spectrum of refracted light mathematically are elegant indeed,[4] but to modern ears his spare analytical prose does not seem to ring with justice and beauty. Indeed, Thomson couches Newton's analysis of rainbow light in language that seems more akin to Virgil's *Georgics*. The religious overtones of Virgil's nature poetry are given new life in *Spring*, where Thomson sees in Newton's orderly universe a perfect image of the divine order.[5]

Thomson also gives poetic voice to the Deist philosophy of such influential writers as Anthony Ashley Cooper, Third Earl of Shaftesbury (1671–1713).[6] In its early eighteenth-century form, English Deism went beyond mere advocacy of "natural religion," which held that reason, not revelation, provides the best avenue to religious truth. Natural religion itself clearly differs from the traditional Thomist doctrine that human reason affords only partial, imperfect insight into religious truths. Elaborating on the Deist belief in a rational, divinely ordered world, Shaftesbury and other newly militant English Deists insisted that the rituals and practice of Catholicism shared a fundamental irrationalism with pagan superstition. Whether James Thomson subscribed to these more radical Deist doctrines is moot; his enthusiastic support of Deism's vision of rational nature is not. At the same time, playful caprice is as evident in Thomson's *Spring* as Deist moralizing is absent.

Antonio Verrio's Decorative Irises

Certainly our next rainbow painting, the *Heaven Room* (Fig. 3-1) of Italian painter Antonio Verrio (c. 1639–1707), seems innocent of any ideological agenda. Consuming the walls and ceiling of Burghley House's cavernous Fifth George Room, Verrio's vast mural convenes the gods of Olympus in energetic, sensual assembly.[7] Yet at various stages of his career, the architect of this fanciful world was fully immersed in the crosscurrents of English political and philosophical life. Verrio brought to England both a fluency in Baroque illusionism and a remarkably pliant attitude toward his patrons' ideologies.[8] In 1671, he had petitioned for admission to France's Académie Royale with a painting that was ultimately shown to Louis XIV.[9] Whether trained at the Académie or not, Verrio's choice of subjects and florid style clearly follow the formulas of French academism. Recently described by one scholar as "a perfect chameleon,"[10] Verrio has long been regarded as a man who was equally casual in his choice of patrons and paramours.[11] Historian Francis Haskell succinctly describes Verrio's endless adaptability: "Even in an age used to changing allegiances [Verrio's] career was remarkable. Within little more than a generation he had put his art at the service of Louis XIV and his greatest enemy William III; he had painted the most Catholic and the most anti-Catholic programmes ever seen in [England]; and he had been required to

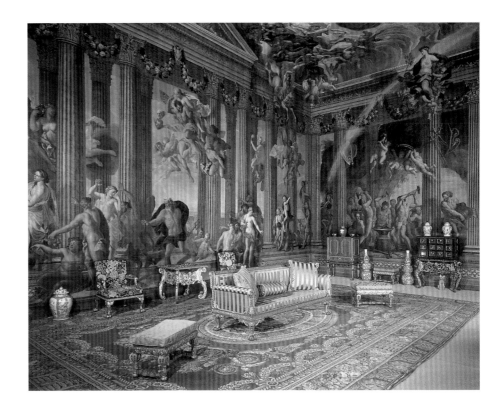

FIG. 3-1

Antonio Verrio, *Heaven Room* mural, before 1696. Fifth George Room, Burghley House (photo: Courtesy The Burghley House Collection, Stamford, England)

figure the 1st Earl of Shaftesbury in the guise of *Faction*[12] and then take advice from the 3rd Earl, his grandson, in depicting the Protestant virtues."[13]

The malleability of Verrio's personality is suggested by two works that flank Fig. 3-1 in time. After a few years in Toulouse and Paris, in 1672 Verrio entered England in the company of Ralph Montagu (later the First Duke of Montagu; 1638–1709), who was acting as Charles II's ambassador to the court of Louis XIV.[14] Hoping for royal patronage, in 1674 Verrio completed *A Sea Triumph, being a large piece with King Charles II in it*, a painting as relentlessly flattering as its unwieldy title suggests.[15] Although 1674 in fact found Charles without *any* sea triumphs, Verrio's agreeable fiction seems to have resulted in his working on a series of *trompe l'oeil* decorations at Windsor Castle. In the *Sea Triumph* a handsome if rather disengaged Charles is borne seaward on a chariot driven by Neptune and surrounded by three women who represent Charles's three kingdoms. Fame holds a scroll that grandiloquently proclaims of Charles "[He holds] command over the ocean who bounds his fame with the stars." Above fluttering putti and the lightning-struck figure of Envy float Minerva and Venus, who admire Charles's anchored fleet below.[16] Supporting several putti is a short arc of the rainbow Iris, whose iconographic function here is obscure at best. A decorative afterthought in a picture designed to curry favor, Iris has indeed sunk far beneath her central role in Elizabeth I's *Rainbow Portrait* (Fig. 2-8).

Verrio was an artist who was more prolific than inspired, and his tireless work (with assistants)[17] on a wide variety of mural programs usually proved more agreeable to his patron of the moment than to posterity. One of Verrio's most overtly political projects was a work that featured

the mythological *Marriage of the Rivers Thame and Isis* (completed 1702).[18] Surrounding the King's Staircase at Hampton Court, this elaborate history painting for William III (William of Orange, reigned 1689–1702) includes not only the celebratory feast of the Roman gods (ceiling) but also a tableau of Romulus, Remus, and the Caesars (wall). Nearly lost among the upper revels is the rainbow of Iris, who appears here as Juno's subservient handmaiden.[19]

Verrio's execution of this grand design has seldom met with approval. Writers from the eighteenth century onward have heaped scorn on the work, with Horace Walpole (1717–97) accusing Verrio of painting "as ill as if he had spoiled it out of principle"[20] and historian Croft-Murray dismissing it as "one of the most unpleasant daubs ever produced by the Baroque age."[21] Verrio was once suspected of having sabotaged his own work as a show of defiance against the Protestant William III.[22] This belief might seem bolstered by the fact that Verrio's eldest son fought against William in Ireland with the forces of James II and was captured in 1690. However, William promptly ordered his release, specifically mentioning Verrio's services at Windsor.[23] In fact, this episode may not tell us much about Verrio's true loyalties. Edgar Wind plausibly suggests that Verrio's decade-long absence from royal commissions (1688–99) was driven more by caution than principle. Ever the survivor, Verrio may have feared his past association with the deposed James, or have been uncertain about William's political longevity.[24] Whatever artistic faults Verrio brought to the King's Staircase, they cannot explain its central message. For that we must examine one of the painting's figures, Julian the Apostate (331–63).

Julian ruled the Roman Empire during the last two years of his life. A baptized Christian and half-nephew of Constantine the Great, Julian professed adherence to the faith until he came to power. Then Julian's intellectual passion for paganism, sharpened by memories of Constantine's heirs murdering his relatives, led him to renounce Christianity. For this apostasy and the Christian persecutions that it unleashed, Julian earned the church's enduring enmity. Fancying himself a philosopher-king, Julian settled numerous ideological scores in his writings. Among these is the satirical *Caesars*, in which Julian's beloved Hellenic culture triumphs over Rome. It is an episode from *The Caesars* that Verrio depicts on the King's Staircase. The demigod Romulus tries to seat Rome's emperors at a Saturnalia table below the gods, but Hercules opposes him with a single Greek who surpasses them all, Alexander the Great (356–323 B.C.). William III, who took Hercules as a favorite emblem, thus is introduced by his protector as the new Alexander in Verrio's mural.[25] To eighteenth-century Protestant partisans, William's inadequate Roman opponents were none other than the popes,[26] to whom the new sovereign denied his kingdom.

But William himself preached religious tolerance, so he likely envisioned Julian as a liberal, accommodating ruler (which Julian was at first). Certainly this was the view the Third Earl of Shaftesbury had of Julian, and he may well have overseen Verrio's work at Hampton Court.[27] Verrio surely met Shaftesbury's expectation that the artist was, in Wind's words, merely "a manual executant who carries out in visible material the ideas dictated to him by the philosopher."[28] Because Shaftesbury later proved to be an exacting director of his artists,[29] Verrio's occasional intolerant, anti-Roman touches in *The Caesars*[30] are more difficult to explain. Perhaps an

iconography combining both religious tolerance and gibes suited William and Shaftesbury. As for Iris's role at Hampton Court, she is no more than a mythological bit player in the hands of an artistic middleman who dutifully drafts others' ideas.

At Burghley House, Verrio's Iris makes a far grander impression (Fig. 3-1). Here Verrio's taste for *trompe l'oeil* architectural painting is blended effortlessly with a typically energetic Baroque gallery of the gods. The combination of realistic perspective and an impossible assembly is compelling indeed at such close quarters.[31] With no program to follow other than visual delight, Verrio's modest but playful talent shines.[32] Often described as Verrio's greatest success,[33] the Heaven Room mural was part of Burghley's extensive refurbishing by John Cecil, Fifth Earl of Exeter (1648–1700). Five generations removed from Lord Burghley,[34] Exeter was among the first (and wealthiest) enthusiasts of the English Grand Tour. Yet so lavish was the European collecting by Exeter and his wife that their estate was saddled with debt for decades, a debt that Verrio assiduously helped build.[35] As Ralph Montagu's cousin, Exeter may have known Verrio personally as well as by reputation. In any event, he hired Verrio to decorate portions of Burghley, where from 1686–97 the artist and his entourage painted six large rooms and a staircase ceiling.[36] Apparently Verrio's stay was as sensational as his paintings.

However discreet Verrio was at court, he evidently suffered from few inhibitions at Burghley. An obviously provoked Exeter once branded the artist an "impudent dogg." Verrio shot back that Exeter was imposing on his time and that assistants could do figure-painting for him (conveniently ignoring that this was Verrio's responsibility).[37] Usually Exeter's hapless secretary dealt with the extravagant and difficult Verrio, whose tastes ran to alehouse carousing, expensive footwear, and bawdy houses. Debt, unwilling female servants, and work at other country houses also distracted Verrio.[38] But despite these diversions, Verrio and his assistants did ultimately transform Burghley's gloomy Elizabethan interior into a Baroque showcase (considerably aided, of course, by its owners' relentless Continental collecting). Verrio and Exeter shared at least one passion, female nudes, and these abound in Verrio's Burghley paintings, including Fig. 3-1.

Even by Baroque standards, Verrio's Heaven Room mural is voluptuous and exuberant. In Fig. 3-1 we see only a part of his energetic tableau. On the left, an angry Neptune (with trident) emerges from the sea, prepared to release Mars and Venus from the net in which Venus's husband Vulcan has ensnared the illicit lovers. Surrounding Neptune are numerous youths, putti, and minor deities who react with embarrassment or excitement to the lovers' predicament. To the right of Neptune, a helmeted Castor and putti tumble from the ceiling's Olympian heights. Above the painted frieze Jupiter and Juno reign supreme, surrounded by the zodiac and such deities as Apollo, Diana, and Minerva.[39]

On the right-hand wall, several Cyclopes labor feverishly at Vulcan's forge and anvil while an unwigged Verrio sits in their midst observing carefully. Above the anvil, putti bear aloft Vulcan's fruit—a shield and helmet. Crowning this frantic scene is Iris, who bears earthward a myrtle branch, symbol of love or fidelity.[40] Poised between Olympus and earth, she is accompanied by her luminous rainbow arch, from which she can survey the chaos of divine lust and labor below.

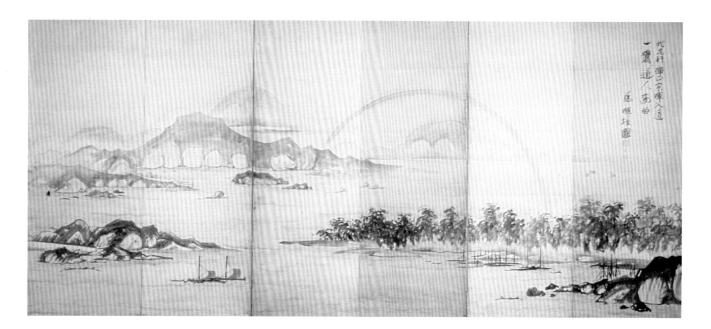

FIG. 3-2
Soga Shōhaku, *Miho no Matsubara*, c. 1765. Kimiko and John Powers Collection, Carbondale, Colorado

Croft-Murray notes: "Iris sends [Verrio] his colours in a rainbow shaft of light which strikes on its downward course two polished shields hung on one of the columns and breaks over the artist's head."[41] Iris's two-tone bow of green and yellow may seem a rather wan rally to the colors. Yet whatever color inspiration Iris gives Verrio here, clearly neither is embroiled in the action around them. Both the artist and his muse seem detached messengers, intent only on telling an earthly audience what they know of heaven's fame and folly.

A Japanese Rarity: Soga Shōhaku's Rainbow

Worlds removed from the Heaven Room's sensuality is the austere tranquility of Soga Shōhaku's (1730–81) *Miho no Matsubara* (Fig. 3-2).[42] But this too is a divine, imaginary landscape, and its rainbow is no less emblematic. Operating from the imperial capital of Kyoto, the cultural heart of Edo-period Japan (1603–1867), Shōhaku was a painter both respected and in some demand.[43] He is known as an eccentric, flamboyant figure in Japanese art,[44] yet Fig. 3-2 also shows that he is aware of the taste of his times and interested in Western pictorial ideas.[45] The surviving vignettes that hint at Shōhaku's life do not tell us why this innovative painter might depict a landscape feature rare in Japanese art—the rainbow.[46]

Japanese graphic arts in Shōhaku's day had been shaped both by Japan's indigenous Shintō religion and by imported East Asian Buddhism.[47] Shintō's nature mysticism underlies Japanese landscape painting, yet Shintō's avoidance of divine imagery means that Shintō cannot be landscape's direct source.[48] Ultimately, much of Japanese art stems from the sixth-century A.D.

arrival of Buddhism from Korea and China. With its elaborate rituals and precincts, esoteric metaphysics, and technical sophistication, the culture of Buddhism gained a firm foothold in Japan by the early seventh century.[49] As Rosenfield and Shimada note, Buddhism brought with it some enduring constants: "the world as known to man's senses is basically false and delusory; an infinitely truer, richer, mightier realm lies beyond; the chief concerns of man's life must be internal, focused on his serenity and spiritual equipoise; man's ultimate goal, no matter how he reaches it, is the attainment of Nirvāna (*satori*), the transcendent state in which all psychic and physical ties to the world are broken and man is freed from endless rebirths."[50]

Buddhism and Thomist Catholicism clearly share a fundamental distrust of (or disregard for) the senses and one's physical surroundings. Yet as was true for Christianity, vivid image-making was key to Buddhism's success in reaching a uneducated lay audience. In thirteenth-century Japan, intricately detailed and elaborately costumed temple statues served much the same purpose as their cathedral counterparts in the West.[51] Over the centuries, enthusiasm for Buddhist and secular styles of Chinese art waxed and waned in Japan. One of the most artistically influential Chinese imports was Zen Buddhism (Chinese Ch'an Buddhism) and its renovated Confucianism. In the thirteenth century, many Japanese monks returned from the mainland with this supposedly uncorrupted strain of Buddhism, and within a century Zen had acquired the shogunate's official patronage.[52] Zen monasteries flourished in such centers as Kyoto, where Chinese-based ink painting (Japanese *suiboku-ga*) developed as an austere alternative to the lush decorativeness of Buddhist art.

Formed by ink brushed on silk or paper (sometimes augmented by colors), *suiboku-ga* was a natural expression of the simplicity inherent in Zen philosophy.[53] Primarily a contemplative, monastic art form at first, by the early sixteenth century *suiboku-ga* was favored by family members of the Muromachi (or Ashikaga) shogunate (1338–1573). The rapidly growing popularity of *suiboku-ga* led to a proliferation of secular practitioners and schools, for which Kyoto was an important center. The Ashikaga painter Kanō Masanobu (1434–1530) founded the most influential such school, which for generations maintained close artistic ties with Zen monasteries while developing increasing secular (and sometimes colorful) varieties of *suiboku-ga*.[54] Shōhaku himself would study under a Kanō-trained artist more than two centuries after the master's death.[55]

Climate too played a role in the evolution of Japanese landscape art, especially in Kyoto where frequent fog and haze limited visibility. In the view of art historian Robert Paine, Kyoto's "visibility, lower than that of the drier climate of many parts of China, has caused the artist in Japan to be more concerned with the strength of outline than with the subtleties of depth sought for by his Chinese neighbour. The decorative flatness and the higher colour of Japanese art also follow" from this.[56] In the companion piece to Fig. 3-2, a screen of *Mount Fuji*, fog encroaches on the mountain's headlands, enveloping much of the middle distance. Similarly, a thin layer of fog partially obscures the forested sand spit that gives Fig. 3-2 its name, the Miho no Matsubara.

Clearly Shōhaku exploited such conventional techniques and forms in his work. Yet

contemporaries and historians alike describe him as anything but conventional. Rosenfield and Shimada observe "Shōhaku often stretched the limits of propriety and good taste in both style and the interpretation of [traditional] themes."[57] Hickman says that "Shōhaku's expressive mean is so distinctly personal, so idiosyncratic in nature, that it can only be properly categorized as highly inventive and neoteric," an experimental attitude that is typical of eighteenth-century Japanese art.[58] Shōhaku's personal idiosyncrasies stamped him early on as a "lunatic,"[59] an outspoken egotist who jested about another Kyoto artist by saying "If you want a [real] painting, you must come to see me; if it's only a drawing you're after, you should try Maruyama Mondo [Ōkyo]."[60] Given his unusual tastes, Shōhaku probably drew some satisfaction from the work of other Japanese art eccentrics.[61] These men included devotees of *bunjin-ga*, or "literati painting," a style that both emulated and exaggerated the subtle nature paintings of Chinese scholar-amateurs.[62]

All these artistic threads (and more) are entangled in *Mount Fuji* and *Miho no Matsubara*. The mountain silhouette dominating the left-hand screen is drawn with the formal linearity of the Kanō academic style, while elsewhere *bunjin-ga*'s freer brush strokes are evident. Curious bubble-shaped clouds, their shape more akin to the rainbow than reality, dot the sky. Shōhaku has rearranged the actual topography here to create what Rosenfield calls a "symbolic topography" that evokes, rather than maps, the region's landscape.[63] Just as his rival Ōkyo did, Shōhaku experiments here with the still-novel techniques of Western linear perspective.[64] Shown from an arresting (and impossible) oblique viewpoint,[65] the rainbow contributes to Shōhaku's illusion of pictorial depth as it bridges the foreground and middle distance. Because the rainbow itself is so rare in Eastern landscape art, Shōhaku's perspective view of it seems all the more odd. Of course, Shōhaku's fanciful rainbow is consistent with his imagined topography, but his bow might have another source. Although Japanese trade with Europe was still limited in the mid-eighteenth century, Western art and science were nonetheless studied avidly.[66] Perhaps Shōhaku encountered the rainbow's oblique image in works based on René Descartes's (1596–1650) or Isaac Newton's optical discoveries.[67] Certainly foreshortened rainbows were far from a rarity in the Western art (for example, Fig. 2-4) then being scrutinized in Japan.

Spanning a static, shadowless world, Shōhaku's unreal rainbow is paired with the scene's other ephemera: ships frozen under sail, motionless fog, and birds in mid-flight. This contrasts with Fuji's ancient solidity and may perhaps reflect contemporary worship of Japan's landmark symbol by a cult that blended Shintō and Buddhist impulses.[68] Shōhaku's nearly achromatic rainbow is a ghostly complement to Fuji's silhouette, but it remains a distinctly lesser partner. Both mountain and rainbow are elements of a silent dream world, yet there seems no doubt which will fade first from waking memory.

Angelica Kauffman: Newtonian Color and the Artist's Rainbow

In contrast to Fig. 3-2, the connections of Fig. 3-3 to Isaac Newton's optics are much surer. *Colour* is one of four paintings by Swiss-born Angelica Kauffman (1741–1807) installed in the

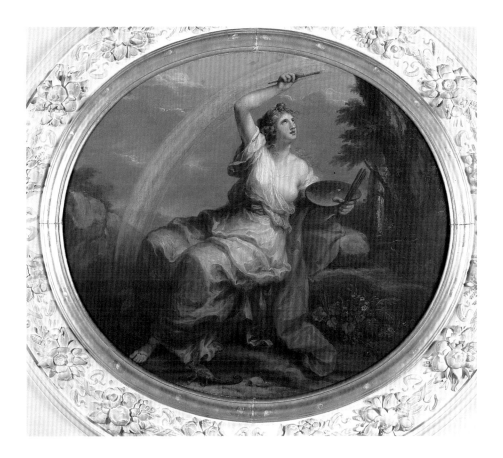

FIG. 3-3
Angelica Kauffman, *Painting*, c. 1779. Royal Academy of Arts, London

entrance hall ceiling of London's Royal Academy of Arts. Its companion pieces are *Invention*, *Composition*, and *Design* which, together with works by American expatriate Benjamin West (1738–1820), illustrate Georgian England's most sophisticated art theories. Each of Kauffman's figures signals its purpose: Invention, her head bearing the wings of a genius, gazes upward thoughtfully, Composition studies a chessboard while holding a drawing compass, and Design sketches from an ancient sculpture.[69] Color, however, seems bolder than her companions, probing the rainbow with a brush in order to fill her palette with its colors.

Kauffman's contemporaries were sure that they understood her symbolism. Writer and literary gadfly Giuseppe Baretti (1719–89) describes *Colour* in his 1781 *Guide through the Royal Academy*: "*Colouring* appears in the form of a blooming young Virgin, brilliantly, but not gaudily dressed. The varied Colours of her garments unite and harmonize together. In one hand she holds a prism, and in the other a brush, which she dips in the Tints of the Rainbow. Under her feet is seen the Cameleon sporting on a bed of various flowers."[70]

In fact, the chameleon sports on rock rather than flowers, and Baretti's prism is not evident anywhere in Fig. 3-3. As art historian Paul Schweizer observes, these discrepancies between word and image probably reflect a subsequent repainting rather than Baretti's errors. Perhaps *Colour*'s female figure raises a paintbrush instead of a prism because Kauffman believes the gesture is self-evident. In other words, James Thomson's explicit imagery of a rainbow prism

may be unnecessary for late eighteenth-century viewers, some of whom would readily equate artists' colors with those of the rainbow.[71] Yet as we will see in Chapter 7, this equation is problematic at best.

Furthermore, artistic tradition had long distinguished the rainbow's unreal, merely "apparent" colors from the "real" colors of pigments. Kauffman may hint at this distinction by including the curious figure of the chameleon. With its ephemeral, changeable colors, the rainbow was known as the "camelion of the ayre" in some iconographic literature current in Kauffman's day.[72] The best known such catalog of symbols and emblems was the 1593 *Iconologia* of Cesare Ripa (fl. 1600), a 1778 English edition of which Kauffman apparently studied and used in other works.[73] We do not know whether *Iconologia* or some similar catalog inspired Kauffman to add a rainbow chameleon to *Colour*. Widely read and thoroughly versed in Greco-Roman and Christian symbolism, she naturally could have drawn her inspiration from any number of sources.[74] However, in a 1758–60 edition of *Iconologia* the rainbow variously appears as an emblem of peace, grace, and the air. On the latter, *Iconologia* tells us that the rainbow is "a symbol of divine benevolence found in the air, and one of the beautiful phenomena peculiar to it."[75] Four separate editions from 1603 to 1677 included both rainbow and chameleon among the attributes of air.[76] Ripa's use of the chameleon becomes clearer when he says that this animal lives solely on air, an erroneous belief arising from the chameleon's ability to go long periods without eating.[77] Add to this the chameleon's changeable colors, and it indeed becomes an apt (although misunderstood) emblem for the rainbow, Kauffman's "camelion of the ayre" in Fig. 3-3.

Kauffman's pairing of chameleon and rainbow may indicate little more than her thorough knowledge of esoteric symbolism. But if the rainbow's colors are as ephemeral and unreal as the chameleon's, are they a particularly good source for artists? In other words, is Kauffman's depiction of Georgian color theory an image that incorporates both Newtonian and anti-Newtonian emblems? Kauffman's influential colleague Benjamin West certainly had no qualms about embracing the rainbow as a color standard for painters, claiming in 1817 that the "*Order of the Colours in a Rainbow*, is the true arrangement in an Historical picture."[78] Whether Kauffman shared his enthusiasm is unknown. However, her position as a respected history painter, combined with Fig. 3-3's prominent display at the Royal Academy,[79] surely must have seemed like formal academic endorsement of Newton's color theory.[80] If *Colour*'s small chameleon is a dissenting (or at least equivocal) note, it is one that might easily be overlooked in a ceiling painting. As a founding member of the Royal Academy, Kauffman surely was aware of the conditions under which her painting would be seen.

Of course, we may be making more of Kauffman's rainbow colors than she did. But she was willing to exploit color symbolism in other paintings with layered meanings, including the seemingly straightforward *Angelica Kauffman Hesitating Between the Arts of Music and Painting* (1794).[81] This self-portrait elevates a difficult (and perhaps embellished) decision in Kauffman's life to the suitably grand form required by the conventions of history painting. Her first biographer reports that in 1760 the young Kauffman, a virtuoso in both painting and music, felt com-

pelled to choose between the two talents. Accompanied by her father, she sought advice from a priest in their home of Milan. Supposedly the priest told them that while music offered easier and earlier rewards, it also presented more distractions to a devout young woman. The greater demands and more gradual success of a painting career ultimately represented the best choice for her.[82] Kauffman's reluctant departure from the arms of Music and her heeding of Painting's sterner call is the subject of the *Self-Portrait*. The tension and regret of this invented scene do not preclude Kauffman's proper (that is, traditional) use of color symbolism. The female figure of Painting is clothed in the artist's traditional primaries of red, yellow, and blue, a choice that is at odds with Kauffman's earlier rainbow palette in Fig. 3-3.[83]

Like Benjamin West, others in Kauffman's circle also wrote spiritedly about color theory and the rainbow. During 1764–65, Kauffman's artistic mentor in Rome was the influential Neoclassical painter Anton Raphael Mengs (1728–79).[84] The Neoclassicism that Mengs helped popularize arose from the twin sources of artistic reaction and archaeological discovery. Neoclassicism grew in part from a reaction against the kind of Baroque sensuality and frivolousness evident in Fig. 3-1. A hunger for the "true" spirit of antiquity also drove Neoclassicism, an appetite spurred by recent excavations at Herculaneum and Pompeii.[85] As many earlier artists had, Mengs sought inspiration and opportunity in Rome, which was then seen as the center of classical art. Mengs and Kauffman also came to admire the ancient Greek art recently championed in print by German art historian Johann Winckelmann (1717–68).

From both these men Kauffman developed the Neoclassical taste that would inform much of her later career.[86] Early on, Mengs wrote about not only the art of antiquity but also such modern topics as color theory. While he enthusiastically endorsed Newton's seven-color spectrum, he made sure that he extracted from it the painter's traditional primaries: "The colours of the Ir[i]s have among them a good harmony; but if one takes away the red, the blue, or the yellow, the harmony is presently destroyed."[87]

Mengs's favorable opinion of prismatic colors is bettered by Henry Fuseli (1741–1825), a fellow Swiss painter (and Kauffman's onetime suitor) living in London. During a lecture given (probably in 1815) while a Professor of Painting at the Royal Academy, Fuseli claimed:

> The principles that regulate the choice of colours are in themselves as invariable as the light from which they spring, and as the shade that absorbs them. Their economy is neither arbitrary nor phantastic. Of this every one may convince himself who can contemplate a prism. Whatever the colours be, they follow each other in regular order; they emerge from, they flow into each other. No confusion can break or thwart their gradations, from blue to yellow, from yellow to red; the flame of every light, without a prism, establishes this immutable scale.[88]

Like Mengs, Fuseli regarded some of Newton's prismatic primaries as more equal than others. Red, yellow, and blue remained for him the most important primaries, evidence for which he took as their appearance in flames. In allowing both Newtonian and artistic primaries, Fuseli

was more accommodating than a previous Professor of Painting, James Barry (1741–1806),[89] but was clearly less so than Benjamin West. In these diverse reactions, we see something of artists' long and often confused debates after Newton. Kauffman's friends and colleagues almost certainly discussed their passionate opinions on Newtonian color with her. Yet she herself seems to have remained silent on the subject, with the exception of her ambiguous portrait of *Colour*.

John Constable on Optics, Landscape Art, and the Rainbow

John Constable (1776–1837) is remembered today as an innovative painter of England's rural landscape. As lovingly as he depicted and reimagined the landscape of his boyhood Suffolk, he also devoted much energy to painting English skies. While not unprecedented, Constable's cloud studies from the 1820s nonetheless are justly famous examples of artistic and meteorological insight.[90] In his last years, Constable found in the rainbow still another sky sign that bridged his interests as amateur scientist and professional painter. His 1831 oil *Salisbury Cathedral from the Meadows* (Fig. 3-4) is an image that portentously jumbles together his ideas on landscape art, English politics, and the rainbow.

Unsold at exhibition, *Salisbury Cathedral* was a work that Constable could not lay down, and it occupied him intermittently for the rest of his life.[91] Constable not only retouched the oil repeatedly but also anxiously directed preparation of mezzotints made after it by engraver David Lucas (1802–81).[92] Two years after the painting's Royal Academy exhibition, Constable wrote to friend and biographer Charles Leslie (1794–1859): "I must give up — — on Saturday morning, as I have much to do to the great 'Salisbury,' and am hard run for it."[93] Several other letters testify to Constable's dogged attention to this painting.[94] Two days before his unexpected death, Constable fretted to Lucas about the *Salisbury Cathedral* mezzotint: "I am greatly pleased to see how well you are preparing for the new bow; the proof is about what I want.... We cannot fail with a proper bow."[95] Such comments are not surprising from an artist as fastidious as Constable, yet they do indicate his unusually deep and long-lived attachment to the work.

Lecturing before the Royal Institution of Great Britain in June 1836, Constable could have been speaking of his own art when he said: "By the Rainbow of Rubens, I do not allude to a particular picture, for Rubens often introduced it; I mean, indeed, more than the rainbow itself, I mean dewy light and freshness, the departing shower, with the exhilaration of the returning sun, effects which Rubens, more than any other painter, has perfected on canvas."[96] *Salisbury Cathedral*'s menacing storm clouds and lightning strike hardly evoke thoughts of "dewy light and freshness." Constable himself captioned the exhibited work with lines from James Thomson's *Summer*: "... while, as if in sign / Of danger past, a glittering robe of joy, / Set off abundant by the yellow ray, / Invests the fields, and nature smiles reviv'd."[97] Just as epigraph and painting differ in tone, so too do the storm and its accompanying rainbow. According to Leslie, Constable regarded this work as "conveying the fullest impression of the compass of his art,"[98] a relationship that we now explore.

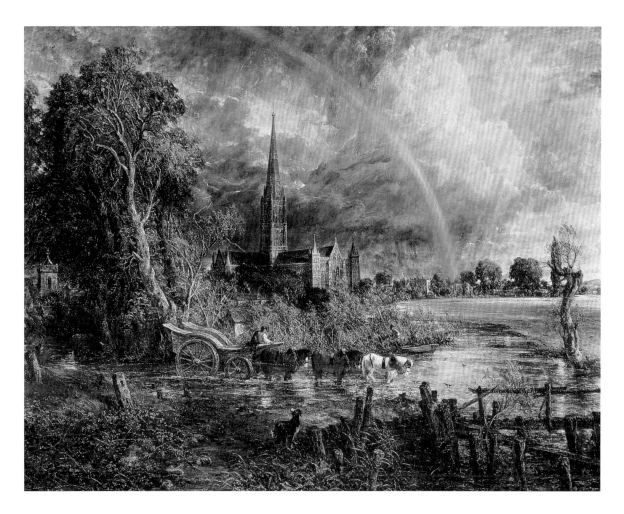

FIG. 3-4
John Constable, *Salisbury Cathedral from the Meadows*, exhibited 1831. Private collection / Bridgeman Art Library, London

Within the rigid social structure of eighteenth-century England, the young Constable enjoyed remarkably good fortune. His father had inherited one gristmill on the River Stour and later ran others, successes that he multiplied with corn trading and coal trading. Eventually able to build a mansion for his family, the elder Constable made the difficult transition from mere tradesman to the gentry, obtaining a comfortable position from which he could indulge young John's impractical passion for art. Work in his father's mill left Constable with a keen appreciation of (and distaste for) the laborer's life. This experience, combined with his family's conventional moralizing about labor's virtues, inclined Constable to view his work as an artist through the lens of high moral purpose.[99]

Constable also took from his boyhood a powerful nostalgia for the tidy, prosperous farmland of East Anglia. Inflation caused agricultural prices to rise substantially during the Napoleonic Wars (1793–1815), and along with increased farm profits came widespread improvements

in animal husbandry, agricultural equipment, and farming practices. Suffolk farmers were already in the agricultural forefront, having long used such advances as seed drills and crop rotation.[100] Thus Constable's early memories were of a proud yeomanry laboring at well-kept, productive, and profitable farms. When he recalled this lush landscape, Constable fondly said that its human and natural scenery "all impart to this particular spot an amenity and elegance hardly any where else to be found," features that "made him a painter."[101] Of course, Constable recalls this idyll safe in the knowledge that neither he nor his family were laborers, a potentially combative class viewed by their "betters" with a mixture of benevolence and unease. For Constable, this unease would boil over in 1831 at the prospect of giving "the government into the hands of the rabble and dregs of the people," including insurrectionist laborers like those who destroyed his vision of an untroubled rural England.[102] Although he never left England, he occasionally traveled within it, honeymooning in Dorset and Wiltshire (the latter county contains Salisbury Cathedral) and once touring the Lake District.[103] On each such occasion, he returned with drawings, oil sketches, and new ideas for his art. While Constable lived happily most of his adult life in London, images from East Anglia and his travels remained fixtures of his painting.

Constable's formal schooling in art never encouraged such rough-finished works as Fig. 3-4. Inspired by the advice of local mentors and the landscapes of Thomas Gainsborough (1727–88), he trained in London under Joseph Farington (1747–1821), a middling landscapist whose political acumen and temperament had earned him the apt title "Dictator of the Academy."[104] Farington harped that Constable's work lacked "finish," the academician's code word for a proper history painting's sleek, finely honed details. Another mentor, painter George Beaumont (1753–1827), seconded Farington in encouraging Constable to follow Academy founder Joshua Reynolds's prescriptions for landscape, a genre that Reynolds had little use for.[105] Among Reynolds's chestnuts in his Academy *Discourses* is a firm warning that academic theory should help artists paint better, not theorize better—that is, art theory was not an end it itself. The counsel of Farington, Beaumont, and the deceased Reynolds apparently stuck, since in 1802 Constable echoes Reynolds as he describes his resolve to study the Suffolk landscape because "Nature is the fountain's head, the source from whence all originally must spring."[106] Constable now returned to his home turf armed with a knowledge of Old Masters and the newly fashionable picturesque.

English writer William Gilpin (1724–1804) first used the term "picturesque beauty" in 1768 to describe landscapes that blended the serene (or beautiful) and the awe-inspiring (or sublime). As a reaction against the order and formality of Neoclassicism, the picturesque shared Romanticism's love of the natural sublime. But while Romantic landscape often favored sublime depictions of raw, untrammeled nature, picturesque landscape usually emphasized the novelty of paired architectural and natural scenery (for example, classical ruins in a calm, otherwise pristine landscape).[107] Remarkably, the picturesque qualities of real English landscapes were to be judged against imaginary views of the Roman Campagna by such painters as Claude Lorrain (1600–82) and Gaspard Dughet (1615–75). English picturesque insisted on clear divisions be-

tween a scene's background, middle ground, and foreground, although ideally this order should be discreetly disguised as topographic accident. In his student work, Constable's studies recast the Stour Valley topography according to picturesque conventions.[108] Of course, the picturesque's delight in contrived nature was fundamentally different from Constable's affection for the real rural landscape of his youth.

While Constable's style would go far beyond picturesque conventions, he used them when convenient.[109] For example, picturesque theorist Richard Payne Knight (1750–1824) had claimed: "The usual features of a cultivated country are the accidental mixtures of meadows, woods, pastures, and cornfields, interspersed with farm houses, cottages, mills, &c. and I do not know in this country that better materials for middle grounds and distances can be obtained."[110] Compare this with Constable's words to his friend Archdeacon John Fisher (1788–1832) in 1825. Enthusiastically describing progress on his painting *The Leaping Horse*, Constable says: "It is a canal and full of the bustle incident to such a scene where four or five boats are passing with dogs, horses, boys & men & women & children, and best of all old timber-props, water plants, willow stumps, sedges, old nets, &c & &c."[111] The power of Constable's evocative art is, of course, much more than any sum of its stock landscape elements. Yet even in Fig. 3-4, "conveying the fullest impression of the compass" of his art, Constable duplicates or adapts elements from perhaps as many as six earlier paintings.[112] Constable knew what pleased him, and he was not embarrassed to reuse it when he "launched with all my usual anxieties"[113] into a major new work.

Whatever artistic anxieties Constable brought to a new canvas, they were joined by few doubts about his scientific knowledge. As noted earlier, Constable was an avid student of the sky, at one point adding meteorologically accurate notes to his cloud studies.[114] Constable owned an edition of Thomas Forster's (1789–1860) pioneering *Researches About Atmospheric Phaenomena* (second edition, 1815), a book that he annotated with considerable insight.[115] Constable later observed that Forster was often wrong,[116] and he made marginal notes in *Researches* when he caught Forster in scientific inconsistencies. In a partially obscured comment in *Researches*, Constable asserts: "This is not correct[:] electrical fluid will convert an . . . ," a confident statement about his knowledge of recent theories on atmospheric electricity.[117] Of course, Constable was only a self-educated amateur, and occasionally his marginalia betray confusion about meteorological terminology. More positively, Constable agrees with Forster by double underlining "All clouds are capable of becoming brighter and darker, according to their relative position with respect to the sun."[118] Writing elsewhere, Constable seems to restate this in clearer, more painterly terms: "any specific effect of lighting on the ground is consistent with one, and only one, distribution of clouds and with one position of the sun in the sky."[119] Constable also highlighted Forster's remarks on color differences between summer and autumn fogs. (John Thornes plausibly suggests that Forster's "yellow fogs of November" are London's infamous smogs.)

Other atmospheric optical problems also attracted Constable. On the rainbow, he sketched raindrop diagrams that reveal his understanding of Newtonian rainbow theory.[120] Most

remarkable, both for their accuracy and extent, are his comments about the rainbow in the series *English Landscape Scenery*, first issued 1830–32.[121] In the letterpress accompanying the *Stoke by Neyland* mezzotint in 1833, Constable offers a thorough survey of the rainbow's features, one well worth repeating:

> Of the RAINBOW—the following observations can hardly fail to be useful to the Landscape Painter. When the Rainbow appears at Noon, the height of the sun at that hour of the day causes but a small segment of the circle to be seen, and this gives the Bow its low or flat appearance: the Noonday-bow is therefore best seen 'Smiling in a Winter's day', as in the Summer, after the sun has passed a certain altitude, a Rainbow cannot appear: it must be observed that a Rainbow can never appear foreshortened, or be seen obliquely, as it must be parallel with the plane of the picture, though a part of it only may be introduced; nor can a Rainbow be seen through any intervening cloud, however small or thin, as the reflected rays are dispersed by it, and are thus prevented from reaching the eye; consequently the Bow is imperfect in that part.
>
> Nature, in all the varied aspects of her beauty, exhibits no feature more lovely nor any that awaken a more soothing reflection than the Rainbow, 'Mild arch of promise'; and when this phenomenon appears under unusual circumstances it excites a more lively interest. This is the case with the 'Noon-tide Bow', but more especially with that most beautiful and rare occurrence, the 'Lunar Bow'. The morning and evening Bows are more frequent than those at noon, and are far more imposing and attractive from their loftiness and span; the colours are also more brilliant, 'Flashing brief splendour through the clouds awhile'. For the same reason the exterior or secondary Bow is at these times also brighter, but the colours of it are reversed. A third, and even fourth Bow, may sometimes be seen, with the colours alternating in each; these are always necessarily fainter, from the quantity of light last at each reflection within the drop, according to the received principle of the Bow.
>
> Perhaps more remains yet to be discovered as to the cause of this most beautiful Phenomenon of Light, recent experiments having proved that the primitive colours are further refrangible. Though not generally observed, the space within the Bow is always lighter than the outer portion of the cloud on which it is seen. This circumstance has not escaped the notice of the Poet, who with that intuitive feeling which has so often anticipated the discoveries of the philosopher, remarks:
>
> > "And all within the arch appeared to be
> > Brighter than that without."[122]

For the first time, we find an artist telling colleagues (and his public) how to paint the rainbow *as it is seen in nature*. Painters such as Leonardo da Vinci had made occasional reference to rainbow colors,[123] but no one seems to have seized on the natural rainbow itself as a

subject worth studying. Constable's instructions reflect a new, analytical attitude toward an evanescent landscape feature. Also new are his serene, unportentous evocations of the rainbow's beauty ('Mild arch of promise')—the rainbow of judgment and deliverance is absent here. Equally important for our story, Constable wrote this letterpress around the time (1833–34) that he was reworking *Salisbury Cathedral*,[124] suggesting that he brought similar optical knowledge to both works. As we shall see, though, Constable's knowledge of optics and his painted rainbows often diverged sharply.

Constable's remarks about rainbow theory come from his scientific reading ("the received principle of the Bow"),[125] as may some of his rainbow descriptions. But Constable almost certainly personally verified his statements about the rainbow's appearance and behavior.[126] We would expect nothing less from the man who would later tell the Royal Institution: "Painting is a science, and should be pursued as an inquiry into the laws of nature. Why, then, may not landscape painting be considered as a branch of natural philosophy, of which pictures are but the experiments?"[127] However remarkable we may find Constable's letterpress, he himself gives off an air of being merely a patient but firm instructor. Very little that Constable says is wrong, but these errors are noteworthy. For example, no one has seen the "fourth Bow" in nature, although the third (or tertiary) rainbow has been sighted rarely.[128] Constable *is* correct in saying that these unseen rainbows would have "colours alternating in each," a statement ultimately derived from Halley or Newton.[129]

At the same time, Constable joins the ongoing controversy over Newton's color theory by saying that the bow's "primitive colours are further refrangible." The "recent experiments" to which Constable refers are probably those of English physicist David Brewster (1781–1868). In 1831 Brewster published scientific and popular-level attacks on Newton's seven primary (or "primitive") colors, claiming to show that only three primaries existed in a prism's spectrum.[130] Fragmentary drafts of Constable's *Stoke by Neyland* letterpress suggest that he may have taken up Brewster's flawed ideas. In one draft, Constable expresses even greater discontent with Newton, saying "Doubts have, however, arisen as to the truth and accuracy of this interpretation" of the rainbow, and he looks forward to "a more reasonable and satisfactory if not certain theory of this exquisite phenomena of light."[131] Constable is not inclined to be a passive observer either of rainbows or rainbow theory.

Neither was Constable mute about political controversy. Economic depression after the Napoleonic Wars had brought hardship to English agriculture, and with it came sporadic incidents of laborer arson and vandalism (especially of work-robbing threshing machines). Constable viewed unrest in East Anglia during 1821–22 with unease, sensing a hateful disruption of the bucolic world that he remembered (but now seldom visited). In 1825, Constable voiced his political conservatism when he labeled "almost every mechanik . . . a rebel and blackguard," adding that whenever a laborer "*is congregated* with his brethren his evil dispositions are fanned—ready to burst into flame."[132] In Constable's mind, the quiet, obedient working poor of his cherished boyhood world had risen to destroy it. A further insult to Constable's comfortable

world view was the Parliamentary Reform Bill introduced in March 1831. A milestone in the postwar reform movement, the bill sought to restore balance in representation between the countryside (which was well represented) and the rapidly growing industrial cities (which often were not). For Constable, this reform would have been nothing less than disenfranchisement of a privileged rural society already ravaged by modern ills. He objected to the bill in his "rabble and dregs" letter, sentiments anticipated by Fig. 3-4.[133] Constable cast the reformers in a diabolical light, seeing dark forces of radicalism poised to attack his conservative bulwark of English Constitution and Anglican Church.[134]

Thus Constable brought the tastes of a lifetime to Fig. 3-4: a keen appreciation for optics and rural detail, a willingness to use picturesque shorthand, and political conservatism hard pressed by a rapidly changing England. In addition, the death of Constable's wife in 1828 left him tinged with melancholy. That profound bereavement, coupled with his despondency over John Fisher's death in 1832, made Constable feel increasingly isolated from the world that remained to him.[135] Constable had first painted Salisbury Cathedral in 1822–23 for John Fisher (1748–1825), Bishop of Salisbury and uncle of young John Fisher. Compared to Fig. 3-4, this earlier *Salisbury Cathedral from the Bishop's Grounds* (exhibited 1823) appears to be a simple architectural portrait, although neither work is topographically accurate.[136] On seeing the earlier picture's towering cumulus, the bishop had crossed iconographic and meteorological swords with Constable: "[If] Constable would but leave out his black clouds! Clouds are only black when it is going to rain. In fine weather the sky is blue."[137]

For Constable and the younger Fisher, however, Salisbury Cathedral was more than a church. It was *the* "Church under a cloud," a national institution beset by the "vulture of reform."[138] The ominous words are Fisher's to Constable; their ominous counterpart in paint is Constable's *Salisbury Cathedral from the Meadows*. Compositionally, Constable has transported a sunlit foreground from Suffolk's Stour Valley to Wiltshire, including such standbys as the countryman's wagon, boat, and dog. Meteorologically, Constable has whipped up a thunderstorm over the late bishop's church that would make him reel.[139] Optically, Constable has created a rainbow that is both grand and impossible.

As Schweizer points out, for Fig. 3-4's implied sun elevation (over 60°), the rainbow could not be seen above the scene's level horizon.[140] Neither do the shadows converge on the rainbow's center, a fact that Constable illustrated in his 1831 study *View over London with Double Rainbow*.[141] Leslie recounts Constable's observation that sunbeams converge opposite the sun, and himself notes seeing these rays converging inside the rainbow.[142] Constable saw this too, since in his *View over London* sunbeams are radii to the bow just as they are in nature (see Fig. 4-6). In Fig. 3-4 Constable ignores even more of his own instructions to painters, since "the space within the Bow" clearly is *not* painted "lighter than the outer portion of the cloud on which it is seen." Finally, for all of Constable's interest in rainbow optics and color theory, he makes a nearly achromatic bow here, one tinged by pastel reds, blues, and what seems like a steely gray. The net effect is of a burnished-metal rainbow that dimly reflects its surroundings, not the triumphantly

radiant arc that Constable prescribes to others. Constable does at least observe his stricture that "a Rainbow can never appear foreshortened, or be seen obliquely."[143] Why do his rainbow theory and practice differ so much here?

In fact, Constable had long practiced what he preached in *English Landscape,* as his accurate rainbow studies *Landscape with a Double Rainbow* (1812)[144] and *View over London with Double Rainbow* demonstrate. Yet in his finished works, Constable tends to use rainbows as picturesque or evocative landscape additions that may or may not be consistent with the original scene's lighting. For example, Constable's 1836 *Stonehenge* adds a rainbow to an 1820 drawing but changes little else.[145] Sunlight and rainbow are at odds in the 1834 watercolor *Mound of the City of Old Sarum, from the South*, another work with political overtones for Constable.[146] The optical incongruities of Fig. 3-4's rainbow suggest that it is an insertion, albeit a prominent one. More direct evidence comes from Constable's preliminary sketches for *Salisbury Cathedral*, which all feature ominous rain clouds but no rainbow.[147] But why complicate an already turbulent scene by adding a grandiose rainbow?

Although Constable himself provides no direct answers, Schweizer's assumption seems quite plausible: for a state church threatened by storm, what more appropriate sign of peace and hope for its future could Constable provide than the traditional bow of the divine? If the church building is visually and metaphorically "under a cloud," could not the rainbow shelter it from that storm?[148] Of course, as we wander further into rainbow iconography, opposing interpretations present themselves: as ephemeral as the departing storm, perhaps Constable's rainbow symbolizes no more than transitory hope for a fading Church of England.[149] However, the fact that Constable plants the rainbow's end in Fig. 3-4 over Archdeacon John Fisher's house[150] suggests a more positive reading. In the end, despite his keen scientific interest and careful instructions to others, John Constable returns to our oldest rainbow dictum—the emblematic rainbow outshines the natural one.

John Everett Millais: A Rainbow of the Senses and Sensibility

If integrating art and science was a priority for Constable, it verged on obsession for one of his bluntest critics, John Ruskin (1819–1900). Writer, critic, and occasional artist himself, Ruskin wielded Victorian England's most influential and self-assured pen on the arts. In his pivotal *Modern Painters* (whose first volume appeared in 1843), Ruskin handled Constable with little reserve. Comparing one of Constable's trees with those by Claude Lorrain, Ruskin said with palpable distaste: "It differs from the Claude outlines merely in being the kind of work which is produced by an uninventive person dashing about idly, with a brush, instead of drawing determinately wrong, with a pen: on the one hand worse than Claude's, in being lazier; on the other a little better, in being more free, but, as representative of tree form, of course still wholly barbarous."[151] In fact, Constable's real deficiency was not painting like his contemporary (and Ruskin's youthful idol) Joseph Mallord William Turner (1775–1851).[152]

To present-day admirers of Claude and Constable, Ruskin's harshness may seem puzzling. However, by Ruskin's standards neither painter had created a true picture, one in which natural forms are "idealized in the right sense of the word . . . by perfect assertion of entire knowledge of every part and character and function of the object, and in which the details are completed to the last line compatible with the dignity and simplicity of the whole."[153] Ruskin embraced meticulous, even obsessive, observation and recording of nature—whether biological, geological, or meteorological—as the prerequisite for true art. He practiced these precepts in his own art, minutely observing the intricacies of rock outcrops and briar stumps alike.[154] Furthermore, Ruskin made scientific forays that Constable probably would have approved of—collecting minerals, recording rainfall amounts, and measuring the sky's blueness with a cyanometer.[155] But such cataloging and quantifying was incidental to Ruskin's higher goal, that of transforming close observation into faithful depiction of a purposeful, divinely shaped nature.[156]

Ruskin was not content merely to improve artists from afar. When the opportunity presented itself, he gladly toured with and trained them, preferably in the style of Turner.[157] One of Ruskin's less malleable charges was John Everett Millais (1829–96). Admitted to the Royal Academy at the age of eleven as a probationary student,[158] Millais was a child prodigy, and this promise was borne out by his early work. His first contact with Ruskin came after Ruskin's 1851 letters to *The Times* of London defending the Pre-Raphaelite Brotherhood.[159] Millais was a founding member of the Brotherhood,[160] a high-spirited, vaguely organized group of artists who objected to what they saw as the contrived formalisms and inadequate techniques of academic art. With its rigid and tortuously long training, the Royal Academy was their immediate institutional nemesis; Reynolds and Raphael were the sorry embodiment of its theory and technique.[161] Although using different approaches, the Pre-Raphaelites all believed that English art could have merit only if it returned to the unaffected simplicity and clear imagery of art before Raphael (especially Italian art).

Sworn to a secrecy that they observed only casually, Millais and other Pre-Raphaelite painters exhibited to favorable reviews in 1849. Their canvases on suitably pre-Renaissance subjects were filled with bright, vivid colors and near-photographic detail, and these provoked murmurs of critical approval.[162] However, with publication of a Pre-Raphaelite literary magazine in 1850, the Brotherhood's iconoclasm became public knowledge and their paintings fair game for the critics. Pre-Raphaelite pictures exhibited in 1850 were found to be "plainly revolting," "a nameless atrocity," or filled with "objectionable peculiarities." Even Charles Dickens (1812–70) joined the fray with a scathing review of Millais's *Christ in the House of His Parents* (1849).[163] After a year of this vitriol, Ruskin came to a sincere though initially lukewarm defense of the Pre-Raphaelites. (Although asked to intercede at first, Ruskin would soon become the Pre-Raphaelites' greatest champion.) Elsewhere he admitted that he too choked on the "clear and tasteless poison of the art of Raphael."[164] In his first letter to *The Times*, Ruskin both defended the Brotherhood's command of linear perspective and characteristically praised a Pre-Raphaelite painter's botanically accurate water plant.[165]

Ruskin and the Pre-Raphaelites agreed on more than matters of drawing. Academic art often treated illumination as if it were a spotlight, highlighting a scene's principal players and then fading into darkness on the periphery.[166] London critics were offended that Pre-Raphaelite illumination was so evenly distributed across the canvas. Ruskin echoed Pre-Raphaelite sentiments in countering that their even illumination, far from being unnatural, emulated the sunlit landscape: "Every Pre-Raphaelite landscape background is painted to the last touch, in the open air, from the thing itself."[167] Pre-Raphaelites also abandoned the fashionable academic practice of adding bitumen to pigments, the goal of which was to create warm, dark tones. Bitumen's disastrous side effect was that ultimately it blackened admixed pigments. The Pre-Raphaelites required a completely opposite technique, so they borrowed the practice of applying thin layers of pigments over a white ground. The opaque ground reflected light through the semitransparent pigment layers, yielding luminous colors akin to those of stained glass.[168] Ruskin's art students later achieved similar effects by viewing a small, uniformly colored part of a scene, immediately copying that color, and adjoining dabs of the copied colors to make a landscape mosaic.[169] Technique and taste in hand, Millais and his compatriots were ready to vanquish the forces of academic darkness, as Millais's *The Blind Girl* (Fig. 3-5) suggests.

Ruskin's meandering, opinionated description of this painting is revealing:

> The common is a fairly spacious bit of ragged pasture, with a couple of donkeys feeding on it, and a cow or two, and at the side of the public road passing over it, the blind girl has sat down to rest awhile. She is a simple beggar, not a poetical or vicious one;—being peripatetic with musical instrument, she will, I suppose, come under the general term of tramp; a girl of eighteen or twenty, extremely plain-featured, but healthy, and just now resting, as any one of us would rest, not because she is much tired, but because the sun has but this moment come out after a shower, and the smell of the grass is pleasant.
>
> The shower has been heavy, and is so still in the distance, where an intensely bright double rainbow is relieved against the departing thunder-cloud. The freshly wet grass is all radiant through and through with the new sunshine; full noon at its purest, the very donkeys bathed in the raindew, and prismatic with it under their rough breasts as they graze; the weeds at the girl's side as bright as a Byzantine enamel, and inlaid with blue veronica; her upturned face all aglow with the light that seeks its way through her wet eyelashes (wet only with the rain). Very quiet she is,—so quiet that a radiant butterfly has settled on her shoulder, and basks there in the warm sun. Against her knee, on which her poor instrument of musical beggary rests (harmonium), leans another child, half her age—her guide;—indifferent, this one, either to sun or rain, only a little tired of waiting. No more than a half profile of her face is seen; and that is quite expressionless, and not the least pretty.[170]

Millais's son John found Ruskin's description "refined and accurate" and the "best of all" the critics'.[171] Yet to modern readers the rough edges of unjustified assumption, acute class con-

90 — THE RAINBOW BRIDGE

FIG. 3-5

John Everett Millais, *The Blind Girl*, 1856. Birmingham Museums and Art Gallery, England

sciousness, and flawed optics poke through Ruskin's account. For example, why assume that either girl is not "much tired"?[172] Does the travelers' apparently dry clothing mean that they earlier found shelter from "the departing thunder-cloud"? How do we reconcile their appearance with Ruskin's statement that the blind girl's eyelashes are "wet only with the rain"? Her sweet, serene face does not seem "extremely plain-featured," nor can we tell if her companion's profile is "not the least pretty." (Here Ruskin mirrors the prejudices of Victorian phrenology: these are the poor, so they must be unattractive.)[173] The younger girl cranes her neck to admire the rainbow, so she is hardly "indifferent . . . to sun or rain." From our perhaps jaded perspective in the early twenty-first century, this seems to be one of those Pre-Raphaelite paintings that

writer Timothy Hilton describes as "very precariously balanced on the indefinable borderline in Victorian art between the moving and the mawkish."[174] Pathos for the blind girl easily slides into sentimental pity,[175] a descent that neither we nor the Victorians are immune to. For middle-class Victorians, even this pity would have been moderated by the patronizing thought that at least *they* were not beggars.

Remarkably, Ruskin describes the summer sunshine as being "full noon at its purest"—an impossibility given that both the rainbow and shadows indicate late afternoon. Millais correctly painted landscape shadows converging on the center of the bow, suggesting that he studied the rainbow according to Pre-Raphaelite dictates—outdoors in the sunlight. Only by observing a real rainbow would he be prompted to use the fairly unflattering (and unconventional) on-axis illumination evident in Fig. 3-5. Certainly few artists before Millais had painted the landscape illumination around the rainbow so realistically. Of course, Millais might have followed Constable's instructions on the proper positions of rainbow and sun. In short, for all of Ruskin's admonitions about painters being faithful to nature, sometimes he as a critic confused facts more than they.

Still, Millais did have problems with Fig. 3-5's rainbow. As his son later observed: "The main rainbow is doubtless too strong and solid [that is, opaque]. Millais himself told the story of how, not knowing that the second rainbow is not really a 'double' one, but only a reflection of the first, he did not reverse the order of the colours as he should have done, and how, when it was pointed out to him, he put the matter right, and was duly feed [paid] for so doing."[176] Contrary to what the younger Millais says, the secondary rainbow is *not* a reflection of the primary.[177] But the secondary's colors are reversed compared to the primary's, and Millais's error suggests that he never observed this difference or misremembered it. Neither does Millais's painting show the primary rainbow's bright interior or the dark band between the bows. Art historian Allen Staley plausibly describes Fig. 3-5's rainbow as "a studio concoction."[178] If so, Millais's concession to the difficulties of plein air rainbow painting still does not rule out his having studied the natural rainbow, because even vivid primary bows may have unmemorable secondaries (see, for example, Fig. 8-8). Given the verisimilitude of some rainbow features in Fig. 3-5 (shadows, sun elevation, and rainbow), Millais cannot be accused of being completely uninterested in the natural bow. The fact that he felt compelled to correct his color mistake (and that his buyer would pay for it) speaks volumes.

However, other rainbows than the natural one inhabit *The Blind Girl*. Millais's son writes: "Sunlight seems to issue from the picture,[179] and bathes the blind girl—blind alike to its glow, to the beauties of the symbolic butterfly that has settled upon her, and to the token in the sky."[180] Historian George Landow notes that the butterfly traditionally symbolizes the soul[181] and that Victorian exegesis had made the rainbow itself "a type of Christ."[182] In *The Stones of Venice* (1851–52), Ruskin says of the rainbow: "In that heavenly circle which binds the statutes of colour upon the front of the sky, when it became the sign of the covenant of peace, the pure hues of divided light were sanctified to the human heart for ever."[183] Thus Victorian viewers would easily accept that *The Blind Girl*'s rainbow is more than picturesque detail, that it signals divine covenant and promise. In this reading, the promise includes a better world to come, a world in

which the pitiful blind beggar one day surely will be restored to soundness of body and purse. Victorians (excepting Ruskin, presumably) would find her soul as pure as her expression, pure enough to stand favorably in judgment before Christ.

Landow's interpretation has not gone unchallenged: Michael Cohen argues that the rainbow is purely a symbol of natural beauty, one that increases our sympathy for the blind girl.[184] While this reading is defensible, the unusual detail of a solitary butterfly alighted on her shawl still seems rather an odd coincidence (recall that Millais's son labeled *The Blind Girl*'s butterfly symbolic). The young Millais further noted the butterfly's importance to his father: "The rooks and domestic animals were all painted from Nature, as was also the tortoiseshell butterfly (not a Death's-head as Mr. Spielmann has it), which was captured for the purpose."[185] In fact, Millais and his Victorian audience need not have chosen between these two interpretations, for despite its profusion of natural detail, *The Blind Girl* and its Pre-Raphaelite rainbow can easily straddle the worlds of appearance and symbol.

Rainbows of the Natural Sublime: Frederic Edwin Church

For all Millais's attention to optical detail in *The Blind Girl*, none of his diligence would have prepared him for the rainbow tour de force with which Frederic Edwin Church (1826–1900) dazzled America a scant year later. Church's 1857 *Niagara* (Fig. 3-6) is an enormous expanse of canvas (7½ feet by 3½ feet) whose principals are stunning reproductions of Canada's Horseshoe Fall and its attendant rainbow. Exhibited at a New York gallery, in its opening two weeks *Niagara* charmed critics and lured tens of thousands to witness its splendors.[186] Reviewers were at a loss for negative words. A *New York Times* correspondent voiced a common sentiment, saying: "to write of this picture is like writing of the Falls themselves. You think of it and your pen hangs idly in your hand, as your imagination brings back to you the grandeur and the grace you gazed upon."[187] A letter to the *Home Journal* more succinctly declared: "this *is* Niagara, *with the roar left out!*"[188]

Church had confounded the conventional wisdom that Niagara Falls could not be adequately captured in paint.[189] During the preceding 160 years, scores of earlier attempts included paintings, engravings, and drawings that showed the Falls from every conceivable viewpoint.[190] But none of these works so captivated critics and the public as Church's *Niagara*. His success sprang from several sources. First, he eliminated any foreground, a move that boldly avoided picturesque convention and thrust viewers to the vertiginous lip of the Fall.[191] Hovering *somewhere* above the rushing torrent, Victorian audiences could enjoy the delicious terror that they might fall and, like the floating tree trunk, instantly be swept away in the river's plunge. Second, Church's depiction of moving water, from the rapids' surging green to the waterfall's turbulent white, is unprecedented in its realism. After *Niagara*'s arrival in London, *The Times* praised the artist's "patient mastery" and noted that when a painting's "running water is the expanse of a mighty river . . . hurrying to such a fall, it may well be imagined what labor has been necessary"

FIG. 3-6
Frederic Edwin Church, *Niagara*, 1857. In the Collection of The Corcoran Gallery of Art, Washington, D.C. Museum Purchase, Gallery Fund

to achieve such a convincing illusion.[192] In his 1867 *Book of the Artists*, writer Henry Tuckerman (1813–71) has John Ruskin pointing out in *Niagara* "an effect of light upon water which he declared he had often seen in nature, especially among the Swiss waterfalls, but never before on canvas."[193] Church had indeed patiently mastered the intricacies of Niagara's flowing water, seeing hydraulic logic where others found only picturesque chaos. Finally, Church impressed audiences with another novelty: his vivid partial rainbow. Tuckerman continues that "so perfect is the optical illusion of the iris in the same marvellous picture" that a momentarily baffled Ruskin "went to the window and examined the glass, evidently attributing the prismatic bow to the refraction of the sun" onto the canvas.[194] The *Home Journal*'s correspondent simply noted that *Niagara* includes "a palpitating broken rainbow rising from its birthplace in the foam, and seeming to change while you look at it."[195]

Church's rainbow is daringly original in two ways. Almost all earlier paintings of partial rainbows had shown continuous segments of the arc,[196] but Church breaks with rainbow tradition by interrupting the arc where the Fall's spray is absent. This painted feature is entirely realistic, as are the "palpitating" variations in rainbow brightness and apparent width. In nature, these are caused by variations in raindrop concentration (spray droplets here) along the rainbow's circular arc.[197] If drops are relatively sparse along some part of this circle, the bow is less bright there, ultimately fading into invisibility if very few drops are present. In places where more drops are found, the middle of the rainbow is brighter, and its previously invisible interior and exterior colors are evident (for example, the 1 o'clock position in the bow). This brightness

variation makes the rainbow's width appear to change (or "palpitate") along its arc.[198] In Niagara's constantly swirling spray, the real rainbow would vary with both clock angle *and* time. Like all rainbows, those seen at Niagara Falls occur at a fixed angle from the observer. Nonetheless, their fairly rapid changes in brightness would leave vivid memories of strange, palpitating rainbows.

Thus Church swept away his contemporaries with his dazzling technique and striking naturalism, but their enthusiasm was rooted deeper than understandable admiration for his *trompe l'oeil* abilities. In part, Church benefited from viewers' weariness with increasingly predictable views of Niagara.[199] After more than a century of diligent artistic effort, painters and their public were responding to Niagara Falls as visual cliché. Church's vantage point was both novel and breathtaking, which accounts for some of the painting's sensational reception. More fundamental than his novelty, however, was the artist's thrilling evocation of the natural sublime. As defined by Edmund Burke (1729–97) in his 1757 *Philosophical Enquiry into the Origin of Our Ideas of the Sublime and Beautiful*, the sublime was "the strongest emotion which the mind is capable of feeling." Because for Burke terror was the most intense emotion, "whatever is in any sort terrible . . . is a source of the *sublime*"[200]—a category into which the lethal, thunderous Niagara Falls clearly fell. Although terror itself was not a sublime reaction, "at certain distances, and with certain modifications, . . . [danger or pain] are delightful, as we every day experience."[201] At Niagara, even timid tourists soon realized that the Falls' greatest dangers were imagined. Charles Dickens's reaction is typical. During his 1842 tour of America, Dickens wrote of his sensations at the base of Horseshoe Fall: "It would be hard for a man to stand nearer to God than he does there. There was a bright rainbow at my feet; and from that I looked up to—great Heaven! to *what* a fall of bright green water! The broad, deep, mighty stream seems to die in the act of falling; and from its unfathomable grave arises that tremendous ghost of spray and mist which is never laid, and has been haunting this place with the same dread solemnity—perhaps from the creation of the world."[202]

Thus in the century after Burke's *Philosophical Enquiry*, Niagara Falls became an American icon of his terrible sublime. Years before Dickens's letter (c. 1830), this sublime had mutated into a religious experience in which immensity of natural form evoked God's limitless power.[203] Whether labeled as sublime or not, such epiphanic views of nature also had moral and social reverberations—divinely shaped nature and the emotions it called forth mingled with American nationalism to nurture such ideas as Manifest Destiny.[204] John L. O'Sullivan (1813–95), the term's originator, could sublimely envision American westward expansion as "the fulfilment of our manifest destiny to overspread the continent allotted by Providence for the free development of our yearly multiplying millions."[205] In the early nineteenth century, many Americans admixed science into this heady brew of nationalism, religiosity, and love of nature. As critic James Jackson Jarves (1818–88) declaimed in mid-century, landscape was "the creation of the one God—his sensuous image and revelation, through the investigation of which by science or its representation by art men's hearts are lifted toward him."[206] So the landscapist too had a role to play, one

analogous to (and mutually supportive of) the natural scientist's discoveries. Artists' depiction of the sublime helped tie together all these ideas, yielding, in the words of art historian Jeremy Adamson, a mid-century "conception of the sublime as the highest form of morally elevating beauty."[207] Remarkable as such attitudes seem today, they were quite literally articles of social faith in Frederic Church's world.

Church's mentor and teacher Thomas Cole (1801–48) shared in these beliefs, yet his art and that of the young Church occasionally sought to elevate American wilderness painting to the grander style of European history painting.[208] Along with Asher B. Durand (1796–1886) and Thomas Doughty (1793–1856), Cole is remembered today as one of the first generation of Hudson River School painters.[209] While neither confined to the Hudson Valley nor organized as a formal school (the label is supposedly a critic's epithet),[210] Hudson River artists devoted themselves to recording the natural splendors of the Northeast in suitably Romantic style. Cole's tastes ran from his "higher style of landscape"[211] in the allegorical series *The Course of Empire* (1836) and *The Voyage of Life* (1839–40), to simpler, more serene images of frontier life in the East.[212] Like his contemporaries, Cole also had a strong nationalistic streak. An upcoming tour of Europe prompted Cole to visit Niagara Falls in 1829, where he dashed off a forgettable paean to the sublime beauty of the Falls, calling them the "mighty portals to the golden west." Cole could not help but notice that these portals were graced by "a far excelling iris,"[213] a natural vision rich with symbolism of divine promise and blessing. In mid-century, both the Falls and their attendant rainbows were often described as material types, natural phenomena that reminded informed viewers of God's divine attributes.

Just as the overwhelming power of the Falls signaled God's wrath, so the "Eternal Rainbow of Niagara" reminded Cole and others of His mercy and covenant.[214] At the same time, Cole could describe rainbows simply as natural phenomena, as he does in an 1825 notebook entry: "The Rainbow is on the outer edge of the rain and gradually mingles with it."[215] For Cole, the natural and symbolic rainbows were equally vivid, and both served the higher ends of sublime imagery. Sometimes scientific and scriptural images of the bow blurred together, as they did for Universalist minister Abel Thomas (1807–80). Recalling his sermon at Niagara's Table Rock in May 1837, Thomas wrote of a union that Cole certainly would have appreciated: "The sermon was of small attraction in such a presence, yet it represented the seven attributes of the Supreme Being, as symbolized by the bow. They are but refractions of that Infinite Love of which Light is the fittest emblem. 'Round about the throne' the distinct yet blending hues of the divine perfections appear, but when faith shall be resolved into sight, there shall be visions only of the Spiritual Sun."[216]

Church's descriptions of rainbows are less rhapsodic than those of Cole and Thomas, but he surely was aware of the bow's dual roles. In March 1856, Church visited Niagara for the first of his three sketching surveys of the Falls.[217] That same month, the influential American art journal *The Crayon* described the totality of the experience awaiting Church: "The sun shone

brightly; the cloud of spray below was white as drifted snow, and the rainbow had followed us all day. . . . No eye has ever penetrated that spectral cloud [of death] to tell us what passes behind it, and we look into it with dread and awe; but upon that very veil is painted the rainbow, and to every soul that looks up there is a separate bow of promise."[218]

Like Thomas's sermon, this remarkable passage seamlessly joins natural and supernatural descriptions of the rainbow in ways that were important to Church's audience. Each viewer sees a different rainbow, and all find the rainbow inescapable,[219] yet these "souls" also admire Noah's "bow of promise." Whether Church read this *Crayon* piece or not, its attitudes were commonplace as he began work on *Niagara* studies in 1856. Compositionally, his masterstroke was to choose an unusually long, low format that encompassed both falls and placed the viewpoint perilously close to the rushing water.[220] Unsatisfied with this panoramic sweep, in early 1857 Church pruned the distant American Fall from his next study, concentrating instead on a closer view of Horseshoe Fall.[221] Significantly, neither the rainbow nor the dislodged snag in Fig. 3-6 are present in this penultimate version of *Niagara* (or its predecessor).[222] Their late addition suggests that Church saw them as useful but not fundamental components in his overall design. Their symbolism adds to the sublime impact of the final version, but clearly for Church the Fall's sweep and shape is paramount.[223]

Perhaps Church hesitated to add his Niagara rainbow for another reason. Although a rainbow could be justified optically in any version of *Niagara*, Church may have been procrastinating on beginning this artistically demanding feature. We know that four years before his 1857 triumph, Church had painted the rainbow in only the most rudimentary fashion.[224] During his first trip to South America (1853), he wrote to his mother about a waterfall he had seen in Bogotá, picturesquely describing "bright rainbows in the mist [that] served to enliven the scene."[225] Yet his oil sketch of that scene, *Waterfall with Rainbow Effect*, shows a rather moribund rainbow. More at ease with the waterfall than its rainbow, Church makes the bow inconsistent with the scene's illumination and paints it as five concentric arcs of opaque color.[226] In another 1853 sketch that includes a rainbow, Church inverts the proper color order of what seems to be a primary rainbow. At least in this sketch Church's rainbow is transparent.[227] Whether Church wrote any more about the rainbow before 1857 is unknown, but the rainbow mastery evident by then in Fig. 3-6 speaks for itself.[228] But even here Church seems to hedge his bets on rainbow colors. While the lower rainbow arc has quite naturalistic colors for a spray bow, the upper arc features an unusually broad band of yellow. Flanked by pastel red and blue, this yellow arc is the only implausible note in this naturalistic masterpiece. Perhaps Church was making a nod here toward the old tradition of the three-primary bow of red, yellow, and blue.[229] However, as a nineteenth-century painter devoted to scientific exactitude, he is unlikely to have harbored misgivings about Newton's prismatic rainbow colors.

Certainly Church was enthusiastic about mid-century science. He embraced the generalist tomes of such authors as German explorer-naturalist Alexander von Humboldt (1769–1859),

geologist and biologist Louis Agassiz (1807–73), physicists John Tyndall (1820–93) and Ogden Rood (1831–1902), and chemist Michel-Eugène Chevreul (1786–1889).[230] In Rood and Chevreul, Church could read about advances in the theory of color perception and its realization in pigments and dyes.[231] Tyndall's 1872 *The Forms of Water in Clouds and Rivers, Ice and Glaciers* had obvious appeal for an artist who was fascinated by clouds[232] and had aggressively pursued icebergs at sea and on canvas.[233] In 1859, Church and Agassiz talked enthusiastically about icebergs,[234] and Church probably read some of his friend's several books on natural history. But the scientist who exerted the earliest and most profound influence on Church was Alexander von Humboldt, whose monumental *Cosmos* surveyed the considerable amount that Humboldt knew about the universe. *Cosmos* was a very readable and popular work, with numerous translations appearing as Humboldt completed each volume.[235] Of particular interest to Church were Humboldt's observations on the tropics of South and Central America, a then-exotic region that Humboldt knew intimately from his grueling campaign of scientific exploration there in 1799–1804. In a tone characteristic of the age, Humboldt exhorted his readers to view the tropics as fertile ground for both scientific and artistic discovery: "Are we not justified in hoping that landscape painting will flourish with a new and hitherto unknown brilliancy when artists of merit shall more frequently pass the narrow limits of the Mediterranean, and when they shall be enabled, far in the interior of continents, in the humid mountain valleys of the tropical world, to seize, with the genuine freshness of a pure and youthful spirit, on the true image of the varied forms of nature?"[236]

With the same kind of enthusiasm that would send him cruising for icebergs in 1859, Church spent six months in South America in 1853, returning in 1857 for a three-month stay soon after his *Niagara* triumph.[237] The trips were transforming experiences for him, providing the basis for a raft of sketches and giving him new ideas for such major canvases as *The Heart of the Andes* (1859), *Cotopaxi, Ecuador* (1862),[238] and *Rainy Season in the Tropics* (1866; Fig. 3-7). So compelling were Church's meticulously observed (and sublimely grandiose) paintings of these exotic locales that he became better known to some as an artist of the tropics rather than his native Northeast. *Heart of the Andes* offered an encapsulated view of the world's climatic regions, executed in the spirit of Humboldt's careful classifications.[239] As a contemporary guidebook observed, "Mr. Church has condensed the condensation of Nature. It is not an actual scene, but the subtle essence of many scenes combined into a typical picture."[240] The booklet divided *Heart of the Andes* into ten discrete terrestrial and meteorological zones through which the visitor diligently trekked.[241] By contrast, *Rainy Season*'s unifying, inescapable centerpiece is its radiant double rainbow. Henry Tuckerman rhapsodized of *Rainy Season* that "the sunshine, beaming across the vapory v[e]il, forms thereon a rainbow, which seems to clasp the whole with a prismatic bridge."[242]

Painted nearly a decade after Church's last South American visit, *Rainy Season* nonetheless exudes an immediacy of observation that would have pleased Humboldt. Lush palms, towering

FIG. 3-7

Frederic Edwin Church, *Rainy Season in the Tropics*, 1866. Fine Arts Museums of San Francisco, Mildred Anna Williams Collection, 1970.9

peaks, and stepped rock formations frame the middle distance, while Church's intrepid observer admires the rain-drenched, theatrical vista. Binding together all these features is the cohesive power of light, what art historian Barbara Novak calls Church's "great organizer."[243] Like its counterpart in *Niagara*, the rainbow in *Rainy Season* fairly pulsates with light, whether arising from changes in the depth of the shower (see the 1 o'clock position) or scattered by rain streamers visible within the bow.[244] As in nature, the sky between the rainbows is often darker than that on either side (11 o'clock position).[245] But while Church's naturalism is noteworthy here, it is hardly rigorous. Despite his reputation for biological and geological accuracy, Church implausibly crowds together in Fig. 3-7 a lake, mountain foothills, badlands, and a rain forest's verge.[246] He also skews his rainbow geometry here. Like Constable, he in places bends the unyielding rule that all shadows must be radii to the bow (that is, that they must converge on the rainbow's center). For example, see shadows cast by some rocks on the left and by the red-cloaked figure and pack animals on the right.

Although less often than his predecessors, Church still occasionally gives rainbow geometry lesser weight than his primary concern, sublimity of expression. This is hardly surprising, because artists and their public (including critics) shared a common belief that scientific accuracy was merely a prerequisite to, not a constraint on, elevated art. John Ruskin often voiced such sentiments, asserting in *Modern Painters*:

> Again, it does not follow that, because such accurate knowledge [of natural forms] is *necessary* to the painter, it should constitute the painter; nor that such knowledge is valuable in itself, and without reference to high ends. Every kind of knowledge may be sought from ignoble motives, and for ignoble ends; . . . while the very same knowledge is in another mind an attainment of the highest dignity, and conveying the greatest blessing. This is the difference between the mere botanist's knowledge of plants, and the great poet's or painter's knowledge of them.[247]

Humboldt invokes "the ancient bond which unites natural science with poetry and artistic feeling," but he too distinguishes "in landscape painting, as in every other branch of art, between the elements generated by the more limited field of contemplation and direct observation, and those which spring from the boundless depth of feeling and from the force of idealizing mental power."[248] However, in the decades after Humboldt's death his "ancient bond" was weakening, and the "mere botanist's knowledge" that Ruskin denigrated was outpacing his generalist audience's understanding and interests. In 1883, overwhelmed by the accelerating pace of an increasingly complex, irreligious science,[249] Church could only say resignedly "I wish science would take a holiday for ten years so I could catch up."[250] Frederic Church never would catch up, and later generations of artists would only flirt with,[251] rather than pursue, the sciences. Yet for more than two millennia, scientific accounts of the rainbow had themselves moved languidly, as we are about to see.

One origin of the vanished rainbow bridge between art and science comes from ancient Greece. The most famous, long-lived Greek rainbow theory was that of Aristotle, whose innovative ideas replaced rainbows of legend with skillfully constructed geometric ones. However, Aristotle's geometric rainbow has optical inconsistencies that would dog it down the centuries. Early commentators on Aristotle alternately attacked and defended his ideas, gradually constructing a confused, if plausible looking, Aristotelian edifice for the rainbow. Aristotle's confusion in sorting out the rainbow's geometry is not unique, as a diverse sampling of rainbow paintings and illustrations suggests. In fact, both the rainbow's symbolism and its optics make the rainbow bridge a difficult one to cross without missteps.

FOUR

OPTICS AND THE DAUGHTER OF WONDER

Cicero's pointed question makes it clear that Iris fascinated the ancients just as she does us. His question also reveals the ambivalence his contemporaries felt about the rainbow. For alongside fledgling efforts to describe it as a part of the natural world were older views of the rainbow as a divinity.

These accounts of an anthropomorphic rainbow considerably predate Cicero (106–43 B.C.). As we saw in Chapter 1, the rainbow of the deluge seems to appear in Akkadian texts, echoing the Hebrew story of the Flood.[2] In *Theogony*, Hesiod (fl. c. 700 B.C.) sets to verse the origin of Iris and her sisters the Harpies, who were the daughters of Thaumas and his wife Electra, herself a daughter of the earth-encircling river Oceanus.[3] But alongside these mythic accounts are records of a nascent meteorology. Ancient Babylonian astronomers assigned separate names to two types of halos,[4] indicating that they sought order not only among the stars but among other celestial lights as well.

> But why should not the glorious Rainbow be included among the gods? it is beautiful enough, and its marvellous loveliness has given rise to the legend that Iris is the daughter of Thaumas [the Greek god of wonder]. And if the rainbow is a divinity, what will you do about the clouds?[1]
>
> Cicero, *De Natura Deorum* (45 B.C.)

This desire for order was satisfied in many ways, and ancient science often embraced mysticism and numerology. Historian George Sarton notes that some Greek scientists could regard myths as "poetical descriptions of things that were not susceptible of scientific explanation" and yet conduct rational inquiry elsewhere with equanimity.[5] This dichotomy was not confined to Western science. The Indian astronomer Varāhamihira (fl. 6th century A.D.) would explain that the rainbow is due both to colored rays from the sun and to "the exhalations of serpents."[6]

The Rainbow and the Evolution of Ancient Science

Because Hesiod and Homer describe origins of and events in the natural world, they are in a limited sense natural philosophers.[7] However, throughout these authors' accounts the gods and their whims control all, and so the natural world is inseparably bound to the supernatural.[8] Such a world view is entirely satisfactory for transmitting moral and literary ideas, yet it describes a natural world ruled by caprice rather than an understandable one. As Chapter 1 shows, the rainbow was long an integral part of the deified, anthropomorphic landscape. The change from a mythic to a material explanation of the rainbow is a protracted one in Western science, and its beginnings can be traced to the sixth century B.C.

In western Asia Minor, among the islands and coastal regions then called Ionia, a few Greek scientists removed the supernatural from their stories of natural phenomena.[9] Furthermore, such accounts are judged for the first time based on their verisimilitude.[10] A succession of Ionian philosophers emerged from the city of Miletus near present-day Söke, Turkey. The first Milesian of whom we have any knowledge is Thales (c. 624–c. 545 B.C.). While none of Thales's works have survived, secondhand accounts suggest how much his outlook differs from Hesiod's. Thales explained earthquakes as the rocking of an earth floating in water, an account that has mythical precedents.[11] Yet Thales makes no mention of an angry Poseidon, and equally important, he offers a universal explanation of earthquakes rather than an ad hoc accounting for a specific earthquake. Thus Thales begins to replace anecdotal storytelling with generalizable explanations, the precursors of modern scientific theory.

Also important to Milesian philosophers was defining the underlying substance or primal material of the world. In Thales's case, water was the most fundamental material, as suggested by his description of a floating earth. For Milesian philosopher Anaximenes (fl. c. 545 B.C.), air reportedly was the world's basic material, and its rarefaction and condensation generated all natural substances.[12] Anaximenes' interests were not just cosmogonic, however. He correctly pointed out that sunlight forms the rainbow, although he did claim that this sunlight is returned to an observer by an impenetrable cloud.[13] Because rainbows are often seen against clouds, this idea would prove to have lasting appeal. Anaximenes' combination of cloud and sunlight may seem elementary to us, but remember that a millennium later learned men like Varāhamihira would still add serpents' breath to the rainbow's sunlight.

A century after the first Ionian philosophers, their materialist philosophy influenced the atomists Leucippus (fl. 440 B.C.) and Democritus (c. 460–c. 370 B.C.). Atomist philosophy held that indivisible, eternal particles called atoms define the world. Infinite in number, ceaselessly moving and colliding, atoms are invisible and inanimate, yet their motions and myriad configurations give rise to the life and materials of the earth. So mechanistic a view of the world may sound quite reasonable to us, but to the Greeks it offered too little of either human volition or the everyday, perceptible world.[14] Thus atomism was merely one of several philosophical schools in ancient Greece, and it was far from the dominant one. Similarly, the Ionians' interest in observing and measuring a dehumanized, godless world did not hold sway for long. There are several reasons for the limited influence of the Ionians' empirical, materialistic science. One reason may have been social rather than strictly intellectual.

The influential philosophers of ancient Athens were probably more isolated from the demands of daily life than their Ionian counterparts. If life were rougher and more mercantile on the islands, we might expect intellectuals there to be more exposed, if not disposed, to working with their hands. As a result, the idea of measurement might have come far more naturally to Ionian scientists than to those on the mainland.[15] While this is a fair generalization, there are important exceptions to it, as we shall see. The Attic slave economy may also have limited the spread of empiricism because manual tasks like experimentation and measurement carried a social stigma. In a slave economy there is also less need to develop laborsaving machines.[16] Significantly, Aristotle believes that substituting machines for slaves requires that the machines be both autonomous and servile. As historian Yvon Garlan describes it, Aristotle's hypothetical replacement of slavery with technology "depends on a mutation in the natural order" that is "relegated to another world, not to the future of this one."[17] Although a lower level of technology does not by itself dictate scientific methodology,[18] a thriving technology and empirical world view do support one another.

Plato, Pythagoras, and Empirical Science

While a distaste for measurement may have limited the influence of Ionian science in Athens, Athenian philosophers were hardly dogmatic on this issue. For example, we know that as influential a thinker as Plato (c. 428–348 B.C.) advocated combining observation and theory. In *The Republic*, Plato derides mere stargazers who are content to collect information indiscriminately rather than develop coherent theories from it. Plato calls for an education in which the philosopher-kings of the ideal state are trained to develop astronomical theories that are supported, but not held thrall, by observations.[19] A modern scientist does just this when he or she decides which information is relevant to a given problem and which is not. Thus in one way Plato and the Ionians agreed on the goals of science. However, Plato's harangue had another profound effect. His blunt dismissiveness about the imprecision of astronomical measurements would be inter-

preted by later Platonists as an indictment of empiricism.[20]

Eventually, Platonism was associated with a bias against experiment. To be fair, Plato's enchantment with mystical views of cosmology also encouraged this reading of his ideas.[21] In the *Timaeus*, Plato reduces the four material elements of Empedocles (c. 490–430 B.C.) to geometric forms.[22] This subservient role of material "accidents" also gave later Platonism a bias against empiricism. As a result of this legacy, Plato is often regarded today as an ardent foe of experimentalism, even though he was not. In fact, Descartes's seventeenth-century analysis of the rainbow bears out Plato's great faith in observations simplified and clarified by the power of mathematics.[23]

Plato's impulse for mathematical idealization derives from Pythagoras of Samos (c. 580–c. 500 B.C.).[24] Today Pythagoras's influence is most commonly recognized in the geometric theorem bearing his name, but it ranged much further. Although Pythagoras flourished within Ionia and was likely exposed to the ferment of Milesian empiricism, he shows us that science there was hardly of a single mind. We cannot be certain, but Pythagoras probably flirted with Egyptian mysticism and Oriental occultism.[25] This seems likely because the religious and scholarly communities that followed Pythagoras's teachings did embrace such mysticism. One of the central ideas of Pythagorean mathematics was the assumption, occasionally couched in mystical language, that all of nature's mysteries could be directly revealed through perfect geometrical shapes and simple integer ratios.[26] The Pythagoreans were fascinated with the notion that the regular solids (cube, pyramid, etc.) and the ratios of musical harmony are present everywhere in nature.[27] In their surviving works, the disciples of Pythagoras do not discuss the rainbow, but their elegant geometry and mysticism would influence its later study.

For example, Pythagorean numerology appeared in Aristotle's seminal writings on the rainbow. Pythagorean idealism about nature also would dominate the commentaries of later Platonists and have a pronounced effect on Christian thought. In the third century, Saint Hippolytus (c. 170–c. 235) serenely wrote that Pythagoras "was the first to reduce the motions of the seven heavenly bodies to rhythm and song."[28] Hippolytus and many others believed that because the motions of the planets could be explained by a purely circular orrery, the world beyond the moon's orbit was open to theoretical analysis. But the sublunar world, devoid of the divine beings and pure forms that existed above, was governed by chance and could be studied only imperfectly.[29] There are echoes of this idealism in medieval works on the rainbow, where Pythagorean numerology manifests itself as interest in the number of rainbow colors.[30] Miracles and measurement coexisted without difficulty, although by the twelfth century some philosophers clearly expressed their preference for the latter.[31] But for others the temporal world simply symbolically affirmed God's design, and so medieval observation and theory sometimes converged to describe the sublunar world's tricolor rainbow as a symbol of the Holy Trinity.[32] For these writers, the cautious interplay of theory and observation that Plato once sought[33] was cast aside for the simplicity of heavenly perfection.

Aristotle's Rainbow: Antiquity's Explanation of the Bow's Geometry

Nevertheless, the most influential ancient writer on the rainbow was an enthusiastic advocate of observing the sublunar world. Aristotle wrote antiquity's most extensive work on the rainbow, and its authority continued largely unshaken into the seventeenth century. Aristotle's elaborately classified, voluminous works on a wide variety of subjects gained a respect that the scattered writings of the Ionian philosophers could not.[34] Although Aristotle's theory of the rainbow is by turns both clear and confusing, its preeminence in the story of the bow makes it worth inspecting closely.

Aristotle was a student at Plato's Academy in Athens, but he was far from an uncritical acolyte. His eventual disenchantment with Plato's duality of body and soul (or matter and form) led him to insist that the two cannot be separated and that we must regard sense impressions of the material world as our means of understanding metaphysical forms.[35] Thus Aristotle was a champion of common sense, taking the un-Platonic view that real objects and phenomena, not illusions, stimulate our senses.[36] While this sounds reasonable, Aristotle's common sense differs from the philosophy of modern science in that it does not always rigorously question the validity of qualitative sense impressions.[37]

In his analysis of the rainbow in *Meteorologica*, this naive trust in the senses occasionally leads Aristotle astray. Aristotle correctly points out that the sun, the eye, and the center of the rainbow lie on a straight line.[38] He also correctly maintains that the bow is merely redirected sunlight,[39] rejecting the idea that it has any objective reality.[40] However, like Anaximenes, Aristotle makes the plausible but mistaken assertion that the rainbow is caused by sunlight reflected from a distant cloud. One insidious effect of this claim is that later Aristotelian interpreters occasionally blurred the subtle distinction between the bow's intangibility and the reflecting cloud's tangibility.

This misconstrued tangibility of Aristotle's rainbow may also stem from his explanation of its circular shape.[41] Much as a draftsman traces out a circle on paper, Aristotle constructs the rainbow as a circle inscribed on a hemisphere that is centered about the observer's eye (Fig. 4-1).[42] We still use this kind of imaginary sphere to indicate the relative positions of the observer and the rainbow, as well as halos and similar optical phenomena.[43] But Aristotle relies on the geometry of the meteorological sphere to explain why only certain parts of his reflecting cloud cause the bow. Typical of Aristotle's vagueness is the fact that he implies, but never explicitly states, that a cloud of minuscule mirrors lies on the surface of the meteorological sphere. Many later rainbow theorists *did* assume that cloud and sphere were coincident, making the rainbow a case of reflection from a concave surface covered by little mirrors.[44] Furthermore, Aristotle implicitly places the sun on the meteorological sphere's surface, which makes the sun and reflecting cloud equidistant from the observer.[45] However, elsewhere in *Meteorologica* he accepts that the sun is larger than the earth, that the sun "is farther than the moon from the earth," and that solar rays reaching the earth are nearly parallel.[46]

Having constructed his imaginary meteorological sphere, Aristotle correctly asserts that

FIG. 4-1

Aristotle's meteorological sphere and rainbow

the rainbow's shape is caused by a circular cone of reflections whose apex is at the eye. But his answer begs the question that we would ask: What is the *physical* cause of this cone of reflected light?[47] Instead, he accounts for the bow's shape and position by using a geometrical argument that suggests only a vague knowledge of reflection geometry.[48] Aristotle's reflection rainbow fails a very simple test, even if he himself had no motivation to undertake it. He states that the rainbow sets as the sun rises.[49] This is true, but he further implies that his model of the reflection rainbow behaves the same way. In fact, reflections from a concave cloud-mirror would rise and set *with* the sun (see Chapter 5's "Robert Grosseteste and the Refraction Rainbow").

That such a fundamental error, easily detected by simple experiment, should have escaped Aristotle seems odd indeed to us. Yet avoidance of experiment lies at the heart of Aristotle's methodology on the rainbow. Aristotle says in *Posterior Analytics* that the rainbow is most fundamentally understood in geometric, rather than physical, terms: "As optics is related to geometry, so is another science to optics, namely, the study of the rainbow. To know the fact of the rainbow's existence is for the natural scientist; to know the reason is for the optician, either simply as such or as a mathematical optician."[50] In Aristotle's usage, the geometrical "reason" for the rainbow's existence is inherently mathematical, and thus superior, to the mere "fact" of its existence discerned by physics and observation.[51] Nevertheless, Aristotle's idea that some fundamental circular symmetry exists in the positions of observer, sun, and reflecting cloud is an advance over earlier theories, which seem to suggest that the bow's circularity is due to the spherical shape of clouds.[52]

Aristotle's theory of vision takes an unusual turn in *Meteorologica*. Although in other texts he describes light as transmitted from sources toward the eye (intromission),[53] in *Meteorologica* he adopts the language of extramission, in which visual rays are projected by the eye and reflected by objects toward light sources.[54] It is unclear whether Aristotle's thinking on vision evolves or is simply volatile. In *De generatione animalium* (On the Generation of Animals),

Aristotle says that intromission and extramission are essentially interchangeable models,[55] yet in *De sensu et sensibili* (On Sense and the Sensible) he labels extramission "an irrational notion."[56] Although extramission is now known to be completely untenable, it is a fixture of *Meteorologica*. For example, Aristotle flatly states that "Sight is reflected from all smooth surfaces, such as are air and water" and later "So it is clear that the rainbow is a reflection of sight to the sun."[57] Although either extramission or intromission will do for describing the rainbow's geometry, Aristotle's choice of extramission means that he cannot realistically explain its optics.

In fact, optical problems abound in *Meteorologica*. Aristotle uses a Greek word that has been translated as "refraction,"[58] yet clearly he ascribes the rainbow to reflection alone.[59] Aristotle never refers to the colors generated by refraction in a prism, apparently regarding these as unrelated to the rainbow.[60] Instead he offers another appealing but faulty bit of reasoning. He proposes that there are two kinds of mirrors: large ones that reflect forms and invisibly small ones that cause colors.[61] He then says that raindrops in the reflecting cloud are like minuscule mirrors and that they yield only the sun's bright colors, not its image. In particular, when the sun is opposite a cloud, because its brightness will make "the cloud a mirror and cause the sight to be reflected to the object [, so] then the reflection must render the colour of the object without its shape."[62] Finally, Aristotle holds that white light is diminished and can take on colors if it is reflected (especially by a dark substance such as water) or if the light travels a long distance ("sight when strained to a distance becomes weaker and less").[63] In fact, Aristotle's assumption about darkening by reflection is perfectly reasonable given the dim, imperfect reflectors with which he was familiar: water and most metal mirrors.

Aristotle notes that the rainbow's three colors are red, green, and purple and that these are "almost the only colours which painters cannot manufacture" by mixing.[64] In concluding his explanation of rainbow colors, he tries valiantly to impose order on his ideas about brightness, reflection, and color:

> The reflection [of clouds in water] diminishes the sight that reaches them. It makes no difference whether the change is in the object seen or in the sight, the result being in either case the same. . . . When there is a cloud near the sun and we look at it it does not look coloured at all but white, but when we look at the same cloud in water it shows a trace of rainbow colouring.[65] Clearly, then, when sight is reflected it is weakened and, as it makes dark look darker, so it makes white look less white, changing it and bringing it nearer to black. When the sight is relatively strong the change is to red; the next stage is green, and a further degree of weakness gives violet. No further change is visible, but three completes the series of colours (as we find three does in most other things). . . . Hence also the rainbow appears with three colours.[66]

In other words, if Aristotle can persuade us (and himself) that his rainbow geometry results in the rainbow's red regions somehow "weakening the sight" less than other regions, then he has satisfactorily explained the bow's color order. Now the inherent problem with Aristotle's rain-

bow color theory emerges. Even if the rainbow's red results from reflected light traveling a shorter distance than the bow's purple (or violet), no amount of honest tinkering with Aristotle's geometry can account for the differing color orders in the primary and secondary bows. Recognizing this, Aristotle performs some intellectual sleight of hand and offers two different mechanisms to yield the two color orders.

Let us briefly accept Aristotle's arguments about color order and see where they lead us. In the inner rainbow, Aristotle claims that each band's brightness (and thus color) is determined by the *area* that it covers (see Fig. 4-1). Accordingly, the primary rainbow's large outer band has the brightest color, red. By this logic, the outer band of the secondary rainbow should be red too. However, Aristotle holds that the brightness of each band in the secondary is determined by the total *distance* that rays travel. Now Aristotle's tortuous geometry requires that he treat the rainbow as if it were caused by a vertical cloud-mirror rather than a hemispheric cloud-mirror. In this new arrangement, the interior rays of the secondary rainbow travel a smaller distance between observer, rainbow, and sun than do the rays of its exterior. As a result, the interior of the secondary rainbow is red.[67] Not surprisingly, Aristotle does not mention that his two different explanations of the two rainbows' color orders are geometrically inconsistent.

Throughout *Meteorologica*, Aristotle generates colors only by darkening white light. From antiquity to the seventeenth century, most writers clearly distinguish between light and color. Whether emitted or reflected, light is regarded as that which makes objects visible, while color is a property of objects' surfaces that merely modifies light. By itself, color does not share light's illuminating power.[68] Now although Aristotle's black-and-white explanation of rainbow colors parallels his arguments on colors generated by mixing pigments,[69] his apparent distinction between rainbow and pigment colors[70] would complicate artistic color theory for centuries. In part, Aristotle's insistence on only three rainbow colors may have come from his own selective observation, but it also meets the requirements of Pythagorean numerology.[71] As Chapter 7 reveals, his rainbow of three colors would become a staple of later literature and art. Recognizing that he must explain the existence of other colors in the rainbow, Aristotle describes how "yellow is due to contrast, for the red is whitened by its juxtaposition to the green."[72] As odd as Aristotle's reasoning is here, at least it sounds consistent with his color theory.

Other problems plague Aristotle's account. He comes quite close to a modern analysis of the rainbow's geometry when he describes rainbows seen in the sunlit droplets of a spray generated by oars.[73] But Aristotle mistakenly maintains that these bows occur because spray droplets, like those in a cloud, form a continuous surface.[74] With this twist of logic, Aristotle makes real spray bows indistinguishable from nonexistent ones supposedly reflected by continuous clouds where "the air in the clouds is already condensing into raindrops but the rain is not yet falling."[75] These confusing passages probably discouraged later writers from dwelling on the role that individual raindrops play in forming the bow. Another of Aristotle's erroneous beliefs is that the rainbow's radius grows larger as the top of bow nears the horizon.[76] Although the arc's radius is virtually independent of the sun's elevation, Aristotle seems to have been deceived here

by the same illusion that makes the moon look largest when it is on the horizon.[77] The persuasiveness of this size illusion, combined with the weight of Aristotle's authority, led others to repeat his claim later.

The Transformation of Aristotle's Theory: Commentators and Corruption

Despite its many flaws and its appeal to Pythagorean numerology, Aristotle's qualitative explanation showed an inventiveness and relative consistency that was unmatched for centuries. After Aristotle's death, much rainbow theory consisted of reaction to his work, although not all of this was uncritical. Among Roman writers, Seneca the Younger (c. 4 B.C.–A.D. 65) holds that an indefinite number of rainbow colors is possible, not just three.[78] Noncommittally reporting on various rainbow theories, Seneca notes that "a number of authorities" support the idea of raindrops, not a continuous cloud, causing the bow.[79] He comes quite close to the modern explanation when he says that "many, even countless, images [of the sun reflected by raindrops] both sinking and falling rapidly are mingled together. In this way, they say, a rainbow is a fusion of many images of the sun."[80] Seneca later seems to reject a role for raindrops and instead returns to Aristotle's cloud-mirror.[81] Nevertheless, both the raindrop mosaic and the multicolored bow continued to be important variants on the dominant Aristotelian theory of the rainbow.[82]

Aristotle's theory became corrupted as subsequent study increasingly relied not on the earliest versions but on commentaries that were in turn rewritten and given the stamp of authority.[83] This scholarly recycling was encouraged as Roman political and intellectual hegemony crumbled. Constantine the Great's 330 A.D. dedication of his imperial capital in Constantinople merely sanctioned accomplished fact, because the eastern and western halves of the Empire were already separated administratively and economically. The empires also became increasingly isolated linguistically and intellectually, and in the Roman West fluency in Greek declined sharply. Aristotle survived in medieval Europe only in the Latin translations of Boethius (c. 475–524), and then only in treatises on logic.[84]

Although widely scattered in time, *Meteorologica* commentaries continued to be written in the Roman provinces. For example, Olympiodorus the Younger of Alexandria (fl. sixth century A.D.) wrote a notable commentary on Aristotle's *Meteorologica*.[85] In it, Olympiodorus ardently defends Aristotle's reflection theory of the rainbow against the refraction theory of an unnamed rival. His reasoning starts with the fallacious claim that refraction always enlarges the apparent size of objects and that reflection reduces it. Olympiodorus then argues that because the rainbow does not resemble a large image of the sun, reflection alone causes the bow.[86] No new rainbow insights come from Olympiodorus, merely resolute (and rather tortuous) defense of the Aristotelian status quo.

Although little more independent-minded about *Meteorologica* than Olympiodorus, Alexander of Aphrodisias (fl. A.D. 198–211) left a far more influential work on it.[87] As head of Aristotle's Lyceum in Athens, Alexander was determined to displace its prevailing synthesis of

FIG. 4-2
Caspar David Friedrich, *Mountain Landscape with Rainbow*, c. 1810. Museum Folkwang, Essen, Germany

Aristotelian and Platonic doctrines with an uncorrupted version of Aristotle's views alone.[88] To this end, Alexander wrote commentaries on many of Aristotle's works, including *Meteorologica*. Alexander does not question Aristotle's basic theory that the primary and secondary rainbow colors are caused by weakening of sight, which in Alexander's words has traveled "through a distant reflection."[89] Yet Alexander's faithfulness to Aristotle is not unthinking. Discussing Aristotle's problematic explanation of the two rainbows, Alexander poses a telling question:

> Someone certainly might ask, if the inner band of the secondary rainbow is red and appears near the outer band of the primary, which is also red, and these two parts of the cloud both reflect sight more strongly to the sun [than others], why at least does not every band intermediate to the rainbows also have the red color? For this [intermediate] part of the cloud is closer to the red outer band of the primary rainbow than is the [red] inner band of the secondary rainbow. Neither sight nor light is reflected [in Aristotle's theory] according to how we see, but the mirrors and cloud do have [these distances and positions described above].[90]

Alexander's challenge to the Aristotelian rainbow is this: If red is the most strongly reflected rainbow color, why is the region between the primary and secondary rainbows dark rather than bright—in particular, why is it not red? He arrives at this question by interpreting Aristotle's cloud-mirror as a distant vertical object (as Aristotle does for the secondary), rather than an object lying on the surface of a meteorological sphere. Then the cloud's top will be more distant than its base, and so the secondary rainbow's top is more distant than the primary's. In this scheme, clearly the cloud between the primary and secondary rainbows is at a distance

intermediate to those parts causing the bows. If the region between the bows is at intermediate distance, Alexander reasons, does not Aristotle's geometry also require it to have intermediate brightness? But in fact it does not. As Fig. 9-2 shows, the sky between the bows is *darker* than either rainbow.

Recall that Aristotle resorted to two different schemes to account for the rainbows' different color orders.[91] Alexander says nothing about this problem, but his pointed question above is damning enough. Once asked, it demanded an answer, yet Aristotle's account provides none. Not until Descartes's seventeenth-century theory of the rainbow would there be a satisfactory explanation of the darkness between the bows. Indeed from Alexander's day to the present, this dark band has been known as *Alexander's dark band*. What scientist would not envy Alexander's nearly two millennia of fame derived from so few words and such a seemingly simple question!

Aristotelian Geometry: Rainbow Basics in Physics and Art

Before the advent of late medieval European theories of the rainbow, the best explanation for the bow's appearance survived in Aristotle's account, even if in a version sprinkled with commentators' errors. Without knowing that discrete raindrops cause the bow or that refraction and reflection are combined within them, Aristotle still was able to make geometrical arguments that are useful in describing the natural bow. Despite its inconsistencies, his work gives us a good indication of what a careful rainbow observer can discern—and of the complications that test the limits of this commonsense approach.

We now consider how three aspects of Aristotle's theory—the bow's shape, size, and relationship to the sun—have figured in artists' paintings. Naturally, we should not expect artists to have an Aristotelian outlook or to embrace the idea of verisimilitude. However, where painters have shown an interest in realism and close observation of nature, we can ask whether the rainbow consistently poses any difficulties for them.

Arc in the Sky: The Circular Symmetry of Rainbow Light

If most people were asked what the rainbow's most characteristic feature is, they would answer "the colors," but even the name of the phenomenon belies this response. The most characteristic feature of the rain*bow* is its shape: it is a bow, or portion of a circle. This point is acknowledged by the many artists who have painted a rainbow as an essentially colorless arc in the sky.

One striking and carefully calculated example of this from the nineteenth century is Caspar David Friedrich's (1774–1840) *Mountain Landscape with Rainbow* (Fig. 4-2). Even though one of Friedrich's great passions was landscape painting, his devout Christianity and his enthusiasm for Romantic ideals made it unlikely that he would be content with unadorned naturalism. Here, in what was originally a night scene, the artist has added the pale swath of a rainbow to the sky. Even a cursory examination of this rainbow shows that it cannot have been taken from nature.

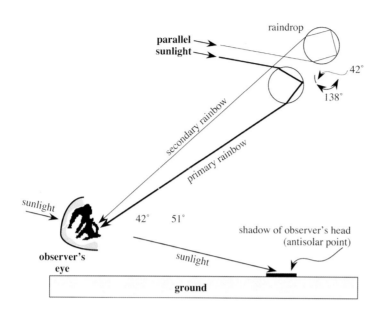

FIG. 4-3

Sunlight that forms the primary (inner) rainbow is bent by raindrops through an angle of 138° and so appears 42° from the antisolar point (42° = 180° − 138°). The sunlight of the secondary (outer) rainbow is bent through 231° and is seen 51° from the antisolar point (51° = 231° − 180°).

There are two contradictory sources of light in the picture: one is presumably the sun, and it illuminates the man in the foreground from behind the viewer. The other is a brilliant nighttime moon that shines through the thick clouds above the rainbow. Matters are no clearer when we realize that neither light is in a location where it could cause the rainbow. The inconsistency was apparent to some of the artist's contemporaries, one of whom was his patron's cousin, Duke Emil August of Saxe-Gotha-Altenburg. He complained bitterly about the license in some Friedrich paintings and seems to take direct aim at Fig. 4-2 as one of "those garish, harsh, contradictory affectations, those peepshows purporting to be mystical allegories—especially the rainbows which remind one of a confectioner's handiwork."[92]

The duke correctly identified the source of his frustration: Friedrich's enthusiasm for recondite allegories and mysticism. Because this painting is filled with Christian symbolism, it is hardly surprising that Friedrich's rainbow is less a natural than a symbolic feature. The fog-shrouded valley that stretches beyond the foreground figure (a self-portrait) represents the valley of death, and it separates the artist from the divine promise of the distant mountain.[93] Arching over the murky depths is God's shining symbol of peace and promise, the rainbow. Its pale colors are likely meant as a pointed symbolic contrast to the forbidding darkness below (and may be meant to show a lunar rainbow). Interestingly, the distant mountain is derived from Friedrich's study of a mountain in Bohemia, so he did not rule out nature studies in his allegorical works. As in other paintings, the rainbow here carries an especially long-lived symbolism that makes its natural appearance relatively unimportant to the artist. The only visual clue that we are looking at a rainbow is the shape of the arc: all the natural bow's other features have been discarded.

But why is the rainbow an arc rather than a spot, or a perhaps a straight line? The answer lies in the symmetry of raindrops. As Anaximenes and Aristotle recognized, the bow is just sunlight that has been bent so it approaches us from another part of the sky. Sunlight that forms

the primary rainbow is bent by reflection and refraction though an angle of 138°.[94] This means that the rainbow appears on the side of the sky opposite the sun. Another way of visualizing this geometry is to note that the shadow cast by your head is 180° from the sun. This point 180° from or directly opposite the sun is called the *antisolar point*.[95] If with one arm you point at the sun, and with the other you point at the shadow of your head, your two arms will lie in a straight line; there is an angle of 180° between them. A spot of light that is 138° from the sun is therefore 42° from the shadow of your head (42° = 180° − 138°), which itself is centered on the antisolar point (Fig. 4-3). Similarly, because sunlight forming the secondary (or outer) rainbow is bent through an angle of about 231°, it appears 51° from the antisolar point (51° = 231° − 180°).[96]

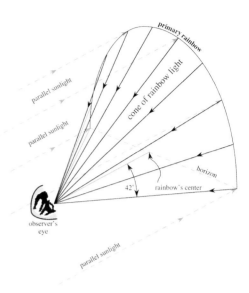

FIG. 4-4

Cone of rainbow light converging on an observer's eye

This analysis still does not fix the rainbow's location very well. Is the spot of light 42° above your head's shadow (at the 12 o'clock position), or the same distance to either the left (9 o'clock) or right side (3 o'clock)? This is equivalent to asking if the raindrop bent the light up, down, or to the left or right. However, a spherical raindrop will not prefer one direction to another. Its very symmetry demands that it treat all directions equally. All locations that lie 42° from the shadow of your head are equally likely to send the concentrated rainbow light to you (Fig. 4-4). Although sunlight reflected once within a raindrop is most concentrated 138° from the sun, *some* light is bent through all angles between 180° and 138° (see Fig. 6-5). Thus the sky between your head's shadow (180° from the sun) and the primary rainbow (138° from the sun) is *brighter* than the sky outside the primary, making the rainbow the bright edge of a disk of light (see Figs. 8-8 and 9-2).[97] This explains John Constable's observation that "the space within the Bow is always lighter than the outer portion of the cloud on which it is seen."[98]

The primary rainbow must therefore be a circle with a radius of 42° and its center at your head's shadow. Put another way, the circle of concentrated rainbow light converges on your eye along the surface of a cone whose radius is 42°. Of course, for the whole rainbow circle to be seen, there must be rain in all those directions, and this seldom happens. We are usually left with only a part of the circle's top half: a bow rather than a circle. The amount of the rainbow arc blocked by the ground depends on how high the sun is in the sky. If the sun is about to set in the west, the shadow of your head will be on the eastern horizon, and the top of the bow will be 42° above it. But the bow's lower semicircle is not visible unless you are elevated well above the surrounding terrain. In all other circumstances, there will not be enough raindrops between your downcast eye and the ground to make the rainbow visible.

If the sun is 30° above the horizon, then the head of your shadow will be 30° below the horizon. In this case, the top of the bow will be only 12° above the horizon (12° = 42° − 30°). Now

a much smaller portion of the bow will be visible, even though the radius of that portion is still 42° (contrary to Aristotle's claim of increased size). When the sun is higher than 42° above the horizon, an earthbound observer cannot see the rainbow.

Whatever the time of day, rest assured that a convenient angular scale for locating the rainbow is always within reach. Splay your fingers and stretch your arm out straight with the palm facing away from you. Now the angle that you see between the tips of your thumb and little finger will be about 22°. Next pivot your outstretched arm around your little finger's tip, making sure not to move that fingertip. When you have pivoted your arm so that your palm faces you (that is, so you have pivoted it half a turn), the tip of your thumb will be about 44° from its original position. If you first used your thumb to cover your head's shadow, the tip of your pivoted thumb will be 44° from the antisolar point—that is, it will slightly overlap the primary rainbow circle.

The Inescapable (and Unapproachable) Bow

The fact that the rainbow appears around the head of your shadow has several interesting implications. In particular, it means that the rainbow is a terribly personal phenomenon. No two people see exactly the same rainbow because each sees it around the head of his or her own shadow. An easy way to convince yourself of this is to move as you watch the bow. As your shadow moves with you, so does the rainbow. One of us (Fraser) has watched a rainbow while driving across the Canadian prairies. Although he traveled down the highway quite rapidly, his rainbow kept pace with his shadow as both raced through the Saskatchewan wheat fields.

This inescapable rainbow depends on having an uninterrupted supply of raindrops 42° from the antisolar point and, to a lesser extent, on the light source's distance. If the light source is very close (for example, a floodlight at night), moving laterally may rotate the line joining your eye, the light source, and the rainbow's center very rapidly around the landscape. If this axis swings far enough, parts of the 42° cone along which rainbow light travels may no longer intersect enough falling raindrops to yield a visible bow. Of course, if you are surrounded by droplets, moving in any direction has no effect on the rainbow. For a distant light source (the sun or moon, for example), the 42° cone scarcely rotates around the landscape when you move laterally. By definition, however, the cone travels with you: when you drive along a road, it tracks along with you. This accounts for the rainbow that raced along the Saskatchewan roadside. Even for distant light sources, some or all of the rainbow will disappear (and thus "leave" you) if your lateral movement causes the 42° cone to pass out of the falling water droplets. Imagine (or, if you feel spendthrift, charter) an airplane that flies over a large waterfall near noon on a sunny day. If we look at movies of the trip, we see different parts of the rainbow arc appear and disappear within the spray (and nowhere else, naturally) as the plane passes over the falls. Those short-lived rainbow segments will always be 42° from the antisolar point. Short of such heroics, however, the rainbow seen in a distant shower's sunlit raindrops follows us wherever we go.

FIG. 4-5
Cars entering a rainbow-painted tunnel just north of San Francisco in Marin County, California (photo: Craig F. Bohren)

This behavior probably explains many cultures' fear of the rainbow. Because it always moves with you, it is inescapable, and in a threatening world something that cannot be outrun is an unwelcome sight. Pursuit is as hopeless as flight, so the rainbow's tantalizing elusiveness has given rise to many fantasies about what will happen if a person manages either to reach it or pass through it. One familiar example is our own myth about finding a pot of gold at the end of the rainbow. Because chasing the rainbow is as futile as chasing the sun, the pot of gold is on one level a symbol of the absolutely unattainable. State lottery advertisements that feature a pot of gold at the rainbow's end have an unintentional irony that shows us just how casually we redefine natural symbols (Fig. 9-6). Far from being a knowing wink about the natural world, the pot of gold has become a blandishment to trust your luck.

The unapproachable rainbow takes on a quite different (and possibly alarming) aspect in numerous legends that claim that a person who passes through the bow will change sex.[99] Anyone who paints rainbows around the entrances to tunnels or buildings should keep this transsexual power clearly in mind. As it is, twice a day hapless Marin County commuters undergo a transformation that would tax anyone's stamina (Fig. 4-5).

FIG. 4-6
Appearing like bright wheel spokes, every sunbeam is a radius to the rainbow (photo: R. T. Fraser)

Shadows Converging on the Rainbow's Center: Parallel Sunlight and Perspective

Seen from the earth, the sun is a fairly small object in the sky; it has an angular diameter of only half a degree. This means that all light rays coming to us from the sun are essentially parallel. But often you see rays of light that emanate fan-like from the sun and look anything but parallel, an effect due to perspective. Parallel rays appear to diverge from the sun in the same way that the sides of a long, straight road seem to diverge as they approach you from the vanishing point. When you turn around, you see the road's sides converging to another vanishing point. Similarly, the rays diverging from the sun will pass by you and converge on the point directly opposite the sun, the shadow of your head. All sunbeams, and thus all shadows, appear to converge there.

On the surface, this may seem quite curious. Why should all other shadows point toward your shadow? You can check this by drawing a straight line from an object to its shadow. When extended, this straight line will pass through the shadow of your head. Only perspective makes all shadows appear to converge on the antisolar point. But this point is also the center of the rainbow, so as you look at the rainbow, all sunbeams and shadows will lie along radii of the bow as they flow straight to its center. There is no other choice: a sunbeam that crosses the rainbow

FIG. 4-7
Eric Sloane, *Earth Flight Environment* mural, 1976. National Air and Space Museum, Smithsonian Institution, Washington, D.C. (photo: Christopher Vaucher)

crosses it at right angles (Fig. 4-6). This relationship between the bow and shadows has long been known and may be strikingly apparent even in casual observation of rainbows. However, observing this pattern and recognizing its universality are two quite different matters. In fact, John Constable's recording of radial sunbeams in his *View over London with Double Rainbow* is more the exception than the rule, as Eric Sloane's impossible sunbeams in Fig. 4-7 suggest.[100]

Myth and Naturalism in Ancient Art: Zeus and the Rainbow

Although there is some evidence that artists were aware of Aristotle's theory in antiquity, the earliest known renderings of the rainbow remain firmly committed to the mythological vision. Because so little classical Hellenic painting survives (aside from stylized vase painting), our oldest illusionistic picture with a rainbow comes not from Greece but from Herculaneum, a prosperous Roman city that met the same end as its ill-fated neighbor Pompeii (Fig. 4-8). Hellenistic motifs in this fresco suggest that it was executed either by a Greek painter or by a Roman artist using Greek prototypes. Zeus appears with his attendant eagle and Eros, while a tricolor

FIG. 4-8
Unknown Greek or Roman artist, *Zeus Reclining Amid the Clouds*, after 50 B.C. Museo Archeologico Nazionale, Naples

rainbow arcs across the aerial view.[101] The shading of the figures and background mountain is inconsistent with the existence of a natural bow, suggesting along with the subject matter that the rainbow is an emblem for Iris. We can only speculate whether the anonymous artist had studied natural rainbows. Clearly he is not concerned solely with realism, despite what our modern vision might lead us to believe.

Unsystematic lighting and perspective are characteristic of this derivative style, which nonetheless suggests the remarkable achievements of ancient illusionism. However, the growth of messianic religions in the later Roman Empire carried with it the seeds of an artistic revolution that would make a mystical, pictographic style dominant until the early Middle Ages.[102] This transformation of art in late antiquity indicates how artists' interest in natural detail is inextricably bound up with contemporary intellectual trends. We now consider another, much later example of this confluence of ideas. As before, we concentrate on those features of the rainbow's geometry that Aristotle described.

Joseph Wright's *Landscape with a Rainbow*: Romanticism and Realism

The work of the English artist Joseph Wright (1734–97) is typical of the early Romantic enthusiasm for science. His paintings of such scientific subjects as *A Philosopher giving that Lecture on*

FIG. 4-9
Joseph Wright, *Landscape with a Rainbow*, 1794. Derby Museums and Art Gallery, England

the Orrery . . . (1766) and *An Experiment on a Bird in the Air Pump* (1768) were well received in his lifetime.[103] Wright's *Landscape with a Rainbow* (Fig. 4-9) is in a number of ways an exemplar of the short-lived Romantic fusion of science and sentiment. Although the picture shows us nature closely observed, it also employs some sublime conventions: the halcyon landscape has a rough, wild look that is partly created by sudden variations of shade and color.[104] For some Romantics, Wright's effortless combining of such details and sensibilities would soon seem irretrievably lost. In little more than a generation, the poet John Keats (1795–1821) would lament that science had relegated the rainbow to "the dull catalogue of common things."[105] Yet in Wright's picture, for perhaps the first time, we sense the majestic brilliance of a natural rainbow, one observed with loving attention to detail.

In fact, it is the cart and driver in Fig. 4-9 that seem mere decoration—the rainbow is central to the composition. If we study the shadows cast by various objects, we see that the

rainbow is painted quite realistically. In part, this may be due to Wright's long-standing fascination with shadows. Wright carefully re-created their geometry in his scientific tableaus, and his dramatic, original lighting in these and other "Candle Light" paintings is his major technical achievement.[106] Furthermore, as art historian Louis Hawes notes of Fig. 4-9, "Wright correctly makes the sky within the arc slightly lighter than that without, something which most artists (along with the public) overlooked until the appearance of Luke Howard's and Thomas Forster's meteorological treatises in the early nineteenth century," a naturalistic touch that is not surprising "given Wright's lively curiosity about natural phenomena and his strongly empirical bent."[107] In fairness to other artists and their public, the primary rainbow's bright interior may not always be clearly evident (see n. 98 above). Nevertheless, decades of Wright's scientific interests converge in Fig. 4-9.[108]

Yet apparently Wright had not labored very long painting rainbows. They do not appear in earlier works,[109] and in 1793 he offhandedly wrote of this picture: "I am trying my hand at a rainbow effect."[110] Like many Romantic artists and poets, Wright's keenness for science and scientifically informed landscape was an amateur's enthusiasm. Science retained its magnetism only as long as it literally seemed miraculous, filled either with remarkable details or a delightfully terrifying sense of the natural sublime. In this picture, though, nature seems less awful than delightful. Here the arc of the rainbow appeals to us, as perhaps it did to Wright, not because it is a Romantic icon but because it is a beautiful and dramatic vision.

The Impossibility of Seeing Rainbows Obliquely

Note in Wright's painting that the rainbow is parallel to the picture plane. As John Constable noted,[111] this duplicates the appearance of the natural rainbow, which is invariably a portion of a circle centered on the shadow of your head. Put another way, the bow can never be seen obliquely. After we consider the bow's shape and color order, this is the natural feature found most often in paintings. It is hardly surprising, though, that oblique representations are often found in the fantastic world of advertising. Like the pot of gold, the insistence on skewed rainbows probably stems either from inattention to nature or from the widespread determination to *make* the rainbow tangible. In this last respect, although commercial artists literally twist nature, they are simply catering to our desire for concrete examples of the unattainable. Our present-day delight with the rainbow as a harmless omen and pretty pattern makes it an obvious choice for this visual nonchalance.

The Misperception of the Bow as a Physical Object

A common thread links the oblique bow with many other unnatural representations. In each case the artist implicitly perceives the rainbow as a physical object. You can walk around a

FIG. 4-10
Postcard of a rainbow leaning against a wall

physical object and view it from the side, you can approach it and touch it, you can climb it. Of course, none of these things is true of the rainbow because it is not an object but an image. It is an image of the sun, albeit a wildly distorted one. This means that the rainbow has no particular position in space, unless that position is infinity. There is certainly a direction in which it appears, but you cannot claim that the bow is, say, one yard away, even if it is caused by a water sprinkler that you hold in your hand. Artists occasionally indulge themselves in rather mordant visual humor on this point, as Fig. 4-10 illustrates. However, many illustrations of this impossibility stem from the plausible assumption that the rainbow is an object, not an image.

We regularly make distinctions between images and objects. When you look into a mirror, your image is clearly as far behind the mirror as you are in front of it. The fact that the mirror is hanging from a wall does not prevent your image from appearing beyond the wall. So too a rainbow may appear in the direction of a shower, but it is not located at the same distance as the water drops. You can check on this by taking a stereoscopic picture of a bow seen in the spray from a garden hose. The rainbow appears infinitely far away, having seemingly punched its way right through foreground objects in its headlong rush to recede from you.

FIG. 4-11

Harry Fenn, *Niagara*, 1873. *Picturesque America* illustration

A simpler though less direct test comes from merely watching how the bow moves when you move. As you move to the left, objects near you appear to shift to your right. The rainbow does not. We have already seen that although the rainbow travels with you, it behaves like an object at infinity. (How many of us as children thought the moon was chasing us because it kept pace with our speeding automobile?) Optically, the rainbow is at infinity even when it appears to be in front of nearby objects. Saying that the rainbow is optically at infinity or that it has a fixed angular size (and thus moves with you) are roughly equivalent statements.

As an example of the subtle problems this can pose, consider Harry Fenn's 1873 *Niagara* from the book *Picturesque America* (Fig. 4-11). Because natural bows have a fixed angular radius of 42°, they have a diameter of nearly 90°. Using the diameter of the bow as a measuring rod to gauge the angle encompassed by the illustration, we find that the view apparently spans more than 270° (that is, three quarters of a circle). But we can see that the picture actually spans much less than 180° because our view does not extend both up and down the river.

Figure 4-11 shows an aerial view, a perspective sometimes favored by earthbound artists of Niagara.[112] If you move back from a physical object, its angular size decreases. Obviously Fenn viewed Niagara's rainbow from the gorge's rim, treated the rainbow as an object, and thus shrank it along with the Falls as he moved to his imaginary aerie. Nowadays we could satisfy ourselves that the rainbow does not behave this way by ascending the observation tower at Niagara Falls, Ontario. Fenn could have checked this by retreating a few hundred feet from the rim and seeing what the rainbow looked like. That he seems not to have done this speaks to the power of our common misperception that the bow is a tangible part of the landscape.

Harry Fenn is hardly unique. Many painters treat the rainbow as if it were a physical object. Sometimes (as in Fenn's case) this misconception could have been righted quite easily. More often than not, though, plein air painters did not have the luxury of a long-lived bow and were at the same time attempting to sketch the rest of the landscape. From a fixed vantage point, and without a systematic understanding of how rainbows occur, it is quite easy to give the rainbow some oddly substantial qualities. As Frederic Church's *Niagara* (Fig. 3-6) suggests, the permanence of Niagara Falls rainbows helps considerably in capturing their nuances. Two additional examples can give us an idea of the subtleties involved. In addition, these paintings' separation by two centuries and several thousand miles shows the pervasiveness of the idea of the tangible rainbow.

Peter Paul Rubens and *The Rainbow Landscape*: Artifice and Naturalism

Peter Paul Rubens (1577–1640) is the most celebrated European artist of the seventeenth century, a gifted man of great erudition who was hailed by a contemporary as "the most learned painter in the world."[113] Despite the ready market for his works, Rubens kept most of his landscapes in his personal collection, probably because of his attachment to them.[114] His devotion to and command of landscape painting clearly helped to make it a mainstay of European art. While today we can appreciate Rubens's landscapes either as backdrops for mythological vignettes or as ends in themselves, recent scholarship suggests that they stem from a very personal iconography. His *Rainbow Landscape* (Fig. 4-12) provides us with an excellent example of this, along with a determinedly contrived rainbow. The painting was probably originally paired with *Het Steen*, Rubens's portrait of his country chateau south of Antwerp.[115]

This pairing would have seemed far from arbitrary to learned seventeenth-century viewers, because each picture evokes an image not only of the Flemish countryside but also of the ideal rural life described in fashionable ancient poems such as Virgil's *Georgics*.[116] In Fig. 4-12 no specific locale is shown, while *Het Steen* includes the distant features of Antwerp (although Rubens has rearranged the local topography). In both paintings, the robust reality of country work and pleasures is played out for us. The *Rainbow Landscape* shows us haymaking and cattle herding, along with the dalliance of the laborers in the foreground. Although neither Virgil nor Rubens would have regarded these peasants as their equals, they both felt that the moral and

FIG. 4-12

Peter Paul Rubens, *Rainbow Landscape*, c. 1636. Reproduced by permission of the Trustees of the Wallace Collection, London

aesthetic benefits of a simple country life are universal. Like its ancient poetic counterpart, Rubens's painting also celebrates the beauties of the rural sky and landscape.

With this background in mind, we now examine the picture's principal feature. The rainbow is easily the bravura centerpiece of this ode to nature, but it is far from naturalistic. As John Ruskin complained about this painting, "Rubens' rainbow . . . was of dull blue, *darker* than the sky, in a scene lighted from the side of the rainbow. Rubens is not to be blamed for ignorance of optics, but for never having so much as looked at a rainbow carefully."[117] There are indeed several problems with the rainbow. It seems to swoop out of the distance on the left and then arc over the foreground trees on the right. Rubens treats the bow as a solid object that is oblique to the picture plane. Ruskin's final complaint is accurate but does not go far enough. Not only is the sunlight inconsistent with the rainbow, but it also strikes nearby objects at a variety of angles. Can we reconcile this unnaturalism with Rubens's reputation as an extraordinarily careful student of natural detail?

To begin, note that Ruskin's first two charges are difficult to justify. The rainbow consists of yellow and blue bands that are arranged in the correct order for the primary bow. The bow is

not darker than the sky, although sections of the arc are no brighter than the background. In fact, some parts of the rainbow are quite bright, especially the glowing band that appears above the trees on the right. In fairness, Ruskin may have been misled by the picture's dirty condition. A recent cleaning has restored its rainbow to a brilliance unknown in the nineteenth century.[118] In any event, reproductions of the painting that predate this cleaning still do not support Ruskin's claims. Perhaps Ruskin was making an oblique reference to the fact that the sky inside the natural bow is often visibly brighter than the sky outside. Rubens certainly does not show that, but in Rubens's day it was standard practice to paint finished works not from nature but from a series of preparatory studies. Chateaus or cows pose no special problems for this technique, but transient rainbows do. Assuming that Rubens simply misremembered the appearance of the natural bow gives us one explanation. However, it seems more likely that Rubens painted from memory a rainbow that did not look brighter inside than out.

As for Rubens's diligence in observing rainbows, note that he seems to have painted a faint supernumerary bow inside the main bow. This pastel band fades toward the base of the rainbow, a detail consistent with nature but rarely noted in scientific writings of the time. In addition, a rainbow reflection seems to be painted realistically in the foreground water.[119] Ultimately, whether Rubens was a careful rainbow observer is debatable, because he mentions the bow in none of his surviving writings. Judging from the number of his paintings that feature the rainbow, Rubens seems to have liked it, but still his bows depart from nature in various ways. Yet Rubens was not uninterested in optical accuracy. In a letter written around the time of the *Rainbow Landscape*, he carefully notes that a contemporary engraving after an "antique landscape . . . seems to me purely an artist's caprice, without representing any place *in rerum natura* [in existence]."[120] Even within this fantasy landscape, though, he objects that "as far as optics are concerned, certain rules are not too accurately observed, for the lines of the buildings do not intersect at a point on a level with the horizon—or, to put it in a word, the entire perspective is faulty."[121]

Rubens had earlier executed frontispieces for books on optics written by a local Jesuit scholar, and the two men probably exchanged ideas on the subject.[122] Whether and how much the rainbow figured in their discussions is unknown. But we can imagine that because Rubens keenly appreciated scientific matters, the texts' theories (including one on color) may have interested him considerably.[123] In all likelihood, Rubens was acquainted with the major points of contemporary rainbow theory. Perhaps the best explanation for his distorted rainbows comes from reconsidering his georgic vision of landscape. Because the *Rainbow Landscape* embodies this view, it is not surprising that its centerpiece functions on several levels. While the rainbow enhances the sky's great beauty, it also figuratively crowns the humble simplicity of the life we see below.

The Christian corollary of this allusion is the Flood story, and both Rubens and his audience were well aware of the rainbow's biblical implications. So based on what we see in the *Rainbow Landscape* and other pictures, it seems reasonable that Rubens studied natural bows,

but that he regarded them as compositional and allegorical devices rather than purely natural phenomena. From this vantage point, rainbows that are really emblems can be very solid indeed.

Conrad Martens: The Rainbow in the Australian Landscape

The Australian painter Conrad Martens (1801–78) shared Rubens's enthusiasm for the lyric qualities of sky and landscape. Although the two artists emerged from quite different painterly traditions, their common interest in the rainbow led them to some common problems. Martens was well schooled in the topographic approach to landscape painting. Born in England, he trained under a fashionable London art teacher and admired painters who achieved, in his words of later years, "faithfulness in colour, form and texture" and "a total absence of all petty details."[124]

At the age of thirty-two he traveled to South America and later shipped aboard HMS *Beagle* in Montevideo as a replacement for the survey vessel's ailing artist.[125] Shipmate Charles Darwin (1809–82), on the eve of making the observations that would one day revolutionize natural history, described Martens as an "excellent landscape drawer . . . a pleasant person, & like all birds of that class, full up to the mouth with enthusiasm."[126] The artist and the naturalist apparently got along well, for Martens wrote cordially to Darwin years later of their "jolly cruize."[127] One tantalizing reference to the rainbow on this trip comes from Darwin, who described a nearly complete rainbow circle formed in the *Beagle*'s salt spray as she cruised the waters off Chile's Chonos Archipelago. Unfortunately for our story, Martens had disembarked in Valparaiso more than two months earlier.[128] We can only speculate whether the two companions had earlier gazed at a similar sight from the rail of the *Beagle*.

In his official capacity as a topographic artist, Martens would have found himself confronted with the challenge of accurately recording the wild and unfamiliar scenery of Patagonia and Tierra del Fuego. As had Frederic Church's South American trip, Martens's voyage also gave him a keen interest in recording the appearance of atmosphere and clouds.[129] Nonetheless, his two-year sojourn did not fundamentally change his Romantic vision of landscape.[130] Martens's eventual settlement in Sydney afforded him a sporadically profitable career as a painting teacher and landscapist, and his lithographed views of the town sold reasonably well.[131] However, numerous commissions to paint country estates led him on excursions across New South Wales, and those travels in that wild country of the 1830s may have conjured up images of Patagonia and sharpened his interest in the picturesque and the sublime.[132]

Certainly sublime landscape elements appear in his *Fall of the Quarrooilli* (Fig. 4-13).[133] The gaunt branches of the snags in the foreground, the precipitous heights, and the alternating gloom and brilliance of the valley below are all designed to charge the landscape with emotion. Another conventional element in this sublime catalog is the arc of the rainbow. Martens painted this imposing view several times, with one version prompting a *Sydney Morning Herald* reviewer to glow in 1849 that it was "a delightful drawing in the best style of this clever artist; rich in colour, but true, full of air, and the whole in admirable keeping."[134] If Fig. 4-13 was the object

FIG. 4-13
Conrad Martens, *Fall of the Quarrooilli*, 1836. Private collection. Courtesy Australian Guarantee Corporation Limited

of the reviewer's pleasure, its rainbow makes his praise for the painting's truth ironic indeed.

In fact, we *assume* that Martens meant the wan arc in Fig. 4-13 to be a rainbow, even though it bears no resemblance to a natural one. This tiny, nearly monochromatic swath implies, as does Harry Fenn's rainbow, that the picture should encompass almost the entire horizon. That is clearly not the case here, even though Martens would later be explicit about a painting's angular width. In his 1856 "Lecture upon Landscape Painting," he noted that "55 deg. of the circle is the most that should be included from left to right of the subject" since "it will naturally be supposed that all which is seen in the picture at one glance can be so seen in nature, and every one looking at a picture *will so place himself as to do so*."[135] Furthermore, the shadows in Fig. 4-13 are inconsistent with the rainbow because they are uniformly cast to the left of objects rather than converging on the center of the bow. This seeming inattention to optics and perspective is all the more surprising when we realize that Martens was an enthusiastic amateur astronomer who painstakingly cast his own telescope mirror.[136]

Nor was Martens indifferent to subtleties of outdoor color. In critiquing another artist's watercolor, Martens complained in 1849 that "I consider the tint of the sky and distance decid-

edly wrong. It is not *pure* air color. It is greenish and should have warm high lights. The rest of his colors are of the purest kind or which only as are seen at midday. Neither can I bring myself to think the handling of the sky to be right."[137] Martens spoke with some authority because, like Constable, he had painted detailed cloud studies.[138]

However, Martens dismissed the notion that strict realism should apply to any element of his (or any painter's) work. In his landscape lecture he quoted Sir Joshua Reynolds: "If we suppose a view of nature represented with *all the truth* of the *Camera Obscura*, and the same scene represented by a great artist how little and mean will the one appear in comparison with the other." Martens warmed to the subject, quoting Reynolds's dictum that imaginative representation is the gifted painter's goal: "In this sense *he* studies nature, and often arrives at his end, even by being *unnatural* in the *confined* sense of the word."[139] Unlike Joseph Wright, Martens's interest in topographic accuracy and his Romantic fascination with science were not joined in the rainbow. Like Rubens, Martens found the rainbow useful as a compositional prop that was also meant to elevate the viewer to a more profound contemplation of landscape. If the rainbow is viewed primarily as a scenic or thematic device, then we can easily think of it as a physical object.

Infinitely Distant Light: The Bow's Ambiguous Distance in the Landscape

Appreciating the fixed angular size of the rainbow is a subtlety that has bedeviled many artists besides Conrad Martens and Harry Fenn. But the bow's constant angular size introduces still another twist to our perceptions of it. By adjusting your position, it is possible to just cover a distant road sign with, say, a coin. When the match is perfect, both the coin and the sign have the same angular size. And yet because you know that the sign is much farther away, you perceive it as being much bigger than the coin: bigger, that is, in its linear dimensions. Something with a fixed angular size will be perceived as being smaller if it is thought to be nearby rather than a long way off.

For example, if you mistakenly believe that a rainbow seen in a water sprinkler is close by, then it will appear to be only several feet in diameter. On the other hand, a rainbow caused by a distant rain shower may seem to span a whole mountain range and be miles in diameter.[140] Related to this illusion is the conviction shared by Aristotle and others that the bow's radius is greater when the top of the bow is close to the horizon. Since we perceive the horizon to be farther away than the zenith, the near-horizon bow appears to be more distant and thus larger. As compelling as these perceptions are, they are all based on a faulty judgment of the distance to the bow. Each bow is optically at infinity and each has exactly the same size.

Rainbow Reflections: The Logic That Defies Common Sense

So without an ability to organize observations of the bow through a knowledge of optics, we have a thorny perceptual problem for even the conscientious observer. The power of our miscon-

ceptions about the rainbow can be illustrated in still another area, the behavior of rainbow reflections. Because the only large reflecting surfaces in nature are bodies of water, we consider rainbow reflections in them. Imagine that you are on a hill looking down on the surface of a calm lake dotted with boats and islands. You must look down at a greater angle from the horizontal to see the boats in the foreground than those in the distance. Since each boat is reflected in the lake, the dividing line between the boat and its reflected image is the line along which the boat touches the water.

This line of symmetry between an object and its reflection is thus at a greater angle below the horizon for nearby objects than for distant ones. In the case of the sun or moon (which are infinitely far away), the line of symmetry is at the astronomical horizon, which we locate by extending a perfectly level surface from us to infinity. If you had no other way of measuring the distance to a reflected object, you could do so by measuring the angular depression of the line of symmetry.

FIG. 4-14
Aloha Airlines advertisement

The rainbow is optically at infinity, so the line of symmetry between it and its reflection is the astronomical horizon. This means that no matter how compelling the impression is that a rainbow touches the water right in front of you, its reflection does not begin there.[141] Rainbow reflections are subtly different from those of objects, and even artists interested in naturalism may overlook the distinction. Although the position of the bow's reflection is unambiguous (unlike its apparent linear size), in some paintings the rainbow's end apparently joins its reflection at the water's surface.[142] Just how often this unrealism is intentional is difficult to say, although probably here unchecked assumptions carry the day.

Yet another explanation may account for these rainbow-reflection errors. We know that the bow's linear size and apparent position in the landscape are ambiguous. That is, the rainbow may seem to be at one distance here, and at another over there, depending on your distance from the background. Aristotle's interpreters made the same sort of subtle error when they confused the location of the reflecting cloud with the location of the bow.[143] So if an unsystematic but careful observer is confronted with this conflicting evidence about the distance to the rainbow, he or she may decide that the bow has at least some characteristics of a solid object. This observer's next conclusion might be that the rainbow's reflection is like an object's, even though this reflection looks quite different. In other words, inappropriately used common sense wins out over contradictory visual evidence. Whatever the reason, the mistaken message is explicit in Fig. 4-14: an oblique rainbow slices into the water just below us, and its reflection meets it at the surface.

Another common misrepresentation of the rainbow is to paint the top of the sun peeking out from behind the bow (Fig. 4-15). Reality is pretty clearly on holiday here. Leaving aside that

FIG. 4-15
"Rainbow People" advertisement

the sun is on the wrong side of the sky, how can the sunlight that forms the rainbow block the sun? The simple fact is that it cannot. Although the Rainbow People inhabit the realm of delightful fantasy, there is no small irony in the wildly distorted standard that the nation's young environmentalists are expected to bear (Fig. 4-16).

Thomas Moran: Partial Rainbows and Epic Landscape

When we refer to the size of the rainbow, usually what we mean is its angular radius or diameter—that is, how far it is across. Sometimes, though, people refer to a small bow when they mean that only a small portion of the bow is visible. The most obvious limitation on rainbow completeness is the lack of rain in a given direction. Because the rainbow must always be in the same position with respect to your shadow, it can appear only if there are sunlit raindrops in the proper direction. For example, there might be a distant shower on the left side of your shadow but none on the right. In that case, only part of the rainbow's left side would be visible.

That is exactly what we see in Thomas Moran's (1837–1926) *Chasm of the Colorado* (Fig. 4-17). The fragmentary arc of the rainbow is framed by streamers of rain that trail across the sky above Arizona's Grand Canyon. Both the finished painting and a study for it suggest that Moran, like Frederic Church, understood that partial rainbows result from the unevenness of rain showers.[144] This unevenness also causes irregular brightness along the bow, and Moran deftly includes that naturalistic touch here.

Thus at first glance Fig. 4-17 simply seems to be a straightforward record of a spectacular bit of Western scenery. Although the initial critical enthusiasm for Moran's large canvas (measuring more than 7 feet by 12 feet) was more restrained than that for his 1872 painting *The Grand Cañon of the Yellowstone*,[145] reviewers still took pains to note that "the marvelous faithfulness of detail attests the photographic accuracy of the picture."[146]

FIG. 4-16
"President's Environmental Youth Awards" shoulder patch

However, from our perspective the painting is hardly a faithful transcription of nature. As we have seen in other artists' works, the painted shadows do not converge on the rainbow's center, but rather appear as parallel projections on the landscape. This bit of unnaturalism is especially noticeable on the left side of *The Chasm*, where the shadowed bluffs imply that no sunbeams cross the scene toward the bow. Furthermore, the bow's angular size implies that we should literally see a panorama of the canyon, which we do not.

These inconsistencies may seem curious in light of Church's spectacular success in 1857 with *Niagara*, a work whose rainbow deftly combines meteorological accuracy and painterly innovation. Moran greatly admired Church,[147] and both men took to heart John Ruskin's advice that "precisely the same faculties of eye and mind are concerned in the analysis of natural and of pictorial forms."[148] That is, landscapists could best realize their goals by exercising a scientist's attention to detail.

It is in Ruskin's then-influential views on nature and art that we can begin to understand Moran's motives. For Ruskin, fidelity to nature was more than simply good form; it was a moral imperative.[149] He saw science as an almost religious enterprise, one closely bound up with his sense of Romantic optimism.[150] The morphological bias of early nineteenth-century geology helped shape his attitudes toward science, and his amateur's eagerness for geology is given its freest rein in his widely read *Modern Painters IV* (1856).[151] However, Ruskin's enthusiasm for science was limited to just this sort of descriptive, encyclopedic system. In his view, science's greatest good was to reveal God's glorious creation through careful observation. The evolution of nineteenth-century science into an analytic discipline that often invoked unseen (and invisible) forces was anathema to Ruskin.[152] Such a reactionary stance was not unusual: we hear echoes of it in Conrad Martens's reluctance to read his friend Charles Darwin's *Origin of Species*.[153]

John Ruskin's early writings had considerable allure for Moran and other painters who embraced the ideals of the Hudson River School's first generation. Second-generation painters

FIG. 4-17

Thomas Moran, *The Chasm of the Colorado*, 1873–74. Smithsonian American Art Museum, lent by the Department of the Interior Museum

like Moran shared with their predecessors a vision of wilderness as a land whose Romantic qualities could be exalted by unstinting devotion to natural detail.[154] Early Hudson River painters such as Thomas Cole showed a verve for just the kind of microscopically observed landscapes that appealed to Ruskin. Equally important, Cole's successors found a special resonance in Ruskin's theological view of landscape, one that helped mold their own heroic vision of the American West.[155]

In Thomas Moran's case, this affinity for Ruskin's views probably dates from the 1850s.[156] When Moran had a chance to accompany a survey team led by geologist Ferdinand Hayden (1829–87) to the fabled Yellowstone in 1871, it surely appealed to his Ruskinian taste for the natural sublime[157] and perhaps to a desire to advance his career.[158] The first sight of Yellowstone Canyon made the young Moran wax sublime in a way that Ruskin himself hardly could have outdone: "The impression then made upon me by the stupendous & remarkable manifestations of nature's forces will remain with me as long as memory lasts."[159] From this expedition came Moran's hugely successful *Grand Cañon of the Yellowstone*. When it was partly finished, Moran wrote to Hayden about his motivation for attempting the subject: "By all Artists, it has hereto-

fore been deemed next to impossible to make good pictures of Strange & Wonderful Scenes in Nature. . . . But I have always held that the Grandest, Most Beautiful, or Wonderful in Nature, would, in capable hands, make the grandest, most beautiful, or wonderful pictures."[160]

Significantly, Moran goes on to ask Hayden's opinion of the geological accuracy of the painting, and he requested a second appraisal as the picture neared completion.[161] This appeal to scientism, combined with a determined pursuit of "Grandest" subjects, shows Moran's allegiance to Ruskin's belief that great landscape painting should both incorporate and transcend topographic description.[162] It is not at all inconsistent with Ruskin's—or Rubens's—ideas that Moran's transcendence involved rearranging the canyon topography to suit his taste.[163] Although Moran's version of scientifically correct landscape is far more literal than that in Rubens's paintings, it still stops short of photographic realism, contemporary reviews notwithstanding. That such realism was rarely sought in nineteenth-century American landscape painting stems in large measure from John Ruskin's persuasive, although jumbled, opinions in *Modern Painters*.[164] It is no coincidence that Moran's clearest statement of his philosophy is his praise for Ruskin's much-admired J. M. W. Turner: "[Turner] sacrificed the literal truth of the parts to the higher truth of the whole. And he was right. Art is not Nature; an aggregation of ten thousand facts may add nothing to a picture, but be rather the destruction of it. . . . I place no value upon literal transcripts from Nature. My general scope is not realistic: all my tendencies are toward idealization."[165]

Another reason that artists eventually became disenchanted with "literal transcripts" was the illusionistic power of photography.[166] However, for Moran and Church photography was still a useful if subordinate ally, as Moran's close collaboration with photographer William H. Jackson (1843–1942) on the Yellowstone expedition shows.[167] In 1873, his appetite whetted for Western vistas, Moran accepted an invitation from explorer John Wesley Powell (1834–1902) to document Arizona's Grand Canyon of the Colorado.[168] It is from this expedition that Fig. 4-17 comes.

Reviewers simultaneously praised the painting's realism and objected to its distortion of the Canyon's dimensions, but they were especially disturbed by the lifeless, desolate character of the landscape. *Scribner's Monthly* editor Richard Gilder (1844–1909), Moran's close friend, was unnerved by the supposedly pitiless violence of the thunderstorm, despairing that "the clouds do not float; they smite the iron peaks below with thunderous hand."[169] Evidence indicates that Moran actually saw the storm and possibly the rainbow depicted here.[170] He probably did not see any malevolence in the storm, but rather regarded both it and the rainbow as elemental icons worthy of the scene's epic grandeur.[171]

Moran had not sought to upset his critics. Their sense of alarm was generally confined to their own well-read circles, and it graphically demonstrates the perils of seeking Ruskin's inspirational ideals in every landscape.[172] The problem was simply that Moran's reviewers had a more conservative sense of what was properly inspirational than the artist. To them, the wild, inanimate landscape seemed sacrilegiously devoid of both life and God. As a counterexample, a year before *The Chasm* was unveiled, Gilder found Moran's use of the rainbow in an austere Yellowstone

landscape to be more agreeable. He happily noted that Moran's watercolor rainbow showed the artist "with all his senses alive for rich and strange and tender shimmering color, rainbow, and mist, with fleeting cloud, and more hues than Iris with her purple scarf can show."[173] The U.S. Congress apparently was not put off by *The Chasm*, purchasing it for $10,000 as a pendant to *The Grand Cañon of the Yellowstone* that already hung in the Capitol.[174]

Given Moran's tendency to rearrange landscape details for his own purposes, we can better account for the discrepancies in his rainbow. Just as some elements of the Canyon's geology were inviolable, so too were some features of the rainbow recorded faithfully. And just as the Canyon's dimensions were to be reworked, so were the rainbow's size and location to be left to his judgment. This combination of naturalism (variable brightness and incompleteness) and unnaturalism (shadows and angular scale) is certainly not new with Moran. However, his critics' reactions suggest that underlying the presumed harmonious relationship of art and science in late nineteenth-century America were unrecognized contradictions.[175]

Ancient Science and the Rainbow: Geometric Description Versus Physical Explanation

To this point, we have seen how artists and scientists across a score of centuries handled the problem of describing the bow's geometry, the problem that is central to Aristotle's theory. We should not necessarily expect that the artists studied the Aristotelian explanation. However, like Aristotle, they used common sense and the evidence of their eyes to construct an image of the bow. In addition, artists and Aristotelian scientists alike have occasionally departed from reality because of the rainbow's apparent tangibility.

Although the similarities between the two approaches are real enough, we also need to understand the important ways in which they differ. First, artists need not, and often have not, restricted themselves to the rational vision. By contrast, Aristotle's appeal to Pythagorean numerology in explaining the number of rainbow colors[176] was not a calculated turning away from reality. For Aristotle, it was merely a case of imposing mathematical order on (and thus deriving knowledge from) sense impressions.[177] Second, Aristotle and many later scientists in antiquity felt compelled to observe Plato's injunction to "save the phenomena"—that is, they constructed theories that primarily *describe* natural phenomena in mathematical or geometrical terms, with little or no concern for physical mechanisms that might *explain* them.[178] As we have seen, though, this ad hoc approach led to some tenuous connections between rainbow theory and observation. By contrast, artists may never seek complete naturalism in constructing their rainbows.

Antiquity's contribution to rainbow theory was its description of the rainbow's essential geometry. Given the supernatural explanations that had once prevailed (and that would continue), the naturalistic writings of Anaximenes, Aristotle, and Seneca are certainly significant accomplishments. Aristotle recognized that the bow's center lies on the straight line connecting the observer's eye and the sun. He also understood that there is some fundamental circular

symmetry that explains the bow, even though he resorted to a contrived explanation of how this symmetry comes about.

But neither Aristotle nor any other of these ancient scientists seized on the essence of the rainbow: that it is a mosaic image of sunlit rain. In fact, our use of the word "rainbow" would have been alien to them since in their terminology it was simply Iris's namesake. As plausible as the idea of the Aristotelian cloud-mirror sounds, we now recognize that it led its adherents into serious inconsistencies. Among these is the problem of explaining convincingly why only an arc-shaped part of the cloud produces the rainbow. As our next chapter shows, a more obvious problem is that rainbows are not always seen against clouds.

In short, ancient science described the rainbow's geometry successfully but failed to understand the bow in any basic physical sense. Given the amount of time and intellectual energy needed to build this physical explanation, we should not be too critical of the ancients. Theirs was a bold and important start in explaining the rainbow mystery. We now need to look beyond the ancient world to trace the slow and convoluted evolution of physical reasoning about the rainbow.

Although Aristotle's rainbow was a fixture of European science for centuries, it was not sacrosanct. Many theorists tinkered with its geometry in determined efforts to improve its realism. Invoking the powers of myth, optics, and geometry, Islamic and Christian scholars alike laboriously increased the span of Aristotle's rainbow, only to be bluntly criticized by their successors. The very intractability of the rainbow problem increased its allure, never failing to attract the interest of both brilliant and pedestrian scientific minds. In fact, the convoluted medieval path toward modern rainbow theory suggests how belief and personality still play a role in science. Not surprisingly, the rainbow bridge links the sciences to their past.

FIVE

UNWEAVE A RAINBOW

Nearly two centuries separate John Keats's lament for the fading spirit of Lamia[2] and its Jacobean source, yet his rendering of the story would have had immediate appeal for a nineteenth-century Romantic audience. In Robert Burton's (1577–1640) *Anatomy of Melancholy* (1621) the Lamia demoness of antiquity had become a love-struck, if deceitful, phantasm who marries her credulous victim. When the wedding guest Apollonius discovers Lamia's deceit, she pleads with him not to reveal her true nature. Unswayed, Apollonius refuses, "and thereupon she, plate, house, and all that was in it, vanished in an instant."[3] Thus the rational, analytical Apollonius literally makes Lamia's lovely illusion vanish. In similar fashion, Keats implies, the natural philosophy of Newton destroyed one of nature's beautiful visions—the rainbow.

In fact, Keats had merely cast one vote of many

> Do not all charms fly
> At the mere touch of cold philosophy?
> There was an awful rainbow once
> in heaven:
> We know her woof, her texture;
> she is given
> In the dull catalogue of common things.
> Philosophy will clip an Angel's wings,
> Conquer all mysteries by rule and line,
> Empty the haunted air, and
> gnoméd mine—
> Unweave a rainbow, as it erewhile made
> The tender-personed Lamia melt into a
> shade.[1]
>
> John Keats, *Lamia* (1820)

on the relationship between scientific analysis and poetic imagination. Did scientific knowledge inform (and thus benefit) or constrain (and thus hobble) poetry? This question had been debated almost since the first appearance of Newton's *Opticks* in 1704. In a characteristic seventeenth-century defense of natural philosophy, Thomas Sprat (1635–1713) argued in his *History of the Royal Society* (1667): "It is now therefore seasonable for *Natural Knowledge* to come forth, and to give us the *understanding* of new *Virtues* and *Qualities* of things. . . . This charitable assistance *Experiments* will soon bestow."[4] We have already seen James Thomson's enthusiasm for Newton's analysis of the rainbow—and his poetic rewording of Newton's ideas.[5] However, doubts began to surface within a few decades of Thomson's effusiveness. In 1769, the writer Elizabeth Montagu (1720–1800) anticipated Keats when she worried that "Echo, from an amorous nymph, fades into voice, and nothing more; the very threads of Iris's scarf are untwisted."[6] Where Thomson had delighted in Newton's gift of the "sage-instructed eye" and its ability to "unfold / The various twine of light,"[7] Montagu saw only unraveling glory.

Such divided artistic opinions on science survived Keats, as evidenced by reaction to *Lamia*. His friend Leigh Hunt (1784–1859) bluntly wrote after Keats's death that "modern experiment" was not inimical to poetry, and furthermore that anyone who believes himself not a poet "as soon as he finds out the physical cause of the rainbow . . . need not alarm himself; he was none before."[8] Hunt's contemporary, the poet William Wordsworth (1770–1850), tried more tactfully to bridge the gap between scientific and artistic outlooks when he wrote: "The beauty in form of a plant or an animal is not made less but more apparent as a whole by more accurate insight into its constituent properties and powers."[9] Nevertheless, Wordsworth's rejection of Keats's science hostility is clear.

Sharp differences between scientific and poetic readings of the rainbow did not originate in the eighteenth and nineteenth centuries. We have seen how Xenophanes and Cicero rejected rainbow myths[10] while other ancients firmly supported them. In Chapter 7 we will see another such schism in artists' reactions to Newton's heretical ideas on color, although there the dogma derives from Aristotle.[11] In fact, the science of the rainbow was dominated for centuries by a conservatism that Keats could easily have admired. So entrenched were Aristotelian ideas on the rainbow that even medieval scholars who undercut them would not propose their wholesale rejection.[12] The path that led to the destruction of Keats's rainbow—from Aristotle to Newton—was a long and uneven one indeed. What are some of the scientific landmarks along that path?

Science, Conservatism, and Aristotle's Unyielding Rainbow

That Aristotle's rainbow theory should have been valued more than direct observation for so long may seem odd to us now. Yet the Aristotelian theory that swept medieval Europe was scarcely known there before the twelfth century. To begin with, the integrity (and intelligibility) of Aristotle's ideas on the rainbow had usually suffered at the hands of commentators in late antiquity.[13] In addition, during the third and fourth centuries European scholars' knowledge of

Greek plummeted, and by the fifth century a theologian as eminent as Saint Augustine was barely conversant with the language. Latin copyists who encountered Greek words in manuscripts felt no compunction about rendering the incomprehensible passage as a blank or unhelpfully noting "Grecus est."[14] Thus because so few Latin texts on the rainbow were extant and because most European scholars read no other language, Aristotle's rainbow theory was at best known indirectly in the West.[15] For example, Isidore of Seville's seventh-century rainbow explanation faintly echoes Aristotle, but Isidore cites Pope Clement I (d. c. 100) as his source.[16] In addition, the strong Neoplatonic flavor of early Christianity would assign the senses a subservient, sometimes irrelevant, role in understanding the workings of nature.[17] With rainbow experiments deemed irrelevant and Aristotle's rainbow theory surviving in obscure paraphrase, scientific understanding of the rainbow stagnated in the Roman West.

In marked contrast, the seventh-century rise of Islam presaged a vital turning point in the rainbow's scientific story. By the eighth century, Arab scholars were eagerly acquiring and studying ancient Greek manuscripts (as well as their Hebrew and Syriac translations) in such centers of learning as Baghdad's Bayt al-Ḥikma Institute.[18] Arabic scholars' fluency as translators and their caliphs' backing combined to give Islam a critical understanding of the Greek scientific tradition that was unrivaled in contemporary Europe. An early example of this Arab eclecticism comes from a scientific encyclopedia written at Baghdad by the Syrian physician Job of Edessa (in Arabic, Ayyūb al-Ruhāwī; fl. 817–32). Conversant with Arabic and Greek as well as Syriac, Job was a member of the Nestorian church, a sect whose scholars made significant contributions to Islamic culture.[19] To that end, in his *Book of Treasures* Job borrows from Aristotle, the Greek physicians Hippocrates (c. 460–c. 377 B.C.) and Galen (A.D. 129–c. 199), as well as Persian and Indian authors[20] as he discusses medicine, chemistry, physics, meteorology, and theology.

In his analysis of the rainbow, Job of Edessa replaces Aristotle's geometric explanation of the rainbow with a purely descriptive one: "[The rainbow] appears to us in the shape of a bow because the heaven, in the place that is opposite the rainbow, appears to us arched. Indeed the heaven appears to us like a vault, and we imagine to ourselves the colours of the rainbow in accordance with this vaulted shape. . . . because the sun is seen by us in the shape of a sphere, and a sphere has a vaulted shape on any one of its sides; and because it is the sun that is the cause of the rainbow—we see its colours in the shape of a bow."[21]

For both men the rainbow is caused solely by reflection, although the reflector Job chooses is quite different from Aristotle's concave cloud: "The explanation of the different colours in the rainbow is the following: after rain has come down and has ceased, and a clear sky has begun, a certain thick, in addition to a thin, even and smooth humidity, remains in the air. When the sun shines on the clear and smooth part of that humidity, it causes a reflection on its thick part, and creates in it to our vision the different colours found in the rainbow."[22]

Before dismissing Job's two kinds of humidity, note that he avoids one of the most serious flaws in Aristotle's explanation: contrary to Aristotle's claim, rainbows are not always seen against clouds (Fig. 5-1; note how the bow spans breaks in the cloud and extends into the cloud-free

FIG. 5-1
A rainbow seen against altocumulus clouds and in cloud-free air

air).²³ Among the scores of Aristotelian commentators who would follow Job, only a few mentioned this deficiency in the master's explanation. Job may in fact be describing the common observation that as we stand in the humid, rain-free air in a shower's wake (the "thin, even and smooth humidity"?), we see the rainbow in the direction of the nearby rain (the "thick" humidity?). This observation leads Job to the plausible but mistaken assumption that two different media are necessary for the rainbow's formation.

Note that Job of Edessa matter-of-factly requires rainfall shortly before the bow's appearance. This clearly contradicts Aristotle's unverifiable claim that a rainbow-reflecting cloud occurs when conditions are "about to rain and the air in the clouds is already condensing into raindrops but the rain is not yet falling."²⁴ Neither does Job depend on Aristotle to enumerate or analyze the rainbow's colors, although here his explanations become decidedly anthropomorphic. After offering "date-red, green and yellow" as the bow's colors, Job suggests that the sun's "fieriness comes into contact in an opposite direction with a matter which is contrary to it, namely the smooth and watery coldness of the air, it fights it, and in the first instance imparts to

it its red colour."[25] Similarly, green occurs when cold, humid air "draws this [sun's] heat to itself and is conquered by it, [and] it receives a red colour; but the part of it which has not been conquered, and has hardened and drawn completely together, gives us a green colour."[26]

As independent as Job's qualitative rainbow description is, clearly he does not overturn Aristotle. Before holding Job of Edessa to too modern a standard, however, consider the rainbow explanation given four centuries later by Bartholomaeus Anglicus (fl. c. 1220–40), a Franciscan scholar who wrote a much-copied encyclopedia entitled *De proprietatibus rerum* (On the Properties of Things). Citing the Venerable Bede[27] as his authority on rainbow colors (itself a dangerous practice), Bartholomaeus offers the four elements as the source of the bow's four colors:

> For of fire he [the rainbow] takes red color in the overmost part, and of earth green in the nethermost, and of air a manner of brown color, and of water somedeal blue in the middle, as Bede says. And these colors be ordained together and set in order, as Aristotle says in *Meteorologica*. And first is red color that comes out of a light beam that touches the outer part of the roundness of the cloud. Then is a middle color somedeal blue, as the quality asks that has mastery in the vapor that is in the middle of the cloud. Then the nethermost seems a green color in the nether part of a cloud [where] the vapor is more earthy.[28]

Clearly Bartholomaeus has mixed up the rainbow's color order in placing blue between green and red. Perhaps he believes that this color sequence is possible, or perhaps he finds the question of no interest.[29] In either case, appeal to authority and an elaborate theory of similitudes seem more important for him than would Job's mere act of observation. It is hardly exaggerating to say that Giotto's roughly contemporary rainbow mandorla in the Arena Chapel (Fig. 2-3) is more naturalistic than Bartholomaeus's rainbow of faith.

Avicenna, Alhazen, and the Rainbow in Arabic Science

As the writings of Bartholomaeus and Job suggest, Arabic studies of the rainbow valued observation at a much earlier date than their European counterparts. Nevertheless, Job of Edessa made only a bit player's contribution to Arabic science's understanding of the rainbow. Within two centuries, several Islamic writers of greater renown eclipsed his modest efforts. The most famous of these was the Persian physician and philosopher Avicenna (in Arabic, Abū 'Alī al-Ḥusayn Ibn 'Abd Allāh Ibn Sīnā; 980–1037).[30] Avicenna wrote extensively on medicine and philosophy, and it is in these disciplines that he achieved his greatest fame. For our story, Avicenna's major contribution comes from his encyclopedia *Kitāb ash-shifā'* (Book of Healing), in which he comments on Aristotle's *Meteorologica*.

Although Avicenna's account not surprisingly accepts many of Aristotle's arguments on the rainbow, it nonetheless poses some difficult questions. Like Job, Avicenna objects to the Aristotelian claim that the rainbow occurs in or on a reflecting cloud. If that were so, he argues, how

could he himself have seen parts of rainbows that did not have cloud backgrounds?[31] In addition, Avicenna notes that rainbows seen in water sprays cannot be explained by appeal to a reflecting cloud. Avicenna's boldest claim is that discrete particles of moisture explain the rainbow, not Aristotle's supposedly continuous cloud. Avicenna states that the rainbow is seen not in a cloud but in "damp air in which small particles of pure transparent water are distributed like dew."[32] His boldness lies in making sunlit drops a *necessary*, rather than merely a *sufficient*, condition for the rainbow. In other words, a more cautious (and, at the time, unassailable) position would have been to claim that both the droplet and the cloud explanations were acceptable. Avicenna is also one of the first writers to state explicitly that the rainbow moves in the same direction as the observer.[33]

Avicenna's observations and reasoning are far from faultless. He incorrectly states that rainbow-generating water particles must be seen against a dark background, and he repeats Aristotle's observation that "persons whose eyes are moist" see rainbows around lamps.[34] Like Aristotle, Avicenna believes that the radius of the rainbow increases as the bow's top nears the horizon.[35] He reluctantly accepts Aristotle's three rainbow colors, all the while insisting that they merge seamlessly with one another. The logical inconsistency of a nominally tricolor rainbow within which Avicenna has observed innumerable colors frustrates him considerably.[36] Another Aristotelian color quandary vexes him as well: the different color orders of the primary and secondary bows cannot be explained by appeal to the radial positions of the colors. Avicenna's counterexample comes from the top of the bow, where the primary bow's red is higher than its violet, while in the secondary bow the relative heights of the two colors are reversed. If, Avicenna argues, you claim that the inner rainbow's red is brighter because that color is higher and thus closer to the sun, your argument fails in the outer rainbow, where the red is lower than the violet.[37] As valid as Avicenna's objections are, they did not bring him to any solutions. He resignedly admits that "My views on the rainbow still appear to me so uncertain that I hesitate to put them down in this book,"[38] a humility seldom evident among writers with even wilder speculations.

Avicenna's contemporary Alhazen (in Arabic, Abū ʿAlī al-Ḥasan Ibn al-Haytham; c. 965–1039) was a mathematician, physicist, and physician who contributed a remarkable range of ideas on optics and vision. Alhazen wrote insightful commentaries on works by Aristotle, Ptolemy, and the Greek mathematician Euclid (fl. c. 300 B.C.), as well as treatises on shadows, the Milky Way, spherical and parabolic mirrors, atmospheric refraction, the moon illusion, and (indirectly) the pinhole camera or *camera obscura*.[39] Two of Alhazen's works particularly interest us. The first is his influential *Kitāb al-Manāẓir* ("Optics" or, as translated in a widely circulated twelfth/thirteenth-century Latin recension, "Treasury of Optics")[40] of c. 1028. In *Optics*, Alhazen ranges over subjects from vision[41] and the eye's physiology to the nature of light itself.[42]

Most important for the story of the rainbow, Alhazen devotes an entire book of *Optics* to refraction.[43] Some ancient accounts of refraction treated it as a novelty,[44] and certainly a quantitative understanding of light refraction had developed more erratically than it had for reflection. In keeping with his stated determination to study optical problems both physically and

mathematically,[45] Alhazen quantitatively analyzes refraction between air and glass, as well as between air and water. To study the latter kind of refraction, Alhazen shines sunlight on hollow glass spheres filled with water and measures the resulting paths of the refracted and reflected light.[46] Although apparently he does not seize on the analogy, Alhazen had in fact constructed one of the first models of a sunlit raindrop. In the centuries to come, rainbow theorists would repeatedly study such water-filled globes, although some would see them not as outsize raindrops but rather as miniature refracting or reflecting clouds.[47] Ultimately in the fourteenth century the model raindrop would inspire the first correct explanation of the rainbow's geometry. This leap eludes Alhazen, but he nonetheless establishes mathematical rules describing how refractive bending depends on the angle at which light enters the sphere.[48] In fact, his blend of meticulously designed optical experiments and careful mathematical analysis is one of the best medieval examples of *geometrical* (or light-ray) *optics*.[49]

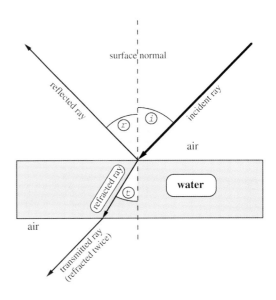

FIG. 5-2

Reflection and refraction of a light ray by a plane layer of water. Angle *i* is the angle of incidence, *r* is the angle of reflection, and *t* is the angle of refraction.

Because refraction and reflection generate the rainbow, we pause briefly to study their essential features. We illustrate the two phenomena in Fig. 5-2, where a ray of light that originates in air is reflected and refracted by a plane layer of water. As a reference direction, we have drawn the water's *surface normal*—that is, the perpendicular to the water surface. This surface normal is not an arbitrary construct—the angle *i* between it and the incident ray is identical to the angle *r* between it and the reflected ray.[50] This equality of the angles of incidence and reflection is called the *law of reflection*. Aristotle's rainbow theory is hobbled because it does not always (and sometimes cannot) equate incidence and reflection angles.[51] Because the law of reflection seems to have been current in Plato's day,[52] Aristotle's inconsistent use of it in his rainbow theory is curious indeed.

Historically, the symmetry of the incident and reflected rays had intrinsic appeal. Thus while the equality of *i* and *r* was sometimes ignored, it was never overtly challenged. Refraction, however, was more problematic. In Fig. 5-2, note that the refracted ray's angle *t* with the surface normal is smaller than *i*. This is true for all refractions into denser media (for example, Fig. 5-2's refraction from air to water), and we explore later the physical reasons for this bending toward the normal.[53] For now, however, we consider the mathematical difficulties that refraction poses. Unlike reflection, for which there is a fairly simple relationship that is independent of the media involved, refraction is more difficult to quantify. In fact, the relationship between *i* and *t* involves the sines of *i* and *t* and the relative speeds of light in the two media (that is, their *refractive indices*).[54] This mathematical relationship, called the *law of refraction*, was not expressed in its

FIG. 5-3

Reflection and refraction of a light ray by a spherical water drop seen in circular cross section.

modern trigonometric form until the seventeenth century. Before then, the demands of exacting measurements and unwieldy trigonometry seem to have made the true nature of refraction difficult to divine.[55]

For the rainbow, we are interested in light's interaction with spherical water droplets,[56] not with plane surfaces of water. Figure 5-3 shows a circular cross section of a spherical raindrop. As in Fig. 5-2, a ray of light is incident on the water's surface, with some of it reflected away from and some refracted into the drop. Because we are still considering air and water, the angles i, r, and t are unchanged from those in Fig. 5-2, although for convenience we have changed the orientation of the incident ray. As before, angles are measured with respect to the surface normal, which for a sphere is the radius that intersects the incident ray.[57] However, because t depends on i, which in turn depends on where the incident ray enters the drop, many different refraction angles t are possible within the raindrop. The laws of reflection and refraction can be applied to any number of reflections and refractions *within* the drop, and it is this exercise that leads to the correct geometrical optics explanation of the rainbow (see Fig. 6-5).

Alhazen, for all his thoroughness and perspicacity in studying refraction and reflection, made few immediate contributions to explaining the rainbow. For example, while he does not directly analyze the rainbow in *Optics*, he does touch on the problem of the rainbow's supposedly illusory colors: "Some people believed that colour has no reality and that it is something that comes about between the eye and the light just as irises [that is, rainbows] come about, and that colour is not a form in the coloured body. But the matter is not as the holders of this opinion believe it to be. For irises are due only to reflection, and reflection can take place only from a particular position and not from all positions."[58]

Thus Alhazen supports the Aristotelian views that the rainbow is caused by reflection alone and that its colors are not real like object colors.[59] Alhazen soon makes the latter point

FIG. 5-4

Alhazen's rainbow model: reflection by a concave hemispherical cloud

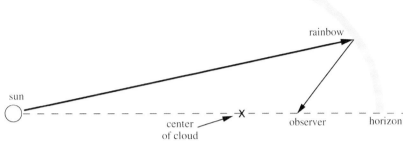

explicit: "Therefore the perception of the colours which the eye perceives in coloured opaque bodies is not due to reflection. That being so, these colours are not like irises."[60] In fact, Alhazen is wrong—the colors of opaque bodies *are* due to reflection, while the rainbow's perfectly real colors are not, at least in the sense that reflection does not separate sunlight into its component colors.[61] Alhazen would have plenty of company in struggling with this issue. Scientists and artists alike would fret intermittently for nearly another millennium about the reality of rainbow colors and how these differed from material colors.[62]

In a later work, Alhazen devotes himself to explaining the formation of rainbows and halos. In this *Maqāla fī Qaws quzaḥ wa al-hāla* (Treatise on the Rainbow and the Halo) of 1028,[63] Alhazen clearly recognizes the difficulty of the task he has set for himself:

> Now among the things . . . which have given rise to much perplexity of thought, are the two effects known as the halo and the rainbow. These effects always exist in dense air and always maintain a regular shape. As for the halo, it always has the shape of a circle, unless something interferes with it that alters it. The rainbow, on the other hand, always has the shape of a segment of a circle. Thus since their subject is air, their investigation must be physical, and since their shape is round, they must also be investigated mathematically.[64]

Alhazen's remark about "dense air" echoes Job of Edessa's two kinds of humid air, and for all his mathematical acumen, Alhazen makes little more headway with the rainbow problem than Job or Aristotle.[65] Like Aristotle, Alhazen correctly observes that the observer's eye, rainbow's center, and sun are collinear. Also like Aristotle, Alhazen erroneously postulates a hemispheric cloud from whose concave surface the rainbow is reflected rather than refracted. While Alhazen's geometrical optics is more lucid than Aristotle's, his rainbow is not.[66] Alhazen's rainbow theory accurately describes reflection from a concave hemispheric mirror (a subject that he knew well), and this reflection does indeed yield a bright ring of light around the observer's shadow.[67] In its predictions, although not its details, Alhazen's model closely resembles Aristotle's (Fig. 5-4).[68]

To demonstrate Alhazen's rainbow model, illuminate the concave side of a hemispheric reflector and study its reflections. A stainless-steel mixing bowl lit by a distant flood lamp or

slide projector will do,[69] even though most mixing bowls have flat bottoms and are not truly hemispherical. Notice the narrow, bright ring of light that forms some distance from the reflector's center—this is Alhazen's reflection rainbow. Your demonstration also vividly illustrates a reasonable objection to Alhazen's model. Like the ring of light, the small, mirrorlike reflection of the lamp at the bowl's center is also intrinsic to his model, and we might reasonably expect to see it in nature if rainbows were caused by reflection from concave clouds.[70] They are not, and so we do not.[71] Another unnatural feature of Alhazen's rainbow model is that, like Aristotle's reflection rainbow, it must rise and set with the sun.[72] Finally, because Alhazen excludes refraction, he cannot realistically explain the rainbow's colors. To try to do so, he relies on Aristotle's reasoning about the cloud being composed of mirrors so small that they reflect only colors, not images.[73]

Ultimately Alhazen's painstaking studies of refraction would bear fruit in correct geometrical optics explanations of the rainbow by others.[74] From the outset, though, Alhazen's ingeniously constructed reflection model of the rainbow was bound to Aristotle's inadequate theory. Both the *Optics* and Alhazen's rainbow treatise essentially vanished from view in Islamic science for nearly 300 years. In Europe, however, a Latin translation of *Optics* enjoyed great success from the thirteenth century onward,[75] and both works would be revivified in Arabic by the fourteenth-century Persian scientist Kamāl al-Dīn al-Fārisī (1266/67–1318/19).[76] To help Kamāl al-Dīn solve a problem in atmospheric refraction, his famous teacher Quṭb al-Dīn al-Shīrāzī (1236–1311) sought out a copy of Alhazen's long-overlooked *Optics*.[77] His interest in Alhazen's work piqued, Kamāl al-Dīn eventually produced (c. 1302–11) an improved version of Alhazen's rainbow and halo theories.[78] While Kamāl al-Dīn could not resolve all of this rainbow theory's problems, he did raise some useful and provocative questions. Like Avicenna, he wondered why parts of rainbows could be seen in cloud-free air. Furthermore, he did not accept Aristotelian beliefs on the brightness of rainbow colors, noting instead that the bow's blues and purples seemed brighter than its reds.[79]

Not outshined by his student, Quṭb al-Dīn had earlier produced his own rainbow theory.[80] In it, Quṭb al-Dīn at a stroke laid bare the essence of the rainbow's optics. He proposed that the primary rainbow was the result of light refracted twice and reflected once within a raindrop. By adding another internal reflection, Quṭb al-Dīn also explained the secondary rainbow. Quṭb al-Dīn thus solved the seemingly intractable rainbow problem with a clarity largely unrivaled by his Western contemporaries.[81] Although neither Quṭb al-Dīn nor Kamāl al-Dīn could explain the rainbow's colors, their work represented the crowning achievement of an intense Arabic interest in the rainbow during the thirteenth and fourteenth centuries.[82] Yet even if Quṭb al-Dīn's remarkable insights had later been circulated in Europe, they would have had to compete, like Alhazen's work, with the newly available corpus of Aristotelian rainbow theory.

The Revived European Rainbow: Translations and the Universities

In one sense, the European recapture of Aristotle's rainbow began with the recapture of the Spanish city of Toledo. The Arabic library of Moorish Toledo was seized when the city fell to

Alphonso VI (c. 1040–1109) in 1085, and scholars fluent in Arabic soon began translating the library's extensive holdings of classical texts.[83] The most famous of these translators was Gerard of Cremona (c. 1114–87), who traveled to Toledo in order to locate Ptolemy's *Almagest* and remained there to learn the Arabic in which it was written. Gerard accomplished this and much more, eventually heading a group of translators in Toledo who produced Latin versions of works by Avicenna, Galen, Hippocrates, Euclid, Archimedes (c. 285–212/11 B.C.), Alexander of Aphrodisias, and Aristotle.[84]

From Toledo, Sicily, and other centers[85] came what one historian calls a "wave of translations from Arabic to Latin"[86] in the twelfth and thirteenth centuries. For *Meteorologica* alone, the numbers are impressive: by one recent count, 113 twelfth-century translations from Arabic survive (including those by Gerard's group) and 175 thirteenth-century translations from Greek are extant.[87] Among Gerard's translations was *Meteorologica*'s Book 3, in which Aristotle lays out his elaborate geometrical theory of the rainbow. Although a twelfth-century Latin translation of Alhazen's *Optics* was once tentatively attributed to Gerard,[88] the translator's identity now is assumed to be unknown.[89]

The growing ranks of Latin translations of Greek and Arabic scientific treatises were to have profound effects on education in medieval universities. Many of the oldest universities (including those at Bologna, Paris, and Oxford) developed from various church schools within each city, and by the thirteenth century the combined schools were organized and flourishing as universities.[90] While curricula and specialties differed among the universities, they shared a common academic structure. The division of faculties was central to a medieval university's academic organization: theology, law, and medicine were the superior faculties, while the arts formed the inferior faculty. Entering students were educated by the arts faculty (hence its "inferior" distinction), while older and more advanced students were taught by the superior faculty.[91] Within the liberal arts were the precursors of the modern undergraduate curriculum: the trivium of grammar, rhetoric, and logic, and the quadrivium of arithmetic, geometry, astronomy, and music.[92]

The expanding university faculties versed themselves in the newly available Latin translations of classical texts. Because Aristotle had written on a wide range of topics with what appeared to be great authority, his texts became a staple of the university curriculum.[93] A fifteenth-century curriculum from Germany's University of Greifswald suggests his prominence. Of the approximately thirty topics and exercises required for the bachelor and master of arts degrees at Greifswald, nearly half bear titles of Aristotle's works.[94] However, identical titles do not imply identical ideas, and Aristotle could not always have recognized his ideas within the medieval university.

Before the widespread availability of Aristotle's scientific works in Latin, clerical instruction in science (such as that by Isidore, Bede, and Rabanus Maurus)[95] based its authority on ecclesiastical and divine sources. Thus a cleric's teaching authority "was guaranteed by a divine call within the ecclesiastical hierarchy; the authority of his teaching was guaranteed by Scripture and the Church Fathers."[96] Such teaching worked well for instruction of monastic orders and

the laity because it viewed the teacher as little more than a passive conduit for received truth. But the new university faculties had far different interests and audiences than their monastic counterparts. Although university instruction occurred within an essentially ecclesiastical organization, and Aristotle's ideas (especially those on logic) often served theological ends,[97] a new educational elite was emerging. Although faculty members were still officially regarded as clerics,[98] many of them had a new and quite different self-image as independent-minded students of the classical texts.[99]

Ironically, this new openness to authorities outside the church led to its own kind of dogmatism—Scholasticism. In Christian philosophy, the Scholasticism espoused by Thomas Aquinas made rational analysis of nature merely an intermediate step to moral and theological wisdom. Aquinas was nonetheless trying to reconcile the inherent differences between the Christian and pagan intellectual traditions. This reconciliation was prompted by the newly available works of pagan authors, the most celebrated of whom was Aristotle. With considerable exertion and skill, university Scholastics assimilated Aristotle's writings by claiming that (1) despite appearances, the works of Aristotle and other authorities were in fundamental agreement on basic issues, (2) the ancient authors had discussed all the important subjects, thus (3) these authors were not to be contradicted lightly, and (4) understanding and emulating the ancient authors provided the best kind of education in logic.[100]

Robert Grosseteste and the Refraction Rainbow

At Oxford we find beginnings of the later Scholastic enthusiasm for Aristotle in the writings of Robert Grosseteste (c. 1168–1253).[101] Despite finishing his education at Paris during the first influx of Aristotle's Latin translations,[102] Grosseteste was scarcely an apologist for Aristotle. In the course of a remarkably active professional life in Oxford,[103] Grosseteste commented on and translated several of Aristotle's works, and he was a key figure in introducing Aristotle into the Oxford curriculum.[104] Although Grosseteste's science could be decidedly Aristotelian, he also was clearly an independent thinker. For example, Grosseteste viewed light as a metaphysical phenomenon, holding that God created light as the universe's first, incipient material form, and that light subsequently diffused from a single point to create the natural world.[105] There were numerous precedents for this Neoplatonic belief in light as the primeval manifestation of God, among them the writings of Saint Augustine.[106] Thus for Grosseteste the study of light and optics was a means of understanding God's handiwork.

Another of Grosseteste's seminal ideas was that of *species*, any of a range of transmitted influences whose philosophical origin is the Neoplatonic belief in the emanation of God's power.[107] For Grosseteste, natural objects affect matter and our senses with a "power [that] is sometimes called species, sometimes a similitude, and is the same whatever it may be called."[108] Light was one kind of species; heat and odor were others.[109] Precursors of visual species were the material

eidola of the Greek philosopher Epicurus (341–270 B.C.), who claimed that visible things had "certain films coming from the things themselves, these films or outlines being of the same colour and shape as the external things themselves."[110] Medieval writers held that when an object is illuminated, each point on it generates species or likenesses of the point's light and color. Streams of these species pass into the eye, where their reassembled pattern produces the object's likeness.[111] Redefining species solved major deficiencies of the Epicurean model,[112] and in this Alhazen anticipated Grosseteste.[113]

For us, another unusual feature of Grosseteste's theory of light is his combination of visual rays (extramission) and luminous objects (intromission). Authors had made visual energy flow either in or out,[114] but only occasionally in *both* directions simultaneously.[115] Grosseteste states unequivocally in his commentary on Aristotle's *Posterior Analytics* that "vision is not completed solely in the reception of the sensible form without matter [that is, species], but is completed in the reception just mentioned and in the radiant energy going forth from the eye."[116] In the same passage, Grosseteste joins his ideas on vision and the rainbow: "Therefore, as light is reflected or refracted at the [transparent] obstacle, so the rainbow is the reflexion or refraction of the light of the sun in a watery cloud and the appearance of images the reflexion of the visual ray at the mirror."[117]

In short, Grosseteste has melded correct optical ideas (a transparent medium both reflects and refracts light) with incorrect ones (mirror images involve visual rays; reflection and refraction are interchangeable in explaining the rainbow). Note that Grosseteste here attributes the rainbow to reflection *or* refraction, seeming to make no distinction between the two. Some of this confusion comes from Aristotle himself, who offers the following strained analogy in *Posterior Analytics*: "the phenomena of echo, reflection and rainbow [are related because] . . . in all of these the problem is generically the same (because they are all kinds of refraction) but specifically different."[118] Although Aristotle assigns refraction no role in *Meteorologica*, Grosseteste seems to have taken Aristotle's often-ambiguous use of "refraction"[119] at face value here.

In his rainbow treatise *De iride* (On the Rainbow) of around 1235,[120] Grosseteste explicitly champions a refraction explanation of the bow, but implicitly relies on reflection as well. Labeled "a pastiche" by a historian with no ax to grind against Grosseteste,[121] *De iride* is both insightful and obtuse. Grosseteste's remarkable insight is that refraction must be involved in the rainbow, a claim that he supports with two arguments. First he argues that direct sunlight falling on a concave cloud would merely cause a "continuous illumination of the cloud," not a bright arc.[122] In this he is essentially correct, although bows are sometimes seen in sunlit clouds, including those from which no rain appears to fall.[123] More tellingly, Grosseteste objects that if the rainbow were due to the sun's reflection by a concave cloud, the bow should move like a reflection, rising and setting with the sun.[124] Because the rainbow does just the opposite, he correctly concludes: "Therefore the rainbow must be produced by the refraction of rays of the sun in the mist of a convex cloud."[125] Grosseteste erred when he dismissed any role in the rainbow for

reflection, but his seemingly simple observation was by far the most substantive objection yet raised against the reigning Aristotelian reflection rainbow.

Refraction had scarcely figured in earlier rainbow theories. Seneca briefly mentions prismatic refraction in his discussion of the rainbow. Like other ancient writers, though, Seneca does not understand the phenomenon well, mislabels it "reflection," and fails to link it to the rainbow.[126] Grosseteste was the first medieval writer to break with the ancient tradition of discounting refraction in the rainbow. In another way, however, Grosseteste is firmly bound to his predecessors' rainbows—an experimentalist in principle, in practice he strays very little from the Aristotelian tradition of selective observation constrained by geometry.[127] Furthermore, Grosseteste's rainbow theory often appeals to authority, leading historian Bruce Eastwood to remark: "When sources fail [Grosseteste], he invents, and the invention is never contradictory to literary sources."[128]

One of Grosseteste's apparent inventions in *De iride* is his law of refraction, in which he makes the refraction angle half the size of the incidence angle for light passing into a denser medium (for example, from air to water).[129] While this imagined "law" is acceptable qualitatively, quantitatively it is quite inadequate compared with Ptolemy's earlier (and reasonably accurate) measurements of refraction.[130] Because even casual measurements would have contradicted Grosseteste's "law" of refraction, he probably offered it for other reasons—say, mathematical simplicity and similarity to the law of reflection.[131] In fact, although Grosseteste says that the angle of refraction's size "is evident from an experiment similar to those" that demonstrate the equality of incidence and reflection angles, he offers no details.[132] Instead, he appeals to a "principle of natural philosophy, namely that every operation of nature takes place in a manner as limited, well-ordered, brief, and good as possible."[133]

This principle of economy that Grosseteste invokes has enjoyed a long and respectable career in Western philosophy and science. Writers ranging from Aristotle[134] to William of Ockham (1285–c. 1349)[135] to Pierre de Fermat (1601–65)[136] have employed similar principles of economy to good effect. Grosseteste's law of refraction is economical in the ad hoc sense that he justifies it by analogy to the law of reflection's economy of pathlength.[137] However, his model of refraction fails as a physical law because it does not adequately describe observed facts. Although Grosseteste's law of refraction was only qualitatively correct,[138] its quantitative form signaled a clear departure from ancient thought that would bear fruit later. At base then, Grosseteste's novel theory of the rainbow comes from an innovative thought experiment on, rather than an empirical analysis of, refraction.[139]

Grosseteste's ideas on refraction in *De iride* are a preamble to his theory of the rainbow, which he describes as "subordinate to" refraction.[140] In other words, Grosseteste believes that refraction completely explains the rainbow. After effectively (but not explicitly) deflating Aristotle's reflection rainbow,[141] Grosseteste launches into his own equally obscure theory.[142] In essence, he proposes that the rainbow is caused by a spherical cloud of mist behind the observer that re-

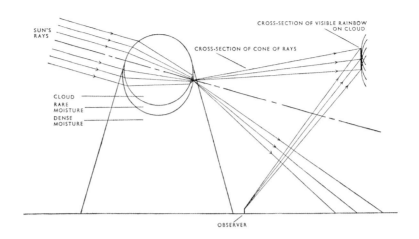

FIG. 5-5

Robert Grosseteste's rainbow model: refraction of sunlight by a spherical cloud. (From "Robert Grosseteste's Theory of the Rainbow: A Chapter in the History of Nonexperimental Science," by Bruce S. Eastwood, *Archives Internationales d'Histoire des Sciences*, vol. 19)

fracts the sun's image onto a second cloud before him. We assume that this cloud in turn reflects the rainbow to the observer (see Fig. 5-5).[143] Despite his incisive criticisms of Aristotle, Grosseteste's refracting cloud is scarcely more plausible than Aristotle's cloud-mirror.

Having raised the indispensable standard of refraction, Grosseteste is determined to carry it forward at all costs. He elaborates on the presumed structure of his refracting cloud, each part of which has a different density:

> Therefore I say that the exterior of a cloud is convex and its interior is concave, which is evident from its nature of lightness and heaviness.... When moisture descends from the concavity of the cloud, it is necessary that the [cone] of moisture thus formed be convex at its top and descend to the earth, thereby being more condensed in the propinquity of the earth than in the upper part. Therefore there will be in the whole four transparencies[144] through which a ray of the sun penetrates, i.e., the pure air containing the cloud, second the cloud itself, third the higher and rarer moisture coming from the cloud, and fourth the lower and denser part of the same moisture.[145]

Grosseteste claims that the net result of the refractions between the various cloud elements is a locus of rays shaped "like the surface of a cone expanded away from the sun" that has "the shape of an arc" and is projected on the cloud opposite the observer.[146] Like the real rainbow, this refraction rainbow would rise as the sun sets (and vice versa). If we believe Grosseteste's optics, the refracting cloud generates a ring of rainbow light with none of the deficiencies of the reflection rainbow. As novel as Grosseteste's invention is, however, it preserves several ancient errors.

First, Grosseteste never traces the paths of the refracted rays, even though he has postulated a law for doing so. If we attempt to construct a diagram such as Fig. 5-5, we inevitably confront both Grosseteste's purely qualitative rainbow geometry and the impossibility of making this diagram work according to his law of refraction.[147] In other words, Grosseteste's blanket claim that each refraction angle is half its corresponding incidence angle (or twice the incidence angle,

if we pass from a denser to a rarer medium) is not observed in Fig. 5-5, nor can it be if we are to produce his rainbow arc. In this sense, then, Grosseteste's rainbow differs little from Aristotle's because it merely "saves the phenomena" by interweaving casual observation and a rather arbitrary geometric construction.[148]

Second, Grosseteste is clearly indebted to Aristotle for parts of his theory of rainbow color. Like Aristotle, he relates light's color to its brightness, noting: "where there is a greater projection of rays, the colour appears clearer and more luminous [that is, redder]; where there is a lesser projection of rays the colour is more violet and obscure."[149] Grosseteste at least accounts for variations in rainbow brightness more systematically (although no more realistically) than Aristotle: "The difference between the colours of one rainbow and those of another[150] derives firstly from the purity or impurity of the recipient transparency and then from the clarity and obscurity of the impressing light."[151] By combining two properties of light (multitude or paucity of rays and clarity or obscurity) with a property of the transparent cloud (purity or impurity), Grosseteste arrives at *six* rainbow colors[152]—an un-Aristotelian number whose origins clearly depend on Aristotle.[153] Although Grosseteste ascribes the rainbow's colors to refraction, he is not referring to prismatic color separation. Instead he simply supposes that refraction, like reflection, causes colors by darkening white light.[154] Grosseteste's assumption here is entirely plausible, because some mirrors of his day (and back into antiquity) would have been less reflective than modern ones.[155]

Finally, after assigning refraction a central role in the rainbow, Grosseteste ultimately depends on the second cloud (the one opposite the observer) as a screen on which the rainbow is projected.[156] We naturally assume that this cloud screen *reflects* Grosseteste's refracted rainbow toward us, yet he does not say so explicitly in *De iride*.[157] John Pecham (c. 1230–92; Archbishop of Canterbury 1279–92), writing at Oxford a generation after Grosseteste, may offer some insight into his predecessor's views. Pecham holds that the rainbow colors seen on the second cloud are not reflected from it, but instead *become* a material bow in the cloud.[158] Of course, Grosseteste himself had earlier muddied the waters by claiming that the rainbow was due to either reflection *or* refraction by a cloud.[159]

We now see that Grosseteste's explanation of the rainbow is problematic. Why invent an implausible spherical cloud when rainbows are known to occur in the presence of spherical raindrops? (Although Grosseteste's rationale is unclear on this point, we do know that he had read about the refractive properties of water-filled glass globes like those described by Seneca.)[160] Furthermore, why construct a theory that requires a fortuitously located second cloud whose optical role is never clearly stated? How can Grosseteste be confident that irregularly shaped clouds will behave like carefully ground lenses and mirrors? Why does only the edge of his projected cone of light produce colors on the second cloud—that is, how can he claim that the refracted light is concentrated into a rainbow arc?[161] (Actually, there *is* more light inside the primary rainbow than outside,[162] so Grosseteste's cone of bright light is defensible.) Finally, if the

rainbow is a projection at a fixed site on a specific cloud, why does the bow follow a moving observer?

In fact, Grosseteste has answers for none of these questions, nor would he likely find them germane. He has instead built a macroscopic theory based on a single large refracting globe, the spherical cloud. With this construction, he legitimately introduces refraction into the rainbow problem, a change that his critique of Aristotle's reflection theory shows is long overdue. However, he then proceeds with Aristotelian geometrizing rather than building a microscopic theory based on raindrop refraction. As Eastwood notes, Grosseteste's method seems to be that of building up "a composite account from the elementary [optical] discussions at hand," and then assuming that this composition "was a reasonable process, because nature acts economically and simply."[163] As Grosseteste's inadequate law of refraction indicates, a physical theory's economy is not the only measure of its validity. Yet for Grosseteste, an unrealistic devotion to economy seems just as important as his careful observation of rainbows and his rational analysis of Aristotle's rainbow optics. He would not be the last rainbow theorist with such conflicting allegiances.

Between Grosseteste and Theodoric: The Rainbow in Thirteenth-Century Science

As significant as Grosseteste's brief rainbow treatise is in our story,[164] we need to remember the very minor place that it occupied in his life. Like other writers on the rainbow, Grosseteste expended much effort grappling with this intractable problem, but he did not make a career of it. Indeed, in one recent study of his life and works, *De iride* merits only a single line.[165] In the broader view, Grosseteste was at the center of thirteenth-century English intellectual and ecclesiastical life as a translator, theologian, and university scholar and administrator.[166] As a theologian, his name would be as honored as his doctrinal views were ignored;[167] as a scientist, his writings fared far better. At Oxford, Franciscan writers on science showed his influence into the fourteenth century.[168] In England and Europe, numerous writers would borrow from and react to *De iride*, and copies of the manuscript found their way into at least six European libraries.[169]

One of the first reactions to *De iride* came from Albertus Magnus (or Albert the Great; c. 1200–1280), a Dominican theologian and philosopher who advocated an Aristotelian Scholasticism while at the University of Paris.[170] A voluminous writer, Albertus succeeded where others had failed: he completed elaborate commentaries on all of Aristotle's known works. Yet like Grosseteste, Albertus was far from a passive conduit for Aristotle's ideas. He had a Neoplatonist's interest in using mathematics to explain the natural world, and he assiduously gathered knowledge of that world from his own and others' eyes.[171] In his discussion of whales, for example, he does not range beyond his own observations and remarks that "We pass over what the Ancients have written on this topic because their statements do not agree with experience."[172] However, Albertus could descend into uncritical storytelling.[173] He tells of witnessing a showdown between a toad and an emerald in which the weaker object was supposed to self-destruct. After the toad had stared at the emerald for a while, Albertus credulously reports that

the gem "began to crack like a nut and a portion of it flew from the ring."[174]

Although Albertus is one of the thirteenth century's best-known scientific writers,[175] his ideas are far from obvious to present-day readers. For example, historian Alistair Crombie says that Albertus believed bright light heated objects because "light was the proper form of the heavenly bodies which universally caused change in the matter of the world."[176] Albertus's views on the rainbow similarly combine new insights and old Aristotelian formulas. Where Grosseteste had briefly presented a novel theory, Albertus offered an encyclopedic survey of the rainbow. The halo and rainbow alone consume some thirty-five printed pages in Albertus's voluminous *De meteoris*.[177]

Albertus begins with a recounting of rainbow myth, followed by a critique of classical rainbow theories. In Albertus's day, Aristotle was often mistranslated as claiming that lunar rainbows could occur no more than twice every fifty years.[178] Albertus summarily rejects this, saying that "truthful experimenters have found by experience" that nighttime lunar rainbows were visible twice in one year.[179] Albertus compares Seneca's rather equivocal statements about individual raindrops causing the rainbow with Poseidonius's (c. 135–c. 51 B.C.) theory of a continuous, concave cloud-mirror.[180] Albertus rejects the cloud-mirror on several counts, although he omits Grosseteste's objection that this model unnaturally requires the rainbow to rise and set with the sun.[181] To be sure, Albertus's account has some difficulties. He lays out a combined reflection and refraction theory that is essentially Grosseteste's rainbow, although he never mentions his predecessor's name.[182] Some confusion exists in Albertus's Latin (and perhaps his thinking) on the distinction between reflection and refraction.[183] In a revealing passage that is reminiscent of Grosseteste's model, Albertus says that sunlight is refracted at the edges of a cone of rain or vapor[184] that descends from a cloud. Moisture beyond the cone then reflects this concentrated light to the eye: "this reflection of rays is in part similar to the reflection of rays coming through a window into a vessel of water and refracted on to the opposite wall."[185]

Clearly Albertus is describing the refraction of sunlight into and then out of a model raindrop, followed by the reflection of that light on a nearby wall.[186] The resulting spectrum is impressive indeed, so much so that both Grosseteste and Albertus apparently were convinced that it must form the rainbow colors. In other words, they believed that rainbow colors are created by refraction and then projected onto a screen of cloud, mist, or vapor. In fact, the primary rainbow is not generated this way; light is instead refracted directly from the raindrop toward the observer (see Fig. 6-5). Albertus thus makes the plausible assumption that reflection from "vapor" outside the raindrop, not a reflection and subsequent refraction within it, directs rainbow light back toward the observer. He reaches this conclusion by misinterpreting a demonstration whose implications seem self-evident to him. However, Albertus has much company: from the cloud-mirror to supposedly illusory colors, the rainbow had repeatedly frustrated casual, "commonsense" explanations.

Much of Albertus's rainbow discussion in *De meteoris* simply rehashes, with little insight, the less tenable parts of Aristotle's and Grosseteste's theories.[187] Albertus's salient contribution

to medieval rainbow theory is his insistence that individual raindrops, not a concave cloud, cause the rainbow. Equally important, he states that an *ensemble* of raindrops redirects sunlight to form the rainbow.[188] This is Albertus's incremental contribution to our story: as a prestigious scientific writer, his endorsement of the raindrop theory of the rainbow made it as credible as the prevailing Aristotelian explanation. Discrete raindrops now had the imprimatur of Dominican science, making it increasingly difficult to accept Aristotle's theory as definitive.

The slow, serpentine progress of medieval rainbow theory is evident in the *Opus majus* of Roger Bacon (c. 1219–92), a work written several years after Albertus's *De meteoris*.[189] Bacon is a complex figure in medieval science: lavishly praised as a herald of seventeenth-century mathematical science, in fact he preached its virtues more than he practiced them.[190] In this Bacon shares some common ground with Grosseteste.[191] In Part 6 of *Opus majus* (Great Work), Bacon differs sharply with Grosseteste's rainbow theory, yet elsewhere in the same treatise Bacon openly admires his methodology:

> For very illustrious men have been found, like Bishop Robert [Grosseteste] of Lincoln . . . and many others, who by the power of mathematics have learned to explain the causes of all things, and expound adequately things human and divine. Moreover, the sure proof of this matter is found in the writings of those men, as, for example, on impressions such as the rainbow, comets . . . and other matters, of which both theology and philosophy make use. Wherefore it is clear that mathematics is absolutely necessary and useful to other sciences.[192]

Bacon takes the Aristotelian position that sense information is a first step toward scientific knowledge, but that the rigor of mathematics must provide the final step.[193] In fact, Bacon's lengthy paean to mathematics in *Opus majus*[194] is probably as mercenary as it is metaphysical. Correspondence between Bacon and Cardinal Guy de Foulques (later Pope Clement IV; reigned 1265–68) led to de Foulques's mistaken belief that Bacon had completed an exhaustive encyclopedia of the sciences, a work that would both aid and glorify Christianity.[195] Franciscan sanctions against writing for or to the papal court silenced Bacon until de Foulques became Pope. Bacon, who initially had merely sought a patron for his vast project, then feverishly completed *Opus majus* and several other works in a secret attempt to satisfy Clement.[196]

Although many earlier writers had made appeals to mathematics, Bacon's taste for applying it to experimental evidence was unusual. However, Bacon usually wrote *about* experimentation rather than describing actual experiments, basing his conclusions instead on inductive reasoning and careful observation.[197] Bacon almost certainly did perform some experiments in the modern sense, for he describes expenditures of £2,000 that include books and instruments.[198] Yet he was very much a man of his times—he saw in science a cure for the church's ignorance and ills,[199] and he embraced Grosseteste's metaphysics of light,[200] alchemy, astrology, and stories of mythical beasts.[201] Ever intemperate in his attacks, Bacon railed against Albertus Magnus, Thomas Aquinas, and uncritical Scholasticism alike.[202]

Much as Descartes would four centuries later, Bacon offers his rainbow theory as an exemplar of a new approach to science. He opens Part 6 (On Experimental Science) of *Opus majus* with a grand statement: "Having laid down fundamental principles of the wisdom of the Latins so far as they are found in language, mathematics, and optics, I now wish to unfold the principles of experimental science, since without experience nothing can be sufficiently known."[203] After discursing for several pages on the virtues of experimental science (in which he invokes Aristotle, Pliny, Augustine, and the prophet Isaiah, among others), he finally and simply states: "I give as an example the rainbow and phenomena connected with it."[204]

Bacon chides Aristotle, Avicenna, and Seneca for having failed to adequately analyze the rainbow and other atmospheric lights. In a manner similar to Albertus, Bacon urges readers to shine a beam of sunlight through a hexagonal prism and to examine "all the colors of the rainbow, arranged as in it, in the shadow near the ray."[205] He believes it is noteworthy that prisms (or "crystals") of other shapes can also produce a spectrum, as will a "glass vessel filled with water and placed in the sun's rays."[206] Aristotle's observation about rainbow colors seen in the spray from oars resurfaces,[207] as does Avicenna's remark about the colors visible in millwheel sprays.[208] In short, Bacon begins by adding several items to the Aristotelian inventory of real and imagined rainbow phenomena.[209]

Yet Bacon does not simply retread old ground. True to his essay's grandiloquent introduction, he departs from the past in one important detail: he measures the rainbow's angular size. Bacon states that the rainbow's summit can appear no higher than 42° above the horizon, and then only at sunrise or sunset (assuming level ground).[210] Conversely, if the sun's elevation is greater than 42°, the rainbow cannot be seen by an observer on level ground. In modern terms, Bacon is saying that the rainbow's angular *radius* is 42°. While writers from Aristotle onward had offered elaborate geometric descriptions of the rainbow, none seems to have quantified its angular size, whether due to a lack of apparatus or a lack of interest.[211] Bacon himself specifies only that "the experimenter take the required instrument," probably an astrolabe, to make these measurements.[212]

To be interested in the rainbow's angular, rather than linear, size is clearly a step forward. If we equate the rainbow's size with that of a distant cloud's surface (as the Aristotelian model does), inevitably we ignore the volume of rainy air that actually modifies sunlight to form the rainbow. In turn, ignoring raindrops makes the dead end of Aristotle's meteorological sphere seem plausible. Bacon does not use clouds per se in explaining the rainbow, instead referring to "an infinite number of falling drops."[213] He also observes that the rainbow, sun, and eye are always collinear, which means that the bow sets and rises inversely with the sun. Yet Bacon repeats the Aristotelian belief that the rainbow's radius increases as the bow sets.[214] While he succumbs to the power of this size illusion, he perceptively notes that more than a semicircle will be visible in rainbows seen "on a high mountain or on a lofty tower." He also understands that, in principle, the rainbow's top can be seen just after sunset (or just before sunrise), when parallel

sunlight illuminates the rainy air above the observer but not the observer himself.[215] Furthermore, Bacon makes the correct and remarkably forthright statements that "there are as many bows as there are observers" and that "it is impossible for two observers to see one and the same bow."[216] Bacon denounces the garbled translations of Aristotle's remarks on the lunar rainbow and correctly notes: "whenever the moon is full and is not veiled by cloud, and there is moist substance opposite it, the bow can appear."[217]

With these insights, Bacon seems poised to offer a correct geometrical optics explanation of the rainbow. However, both his theoretical and observational vision now grow cloudy. He emphatically rejects Grosseteste's refraction theory in favor of his own reflection theory, which he supports with illogic and selective observation. Bacon begins by noting that the bow always follows the observer, no matter how fast or far he moves. Like the sun, the rainbow appears to move through the landscape with the observer. From this safe (and perfectly accurate) start, Bacon edges onto thinner ice. He correctly attributes the sun's apparent motion to "its excessive distance," and notes that "in this way the bow may seem to move in a direction parallel to the beholder."[218] Yet he wrongly concludes from this that "the bow is seen only by reflected rays of the sun, because if it were seen by incident rays, the bow would be an object fixed in one place in the cloud," just as clouds themselves appear fixed.[219] Here Bacon ignores the fact that light coming from clouds is reflected light. Thus we are led to the strange conclusions that (1) incident light (such as directly observed sunlight) cannot appear to move like the sun and (2) reflected light must move like the sun, a fiction that the apparent immobility of clouds and distant landscape features contradicts.

In fact, Bacon's problems here may stem from his eagerness to denounce the obvious flaws of Grosseteste's refraction rainbow. Bacon subtly broadens his sources of cloud light to include "incident *or* refracted rays" and then makes a remarkable comparison: "Similarly when a color is produced by *incident* rays through a crystalline stone [that is, a prism], *refraction* takes place in it, but the same color in the same position [on a wall] is seen by different observers"[220] (emphasis added). Thus he links incident and refracted light to images that, unlike the rainbow, do not move with the observer. Ultimately Bacon arrives at an incorrect conclusion: "It is evident, therefore, that the bow is not caused by rays falling directly or by refracted rays."[221] Lost here is the simple fact that refraction by a single prism (Bacon's example) does not describe refraction by a shower's myriad raindrops any more than reflection by a single mirror describes the combined reflections of those drops. In particular, the rainbow's apparent lateral motion depends on there being an uninterrupted supply of raindrops as you travel. Bacon's optical reasoning is flawed, and so is his theory.

Although Bacon uses Grosseteste's language of species and extramission ("the reflected visual ray")[222] in discussing the rainbow, he has no use for Grosseteste's rainbow optics.[223] In a swipe clearly aimed at his predecessor, Bacon dismissively says "those are in error who say that the bow is caused by refraction," and he then raises several well-founded objections to Grosseteste's

ideas.[224] While Bacon evokes the image of Grosseteste's descending cone of moisture,[225] he fills it not with a refracting mist but with reflecting "raindrops of small size in an infinite number." From these spherical drops "reflection takes place in every direction as from a spherical mirror, and since they descend without an interval they seem from a distance to be continuous,"[226] thus producing a continuous, distorted image of the sun—that is, the rainbow.

Having successfully attacked Grosseteste's refraction theory, Bacon must now defend his own reflection theory.[227] This proves more difficult, as Bacon's often ad hoc arguments indicate. If raindrops reflect light in every direction (which is true), then the problem he posed for Grosseteste now haunts him: How do raindrops produce an arc of bright light rather than a disk of light? Bacon's answer sounds definitive, but it is not. To restrict the directions from which rainbow light comes, he asserts that "drops are not present everywhere from which rays are reflected to the eyes at angles equal to the angles of incidence."[228] What does he mean by this statement?

Bacon implies, but never explicitly says, that each rainbow ray is reflected from a raindrop's concave rear surface (an internal reflection) rather than from its convex front surface (an external reflection). In fact, neither internal nor external reflections can by themselves produce a rainbow. Consider external reflections first. We see bright, mirror-like reflections from a raindrop's exterior only when our viewing angle of the drop equals the sunlight's incidence angle on it (see Fig. 5-3). For a spherical raindrop, parallel sunlight encounters the drop at incidence angles ranging from 0° to 90°, resulting in angles of reflection toward us that also range between 0° and 90°. In Fig. 5-3, we drew the incidence angle i at 45°, which yields a reflection angle r of 45°, thus deflecting part of the light ray by 90° from its original direction. If a light ray just grazed Fig. 5-3's raindrop ($i = 90°$), then the corresponding r of 90° would cause the light to continue straight ahead—that is, the ray would not be turned at all. In fact, Bacon's correct statement about the equality of i and r imposes no restrictions on the angles through which a convex spherical mirror reflects rays. In other words, spherical raindrops will externally reflect sunlight to us from *all* parts of the sky, although these reflections will be brightest near the sun.[229]

What about Bacon's implication that internal reflections from a raindrop's concave rear surface cause the rainbow? For sake of argument, pretend that we can somehow eliminate all the sunlight that a raindrop refracts and externally reflects. In our thought experiment, each raindrop would become a miniature version of Alhazen's reflecting hemispheric cloud. From the antisolar point to angles far outside the rainbow's 42° radius, we would see these sunlit raindrops as bright spots of reflected light. Collectively, these internal reflections would produce a nearly uniform field of light. Thus internal and external reflections from raindrops are equally incapable of concentrating sunlight into a rainbow. Why is Bacon convinced that they can do so? Perhaps like Grosseteste championing refraction, Bacon is so determined to make reflection answer the rainbow problem that he turns a blind eye to inconsistencies in his theory. Historian David Lindberg notes, "When it came to saving his theory, Bacon had no qualms about introducing into his professed microscopic treatment of the cloud, properties characteristic only of

concave mirrors considered on a macroscopic scale."[230] Whether knowingly or not, Bacon confuses reflection by a single large concave mirror with that by an array of small concave (or even convex) mirrors. The former *can* produce a single bright arc some distance from the antisolar point, although the arc's location depends on the observer's distance from the mirror and its size (see Fig. 5-4). By contrast, neither internal nor external reflections from spherical raindrop "mirrors" will yield anything like a rainbow.

Other weaknesses appear in Bacon's rainbow theory. Although admitting that "quite lively colors appear in the bow," Bacon retorts that this liveliness is no more real than the colors themselves, which have "no other cause than defect in vision."[231] Here he takes the Aristotelian position that the rainbow's colors are apparent rather than real and are caused by weakening of sight. Among Bacon's supporting evidence is the old Aristotelian chestnut about illusory "rainbow" colors seen through bleary eyes. But Bacon says that colors produced by a prism are real because "there is color before it is seen [projected] here, and it is seen by different people in the same place."[232] Thus the reality of the rainbow's colors is suspect because they keep pace with the observer. More Aristotelian notions about color follow. Small spherical mirrors, Bacon says, "change the size and shape of the object of vision in many ways, and render shapes monstrous, and destroy all relationship of the parts of an object to one another," remarkable transformations that let these raindrop mirrors "change the color and cause a color to appear from that which is without color, and conversely."[233] Bacon parts company with Aristotle on the number of rainbow colors, claiming that there are five (white, blue, red, green, and black).[234] He justifies this number on metaphysical grounds, which in turn leads him to a similar analysis of the eye's construction.[235]

Like Bacon, it is all too easy for us to point out our predecessors' failures. As flawed as parts of Bacon's rainbow theory are, he was correct to object to Grosseteste's uncritical reliance on refraction. In his zeal to reintroduce reflection into the problem (a necessary step),[236] Bacon ignored both observations and theory to arrive at the answer he "knew" awaited him. That such problems are not restricted to the thirteenth century is clear from some compelling present-day examples of lost scientific objectivity.[237] Whatever Bacon's stumbles, he was an astute observer who advanced the idea that objective measurements of the rainbow would ultimately reveal its secrets. Certainly his analysis of the rainbow abandons the mysticism of Bartholomaeus Anglicus, whose writings precede Bacon's by little more than a generation. At the close of his analysis of the rainbow, Bacon humbly admits: "I do not think that in this matter I have grasped the whole truth, because I have not yet made all the experiments that are necessary."[238] It is from such attitudes that more truths about the rainbow would emerge.

Our final figure in the thirteenth-century flurry of rainbow research is the Silesian scholar Witelo (1230/35–before 1292).[239] Educated at Paris and Padua (c. 1253–68), Witelo wrote several manuscripts that have survived, the most famous of which is his *Perspectiva* (or *Optica*) of c. 1270–74.[240] Written as an optics textbook during Witelo's sojourn at the papal see in Viterbo,

Perspectiva owed so substantial a debt to Alhazen's *Optics* that Witelo was sometimes uncharitably called "Alhazen's ape."[241] Witelo's other sources almost certainly include Grosseteste and Bacon, whose ideas, if not names, he uses often.[242] Although he embraced Grosseteste's metaphysical view of light, Witelo does not use the word "species," and nowhere does he adopt the extramission theory of sight.[243] Nevertheless, Witelo does not deny the *idea* of species, merely the term. For him, "In all these modes of vision [direct, reflected, and refracted rays] the natural forms go to the eye and visual rays do not go out to seize the forms of things."[244] Thus Witelo's "form" had the same power as Grosseteste's (and Bacon's) "species."

Witelo insisted on pairing careful observation and mathematics, as had Bacon, and he excelled at designing and testing optical devices.[245] Even though Witelo's deeds did not always live up to his words, a new and uncompromising spirit is evident in his statement that, to thoroughly analyze refraction, one "depends on experiments with instruments rather than on other kinds of demonstration."[246] Such an attitude makes Bacon's qualitative prism demonstrations look modest indeed. Witelo's measurement of refraction between two media meticulously follows Alhazen's example, even though his results are inadequate by modern standards. In particular, Witelo invents some angles of refraction from water to air (probably by mathematical extrapolation) for cases where refraction is physically impossible![247] Despite such missteps, the *Perspectiva* so far surpassed the usefulness of the qualitative, often metaphysical, optical treatises preceding it that it remained a valued work into the seventeenth century.[248]

As we have come to expect from medieval scientists, Witelo's contributions to rainbow theory in *Perspectiva* combine novelty and Aristotelian dogma. *Perspectiva* was prompted, so Witelo says, by his observing a waterfall rainbow near Viterbo.[249] Where earlier thirteenth-century authors had rallied behind refraction *or* reflection, Witelo sees both mechanisms at work. Yet this advance in principle is hardly one in practice, for Witelo describes a remarkably convoluted interplay of light that is reflected externally and refracted internally by different raindrops.[250] Witelo repeats Bacon's error that reflection must be involved because the rainbow rays' angles of reflection and incidence are equal.[251] Bacon suggests in *Opus majus* that the sun's "excessive distance" makes the rainbow inescapable. Witelo misses this nuance and instead claims that the rainbow's apparent motion arises because it is a refracted, rather than a reflected, image. (Recall that Bacon reached the opposite conclusion from the same evidence.)[252] For the wrong reasons, then, Witelo rightly concludes: "Therefore the rainbow is seen not only by reflection but by the refraction of light within the body from which it is reflected."[253] (The "body" that Witelo refers to includes two different raindrops.)

Like Bacon before him, Witelo relies on Aristotelian truisms when he discusses the rainbow's colors. He believes that three "primary" colors occur in the rainbow and that others are composites of these.[254] Furthermore, he imagines that a stage exists between cloud and rain in which drops in "dewy air"[255] act as mirrors that present the sun's color but not its form. Witelo notes that prismatic colors refracted by a water-filled globe "are not truly like the colors of the rain-

bow, for the former are seen directly while the latter are seen by reflection."[256] Instead he proposes that the "univocal and convertible" cause of rainbow colors is varying mixtures of water's darkness and sunlight's brightness (that is, the Aristotelian explanation).[257] Given this conviction, Witelo naturally makes red the brightest rainbow color, and he offers a game, although ad hoc, geometrical explanation of the presumably darker colors inside the bow. Noting that different colors are refracted by different amounts, Witelo writes of "a certain dispersion of rays,"[258] though he does not mean "dispersion" in the modern sense of prismatic separation of white light into its component colors. Like Grosseteste, he holds that a ray's brightness is reduced the more it is refracted (that is, the more it is deviated from its original direction). Because red is refracted less than other colors, he believes that it is least mixed with darkness and thus is the brightest rainbow color. Witelo follows Aristotle by also allowing reflection to weaken rays and thus produce colors. Witelo's color theory weaves a very tangled web indeed.

However obscure he is on the rainbow's colors, Witelo's understanding of its macroscopic geometry is almost as clear as Bacon's. Both men recognize that the surface of a 42° cone defines the drops sending rainbow light to the observer (see Fig. 4-4).[259] Furthermore, by definition this cone moves when the observer moves. But still the devil is in the details: *How* is rainbow light concentrated at 42° from the observer's shadow? For this, neither Witelo nor Bacon has a satisfactory answer, although both believe that they do. Witelo's complicated explanation has some raindrops acting like spherical lenses that refract and concentrate light onto other drops. These drops in turn reflect rainbow light to the observer.[260] Interestingly, Witelo quibbles with Bacon on whether the rainbow's radius is constant: "certain people [observe] that the altitude of the rainbow and the altitude of the sun together always make 42°, which is shown by the present theorem to be impossible."[261] Witelo is right in a minor way, but the size of drops in a shower has far greater influence on the bow's radius, a fact that neither he nor Bacon could have known.[262] While Witelo was far ahead of Bacon and Grosseteste in his combining of refraction and reflection, he failed to make the crucial (and hardly self-evident) connection that the two processes occur *within* each raindrop contributing to the rainbow.

Theodoric of Freiberg's Rainbow in a Raindrop

That connection came with a new century and a new theory of the rainbow. In the first decade of the fourteenth century, a Dominican scholar and administrator named Theodoric of Freiberg (c. 1250–c. 1310) wrote a lengthy and highly original treatise on the rainbow.[263] By pairing refraction and reflection within a drop, Theodoric could explain plausibly (although not quite correctly) the colors and positions of the primary and secondary rainbows. We can still use some features of his theory today. We do not know when Theodoric found time to achieve his breakthrough, for his professional life sounds harried indeed. In 1293, he was named provincial of Germany and held that post for three years, and he is referred to as "Prior of Würzburg" a

decade later (1303).[264] So Theodoric likely was burdened with administrative duties during the last decade of the thirteenth century.[265] Yet he writes that in 1304 the Master of the Dominicans, Aymeric, asked him to record the results of his rainbow research, thus implying that Theodoric had already completed much of the work.[266] The result of Aymeric's request is Theodoric's *De iride et radialibus impressionibus* (On the Rainbow and Radiant Impressions, c. 1304–10), one of his nearly thirty surviving works.[267] Like many medieval authors, Theodoric wrote on a wide range of subjects: theology, metaphysics, logic, and the sciences. If we can judge by *De iride*'s originality, Theodoric was unlikely to be a slavish imitator whatever subject he chose.

Theodoric benefited from the rush (by medieval standards) of thirteenth-century rainbow research. As a German Dominican, he not surprisingly cites Albertus Magnus on the rainbow,[268] and he seems thoroughly steeped in Scholastic methodology for studying nature.[269] Part of that methodology includes posing and answering specific questions about natural phenomena. Logic was the Scholastic's tool for addressing such questions, and Theodoric often employs the logician's conventions of definition, classification, and demonstration.[270] In four of his works on metaphysics and logic, Theodoric painstakingly elaborates the methodology that he would later put to use in *De iride*, where Theodoric emphasizes that he is engaged in an exercise in logic. Citing Aristotle's distinction between optics and physics in *Posterior Analytics*, Theodoric says that "in the science of the rainbow it is the function of physics to determine what the rainbow is and of optics to determine the reason," which he takes to mean "that [logical] definition is two-fold."[271] Theodoric's variation on Aristotle's conclusion is that "it is the function of optics to determine what the rainbow is, because in so doing it shows the reason for [the rainbow]," and thus "the science of optics subordinates to itself the science of the rainbow and of the other impressions produced by rays in the sky."[272] Given this fairly strict Aristotelian reading, we might expect Theodoric to produce only a tepid gloss on Aristotle's rainbow theory. Instead, he demonstrates the lengths to which a keen and unconventional mind can extend Aristotle's ideas within the Scholastic tradition.

First, Theodoric is far from opposed to observation and experiment. After noting that Aristotle should be given due respect, Theodoric insists: "But it is to be understood, according to the same Philosopher, that one never should depart from that which is evident from the senses."[273] In his introduction to *De iride*, Theodoric states that because the best science provides certain knowledge or examines noble subjects, knowledge of the beautiful rainbow is assured "by the combination of various infallible experiments with the efficacy of reasoning."[274] Beyond geometry and experiment, Theodoric relies on the principles of economy (as had Grosseteste) and falsification (as Bacon had used against Grosseteste's rainbow theory).[275] Like Bacon, Theodoric implicitly attacks Grosseteste's theory by showing that it leads to features not seen in nature. In fact, Theodoric probably was familiar with all major thirteenth-century writers on the rainbow.[276]

However, the power of Theodoric's methodical, schematic approach in *De iride* becomes evident when he classifies the sky's "radiant impressions" by microscopic optical *process* rather

than by their macroscopic *appearance*. Theodoric categorizes optical phenomena as those arising from (1) one reflection, (2) one refraction, (3) two refractions with an intermediate reflection inside a water drop or crystal sphere, (4) the same, only now with two internal reflections, and (5) total reflection at the border between two media.[277] This technique is quite modern, even if Theodoric's outlook as a whole is not. Theodoric's grounding in Dominican attitudes is evident when he invokes the Book of Job's Chapter 38 while asking the question "By what way is the light scattered and heat distributed upon the earth?"[278] Like his predecessors, Theodoric uses the Neoplatonic idea of multiplication of species (or forms),[279] as well as the Aristotelian distinction between material and efficient causes.[280]

Theodoric's methodical analysis of refractive color in *De iride* draws on his two earlier works on light and color.[281] He believes that there are four "simple" (or primary) colors between the extremes of black and white, and he rejects the supposed Trinitarian basis for three rainbow colors by briskly noting that man does not have three eyes or teeth.[282] Theodoric's four colors are red, yellow, green, and blue, all of which are evident in rainbows, dew drops, mill-wheel sprays, and prisms. These colors always follow one another, he says, "in the same inviolable order."[283] He challenges the Aristotelian claim that the rainbow's yellow is illusory by describing the yellow generated when water drops are sprinkled into sunlit air.[284] Why does Theodoric so firmly defend four colors? Ironically, his rejection of Aristotle's tricolor rainbow stems from his own Aristotelian theory of color contraries.

Theodoric proposes that two pairs of qualities determine color—light's brightness or darkness[285] and the transparent medium's boundedness or unboundedness.[286] The curious notion of boundedness comes from Theodoric's observations of prisms. In them, he noticed that the supposedly brighter red ray was deviated least from its glass-air boundary (that is, the glass surface on the side opposite the incident ray).[287] Blue, supposedly the darkest color, was bent farthest from the surface normal and toward the prism's opposite boundary. Thus blue and red are the bounded colors, and green and yellow are the unbounded. Following tradition, Theodoric makes red and yellow the brighter colors, with green and blue being the darker ones. By combining these qualities of brightness and boundedness, Theodoric hopes to derive a consistent theory of color. Predictably, his ad hoc principles could not be forced to fit observations of prismatic refraction, so Theodoric resorts to an equally ad hoc reworking to make them fit.[288]

As unpromising as Theodoric's color theory sounds, at least it was constrained by his careful observation of refraction in prisms and water-filled glass spheres. Moreover, Theodoric went a step beyond the by-now conventional descriptions of light beams' paths within these model raindrops.[289] Rather than studying only the light *refracted* at a sphere's rear surface (as Albertus Magnus and Roger Bacon had), Theodoric followed the light *reflected* by that surface: "Let the radiation enter the oft-mentioned transparent body and pass through it to the opposite [that is, rear] surface and from that be reflected internally back to the first surface by which it originally entered, and then after passing out let it go to the eye; such radiation, I say, in as much as it is

produced by a transparent spherical body, serves to explain the production of the rainbow."[290]

Theodoric is right. Simply by extending the paths of beams within the raindrop, he has solved most problems that dogged earlier authors. First, the combination of reflection and refraction within a given drop bends sunlight through almost 180°, thus placing the rainbow colors opposite the sun. In fact, Theodoric would recognize his model's essential features in our Fig. 4-3: sunlight is refracted into a drop, some of this is reflected from the drop's rear surface, and a fraction of that light is refracted out of the drop toward the observer. Second, Theodoric seems poised to free himself from the Aristotelian concave cloud. Gone is the need for a problematic reflecting (or refracting) cloud—each raindrop is a self-contained prism *and* mirror. Like Bacon and Witelo before him, Theodoric recognizes that all sunlit drops at the proper angle from the sun will send rainbow light to us, although he erroneously believes that the drops' linear distance from us is crucially important.[291] Unlike his predecessors, Theodoric correctly fits together the pieces of the raindrop refraction-reflection puzzle.

However, we should not overlook some odd trappings of Theodoric's theory. In at least two instances, he makes corresponding angles of incidence and reflection unequal.[292] Also implicit in his theory is that rainbow colors are determined by the angle between a raindrop's incident and emergent rays, with red caused by the largest angle and blue the smallest. Thus light entering nearest the raindrop's center yields the rainbow's blue, while light entering nearest its edge yields red.[293] Theodoric is correct that light causing the rainbow's red enters the drop more obliquely than does that causing its blue (see Fig. 6-6). However, his reasoning is backwards here—the angle separating incident and emergent rays merely describes the rainbow's color order, but does not explain it optically. In fairness, Theodoric may have wandered into this difficulty for good reason. He believes that the ancient tradition of treating light as one-dimensional rays will not generate visible beams, so he fastens on the idea that rainbow colors are linked to some *measurable* distance on the drop. For example, although we would use different language, Theodoric is right in saying that "the place on the drop from which the foregoing colors depart and are transmitted to the viewer has a width that is proportioned to the width of incidence already mentioned."[294] So Theodoric correctly assumes that finite-width light beams entering and exiting raindrops are required to produce a rainbow,[295] even though this fact by itself does not explain the bow.

Another problem arises when Theodoric constructs his raindrop mosaic, or large-scale model of the rainbow (Fig. 5-6). Figure 5-6 is a simplified version of Theodoric's original diagram, and in it is resurrected a cross section of Aristotle's meteorological sphere. By placing the sun and raindrops at equal distances from the observer, Theodoric requires that rays of sunlight diverge significantly.[296] In reality, sunlight is nearly parallel, and Theodoric's mistake here is quite out of character with his usually careful constructions. Furthermore, Theodoric makes rainbow rays emerge parallel from his drops, although this mistake is subtler.[297] (Figure 6-5 illustrates how light rays actually diverge from a drop.) We are not quibbling with Theodoric's pictorial device of

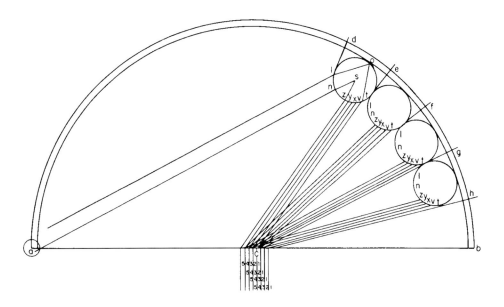

FIG. 5-6

Theodoric of Freiberg's model of the primary rainbow: two refractions are correctly separated by a reflection within a raindrop. However, Theodoric places the drops along the surface of a meteorological sphere. (From *A Sourcebook in Medieval Science*, p. 438, ed. Edward Grant, Cambridge, Massachusetts: Copyright © 1974 by the President and Fellows of Harvard College)

substituting a few enormous drops for many small ones, something that we ourselves do in Fig. 4-3. Instead, we are concerned with his crucial misstep of making sunlight divergent. In any event, the large arc *a-b* that Theodoric calls "the altitude circle" (that is, a vertical cross section of Fig. 4-1's meteorological sphere) is an intrinsic part of his impossible raindrop mosaic.

Perhaps as a way of adding naturalism to his thoroughly unnatural meteorological sphere, Theodoric twice tells readers that "the place of elevation of the drops on the altitude circle from which the rainbow appears is not a point, but occupies a distance on the altitude circle that corresponds to the width of the entire rainbow and also of each of its component colors."[298] Furthermore, he understands that *any* drops at the proper angle from the sun, not just those along his altitude circle, will send rainbow colors to the observer.[299] Given these insights, we can only wonder why Theodoric believes that drops causing the rainbow are at a more or less fixed distance from the observer. Remarkably, although Theodoric says that he used an astrolabe to measure the rainbow's angular radius, he lists this as 22°, little more than half its actual 42° value.[300] Theodoric writes that the secondary rainbow's radius is approximately 11° greater than the primary's. While this angular *difference* is nearly correct (it is actually closer to 9°), obviously his secondary bow's radius will still be much too small.[301] Theodoric also knows that different drops send the observer different colors[302]—that is Fig. 5-6's central purpose (note that each drop corresponds to one of his four rainbow colors).

Theodoric now joins his flawed color theory and raindrop mosaic to form a unified explanation of the rainbow's appearance. Referring to Fig. 5-6's uppermost drop *de*, Theodoric says: "the arc described on the drop that is included between the place of incidence, which is *ln*, and the place of departure toward the viewer, *zyxvt*, is larger or smaller according as the spherulet is more or less elevated above the horizon on the altitude circle."[303] In other words, as a drop

descends, the light beam that contributes to the rainbow enters and exits nearer the drop's center than when the drop was higher. Because Theodoric has said that light entering closest to the drop's center yields blue, drops that give blue rainbow light will be closest to the horizon, as will the rainbow's blue band. Drops at still lower altitudes "transmit some incident radiation to the viewer, but not with the colors of the rainbow; rather [they transmit] a kind of white light, unmixed with colors."[304] Thus in Fig. 5-6 the observer *c* receives red light from drop *de*, yellow from *ef*, green from *fg*, and blue from *gh*. In order for Theodoric to conclude this, however, he has had to pair his rather tortuous ideas on color with a faulty rainbow geometry.

Given all these problems, does Theodoric's theory represent any progress? The answer is a resounding "Yes!" Despite its mistakes and shortcomings, Theodoric's model nonetheless has broken free of contrived, nonexistent clouds and devious combinations of reflection and refraction. His basic geometry of refraction, reflection, and refraction within a raindrop is fundamentally sound, even though his color theory is unrealistic. A better measure of Theodoric's innovation is that he adds a second internal reflection to a raindrop and correctly explains the color order, location, and reduced brightness of the secondary rainbow (a subject explored in Chapter 6).[305] Theodoric also understands why the region between the two bows is dark and why the interior of the primary rainbow can be bright.[306]

While the quantitative details of Theodoric's theory are often wrong, his qualitative insights are not. Although leaning a little toward hyperbole, Carl Boyer's opinion still bears repeating: Theodoric's was "one of the greatest scientific triumphs of the Middle Ages. It is difficult to overestimate the significance of his step in immobilizing the raindrop. For the first time the rainbow in the laboratory could be studied more thoroughly than the astronomer in the observatory scans the heavens."[307] Alistair Crombie says simply: "Theodoric of Freiberg's explanation of the rainbow affords striking proof of the effectiveness of the medieval theory of experimental science in solving a concrete problem."[308] In the opening decade of the fourteenth century, medieval science at last seems poised for the great accomplishment of unweaving the rainbow.

Between the Ancient and Modern Rainbows

To modern eyes, medieval rainbow theory may resemble a strange whirlpool within which odd bits of myth, insight, and dogma endlessly swirl. Like intellectual flotsam, the same facts and fictions repeatedly pop to the surface, occasionally joined by a new idea, only to submerge again. The linear progress that we assume is the norm of modern science is nowhere evident. However, an alternative view of the two scientific cultures may make better sense. Perhaps it is we, beneficiaries of a centuries-long rooting out of scientific false starts and dead ends, who have the distorted view of scientific progress.

Most scientists would readily admit that their own day-to-day work never resembles the seemingly straightforward path outlined in introductory science texts. In fact, science is always a

work in progress—today's clever idea may be tomorrow's untenable hypothesis, never to be heard of again. Of course, we are not saying that the world view of modern science is the same as that of Grosseteste or Albertus Magnus. Experimental evidence, not distinguished authority, is the only true judge of a theory's validity today.[309] Furthermore, both by inclination and by weight of accumulated facts, we are far less likely to give credence to hearsay (the medieval writer's myths) than were medieval scientists. Nevertheless, we should appreciate that rainbow theory advanced slowly not only because of scientific obtuseness and conservatism.[310] Although the first correct theory of the rainbow is easy to explain in hindsight, deriving it required great perseverance, winnowing, and imagination. With that preamble in mind, we now move toward the crowning achievements of seventeenth-century geometrical optics: the rainbow theories of Descartes and Newton.

Neither medieval innovation nor conservatism would disassemble Aristotle's rainbow theory, which accommodated a wide variety of additions and rearrangements. As sixteenth-century writers would do with most of Aristotle's science, they continued to exploit, question, and modify his ideas on the rainbow. However, with a new century would come a wholesale dismantling of the Aristotelian rainbow, which was replaced by rainbow theories that still bear their authors' names: Descartes and Newton. Just as new scientific ideas are scrutinized today, so too did the new seventeenth-century rainbow theories initially meet with both acceptance and rejection. Add to this their authors' own scientific fallibilities, and we can clearly see the difficulties of constructing the bridge to modern rainbow theory.

SIX

BEYOND THE MEDIEVAL RAINBOW

For the first two decades of the fourteenth century, the rainbow seemed a charmed phenomenon. As an object of artistic and scholarly interest, it drew such innovators as Kamāl al-Dīn, Giotto (Fig. 2-3), Theodoric of Freiberg, and Dante. Yet however much we might like to make this coincidence a ground swell of intellectual enthusiasm for the rainbow, events speak otherwise. In fact, no communication or even shared interest would have brought together these four remarkable men, and for all of them the rainbow was merely a passing interest.

Nonetheless, a common issue faced by all was the rainbow's stature as an icon of Islamic or Christian faith, whether that image worked for or against their particular ends.[2] As an icon of scientific interest, the rainbow languished for the balance of the century in Europe, lost in a kind of Aristotelian limbo. Theodoric's remarkable new theory survived, but only just—three manuscript copies of *De iride*

> Like as, concentric and of self-same hue,
> When Juno has sent forth her handmaiden,
> 'Mid filmy clouds the double bow glides
> through—
> The outer iris born of that within,
> In fashion of her wistful voice whom love
> Consumed like vapours that the sun drinks in;
> Whence men foreknow that never flood
> shall move
> A second time to drown the world beneath—
> Such was God's pledge to Noah, such
> the proof;
> So did those sempiternal roses wreathe
> Twofold about us and, antiphonal
> In song, the outer to the inner breathe.[1]
>
> Dante Alighieri, *The Divine Comedy*
> (c. 1307-21)

are now extant,[3] and the work was borrowed from intermittently at best.[4] In the centuries after its creation, *De iride* never seems to have been irretrievably lost,[5] just neglected or unappreciated. For example, the *Meteorologica* commentary of the Christian convert Themon Son of the Jew (fl. 1349–61) faintly resembles some of Theodoric's views on the rainbow, although Themon never mentions him.[6] However, Aristotelian readings of the rainbow flourished. Whether with clarity or confusion, writers repeatedly mined the views of Aristotle and his early commentators.[7] This vein of rainbow theory had long since given out intellectually, but late medieval and early Renaissance writers continued to see it as a rich source of ideas. Figures ranging from Alessandro Piccolomini (1508–78),[8] compiler of the first printed star charts, to Leonardo da Vinci[9] all invoked the Aristotelian rainbow to some degree.

Not all Renaissance writers on the rainbow fancied themselves its theoreticians. In his short life, Englishman Leonard Digges (1520–c. 1559) attended Oxford, published a practical treatise on surveying, invented the theodolite,[10] and very likely built successful refracting and reflecting telescopes.[11] Digges' talents were not merely limited to applied optics, as his detailed work on the mathematics of surveying indicates.[12] Yet in his 1555 almanac *A Prognostication of Right Good Effect*, Leonard Digges gives free rein to his practical side with a miscellany of predictive charts and descriptions. Propitious times for bloodletting, bathing, planting, and gelding (sometimes accompanied by a detailed table)[13] are paired with Aristotelian descriptions of winds, earthquakes, and the rainbow.[14] Digges scarcely has time to dwell on the rainbow's cause, instead preferring its rather changeable predictive powers: "The Raynbowe is the shynyng, and rebounding of beamys of light, that tourne to the contrarie vapour agayne, in the cloude. It declareth sometyme rayne, and many tymes fayre wether: when the one, and how the other, is before opened."[15]

In that earlier discussion, Digges reworks old folkloric ground, some of which is still familiar today: "If in the mornyng the raynebow appere, it signifieth moysture, onlesse great drouthe of ayer woorke the contrarie. If in the euening it shew itself, fayre weather ensueth: so that aboundaunt moyste ayer take not awaye the effect. Or thus. The rayne bowe appering, if it be fayr, it betokeneth fowle weather: if fowle, loke for fair weather. The grener, the moare raine: redder, wynde."[16]

Although Digges elsewhere invokes Aristotle's name to give his account respectability,[17] it is clear that explaining the rainbow is of secondary importance to him. This may seem surprising, given the sophisticated optical demonstrations in his other works. However, when Digges composed his *Prognostication* he likely had dissemination of "practical" information (and perhaps profit) in mind, not abstruse theories. Widely circulated as this book was, both Digges[18] and Aristotle benefited from its popularity.[19] But the usefulness of Digges' rainbow-colored weather forecast must have seemed suspect even to his contemporaries. In that sense, Digges' supposedly utilitarian rainbow is no less fanciful than the poetic Iris, whom John Davies' Saint Swithin scolds before Queen Elizabeth I.[20] When folklore and entertainment converge, optical theory inevitably takes a back seat.

Francesco Maurolico and the Raindrop of Mirrors

Yet not all rainbow fancy was based in folklore. In the mid-1500s, the Sicilian mathematician Francesco Maurolico (1494–1575) set to paper his elegant reflection-only theory of the rainbow.[21] Maurolico seems an unlikely creator of a farfetched rainbow model. Already accomplished as a translator of Greek scientific and mathematical works, Maurolico had published histories of church martyrs and Sicily, and in 1535 he helped design a triumphal arch for the Holy Roman Emperor Charles V.[22] Maurolico's 1550 appointment as abbot of Sicily's Castronuovo monastery may have provided an atmosphere conducive to his research—at least the church raised no objections to such work. In 1560, Maurolico retired to his family home near Messina, where his many visitors included the Jesuit astronomer Christopher Clavius (1537–1612), architect of our Gregorian calendar.[23] Clavius arranged for posthumous publication of Maurolico's rainbow theory, which appeared as part of Maurolico's optical treatise *Photismi de lumine et umbra* (Elucidations Concerning Light and Shadows).[24] In it, he analyzes not only the rainbow but also problems in catoptrics, dioptrics, and shadow formation.[25]

Maurolico was quite clear on what a rainbow theory must do. In the *Photismi*'s earlier portion (1553), Maurolico scorns unnamed writers' efforts and pinpoints their collective inadequacy: "All of them have either failed to consider or have slighted the size of the angle under which the rainbow is seen. But upon this nearly the whole demonstration ... depends."[26] In *Photismi*'s conclusion (1567), "Problems in the Field of Optics and the Rainbow," Maurolico explicitly chastises Pliny, Averroës, Pecham, and especially Witelo for their obscurity on the rainbow.[27] Determined to avoid his predecessors' errors, Maurolico devotes much of the *Photismi* to explaining the rainbow's size and position.

In his opening statement, Maurolico's approach signals both promise and peril: "The rainbow is the result of the sun's rays falling upon a moist cloud, at an angle which is half a right angle, and refracted to the eye from every side; thus giving the rainbow its circular form."[28] Gone are earlier medieval concerns about species, extramission, and cloud geometry. Instead we have seemingly straightforward and modern statements that interweave solar rays, refraction, and circular symmetry, soon to be followed by parallel sunlight. However, older ideas still lurk here—Maurolico invokes a "moist cloud," his "refraction" is actually "reflection,"[29] and his "half a right angle" (45°) is not the same as the rainbow's 42° radius.

On the rainbow's medium, Maurolico gradually becomes clearer, moving from "a cloud of droplets" to "individual drops of moisture" and finally to "raindrops."[30] But what do these drops do? Here Maurolico's geometry is as abstruse as his logic is disingenuous. He claims to demonstrate that the rainbow is a cone of light whose base angle is 45°. Unfortunately, this elaborate geometric demonstration begins with the faulty assumption that the horizon sun's rays have "terminal points" on a plane at right angles to the ground. In other words, when the sun is on the horizon, rainbow light *must* emanate from a plane perpendicular to the earth's surface.[31] From this strange (and once-mentioned) requirement, all of Maurolico's faulty geometry flows.

Of course, there is no *physical* basis for choosing this vertical plane as the rainbow's source, but physical explanation interests Maurolico only as an afterthought to rainbow geometry. Perhaps Maurolico has succumbed here to the powerful illusion that the rainbow is a flat object.[32]

Maurolico then huffs at "the folly of those who, not considering it necessary that colors similar to those of the rainbow must be inflected [that is, reflected] from all sides at equal angles of deviation, seek to explain the [rainbow's] circular form by the concavity of the cloud."[33] He thus rejects the Aristotelian cloud-mirror and meteorological sphere only to erect another equally faulty (although subtle) facade, the disk of rainbow light perpendicular to the sun's rays. Furthermore, Maurolico uncritically accepts the long-lived fiction that the equality of incidence and reflection angles *by itself* fixes the rainbow's angular size.[34] After demonstrating macroscopically why rainbow light is 45° from the antisolar point,[35] Maurolico next explains this microscopically. To do so, he builds an intricate picture of reflection within a single raindrop. In his theory, refraction is less than unimportant, it is nonexistent (Fig. 6-1; note that none of the entering rays is bent). Given that Maurolico devoted an entire book of the *Photismi* to refraction, this single-mindedness is odd indeed.

Two kinds of reflection send rainbow light to the observer in Maurolico's scheme. Light is reflected externally by a drop (point H in Fig. 6-1) and internally (point D) to the observer (point M). More or less correctly, Maurolico reasons that such reflections "cannot produce much effect at the eye of the observer unless [they are] intensified by many repetitions."[36] He is correct that a single reflected ray, whether reflected internally or externally, will not yield a visible amount of light, but his mechanism for intensifying the internally reflected light (repeated internal reflections) is incorrect. Now he comes to the crux of his theory: "These reflections are multiplied then when at the same points in the circumference, equal angles of inclination [that is, incidence and reflection] being maintained, they are repeated from point to point in a circle. For a succession of rays strengthens the first, second, third, and other successive reflections."[37] In other words, Maurolico believes that the raindrop is a hall of mirrors in which reflections carom around octagonally, eventually exiting toward the observer in much-strengthened form.

Why does Maurolico believe that repeated reflections occur only at the eight points A through H in Fig. 6-1?[38] Put another way, how does he arrive at incidence and reflection angles of which eight pairs make a complete circle? To accomplish this mathematically, Maurolico's i and r must each be 22.5°, with their combined deviation adding to 45°. So these eight pairs of 45° reflections circle the drop (45° x 8 = 360°). As for an optical explanation, Maurolico helpfully offers that for smaller i, "the reflected ray is weakened by its nearness to the incident ray" (that is, i and r are somehow too close), while for larger i "the light is weak because of the obliquity of the [incident] ray."[39] Without any justification he next reveals that "the most effectual angle [that is, $i + r$] is, indeed, half a right angle," or 45°. Trailing non sequiturs behind him, he thus arrives at his answer.

Not surprisingly, a few troublesome details remain. First, why do light rays stop caroming after a fixed number of internal reflections and obediently exit the drop toward the observer?

Why do they not bounce indefinitely? Second, Maurolico's figure (our Fig. 6-1) is a frustrating maze indeed. No matter how patiently we follow light rays from M back through their Byzantine trip within the drop, we cannot return to the sun (except for the single-reflection path MDK, which Maurolico describes as essentially invisible).[40] In other words, tracing rays within Maurolico's drop gets us nowhere. Third, Maurolico invokes repeated internal reflections as a way of *intensifying* light, yet elsewhere he says that "reflected rays are usually weakened."[41] In fact, his conflicting statements on reflection may indicate his distinction between imperfect reflection by metal-backed mirrors[42] and the presumably brighter reflection occurring within raindrops. Yet if he makes such a distinction, he does not state so. Stranger still, when Maurolico proposes thirty-two internal reflections to explain the secondary rainbow, he matter-of-factly notes that the reflected light "is weakened through other deviations [that is, additional reflections] and hence exhibits fainter colors, while the ray feels its way through several points other than the eight."[43] Finally, why does Maurolico propose that the primary rainbow's radius is 45° rather than the observed value of 42°?[44] To answer this, he turns to the reasonable (if convenient) realm of physical imperfection. Forthrightly admitting that he lacks a sure answer, he ventures that perhaps "the falling drops are somewhat elongated or somewhat flattened," a departure from sphericity that reduces the rainbow's size.[45]

If Maurolico's account of the rainbow's angular size is flawed but coherent, his theory of rainbow colors verges on the incomprehensible. Translator Henry Crew says with remarkable understatement that Maurolico's reasoning on color is "far from clear,"[46] even as he follows Maurolico into a marvelously tangled thicket of geometric details. One of Maurolico's diagrams on rainbow color moves the usually supportive Carl Boyer to say resignedly: "It presumably is but part of one of the vague geometrical schemata to which [Maurolico] resorts when in trouble."[47] Maurolico is of several minds on the number of rainbow colors. At one point he proposes four (orange, green, blue, and purple), and then he interposes three colors between these to arrive at seven, even as he correctly claims that "one color of the rainbow does not change into another instantly: the change is gradual, through a mean value which lies between" the flanking colors.[48] As for a physical (rather than geometrical) explana-

FIG. 6-1

Francesco Maurolico's rainbow model of sunlight's myriad reflections within a spherical raindrop. (From *The* Photismi de Lumine *of Maurolycus*, p. 80, trans. Henry Crew, Macmillan Co., New York, 1940)

tion of rainbow colors, Maurolico unconvincingly says only that they are caused by changes "in the number and density of falling drops" in different directions, as well as by the uneven distribution of sunlight on a raindrop's rear surface.[49] Untroubled by any doubts about his own impenetrable color theory, Maurolico exposes rainbow "errors in which many people have become entangled," including the belief that "the different colors depend upon the density or rarity of the air."[50] This attack on Grosseteste's rainbow model is justified, but Maurolico can ill-afford to be smug here.

Maurolico in fact makes several valuable contributions to our understanding of the rainbow. His primary rainbow's brightness increases from outside to inside (purple is brighter than orange), a sequence that at least is more realistic than Aristotle's, even if it does not exactly duplicate nature.[51] Maurolico's theoretical value for the secondary rainbow's radius, $56\frac{1}{4}°$, is close to the actual value of $51°$, although his reasoning here is even more ad hoc than for the primary rainbow.[52] Furthermore, Maurolico astutely notes that if the sun's elevation were greater than the primary's radius but less than the secondary's, only an isolated portion of the secondary bow would be visible above level ground.[53] He perceptively frets that "in a bow which is for every reason clear cut there still lurk other zones of color," an oblique reference to the supernumerary bows sometimes seen within the primary.[54] Finally, Maurolico nicely observes that very real rainbow colors seen in the cloud "are not, so to speak, an inseparable property as is the color of cloth,"[55] and he later says that "the colors of the rainbow are not impressed upon the falling drops."[56] Both statements show that Maurolico was capable of clear insights despite his generally murky account of rainbow color.

Francesco Maurolico might seem to have little positive to contribute to our story. In fact, his contributions are as much illustrative as substantive. If a man described as "probably the greatest geometer of the century"[57] could fall so wide of the mark in analyzing the rainbow, what does that suggest? Certainly Maurolico's inadequate rainbow theory illustrates the dangers of excessive devotion to geometric invention at the expense of observation. Yet Maurolico was careful to discard some obvious Aristotelian fictions (for example, the concave mirror-cloud), even as he invented new ones. Treating the sunlit raindrop as the rainbow's sole source—an advance over Theodoric's muzzy "altitude circle"—shows an instinct for the microscopic analysis that René Descartes would use effectively in the next century. Even Maurolico's failure to derive a sensible color theory was no more remarkable than Descartes's. In short, Maurolico vividly illustrates the nature of scientific progress on the rainbow. Armed with powerful analytical tools and some keen observations, Maurolico nevertheless made bad judgments, or perhaps willful oversights (such as neglecting refraction), that inexorably led him to a failed theory.

William Gilbert's Rearguard Rainbow

Flawed though it is, Francesco Maurolico's rainbow model is at least determinedly independent. The same cannot be said about the rainbow maunderings of the famous English scientist Will-

iam Gilbert (1544–1603). Appointed physician to Elizabeth I in 1601 (he continued to serve James I), Gilbert's enduring fame is as a pioneer researcher in electricity and geomagnetism. First published in 1600, Gilbert's book *De magnete* . . . (On the Magnet . . .) is a model of Renaissance experimental science in which Gilbert establishes from years of study that the earth acts like an enormous spherical magnet. Gilbert's experimental analysis of electrical phenomena in *De magnete* is so farsighted that his modern reputation is as "the father of the science of electricity."[58]

However, lingering unpublished after Gilbert's death were scientific manuscripts of a markedly different character. Collected soon after Gilbert's death by his half-brother and published in 1651, the *De mundo nostro sublunari philosophia nova* (On a New Philosophy of Our Sublunar World)[59] included a rainbow theory that clearly demonstrates the stubborn persistence of Aristotle's reputation. In Gilbert's case, this involves both unintentional borrowing of Aristotle's ideas and relentless gainsaying of Aristotelian Scholasticism.[60] For example, Gilbert offers some rather disingenuous arguments for replacing antiquity's four elements with one: earth. At the same time, Gilbert's account of the moon's features and its effects on tides show him to be a more advanced thinker than many of his Scholastic contemporaries.[61] Furthermore, some of Gilbert's indecisiveness in *De magnete* is resolved by the time of *De mundo*, where, for example, he clearly commits himself to a heliocentric solar system.[62] Yet on the rainbow Gilbert shows little originality.[63]

In essence, Gilbert believes that the rainbow is caused by sunlight shining into a vapor that is backed by a dark object such as a mountain or cloud. It is the dark background that reflects the rainbow image to us, not the vapor.[64] This belief parallels Avicenna's claim that "If no colored background stands behind those [water droplets], however, then they do not work as mirrors."[65] Gilbert's analogy here is to the tin or pitch backing of glass mirrors, without which the transparent medium returns little light to the observer. Gilbert acknowledges that neither the rainbow's shape nor its size is affected by the distance to its reflecting background, and he illustrates this with a mountain one stadium (about 607 feet) or less distant and a cloud two miles from the eye (points B, F, and A respectively, in Fig. 6-2).[66] Under these conditions observers see an unbroken rainbow arc GDC. If cloud is absent between points D and E, Gilbert insists that because "the air is clear, then [the rainbow is] there imperfect and weak."[67] Of course, all of Gilbert's careful argumentation ignores the fact that rainbows need not be seen against clouds or dark backgrounds (for example, Fig. 5-1).

Gilbert's explanation sometimes is more obscure than the Aristotelian one he scorns. In wording reminiscent of Job of Edessa, Gilbert calls the rainbow "a reflection, not of the form of the sun, but rather a representation of luminous air borne back to the eye" by air that must be "dense, and yet smooth enough" to "bear back the whole form of the sun."[68] A few sentences later Gilbert proclaims that the rainbow "is not a reflection [as such], but rather . . . a figure [that] itself exists from a mixture of light and vapor. It is a kind of reflection of the light, not of the form or of the colors."[69] To explain the rainbow colors within this figure, Gilbert draws a remarkable analogy to the calcination of lead. As flame makes the lead ever hotter, he notes, the

FIG. 6-7
William Gilbert's rainbow theory, which involves dark backgrounds and reflective vapor. (From William Gilbert [Guilielmi Gilberti Colcestrensis Medici Regii], *De Mundo nostro Sublunari Philosophia Nova*, p. 272 [Ludovicum Elzevirium, Amsterdam, 1651])

colors green, yellow, and red appear in sequence. Similarly, the rainbow's most intense light is red, followed by the weaker yellow and green.[70] Here Gilbert simply repackages Aristotle's rainbow color theory and adds another layer of analogy atop it. Thus in places, Gilbert's ideas on the rainbow are no less fanciful than Isaac Oliver's contemporaneous *Rainbow Portrait* of Queen Elizabeth (Fig. 2-8).

Gilbert eagerly refutes what he believes is Aristotle's theory of the secondary rainbow—that it is merely a reflection of the primary. This belief does indeed date from antiquity, but blame cannot be laid at Aristotle's feet.[71] Gilbert quite rightly notes (as had Maurolico)[72] that if the secondary rainbow were a plane mirror's reflection of the primary, it would appear concave side up. Mistakenly believing the mathematician Josse Clichtowe (d. 1543) had advocated this view, Gilbert triumphantly asks: "But why do you do this, Clichtovaeus? Since you have everything rectilinear, why not also invert the whole proportion and form of the thing? See how you refute your own example."[73] Not surprisingly, trumping dead authors proves far easier for Gilbert than answering the questions posed by the rainbow itself. Why should Gilbert's careful and perceptive studies of magnetism and electricity stand in such contrast to his "vague, speculative, and wearisome"[74] notions on the rainbow? Barring revelations about Gilbert's rainbow theory, we will never know. However, as Roger Bacon's flying dragons and the exploding emerald of Albertus Magnus suggest, intellectual fashions are indulged in by scientists as readily as anyone else. William Gilbert's intellectual indulgence in *De mundo* seems to include simultaneously sniping at Aristotle's science and offering arguments that are squarely in the Aristotelian Scholastic tradition. Describing Gilbert's cosmology in *De mundo*, Suzanne Kelly could also be characterizing his rainbow, which certainly is no less "a curious mixture of both old and new ideas."[75]

Johannes Kepler: On the Rainbow's Cusp

Although the German-born astronomer Johannes Kepler (1571–1630) postdated Gilbert by only a generation, his later contributions to rainbow theory were as modern as Gilbert's were medieval. As successor to astronomer Tycho Brahe (1546–1601) at his imperial observatory outside Prague,[76] Kepler greatly extended Brahe's work and made basic discoveries about orbital geometry that underlie Isaac Newton's gravitational theory. Kepler also gave the first rigorous account of the optics of human vision, as well as fundamental optical explanations of the camera obscura, spectacles, refracting telescopes, and many other optical systems.[77] Given this background, we may be surprised that Kepler's ideas on the rainbow evolved in meandering fashion for nearly two decades.[78] While ultimately he would not solve this intractable optical puzzle, he came very close indeed.

Kepler began his professional life as a divinity student at Tübingen, yet his first employment was as a teacher of mathematics and astronomy in the Austrian city of Graz. Although he did not shrink from the remoteness of his new job (Graz is southeast of the Alps), he did worry about "the unexpected and lowly nature of the position, and my scant knowledge in this branch of philosophy."[79] But self-doubt seldom constrained Kepler, and a little more than a year after arriving in the provinces (1595), he was confident that he had discovered the secret of the universe's structure.

Like Plato and the Pythagoreans before him, Kepler was drawn to the thoroughly fallacious notion that the regular solids[80] shape natural structures. For Kepler, it was the alternate nesting of spheres and regular solids that proved fascinating: each regular solid could be inscribed within a sphere, and within that solid could be inscribed another sphere and a different, smaller solid. Where others would observe merely a neat geometric construction, Kepler saw the immutable ordering of the solar system. When the five regular solids were successively inscribed and circumscribed by six spheres, Kepler believed that the spheres fixed the spacing of the solar system's six planets.[81] These six planets were those proposed by Copernicus (Mercury, Venus, Earth, Mars, Jupiter, and Saturn), and their number was incompatible with Ptolemy's seven planets (the Moon, Mercury, Venus, the Sun, Mars, Jupiter, and Saturn).[82] To his delight, Kepler found that the ratios of the distances between inscribed spheres duplicated (more or less) the ratios of interplanetary distances.[83] To boot, his "discovery" offered geometric confirmation of Copernicus's heliocentric theory. With a single inspiration (and months of elaborate ad hoc calculations), the twenty-four-year-old Kepler had thus solved an elusive and fundamental "cosmographic mystery."[84] Kepler's later and very substantial contributions to astronomy never shook his belief in this youthful fantasy.

In a burst of creative energy, Kepler completed his *Mysterium cosmographicum* by early 1596, and he was so anxious to shepherd his manuscript through printing that he arranged for a two-month leave of absence from his teaching post, a leave that he arbitrarily extended by five months.[85] Yet such academic risk-taking was not Kepler's only audacity. While the *Mysterium*

trod familiar medieval paths of astronomical mysticism, it also took a distinct turn toward the kind of scientific empiricism advanced in Gilbert's *De magnete*. At the opening of the *Mysterium*'s second half, Kepler bluntly says of his painstaking geometric constructions: "Let us now pass to the distances between the astronomical spheres and the geometrical derivations: if they do not agree, the whole of the preceding work has undoubtedly been a delusion."[86]

Kepler nearly doubled the book's length in the second edition of *Mysterium* (1621) with extensive notes on the original. He alternately condemns his youthful errors of calculation and astrological digression while defending the fundamental soundness of his geometrical scheme.[87] Kepler's elaborate self-analysis provides us with a first glimpse of his ideas on the rainbow. In *Mysterium*'s Chapter 12, Kepler offers yet another Pythagorean model of heavenly structure, this time of the zodiac's twelve signs and their relationship to the rational-number intervals of the medieval hexachordal musical scale.[88] After lengthy argument, Kepler concludes that there are "two classes of harmonies, three simple and perfect, and two double and imperfect," for which he has shown that "the perfect harmonies must be fitted to the cube, pyramid, and octahedron, the imperfect to the dodecahedron and icosahedron."[89] Chapter 12's lengthy aside prompts Kepler to make yet another digression, this time in the form of marginal notations that probably predate 1600.

In these notations, Kepler extends his comparison of musical and astronomical harmonies to include color progressions, of which the rainbow is an obvious example.[90] He points out that although there are countless notes within the hexachordal scale, only some of those are both pleasing and rational (that is, beautiful both to the senses and to mathematics). Does such a distinction also exist in the rainbow's seamless but discrete colors? Kepler has no answer for this question, but he nonetheless offers an explanation for the way rainbow colors are ordered: "Indeed, yellow is in the middle in a certain sense, progressing on the one hand outward through red toward darkness [outside the primary], because of a diminution of the solar body and an admixture of shadow with the cloud's misty substance. From yellow toward the inside [of the primary] through blue-green, purple, violet, toward darkness is a transition due to another cause. Surely all of this is refracted."[91]

Essentially, Kepler proposes two means of generating rainbow colors. Between yellow and red, he imagines a variation on the Aristotelian mechanism of reflected sunlight mixed with the cloud's darkness.[92] Inward of yellow, refraction somehow takes over and generates the remaining rainbow colors. Casting about for Pythagorean ratios, Kepler asks hopefully: "And lo, is not the magnitude of the rainbow always about 45°, which is the measure of half a right angle?"[93] Kepler's diffident and certainly offhand speculations here scarcely qualify as a rainbow theory, and in them we see the same problems that plagued the accounts by Gilbert and Maurolico.[94] Had Kepler asked no further questions about the rainbow, his contribution to its story would have been of little note.

Despite this private tentativeness, Kepler published his rainbow ideas in the 1601 *De*

fundamentis astrologiae certioribus (On the More Reliable Bases of Astrology).[95] The parallels with his *Mysterium* marginalia are obvious: "The colors of the rainbow are, to be sure, divided into two classes: one has its source in obfuscation, or deprivation of light; the other, from refraction, or tinting. The source of each class is from the very light itself or, from a white glow analogous to light, which, occupying the middle circle of the rainbow [that is, yellow], cuts it, as it were, in two. From one side it is diminished, and from the other it is refracted; finally on both sides it ends in black or darkness."[96] Kepler's rainbow muddle is no clearer here. Why divide the rainbow into two distinct color regimes, especially without offering any reason for doing so? Like Maurolico and many others before him, Kepler at least once uses "reflection" and "refraction" as synonyms,[97] and in *Fundamentis* at least he makes both responsible for causing rainbow colors.

Kepler's struggles with the rainbow occasionally led to remarkable gaffes. One is his claim in *Paralipomena ad Vitellionem* (Supplement to Witelo, 1604)[98] that the rainbow is caused by aqueous material *between* the sun and the observer, not by droplets or a cloud opposite the sun (that is, a variant on Grosseteste's refracting cloud). With no equivocation Kepler states: "Therefore let the aqueous material, which is between an observer and the sun, be either rain or a transparent cloud or mist (for rainbows can also be seen in mist). This, I say, forms and configures the refractions of the rays of the sun; that which is indeed [beyond] the observer receives these refracted rays of the sun.... On that account it is not true that the rays of either the sun or vision are reflected or broken in just that place in the cloud where the rainbow appears."[99]

Such outdated ideas are part and parcel of Kepler's fitful search for a satisfactory rainbow theory. Yet Kepler was far from an uncritical transmitter of Scholastic ideas. Elsewhere in *Paralipomena*, he firmly rejects a Scholastic canard that distinguished between the rainbow's supposedly false colors and the true colors of objects: "Since the colours observed in the rainbow are of the same kind as those found in coloured bodies, they have the same origin."[100] In a letter of 1605, Kepler implicitly rejects Aristotle's meteorological sphere during a rather obscure demonstration that "it is not the shape of the air but the flow [of falling raindrops] itself that causes rainbows and halos."[101] Aristotle is not honored even backhandedly in Kepler's subsequent analysis of refraction, where he crows that Aristotle's color explanation "is, as I see it, turned round; shall I resist a Pythagorean shout?"[102]

Despite such occasional concentrated efforts, the rainbow was clearly on the periphery of Kepler's optical interests.[103] Kepler most nearly succeeded in explaining the rainbow when he unequivocally settled on the raindrop as its agent. However, Kepler chose the seemingly unpromising model of a raindrop with multiple internal reflections, which he outlined in a 1606 letter to English mathematician and scientist Thomas Harriot (1560–1621).[104] Although Kepler seems to have had no knowledge of Maurolico's similar theory,[105] the parallels are obvious. The advance in Kepler's theory is that he realistically adds refraction, and he makes his rainbow ray exit the drop after one internal reflection (line GT in Fig. 6-3). Kepler correctly states that the refraction

FIG. 6-3

Johannes Kepler's combined reflection/refraction theory of the rainbow. Kepler believed that the tangent ray MA, reflected once within a raindrop, caused the rainbow ray GT. (From Johannes Kepler, *Joannis Kepleri Astronomi Opera Omnia*, vol. 2, p. 70, ed. Christian Frisch [Heyder & Zimmer, Frankfurt am Main and Erlangen, 1859])

angle (*t* in Fig. 5-3) is largest for parallel sunlight when the ray is tangent to a raindrop (ray MA in Fig. 6-3).[106] Because Kepler believes that rays passing near the edge of a water-filled glass globe take on prismatic colors and that those passing closer to the center do not, only tangent rays such as MA cause his rainbow. Satisfied that he has explained the rainbow's colors, Kepler then throws his considerable mathematical skills into making the tangent rays produce light 135° from the sun, his presumed location of the primary rainbow.

Compared to Maurolico, Kepler has a much clearer, if still imperfect, understanding of the trigonometric relationship between the incident (MA) and refracted rays (AB).[107] Nevertheless, Kepler is satisfied that because his once-reflected ray GT emerges 135° from the sun,[108] he has satisfactorily explained the rainbow. The problem with Kepler's geometry is one that he himself recognized—refraction from air to water actually produces an angle larger than that drawn in Fig. 6-3 (that is, AB should be a longer chord). Undaunted, Kepler ascribes the difference between observed angles of refraction and those required by his model to rainwater's tepidness. Tepid raindrops, he reasons, cause less refractive bending than is observed for the supposedly cooler water used in refraction measurements.[109] Although Kepler is correct that refraction decreases with increasing water temperature, this reduction is actually much smaller than he hopes.[110] Furthermore, his implication that raindrops must be warmer than standing water is suspect, as anyone drenched by a summer thunderstorm's cold rain knows well.

Judging from Kepler's surviving works and letters, his interest in the rainbow from 1606 onward was intermittent at best. In correspondence of 1607 and 1608, Kepler revisits the rain-

bow problem, never completely satisfied with his existing ideas. Yet Kepler's next optical treatise, his influential *Dioptrice* of 1611,[111] shows no further progress on the problem. There Kepler simply reiterates his claim that the rainbow colors occur where the incident ray's refraction is great,[112] a view that he still voices in a letter of 1619.[113] In fact, most of Kepler's speculations about raindrop-generated rainbows were confined to private correspondence. Kepler would have derived little comfort from knowing that his correspondent Harriot had earlier discovered the correct law of refraction (by 1597) and almost certainly understood the rainbow's optics![114] Unfortunately for both Kepler and science, Harriot's remarkable optical discoveries long remained private manuscripts.

What then is Kepler's contribution to rainbow theory? While he never satisfactorily accounted for the rainbow's position, his failures clearly are nearer misses than those of Maurolico and Gilbert. First, Kepler's mature rainbow theory (1606 on) totally dispensed with reflecting clouds and instead examined refraction and reflection within individual raindrops. Second, despite his ambivalence in the *Mysterium cosmographicum*, Kepler ultimately recognized that refraction alone causes the rainbow's colors. Third, his optical expertise led him to a more promising dead end than any of his predecessors: he associated rainbow formation with an extremum of the deviated sunlight. Kepler plausibly chose the ray that is refracted *most* on entering the drop. Had he concentrated instead on the ray whose net refraction and reflection (its deviation angle)[115] is *least*, he would have arrived at the answer that so long eluded him. With only a little more insight and luck, Kepler might have achieved the first satisfactory rainbow theory.

René Descartes: The Rainbow Fixed in the Sky

When Johannes Kepler died in 1630, the rainbow problem still lingered unsolved despite millennia of earnest and often inspired intellectual effort. Yet a mere seven years later the first satisfactory rainbow theory would appear in a short essay written by René Descartes, *De l'arc-en-ciel* (On the Rainbow).[116] Mathematician, scientist, and philosopher, Descartes was a seventeenth-century French polymath who spent much of his working life in Holland (1628–49).[117] His move to Holland might have been prompted by a desire for a more liberal intellectual and religious climate than prevailed in the increasingly intolerant France of Louis XIII (reigned 1610–43) and Cardinal de Richelieu (1585–1642). Ultimately, however, Descartes would find the Calvinism of the Netherlands more hostile than France's Counterreformation Catholicism.[118] A more likely reason for Descartes's move is that he sought refuge from the distractions of daily contact with patrons and fellow philosophers alike.[119] A man of independent means,[120] Descartes might have lived the unproductive life of an intellectual dilettante and expatriate idler,[121] yet nothing could be further from the truth.

For example, Descartes's groundbreaking essay on the rainbow is but one chapter in his *Discours de la méthode* (Discourse on Method, published 1637), in which he first outlines and

then illustrates his new philosophy of science. Like Roger Bacon before him, Descartes was confident that he had invented a foolproof method for scientific inquiry. First, Descartes vows "never to accept anything as true that I did not know evidently to be such," although he is silent about what constitutes a self-evident truth.[122] Second, he divides "each of the difficulties that I examined into as many parts as possible," provided that such division aids in solving the problem before him. Third, he strives to "direct my thinking in an orderly way, by beginning with the objects that were simplest and easiest to understand, in order to climb little by little, gradually, to knowledge of the most complex." Finally, he pledges always "to make enumerations so complete, and reviews so general, that I would be sure of omitting nothing."[123] As is typical of Descartes, he presents his nominally inductive method[124] as both unprecedented and virtually self-evident. In fact, he had arrived at his four rules via distinct philosophical precedents and years of intellectual exertion.[125]

Descartes's prologue on methodology occupies a mere sixth of the *Discours*—its bulk is devoted to practical, often highly innovative, examples of Descartes's application of his theory. In the discourses collectively entitled *La dioptrique* (Optics), the application is to dioptrics and catoptrics, where one signal advance is the first publication of a quantitatively correct law of refraction.[126] In the discourses called *La géométrie* (Geometry), Descartes develops both analytic geometry and modern algebraic notation,[127] while in *Les météores* (Meteorology) he takes on, with varying degrees of success, the Aristotelian stronghold of meteorology. Methodical in both senses of the word, Descartes follows roughly the sequence of Aristotle's *Meteorologica*, with the result that his revolutionary chapter on the rainbow appears in the closing pages of *Les météores*.

Yet the inconspicuous location of *De l'arc-en-ciel* belies its importance to Descartes. In October 1629 Descartes wrote to his friend Marin Mersenne (1588–1648),[128] "I believe that I can now give an account of [atmospheric phenomena], and I have decided to write a small treatise that will include an explanation of the cause of the rainbow, the matter that has given me the greatest difficulty." So tentative is Descartes about this work that he tells Mersenne he plans to publish it anonymously so that he may view its scientific reception in secret.[129] Although another eight years would elapse before publication, Descartes still omitted his name from the *Discours* and its essays.[130] Whatever the private anxieties of its author, there is little tentativeness in *De l'arc-en-ciel*'s tone. Descartes attacks the rainbow problem forearmed both with supreme confidence and with an unrivaled knowledge of geometrical optics: "The rainbow is such a remarkable phenomenon of nature, and its cause has been so meticulously sought after by inquiring minds throughout the ages, that I could not choose a more appropriate subject for demonstrating how, with the method I am using, we can arrive at knowledge not possessed at all by those whose writings are available to us."[131]

Descartes was seldom generous in praising others' abilities,[132] so his passing reference to "inquiring minds" and to "those whose writings are available to us" is as close as he gets to

acknowledging any intellectual forebears on the rainbow problem. For some, his self-confidence (or, less charitably, arrogance) tarred him as a scientific opportunist or, worse yet, plagiarist. On the rainbow alone, Descartes would be charged with using the unacknowledged ideas of Kepler[133] and the cleric Marcantonio de Dominis (1566–1624).[134] Equally heartfelt were critics' suspicions about the origins of *La dioptrique*'s law of refraction.[135] This law is worth examining in detail, for it is one of several keys to Descartes's success with the rainbow.[136]

In *La dioptrique*, Descartes interweaves implausible physical reasoning and impeccable geometry to arrive at a refraction law expressed in terms of the linear components of the incident and refracted rays.[137] His approach is in fact identical to comparing the sines of the incidence and refraction angles, which form a constant ratio for a given pair of media (for example, air and water) regardless of the actual value of the incidence angle.[138] Unknown to Descartes, this ratio depends not only on the two media but also on the color of the refracted light. This latter dependence is Newton's important discovery and would complete the geometrical optics explanation of the rainbow (see next section). For the special case of direct incidence when a ray is perpendicular to the surface of the refracting medium (that is, $i = 0°$), the angle of refraction $t = 0°$, and we say that no refraction occurs. Descartes knows that he is describing a constant ratio of sines,[139] yet in the context of *La dioptrique*'s discussion of lenses, using the linear-measure language of the lens-maker's optical bench makes good sense.[140]

Descartes's constant ratio of sines is the law of refraction that had eluded optical theorists and experimenters for centuries—Kepler had almost derived its trigonometric form,[141] and Ptolemy, Alhazen, and Witelo had all offered other approximations to it.[142] Despite Descartes's own careful measurements, he himself may simply have stumbled on the correct equation (called the *sine law*).[143] Certainly his geometric analysis of the sine law seems to drive his physical explanation of refraction.[144] In turn, this suggests that his formulation of the refraction law might be due more to ad hoc mathematics than to Cartesian induction.[145]

If we apply physically relevant formulas to observations, the formula that best predicts those observations may well be a physical law. However, Descartes seems to go beyond this safe territory and into the far chancier realm of using a model based on macroscopic observations (the sine law) to describe unobservable microscopic "features" of refraction. The fact that none of these microscopic features exists is the central problem with Descartes's account. For example, Descartes claims that light refracted from a rarer to a denser medium (for example, air to water) *speeds up* as a result. This seems curious, because earlier in *La dioptrique* Descartes implies that light is transmitted instantaneously.[146] In his *Le monde ou traité de la lumière* (The World or Treatise on Light, completed 1633 but published posthumously), Descartes is more direct, stating that light extends "instantaneously" from luminous bodies.[147] If *La dioptrique* readers tried to reason through the notion that instantaneously distributed light has a speed (let alone a changeable speed), they would likely be perplexed.[148] In fact, light actually travels *more slowly* in the denser refracting medium, although Descartes has no way of knowing this. He

makes this mistake probably because both his refraction geometry and another assumption demand it.

Descartes plausibly compares light's refraction to a ball flying at an angle toward a thin cloth that is suspended flat. If the cloth is thin enough, the ball breaks through it (much like a light ray, Descartes hopes), although its speed and direction are now changed. He resolves the ball's velocity into components parallel and perpendicular to the cloth. Only the perpendicular velocity component changes, he assumes, "because in no way does this cloth oppose [the ball's] going in this direction [parallel to the surface]."[149] Today we know that refraction changes *both* velocity components and that their differing magnitudes merely describe, rather than explain, the path the light ray takes through the medium. (See Chapter 8's "A Microscopic Explanation of Rainbow Colors" for the modern explanation of refractive bending.) Descartes's reliance on macroscopic models of collision may be what leads him astray here,[150] but his macroscopic refraction law does correctly tell him that the light ray must bend toward the surface normal on entering the denser medium (see Fig. 5-3). Because he believes that the parallel velocity component is unchanged, the only way he can bend the ray's path correctly is to *increase* the perpendicular velocity component. To do this, Descartes requires that light's speed be greater in the denser medium.[151] Thus, with a brilliant geometric demonstration, Descartes arrives at a physical impossibility.[152] Although his microscopic analysis of light refraction is incorrect, his macroscopic description of refraction survives unscathed to the present.

The difficulties in Descartes's justification of his refraction law,[153] combined with uncertainties about its priority, generated a long-lasting suspicion that Descartes plagiarized the sine law. Descartes's secretiveness[154] and general unwillingness to acknowledge his predecessors has fostered the belief that he simply appropriated the law of refraction from Dutch mathematician Willebrord Snel (1580/81–1626). Descartes probably formulated his sine law before 1628, while Snel's now-lost work may date from the mid-1620s.[155] Snel did not write his refraction law using sines (he used another trigonometric function), nor did he publish it. Both Snel and his colleagues seemed unaware of its significance, and it was only some decades after publication of *La dioptrique* that plagiarism charges were leveled against Descartes.[156] Further complicating the picture is Thomas Harriot's earlier experimental description of the sine law, although his discovery clearly predates the Snel/Descartes controversy.[157] Unfortunately, no clearly damning or exonerating documents exist to settle the question of Descartes's originality,[158] but circumstantial evidence strongly suggests that Descartes developed his refraction law independent of Snel, although probably a few years later.[159]

However inelegant Descartes's explanation of his refraction law is, there can be no doubt of its significance. Unlike Snel, Descartes knew that he had discovered a completely general and powerful description of the path of light rays within transparent media. Furthermore, Descartes recognizes (albeit backwards) that light changes speed when it passes into a new medium. With the sine law in hand by 1628, he is prepared to take on the vexing question of the rainbow. Here Descartes's application of his method is more straightforward,[160] and it suffers few of the mis-

FIG. 6-4

Within the confines of geometrical optics, René Descartes's model raindrop correctly explains the primary and secondary rainbows. (From René Descartes, *Oeuvres de Descartes*, vol. 6, p. 326, ed. Charles Adam and Paul Tannery [Léopold Cerf, Paris, 1897-1910])

steps that dog his development of the refraction law.

Like many medieval investigators, Descartes settles on a water-filled glass sphere as his model of a raindrop (Fig. 6-4).[161] Although this model is not new, Descartes examines its sunlit properties with unprecedented thoroughness:

> when the sun came from the section of the sky marked AFZ, and my eye was at point E, then when I put this ball in the location BCD, its part D appeared to me completely red and incomparably more brilliant than the rest; and I discovered that whether I approached it or drew back from it, and whether I placed it to the left or right, or even made it turn around my head, provided that the line DE always had an angle of approximately 42° with the line EM, which must be imagined to extend from the center of the eye toward that of the sun, this part D always appeared equally red. But as soon as I caused this angle DEM to become ever so slightly bigger, this red color disappeared. And if I made the angle slightly smaller, the color did not disappear all at once, but rather it first divided into two less brilliant parts, in which one saw yellow, blue, and other colors.[162]

Descartes's analysis is both meticulous and perceptive. He recognizes that a sunlit raindrop always sends him a bright color at a particular angle from the antisolar point (angle DEM), whether DEM lies to his left, right, or any other direction. The volume of rain shown in Fig. 6-4 makes it clear that any suitably located raindrop can accomplish this.[163] Of course, the idea that circular symmetry explains the rainbow's shape dates from Aristotle, and Descartes's rainbow

predecessors had sometimes recognized that spherical raindrops were the rainbow's likely source. However, no one before Descartes had assembled the pieces of the rainbow mosaic so clearly and completely.

Yet Descartes's analysis is not complete. He determines that if DEM is greater than 42°, he receives no light from his model raindrop. But if the drop is at the somewhat larger angle KEM (about 51°), he sees a weaker spot of red light, and as KEM increases he sees the same (although darker) color sequence that occurred when DEM decreased below 42°. From this Descartes concludes that he has simulated the color sequences of both the primary and the secondary bows.[164] Furthermore, Descartes recognizes that it is only the drops' angular distance from him, not their linear distance, that determines which, if any, colors he can see. At this point, Descartes surpasses Theodoric's and Maurolico's understanding of rainbow geometry. Gone are their fictitious altitude circles and fixed planes of raindrops, replaced now by unbounded volumes of rainy air. For the first time ever, Descartes has completely divorced the rainbow's geometry from the shapes of clouds and rain showers.

Still further insights await in Descartes's account. From his knowledge of refraction and reflection, he can accurately predict the path of any ray within the drop.[165] Descartes notes that only when he blocks certain light rays entering, traversing, or exiting the raindrop (that is, rays AB, BC, CD, or DE in Fig. 6-4) can he make the primary rainbow disappear. Similarly, blocking rays along the path FGHIKE eliminates the secondary rainbow, unlike any other shading of the drop. From this knowledge, Descartes can answer the millennia-old question "What causes the rainbow?":

> Therefore the primary rainbow is caused by the rays which reach the eye after two refractions and one reflection, and the secondary by other rays which reach it only after two refractions and two reflections; which is what prevents the second from appearing as clearly as the first.[166]

In other words, the primary rainbow is due to light refracted into a raindrop, internally reflected once from its rear surface[167] and refracted a second time toward the observer. To explain the secondary rainbow, we need only add a second internal reflection between the refractions into and out of the drop. Because each internal reflection is paired with a refraction of light out of the drop, the secondary rainbow will almost always be darker than its accompanying primary.[168] Note too in Fig. 6-4 that the second internal reflection (angle HIK) deviates the sunlight through an angle greater than 180°. As we shall see shortly, this is key to explaining the secondary rainbow's reversed colors.

Had Descartes stopped there, he justly would have been hailed as having mastered the rainbow problem. But as he himself immediately recognized in *De l'arc-en-ciel*, "the principal difficulty still remained, which was to understand why, since there were many other rays there which, after two refractions and one or two reflections, can tend toward the eye . . . it is nonetheless only those of which I have spoken [that is, at angles of 42° and 51°] that cause certain colors to appear."[169] Descartes begins his analysis of this second basic rainbow problem by studying

refraction in a prism. He again has many predecessors who tried this, although none with quite the same insight. Although Descartes's theory of colors is unsatisfactory, he nonetheless takes the well-established fact that a prism refracts red light more than blue and carefully applies this to the rainbow.[170]

Descartes draws several important conclusions from his comparison of a prism and a refracting raindrop. First, the drop's curved surface does not cause the colors, because these are present in light refracted by the triangular prism. Second, reflection is not required to generate colors, because the prism does so without internal reflections. Third, only a single refraction is needed, not several, and equally important, a second refraction does not eliminate the colors produced by the first.[171] Finally, Descartes incorrectly states that only a narrow band of light passing through the prism can generate colors. He somehow persuades himself that if the slit generating the band is too wide the colors disappear, yielding only white light.[172] However, Descartes rightly concludes that his observations of refraction by prisms can be extrapolated to refraction by raindrops.

To do so, Descartes revisits the model of light he developed in *La dioptrique*. He imagines light to result from small spheres of elemental air that transmit pressure from a light source.[173] Of these spheres of air, he says that light causes "the action or movement of a certain very fine material whose particles must be pictured as small balls rolling in the pores of earthly bodies."[174] These balls all touch, so that they share one another's speed and rotation, and they impart different properties to transmitted light via changes in their rotational speeds.[175] When the balls encounter the edge of a slit that covers a prism, Descartes believes that any ball next to the slit begins to rotate.[176] According to Descartes, this ball's neighbors either slow down or speed up its rotation, thereby producing a color. Similar changes in the rotational speeds of other balls across the slit yield the range of prismatic colors.[177] Descartes is somewhat equivocal about the role of the prism slit. He believes that he cannot produce a spectrum without the slit, yet it plays hardly any role in his tortuous explanation of prismatic colors. As for other kinds of colors, Descartes admits that "shadow and refraction are not always necessary to produce them; and that instead . . . the size, shape, situation, and movement" of the particles that compose a material somehow determine its non-prismatic colors.[178] As ingenious as Descartes's rotating-ball analogy is, it makes no mechanical sense,[179] leaving astute readers more perplexed about color formation than before.

Descartes's flawed color model at least replaces Neoplatonic species with a purely mechanistic theory of light that anticipates its more realistic successors.[180] Descartes takes a long-overdue swipe at Scholastic optics when he compares its "real" surface colors and "apparent" prismatic colors:[181] "I cannot approve the distinction made by the [Scholastic] philosophers when they say that there are some true colors, and others which are only false or apparent. For because the entire true nature of colors consists only in their appearance, it seems to me to be a contradiction to say that they are false, and that they appear."[182] (Recall that Kepler had earlier raised the same well-founded objection.) Even though Descartes cannot successfully describe the

FIG. 6-5

Rays of parallel sunlight refracted and reflected by a spherical raindrop shown in circular cross section. For a single internal reflection, light's minimum deviation is about 138°, which determines the location of the primary rainbow (ray **M**).

causes of rainbow colors, he makes them just as real as those of objects.

Having correctly described (although not explained) prismatic refraction, Descartes now integrates this with his geometric analysis of refraction and reflection within a raindrop. Here his resolve in the *Discours* to "divide each of the difficulties that I examined into as many parts as possible"[183] bears its greatest fruit. He is perplexed that raindrops do not offer "any shadow which cut off the light"[184] in the same way that the slit mounted on his prism does. In other words, where in the raindrop is the opaque edge that Descartes incorrectly assumes is required to generate refractive colors?[185] Although this edge eludes him, he nonetheless finds the answer he really seeks when he has "taken my pen and calculated in detail all the rays which fall on the various points of a drop of water, in order to see under what angles they could come toward our eyes . . . , I found that after one reflection and two refractions, very many more [rays] can be seen under the angle of 41° to 42° than under any lesser one; and that none of them can be seen under a larger angle."[186]

Thus a great clustering of refracted and internally reflected rays between 41° and 42° from the antisolar point produces the concentrated rainbow light. At larger angles, Descartes finds no light, and this "Cartesian shadow" is the clearly defined outer edge of the primary rainbow. When Descartes patiently traces the paths of rays that undergo two internal reflections, he finds that "very many more of them come toward the eye under a 51° to 52° angle, than under any larger one; and no such rays come under a lesser."[187] In other words, the secondary rainbow's

inner edge is at about 51° from the antisolar point, 9° outside the primary rainbow's outer edge. Certain that he has found his requisite shadows, Descartes nonetheless recapitulates his painstaking geometry on pages that follow, "so that those who know mathematics can see whether the calculation I have made of these rays is sufficiently exact."[188] Descartes presumably would have been stunned to know that Thomas Harriot performed essentially the same calculations decades earlier (although Harriot never published his work).[189] Yet Descartes does give the first satisfactory explanation of Alexander's dark band, because his theory explains why sunlit raindrops send us almost no light in this approximately 9°-wide region between the bows.

Figure 6-5 is a modern-day version of Descartes's ray-tracing exercise for the primary rainbow. In it we show a circular cross section of a spherical raindrop that is illuminated by parallel rays of sunlight.[190] A ray that arrives on the drop's axis is turned or deviated[191] by 180° when it is reflected once from the drop's rear surface. However, because $i = 0°$, this light is not refracted. The farther the incident ray is from the raindrop's axis, the *smaller* the deviation that results from two refractions and one internal reflection. In other words, the greatest deviation is 180° for the on-axis ray. Rays entering the drop more obliquely must be deviated *less* than 180° because their direction after exiting the raindrop is closer to that of direct, undeviated sunlight. Notice the ever-diverging angles between the incident (incoming) and deviated (outgoing) rays for rays Q through M in Fig. 6-5. These are ever-decreasing deviation angles, but when the deviation drops to 138° (ray M), it decreases no further. Any ray that enters the drop farther from its axis (for example, ray L) undergoes a deviation *larger* than 138°. So the ray deviated by 138° is indeed special; it undergoes the smallest bending of all. Called the *minimum deviation ray*, it is the ray responsible for the rainbow.[192]

In Fig. 6-6 we show the minimum deviation ray of red light, which is 138° from the sun or 42° from the antisolar point. (The light gray lines extending from Fig. 6-6's raindrop simply show the angle through which the minimum deviation ray is bent; they are not light rays themselves.) Near the minimum deviation ray is the clustering of rays that Descartes observed as the primary rainbow. In Fig. 6-5, two of these rays are drawn as dashed lines. Notice that they are nearly parallel to each other and to the minimum deviation ray, meaning that a large amount of light comes to us from the direction that is 138° from the sun or 42° from the antisolar point. As Descartes correctly reasoned, this bright light constitutes the rainbow.

The last major question remaining for Descartes is why the color orders of the two rainbows differ. Because he knows that a prism refracts red through a smaller angle than violet, he tries to extrapolate what he has seen there to a raindrop. His instincts here are good—in fact, red is seen on the outside of the primary rainbow because it is refracted *less* than other colors. In Fig. 6-6, the solid line shows the path of red light at minimum deviation, and the dashed line shows the path of violet light. We say that the violet ray is bent through a larger angle because it more nearly approaches the backward direction, the direction opposite undeviated sunlight.

Because red's refraction is the smallest of any color's refraction at a given i, red's minimum deviation angle is also the smallest, placing it *nearest* the sun and *farthest* from the antisolar

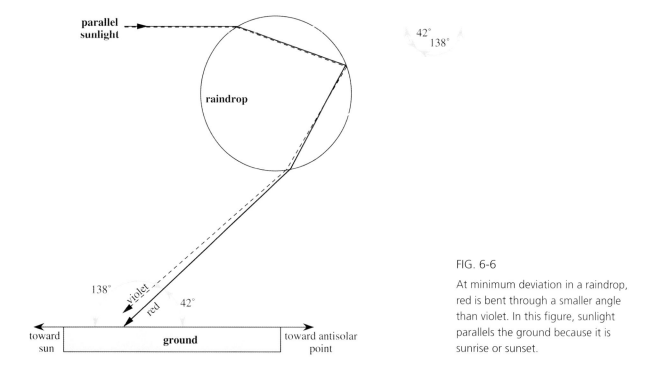

FIG. 6-6

At minimum deviation in a raindrop, red is bent through a smaller angle than violet. In this figure, sunlight parallels the ground because it is sunrise or sunset.

point (that is, it is on the primary rainbow's exterior). Conversely, because violet is refracted more than any other color, its minimum deviation angle is the largest, placing violet farthest from the sun and nearest the antisolar point (that is, on the primary's interior). Light of all different colors exits every drop through a range of minimum deviation angles, but only when a particular color's minimum deviation ray enters our eye do we see that ray's color. For example, in Fig. 6-7 only rays r_1 and v_2 enter our eye, yielding red in the direction of r_1 (the primary's outside) and violet in the direction of v_2 (the primary's inside). Other red and violet rays (for example, rays r_2 and v_1) pass either below or above our eyes, so we do not see their light. Descartes uses some of this logic in deciphering the rainbow's color order, but ultimately his explanation suffers because he never couples a ray's deviation to its color.[193]

Instead, Descartes implies that the color order of refracted white sunlight depends solely on where rays enter the drop (in modern terms, the incidence angle i).[194] Because he knows that *some* difference in the incident white light must cause its color separation, this mistake is understandable. Nevertheless, it hobbles his rainbow theory. Descartes can only weakly offer that red appears on the primary's outside because, as is true in his sunlit prism, a red ray traverses a thinner portion of the refracting medium than the blue ray.[195] Because a raindrop is thickest at its diameter, and because the diameters of drops that contribute to the rainbow's red are outside the primary rainbow (see Fig. 6-7), Descartes reasons that red rays must appear on the primary's exterior. Conversely, because the diameters of drops contributing to the secondary rainbow are inside the radius of that rainbow, red must appear on its inside (see Fig. 4-3 for positions of the secondary and primary rainbows' raindrops).[196] As plausible as this explanation sounds, it also

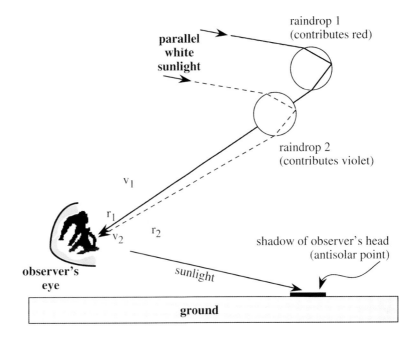

FIG. 6-7

Two drops of many that contribute to the mosaic of rainbow colors. Because red has a smaller minimum deviation angle than violet, the rainbow's red is closer to the sun (that is, on the outside of the primary rainbow).

holds for drops causing the primary rainbow's *violet* rays (that is, their diameters are outside the violet band, as Fig. 6-7 indicates). Descartes's explanation in fact yields *no* particular color order, whether for the inner or outer rainbow. In his October 1629 letter to Mersenne, Descartes not surprisingly reveals that "the explanation of the colours of the rainbow has given me more trouble than all the rest."[197]

The secondary rainbow's reversed colors actually arise in the same way as those of the primary rainbow: red light at minimum deviation is bent less than blue light, and thus red appears closer to the sun. However, because minimum deviation rays for the secondary bow are bent through more than 180° (see Figs. 4-3 and 6-8), "closer to the sun" now means that red appears on the secondary rainbow's inner edge. In essence, deviating sunlight through more than 180° turns the rainbow colors inside out.[198] Descartes knows that light forming the secondary rainbow is deviated through more than 180°,[199] but he seems not to appreciate the significance of his own geometry.

Visually speaking, no point in the sky appears to be more than 180° from any other point (for example, the sun and antisolar point at sunset are two such extreme points), even though light rays themselves can be deviated through 360° or more. Unlike colors of most tangible objects, we cannot easily decipher the angular deviation of celestial color patterns. For example, consider a small stained-glass window that we hold before us perpendicular to the ground. If we rotate the glass 180° like a paddle wheel, its pattern of transparent colors turns upside down. Understanding this color reversal is quite easy, but if we substitute the secondary rainbow's disembodied colors for those of the colored glass, we confront a color reversal that defies easy interpretation.

Perhaps anxious to be done with difficult rainbow questions, Descartes immediately fol-

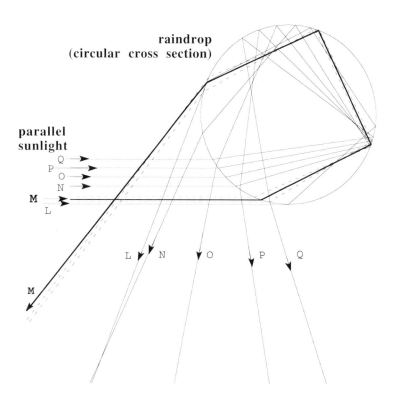

FIG. 6-8

Rays of parallel sunlight refracted and reflected twice by a spherical raindrop. For two internal reflections, light's minimum deviation is about 231°, and this determines the location of the secondary rainbow (ray **M**).

lows his garbled explanation of its color sequence with a confident statement: "Thus, I believe that no difficulty remains in this matter, unless it perhaps concerns the irregularities which are encountered [in the rainbow's shape and position]."[200] Much more indeed remained, as we will see. Yet Descartes, despite occasional missteps, did what no one before him could—he clearly laid out a mechanistic, microscopic theory of the rainbow that is still valid and useful today. Despite his failed color theory, Descartes understands the rainbow's fundamental geometry well enough that he can explain many of its features and predict its behavior. In fact, he concludes *De l'arc-en-ciel* by accurately describing the appearance of a rainbow fountain[201] and a rainbow formed by reflected sunlight,[202] even though he has seen neither.

With the benefit of hindsight, we can see that Descartes's theory is a pivotal moment in the rainbow's scientific history. True to Descartes's own high expectations of his work, modern writers still view it as "a triumph of his scientific method"[203] that skillfully marries careful observation and mathematical analysis. What did Descartes's contemporaries think? Carl Boyer notes: "In some quarters the work of Descartes remained unappreciated until well into the second half of the [seventeenth] century, in others it was actively opposed."[204] As evidence of this cool reception, Boyer offers some half-dozen rainbow theories from the mid-seventeenth century that variously ignore, dismiss, or reject Descartes's work,[205] their authors often invoking Scholastic or Neoplatonic arguments to explain the rainbow. At least one French scientist, Pierre Gassendi (1592–1655), took Descartes's rainbow theory to be authoritative.[206] Given Gassendi's interest in replacing Aristotelianism with a mechanistic atomism, it is not surprising that he

finds Descartes's approach commendable. The Jesuit mathematician Jean Ciermans (1602–48) effusively praised the rainbow theory of *Les météores* as an instance where Descartes's "brilliance, above all, appears."[207] Although scarcely a rainbow prophet without honor, Descartes would never realize his hopes for universal acclaim.[208] The synonymous pairing of "Descartes" and "rainbow" would come only in later generations, for in the mid-seventeenth century the Aristotelian rainbow remained a fixture of the intellectual landscape.

Isaac Newton and the Coloring of the Cartesian Rainbow

In the decades after Descartes's death, this landscape began to change. Throughout European science, Aristotelian views were increasingly seen as not only wrong but also irrelevant. As Aristotle himself had advocated, the senses were to be the first test of natural philosophy. And sense information, winnowed by mathematical analyses like those of Descartes's, showed far more promise than did the tired Scholastic permutations of Aristotelian science. The medieval enthusiasm for ancient authority ebbed rapidly, replaced by a keen desire to analyze nature at first hand.[209]

By the late seventeenth century, the more plausible parts of Descartes's rainbow theory had all but replaced their Aristotelian counterparts. Scientists ranging from Francesco Grimaldi (1618–63), discoverer of diffraction,[210] to Edme Mariotte (1620–84), co-discoverer of Boyle's law, borrowed either implicitly or explicitly from Descartes's theory.[211] By 1681, Mariotte could confidently write: "There are few scientists who are not satisfied by the explanation of Descartes."[212] In 1693, the influential Dutch scientist Christiaan Huygens (1629–95) noted: "The most beautiful thing that [Descartes] has found in physical matters, and that alone perhaps was well met, is the explanation of the double rainbow, i.e. with regard to the determination of its angles or apparent diameters." Of Descartes's dubious color theory, however, Huygens bluntly said that "nothing is less probable in my opinion."[213] Huygens's own theory of light, when transformed by nineteenth-century optics, would offer the first substantial progress beyond the Cartesian model of the rainbow.[214] Huygens himself found little to fault in Descartes's rainbow beyond its color notions, and his immediate contribution to the rainbow was to greatly simplify Descartes's tedious calculation of minimum deviation rays.[215]

Nevertheless, a truly satisfactory account of the rainbow's colors had yet to be joined to Descartes's rainbow geometry. For example, Grimaldi could add only a quasi-Aristotelian theory of dense red rays and sparse violet rays (bright and dark rays, respectively) to his Cartesian rainbow.[216] Equally unsatisfactory was Mariotte's unwieldy scheme in which separate white and colored light rays were governed by different laws of refraction. Yet even such awkward contrivance did not keep Mariotte's rainbow theory from prominence in the late 1600s.[217] Remarkably, the first acceptable theory of rainbow colors languished even as Mariotte's flourished. To understand this curious state of affairs, we must move from the Continent to Stuart England and examine the evolution of Isaac Newton's groundbreaking optics.

Within the vast scope of Newton's scientific interests, the colors of the rainbow emerged

early on. While still an undergraduate at Trinity College in Cambridge, Newton was drawn to the problems that color posed both philosophically and practically. As we have seen in Descartes's case (and will see again in Chapter 7), Aristotelian notions of color contrasted starkly with the models of light emerging in the new optics.[218] These mechanistic theories of light, despite their flaws, were supplanting the older models. This transformation occurred in part because optical devices such as the telescope and microscope were dogged by persistent color distortion problems.[219] Multiple, overlapping colored images of stars and planets were the bane of early telescopic astronomy. In modern terms, this *chromatic aberration* arises because light's index of refraction varies with wavelength. Thus in simple refracting telescopes, different wavelengths are focused by different amounts, producing confused, overlapping images, and a major optical problem of Newton's day was designing an error-free *achromatic lens*. Although Newton would ultimately and incorrectly maintain that chromatic aberration posed insurmountable problems for refracting telescopes, refractive colors were key to his early optical interests.[220]

Newton's ideas on color first appear in 1664–65 notebook entries that describe his student readings and experiments. In these entries, the *Questiones quaedam philosophicae* (Certain Philosophical Questions),[221] Newton weighs not only the traditional Aristotelian explanation of color but also the most recent writing on color, Robert Boyle's 1664 *Experiments and Considerations Touching Colours*.[222] Boyle's considerable influence is evident in the *Questiones*, yet Newton's notes are far more than diligent student paraphrases.[223] Whether due to oversight or unfavorable opinion, Newton does not mention Descartes's color theory. In a slightly later manuscript (1665–66), Newton does cite Descartes's observations of sunlight refracted by a water-filled glass sphere as the explanation for the rainbow.[224] Whether significant or not, Newton begins the *Questiones* where he suddenly ends his gloss on the Scholastic commentator Johannes Magirus (d. 1596)—at Magirus's notes on apparent colors.[225]

While Newton labeled one short section in the *Questiones* "Of Species Visible," he has in mind no Neoplatonic notions of light. Rather, he uses Scholastic terminology merely to advance a corpuscular theory of light, then quickly moves on to the more interesting task of describing his own observations on vision and subjective colors.[226] In a subsequent section entitled "Of colors," Newton firmly rejects the Aristotelian model of color formation (unlike Boyle), saying: "No color will arise out of the mixture of pure black and white, for then pictures, drawn with ink would be colored, or printed would seem colored at a distance, and the verges of shadows would be colored, and lamp-black and Spanish whiting would produce colors."[227] The young Newton also rejects, if only tacitly, Descartes's notion that colors somehow require shadow edges.

When Newton turns to experiments with prisms, his ingeniousness is evident. A later *Questiones* section (also entitled "Of Colors") summarizes fourteen separate trials in which Newton abuts pairs of colors (or black and white) and then views the color boundary through a prism. His analysis of the resulting colored fringes (called boundary colors) reveals a clear, if not yet definitive, understanding of refraction.[228] Furthermore, although Newton uses a corpuscular theory of light whose flavor is Cartesian,[229] his experiments lead him to the distinctly un-Carte-

sian conclusion that "slowly moved rays [that is, blue] are refracted more than swift ones [that is, red]."[230] (In fact, only *within* a refracting medium such as glass or water does light's speed vary with color.) At this stage, Newton does not seem to believe that any given ray must have a unique speed (and thus color), but merely that a ray's ability to evoke color depends on its speed.[231]

Although Descartes had also observed prismatic colors, he never associated them with differences in light's propagation speed, attributing them instead to differences in spheres' rotation speeds. Newton's nascent ideas about colors have the advantage of being more realistic, even though his assumptions about what causes light to be refracted are just as speculative as Descartes's.[232] Nevertheless, the fact that refraction depends on color (wavelength, strictly speaking) is crucial to explaining the rainbow correctly. In 1664, the young Newton already has the germ of this idea.[233]

A second experiment in "Of Colors" makes Newton's advance even clearer: "That the rays which make blue are refracted more than the rays which make red appears from this experiment: If one half of the thread *abc* is blue and the other red, and a shade or black body be put behind it, then looking on the thread through a prism one half of the thread shall appear higher than the other, and not both in one direct line, by reason of unequal refractions in the two differing colors."[234] In other words, the horizontal thread appeared broken when Newton viewed it through a prism whose axis was also horizontal (Fig. 6-9). The thread's red side appears either lower or higher than the blue, depending on whether the prism's apex points up or down, respectively. Because red light is refracted *less* than blue, red is *closer* to the path that undeviated light would follow between the source (the thread, here) and eye. Thus in Fig. 6-9 the thread's red side appears below its blue side, closer to the direction of undeviated light. Except for the fact that light reflected by the thread toward the prism will diverge more than sunlight, we see the same refraction pattern in Fig. 6-9 as in Fig. 6-7, our diagram of the rainbow's color order (recall that the rainbow's red is closer to the sun's direction than is its violet).

Newton may not have fully appreciated the details of this disarmingly simple experiment,[235] especially that there are small differences in the angles of incidence *i* of red and blue light. Nevertheless, even if he missed such a nuance, Newton is absolutely correct that the amount of refraction depends on color, with blue light refracted more than red. Newton honored this simple experiment years later by citing a variation on it in his seminal *Opticks*.[236] So impressed was he by this apparently inescapable relationship between refraction and color that, at least publicly, he denied the possibility of making practical achromatic lenses. Instead, he turned his attention to constructing a reflecting telescope that avoided such problems.[237]

In early 1665, shortly after Newton recorded his first ideas on color, the eminent English scientist Robert Hooke (1635–1703) published his *Micrographia* (Small Drawings). Largely devoted to cataloging Hooke's voluminous microscopic observations, *Micrographia* also included his speculations on color vision and color.[238] In contrast to Newton, Hooke's views had a distinctly Scholastic flavor. For example, Hooke believed that light was composed of pulses (rays of finite width) and that colors occurred when these pulses became "confus'd."[239] Colors arose when a ray's finite-width front was oblique, rather than perpendicular, to the ray's direction.

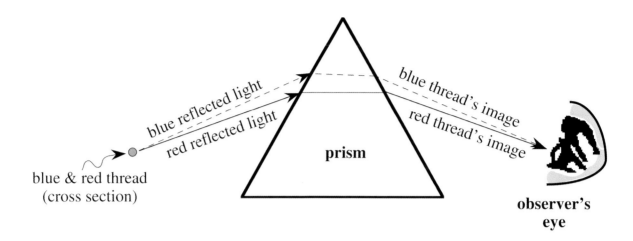

FIG. 6-9

Isaac Newton's demonstration that red and blue light are refracted by different amounts. As in the rainbow, because red light is refracted less than blue, red appears closer to the light source's direction (the thread, here). Thus the thread's red side appears below its blue side. (Angular differences between rays have been exaggerated.)

Refraction changed the ray-front angle because the ray changed direction while its front did not. Blue and red differed because their ray-fronts sloped differently, and other colors were the result of mixing these two extremes on the retina.[240] In this, Hooke shares Boyle's Aristotelian belief that colors are the result of somehow modifying pure white light.[241]

Newton, however, was on the verge of making a break with Aristotelian tradition, even though he does not do so explicitly in the *Questiones*.[242] For Newton, white light such as sunlight is *not* the pure, homogenous font of colors that Aristotle imagined. Instead, it is white light that is "confused," a heterogeneous mixture of prismatic colors.[243] Newton hints at this in the *Questiones*, suggesting that we "Try if two prisms, the one casting blue upon the other's red, do not make a white."[244] Despite his clear differences of opinion with Hooke, when Newton first read *Micrographia* in 1665[245] he had no reason to quarrel with the renowned scientist. Within a decade, though, misunderstandings and mutual arrogance would taint the two men's professional and personal dealings.[246]

When plague came to Cambridge in 1665, the university closed. Newton, who had graduated that April, retreated with his remarkable (although unpublished) scientific ideas to the relative safety of his family's manor house near Woolsthorpe, Lincolnshire. At Woolsthorpe manor, Newton had earlier proven himself a failure as a gentleman farmer,[247] yet now in its rural isolation he managed to nurture his skills as a scientist and mathematician.[248] Years later, Newton sought to withdraw from the public eye in order to bolster his intellectual, rather than physical, vitality. Much as Descartes had, Newton later resolutely avoided the inquiries of importunate correspondents.[249] Yet success for Newton required that he ascend the university hierarchy, so he began his climb when Cambridge reopened in 1667.

By October 1667, Newton had been elected a minor fellow of Trinity College, the first step

upward within Cambridge's elaborate academic structure. Cambridge was not a robust institution in the late seventeenth century, beset as it was by political intrigues, crown patronage, and a torpid academic system in which senior fellows and professors often idled through appointments that they treated as sinecures.[250] As an undergraduate, Newton had largely isolated himself from the formulaic Scholasticism that ruled the university by engaging in rigorous self-study like that which produced his *Questiones*.[251] As Newton biographer Richard Westfall dryly notes, when Newton returned to Cambridge, a "philosopher in search of truth, he found himself among placemen in search of a place."[252] Not surprisingly, Newton largely withdrew from the company of Trinity's academic mercenaries and immersed himself in studies of chemistry and mathematics.[253]

Newton's evident mathematical ability brought him to the attention of Isaac Barrow (1630–77), Lucasian Professor of Mathematics at Trinity.[254] Barrow had use for Newton's optical prowess in 1668 (or 1669), when Newton helped him prepare Barrow's lectures on optics for publication.[255] An ambitious man, Barrow had set his sights even higher than his already prestigious chair. So in October 1669 Newton, surely helped by his close relationship with Barrow, was appointed to the Lucasian chair as Barrow moved up.[256] Newton's new professorship specified not only teaching duties and office hours but also that he deposit copies of his lectures in the university library.[257] Like Barrow, Newton chose to prepare a series of lectures on optics. These *Optical Lectures* exist in two forms: Newton's shorter manuscript, the *Lectiones opticae*, and the University's later, expanded *Optica*. Together these two manuscripts span the years 1670–72,[258] and they include Newton's first detailed explication of the sketchy color theory first voiced years earlier in his *Questiones*. Although the *Lectures* remained unpublished in Newton's lifetime, they represent the zenith of his interest in optics and colors. Furthermore, they are also the basis for his first publication on the subject, a revolutionary letter on refraction and color published in February 1672 in the *Philosophical Transactions of the Royal Society*.[259] We examine the repercussions of his letter, Newton's "New Theory of Light and Colours," later in this and the next chapter, but for now we look at its antecedents.

In the *Questiones*, Newton's investigations of spectral colors were largely confined to colors seen while looking through prisms, rather than those projected by a prism onto a screen.[260] In later notes (1665–66), Newton analyzed projected spectra extensively,[261] and those are the observations that drove his subsequent work on colors. Newton begins the *Lectiones* with a characteristic combination of humility and high-handedness. After apologizing for revisiting the well-trammeled ground of telescope optics, Newton dismisses attempts to avoid spherical lenses' deficiencies by grinding lenses with other curvatures: "It is, to be sure, a futile endeavor, and lest they devote their efforts any longer to a hopeless occupation, I venture to promise them that even if everything were to turn out thoroughly successfully, it still would fall far short of their expectations."[262]

The problem that Newton defines here is chromatic aberration: "Concerning light, therefore, I have discovered that its rays differ from one another with respect to the quantity of refraction: Of those rays that all have the same angle of incidence, some will have an angle of

FIG. 6-10

Newton's demonstration that differential refraction broadens the sun's circular image into an oblong (*Lectiones opticae*, figure 2). By permission of the Syndics of Cambridge University Library

refraction somewhat larger than others."[263] Although Newton's pronouncements (or perhaps posturings) about the inevitability of chromatic aberration in lenses are wrong,[264] we now know that they are paired with a great optical success—explaining the rainbow's colors. After methodically discussing how refraction separates sunlight into its constituent colors (in modern terms, *dispersion*), Newton concludes: "Hence, insofar as the rays are so disposed that some are refracted more and more than others, they generate in order these colors, red, yellow, green, blue, and purple, together with all the intermediate ones that can be seen in the rainbow. The production of the colors of the prism and rainbow will be readily evident from this, but having now perfunctorily noted these things, I postpone what I have to say about colors for later."[265]

Thus with a nonchalant wave of the writer's hand, Newton completes the geometrical optics explanation of the rainbow. In fact, the *Lectiones* offers more assertion than explanation of the rainbow (he would return to the rainbow in *Optica*), and Newton quickly presents further demonstrations of differential refraction "lest you think that I have set forth fables instead of the truth."[266] First, Newton describes a spectrum demonstration that will reappear in both his "New Theory" letter and *Opticks* (Fig. 6-10):

> In the wall or window of a room, let F be some hole through which solar rays OF are transmitted. . . . Then place at that hole a triangular glass prism AαBβCκ that refracts the rays OF transmitted through it toward PYTZ. You will see these rays . . . formed into a very oblong figure PYTZ, specifically, one whose length PT is four times and more its breadth YZ. Hence, this definitely appears to establish that at equal incidence some rays undergo a greater refraction than others; for if the contrary were true, that solar image would seem almost circular.[267]

Although he is a little tentative ("definitely appears to establish") and his minimum ratio YZ:PT will later change to nearly 1:5,[268] Newton is essentially correct: if refraction did *not* vary with color, the image of the sun's disk could be made circular for some prism orientation.[269] In other words, if refraction deviated all the sun's rays by equal angles, the result would simply be a colored, circular image of the sun. Because Newton cannot make the sun's refracted image circular, he is convinced that rays producing different colors are refracted by different amounts. Furthermore, the order of refracted colors does not depend on the sunlight's incidence angle i. But Newton does not rest merely on demonstrations and plausible qualitative claims. In a lengthy geometrical argument, he shows that the "received view" of refraction must produce a nearly circular solar image for one i.[270] In particular, the "received view" predicts a circular image when a ray coming from the middle of the sun undergoes minimum deviation.[271] That Newton cannot produce this circular image leads him to conclude that conventional wisdom about refraction "is contrary to the truth, and the [angle of] refraction at the same incidence varies."[272]

What of Descartes's (and others') implication that dispersion depends on small differences in i? Because i varies slightly in Figs. 6-9 and 6-10, could this generate the different refracted colors? Furthermore, might not the sun's diameter of half a degree account for the elongation of the spectrum? In other words, because the sun's measurable width results in rays that are not parallel, perhaps this angular divergence causes the oblong spectrum. Newton acknowledges that the sun's angular size and angular divergence of sunlight produce the *width* (rather than the extended length) of the spectrum. The spectrum's length is another matter. In earlier experiments where he collimated sunlight by placing an aperture between his shutter (hole F in Fig. 6-10) and prism, Newton had anticipated such objections.[273] This aperture reduced the divergence of sunlight to about one-tenth of a degree, all but eliminating changes in i across the prism. Significantly, although the sun's smaller image produced a spectrum of smaller length and width, the *ratio* of width to length remained virtually unchanged, thus reinforcing Newton's position. Finally, in a 1672 letter, Newton describes transmitting the magnified image of Venus through a prism, noting that the planet's rays were "much lesse inclined one to another" than the sun's rays. Once again, the projected spectrum was asymmetric, being "drawn out into a long splendid line by the Prisms refraction."[274] Faced with such compelling arguments, only the most obstinate could still support the Cartesian view of refraction. With his rigorous combination of optical and geometric demonstration, Newton could legitimately claim that parallel white light was indeed refracted into an elongated spectrum, and that these differentially refracted rays caused different colors.

Elsewhere in the *Lectiones* and *Optica*, Newton lays out more details of his evolving theory of colors. Newton now forges into uncharted terrain—there is no contrary tradition or person to react against, only the unknown nature of light and color. Undaunted by the task he has set himself, Newton confidently establishes several fundamental and original color principles. First, he shows that spectrum colors are immutable in the sense that they cannot be further divided, nor can their color be changed by reflection or refraction. Newton demonstrates that successive

refractions do not yield new spectral colors, but instead merely bend the existing colors.[275] In his 1672 "New Theory" letter, Newton describes this as his "experimentum crucis,"[276] and indeed it is a crossroads experiment for Newton, because it convinces him that spectral colors are the most fundamental, irreducible components of white light. In another ingenious experiment, Newton works in a darkened room where he shines prismatic blue, then red, on a paper covered with separate areas of red and blue paint. In blue light, both paints look blue, although the "red paint afforded much the fainter & darker blew." (Newton has already established that the paints look equally bright in white light.) Similarly, when red light illuminates the paints, "they both appeared perfectly red but the painted blew afforded much the fainter Red."[277] Thus prismatic colors reflected by objects could not be altered by the reflection, except to change their brightness. Although Newton does not explicitly note this, his remarkable observation clearly contradicted Scholastic tradition, which maintained that color was an inherent property of objects, not their illumination.

Newton's second novel principle is that sunlight must be a heterogeneous mixture of spectrum colors, and that these colors are inherent in white light even though they are invisible before refraction.[278] As in his earlier arguments about refrangibility, Newton makes the case for these color ideas with a combination of inspired insight and methodical thoroughness. To demonstrate that compounded spectrum colors produce white, Newton takes several different tacks. In one experiment, he partially overlaps the spectra of three prisms. As Fig. 6-11 shows, in the overlap's central region, "where the Reds, yellows, Greenes, blews, & Purples of the severall Prismes are blended together there appeares a white."[279] In a variant on this, Newton cuts small horizontal slits at different vertical positions in a piece of paper and then covers a prism's illuminated face with the paper. If a screen (such as a second piece of paper) is held close to the illuminated prism, the slits project separate colored lines onto the screen. At greater distances, these lines merge to produce a central region of white that is flanked by red and blue. As screen distances increase, the white region becomes narrower until it ultimately vanishes, leaving only adjacent areas of blue and red.[280] In a corollary of these two experiments, Newton cleverly shows that spectrum colors are not destroyed when they mix to form white light. He focuses a prism's refracted light with a lens to produce a spot of white light near the lens' focus. By interposing a toothed wheel between the lens and prism, Newton blocks some of the spectrum colors and thus changes the white spot to a colored one. When the wheel rotates *slowly*, the lens projects a slowly varying succession of colors. However, when the wheel spins rapidly only white is visible, even though not all colors are present at once in the spot.[281]

As remarkable as the material on colors in the *Optical Lectures* is, at best it would have been available only to the Trinity denizens brave enough to take on its difficult, radical ideas.[282] Newton was, after all, overturning millennia of conventional Aristotelian wisdom about the nature of color. Eager to share his hard-won insights with a wider audience, Newton described his "New Theory" in a letter to Henry Oldenburg (1626–78), Secretary of the Royal Society.[283]

FIG. 6-11

In one of Newton's demonstrations of sunlight's compound nature, the central region of three prisms' overlapping spectra is white. (Reprinted, by permission, from J. E. McGuire and Martin Tamny, *Certain Philosophical Questions: Newton's Trinity Notebook*, p. 478. Copyright © 1983 by Cambridge University Press)

Although Newton had reservations about printing the letter in the Society's *Philosophical Transactions*, publication would give him the audience he sought. In his letter, Newton with missionary zeal briefly summarized his several years of painstaking work on colors.[284] However, he strikes the disingenuous pose that his labors were actually a rapidly unfolding chain of inexorably linked insights. Unfortunately, Newton's letter omits some of the clarifying diagrams so prominent in the *Lectiones*. Newton would later admit to Oldenburg that some of the "New Theory" experiments "may seem obscure by reason of the brevity wherewith I writ them wch should have been described more largely & explained with schemes if they had been then intended for the publick."[285]

Scientific reaction to the "New Theory" was scarcely the seamless flow of accolades that Newton might have expected (we consider how the theory was received by artists in Chapter 7). In fairness, our own satisfaction with Newton's ideas may owe as much to knowing that he is correct as to the logic of his arguments. For example, is there any iconoclasm in showing that a second prism simply bends (rather than further disperses) refracted colors?[286] From a Scholastic standpoint, we might maintain that once white light has been modified (not merely analyzed) by a prism, one should not expect to modify it by a second refraction. Furthermore, white light does *not* look like a heterogeneous mixture of many colors, but rather like an entirely different kind of homogeneous light.[287] Thus Newton's contemporaries can be forgiven for viewing his work

not as prescient but merely as one of several plausible color theories.[288] To further aggravate matters, the condensed form of Newton's letter made for easy misinterpretation, as the confusion on the part of both Huygens and the Jesuit scholar Ignace Pardies (1636–73) would soon demonstrate.[289]

Although praise for Newton's "New Theory" was often enthusiastic, it was far from universal. Huygens quickly offered qualified praise for the young Cambridge professor's iconoclastic work, although he and Newton later disputed some of its fundamental implications.[290] A week after Newton's "New Theory" had been read to great acclaim before the Royal Society, the influential Hooke read his own letter to the Society.[291] Writing to Oldenburg (who transmitted the letter to Newton), Hooke defensively notes his own "many hundreds of tryalls" on refraction and colors, agrees with Newton's conclusions when convenient, and vigorously rejects them when it is not.[292] Hooke's flawed ideas in *Micrographia* do contain a germ of the wave theory of light that would supplant Newton's corpuscular theory in the nineteenth century.[293] Yet Hooke's claims were more plausible than proven,[294] and Newton found this lack of rigor intolerable, an attitude doubtless fostered by Hooke's condescension. Thus Newton wrote to Oldenburg in June 1672 that Hooke "knows well yt it is not for one man to prescribe Rules to ye studies of another, especially not without understanding the grounds on wch he proceeds."[295]

Newton found the reactions of others to the "New Theory" no less provoking. Over the next six years, various inept or confused correspondents occasionally agitated him about the validity of his conclusions.[296] In fact, although Newton had considered publishing *Optica* in early 1672, the anxieties and upsets generated by his "New Theory" persuaded him otherwise. When a friend offered in April 1672 to arrange for *Optica* to be published, Newton demurred, saying that he had found "already by that little use I have made of the Presse, that I shall not enjoy my former serene liberty till I have done with it."[297] If Oldenburg had not deleted two sentences from Newton's "New Theory" letter before publication, Newton's serenity might have been even more disturbed. At one point Newton confidently asserts: "A naturalist would scearce expect to see ye science of those [colors] become mathematicall, & yet I dare affirm that there is as much certainty in it as in any other part of Opticks."[298] What Newton means here by a mathematical color science is that a formula describing dispersion (that is, how a medium's refractive index n varies across the spectrum) could be joined to the sine law and thus completely specify refraction of colors between any two media.[299] However, despite his promise that colors could be described mathematically by "most rigid consequence," Newton never established a general law of dispersion, nor did he adequately test those that he assayed.[300] Thus Newton failed in his quest to find a general mathematical relationship between color and refraction, and his attempts to do so were confined to the unpublished pages of the *Optical Lectures*.

Given Newton's sensitivities and the furor that attended even his limited quantification of colors, this failure may have been a kindness. Certainly by the early 1690s, when Newton had begun to codify and revise his earlier work for *Opticks*, he abandoned some of the bolder claims made in the "New Theory." Absent from *Opticks* were assertions that spectral colors could be

proven immutable and innate in sunlight, replaced by numerous demonstrations that many different color mixtures *could* produce white.[301] If it was impossible to prove that sensibly homogenous white light was in fact heterogeneous, Newton could at least make the case that this was nearly certain.[302] Yet the notoriety attending the "New Theory" had not translated into its widespread acceptance, and Newton refrained from publishing more on light and colors. Newton's innate cautiousness about publication, his fractious relationship with Hooke, and other factors[303] kept *Opticks* from the presses until 1704, the year after Hooke's death. With the troublesome Hooke gone and Newton's reputation as Europe's premier scientist established, *Opticks* was widely greeted as the definitive work on catoptrics, dioptrics, and color. In fact, the book still bore some of the subtle inconsistencies and shortcomings that had plagued Newton's earlier work,[304] but these were easy to overlook amid its wealth of careful experiment and rigorous logic. Westfall overstates the case only slightly by saying: "Through the eighteenth century, [*Opticks*] dominated the science of optics with almost tyrannical authority."[305] Certainly by the 1770s the theory and manufacture of successful achromatic lenses had demonstrated Newton's fallibility in optics, and some defensiveness was evident among his supporters.[306] Nevertheless, in the eighteenth century *Opticks* dominated the scientific discussion not only of color but also of the rainbow.

Newton devotes a short section of *Opticks* to the rainbow, in it drawing on his earlier analysis in *Optica* and the "New Theory."[307] Historically speaking, he gets off to rather a shaky start by inventing refraction theories of the rainbow known to "some of the Antients, and of late more fully discover'd and explain'd by the famous *Antonius de Dominis* Archbishop of *Spalato*, in his book *De Radiis Visûs & Lucis* [of 1611]."[308] Writing in the late seventeenth century, Newton is understandably innocent of antiquity's near-complete avoidance of refraction in the rainbow. However, even a casual reading of the work of de Dominis shows its major failings—mangling the optics of the secondary rainbow and not including a second refraction out of the raindrop.[309] Furthermore, Newton casually mentions Descartes as having pursued the "same Explication" as de Dominis, which Descartes manifestly did not.[310] Whether or not Newton intentionally denigrated Descartes's contribution, he had unknowingly launched an unfortunate and lasting debate about the relative merits of Descartes's and de Dominis's contributions.[311]

Pursuing the Rainbow's Colors

Having muddied the historical waters, Newton proceeds to clarify the optical ones: "But whilst they [de Dominis and Descartes] understood not the true Origin of Colours, it's necessary to pursue it here a little farther."[312] Newton had already done so in his "New Theory" letter, although not as one of his central points:

> Why the colours of the rainbow appear in falling drops of rain, is also from hence evident. For, those drops which refract the rays disposed to appear purple, in greatest

quantity to the spectator's eye, refract the rays of other sorts so much less, as to make them pass beside it; and such are the drops on the inside of the primary bow, and on the outside of the secondary or exterior one. So those drops, which refract in greatest plenty the rays apt to appear red, towards the spectator's eye, refract those of other sorts so much more, as to make them pass beside it; and such are the drops on the exterior part of the primary, and the interior part of the secondary bow.[313]

In *Opticks*, Newton explains the geometry of the rainbow in great detail before accounting for its colors. He bypasses Descartes's cumbersome exercise of tracing multiple rays through a water drop to find the minimum deviation angle. Instead, Newton silently invokes his mathematical invention of the 1660s, differential calculus, to specify the minimum deviation rays of the primary and secondary rainbows.[314] He sees that his formula for determining extrema of the deviated rays can be repeated "and so on infinitely," thereby yielding rainbows caused by any number of internal reflections.[315] Maurolico's repeated internal reflections had at last found a realistic escape from the raindrop, although Newton plausibly notes that the "Light which passes through a drop of Rain after two Refractions, and three or more Reflexions, is scarce strong enough to cause a sensible Bow."[316] In fact, Newton's views are neither the first nor the last words on the subject, as we shall see in Chapter 9's "Tertiary Rainbows and More."

Newton at last closes with his color quarry, saying that "the Rays which differ in Refrangibility will have different Limits of their Angles of Emergence, and by consequence according to their different Degrees of Refrangibility emerge most copiously in different Angles, and being separated from one another appear each in their proper Colours."[317] With a knowledge of water's refractive indices, Newton then determines those angles, calculating radii of 42° 2' for the primary rainbow's red and 40° 17' for its violet. He gives the secondary rainbow's radii as 50° 57' (red) and 54° 7' (violet), values scarcely different from modern ones.[318] Between the color extremes of red and violet Newton lists what would become the canonical rainbow colors of orange, yellow, green, blue, and indigo.[319] To modern readers, indigo is a mysterious addition to this list, being neither very familiar nor easily distinguished from violet. As we show in our next chapter, Newton had not always called indigo a spectral color, and a philosophical agenda rather than mere observation likely added it to his list.[320]

Following his analysis of the primary and secondary rainbows' color orders, Newton deftly explains the circular symmetry of the bows and the reason for the secondary's dimmer colors. Similar to Descartes, Newton notes that there will be "two Bows of Colours, an interior and stronger, by one Reflexion in the Drops, and an exterior and fainter by two; for the Light becomes fainter by every Reflexion" out of the drop.[321] He calculates the widths of the two bows and notes that the secondary bow will be almost $1\frac{1}{2}°$ wider than the primary bow.[322] Newton then compares these theoretical values with his own exacting measurements, remarking that his efforts were once hindered because "the violet . . . was so much obscured by the brightness of

the Clouds."[323] He calmly accepts the difficulty of distinctly measuring rainbow radii outdoors, although his successors were sometimes more troubled by nature's apparent divergence from his laws.

In fact, Newton's studies later in *Opticks* of colored fringes seen between compressed glass surfaces would ultimately do more to upset the Newtonian rainbow than any problematic measurements of natural bows. Newton devoted much energy to observing and analyzing these fringes (later called "Newton's rings").[324] His inability to explain them completely left dangling a problem whose nineteenth-century solution would once again revolutionize science's understanding of the rainbow.[325] However, in the intervening century, Newton's theory would serve as a much-used touchstone for scientific and artistic views of the rainbow. While Newton's optics reigned largely unchallenged in the sciences, in the arts his analytical rainbow came to be regarded as a usurper. We now turn to the sometimes contentious reception of Newton's rainbow and its colors.

One of Newton's signal achievements was providing the first satisfactory account of rainbow colors. However, his explanation contradicted long-held Aristotelian conventions and challenged artists' traditional views about the practice of color mixing. Newton's heretical color ideas drew both praise and criticism from eighteenth-century artists and scientists, who would engage in a passionate debate about color theory that long outlived its instigator. While Newton could not definitively answer all the color questions he raised, his work nonetheless underlies the development of present-day color theory. Like the two bases of a real bridge, artists' and scientists' apparently unconnected ideas about color are in fact linked by the rainbow's bridge of color.

SEVEN

COLOR THE RAINBOW TO SUIT YOURSELF

That Milton (1608–74) and Shelley (1792–1822) do not agree on the rainbow's colors should not surprise us. In fact, as we saw in Chapter 4, disagreements about the number and kind of rainbow hues can be traced to antiquity. What may be surprising is that *both* Milton's and Shelley's counts are visually defensible, even within the same rainbow. How can this be? Answering this seemingly simple question requires that we explore some complex perceptual and symbolic demands that the bow makes of us.

We begin by literally taking a page from a children's coloring book, *The Story of Noah* (Fig. 7-1). At first glance, nothing seems unusual about this scene. In earlier pages, the book's young readers have been instructed on how to color key scenes from Noah's life, and now they are shown a template for the joyous moment described by Milton. Here their instructions are as detailed as they are revealing. The color of Noah's

> The triumphal arch, through which I march
> With hurricane, fire, and snow,
> When the Powers of the Air, are chained
> to my chair,
> Is the million-coloured Bow;
> The sphere-fire above its soft colours wove
> While the moist Earth was laughing below.[1]
>
> Percy Bysshe Shelley, *The Cloud* (1820)

> Anon dry ground appears, and from his ark
> The ancient sire descends with all his train;
> Then with uplifted hands, and eyes devout,
> Grateful to Heav'n, over his head beholds
> A dewy cloud, and in the cloud a bow
> Conspicuous with three listed colors gay,
> Betok'ning peace from God,
> and cov'nant new.[2]
>
> John Milton,
> *Paradise Lost*, Book XI (1674)

FIG. 7-1

Debarkation drawing from *The Story of Noah*. (From *The Story of Noah, A Scripture Activity Book with a Story from the* Good News Bible, pp. 38–39. Copyright © American Bible Society. Used by permission.)

robe is listed, as are the animals' colors. At last the rainbow's turn comes. After all the detail lavished on such unknowns as clothing colors, children encounter the blithe instruction "Color the rainbow to suit yourself."[3]

Remarkably, the one natural feature whose colors have *not* changed over historical or zoological time is simply cast adrift here. If the colors of clothing and animals are fixed, why are the rainbow's colors arbitrary? An obvious explanation is that the coloring book's authors themselves believe that rainbow colors are unfettered. Like Milton or Shelley, they may assign more symbolic than physical significance to the rainbow's colors. For example, Milton's "three listed [striped] colours" may allude to the Holy Trinity. Similarly, Shelley's "million-coloured bow" may simply be a Romantic invocation of Nature's incalculable variety. In either case, the authors are likely to have symbolic agendas that supersede mere physical description.

Can we assume the same about *The Story of Noah*'s authors? Maybe, but the very indefiniteness of their instructions suggests that they have no special symbolism in mind. Stating that the rainbow's colors are arbitrary (rather than incalculable) might imply a kind of Christian mysticism, but a simpler idea seems better here. Perhaps observation of natural or painted rainbows leads the authors to believe that rainbow colors really *are* capricious. As we have seen already, the colors of painted rainbows can be as varied as they are impossible. If these bows are the authors' visual reference, then their nonchalance is easy to understand. While we cannot be certain what prompted *The Story of Noah*'s nonchalance, we can explore some plausible explanations for it, and in turn we will better understand the observational and symbolic problems that the rainbow poses for us.

Aristotelian Color Theory and the Rainbow

We begin by examining some key moments in the history of rainbow colors. Not surprisingly, the

rainbow's status as a paragon of color means that we shall also be examining several key moments in the history of color theory. As we have seen in earlier chapters, that history is framed by two starkly different views of color—those of Isaac Newton and Aristotle.

Because Aristotle's ideas on color permeate much of later artistic understanding and practice, we start with them. As odd as some of these ideas may seem today, their explanation by Aristotle was reasonably consistent, and this contributed to their durability. Aristotle lays out many of his ideas on color in *De sensu et sensibili*, where he allows for the possibility of "a plurality of colors besides the White and Black; and we may suppose that many are the result of a ratio" of black and white.[4] He describes seven basic colors, including five between the bounds of black and white: yellow ("a variant of white"), red, green, blue, and purple ("sea purple").[5]

In other words, Aristotle proposes that white and black (or light and dark) are mixed to produce all other colors and that the proportions of white and black determine each color. For example, yellow (the lightest color) has more white than any other color, red contains less white, green less still, and violet (the darkest color) has the smallest amount of white.[6] Aristotle apparently is not concerned about the obvious practical difficulty that mixing black and white substances almost never yields any result but gray. Thus Aristotle implies that white light is the *source* of all colors, without its being *composed* of all colors. The explicit notion that white light was indivisible was a leap made by others, but Aristotle had set the stage for the bitter reaction to Newton's analytical division of white light. Unlike Newton, Aristotle made color (or *hue*) and brightness (or *tone*) interdependent.[7]

The Aristotelian tradition made some other subtle yet enduring distinctions between painted and natural rainbows. In *Meteorologica*, Aristotle proposed only three, rather than seven, principal colors for the rainbow: red, green and purple.[8] We have already seen examples of tricolor rainbows in the *Vienna Genesis* (Fig. 2-1) and the Roman *Zeus Reclining Amid the Clouds* (Fig. 4-8). Furthermore, in *De coloribus* (On Color) an Aristotelian follower (perhaps Theophrastus, c. 371–c. 286 B.C.) used Aristotle's ideas to distinguish three kinds of color mixing: (1) juxtaposing small areas of color (as nineteenth-century pointillists would do),[9] (2) transferring one material's color to another (as in dyeing),[10] and (3) blending colors either by illuminating colored materials with colored lights or by mixing materials of different colors.[11]

This last kind of color blending apparently describes the results achieved, if not the process used,[12] when painters mix pigments. The distinction between juxtaposed color areas and the painterly mixing of color had special implications for the rainbow, because in *Meteorologica* Aristotle refers to the bow's colors of red, green, and purple as colors "which painters cannot manufacture" by mixing.[13] To confuse matters further, while *Meteorologica* describes the rainbow color yellow as the result of "contrast" (that is, juxtaposition),[14] *De coloribus* never mentions the rainbow. This Aristotelian separation of artists' pigments and rainbow light was transmitted to many later painters independent of whether they had actually read Aristotle's writings.

A possible illustration of Aristotle's theory in antiquity comes from excavations at Pergamum in present-day Turkey. In a building dated to the reign of Eumenes II (197–159 B.C.), a colorful

mosaic fragment offers intriguing parallels to Aristotle's ideas on color and the rainbow.[15] The fragment is a square corner consisting of thirty rows of tesserae whose colors range from red on the inside through pastel red and pastel yellow, yellow, yellowish-green, green, and bluish-green on the outside. Obviously, this color order reverses that of the primary rainbow, and the black rays that edge the mosaic are unnaturalistic too. However, classicist Gloria Merker reports that the mosaic "is thought to represent a rainbow rimmed with black [cloud] rays,"[16] an idea paralleled by Aristotle's remark in *Meteorologica* that "the rainbow is purest when the cloud is blackest."[17] (Aristotle had himself borrowed from Anaximenes' rainbow theory, which held that the bow's colors were caused by mixing sunlight with a cloud's blackness.)[18] What might the Hellenistic artist be trying to achieve here? Allowing that the mosaic is a stylized rainbow, perhaps the artist is observing Aristotelian rules for depicting the rainbow by juxtaposing the tesserae's discrete colors. Such a plan would avoid the color problems that Aristotle predicted for rainbows rendered in mixed paints.

Aristotle's statements on rainbow colors did not go unchallenged in antiquity. Seneca the Younger held that in the rainbow, "Since there are two things, the sun and the clouds, . . . it is not surprising, then, that as many kinds of colour are revealed as can be intensified or greyed in numerous ways."[19] Despite Seneca's hints that the rainbow has an indefinite number of colors, Aristotle's theories of color and the rainbow were the enduring ones. Historian Martin Kemp notes that a "relatively consistent aspect of the [Aristotelian color] tradition—and the one which was to separate it most sharply from Newton's ideas—was that colour existed as an actual property of surfaces and the surrounding medium, not as a sensation produced in the eye by certain characteristics of transmitted and reflected light."[20] In other words, Aristotelian color is inherent color linked to tangible objects, thus making the intangible rainbow's colors almost alien. At the same time, contradictions in Aristotle's statements on the nature of light and color would lead to long-lived philosophical and artistic speculation that the rainbow's colors were merely "apparent," rather than "real," like the artist's material colors.[21] Historian Alan Shapiro observes that "medieval Aristotelian commentators introduced the distinction between apparent or emphatical colors, which are transient colors appearing without a colored body, as in the rainbow or a prism, and real or true colors, which are intrinsic qualities of colored bodies."[22]

Just as was true of Aristotle's rainbow theory, neither was his color theory regarded as dogma by ancient writers. According to Pliny the Elder (A.D. 23–79), Aristotle's contemporary Apelles (fl. fourth century B.C.) was one of four famous Greek artists "a single one of whose pictures the wealth of a city could hardly suffice to buy."[23] Yet neither Apelles nor his fellow luminaries are explicitly associated with Aristotle's ideas, and Pliny's description of their color palette hardly makes it sound Aristotelian: "Four colours only—white from Melos, Attic yellow, red from Sinope on the Black Sea, and the black called 'atramentum'—were used by Apelles, Aetion, Melanthios, and Nikomachos in their immortal works."[24] Even though none of their works survived, Apelles and other ancient artists were revered for their powers of illusionism in the centuries after Pliny.[25] However, their presumed palette was not adopted by even their most

ardent Renaissance admirers, if only because the absence of blues and greens made it impractical.[26]

When Renaissance artists discussed colors that change across seemingly uniform surfaces, their vocabulary naturally inclined toward the unpainterly colors of the rainbow. Following the lead of Cennino Cennini (c. 1370–c. 1440), Giovanni Paolo Lomazzo in 1590 emphasized that such *cangianti* ("changing" or "iridescent") colors used in highlights and shadows are most appropriate "for nymphs of meadows and fountains and such-like, and also for certain angels, whose garments reflect nothing other than the rainbow."[27] Meteorologically speaking, it is not surprising that the word *cangianti* pairs rainbow iridescence and changeability. That artists were encouraged to use such colors sparingly may seem odd to us, but not to someone schooled in Aristotelian color theory.

By contrast, Leonardo da Vinci's more scientific interest in color made him less likely to view the rainbow's colors as unnatural. In later life, Leonardo developed an almost Impressionistic interest in transient outdoor colors, and he also made systematic studies of color contrasts in nature. Far from dismissing the rainbow's role in painting, he recommended it as the ultimate test of a painter's command of color in his *Treatise on Painting*: "If you wish the proximity of one color to make another which it borders attractive, observe that rule which is seen in the rays of the sun that compose the rainbow, otherwise called the iris. Its colors are caused by the motion of the rain, because each little drop changes in the course of its descent into each one of the colors of that rainbow, as will be set forth in the proper place."[28] Elsewhere, Leonardo advised painters: "Make the rainbow in the last book 'On Painting.' But first make the book of the colours produced by the mixture of the other colours so that by means of these colours used by painters you may be able to prove the genesis of the colours of the rainbow."[29]

Note that Leonardo has not made painterly color (colors from mixing pigments) subservient to the rainbow's colors, but neither does he consign rainbow colors to a realm beyond the painter's. In addition, Leonardo appears not to fret about any presumed Aristotelian gap between tangible and intangible colors. However, Leonardo's bridging of this gap was both early and unusual among practicing artists. In a letter of August 1635, no less a painter than Peter Paul Rubens distinguished between "the proper colors of the objects" and "colors resembling a rainbow,"[30] an Aristotelian division of tangible (or inherent) from intangible (or merely apparent) colors.

The interest Rubens had in optics and colors considerably predates this letter. He designed both a title page and several vignettes for the Jesuit scholar François d'Aguilon (or Franciscus Aguilonius, 1566–1617) in Aguilonius's 1613 treatise on optics, *Opticorum libri sex*. Some of the vignettes are quite specific to Aguilonius's accompanying arguments on optics, suggesting that Rubens and Aguilonius had had a substantial exchange of ideas.[31]

Rubens's title page shows us Juno seated above Mercury, who holds the severed head of the hundred-eyed guardian Argus Panoptes. In Roman myth, Juno directed Argus to guard the luckless Io, whom the philandering Jupiter had tried to disguise from Juno by turning the maiden into a heifer. Mercury's lyre charmed all of Argus's eyes to close, and Mercury slew him.[32] One version of the story holds that Juno rewarded Argus for his ill-fated service by installing his eyes

in the peacock's tail. In Rubens's title page, a resplendent peacock attends Juno, and the "eyes" on its multicolored tail suggest that the eyes of the monstrous Argus have found a higher purpose by serving Juno's (and Aguilonius's) rational inquiry into light.

Rubens painted his *Juno and Argus* (Fig. 7-2) at about the time (1609–11) of the *Opticorum*'s publication and probably was motivated to do so by his experiences in illustrating the book.[33] Certainly there is good evidence that Rubens's color scheme is consistent with the *Opticorum*'s color theory.[34] In Fig. 7-2, Juno and her peacock are now accompanied by Iris, who appears both in the flesh and in her rainbow guise. Rubens has departed from both the original myth and from Ovid's retelling of it, suggesting that he wants to make a visual link between the rainbow's and the peacock's vivid colors. Such revisionism is not surprising because, as historian Charles Parkhurst notes, "in Rubens' day Iris was inseparable from any work dealing with vision, optics or refraction."[35] Rubens's color choices here, like those of Aguilonius, derive from Aristotelian tradition. In his *Opticorum*, Aguilonius defines as "simple" (or primary) the colors yellow, red, and blue that lie between the Aristotelian extremes of white and black.[36] In turn, these simple colors give rise to the "composite" colors orange, purple, and green. Aguilonius's choice of red, yellow, and blue primaries also conforms to long-standing artistic practice.

In *Juno and Argus*, the rainbow interleaves "composite" colors with "simple" ones, suggesting that Rubens is honoring Aguilonius's taste (and his own) for Aristotelian color theory.[37] However, in the same painting Rubens also juxtaposes small patches of color to enhance flesh tones in the pointillistic fashion described in the Aristotelian *De coloribus*.[38] Thus the rainbow's intangible colors are painted according to the Aristotelian rules for coloring tangible objects, while the opposite is true for the coloration of the very tangible goddesses. Amid this confusion, we can safely conclude only that reconciling Rubens's few documented ideas on color theory[39] with his actual practice is difficult at best.

Aguilonius himself appears to be familiar with both the practice and qualitative theory of color mixing, because he clearly distinguishes between juxtaposing patches of color "so small that they escape the eye" and mixing "simple" colors to produce "composite" ones (for example, mixing yellow and blue to obtain green).[40] Other contemporary writers on color such as the artist Matteo Zaccolini (1574–1630) were equally facile in combining observation, Aristotelian theory, and their own ideas. For example, in his treatise *Prospettiva del colore*, Zaccolini analyzes how light scattered within the atmosphere affects the brightness and color of distant objects. Zaccolini is observant, but he is scarcely prescient: his explanation for the bluish tint of distant landscape features draws from the color theories of both Aristotle and Leonardo.[41]

A quite different attitude toward depicting outdoor color thrived in some seventeenth-century academic circles. Kemp notes: "[The] vagaries of colour in nature were regarded as too transitory and variable to be anything other than dangerous for the painter of great subjects, who must aspire to eternal verities. Colour belonged, as Noel Coypel [1628–1707] was to stress, to the lower, sensuous realms rather than to the higher, philosophical considerations of great art."[42] In other words, some academicians believed that the irrational sensuousness of color required that artists subordinate it to the rationality of design.

FIG. 7-2

Peter Paul Rubens, *Juno and Argus*, 1611. (From Rheinisches Bildarchive, Cologne) (photo: Courtesy Wallraf-Richartz-Museum, Cologne)

Newton's Disquieting Color Ideas

Until the widespread circulation of color theories based on Newton's *Opticks*, scientists' and artists' ideas on color had existed harmoniously apart. As noted in Chapter 6, Newton was preceded in analyzing sunlight's spectrum by Descartes, Hooke, Boyle, and others.[43] However, for many artists such experiments would have been irrelevant because Aristotelian color theory deemed that, like the rainbow, the colors generated by a prism belonged to a class "which painters cannot manufacture" by mixing. As long as the two classes of color appeared to exist independent of one another, frictions were unlikely to occur.

Newton upset this balance by dismissing two central tenets of Aristotelian color theory. In experiments done around 1666 he passed a small circular beam of sunlight through a triangular glass prism and then scrutinized the resulting oblong spectrum in a darkened room.[44] One of Newton's remarkable observations was that a second prism could merge his spectrum colors

FIG. 7-3

George Romney, *Newton and the Prism*, 1794. (From William Hayley, *The Life of George Romney, Esq.* [Chichester: Printed by W. Mason for T. Payne, Pall Mall, London, 1809])

into light that was "entirely and perfectly white, and not at all sensibly differing from a direct light of the sun."[45] Newton's interpretation of these observations in his "New Theory" letter departed sharply from earlier color theories.

First, recall that Newton declares spectrum colors to be the *constituents* of white light, rather than the *product* of somehow modifying white light with darkness.[46] Stated another way, the Aristotelian assumption was that white light was pure and homogenous in the sense that it could not be altered or reduced to more basic forms. Newton's achievement was to demonstrate that only the spectrum colors were pure and homogenous.[47] Second, Newton reasons that identifiable colors are not confined "to the more eminent colours, but even to all their intermediate gradations" and that "so to all the intermediate colours [between red and violet], in a continued series, belong intermediate degrees of refrangibility."[48] Clearly Newton implies here that sunlight contains an *indefinite* number of colors, each of which a prism refracts by a different amount.

Newton goes on to state that there are two kinds of colors: "primary" (or "simple") and "compounded."[49] He lists the primary colors as "red, yellow, green, blue, and a violet-purple, together with orange, indigo, and an indefinite variety of intermediate gradations."[50] From this indefinite number of primaries, an indefinite number of compound colors can be made.[51] However, even Newton seems daunted by this endless flexibility, because he lists seven *discrete* primaries above, and earlier in his *Optical Lectures*, he cited only five primaries.[52] By the first edition of *Opticks* Newton appears to have settled on seven "homogeneal" or primary colors: red, orange, yellow, green, blue, indigo, and violet.[53] The number seven derives not strictly from visual observation but also from Newton's belief that sight and hearing are related. Because each musical octave contains seven tones and semitones, he reasoned that the spectrum should have

FIG. 7-4

A visible spectrum generated by transmitting a slide projector beam through a triangular glass prism

seven colors.[54] Whatever number he chose beyond three, he had committed heresy against Aristotelian color theory.

History painter George Romney (1734–1802) freely interpreted Newton's experiments in his *Newton and the Prism* (Fig. 7-3).[55] Aside from Romney's spurious addition of an indigo band next to the red, his painting gives a good idea of the colors that Newton would have seen.[56] In Fig. 7-4 we have recreated Newton's display of a prismatic spectrum, although we used a slide projector rather than the sun as our light source. Aside from its curvature, our spectrum is one that Newton could have produced.[57] As Newton noted, the degree of refractive bending corresponds to the color of the light seen in the spectrum. In Fig. 7-5 we show how this variable refractive bending works within a triangular prism. As does Romney's painting, Figure 7-5 shows that reds are bent least from the white light's original direction, and violets are bent through the largest angle. Figure 7-6 shows an approximate color map of the resulting spectrum.

Although Newton did not do so, we may describe light as long trains of sinusoidal waves. Using this wave model of light, each part of Fig. 7-6's spectrum can be assigned a particular wavelength, the distance between a successive pair of wave crests or troughs.[58] The wavelengths of visible light range from about 380 nanometers (nm) for violet to 700 nanometers for red. (A nanometer is one-billionth of a meter; a typical human hair is about 100 times wider than a wavelength of red light.) Thus within a beam of parallel sunlight, short-wavelength violet is refracted more than longer-wavelength red when the beam encounters a prism or raindrop (see Fig. 6-6).

Newton unequivocally linked prismatic colors to the colors and color order of the primary and secondary rainbows,[59] thus severing an Aristotelian tie that had lasted two millennia. Yet Newton had not completely removed all the impediments to understanding rainbow colors. He

FIG. 7-5

Variable refractive bending of a light beam by a triangular glass prism

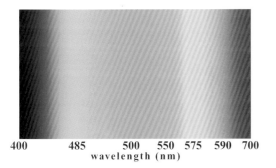

FIG. 7-6

Approximate mapping of wavelengths of light into colors

himself was partially aware of one important stumbling block, noting sternly in *Opticks*: "And if at any time I speak of Light and Rays as coloured or endued with Colours, I would be understood to speak not philosophically and properly, but grossly, and accordingly to such Conceptions as vulgar People in seeing all these Experiments would be apt to frame. For the Rays to speak properly are not coloured. In them there is nothing else than a certain Power and Disposition to stir up a Sensation of this or that Colour."[60]

In modern terms, Newton is warning us not to equate wavelength with color. This warning is more than mere semantic quibbling. In fact, Newton himself had difficulty with the distinction. Perhaps persuaded by his own visually compelling display of the recombined spectrum, he insisted that white sunlight must contain all the primaries he had observed. In his 1672 paper, Newton unequivocally states that white light "is ever compounded, and to its composition are requisite all the aforesaid primary colours, mixed in a due proportion."[61] His logic is essentially this: because white sunlight contains all colors and because those separate colors cannot be further altered, then all colors are required to make white light.[62] Challenged in 1673 by Christiaan Huygens that yellow and blue alone were adequate as primary colors, Newton responded with a stout defense (and subtle reshaping) of his theory.[63]

The sticking point for Newton was that Huygens's two-primary white light would not contain the same "due proportion" of primary colors that existed in sunlight, so he objected to this white as being "of a different constitution" than sunlight.[64]

Figure 7-7 illustrates Huygens's demonstration that a mixture of blue and yellow light can produce white.[65] In fairness to Newton, not just any blue and yellow will do, and usually the mixture yields a pastel green (a problem with Huygens's challenge that Newton was happy to point out).[66] Today we would say that such a yellow and blue are complementary colors—that is, a mixture of these lights yields white. Cyan and orange lights are another pair of complementary colors, as are red and green.[67] Confusingly, the term "complementary" is often used simply to describe colors that contrast strongly when juxtaposed, even if their mixture does not produce white.[68]

Figure 7-7 raises several theoretical problems. First, it clearly indicates that we need not mix all colors in order to produce white. Second, how does Fig. 7-7 square with the common experience of artists that mixing blue and yellow pigments yields a green darker than either of the original colors? Third, if we mix pigments rather than lights, how could mixing two colors

that seem not to contain the spectrum color green yield a color that is undeniably green? We return to these problems shortly, for they are ones that Newton never fully reconciled with his theory, and we will have to go well beyond his lifetime to find our answers.

Despite Newton's difficulties in explaining what he called the "curious" kinds of white light described by Huygens, in the eighteenth century the insight, breadth, and sheer complexity of his color analysis made him a figure whose ideas commanded attention if not respect.[69] In what ways did Newton change the landscape of color theory? The answer is that not only did he free color from objects' surfaces, he even divorced it from the light rays themselves.

A more un-Aristotelian position is difficult to imagine, and generations of writers and artists pronounced their dissatisfaction with Newton's vexing but influential ideas. The Jesuit priest Louis Bertrand Castel declared in 1740 that he would "concentrate above all on the material and normal colors of painters" instead of the "accidental colors, like the incorporeal ones of the prism and the rainbow."[70] Clearly for Castel, Aristotle's intangible rainbow colors were not to be reconciled with the artist's tangible ones. James Barry, Professor of Painting at England's Royal Academy, fulminated in the late eighteenth century that he felt "but little conviction or satisfaction in the splendid theories deduced from prismatic experiment." Barry stoutly maintained that it was "not evident from this [demonstration of prism colors], that what they call the specific coloured rays or pencils did previously exist in the light."[71] Barry's anonymous "they" undoubtedly included Newton.

FIG. 7-7

Blue and yellow mixed to make white—Huygens's color problem for Newton

Barry then huffed that "our philosophers have pretended to discover in the rain-bow just seven primitive colours, and they make no mention of any derivative colours in that phenomenon. But if they mean by primitive colours, colours simple and uncompounded of any others, why seven, when there are but three?"[72] Rather than the suspect Newtonian spectrum, Barry relied on three primaries of yellow, red, and blue, and he offered both Aristotle's and Milton's descriptions of the rainbow to support his position. Undoubtedly Barry would have derived comfort from the bicolor primaries of Hooke[73] and Huygens.

Denunciation of Newton's ideas became a trusty rallying cry for some British aesthetes. The history painter Benjamin Haydon (1786–1846) recounts hosting a dinner party in 1817 that included his friends Keats, Wordsworth, and critic Charles Lamb (1775–1834). During the dinner's giddy progress, Keats and Lamb agreed that Newton "had destroyed all the poetry of the rainbow by reducing it to the prismatic colours,"[74] and Haydon noted approvingly: "It was impossible to resist [Lamb], and we all drank 'Newton's health, and confusion to mathematics.'"[75]

FIG. 7-8

John Constable, Rainbow Diagram, c. 1833. Private Collection. (From Graham Reynolds, *Later Paintings and Drawings of John Constable* [Paul Mellon Centre for Studies in British Art and Yale University Press, 1984])

However, many influential artists were receptive to Newton's theory. Benjamin West, president of the Royal Academy, is paraphrased as claiming that "all combinations [of colors] are derived from the Prismatick colours" and that the "*Order of the Colours in a Rainbow*, is the true arrangement in an Historical picture."[76] In an 1818 lecture to the Academy, J. M. W. Turner espoused a color theory with Aristotelian and Newtonian branches. Proposing separate schemes for mixing intangible "aerial" and tangible "material" colors, he notes: "White in [the] prismatic order, [as] in the rainbow, is the union or compound [of] light, as daylight; while the commixture of our material *colours* becomes the opposite, darkness."[77] Clearer about distinctions between pigment and prismatic colors than many of his contemporaries, Turner would still continue to struggle for decades to reconcile (or at least understand) the two types of color mixing. Ultimately, he seems to have rejected doctrinaire Newtonian theory and at one point tried a quasi-pointillist technique that anticipates Seurat.[78]

In an otherwise inconsequential rainbow diagram (probably of 1833), John Constable gives us a clear view into his indecision about rainbow colors—an indecision or confusion that he shared with many other artists sorting out the tangled threads of competing color theories (Fig. 7-8).[79] Figure 7-8 is remarkable not for its artistic merit but for the notes that Constable made on it. As if a dutiful Newtonian, he observes at the bottom of the page: "There is no limit to the number of prismic colours." Next he labels Newton's seven spectrum primaries, in the correct meteorological order, on delineated rainbow bands. Apparently to reconcile this spectral ordering with rainbow observations, Constable has also drawn in dark pencil three arcs that group the spectrum primaries into broader bands of red-orange, yellow-green, and blue-indigo-violet. We can see further evidence of his scientific and artistic balancing act in his notes "3 primary" and "7 prismatic." Thus in one simple diagram, Constable has outlined (1) observation and artistic practice in painting rainbow colors, (2) Newtonian color theory as applied to the rainbow, and (3) Newton's own inconsistency about the number of spectrum colors.

Toward Modern Color Theory: Moving Beyond Newton

Constable's earnest rainbow diagrams[80] clearly indicate that Newton's artistic reception was not universally hostile. However, the shortcomings of Newton's color theory, both real and imagined, made it an occasional target for revision (or rejection) by artists and scientists alike. For some artists, one of Newton's more troublesome inventions was his geometric scheme for color mixing.

In *Opticks*, Newton followed his experiments on prismatic refraction with a diagram that

claimed to describe color mixing.[81] His system was based on a color wheel whose rim consisted of sunlight's spectrum colors (Fig. 7-9). The wheel's center corresponded to perceived white, or the recombination of these spectrum colors. Newton outlines how the location of an arbitrary color might be calculated from the size of small "Circles proportional to the Number of Rays of each [spectrum] Colour in the given Mixture."[82] This newly mixed color would lie somewhere within the wheel. The mixture's closest kin among the spectrum colors could be found by drawing a radius through the new color to the wheel's rim. In addition, Newton defined the new color's "Fulness" or vividness[83] as proportional to its distance from the wheel's center. Newton's color scheme is strikingly similar to the one we use. That similarity is no accident, because modern color measurement can directly trace some of its fundamental assumptions to Newton.[84]

FIG. 7-9

Newton's color wheel. (From Isaac Newton, *Opticks, or A Treatise of the Reflections, Refractions, Inflections and Colours of Light*, p. 155. Copyright © 1952 Dover Publications, New York)

The notion of using a circle to arrange colors was not new, but using it as a graphical color calculator was.[85] However, Newton's color wheel is a calculator for a particular kind of color mixing: it describes the mixing of colored lights or its analog, juxtaposing small patches of color (the first kind of Aristotelian color mixing). It could not reliably predict the mixing of artist's pigments unless those pigments were mixed dry (that is, not dissolved or suspended in a binder such as oil).[86] Newton himself studied such dry pigment mixtures, and his observations imply that the different kinds of mixing are not as irreconcilable as Newtonians and Aristotelians supposed.

Such observational nuance was lost in the often heated color theorizing that followed Newton. Angelica Kauffman's sometime friend, German writer Johann Wolfgang von Goethe, adopted a devoutly anti-Newtonian stance to which he gives full voice in his *Zur Farbenlehre* (Doctrine of Colors) of 1810: ". . . for no aristocratic presumption has ever looked down on those who were not of its order, with such intolerable arrogance as that betrayed by the Newtonian school in deciding on all that had been done in earlier times and all that was done around it. With disgust and indignation we find Priestly, in his History of Optics, like many before and after him, dating the success of all researches into the world of colours from the epoch of a decomposed ray of light, or what pretended to be so."[87]

In fact, Goethe went on to carefully observe several color phenomena that Newton's prismatic colors could not explain. Emphatically rejecting Newton's account of spectrum colors, Goethe constructs his own elaborate Aristotelian explanation of them. Echoing Huygens and Hooke, he notes that the "natural philosopher . . . assumes only *two* elemental colours" of blue and yellow, while allowing that "the painter is justified in assuming that there are *three* primitive

colours from which he combines all the others."[88] In fairness, Goethe was much more than a Newtonian rejectionist—he was keenly interested in color phenomena still studied today, such as color afterimages and the blue tint seen in some shadows outdoors.[89]

Also published in 1810, German painter Philipp Otto Runge's (1777–1810) *Die Farbenkugel* (The Color Sphere) provides an exquisitely detailed, rational model of color. Runge expanded Newton's color wheel as a sphere in which the third dimension is now a color's brightness. Like Goethe, he was interested in colored shadows and other outdoor color problems.[90] Unlike Goethe, he attempted to reconcile Newton's seven primary colors with the artist's traditional three of red, yellow, and blue.[91] As a practicing artist, Runge understood the aesthetic use of complementary colors, if not their theoretical explanation.

Thus for more than a century after publication of *Opticks*, artists and art theorists alike eagerly accepted, passionately rejected, insightfully criticized, and sometimes simply muddled Newton's provocative color ideas. However, the most substantial progress in understanding color theory and Newton's contributions to it would come neither from polemics nor elegant pictorial models. In the nineteenth century, scientists Thomas Young (1773–1829), Hermann von Helmholtz (1821–94), and James Clerk Maxwell (1831–79) began to reconcile everyday perceptual experience with Newton's essentially correct physical model of light.[92] Our present-day understanding of color perception can ultimately be traced to their ideas.[93]

Color Mixing and a Little Physics: A Conundrum Resolved

As we have seen, one concern of artists and scientists since antiquity has been explaining, or at least coping with, the various kinds of color mixing. What is our modern understanding of the problem? First, we now recognize that there are two seemingly distinct kinds of color mixing, and we call these *additive* and *subtractive*. Figures 7-10 and 7-11 illustrate their differences. In additive color mixing, we (1) mix lights of different colors (as in stage lighting) or (2) juxtapose areas of color so small that we cannot resolve them, and thus blend them into a single color (as in color television). As Huygens claimed and Fig. 7-7 suggests, we do not need to mix all spectrum colors to obtain white. Three or even two carefully chosen colors will do. Additive color mixing corresponds to the first kind of Aristotelian color mixing and to that predicted by Newton's color wheel. We call this mixing "additive" because our eyes literally add up the brightnesses of the different light sources and the mixed color is *always* brighter than either of its components.

Color television and computer monitors are pervasive examples of the second kind of additive mixing. To see how their additive mixing works, scrutinize an image on a color television. At a distance of a few inches you can begin to resolve the seemingly continuous image into a discrete mosaic of red, green, and blue dots. For television, the image and the mosaic tend to be mutually exclusive perceptions—if you are close enough to see the mosaic, the image is lost, and if you are far enough from the screen to discern an image clearly, the mosaic will be invisible.[94] Newton achieved the same additive mixing when he mixed dry pigment powders and compared

the brightness of the sunlit powder with that of a shaded piece of white paper. His mixture of orpiment, blue bisc, bright purple, and *viride aeris* (a green), when seen at a distance of several yards, "appeared intensely white, so as to transcend even the Paper itself in Whiteness."[95]

The rainbow too is an example of additive color mixing because it is a mosaic of colors refracted and reflected from myriad water droplets.[96] But the image-mosaic duality is less obvious in the rainbow's case. We cannot resolve the mosaic of colors when we see a rainbow in a distant rain shower; we simply see the rainbow image. However, when we scrutinize a rainbow in the spray of a nearby sprinkler, we can see both the rainbow image and bright reflections from some of the individual droplets. This visibility of individual drops in nearby sprays undoubtedly adds to our perceptual confusion about the rainbow's distance from us. Remember that even though the droplets are close, the rainbow itself has *no* particular distance from us—it is just an image of the sun.

FIG. 7-10

Additive color mixing, in which we simulate the overlapping of colored lights

Figure 7-11 shows us an example of subtractive color mixing, the kind of mixing that artists achieve when they blend paints. Note that each mixture is *darker* than its constituent colors and that when we combine all three colors in the center of the diagram the result is nearly black. Why are the results so different from the additive mixing in Fig. 7-10? The answer is that the two types of mixing are very different physically. To understand this we must consider a little qualitative physics. In Fig. 7-12 the dashed line indicates the fraction of

FIG. 7-11

Subtractive color mixing, in which we simulate the mixing of paints

incident light that a red pigment sample reflects at different wavelengths.[97] At 700 nanometers, the red pigment reflects about 76 percent of the light illuminating it, so its reflectance there is 0.76.[98] Such a curve of reflectance versus wavelength is called a *reflectance spectrum*. As we would expect, the dashed line for the red pigment rises as we move toward longer wavelengths at the red end of the spectrum. The thin solid line in Fig. 7-12 shows the reflectance spectrum for a blue pigment.

Imagine that we finely grind and suspend our red pigment in a transparent binder such as oil. If we spread the resulting paint thickly enough that we cannot see the underlying surface, then the dashed line in Fig. 7-12 describes the fraction of light that is reflected at each wavelength. Stated another way, the dashed line describes how much of the incident light the red pigment does *not* absorb. Because our sample is thick enough that it does not transmit any light, incident light that is not reflected must be absorbed. At 700 nanometers, where the red pigment

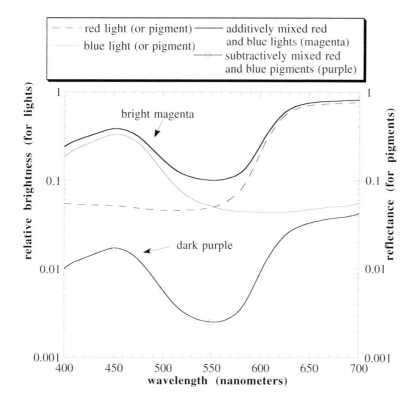

FIG. 7-12

Spectra of red and blue pigments mixed subtractively and of red and blue lights mixed additively

reflects 0.76 of the incident light, the amount absorbed is 1 − 0.76, or 0.24. In other words, because at 700 nanometers 76 percent of the light is reflected, 24 percent must be absorbed. In the violet region of the spectrum at 400 nanometers, the red pigment reflects very little (less than 6 percent of the light illuminating it),[99] so it absorbs most of the light.

When we mix our red and blue pigments as oil paints, at each wavelength the red paint will absorb some fraction of the incident light that has been reflected by the blue paint (or vice versa; the order is immaterial). Naturally the color of our paint mixture depends on the relative proportions of red and blue; here we assume that they are mixed in equal amounts. At 400 nanometers, the blue paint reflects about 18 percent (0.18) of the light reaching it. Now the red paint absorbs 94 percent of this 18 percent reflected light, meaning that only 1 percent of the incident light reaches our eye.[100] It is as if each paint acts as a color filter for the other's reflected light. In fairness, we have simplified the reality of paint interactions considerably here,[101] and we know that additive and subtractive mixing can occur simultaneously within a given mixture. Nevertheless, in subtractive color mixing a kind of filtering does occur across the spectrum, with the amount depending on the spectral reflectances of the paints.

The net result is that mixing pigments in the form of paints sharply reduces the total amount of light that is reflected, so much so that colors may be indistinguishable. For example, Newton describes mixing unequal proportions of red lead and the green *viride aeris* powders, resulting in "a dun Colour like that of a Mouse."[102] We see a similarly unappetizing result in Fig. 7-11, where mixing red and green produces a brown darker than either of its constituent colors. Further-

more, brightness is reduced with every additional paint that is added to a mixture. Now we can better understand painters' traditional proscriptions against mixing colors on the canvas. As Roger de Piles warns in 1677, mixing together "a beautiful red, a beautiful yellow, a beautiful blue and beautiful green" will "make them nothing other than the colour of earth."[103] As Fig. 7-11 indicates, these subtractive mixing results are very different than the results obtained from additive mixing.

Perceptually, the differences between subtractive and additive color mixing are very real indeed. Physically, however, the spectra produced by subtractive and additive mixing resemble each other closely, with the important exception that subtractive mixing produces a much darker material. Look again at Fig. 7-12, this time comparing the results of additively and subtractively mixing our red and blue pigments (the thick curve and the curve with small circles, respectively). For the additive mixing case, we can consider the colors to be lights whose brightness equals that reflected by their pigment twins. Now the results of additive and subtractive mixing look strikingly similar, considering only the *shapes* of the mixtures' spectra. In fact, the resulting magenta and purple are approximately those shown in Figs. 7-10 and 7-11. There is little question that the two colors are both purplish, but even a careful observer could be persuaded that the two kinds of mixing result in fundamentally different colors: one very dark and one very bright.[104]

The idea that brightness and color (or hue) interact to determine our perception of colors clearly has Aristotelian roots. Artists such as Runge have recognized it (in his *Die Farbenkugel*), and it is the basis of many modern color classification systems.[105] When the Pre-Raphaelite painter William Holman Hunt experimented with the proper color balance for a nighttime scene, he was startled by the effect of brightness on color: "To test the character of intensified moonlight, I used a lense on a bright night, and to my surprise found that the focus transmitted was not of silvery tone, but that of warm sunlight, and this I adopted."[106] Focusing moonlight increased its brightness and simultaneously changed its apparent color, but not the shape of its spectrum. As we have seen, this interaction of brightness and color has had profound effects on both the history of painting and the development of color theory. In the case of the rainbow, the subtle differences between additive and subtractive color mixing often consigned the bow to an almost unnatural status.

Thus the long-standing disagreement about which kind of color mixing is appropriate to painting can be understood in two ways. First, as artists have known for centuries (although not expressed in our terminology), additive and subtractive mixing can be used to achieve very different color effects.[107] Second, although the two kinds of mixing differ fundamentally in their perceptual results, both depend intimately on the same properties of paint or other media.

Quantifying the Rainbow's Colors

Thus far we have used perceptual terms like brightness, color, and vividness only qualitatively.[108] Because visual perception remains intrinsically subjective (at least given present research tech-

niques), we cannot describe color in a purely neurological, quantitative way. Instead, we settle for the indirect methods of psychophysics in which we assume that if we quantify observers' responses to known light sources, then we have objectively measured their subjective color experience. We can choose among many different color metrics to describe the colors of the rainbow. Although no single system is universally accepted, one used widely in science and industry is a colorimetric system developed by the Commission Internationale de l'Eclairage (CIE). The CIE's colorimetry is especially useful for us because it allows us to relate light spectra and color perception quantitatively.

Figure 7-13 illustrates a recent CIE colorimetric standard, the 1976 UCS (Uniform Chromaticity Scale) diagram. Think of this chromaticity diagram as a color wheel similar to Newton's (Fig. 7-9), except that it has been reshaped to better accommodate some idiosyncrasies of human color vision. Pure spectrum colors are found on the diagram's curved border, and less pure (less vivid) colors are inside it. However, we now need to redefine the term "spectrum color." In colorimetric usage, only monochromatic (single-wavelength) light sources generate spectrum colors. These colors are the "simple" colors that Newton assumed he saw refracted by his prism. In fact, his prismatic colors really were not pure, nor could any of us detect light that is literally monochromatic.[109] So colorimetrically speaking, laser light is a better source of spectrum colors than a sunlit prism.

The curved border of the UCS diagram consists of the monochromatic spectrum colors, which range from short wavelengths at its bottom corner to long wavelengths at the upper right. This curved part of the border is called the *spectrum locus*. A straight line connects these two spectral extremes, and mixtures of monochromatic red and blue along it generate purples. Thus purples are not spectrum colors proper (they are not monochromatic), but they are the purest possible colors that link the ends of the visible spectrum. One point in the interior of Fig. 7-13 is a white, or *achromatic*, stimulus. We can form any other interior color by mixing a specific amount of this achromatic stimulus with a spectrum color (or a purple). Much as in Newton's color wheel, the wavelength of a spectrum color is determined by drawing a straight line that connects the achromatic stimulus, the color of interest, and the locus of spectrum colors. The resulting monochromatic spectrum color defines the arbitrary color's *dominant wavelength*. Furthermore, the arbitrary color's fractional distance between white and its spectrum color defines its purity.[110] At last we have quantified our descriptive terms "hue" (or "color") and "vividness" as dominant wavelength and purity, respectively. The parallels between the UCS diagram and its progenitor, Newton's color wheel, are fairly obvious.[111]

How should we interpret the rectangular coordinate system in Fig. 7-13? Ultimately, the source of the coordinates u' and v' is psychophysical experiments in which subjects matched the colors of test lights by mixing red, green, and blue reference lights in varying intensities. To first approximation, the u' coordinate represents the relative amounts of green and red in a color, and v' indicates the relative amounts of green and blue. To convey a sense of what these numbers mean, we have calculated and displayed the colors that fill the interior of the UCS diagram (Fig.

FIG. 7-13

Maximum-brightness CIE 1976 UCS diagram

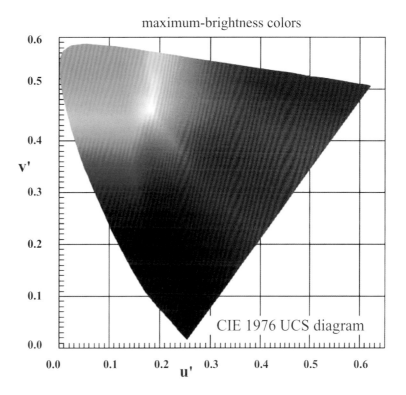

7-13). Now we must confess to our own artistic license. As the discussion above implies, we can reproduce all perceptible colors *only* if we use an enormous number of monochromatic lights. Our version of the UCS diagram was originally generated on a computer's red-green-blue color monitor. Obviously, trichromatic systems like color television and film can only *approximate* certain parts of the UCS diagram. (We have diligently tried to minimize the color shifts that photography and printing themselves introduce.) Thus we need to be skeptical about any diagram that claims to reproduce all possible colors.

In making the colors of Fig. 7-13 we have varied *brightness*, the remaining attribute of color sensation. The CIE quantifies brightness by means of psychophysical experiments similar to those for color matching.[112] Ironically, the three bright spokes in the interior of Fig. 7-13 nicely illustrate a visual idiosyncrasy that the UCS diagram was not meant to display. In fact, the spokes are only slightly brighter than their surroundings. These are examples of *Mach bands*, which are perceptual artifacts caused by the way the human visual system enhances light and dark borders.[113] You can demonstrate that the bright lines in Fig. 7-13 are not real by covering one side of a spoke with a piece of paper (even subtler dark Mach bands appear perpendicular to the bright ones). Now the illusory brightness shift between the spoke and its surroundings disappears. Far from being irrelevant curiosities, Fig. 7-13's Mach bands suggest that our perception of the rainbow may also be affected by abrupt brightness changes (say, at the primary's outer edge).

Figure 7-14 shows the results of keeping brightness uniform within our colorimetric dia-

FIG. 7-14
Uniform-brightness CIE 1976 UCS diagram

gram. The bright spokes have disappeared, but so has the diagram's white center. In its place is a dull, nearly colorless area that we call the *achromatic region*. The disappearance of white is an inevitable consequence of producing colors of uniform brightness on a device that uses additive color mixing, in this case a computer's color monitor. In other words, mixing the color monitor's red, green, and blue primaries at maximum brightness produces white. However, this white is now brighter than surrounding colors, which by definition are created by reducing the brightness of one or more of the primaries. To avoid the brightness difference between the center of the diagram and its surroundings, we mix equal amounts of red, green, and blue at lower brightness levels. The result is that the white achromatic stimulus disappears and is replaced by a broad, pastel achromatic region.

Some Important Departures from Colorimetry

Colorimetry seems to imply that human color vision works much like a versatile television camera. However, Fig. 7-15 should give us pause. Most readers will be startled to realize that its gray squares do not change color between the yellow and blue backgrounds, a fact that can be verified by tracing along the line that connects the squares. The square on the blue background has a slight yellow or reddish cast, while its neighbor seems to be a much colder bluish gray. Stare as we might, the squares stubbornly refuse to assume the same color. This striking phenomenon is called *simultaneous color contrast*.[114]

FIG. 7-15
Simultaneous color contrast

Matters are no less unnerving when we move to Fig. 7-16, in which we see blue, yellow, red, and green squares printed on a gray panel. An identical gray panel adjoins this one, except that the squares are white there. Concentrate on the black dot at the center of the left panel for one minute, then shift your gaze to the center of the right panel. Instead of white squares, there are ghostly afterimages of the colored squares, which now appear in complementary colors (that is, a red square results in a green afterimage, a yellow square causes a blue afterimage, and so on). As television cameras, apparently humans leave much to be desired.

Simple experiments such as these led German physiologist Ewald Hering (1834–1918) to propose an *opponent-color* theory of color vision.[115] In its modern form, opponent-color theory links the physiology of the eyes with processing of their output at higher levels in the visual system. Thus opponent-color and trichromatic color theories complement, rather than contradict, each other in explaining color vision.[116] In fact, artists have recognized and exploited opponent-color effects for centuries, as Leonardo da Vinci suggests in his *Treatise on Painting*: "Among colors of equal perfection the one which will appear most excellent is that which is seen with its direct contrast [that is, its complementary color]. A direct contrast is a pale color with red, black with white—although neither one of these is a true color—azure blue and golden yellow, green and red. Every color is more discernible when opposed by its contrast than by one like itself."[117]

In the centuries between da Vinci and Hering, complementary (or opponent) color effects were studied by a wide variety of artists and scientists. Newton himself had experimented with color afterimages as an undergraduate, although those youthful observations did not influence his mature color theory.[118] In 1743 the French naturalist and encyclopedist Georges-Louis Leclerc de Buffon (1707–88) performed some of the earliest scientific experiments on colored shadows seen outdoors.[119] His interest in these "accidental" or subjective colors spanned several decades, and he accurately reported that shadows of sunlit objects were often blue during the day,[120] turning green when the sunlight reddened. Color afterimages attracted Buffon's attention too: "If one looks steadily, and for a long period at a stain or a figure, say a little red square, on a white ground, one begins to see around [it] a sort of crown of weak green. If one stops to look at

FIG. 7-16
Color afterimages

the [figure], and looks at the white [ground] one distinctly sees a square of pastel green verging a little on blue."[121] The French artist Pierre Henry de Valenciennes (1750–1819) was much taken with Buffon's observations,[122] and he suggested that "shadows appear bluer than they really are [because of] the opposition with the colored light emanating from the sun at this time of day; and this is so true that when the sky is covered with clouds, shaded areas do not have as pronounced a hue as when it is in contrast with the original light."[123]

Like Buffon, British physicist Count Rumford (Benjamin Thompson, 1753–1814) also studied colored shadows. He determined that these were subjective phenomena and that a light and its apparently colored shadow had complementary colors. Probably unaware of Valenciennes's interests, Rumford also recommended studying colored shadows as a practical guide for artists.[124] David Brewster, who ardently defended Newton's rainbow theory,[125] nevertheless tried to debunk his color theory by demonstrating that sunlight spectra had some supposedly non-Newtonian properties. By viewing spectra through colored filters, Brewster satisfied himself that their oranges and greens were compounded of red, yellow, and blue primaries. He then felt justified in replacing Newton's continuous spectrum with one composed of his three primaries, a substitution that, at least for Brewster, explained color's complementary nature.[126]

In his capacity as director of dyeing at the Gobelin tapestry works, French chemist Michel-Eugène Chevreul developed detailed instructions for artists to use in gauging the effects of simultaneous color contrast and color afterimages. Chevreul's concern was less aesthetic than economic—the colors of Gobelin fabrics were not adequately predicted by either Newtonian theory or painterly practice. In particular, the many juxtaposed color fibers in tapestries gave them mosaic-like qualities, with the result that both additive color mixing and opponent-color processes affected the appearance of the finished product. Chevreul's *Principles of Harmony and Contrast of Colors* (1839) would gain a wide artistic readership in the nineteenth century. Among Chevreul's many insights was that the apparent purity of a color depends on its hue, a phenomenon explicitly described in the CIE 1976 UCS diagram (Figs. 7-13 and 7-14).[127]

Chevreul did not view his rules for exploiting simultaneous color contrast as mere theoretical niceties: "To conclude, in all I have said on the subject of the immediate applications of the

law of contrast to painting, I have given precepts adapted to enlighten the artist as well as the critic, since he cannot avoid them without evidently being unfaithful in the imitation of his model."[128] In other words, Chevreul recommends that complementary colors be juxtaposed because simultaneous contrast from each will enhance the vividness of its complementary neighbor.[129] Thus if red adjoins green, simultaneous color contrast causes the red to induce green in its green neighbor (and vice versa). These are the kinds of color harmonies that so fascinated Chevreul and that he strove to exploit. Ultimately, however, he favored imagination over rule, hoping that artists "will not attribute to me ideas which I do not entertain, but, on the contrary, they will see plainly that I have never misunderstood the qualities which neither instruct nor make the great artist. It is in this spirit that I have spoken of the harmonies of colours."[130]

Numerous connections have been proposed between Chevreul and the great French colorist Eugène Delacroix (1798–1863). While Delacroix was trained in an artistic color tradition directly descended from Rubens, he was far from hostile to new ideas about color. The extent of Delacroix's exposure to Chevreul is uncertain,[131] but we do know that his art and writings echo the corpus of published color theory to which Chevreul made seminal contributions.[132] The interest Delacroix had in simultaneous color contrast predates Chevreul's *Principles* and is clearly evident in Delacroix's Morocco sketchbooks of 1832: "The three secondary colours are formed from the three primary. If you add to a secondary colour the primary that is opposite,[133] you will neutralise it; that is to say you will produce its essential half-tone.... Note the green shadows in red. The faces of the two little peasants—the one who was yellowish had violet shadows; the other who was more rosy had green shadows."[134]

Delacroix's use of additive color effects and complementary-color contrasts became more pronounced in later decades. In 1854, Delacroix vowed to "banish all earthy colours"[135] from his palette, a move that anticipates the Impressionists' enthusiasm for unmixed primary pigments. Eleven years later, the writer Frédéric Villot (1809–75) commented on Delacroix's exploitation of Chevreul-like principles: "he interlaces the tones, breaks them up, and, making the brush behave like a shuttle, seeks to produce a tissue whose many coloured threads constantly cross and interrupt each other."[136] However, like other nineteenth-century artists[137] and Chevreul, Delacroix did not value rigorous color analysis above intuitive color experience. Science and color were not antithetical for Delacroix, but neither did their union solve all artistic color problems.

Georges Seurat, Color Theory, and *L'Arc-en-Ciel*

One artist famous as a devotee of scientifically informed color is Georges Seurat (1859–91). In major works such as *Une Baignade, Asnières* (1883–84) and *Un Dimanche après-midi à l'Ile de la Grande Jatte* (Sunday Afternoon on the Island of La Grande Jatte [1884–86]),[138] Seurat labored to refine what he called "the technique of *optical mixture*,"[139] in which he juxtaposed small dots of unmixed pigment. In modern terms, optical mixture occurs when these dots are too small to be resolved individually and their reflected light instead mixes additively.[140] Seurat

believed that paintings composed of many such dots would be inherently brighter (that is, more reflective) than those done conventionally in subtractive pigment mixtures. Furthermore, Seurat believed that optical mixture had the advantage of mixing light in the same way that natural objects, their surroundings, and light sources do. By understanding this mixing analytically, he believed, he could outdo Impressionism's more intuitive approach to simulating nature. To justify his technique, Seurat also invoked the language of visual perception.[141] Although Seurat's understanding of these complex ideas ranged from good to mediocre, he pursued them diligently in paint for the rest of his life.[142]

With its appeal to scientific accounts of color mixing, Seurat's pointillism (and the related technique of divisionism)[143] found ready takers among some French Impressionists, including Paul Signac (1863–1935) and, briefly, Camille Pissarro (1830–1903). In 1890 Seurat rather defensively claimed priority over his fellow artists in inventing pointillism, writing that he had been "searching for an optical formula on this basis ever since I held a brush 1876-1884."[144] Seurat also asserts that "*purity of the spectral element* [is] *the keystone of my technique*," and that "I abandon *earth colors* from 82 to 1884,"[145] although both of these choices have artistic precedent (for example, Delacroix and the Pre-Raphaelite and Impressionist palettes). Seurat's contemporary Gustave Kahn (1859–1936) quotes him as saying: "scientifically, with the experience of art, I have been able to find the law of pictorial color."[146] However, Seurat's pronouncements about this Neo-Impressionist style were rather grander than its reality on canvas.

In fact, Seurat drew inspiration for pointillism from both artistic and scientific sources. Delacroix, Pissarro, and Pierre-Auguste Renoir (1841–1919) had already juxtaposed small, multihued brushstrokes that de facto accomplished Seurat's optical mixing.[147] Seurat's most important scientific sources on color theory were Chevreul's *Principles of Harmony and Contrast of Colors* and a recent French translation of Ogden Rood's *Modern Chromatics*, a copy of which Seurat owned. Seurat copied entire passages from Chevreul and he resolutely tried to exploit and enhance simultaneous contrast, although Chevreul had warned against the latter practice.[148] Seurat took brief notes from Rood's chapter "On the Production of Colour by Absorption,"[149] and later in Rood's book he could have read this description of a long-lived artistic practice: "We refer to the custom of placing a quantity of small dots of two colours very near each other, and allowing them to be blended by the eye placed at the proper distance. . . . The results obtained in this way are true mixtures of coloured light, and correspond to those above given. . . . This method is almost the only practical one at the disposal of the artist whereby he can actually mix, not pigments, but masses of coloured light."[150] We do not know whether this passage was part of Seurat's scientific rationale for pointillism, but it would have provided a strong intellectual buttress from a respected and popular scientific author.

Certainly Neo-Impressionist canvases were regarded as novel. Contemporary critic Félix Fénéon (1861–1944) erroneously cheered that "the luminosity of optical mixtures is always superior to that of material mixture, as the many equations worked out by M. Rood show." He further noted: "Monsieur Seurat is the first to present a complete and systematic paradigm of

this new technique."[151] Other writers were not convinced of the success of pointillism. Critic Émile Hennequin (1858–88) wrote that "Seurat's pictures, like those of the artists who follow him, are almost entirely lacking in luminosity," adding that of *La Grand Jatte*, "you cannot imagine anything more dusty or lustreless."[152] Other contemporary criticism of *La Grande Jatte* accused Seurat of an over-reliance on scientific technique. Fénéon spiritedly defended the artistic prowess of the Neo-Impressionists, and in an excess of zeal he dismissed as "dreadful" physicist Rood's amateur paintings, sight unseen.[153]

What could Seurat and his fellow Neo-Impressionists have hoped to accomplish with optical mixing and pointillism? First, as is evident in Fig. 7-12, pointillism's additive mixing of light reflected by pigments does yield inherently brighter colors, provided we compare these with colors produced by subtractive mixing (that is, blending or glazing) of the *same* pigments. As art historian Alan Lee notes, this last proviso is crucially important.[154] Because subtractively mixed pigments are so dark, artists traditionally had used different pigment blends than the pointillists. Furthermore, conventional pigment blends often were admixed with white to make them brighter (at the necessary expense of the blended color's purity). In general then, pointillist paintings are *not* brighter than brightly painted conventional works.[155] Second, optical mixture of complementary-color pointillist dots produces nearly achromatic results, *not* the pure hues that Seurat and others strove for.[156] The near-neutral grays that result from pointillist complementaries are simply darker versions of the white produced by additively mixing colored lights (Fig. 7-10).[157] This achromatic bias of pointillist works probably accounts for some of Hennequin's unfavorable reaction to *La Grande Jatte*. Third, Seurat's practice of artificially enhancing simultaneous color (and brightness) contrasts in his paintings was not a naturalistic touch. As Chevreul himself pointed out, simultaneous contrast was a phenomenon inherent in vision, not something to be added by painters.[158] Finally, Seurat's claims about pointillism's enhanced naturalism are unjustified—pointillism's color mixing is no more or less representative of color in nature than that of earlier painting. Seurat wrongly assumed that an object's "local" or surface color (itself a specious Aristotelian notion) and its illumination mix additively.[159] No matter how they are applied, pigment colors depend on exactly the same processes of absorption, reflection, and scattering that affect, say, a sunlit river bank (Fig. 7-17).[160]

Seurat explores his evolving color ideas in *L'Arc-en-Ciel*, one of numerous studies for *Asnières*. Although not done in pointillist style, Fig. 7-17's free brushwork and juxtaposed color patches offer an Impressionist foreshadowing of Seurat's later technique. As far as we know, the rainbow appears in this study only, suggesting that Seurat conceived of it as an interesting but ultimately unimportant color problem.[161] By including a rainbow, Seurat may have been following the exhortation that he had read years earlier in Charles Blanc's *Grammar of Painting and Engraving*, where "God . . . , the eternal colourist . . . has left us the ideal of colour, as it were, in showing us the rainbow, where he lets us see . . . the mother tones which engender the universal harmony of colour."[162] Certainly the notion of a divine color model would have appealed little to Seurat, but perhaps Blanc's echoes of Chevreul's "harmony of color" did.

FIG. 7-17
Georges Seurat, *L'Arc-en-Ciel*, 1883. Berggruen Collection, National Gallery, London (© National Gallery, London)

L'Arc-en-Ciel is only a sketch, so we should not read too much into it. Nevertheless, the rainbow's impossible geometry and meteorology suggest that Seurat added it here primarily as a color vehicle. To all appearances, only small cumulus clouds dot Fig. 7-17's clear sky, so no rain is falling. (The completed *Asnières* itself depicts a sunny day.) Furthermore, the sketchy shadows place the sun high in the sky and to the picture's right, so the rainbow cannot appear here even if rain were present. Finally, Seurat is not even concerned with making the arc circular, since its base bends more sharply than its upper parts. Yet he is interested in building up the bow with a series of short, radial brushstrokes in orange, yellow, and green. Simultaneous color contrast enhances the yellow-green color border of Seurat's rainbow. However fleetingly, the rainbow commands Seurat's interest as a problem in color and brushwork as he develops his Neo-Impressionist technique.

On balance, Seurat is certainly not a color charlatan. Like Constable, he brings the enthusiasm and determination of a sincere amateur to the color theory of his day.[163] That he failed to understand its nuances (and inconsistencies) is not surprising since, like Constable, even color

ideas that merely sounded plausible could have satisfied his professional curiosity. That Seurat's use of color did not improve remarkably on his predecessors' is easy to see in hindsight. Yet like many another advocate, Seurat may have been oblivious to the visible shortcomings of his chosen cause. Certainly he believed that pointillism was simply a technical means to a coloristic end, saying: "[Writers and critics] see poetry in what I do. No. I apply my method and that is all."[164] Fellow Neo-Impressionist Paul Signac was more observant about that end, distinguishing in 1899 between the visual consequences of pointillism ("dotting") and divisionism:

> The technique of *dotting* has a more modest role: it simply renders a painting's surface more vibrant, but it does not ensure brightness, intensity of coloring, or harmony. For complementary colors, which are friends and enhance each other when contrasted, are enemies that destroy each other when mixed, even optically. A red surface and a green surface, contrasted, stimulate each other, but red dots mixed with green dots form a gray, colorless mass.
>
> *Divisionism* in no way requires a touch shaped like a *dot*. It can use this touch for small canvases, but utterly rejects it for larger compositions. The size of the *divided touch* must be proportioned to the size of the work, otherwise the picture is liable to lose its color.[165]

Do opponent-color processes such as simultaneous color contrast affect our perception of the rainbow? Seurat's modest *L'Arc-en-Ciel* implies (if only unintentionally) that they might. Yet despite more than a century of scientific work on opponent colors, the best answer we can offer is "perhaps." Without psychophysical testing of subjects, this plausible idea really cannot be studied adequately. Yet as Seurat's work suggests, if reds and greens (or yellows and blues) are paired in the bow, simultaneous color contrast could enhance the apparent purity of these rainbow colors. What we can be certain of is that additive color mixing explains much of the rainbow's appearance in nature.[166] First, rainbow light from distant raindrops mixes optically whenever we cannot discern individual drops. Second, because the rainbow's colors are additively mixed with those of the landscape or sky, "all the colors of the rainbow" must necessarily include those of the background. At worst, background colors outshine the rainbow so much that the rainbow itself cannot be distinguished from them, and the bow disappears.

Metamerism and the Problem of Defining White

Another problem in describing the rainbow's colors is defining the term "white." At first, the notion that "white" is not well-defined seems odd, but an everyday example illustrates the problem. As the sun's elevation changes during the day, the spectrum of direct sunlight also changes. If the sun is more than about 30° above the horizon, most of us would readily call its illumination white. However, even here sunlight is far from spectrally uniform, even though spectral uniformity is often used as a synonym for whiteness. As the sun sets, its spectrum is increasingly

FIG. 7-18

Visible spectra of some "white" light sources

dominated by longer wavelengths: sunlight becomes redder. Yet most of us would persist in saying that sunlight is white until the sun is only a few degrees above the horizon. This fixity of color description, despite very real spectral changes, is called *color constancy*.

In Fig. 7-18 we have drawn curves showing the relative amounts of energy at visible wavelengths for several sources of nominally white light. These curves are called *energy spectra*, and like reflectance spectra they are closely related to our perception of color. In Fig. 7-18 the spectra's shapes differ starkly, meaning that their spectral energy distributions are quite dissimilar. Yet each of these light sources seen by itself looks white. For example, no reader with normal color vision is likely to notice changes in white paper's color whether he or she examines it in shadow, noon sunlight, or by incandescent lamp light. Most of us will claim, at least at first glance, that the white we see on a television screen is the same as that of the sunlit paper, even though these two light sources have distinctly different locations on Fig. 7-13's chromaticity diagram.

Color constancy is essentially a temporal phenomenon. In other words, even though the illumination spectrum changes with time, we interpret the colors of our surroundings as unchanging. This perceptual resistance to spectral change has some distinct evolutionary advantages. For example, the spectrum of direct sunlight differs greatly from that of shade, which is dominated by the color of skylight.[167] If we recognize a dangerous animal whether it stands in sunlight or shade, our chances of surviving the encounter obviously are improved.[168] We need to consider sunlight's color constancy as we analyze the rainbow, because many of our rainbow

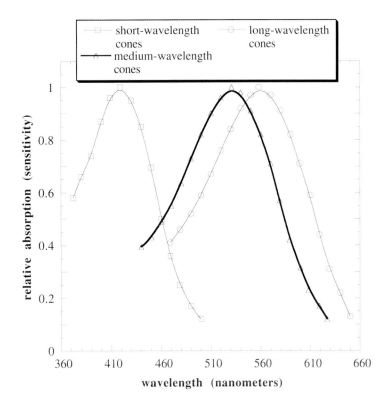

FIG. 7-19

Spectral absorption by the three types of cones in the human eye

photographs were taken when the sun was low in the sky and sunlight's spectrum is reddened. Among other side effects, color constancy means that observers will tend to overestimate the similarity of rainbow colors generated by very different sunlight spectra.

Recall the questions raised by Fig. 7-7, our example of complementary colors. We have already answered one of those questions, that of why mixing pigments results in a color darker than either of the original colors. What of our other questions? They are both variations on a single question, one that bedeviled Newton. To rephrase it in modern terms: If two color samples match, are their energy spectra identical? For example, does additively mixing blue and yellow light to yield white (as we have done in Fig. 7-7) mean that we have created a color whose spectrum is the same as that of sunlight? In general, the answer is "no."

This perceptual confusion of physically different stimuli is called *metamerism*, and examples of such stimuli are *metamers*.[169] The additive mixture of blue and yellow in Fig. 7-7 is a metamer for white. With some care, we could make a white on a color television that is a metamer for sunlight. Figure 7-18 indicates that the two sources of identical white light would have radically different energy spectra.[170]

Why does metamerism's perceptual confusion occur? Our retinas have only three types of photoreceptors that function in bright daytime conditions. These photoreceptor types (collectively called *cones*) each respond to energy from a broad region of the visible spectrum, and these regions overlap considerably.[171] Figure 7-19 shows how the three cone types absorb light

FIG. 7-20

Primary rainbow in State College, Pennsylvania, 1973 (Rainbow Kenfield)

across the visible spectrum. The more light a cone receptor absorbs at a given wavelength, the more sensitive it is at that wavelength.

Two factors contribute to metamerism. First, the magnitude of each cone's response to a light source preserves no information about the individual wavelengths that stimulated the cone. Second, the overlap in the cones' spectral sensitivities means that light sources whose spectral details differ substantially may evoke exactly the same trio of responses from the three classes of cones.[172] In other words, the spectrally different lights will be perceptually identical.

Does metamerism have any implications for our perception of rainbows? Once again, we cannot know without psychophysical tests of rainbow observers, but we do offer a plausible suggestion. Metamerism probably contributes to our impulse to count the rainbow's colors. Consider Newton's (or Constable's) indecision over the number of rainbow colors. While either man could accept intellectually that rainbows have an indefinite number of colors, metameric blurring of fine spectral distinctions probably encouraged both to settle on a specific number. Clearly symbolic or practical considerations did much to determine the actual number chosen. However, the idea that the rainbow contains *some* specific number of colors may well be driven by metamerism.

FIG. 7-21
Primary rainbow near Jönköping, Sweden, 16 July 1978 (Rainbow Sweden)

How Many Colors Does the Rainbow Have?

The simple answer to the question "How many colors does the rainbow have?" is "As many as you think you see." Cultural and philosophical expectations about color naming ultimately render this question meaningless. Nevertheless, the enduring human impulse to name and enumerate the rainbow's colors makes the question a tempting one. So here we use colorimetry to quantify the colors of some sample rainbows, while recognizing that we are using the conventions of Western color naming and are addressing an early twenty-first century audience. As we have seen, colorimetry is far from a panacea for the myriad problems of color description, nor should it be offered as such.[173] Nonetheless, if we recognize colorimetry's limitations, it remains a valuable technique for systematically relating colors to the energy spectra that cause them.

Figures 7-20 and 7-21 are our sample rainbows, and we analyze their rainbow colors using the CIE 1976 colorimetric system. First we electronically digitize the original slides of these figures, as well as slides of a card that contains many different color samples. The resulting digital images consist of hundreds of thousands of discrete dots of color known as picture elements, or *pixels*. Each pixel's color can be completely independent of its neighbors' colors,

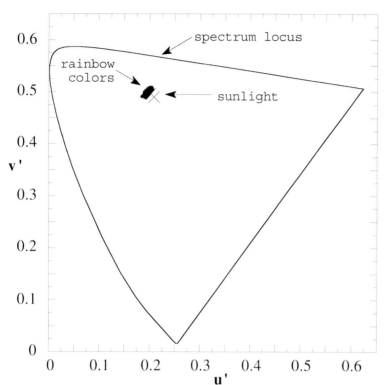

FIG. 7-22
CIE 1976 UCS chromaticities of Fig. 7-20

although in natural scenes the differences usually are fairly small. Now each pixel's color is encoded as a number, and we can relate this number to the brightness and color in the corresponding part of the original rainbow slide. If the same sunlight spectrum generates the rainbow and illuminates the color card, we can use the card's known colors to describe the rainbow's many unknown colors quantitatively.[174]

The time and location of the rainbows in Figs. 7-20 and 7-21 specify the sun's elevation, which in turn lets us estimate sunlight's spectrum. In Figs. 7-22 and 7-23 we have outlined the CIE 1976 UCS diagram, and within each diagram we have drawn the rainbow chromaticities of Figs. 7-20 and 7-21 and marked the color of our estimated sunlight with an x.

Figures 7-22 and 7-23 are at once revealing and not very helpful in answering our question above. The diagrams are revealing because they show what a tiny fraction of perceptible colors these vivid rainbows span. How can this tiny gamut of rainbow colors be reconciled with the rainbow's reputation as a nonpareil color standard? We examine this question in the next chapter. Our CIE diagrams are not very revealing, however, when we try to glean details about the colors of our two rainbows.

To do this, we need to zoom in on the data, which we do in Figs. 7-24 and 7-25. In both of these enlarged views we once again mark the chromaticity of sunlight with an x. Now we have drawn +'s to mark the chromaticities of the many image pixels that define the rainbows. Note

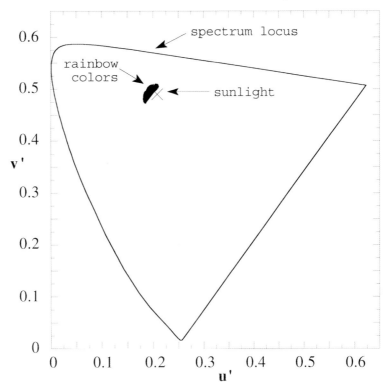

FIG. 7-23
CIE 1976 UCS chromaticities of Fig. 7-21

that these thousands of +'s are not distributed uniformly. Where they are clumped together, the original scenes had many small shifts between colors; where the +'s are spread thin, steps between colors are larger. (Recall that moving within the CIE diagram means moving to a new color.)

Some chromaticity shifts may be so small that they result in no noticeable change in color. One psychophysical measure of this minimum colorimetric distance is the "just-noticeable difference" or JND.[175] In both Fig. 7-24 and Fig. 7-25, a small circle indicates the size of the JND for this region of the colorimetric diagram.[176] In essence, identifying a clump of +'s within one JND of one another means that we have located a single, identifiable color. A single color may encompass more than one JND, but if two distinct clumps of +'s are separated by more than one JND, we are likely to identify them as two separate colors.

What are the identifiable colors in Fig. 7-20? Visually, the rainbow in Fig. 7-20 appears to have about four distinct colors: orange, yellow, cyan, and purple. In Fig. 7-24 (our analysis of Fig. 7-20), we see four fairly distinct +-clusters that correspond to these colors. Green is present, but its samples are separated by fairly large colorimetric jumps (some greater than one JND). Visually, green is difficult or impossible to find, while the closely clustered blue chromaticities are actually those of the cloud background.

In Fig. 7-21's more vivid rainbow, we once again see orange, yellow, cyan, and purple. Now the orange is more pastel (that is, less pure). Yellow is most evident near the base of the bow,

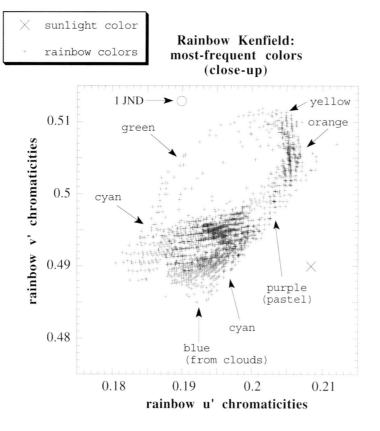

FIG. 7-24

Close-up CIE 1976 UCS chromaticities of Fig. 7-20

meaning that yellow pixels will be common, but not abundant, when we consider the entire rainbow arc. We can also see a distinct green near the bow's base. In Fig. 7-25's analysis of Fig. 7-21 we find objective confirmation of our subjective visual impressions. The emergence of the green +-cluster is especially striking, as is the preponderance of blue +'s from the sky and clouds. Excluding this sky background, we can say that the rainbow in Fig. 7-21 has about five distinct colors.

Does Fig. 7-25 show us five rainbow colors? Yes, it does—at least in the sense that we can identify five distinct clumps of chromaticities. Of course, we can just as well say that this rainbow has more than 3,300 identifiable colors, the number generated by our colorimetric analysis. By this quantitative measure, Fig. 7-20's rainbow has nearly 1,600 identifiable colors, not just the mere four that we can identify visually. This epistemological morass deepens when we realize that if we increase the angular and spectral resolution of our image analyses we can identify even more colors in the same rainbows.

Should We Color the Rainbow to Suit Ourselves?

We seem to have come full circle. Either rainbow colors can be counted on the fingers of one hand or they are virtually innumerable. Which estimate is truer? Perhaps neither is better than

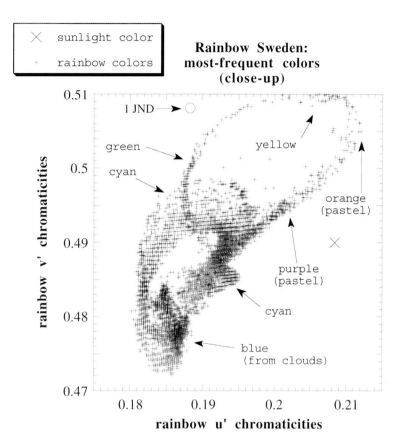

FIG. 7-25
Close-up CIE 1976 UCS chromaticities of Fig. 7-21

the other. As with many of life's posers, perhaps we should resign ourselves to this duality and simply enjoy the rainbow's colors uncounted.

Yet our answer is not an evasion. We have learned that the Newtonian and Aristotelian cases for seven or three rainbow colors have less to do with nature than with cultural and philosophical preconceptions. The rainbow's colors are just as intangible as those on an artist's palette, yet they are just as innately human in their origins. As Leonardo da Vinci hoped, the rainbow has rightly assumed its honored place in "the last book" on painting by helping a variety of artists, philosophers, and scientists better understand how we as observers make a world filled with color.

What of *The Story of Noah* and its blithe rainbow coloring instructions? Admittedly, adults may find it satisfying to give a child license to color with abandon *something* in Noah's momentous scene. Whether the child cares about those instructions at all is another matter. If, like the authors of *The Story of Noah*, we only color the rainbow to suit ourselves rather than nature, we will have lost a key that unlocks doors to understanding our visual world. Now, however, we want to turn our attention a little less inward and see what information the rainbow's colors can provide about the world outside ourselves.

Long before Newton, unusual varieties of rainbows had prompted sporadic scientific interest. After Newton, these varietal bows raised nagging doubts about the completeness of his answers and would ultimately lead to powerful new rainbow theories in nineteenth-century optics. With these theories, we can see that "all the colors of the rainbow" are actually quite different from our preconceptions. Yet for nineteenth-century artists still debating the validity of Newton's rainbow colors, these new optical theories clearly were peripheral—the divorce between the rainbows of interest to them and to scientists was nearly complete. Ironically, the nineteenth century produced some of the strongest claims about the unity of artistic and scientific enterprise, testimony to the rainbow bridge's tenuous power.

EIGHT

WHAT ARE "ALL THE COLORS OF THE RAINBOW"?

Although we cannot be certain what kind of bow Thomas Barker saw during the winter of 1739–40, we can be sure that he did not see a rainbow proper. Our clue (and Barker's) is his bow's "indistinct" colors. As we have seen earlier, two characteristics earn almost any sky feature the name "rainbow"—an arc shape and colors. Because not all colored arcs in the sky are rainbows, Barker is quite right to be skeptical about calling the "broader, fainter" arc he saw a rainbow.

What Barker calls a "Frost Rainbow" probably is a *cloudbow* (Fig. 8-1).[2] (The bright light immediately surrounding the airplane shadow in Fig. 8-1 is not a cloudbow but a *glory*.[3]) At first glance, this broad, anemically colored bow looks so different from the rainbow that we may be forgiven if we side with Barker and believe that it is "too much confused to be form'd by spherical drops of water." Barker makes the plausible but erroneous assumption that instead of raindrops, his bow is formed by "very small round & icy

> I saw in that part of the Skie, where a Rainbow would naturally be; Something, which was like one, but much broader, fainter, and though colour'd yet indistinct; there was no appearance of Rain, nor do I believe there was any: And indeed the Bow was too much confused to be form'd by spherical drops of water.[1]
>
> Thomas Barker,
> "A remarkable cloud rainbow" (1739)

FIG. 8-1

A cloudbow, also known as a fogbow or pilot's bow, seen from an airplane

FIG. 8-2

A water-drop bow seen in a spray of sunlit drops (photo: Michael E. Churma)

hail."[4] However, hail is neither clear enough nor symmetric enough to be an adequate substitute for transparent, spherical water drops. In fact, both the rainbow and the cloudbow are merely varieties of water-drop bows. In the case of cloudbows, the water drops are those of the clouds themselves.

As many an inquisitive (and wet) child has discovered, making a rainbow does not require that you wait for rain—a sunlit spray of water drops from a hose will do just fine (Fig. 8-2). So raindrops apparently are not uniquely qualified to form rainbows (or water-drop bows, more generally). But how do water droplets in clouds yield a bow whose appearance differs so radically from a bow produced by rain droplets?

Surprisingly, explaining the essentially colorless cloudbow also tells us how some colorful but subtle rainbow features arise. In Fig. 8-3, note the narrow pastel bands inside the primary rainbow—the supernumerary bows. Although reports of the supernumeraries date from the thirteenth century, neither Newton's nor Descartes's theories of the rainbow can account for them.[5] By the mid-eighteenth century, increasingly frequent accounts of the supernumeraries and cloudbow provoked scientific interest (and consternation), ultimately leading to new theories of the rainbow.

Neither the cloudbow nor the supernumeraries have contributed much to the rainbow's cultural symbolism. After all, they roil the simple rainbow image considerably, and the fact that their scientific explanation was even more abstruse than Newton's made them relatively uninteresting to most lay audiences. By the nineteenth century, artistic interest in rainbow optics usually lagged behind the science itself (the cases of John Constable and Frederic Church are typical). Ironically, while some artists' interest in rainbow science reached its zenith, scientific study of the rainbow had already moved far beyond the scientific expertise of most artists. Given this increasingly tenuous rainbow bridge between science and art, our story of cloudbows and supernumeraries is primarily a scientific one. Nonetheless, it is a story that has great rewards for even the most casual rainbow observer.

Cloudbows: The "Circle of Ulloa"

In 1748, Spanish explorers Jorge Juan y Santacila (1713–73) and Antonio de Ulloa (1716–95)

FIG. 8-3

Supernumerary rainbows inside a primary rainbow at Kootenay Lake, British Columbia, 12 July 1979

gave an account of glories and a cloudbow that Juan's party had seen from Mount Pambamarca in present-day Ecuador (Fig. 8-4).[6] Juan and Ulloa were far from the first to write on cloudbows—Theodoric of Freiberg's account of cloudbows preceded the Spaniards' by nearly 450 years, Witelo had mentioned cloudbows even earlier, and Avicenna clearly describes an eleventh-century cloudbow. Early documentation, however, did not mean early explanation. While Theodoric correctly notes that the cloudbow (or fogbow) and the primary rainbow arise in the same way, he offers no convincing explanation of why their colors differ.[7] Witelo simply accounts for the "completely white rainbow" with a combination of thin vapor and clear illumination.[8] No more persuasive is Avicenna's statement that the diameter of his cloudbow shrank because he grew more distant from the sun as he descended the mountain toward the bow.[9]

Leonardo da Vinci's typical meteorological insightfulness is evident when he describes the cloudbow. In his *Treatise on Painting*, written a few years before his death in 1519, Leonardo explains why some rainbows are red when the sun is low in the sky. He then expands on the topic, noting: "That redness, together with the other colors [of the rainbow], is of much greater intensity, the more the rain is composed of large drops, and the more minute the drops, the paler are the colors. If the rain is of the nature of mist, then the rainbow will be white and so completely without hue."[10]

More than two hundred years later, Juan and Ulloa could add nothing to this cloudbow explanation, noting simply that "beyond those Rainbows [that is, glories], one saw at some distance a fourth Arch of a whitish hue."[11] Despite this perfunctory description, Ulloa's account was so widely circulated that his name later attached itself to the cloudbow as the "circle of Ulloa."[12] Yet the eighteenth century's growing scientific interest in exotic water-drop bows demanded more than expanded nomenclature. Observers knew that cloud drops were much smaller than raindrops, and presumably this size difference determined the colors of the resulting bow. But how?

FIG. 8-4

Eighteenth-century illustration of a cloudbow and glories seen by Jorge Juan y Santacila's scientific party. The cloudbow is the large white arc surrounding the bull's-eye glory pattern. The relative angular sizes of the cloudbow and glories are at odds with nature and Juan's accompanying text. (From David K. Lynch and Susan N. Futterman, "Ulloa's Observations of the Glory, Fogbow, and an Unidentified Phenomenon," *Applied Optics* 30 [1991], p. 3540)

Both Descartes and Newton believed that the rainbow's colors were unaffected by raindrop size.[13] In fact, Descartes quite casually notes that raindrops' "being larger or smaller does not change the appearance of the arc."[14] Yet for centuries before Descartes and Newton, rainbow observers had recognized that not all rainbows look the same. For example, Robert Grosseteste noted the "difference between the colours of one rainbow and those of another" in his thirteenth-century *De iride*,[15] and Avicenna had commented on the colorlessness of his cloudbow. Not only do cloudbows and rainbows differ in their colors, but even a given rainbow can show color and brightness variations around its arc (Fig. 8-5).[16] Furthermore, by the eighteenth century measurements showed that (1) although supposedly fixed by Newton, the rainbow's width varied, and (2) the angular diameter of cloudbows was markedly smaller than that of rainbows.[17]

One cloudbow explanation with a decidedly Aristotelian tinge was that clouds' small drops produced too little light for rainbow colors to result, yielding only white light. As we saw in Chapter 7, reduced brightness *does* affect rainbow colors, making the lunar rainbow white. (England's Princess Margaret is among those lucky enough to have seen a bright, and thus vividly colored, lunar rainbow.)[18] But blaming the colorlessness of the cloudbow on its small drops was unsatisfactory because rainbows no brighter than cloudbows were quite colorful. Some scientists thought that cloudbows and supernumeraries were formed by distorted, nonspherical drops, an idea supported into the nineteenth century.[19] Although this idea is plausible, we now know that it is both wrong and inconsistent with the small size of cloud drops.

A far less plausible explanation was that cloudbows require cloud drops in the form of

hollow spheres, or vesicles. This vesicular theory of the cloudbow was already rather shopworn when revisited in 1845 by French physicist Auguste Bravais (1811–63). In an elaborate geometrical optics analysis, Bravais claimed that the speculative (in fact, nonexistent) vesicles were required to produce cloudbows, a claim met with widespread scientific skepticism.[20] However, a powerful new theory already accounted for both the cloudbow and the supernumerary bows, rendering Bravais's analysis little more than a scientific rearguard action. To understand how this new theory arose, we now turn to rainbows that were not supposed to exist—the supernumerary bows (Fig. 8-3).

Supernumerary Bows: Cloudbows' Superfluous Cousins

Theodoric had commented in his *De iride* not only on cloudbows, but also on the pastel purple and green bands seen within the primary rainbow. He confidently (and incorrectly) explained them as being similar to the pale colors seen at the fringes of the colors of a sunlit prism.[21] Witelo preceded Theodoric in mentioning these pastel bows in his *Perspectiva* of c. 1270–74.[22] Yet despite sporadic interest in these bows in the following centuries, they remained largely a troublesome curiosity for rainbow theorists.

Since antiquity, philosophers and commoners alike tended to assume that the term "rainbow" meant a single circular arc of nonrepeating colors. In other words, the "iris" described by most writers was what we now call the primary rainbow. In both theory and myth, the secondary rainbow had been assigned a place of clearly secondary importance. So what were observers to make of the supernumeraries' even more peripheral bands of pastel color? The hard-won achievements of Descartes and Newton seemed threatened by these marginal additions to the rainbow proper.

One common reaction to being confronted with the unexplained is to label it inexplicable, which in this case meant labeling the pastel bows "spurious" or "supernumerary."[23] The supernumerary bows thus acquired their faintly reproving name, one that has persisted long after we know that they are an integral part of the rainbow, not a vexing corruption of it.

Doubtless eighteenth and nineteenth-century optics would have arrived at explanations of the supernumeraries even if these bows had not been the subject of spirited scientific discussion. But we can be equally sure that awareness of the supernumerary problem spurred on some theoreticians. With this in mind we come to one of the eighteenth century's more unlikely optical catalysts, Benjamin Langwith (c. 1684–1743), Rector of Petworth. In a letter to the Royal Society's *Philosophical Transactions* in 1723, Langwith detailed his recent observations of supernumerary bows: "The first series of colours was as usual, only the purple had a far greater mixture of red in it than I had ever seen in the prismatic purple; under this was a coloured arch, in which the green was so predominant, that I could not distinguish either the yellow or the blue: still lower was an arch of purple, like the former, highly saturated with red, under which I could not distinguish any more colours."[24]

Bear Fig. 8-3 in mind as you read Langwith's observation, for he has succinctly captured many of the supernumerary bows' features. Langwith even self-confidently questioned the rainbow wisdom of Royal Society president Isaac Newton: "I begin now to imagine, that the Rainbow seldom appears very lively without something of this Nature, and that the suppos'd exact Agreement between the Colours of the Rainbow and those of the Prism, is the reason that it has been so little observed."[25]

In another remarkable observation, Langwith noted that supernumerary bows were absent from the bases of vivid rainbows but visible near their tops. He speculated presciently that "this effect depends on some property which the drops retain while they are in the upper part of the air, but lose as they come lower."[26] Identifying just what this change in the drops is has proven to be a surprisingly long-lived problem,[27] one that we take up in Chapter 9.

As the eighteenth century progressed, many other accounts of supernumerary rainbows surfaced in scientific journals and textbooks. Explanations ranged from the bows' being merely an illusory visual artifact to their being caused by sulfur compounds dissolved in the drops. In addition, the same incorrect arguments advanced for the cloudbow were also given for the supernumeraries—that the raindrops must be either hollow or asymmetric. Elaborate geometric variations on Newton's and Descartes's theories would also prove unsuccessful in correctly explaining the supernumeraries.[28] For that explanation, we must move to the nineteenth century.

Thomas Young and the Interference Theory of the Rainbow

By 1800 most English scientists believed, as had Newton, that the behavior of light was best explained as a series of small particles traveling from the light source to the eye. In the late seventeenth century, Robert Hooke and Christiaan Huygens had asserted that light behaved more like waves than particles.[29] Throughout the eighteenth century the controversy simmered, and at least in England, Huygens's ideas were considered somewhat suspect. In fact, all our explanations of the rainbow so far could just as easily have used the words "the path of the particles of light" instead of "the rays of light." Nothing, not even our discussion of rainbow colors, depends on light being thought of as a series of waves.

However, in an 1803 lecture the English physician and scientist Thomas Young asserted that supernumerary bows could be explained only if light were thought of as a wave phenomenon. Although Young used his wave theory to address several puzzling optical problems in addition to the supernumeraries, explaining these was clearly his signal achievement. Young noted in particular that Langwith's supernumeraries "admit also a very easy and complete explanation from the same [light wave] principles" and that the "circles sometimes seen encompassing the observer's shadow in a mist" (glories) were wave phenomena.[30] Young went on to state confidently: "Those who are attached to the NEWTONIAN theory of light, or to the hypotheses of modern opticians, founded on views still less enlarged, would do well to endeavour to imagine any thing like an explanation" of such light-wave patterns.[31]

FIG. 8-5
A primary rainbow showing color variations around its circumference. State College, Pennsylvania, 1973

Thus the supernumerary rainbows proved to be the midwife that delivered the wave theory of light to its place of dominance in the nineteenth century. The seeming disparity between the two theories of light has narrowed to the point that either one can explain a tremendous wealth of optical phenomena. Light can be thought of as either waves or particles, and only convenience and simplicity determine which model we use to study a particular optical problem. For the rainbow, we now switch to the wave model of light.

Interference is the wave property that interested Young and that we use to explain supernumerary bows. One way of visualizing interference is to imagine waves on a lake. If the wakes of two boats cross, their waves will interfere. Where the crests of two waves coincide, they reinforce each other to make a larger wave. However, if the crest of one wave sits in the trough of another, the two disturbances cancel each other and the water will be at its original level. When waves combine to make a larger wave, the effect is called constructive interference; when they cancel, it is called destructive interference. Our analogy's details change slightly when we switch from water to light waves, but Fig. 8-6 nonetheless suggests the parallels.

FIG. 8-6

Computer simulation of an interference pattern created by two expanding circular light waves. If a wave trough and crest coincide, the pattern is darker than either wave's average brightness (destructive interference). If wave crests or troughs coincide, the pattern is brighter (constructive interference).

In fairness, we should note that Newton himself was aware that water wave interference affected ocean tides and that he could explain some optical phenomena by assuming that light had wave properties. Nevertheless, because Huygens was unable to explain satisfactorily how pulsating light waves could travel in straight lines, Newton rejected the wave theory of light and resolutely insisted that light consisted of streams of particles.[32] Thus far from merely being a scientific iconoclast, Young saw in his own experiments how to overcome shortcomings in Huygens's wave theory and how Newton's wave theory of the tides had significance for optics.

Despite Young's intellectual evenhandedness, his claims of scientific superiority to Newton on the rainbow cast him as an iconoclast. Scathing published attacks on his theory accused him of disrespect for Newton—not a surprising reaction given that the supernumeraries themselves were deemed an affront to Newton's reputation.[33] But Young's theory soon faced a far more serious challenge than reactionary tirades. French engineer Étienne-Louis Malus (1775–1812) and David Brewster of England demonstrated separately in 1808 and 1815 that reflected sunlight and rainbow light both have a property not readily explained by Young's theory.

That property is *polarization*, which usually is invisible to us. However, we can detect polarization (and cause it) by using a polarizing device, the most familiar example of which today is polarizing sunglasses. What do polarizers such as sunglasses do? In very general terms, they block the transmission of some light-wave components while allowing others to pass, thus imposing undulatory order on light that may have very little (such as sunlight). This state of order is not an all-or-nothing proposition. Degrees of partial polarization (that is, neither completely polarized nor unpolarized) are the rule, not the exception, in nature. If a light source is at

least partially polarized, a polarizer can in certain orientations visibly reduce the light's intensity, which is what polarizing sunglasses do to glare reflected from highways.[34]

Because sunlight itself is unpolarized, the discoveries by Brewster and Malus that two common sources of atmospheric light are partially polarized seemed remarkable. Especially troubling for Young was the fact that the geometry of Newtonian-Cartesian rainbow theory easily explained the rainbow's high degree of polarization. By contrast, Young was at a loss to explain how his model of a light wave (which he likened to the back-and-forth motions in sound waves) could yield the observed polarization.

As a consequence, Brewster could serenely say that "observation agrees so well with the results of calculation that there remains no doubt of the truth of the Cartesian explanation." Young glumly but gamely admitted to Malus in 1811: "Your experiments show the insufficiency of a theory which I have adopted, but they do not prove it false."[35] Young was correct. The insufficiency of his theory (and of previous wave theories) was its depiction of the waves themselves.

Recall that Young described light waves as similar to sound waves, in which air expands and contracts (that is, oscillates) along the same direction that the sound wave propagates.[36] Such a wave is called *longitudinal*. Another kind of wave is generated if you tether one end of a rope and then whip the other end up and down: the rope itself does not move forward, but a wave with up-and-down oscillations moves forward along its length. In such a *transverse* wave, oscillations occur perpendicular to the direction in which the wave itself moves.

Nearly simultaneously, Young and the French engineer Augustin-Jean Fresnel (1788–1827) independently conceived of the same answer to wave theory's polarization problem.[37] If light waves were transverse rather than longitudinal, then they could indeed be polarized and be affected by polarizers. Consider an example. If our rope wave has up-and-down oscillations and we make it oscillate within a narrow vertical opening, the wave is unaffected (that is, it is transmitted) beyond the opening. However, if we turn the narrow opening so that it is horizontal, the rope wave will be damped out (that is, *not* transmitted) beyond the opening. The transverse rope wave thus responds to a polarizer, in this case the narrow opening.

With this solution in hand, Young and Fresnel could rightly claim that the wave theory of light offered a superior explanation of the rainbow. Not only could the interference theory of the rainbow account for the primary, secondary, and supernumerary rainbows, it could also describe their polarization. Nevertheless, scientific conservatism and unsolved theoretical problems with wave theory combined to make its acceptance slow.

This resistance is nicely summarized by Brewster, who would write defensively in 1833 about the wave theory of light: "I have not yet ventured to kneel at the new shrine, and I must even acknowledge myself subject to that national weakness which urges me to venerate, and even to support, the falling temple in which Newton once worshiped."[38] As for the rainbow itself, Young could use wave theory to account for the color and brightness of the supernumerary bows and even to estimate the sizes of raindrops that yielded supernumeraries.[39] However, neither he nor Fresnel gave a thoroughly quantitative account of the interference theory of the

rainbow. Such quantification would not appear until the 1830s, when once again a scientific temple would need repairs, this time Young's. We save that story for Chapter 9.

Interference as a Model for All the Bows

As Fig. 8-6 suggests, interference by water waves was for Thomas Young an apt analogy to interference by light waves. When one portion of a light wave passes through another there may be either constructive interference, which gives brighter light, or destructive interference, which gives darkness. Amazingly, light can cancel light to give darkness! However, Fig. 8-6 also shows that the waves are not altered at points beyond their intersection. In everyday terms this means that the rainbow's interference patterns cannot cast shadows, nor will one light beam block another. The reason is that any two light waves can only interfere *locally* where they cross.

But can we cross two flashlight beams and get darkness at their junction? Obviously not. Such light is said to be *incoherent*: flashlight beams contain a jumble of waves reminiscent of a lake surface on race day. While wave interference occurs between individual crests or troughs, no consistent pattern emerges from the chaos. Only when the light waves march across each other in orderly ranks does a coherent pattern of light and dark bands emerge.

On the very fine scale of tiny raindrops even sunlight will be coherent. One way of visualizing this is to recall that plow furrows in a hilly field may appear straight and parallel for a short distance, but that over longer distances they clearly wander around the land's contours. Similarly, on a very small scale any light source will be coherent. Most raindrops are less than a few millimeters in radius, much less than the distance over which sunlight is coherent. Thus light-wave interference in sunlight forms the supernumeraries—and the primary rainbow.

To see how this works, we first note that supernumerary bows are not caused by interference between two light waves. Instead, two different portions of the *same* light wave interfere. In Fig. 8-7, we once again show a circular slice through a raindrop, much as we did in Fig. 6-5. Now, rather than parallel light rays entering the drop, a series of wave ridges and troughs (Fig. 8-7's vertical lines) advances toward the drop as a front of parallel waves. Think of the parallel lines as representing the wave fronts of parallel rays of sunlight. (In order to make individual lines legible, we have spaced them much farther apart than one wavelength of light.) Rays, which are always locally perpendicular to their corresponding waves, show the waves' direction of travel.

The advancing wave front is refracted into the droplet, and some of it is reflected by the drop's rear surface. In turn, some of this internally reflected light is refracted out of the drop to form the rainbow. As the wave front traverses the drop, it folds over on itself, as Fig. 8-7's cross-hatching indicates. When the wave's two portions are superimposed, they interfere to produce a pattern of bright and dark bands. This interference pattern is drawn as a moiré pattern in Fig. 8-7, and light waves refracted and reflected by drops produce much the same effect in your eye.

The bright and dark bands radiating from the drop in Fig. 8-7 simulate the bright and dark

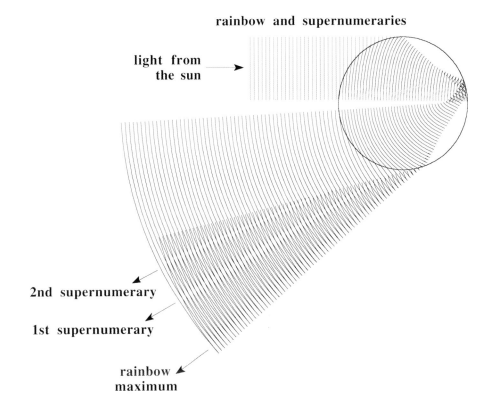

FIG. 8-7

A moiré pattern that mimics the constructive and destructive interference pattern of sunlight refracted and reflected by a raindrop

bands of light that form the rainbow. In fact, the large bright region at the angle of minimum deviation is the primary rainbow.[40] This region, in turn, is separated from the first supernumerary bow (the next bright band) by a band of darkness. The supernumerary bows are thus as much a part of the whole phenomenon as the primary bow itself: each represents a region of maximum brightness in the interference pattern that results when the wave front folds over on itself near the angle of minimum deviation.

Even though the supernumerary bows are an integral part of the rainbow, they are not always seen with the primary or secondary rainbow. In fact, seeing any more than a faint first supernumerary is often the highlight of a rainbow chaser's year. The three distinct (and ghostly fourth) supernumerary bows in Fig. 8-8 are as beautiful as they are unusual. We explore the reasons for this rarity in Chapter 9.

A Microscopic Explanation of Rainbow Colors

We can use Fig. 8-7 to address a question that Descartes could not answer and that hobbled his rainbow theory: why is red light bent less than violet for a given angle of incidence i, including at minimum deviation? In other words, why is red light bent less than violet in the rainbow? We begin by reexamining refraction from a microscopic standpoint, something that Descartes tried to do, although he did so incorrectly and in much different fashion than modern optics.

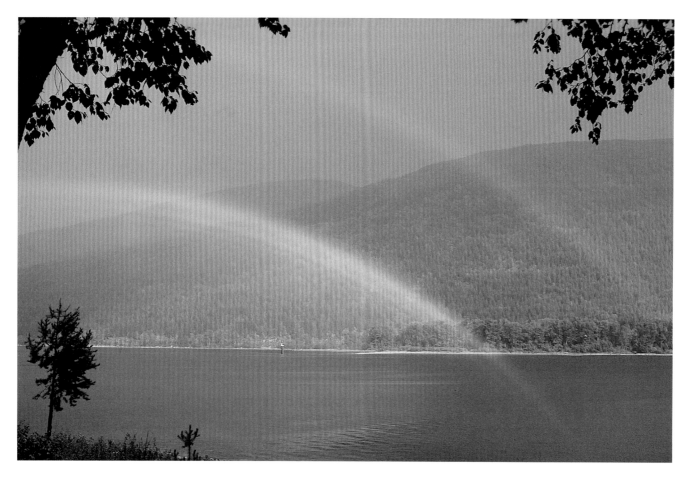

FIG. 8-8

Primary and secondary rainbow with four supernumerary rainbows inside the primary, Kootenay Lake, British Columbia (Rainbow Kootenay). The fourth (innermost) supernumerary is extremely faint, even in the original slide.

Like radio waves, light may be thought of as a very rapid oscillation of an electric field. As the light traverses a transparent medium such as glass, water, or even air, it sets the molecules vibrating. Strictly speaking, only the electrons in the molecules are materially influenced by the passing light wave's electric field. Electrons cannot vibrate as fast as the wave, and these lagging electrons cause the light to slow down. The light vibrates just as fast as it ever did, but now travels through the transparent medium at a somewhat slower speed. Violet light, with its shorter wavelength, has a higher frequency than does red light.[41] Thus the medium's electrons have even less success in keeping up with the oscillations of violet light than red light.

The net result is that violet light travels more slowly than red light in a medium such as water. Merely because violet light travels more slowly through water does not by itself account for the rainbow's color dispersion. How does a variation in speed result in a sideways shift? Imagine a car traveling down a narrow paved road. If its right wheels run onto the gravel shoul-

der, the car will swerve to the right. The wheels on the right have been slowed by the soft shoulder, and because the car's right side is now traveling slower than its left, the car will turn to the right. This is just the way that bulldozers are steered. For example, to turn to the right, the treads on the right are braked and those on the left are allowed to run at normal speed.

With this image in mind, reexamine Fig. 8-7. The parallel wave fronts that approach Fig. 8-7's raindrop are each perpendicular to the corresponding beam of parallel sunlight. Where this light beam enters the raindrop obliquely, one side of the beam (or one side of the corresponding wave front) encounters the water before the other. In Fig. 8-7, the lower side of the beam enters the raindrop first. Because this part of the beam (or wave front) slows first, the beam turns more sharply into the drop (that is, closer to its surface normal, which is a drop radius here; see Fig. 5-3). Thus the light is refracted or bent, and the amount of bending depends on how much the beam is slowed when it first enters the water drop. Because violet light is slowed more than red, violet light undergoes more refractive bending than red light. As Figs. 6-6 and 6-7 indicate, this greater deviation of violet compared to red puts violet on the primary rainbow's interior and on the secondary bow's exterior.

Why Do Cloudbows and Rainbows Look so Different?

Since Theodoric's day one question in particular has dogged comparisons of the rainbow and cloudbow: why do the bows look so different? Young's theory holds that the sizes of raindrops generating a rainbow change its appearance. For example, Fig. 8-9 shows a moiré interference pattern for a cloud drop that is twenty-five times smaller than Fig. 8-7's raindrop.

Notice how Figs. 8-7 and 8-9 differ. A small cloud drop gives widely spaced bows, but the larger drop yields more tightly spaced bows and each bow is itself narrower. In Figs. 8-7 and 8-9, the first supernumerary for the cloud droplet occurs at about the same deviation angle as the raindrop's second supernumerary. As Young himself noted, you can estimate the raindrop size in a shower based on the spacing between supernumerary bows.[42] Clearly this spacing *decreases* with *increasing* drop size. Why should this be so?

One answer comes from translating Young's explanation into modern terms. Young correctly maintained that the spacing of bright and dark bands in the folded wave front depends on the pathlength the wave has traversed within the drop. Yet even cloud drops are many times larger than the wavelengths of light—Fig. 8-9's cloud drop has a radius ten times larger than the wavelength of green light. So the pathlength description is a little more involved than we might first suspect. Greenler explains the cloudbow's broadening in terms of *diffraction*,[43] a phenomenon undoubtedly known to Young (and one that can be subsumed within his interference explanation).

How do we explain the pastel colors of cloudbows? First, note that each color's position in any bow is determined by refraction—red is deviated the least and violet the most. In the pri-

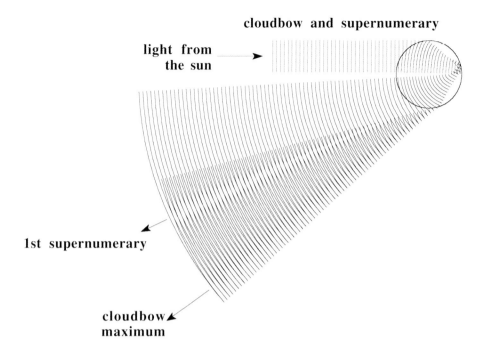

FIG. 8-9

Constructive and destructive interference pattern of sunlight refracted and reflected by a cloud drop

mary rainbow, colors thus occupy different positions, with red to the outside. But the primary bow is just the first interference maximum, and the width of that maximum for each color depends on the size of the raindrops. If the drops are very large, the width of each color band will be narrow and so the various colors will not overlap much, resulting in fairly pure rainbow colors. With small drops the story is quite different. Each band of color can be so broad that all colors overlap, and additive color mixing yields a pallid or even white bow. So the phrase "all the colors of the rainbow" is a very slippery one indeed.

Water drops in the atmosphere have a tremendous range of sizes. The radius of the largest raindrops rarely exceeds 2.5 millimeters (mm), and a typical raindrop has a radius of about 0.5 mm. Drizzle drops have radii of about 0.1 mm, while those of a typical cloud or fog drop are about 0.01 mm. Bows can be generated by any of these drops, but only a rain shower that has quite large drops can produce a bow with vivid colors. Indeed, only when the drop radius is larger than about 1/3 mm can we see red in the bow.

For the smaller drops found in drizzle, rainbow colors are quite pastel. The bow formed by cloud drops is white, with only the faintest hint of red or yellow to the outside. As a result, when the bow is seen in clouds or fog it is sometimes called the white rainbow, but this term is really an oxymoron. Any drop big enough to be called *rain* is too big to give a white *rain*bow. Our use of the term cloudbow or fogbow is not accidental. Combining the cloudbow's rarity and the misnomer "white rainbow" can confuse even the most diligent author. In Walter Maurer's survey of the rainbow in Sanskrit literature, he notes with puzzlement: "Some texts . . . specify a white (*śveta*) rainbow, and here again one wonders whether some other atmospheric phenomenon is meant."[44]

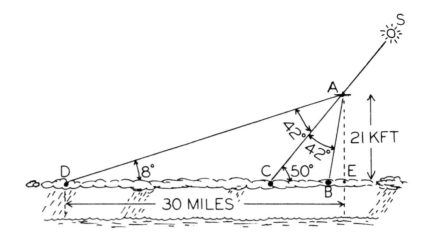

FIG. 8-10

Viewing geometry for a cloudbow seen from an airplane. Point "C" is the airplane shadow, around which James McDonald saw a glory. Some 42° from this shadow, he saw an apparently elliptical cloudbow. (From James E. McDonald, "A Gigantic Horizontal Cloudbow," *Weather* 17 [1962], p. 244 [a publication of the Royal Meteorological Society])

Because both the cloudbow and the cloud against which it is seen are white, the bow can be recognized only as a curved band that is brighter than the cloud, much as Thomas Barker did. We can easily confuse the cloudbow with the glory, which looks something like a small, pastel rainbow around the airplane's shadow on the cloud (see Fig. 8-1). The glory has a radius of only a few degrees, so the complete circle is relatively easy to see. On the other hand, the cloudbow has a radius of about 40°, so seeing all of it from an airplane's small passenger window usually is difficult.[45]

Although we usually see cloudbows from aircraft these days, we can also see them on a bank of fog. Imagine a clear night in the fall when fog has formed over the land. In the morning, if the fog begins to thin before the sun has climbed high in the sky, you may have the eerie experience of seeing a cloudbow arching over your shadow on the fog. This in fact is what Jorge Juan's party saw from Mount Pambamarca, although they described being "enveloped in the clouds, which [were] dissipated by the first rays of the Sun."[46] Because fog is just another name for a cloud that envelops you on the ground, no distinction need be made between the fogbow and cloudbow.

The viewing geometry of cloudbows can be confusing indeed. If we look down from an airplane or mountain at a horizontal deck of clouds below us, what will the cloudbow look like? Figure 8-1 suggests that we will see a circular arc. Yet our on-scene impression may be quite different, as the following account indicates. In September 1961, atmospheric physicist James McDonald was looking down from his airplane seat at a cloudbow some 21,000 feet below. At first puzzled by what he saw, he suddenly found that the cloudbow's "true nature was then unambiguously revealed when I noted further that here and there along its course it assumed a most vivid rainbow banding where I was looking down through breaks in the 8,000-ft [cloud] deck" at rain showers below (Fig. 8-10).[47] In other words, McDonald had the rare treat of seeing a cloudbow interspersed with rainbow segments as he flew along!

As Fig. 8-10 indicates, McDonald was looking at an oblique angle below the horizon. This

meant that the cloud drops producing the cloudbow, along with their companion raindrops that produced the rainbow, traced out an ellipse on the cloud deck. This fact, combined with a very human perceptual insistence on placing the rainbow or cloudbow at *some* position in the landscape, led McDonald to the compelling illusion that the bow was an ellipse. Of course, because every raindrop or cloud drop contributing to McDonald's arc was about 42° from the head of his shadow (the antisolar point), he was by definition seeing a *circle* of light. Yet had we been there, we too would have been convinced perceptually, if not intellectually, that we were looking at an ellipse.[48]

At your next opportunity to see a cloudbow from an airplane, ponder your visual impression of the bow's shape. Regrettably, you will have to contend not only with the limitations of your visual system, but with those of airplane windows as well. Not much has changed since McDonald noted with understandable frustration that his small airplane window "precluded my seeing the full ellipse . . . , a limitation arguing the need for glass-bottomed jet transports for meteorologically inclined passengers."[49]

A Map of the Rainbow's Colors

Whatever geometric confusion the cloudbow or rainbow causes, we can be certain that the cloudbow will be essentially colorless and that rainbows will not. Rather than merely describing how rainbow colors depend on drop size, why not display the colors themselves? We have done just that in Fig. 8-11, a map of the colors predicted by a successor to Young's interference model.[50] In this map, drop radius is scaled logarithmically along the horizontal axis, and it increases from cloudbow sizes on the left (0.01-mm radius) to the size of a large raindrop on the right (1-mm radius). Figure 8-11's horizontal axis has black tick marks where too little space is available for the corresponding radius label (for example, 0.06 mm). Otherwise, radius tick marks are red and their corresponding labels are black. Deviation angle (or angle from the sun) is Fig. 8-11's vertical axis, and it increases downward. We have, in effect, made our map look as though we were scanning the primary rainbow from outside to inside. Thus Fig. 8-11 shows us thin slices through many different rainbows, each one of which is colored as if a single drop of a particular size were responsible for the rainbow slice.

Perhaps the most striking feature of Fig. 8-11 is the broad expanse of nearly colorless bows on its left side. Here we are in the province of cloudbows, a region that extends up to drop radii of about 0.1 mm. Note that for the smallest drops (0.01-mm radius) the cloudbow's breadth is huge—it spans more than 8°.[51] A bow 8° wide sounds impossible, but as we shall see, Fig. 8-1's cloudbow is nearly that wide. Between 0.02 and 0.1 mm, the first cloudbow supernumeraries emerge, each of them as colorless as their corresponding primary. As we move rightward (to larger drop sizes) and downward (to larger deviation angles) within Fig. 8-11, the spacing and the width of the supernumeraries narrows, as Young predicted. Note too that as drop size de-

FIG. 8-11

An interference theory's map of primary rainbow colors versus drop size (Airy theory). The colors have been smoothed (blurred) by the 0.5° angular width of the sun.

creases, the bow's angular *radius* (as distinct from its angular breadth or width) decreases. In principle, this decrease in radius can be as much as 2° to 3° as we move from raindrops to cloud drops.[52]

To the right of 0.1-mm drops, rainbow colors begin to appear, beginning with an increasingly vivid red on the outside of the primary near deviation angles of about 138°. This is the familiar red exterior of the rainbow proper, although at drop sizes below about 0.2 mm it lacks equally vivid counterparts within the rainbow. At these drop sizes, the supernumeraries too have become more colorful, although as Langwith noted, their colors resemble prismatic colors very little. Instead, pastel reds and greens like the ones seen in Fig. 8-8's supernumeraries dominate. Note too that the spacing of the supernumeraries has become positively claustrophobic—at 0.2-mm radius, patient counting reveals eight supernumeraries.

At large drop sizes, the supernumeraries account for a smaller *fraction* of all the rainbow light than their small-droplet cousins do. Figure 8-11's evidence for this is the gradual darkening of the supernumeraries as we look from left to right. However, because the *overall* brightness of the rainbow increases with drop size, the large-droplet supernumeraries will actually be brighter than those seen in a cloudbow. Unfortunately, these combined color and brightness changes are too complex for us to display legibly in Fig. 8-11, so in it we ignore the fact that the bow's overall brightness increases with drop size.

At the largest drop sizes (0.25–1 mm radius), we finally begin to see the canonical rainbow colors. If you like, you may find seven or more colors in the rainbow.[53] We suspect that most readers will, like us, find at most only six distinct colors—red, orange, yellow, green, blue (or

perhaps cyan), and violet—for the 0.3-mm radius drops. For drops larger than this, blue actually disappears from the rainbow, as suggested by Fig. 7-21.

Observed and Intrinsic Rainbow Colors

Tempted as we may be, we should not regard Fig. 8-11 as an infallible field guide to rainbow colors. Many factors besides drop size determine rainbow colors in nature. Among these are (1) the horizontal depth of rain showers (a thin sheet of rain will produce less vivid colors than a thick one), (2) the range of raindrop sizes in a shower (many different drop sizes coexist in rainfall, not just the solitary sizes of Fig. 8-11), (3) scattering and absorption by other atmospheric particles (for example, dust or haze can produce reddened sunlight and thus reddened rainbows), (4) flattening of falling raindrops by air drag, and (5) the illumination of the rainbow's background.

For now, we concentrate on the last (but far from the least) of these real-world effects, the rainbow's background illumination. Remember that rainbow light can interfere locally with itself in the raindrop, but that interference will not affect incoherent light from the background. Thus the rainbow's colors are mixed additively with those of its background. In a specially prepared scene such as Fig. 8-2, we all but eliminate background light by draping the background in black. Note that the very thin spray of droplets in Fig. 8-2 yields a bow bright enough to be seen against black velvet, but that the bow disappears against the light-colored bricks.

So Fig. 8-2 suggests that if we took such extreme measures on the scale of a rain shower we would see a rainbow with purer, more distinct colors. Obviously it is impractical to drape landscapes in black velvet on the chance that we might see a naturally occurring rainbow, but we can achieve much the same effect if we remove the background electronically, rather than physically, when we analyze digitized images of rainbows.[54]

If in a digitized image we average along many different radial slices across a rainbow, we can get an accurate idea of the rainbow's *intrinsic* colors (that is, with background light removed), rather than merely its *observed* colors (that is, with background light included). Naturally, if we include the background illumination we will measure rainbow colors as we usually see them. We distinguish between observed and intrinsic rainbow colors because the intrinsic colors tell us how sunlight and the raindrops have contributed to the rainbow, independent of the myriad color variations in the cloud background. So let us examine these observed and intrinsic colors for a cloudbow and three separate rainbows—Fig. 8-1 and Figs. 7-20, 7-21, and 8-8, respectively.

Figure 8-12 is a colorimetric analysis of the vivid rainbow in Fig. 7-20. In Fig. 8-12 we have shown the entire gamut of perceptible colors, which is bounded by the monochromatic (that is, 100 percent pure) colors of the horseshoe-shaped spectrum locus. For reference, within this locus we have marked some typical red, green, and blue color limits for color television. Because

FIG. 8-12

The CIE 1976 UCS diagram, within which are (1) the red, green, and blue primaries of a typical color television (marked by diamonds), (2) an estimated sunlight color for Fig. 7-20 (marked by an x), and (3) the observed and intrinsic colors (thick and thin curves, respectively) seen as we look radially across Fig. 7-20's rainbow.

television is an additive mixing system, it can generate all the colors within the triangle bounded by the diamonds in Fig. 8-12. Clearly television can reproduce most colors, which is another way of saying that it spans much of the human color gamut. (The television primaries shown here are actually those for a computer's color monitor; conventional color televisions will have somewhat different primaries.)

Now look at the tiny ellipse near the sunlight color's chromaticity (marked by an x). This ellipse is the entire gamut of observed colors in Fig. 7-20's splendid rainbow! We drew this elliptical *chromaticity curve* by connecting in sequence the individual rainbow chromaticities that we measured from the outside to the inside of the bow. The ellipse seems impossibly small, especially when we imagine a beautiful rainbow in comparison to television's presumably pedestrian colors. But there is no contest. Television can unquestionably generate both more colors, and more vivid colors, than we see in Fig. 7-20. Surely, though, the spectacular rainbow in Fig. 7-21 can challenge color television. However, as we see in Fig. 8-13, once again color television has a far greater color gamut. By one measure, our color-television primaries span a color gamut some thirty times greater than that of Fig. 7-20's observed rainbow colors and nineteen times greater than Fig. 7-21's observed rainbow colors.[55]

FIG. 8-13

Figure 8-12's analysis repeated, this time for Fig. 7-21's rainbow

Even if we digitally remove the color and brightness of each rainbow's background, the resulting intrinsic rainbow colors cannot compete with those of color television. In Figs. 8-12 and 8-13 the gamuts of the intrinsic rainbow colors are considerably larger than those of the observed colors (2.5 and 3.8 times greater, respectively). Remember, of course, that we will not see these intrinsic colors as we admire a rainbow outdoors; only the observed colors are evident.

Do Figs. 8-12 and 8-13 mean that the phrase "all the colors of the rainbow" is a cheat? Not really. Although observed color gamuts in even the most spectacular rainbows are small, recall that the spectrum locus defines the limits of color perception. Monochromatic lights define its 100 percent pure colors, and such lights are all but absent from our everyday color environment. Television's nearly pure color primaries are important exceptions, but even they are seldom seen as large areas of uniform, unmixed color. And we almost certainly do not simultaneously compare television primaries with a rainbow seen outdoors. So, while we *can* see light of 100 percent purity, we almost never *do* see it in nature.

For example, the blue sky has a theoretical maximum purity of only about 41 percent, and observed sky purities will be even smaller.[56] Vivid phenomena like the green, red, and blue flashes occasionally seen with a rising or setting sun[57] have higher purities than either the rainbow or the blue sky, although the colors of the flashes are usually quite short-lived. The colors of parhe-

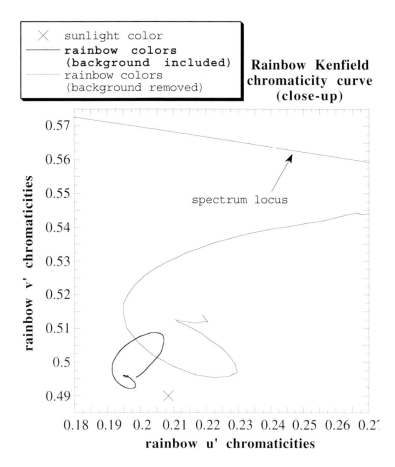

FIG. 8-14

Close-up of Fig. 8-12's rainbow chromaticities, showing both observed and intrinsic rainbow colors (Rainbow Kenfield)

lia and some other ice-crystal optics may persist longer than a rainbow and are likely its equal in purity. Yet deserved or not, it is a vivid rainbow's long arc of reasonably pure hues that sticks in the popular imagination as a paragon of color variety.

In Figs. 8-14 and 8-15, we zoom in on the rainbow chromaticity curves of Figs. 8-12 and 8-13, respectively. This closer inspection reveals that Fig. 8-12's apparently closed ellipse of observed rainbow colors (thick curve) opens into a G-shaped curve. This curve opens even more when we remove the background colors (thin curve), revealing that the outside of the bow would be quite red (that is, have high u' values) were it not for the bluish cloud background. In fact, removing the pale blue of the clouds rotates the entire chromaticity curve. Similar shifts occur in Fig. 8-15, our close-up view of Fig. 8-13. These changes in the chromaticity curves are significant because they reveal color gamuts that rainbow theory has long predicted[58] but that have never been measured in nature before now.

Rainbow Brightness: Color's Constant (and Sometimes Confusing) Companion

Figures 8-16 through 8-19 take two different tacks in showing us how brightness changes across the rainbows of Figs. 7-20 and 7-21. In Figs. 8-16 and 8-17, we have drawn curves of relative

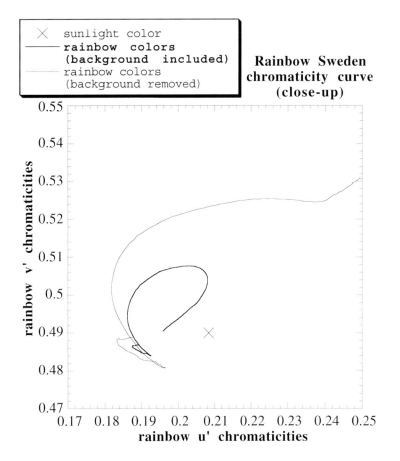

FIG. 8-15

Close-up of Fig. 8-13's rainbow chromaticities, showing both observed and intrinsic rainbow colors (Rainbow Sweden)

rainbow brightness versus angle from the sun for both the observed rainbow (sky background's brightness included; thick curve) and the intrinsic rainbow (background brightness removed; thin curve). In both figures, brightness is relative to that of a perfectly reflecting white card seen under the same illumination.

As we look from left to right in Figs. 8-16 and 8-17, we are looking from outside the primary rainbow to inside. The primary rainbow's maximum brightness is evident as the large peaks on the left side of each figure. To the right of this peak is a smaller peak showing us the first and only supernumerary bow evident in Figs. 7-20 and 7-21. As we might expect, the very bright rainbow in Fig. 7-21 is measurably brighter than Fig. 7-20's rainbow (compare the vertical axes in Figs. 8-17 and 8-16). Figures 8-16 and 8-17 also show us that removing the fairly uniform sky brightness makes the intrinsic rainbows darker than the observed ones, but that the resulting brightness curves have essentially the same shape for a particular rainbow.

So far we have looked at separate chromaticity and brightness curves for the rainbows of Figs. 7-20 and 7-21. What if we combined this information in a single, unified curve for each observed rainbow? We see such curves in Figs. 8-18 and 8-19, where we have drawn a perspective view of the u', v' chromaticity plane and added brightness as a vertical dimension. For

FIG. 8-16

Observed and intrinsic rainbow brightness for Fig. 8-14's chromaticity curve. See Fig. 7-20 for the corresponding rainbow, Rainbow Kenfield.

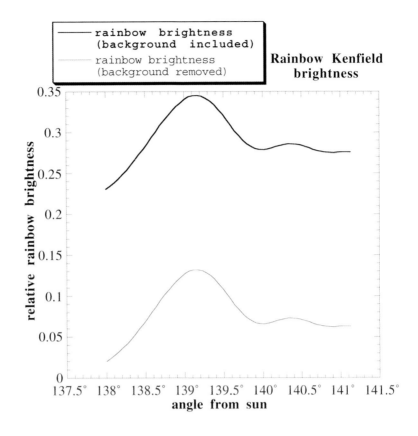

FIG. 8-17

Observed and intrinsic rainbow brightness for Fig. 8-15's chromaticity curve. See Fig. 7-21 for the corresponding rainbow, Rainbow Sweden.

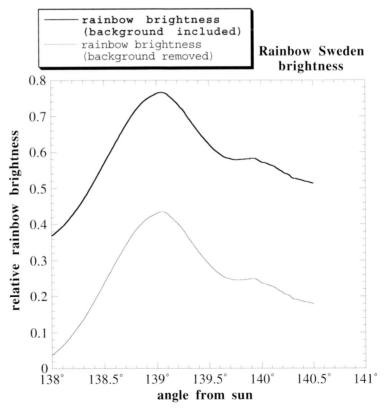

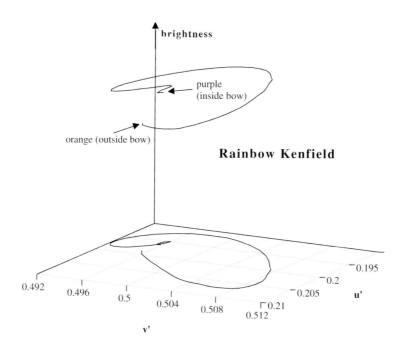

FIG. 8-18

Perspective view of combined rainbow chromaticity and brightness changes drawn separately in Figs. 8-14 and 8-16. These curves are for the observed Rainbow Kenfield.

comparison, we have duplicated the chromaticity curves of Figs. 8-14 and 8-15 on the gridded u', v' chromaticity plane.[59] Above these chromaticity curves proper, we have drawn the combined chromaticity and brightness curves, which loop and twist in three dimensions.

Now some mysterious features of Figs. 8-14 and 8-15 are explainable. The convoluted squiggles on the inside of the observed rainbow chromaticity curves[60] are the simultaneous changes in color and brightness in the supernumerary bows. When we project this three-dimensional curve onto a plane (as we have in Fig. 8-15), the line crosses over itself, yielding a complicated two-dimensional squiggle. Also note that for both rainbows, the darker orange on the rainbow's exterior rapidly gives way to brighter colors in its interior. Recall that one truism of Aristotelian rainbow theory was that the rainbow's *brightest* color is red.[61] In vivid rainbows such as Figs. 7-20 and 7-21, even naked-eye observers can readily see that red is the rainbow's *darkest* color.[62] However, because Aristotle's color theory made red a very bright color, presumably his fiction about the rainbow's red represents the triumph of color theory over rainbow observation.

We see much the same pattern in Fig. 8-20, our close-up perspective view of rainbow color and brightness for Fig. 8-8. As Fig. 8-8's multiple supernumeraries suggest, Fig. 8-20 will have many chromaticity squiggles in it. These are fairly clearly resolved in the three-dimensional curve, but we have also labeled their broad expanse in Fig. 8-20. Note that the brightness of the supernumeraries decreases as we move toward the rainbow's center. This trend supports the rainbow model shown in Fig. 8-11, where the supernumeraries' brightness decreases with increasing angular distance from the sun.

FIG. 8-19

Perspective view of combined rainbow chromaticity and brightness changes drawn separately in Figs. 8-15 and 8-17. These curves are for the observed Rainbow Sweden.

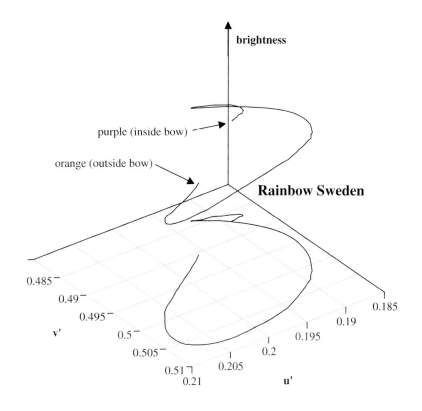

FIG. 8-20

Perspective view of combined rainbow chromaticity and brightness changes for Fig. 8-8's rainbow (Rainbow Kootenay)

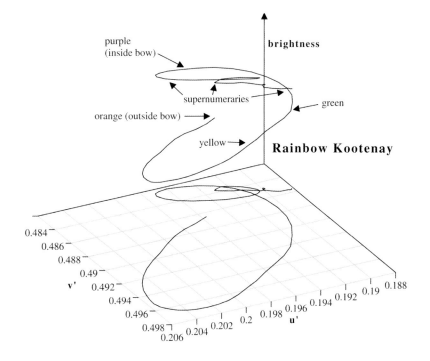

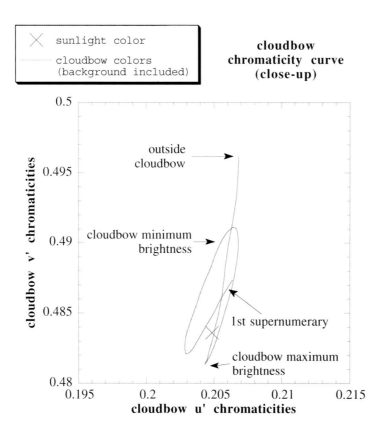

FIG. 8-21
Comparison of cloudbow and rainbow chromaticity curves. See Figs. 8-1 and 8-8 for the bows' photographs.

FIG. 8-22
Principal colorimetric features of Fig. 8-1's cloudbow

Why Is the Cloudbow So Dull?

Although we know why the cloudbow and the rainbow look different, just how different are their colors? Part of our answer comes in Fig. 8-21, in which we compare the chromaticity curves of Fig. 8-1's cloudbow and Fig. 8-8's rainbow. Several features are noteworthy here. First, the cloudbow is not very colorful—it does not stray far from the color of sunlight (marked by an x). Second, the cloudbow curve in Fig. 8-21 looks as smooth as the rainbow curve (thick curve). Although we can measure some small-scale brightness fluctuations in Fig. 8-1 (probably due to photographic film grain), no regular patterns are visible beyond those of the glory, cloudbow, and supernumeraries. Third, Fig. 8-22 indicates that the reddish outside of the cloudbow is its most colorful region, because chromaticity here is the farthest from white of any cloudbow colors. Figure 8-1 corroborates this visually. Finally, Fig. 8-1's cloudbow color gamut is only about half that of Fig. 8-8's rainbow.

In the sense that this cloudbow has poorer colors than Fig. 8-8's rainbow, this last result is not surprising. However, should not the essentially white cloudbow have a *tiny* color gamut compared with Fig. 8-8's vivid rainbow? The answer to this seeming puzzle is that the cloudbow's measured color gamut is taken from a ring nearly 12° wide in Fig. 8-1, while Fig. 8-8's larger color gamut spans a ring only 4° wide. Although we cannot be certain, it seems plausible that the rainbow's more compact display (that is, its smaller angular width) enhances the apparent vividness of its measurably purer colors.

We said earlier that Fig. 8-1's cloudbow was quite wide compared with the rainbow. Figure 8-23 indicates just how great the difference is. The cloudbow itself spans about 6°, and its first supernumerary maximum occurs more than 7° from the cloudbow maximum. Compare these figures with the rainbow's 2° width and the mere 1° separation between the rainbow and the first supernumerary. As Fig. 8-11 predicts and Fig. 8-23 demonstrates, the cloudbow has a smaller angular *radius* (as distinct from its width) than the rainbow; the cloudbow radius in Fig. 8-23 is estimated to be about 1° less than the rainbow radius.[63] Thus the cloudbow is angularly broader than the rainbow, but its total angular size is somewhat smaller (although the difference in radius is much less obvious than the difference in breadth). Visually speaking, there is little doubt that the cloudbow is a poor second to the narrower, more vivid rainbow. Part of the rainbow's visual impact stems from its brightness, which obviously is much greater than the cloudbow's in Fig. 8-23.

Figure 8-23 supports a claim we made about our rainbow color map, Fig. 8-11. We said then that cloudbow supernumeraries are not much dimmer than the cloudbow itself, which is what we see in Fig. 8-23. However, this figure also makes it clear that the brightness of the rainbow supernumeraries falls off much more dramatically and within a much smaller angular distance. The combination of pastel colors and low, slowly changing brightness virtually guarantees the cloudbow's status as the visual also-ran among water-drop bows.

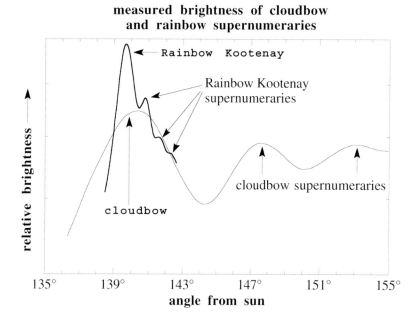

FIG. 8-23

Comparison of the relative brightness and width of Fig. 8-1's cloudbow and Fig. 8-8's rainbow. Brightness is scaled logarithmically here.

Turner and *The Wreck Buoy*: A Cloudbow in Disguise?

We have found no unequivocal representations of fogbows or cloudbows in older paintings, and we are unaware of any modern commercial art that suggests them.[64] However, a work by J. M. W. Turner might be taken for a cloudbow. In *The Wreck Buoy* (Fig. 8-24), the bow's nearly colorless appearance and great breadth hint that Turner may have had a fogbow in mind, although the background does not much resemble fog.

Contemporary reaction to *The Wreck Buoy* does not clarify Turner's intentions very much. Turner's biographer Walter Thornbury (1828–76) described the repainting as having come out "gloriously with a whitened, misty sky and a double rainbow."[65] Aside from Thornbury's suggestion of rainbows in the mist, however, Victorian comment on these pastel bows was often more merciless than meteorological. The *Illustrated London News* frostily described *The Wreck Buoy* as "evidently a picture painted twenty years ago, left lumbering about, and then cleaned up, or intended to be so, by the insertion of two or three new bright rainbows."[66] Even more blunt was *The Spectator*, which slammed Turner's rainbow, crying that "[nature's] faultless arc is shaped no better than the vault of an ill-built wine-cellar."[67]

The Wreck Buoy was far from a critical failure though. John Ruskin admired it, as did others.[68] But why should Turner have painted such a wan (and obviously discomfiting) rainbow here? One possibility is that he merely wanted to give the impression of a rainbow, and so only its grossest features seemed pertinent to him.

Another possibility is that Turner's pairing of a traditional symbol of deliverance (the rainbow) with one of disaster (a shipwreck) gives the viewer a mixed symbolic message.[69] Of course, the subject of *The Wreck Buoy* is itself unusual, for it depicts both a maritime disaster and a

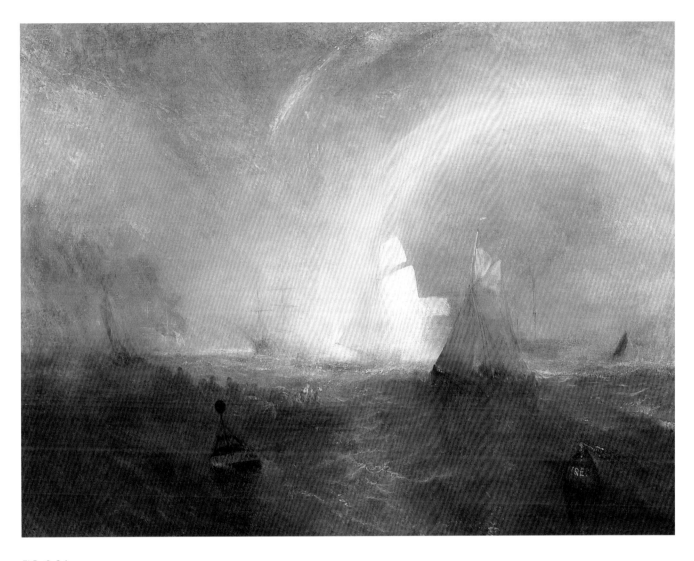

FIG. 8-24

J. M. W. Turner, *The Wreck Buoy*, c. 1807, repainted 1849. Walker Art Gallery, Liverpool, England. See *Sudley: The Emma Holt Bequest*, a catalog by Mary Bennett and Edward Morris (Liverpool, 1971, pp. 75–76). Courtesy The Board of Trustees of the National Museums and Galleries on Merseyside, England (Walker Art Gallery, Liverpool)

warning device for avoiding future disasters. In this sense, the rainbow (or fogbow) serves its usual function as a harbinger of hope. Yet Turner's view of the repainted *Wreck Buoy* may also reflect the pessimism of his 1843 *Light and Colour (Goethe's Theory)—the Morning After the Deluge—Moses Writing the Book of Genesis*. Turner's epigraph there bleakly notes: "In prismatic guise / Hope's harbinger, ephemeral as the summer fly / Which rises flits, expands and dies."[70] Like *Light and Colour*'s prismatic wash of color, the wan and broad *Wreck Buoy* rainbow scarcely resembles the traditional rainbow of hope. Before making too much of this, we should note that Turner's keen interest in color theory and rainbow optics[71] was paired with a penchant for painting nearly colorless rainbows, as in *Buttermere Lake* (Fig. 8-25).

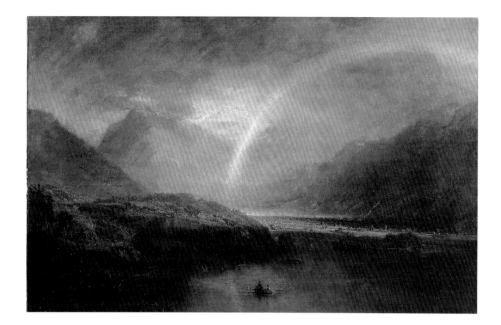

FIG. 8-25
J. M. W. Turner, *Buttermere Lake*, 1798. Tate Gallery, London

Turner included with the Royal Academy exhibition catalog entry for *Buttermere Lake* an epigraph from James Thomson's poem *Spring*.[72] Turner's choice seems odd because Thomson explicitly describes a "grand ethereal Bow" that "Shoots up immense; and every hue unfolds."[73] That is hardly what we see in *Buttermere Lake*—or in *The Wreck Buoy*. In both paintings, Turner's agenda is less meteorological than pictorial. Turner's Romantic interest in a sublime view of nature meant that mere literal details could always be altered to achieve a desired epiphanic effect.

As an example, in his watercolor *Rome: The Forum with a Rainbow* Turner presents us with a topographically rearranged view of the Forum[74] and a meteorologically impossible rainbow (Fig. 8-26; the scene's lighting is inconsistent with the rainbow). This combining of ruined antique grandeur and splendid natural beauty into a sublime whole would have been for Turner a far more important goal than simply transcribing on-scene details. Similarly, Turner may have had meteorology in mind when painting *The Wreck Buoy*. The picture's broad, wan bow certainly is similar to a cloudbow, and perhaps Turner's extensive travels and eclectic reading had introduced him to the cloudbow's ghostly form. We may never know Turner's intentions here, but the idea remains a tempting one.

The Supernumerary Road to Rainbow's End

As vital as the cloudbow and supernumeraries are and have been to the rainbow's story, their comparative rarity makes them a rainbow dessert course, not an entrée. But is there even more to the visually delicious supernumerary bows than we have suggested? In fact, the supernumeraries

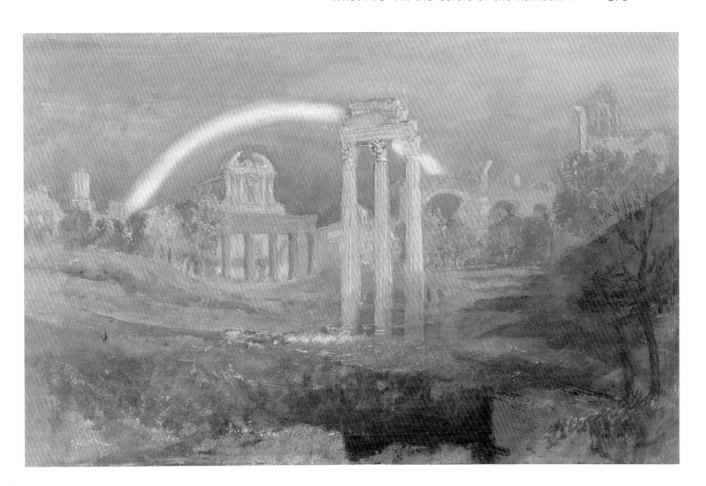

FIG. 8-26

J. M. W. Turner, *Rome: The Forum with a Rainbow*, 1819. Pencil, watercolor, and bodycolor. © Tate, London, 2000

are far from uniform, and this lack of uniformity partly explains why they were considered "spurious" bows. We shall see next what supernumerary variations within a given rainbow tell us about rainbow itself. For the practically minded, however, we can recast Chapter 9's science in a single phrase—we know where the rainbow's pot of gold is!

Scientific study of the natural rainbow continues to the present, and it shows that the rainbow has yet many more secrets to reveal. For example, greed aside, why would folklore tell of a pot of gold at rainbow's end? Why do we see variations in color and brightness around the bow? Have artists sometimes painted these changeable rainbow colors? Could we ever see a sky filled with rainbows? Fittingly, our answers show that the end of the scientific rainbow bridge still recedes before us.

NINE

THE END OF THE BOW

What is it about the rainbow's end? Why should one small part of the rainbow have such a hold on our imagination? As our epigraphs here suggest, this fascination spans many cultures and takes on diverse forms. At one extreme, Lawrence's Ursula Brangwen sees in her epiphany that the brilliance of the rainbow's end is seated amid spiritual deadness awaiting revival. Yet the literary rainbow's end usually lacks any hint of the negative—it is indeed earth's auspicious crown. For most of us, though, the brilliance at the end of the rainbow is less about glory than about gold (Fig. 9-1).

Myths about a pot of gold at rainbow's end are common, as we saw in Chapters 1 and 4. The reasons for these myths are, of course, as much cultural as natural. But what can nature tell us about the enticing yet unattainable pot of gold? Equally important, what does the brilliance at the end of a vivid rainbow tell us about the bow itself?

> Hail, many-colour'd messenger that ne'er
> Dost disobey the wife of Jupiter;
> Who, with thy saffron wings, upon my flowers
> Diffusest honey-drops, refreshing showers;
> And with each end of thy blue bow dost crown
> My bosky acres and my unshrubb'd down,
> Rich scarf to my proud earth . . .[1]
>
> Ceres' greeting to Iris; William Shakespeare, *The Tempest*, Act IV (1623)

> A rainbow that is auspicious and capable of causing rain must be unbroken, touch the ground at both ends, be lustrous, glossy, thick, vari-coloured, double and to the rear of the viewer.[2]
>
> Walter H. Maurer, "The rainbow in Sanskrit literature" (1967-68)

> The arc bended and strengthened itself till it arched indomitable, making great architecture of light and colour and the space of heaven, its pedestals luminous in the corruption of new houses on the low hill, its arch the top of heaven.[3]
>
> D. H. Lawrence, *The Rainbow* (1915)

276 — THE RAINBOW BRIDGE

FIG. 9-1
Jeff MacNelly cartoon, Today's unaffordable rainbow pot of gold (© Tribune Media Services, Inc. All Rights Reserved. Reprinted with permission.)

Rainbow's End and the Onion

Like every other branch of learning, the study of the rainbow is a giant onion. Each cook merely succeeds in removing another layer, and then, after a short blush of satisfaction, some iconoclast points out that there is at least one more layer to be removed before the core is attained. Unlike Alexander the Great, who solved the problem of the Gordian knot by slicing right through it with his sword, the greats of science are but onion-peelers.

We have come to another layer of the onion. Certainly bows can be produced in clouds or drizzle (Figs. 5-1 and 8-8), but usually it is a bow in a rain shower that we admire. We now need to consider this archetypal rainbow more closely. Bright rainbows exhibit all the features discussed so far: red is on the outside of the primary bow and inside of the secondary bow, the sky is bright within the primary bow and dark between the two bows, and a filigree of supernumerary bows graces the inside of the primary bow. But rainbow variations do not stop there.

Bright rainbows have a characteristic gradation of color and intensity along their arcs. Near the base, colors approach the brilliant vividness of popular myth, but high on the arc they are much more pastel (for example, see Fig. 7-21). Similarly the supernumerary bows, which may in fact be super numerous near the top of the bow, vanish one by one as we look toward the base (see Fig. 9-2). If these gradations occurred only occasionally, we might reasonably think that random variations within the rain shower were responsible. Yet this explanation implies that in the next shower we are just as likely to see vivid colors at the rainbow's top and pastel ones at its base. Unfortunately for our random-variation theory, when gradations along the bow are evident, their trend is always the same—toward the rainbow's base, colors are more vivid and the supernumeraries fade.

FIG. 9-2
Primary and secondary rainbow, with the supernumeraries fading toward the base of the primary. Rossland, British Columbia, 1972 (photo: R. T. Fraser)

Flattened Raindrops and the Pot of Gold

Clearly our explanation of the rainbow is incomplete. To complete it, we need to consider the nature of rain showers, in which drop radii range from drizzle (0.1 mm) to the biggest raindrops (about 3 mm). Might not small drops be responsible for one portion of the rainbow while larger drops predominate elsewhere? For example, the rainbow's top has the pallid colors of a bow formed in drizzle, while the rainbow's base has colors that could arise only from big drops (see our rainbow map, Fig. 8-11). In addition, recall Benjamin Langwith's 1723 suggestion that supernumeraries disappear near the rainbow's base because of "some property which the drops retain while they are in the upper part of the air, but lose as they come lower."[4]

Might not the drops be very small near the base of the cloud but have grown much larger by the time they reach the ground? As we are about to see, this explanation is consistent with how rainbow gradations appear in drizzle but not in rain showers. Even if the distribution of drop sizes did change with height in a shower (and it does not appreciably), that alone would not explain the observed rainbow gradations. We can see why by combining observation with a simple thought experiment.

For the moment, pretend that large drops *do* predominate near the ground in a rain shower. If raindrops are larger near the ground, then when you stand in (or near) the shower large drops will fall all around you, including in the direction of the rainbow's top. Because large raindrops exist in that direction, will the rainbow's top now be vivid? No, observation tells us that it is as pastel as ever. (If we look at a *distant* shower, any vertical stratification of drop sizes would affect the rainbow.) What, then, is the correct explanation of the rainbow gradations?

FIG. 9-3

Cutaway view of a raindrop flattened by air drag during its fall. The drop's vertical cross section is an ellipse, while its horizontal cross section is a circle. Cross sections at intermediate angles are ellipses whose shapes range between the horizontal and vertical cross sections.

The actual explanation is at once more subtle, more complex, and more interesting. The rainbow gradations depend on the shape of raindrops. Free-falling drops look quite different from the teardrop-shaped rain that runs down a windowpane.[5] Like tiny soap bubbles, very small raindrops are spherical because the drop surface acts like a thin elastic membrane. However, a big drop is more massive and falls much faster. As it does, the airstream flowing around the drop distorts it, flattening its top and bottom to yield a shape like a hamburger bun, not a tear.

Thus far we have assumed that all raindrops are spherical, and so we drew each drop's cross section as a circle (see Figs. 6-5 and 8-7). A circular cross section gives a rainbow angle (or minimum deviation angle) of 138°, placing the rainbow 42° from the head of your shadow. What happens to the rainbow angle for large, flattened drops? To illustrate, we approximate a vertical cross section through a large drop's hamburger-bun shape as an ellipse (Figs. 9-3 and 9-4). As the drop grows, this elliptical flattening increases, and so does the rainbow angle. For example, if the drop radius grows to 1 mm, the rainbow angle increases from 138° to 149°.[6] The rainbow from this flattened drop would therefore sit only 31° from the head of your shadow,[7] some 11° *inside* the conventional rainbow.

Drops of other radii position the bow elsewhere; a 0.5-mm radius drop places its bow just 2.5° inside the conventional rainbow position. Bows from all the larger drops will thus be spread across the space inside the 42° bow. Because red from one drop size will be superimposed on blue from a second drop, and yellow from a third, no color pattern emerges. Instead, the space inside the bow will be filled with additively mixed white light.

Something is wrong! Even though the preceding argument is correct, it implies that no rainbow could ever have good colors. After all, only large drops give good colors, and large ellipsoidal drops apparently cannot contribute to the rainbow, but instead spread their light inside it. The seeming paradox is resolved by remembering the hamburger-bun shapes of large, falling raindrops.

The top of the rainbow is produced when sunlight passes vertically through a drop, so that

FIG. 9-4

Elliptical cross section through a flattened 1-mm raindrop. The minimum deviation angle (marked by ray **m**) has increased to 149°, compared with 138° for a spherical drop's circular cross section (see Fig. 6-5).

large drops, which are elliptical in vertical cross section, will not contribute to the rainbow there. Thus the rainbow's top has the pastel colors produced by small drops. The bottom of the rainbow, however, is caused when sunlight makes a horizontal slice through a drop, and even large raindrops are circular in horizontal cross section. So large raindrops *do* contribute to the rainbow, but only near its base. Only near the rainbow's end, then, do we see the brilliant, vivid bow that results from big drops.[8] In fact, because all sizes of raindrops are circular in horizontal cross section, *all* drops contribute to the base of the bow, making this the brightest part of the arc.[9] In a sense then, Benjamin Langwith was correct when he surmised that raindrops have some property that changes as we look lower in the sky. What he could not imagine was that aerodynamic distortion of large drops is what makes their rainbow light look different in different directions.

Thus the aerodynamic distortion of large raindrops acts like a filter. It prevents large drops from contributing to the top of the bow but allows them to dominate at its base. Now we have an optical explanation for the pot of gold. First, there must be a rain shower with many large drops, which in turn requires a heavy rainfall (in other words, a gentle shower probably will not yield enough large drops). Second, only near the rainbow's end can these large drops send their bright, pure colors to us without overlap. The net result is what we see in Fig. 7-21—a bright glow of vivid colors near the earth. Surely in that direction we can find an object with a golden glow—perhaps a pot of gold!

In our more sober moments, we all know that the pot of gold is as unreachable as the rainbow's end.[10] For that reason, the notion that we can *somehow* reach the rainbow's end is tempting indeed. Perhaps with that in mind, landscape designer William Kent (c. 1685–1748) has fancifully deposited the rainbow's glowing end in poet Alexander Pope's garden, amid the spray of a fountain adorned with equally fanciful mythological figures. Pope is known to have studied

FIG. 9-5

William Kent, "A View in Pope's Garden, Twickenham," c. 1725–30, pen, ink, and brown wash. The British Library, London (photo: Courtesy The British Museum)

color and optics actively, which makes his appearance alongside Kent in Fig. 9-5 especially interesting.[11] We do not know whether Kent and his patron appear here as admirers of the garden's invented beauty or of the rainbow's natural beauty, but we do know that Pope holds a "Perspective Glass" or telescope, with which he could better admire both garden vistas and rainbow colors.[12]

Today, rainbow's-end fantasies often have a more questionable purpose. Given the vanishingly small chance of winning large prizes in a state lottery, an ad for the Illinois lottery (Fig. 9-6) is either slyly humorous or (more likely) painfully ironic. Of course, Illinois has a great deal of company—several other lotteries have used the same elusive symbolism, and investment companies too are fond of ironic rainbow's-end imagery. This irony is firmly entrenched in English: *Webster's Third New International Dictionary* offers both "illusion" and "attainment of success or fortune" among its definitions of "rainbow."[13]

FIG. 9-6

Pot-of-gold advertisement for the Illinois state lottery

Why Are Supernumeraries Visible in Rain Showers?

Earlier we claimed that the supernumerary bows are an integral part of the rainbow, implying that any time a rainbow is seen, so are the supernumeraries. But that is not the case. Indeed, it is unusual to see anything but a faint first supernumerary, so that seeing three or four (Fig. 8-8) is the highlight of a rainbow-watcher's year. Why are supernumeraries so rarely visible? To answer this question, we begin by seemingly demonstrating that supernumeraries can *never* be seen in rain showers!

Compare Chapter 8's simulations of the supernumerary bows caused by drops of different sizes (Figs. 8-7 and 8-9). Small drops give widely spaced bows, but as the drops get larger the supernumerary bows become more tightly spaced and each bow becomes narrower. Note too that the color of the primary bow is strongly affected by the width of the pattern. When the drops are small, each bow is broad, including the primary bow. As a result, the bow's colors overlap and appear pastel (for example, inspect Fig. 8-11 at a drop radius of 0.1 mm).

Because the spacing between supernumeraries decreases with increasing drop size, sometimes we can estimate drop sizes in rainfall. This technique works reliably only when the rainbow is seen in drizzle, as in Figs. 8-3 or 8-8, for only there do we find a very narrow range of drop sizes. In Fig. 8-8, large drizzle drops fall faster and evaporate more slowly than do the smaller ones. Thus the drop sizes separate according to altitude, with small drops dominating just below the cloud base and larger drops dominating closer to the ground. The resulting rainbow has supernumerary bows that are widely spaced at its top and narrowly spaced near the ground. We can then use Fig. 8-11's rainbow map to estimate the drop sizes that dominate at different altitudes beneath the cloud.

If our reasoning above is correct, we should occasionally be able to see gradations in supernumerary spacing as we look along the rainbow arc. Walker describes just such a rainbow in which the angular separation of the supernumeraries decreased as he looked toward the base of the bow.[14] In other words, the supernumeraries were more narrowly spaced near the ground (where comparatively large drops predominated) than they were at the top of the rainbow (where

FIG. 9-7

Supernumerary visibility for a range of spherical raindrop sizes typical of stratus-cloud rainfall. Each train of peaks and troughs represents the brightness maxima and minima caused by a single drop size (brightness is scaled logarithmically here). The "sum curve" additively mixes rainbow light from the various drop sizes (that is, it indicates rainbow brightness as we would see it in nature). The bright primary peak is distinct, but no supernumeraries are visible.

smaller drops predominated). Because Walker's rain shower was distant, he was not surrounded by large drops, and thus the effects of drop-size sorting with altitude were evident as he looked from the top to the bottom of the rainbow.

Earlier we said that changes in the distribution of drop sizes with altitude could explain rainbow gradations in *some* cases. Drizzle is such a case: in drizzle it is changes in drop size, not shape, that determine supernumerary spacing along the rainbow arc. However, our explanation is still incomplete, because most supernumeraries are seen in rain showers, not drizzle. As we noted earlier, rain showers have drops of many different radii, ranging from less than 0.1 mm (drizzle drops) to as much as 3 mm. Because the spacing of the supernumeraries varies greatly over this large range of drop sizes, we could argue that supernumeraries will *not* appear in rain showers. Why? If the supernumerary maximum of one drop size is matched by the supernumerary minimum of another at the same deviation angle, the net result is that drops of many different sizes will obscure an individual drop's supernumeraries. Figure 9-7 indicates how this obscuration works.

Figure 9-7 shows how supernumerary brightness varies across the rainbow for spherical drops whose radii range from 0.05 mm to 1.0 mm. In creating Fig. 9-7, we have used a successor to Thomas Young's interference theory of the rainbow, one developed by England's Astronomer Royal, George Biddell Airy (1801–92). Airy's theory of the rainbow extended and mathematically formalized Young's largely empirical explanations of interference within a raindrop.[15] We bypass the details of Airy's theory here, except to note that Boyer discusses them at length.[16]

As in Fig. 8-16, rainbow brightness increases upward along the vertical axis of Fig. 9-7, while the angle from the sun (the deviation angle) increases rightward along the horizontal axis. Recall that in Fig. 8-16 we showed observed rainbow brightnesses; here we show brightnesses

FIG. 9-8

Empirical relationships between a raindrop's radius and its abundance in two typical rain showers (rainfall rates are listed in inches per hour). A stratus cloud (see Fig. 8-8) not only produces fewer drops in total than a vigorous thunderstorm does, but also has proportionately fewer large, flattened drops (radii greater than about 0.6 mm).

calculated from Airy's theory. In Fig. 9-7, the brightness maxima and minima generated by a single drop size are shown as a left-to-right train of brightness peaks and troughs (individual trains can be discerned to the right of the leftmost maximum). Because rainbow brightness increases with increasing drop radius, these individual trains move upward as drop radius increases. Thus the lowest train in Fig. 9-7 corresponds to supernumeraries generated by drizzle, while the highest train is caused by a raindrop with a 1 mm radius. Another consequence of increasing drop size is that the peaks and valleys shift leftward and also decrease in width.

For further realism, we have weighted the vertical position of each train (that is, its overall brightness) by the abundance of the corresponding drop size in light stratus-cloud rainfall (Fig. 9-8). In nature, the brightness of the supernumerary from a given drop size depends both on the drop radius and on how many such drops there are in the rainfall. In Fig. 9-7's simulated stratus rainfall, 0.4-mm drops are the most abundant, while there are only about 6 percent as many 1-mm raindrops and 0.1-mm drizzle drops.[17] Finally, Fig. 9-7's supernumerary brightnesses have been weighted by the 0.5° angular width of the sun, which slightly smooths their peaks and valleys.[18]

Above the individual supernumerary curves in Fig. 9-7 is a "sum curve" in which we have added the brightnesses contributed by all drop sizes. If we were observing this rainbow outdoors, we could not separate the brightness contributions of individual drop sizes. Thus the sum curve indicates how *we* would see the rainbow's brightness vary across deviation angle. The sum curve clearly shows a brightness maximum for the primary rainbow at a deviation angle of about 138.5°, but there is no evidence of any supernumerary peaks at larger angles.

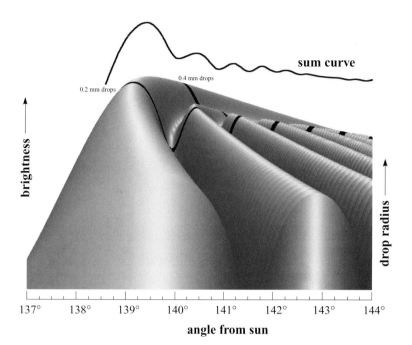

FIG. 9-9

Figure 9-7's results redrawn, now considering how aerodynamic distortion increases minimum deviation angles for large raindrops. Several supernumeraries are now evident in the rainbow's sum curve.

As we noted above, the reason that supernumeraries are absent in Fig. 9-7 is that one drop size's supernumerary maximum occurs at the same deviation angle as another drop size's minimum. We can easily see this among rows of small-drop supernumeraries, where the maxima and minima of different drops gradually overlap each other. Brightness peaks and valleys shift leftward to ever-smaller deviation angles as drop size increases. In increasing detail, this overlapping pattern is repeated for the larger drops, and the net result is that only the first interference maximum—the primary rainbow—survives the chaos. Did our choice of a particular rainfall type (and its corresponding distribution of drop sizes) cause this result? No. In fact, no distribution of drop sizes that is typical of rain showers will yield distinct supernumeraries.[19]

Have we just demonstrated that supernumeraries cannot occur in rain showers, as distinct from drizzle? Not quite. As we did when analyzing the pot of gold, we can reconcile theory (as seen in Fig. 9-7) and observation (as seen in Fig. 9-2) if we consider the distorted shapes of large raindrops. Remember that air drag on falling drops will distort large raindrops but not small ones. As Fig. 9-4 indicates, the flattening of large drops will increase the minimum deviation angle (that is, move the primary rainbow closer to the head of your shadow).

Flattened drops will move both the primary rainbow *and* the supernumeraries to deviation angles larger than those for spherical drops. Because drop distortion increases with size, this shift of the primary and supernumeraries to larger deviation angles will increase with drop radius. That is the situation shown in Fig. 9-9, where we have recalculated the angular positions of Fig. 9-7's supernumerary maxima and minima based on empirical data relating a drop's size to its aerodynamic distortion.[20]

As expected, Fig. 9-9's supernumerary brightness trains shift very little from their Fig. 9-7 positions when the drops are small (that is, near the bottom of Fig. 9-9). However, the increase in

the primary and supernumerary deviation angles becomes more and more pronounced as drop size increases toward the top of the figure. What happens to the rainbow's brightness as a consequence? As we see in Fig. 9-9's sum curve, distinct supernumerary bows now emerge as a result of the larger drops' shifted supernumeraries.

To make Fig. 9-9 easier to interpret, we have limited the drops that contribute to its sum curve to those with radii of less than 0.4 mm. This limitation would clearly be impossible if we were observing the rainbow outdoors. However, limiting the range of drop sizes here simply makes our sum curve easier to understand. In nature, drops with a radius that is greater than 0.4 mm can make the supernumeraries *brighter* than the primary rainbow (the reverse of what we expect), but their individual brightness maxima and minima will still be evident.

Pruning the large-drop contributions to Fig. 9-9's sum curve in fact points to a surprising result—that only drops in a narrow range of sizes cause the supernumerary bows that we see in rain showers. To see why this is so, look at Fig. 9-9's brightness trains. Notice that the primary and supernumerary maxima occur at the smallest deviation angles when drops' radii are between about 0.2 mm and 0.4 mm (marked on Fig. 9-9). Larger and smaller drops simply contribute to the jumble of light inside the primary rainbow; no pattern emerges as bows from drops of one size cancel those from another. Furthermore, supernumeraries seen in rain showers will all have the same angular separation of about 0.5° to 0.75°. We see this uniform spacing in rainbow theory if we compare the deviation angles that separate the supernumerary peaks in Fig. 9-9's sum curve. We see it in nature, although with less precision, if we examine supernumeraries' angular separation in photographs such as Fig. 8-8.[21]

Vanishing Supernumeraries: A Rainbow Mystery Solved

We have left an earlier question unanswered—why do supernumeraries look distinct near the top of the rainbow yet fade toward its base? To answer this question, first reexamine Fig. 9-3, our cutaway view of a large and thus flattened raindrop. As Fig. 9-3 indicates, horizontal cross sections of large raindrops are circular, while vertical ones are elliptical. The rainbow's top is caused by sunlight passing through a vertical cross section of a raindrop, while its base (if the sun is on the horizon) is caused by sunlight passing through a horizontal cross section.

The consequences for the top and base of the rainbow are obvious. Near its top, where sunlight traverses vertical cross sections, the brightness pattern seen in Fig. 9-9 prevails. Small drops (about 0.2–0.4 mm radius) will yield both a primary bow and visible supernumeraries. Drops smaller than 0.2 mm will contribute very little light to the top of the bow because, as Fig. 9-9 shows, primary and supernumerary brightness increases with drop size. Drops larger than about 0.4 mm spray their primary and supernumerary light in a jumble within the visible primary bow.

However, as we move toward the rainbow's base, sunlight contributing to the bow traverses raindrop cross sections that are increasingly circular. Now the rainbow's brightness pattern

begins to approach that of Fig. 9-7's sum curve—supernumeraries of different drop sizes begin to overlap one another, thus obscuring the distinct pattern evident higher on the bow. Recent research even suggests that along the rainbow's sides (although not at its vertical base) drops larger than 0.5 mm in radius will yield distinct supernumeraries.[22]

Can we ever see supernumeraries near the ground? Yes, because the rainbow's center is as far below the horizon as the sun is above it, we *can* see supernumeraries near the ground when the sun is well above the horizon (say, 15° or more). But nothing has changed significantly in the geometry of sunlight and flattened raindrops. If we were to see the rainbow below the horizon (as when you look down from a high hill), the base of the bow would still lack supernumeraries.

Supernumeraries are also obscured in heavy rainfall. In a thunderstorm downpour the proportion of large drops in the rain increases so much that supernumeraries are obscured by a veil of bright light inside the primary rainbow (compare Fig. 9-8's two drop-size curves). Our chances of seeing supernumerary bows are best in drizzle or light rain. Heavy rains, with their preponderance of large drops, will give bright, vivid colors near the rainbow's base, but the supernumeraries will be invisible.

So when you do see supernumeraries, you are the beneficiary of special circumstances. Upper parts of the rainbow must be visible, for only there can you see any of the supernumerary bows. Because only relatively small drops can contribute to distinct supernumeraries, the supernumeraries will be less brilliant than their vivid primary counterpart at the rainbow's end. Seeing the muted colors of the supernumeraries also requires that the rainfall not be too heavy. In other words, a downpour is excess but a gentle summer shower is just right. Given these circumstances, a patient and knowledgeable rainbow observer is rewarded with the supernumeraries' delicate filigree of pastels.

Jasper Francis Cropsey and the Supernumerary Bows

As for fogbows, we have found no clear-cut examples of supernumerary bows in the graphic arts. One painting of a double rainbow does tempt us to wonder whether the artist had observed the fading of supernumeraries toward the rainbow's base. Jasper Francis Cropsey (1823–1900) was among the second generation of Hudson River School artists, a group that also included Albert Bierstadt (1830–1902) and Frederic Church.[23] Like Church and Bierstadt, Cropsey was a keen observer of meteorological phenomena.[24] In an 1850 letter to his wife, he reverentially describes his visit to the Hudson River studio of the late Thomas Cole. Buoyed by the artistic aura of Cole's estate, Cropsey nonetheless takes time to describe changes in atmospheric light and color. Of his party's return trip down the Hudson, he notes that the passage "was delightful—was very showery, hence kept up a continual lightning, which we sat and watched till past 11 oclock [P.M.]."[25] Given this attention to meteorological details, we should not be surprised that Cropsey painted at least six canvases that feature rainbows.[26]

In 1855, Cropsey wrote a short piece for the art journal *The Crayon*.[27] In it, he catalogs

clouds both scientifically and poetically: cumulus are "grand masses of dreamy forms floating by each other, sometimes looking like magic palaces," and cirrus, "the highest and most distant cloud formation," inspire him to quote Wordsworth and Shelley.[28] For the low-lying nimbus or rain cloud Cropsey relies on the language of the sublime. This region so near the earth awakens "the deepest emotions of gloom, dread, and fear; or [sends] thrilling sensations of joy and gladness through our being."[29] The rain cloud gives rise not only to "beautiful dreamy effects of the breaking up of mists and fogs" but also to a grander spectacle: "It must have large claim upon our ideas of beauty, on account of its being the cloud in which the rainbow appears."[30] Given Cropsey's evident interest in meteorology and his association with *The Crayon*, he may well have read an unsigned 1860 essay in it entitled "A chapter on rainbows in landscapes."[31] Like Constable's 1833 rainbow guide, this rainbow essay meant for artists is so unusual that it warrants examining in detail. Its author opens with a world-weary nod toward his audience's presumed enthusiasm for rainbows: "It is not our task to defend 'conventionalities or the fetters which European prejudices have imposed on Art;' we only wish the artist would use his discretion with the size of his canvas, chastity in his effects, his knowledge as to the fewest and most durable colors, and not abuse with superfluities or put the same in their proper place if he wishes to make use of any. But since we can do without gilt haloes in Raphael's virgins, we certainly do not wish for rainbows in better class landscapes."[32]

After this backhanded introduction, the *Crayon* author patiently lays out a detailed scientific essay on the rainbow that, a few errors notwithstanding, is a model of clarity. Among other features, the *Crayon* author correctly notes that (1) refractions and internal reflections of parallel sunlight yield the bright rainbow light, (2) differences in refraction result in separate bands of rainbow colors, (3) the primary and secondary rainbows' center is always the antisolar point, (4) the rainbow rises as the sun sets (and vice versa), (5) on level ground the rainbow is at most a semicircle, and (6) breaks in the rain curtain mean breaks in the rainbow. Very explicit instructions about the naturalistic relationship between landscape shadows and the rainbow are also given. The author even includes a projective diagram to "show how to apply the rainbow to a landscape."[33]

Nevertheless, some missteps appear. In explaining how to use the rainbow diagram, the *Crayon* author mistakenly claims that "the bows must be constructed 'in perspective'" (that is, obliquely) when the painted landscape is sunlit from the side. He also asserts incorrectly that "The interval between the two bows has been sometimes observed to be occupied by an arch of faint colored light; this is ascribed to the reflection of one of the bows."[34] This is probably a mangled description of a supernumerary, yet its location and cause are both incorrect.

Might Cropsey have seen this rainbow cookbook and used it in subsequent rainbow paintings? We do not know, but its prominent appearance in a journal to which he had contributed is intriguing. Unfortunately, we find little encouragement for our speculation in Cropsey's *Dawn of Morning, Lake George* (Fig. 9-10). In it we see a double rainbow arcing over an Adirondack lake. Contrary to the *Crayon* author's description, the colors of the secondary bow appear to

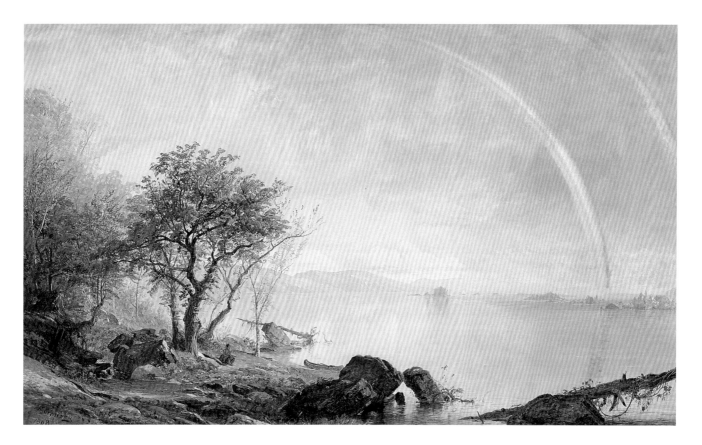

FIG. 9-10

Jasper Francis Cropsey, *Dawn of Morning, Lake George*, 1868. Collection of the Albany Institute of History and Art

have the same color order as the primary bow, or at least are ambiguous. However, our main interest is the inside of the primary rainbow. A blue inner band fades as it approaches the rainbow's base, suggesting that Cropsey may have been familiar with the supernumeraries' similar behavior. As meticulous as it is, nothing in the *Crayon* author's account suggests this fading of the supernumeraries.

Could Cropsey thus be mimicking the behavior of natural supernumeraries and outstripping the most naturalistic rainbow advice of his day? As tempting as this notion is, problems with the scene's naturalism make it suspect. Not only is the color order in the secondary bow problematic, but both the rainbow's elevation and reflection are possible only if the sun is rising or setting. Yet shadows in the scene indicate that the sun is some distance above the horizon (the painting's title notwithstanding), and it certainly is not at the viewer's back. If Cropsey had learned from *The Crayon* about positioning rainbows in the landscape, it is not evident here.

A more immediate worry for us is that while the inside of the primary fades toward the rainbow's base in *Lake George*, it also fades toward its *top*. In fact, we are more justified in simply labeling this blue inner band as part of the primary. Although Cropsey may have meant to

capture the subtle gradation of supernumerary brightness in *Lake George*, the painting's departures from nature suggest otherwise. If *Lake George* has a lesson for rainbow connoisseurs, it is that no matter how naturalistic a painting may seem initially, those first impressions can be deceiving.

Does the Secondary Rainbow Have Supernumeraries?

Thus far we have talked only about supernumeraries of the primary rainbow. Should not the secondary rainbow also have supernumeraries? In the early fourteenth century, Theodoric of Freiburg speculated on their existence, but he admitted that he had not seen them himself.[35] Although he does not supply any details, Carl Boyer notes that "occasionally there are supernumerary arcs visible above the secondary."[36] This paucity of observation continues to the present. In fact, we know of no photographs of secondary supernumeraries seen in a rain shower, but they have been seen outdoors in artificially generated water sprays.[37] Why do we see only these hothouse varieties of secondary supernumeraries?

To answer this question, we first need to know where to look for secondary-rainbow supernumeraries. Recall the secondary rainbow's inside-out geometry (Figs. 4-3 and 6-8). Rainbow light forming the secondary bow is reflected twice inside the drop and thus is deviated through an angle of more than 180° (about 231°). Using the same reasoning that we did for the primary-rainbow supernumeraries, we would expect to see the secondary-rainbow supernumeraries at deviation angles larger than the secondary rainbow. However, these larger deviation angles will be *outside*, not inside, the secondary bow. William Livingston's photograph of a supernumerary outside the secondary of a water-spray bow[38] illustrates our point.

For starters, secondary-rainbow supernumeraries are difficult to see because their brightness is low. Since each reflection within a raindrop is paired with a refraction of light out of the drop, the secondary rainbow is intrinsically darker than the primary rainbow, assuming that raindrops are distributed uniformly in front of us (in theory, a primary bow is about 1.8 times brighter than its accompanying secondary bow). Consequently, the secondary rainbow's supernumeraries will be darker than their primary-rainbow counterparts. If the secondary supernumeraries are quite dim, they may be indistinguishable from their background. Yet even on those occasions when a secondary rainbow is fairly bright (for example, Fig. 9-2), we do not see its supernumeraries. Why is this so?

Meteorologist Günther Können shows that, unlike the primary rainbow's minimum deviation angle, the minimum deviation angle for the secondary rainbow actually *decreases* slightly as drops become larger and more flattened.[39] In other words, to redraw Fig. 9-7 for the secondary rainbow, we would have to shift the large-droplet wave trains to the left, not to the right as we did in Fig. 9-9. The resulting figure would show minimum deviation angle decreasing steadily as drop size increases from small cloud drops to large rain drops. As a result, drop distortion no

longer acts as a filter that provides a visible range of supernumerary bows—all the brightness maxima and minima of the secondary supernumeraries are mixed into an incoherent pattern.

Yet all is not lost. For a given size of flattened raindrop, the minimum deviation angle changes slowly with sun elevation.[40] We ignored this dependence in discussing the primary rainbow's supernumeraries because it is not very large there, but to produce any secondary-rainbow supernumeraries we must now include the effects of sun elevation on minimum deviation. Können notes that when the sun is fairly high in the sky (at elevations above about 35°), minimum deviation angles for the secondary rainbow actually increase as the radii of the flattened drops increase, just as in the primary bow.[41]

The consequence of this reversal is a secondary-rainbow analogue of what we see in Fig. 9-9—visible supernumeraries of the secondary rainbow. Können shows that this enhancement of the secondary rainbow's supernumeraries is strongest in the red part of the spectrum, as Livingston's photograph of these supernumeraries seen through a red filter indicates.[42] So at last we have found a rainbow phenomenon that is best seen through rose-colored glasses!

Tertiary Rainbows and More

Like the secondary rainbow's supernumeraries, the rainbow caused by *three* internal reflections is elusive indeed. Yet this tertiary bow is entirely possible in principle, because thrice-reflected light within a raindrop has a minimum deviation angle just as rays reflected once or twice do. For 700-nm red light, this minimum deviation angle is about 317.4°, which places the tertiary rainbow's red some 42.8° from the sun and its 400-nm violet 37.5° from the sun (allowing for the sun's angular width). Isaac Newton in his 1704 *Opticks* was one of the first to calculate the tertiary rainbow's position, although Edmond Halley's published calculations preceded his by four years.[43] As a practical matter, Halley dismisses the tertiary rainbow as being "lost in opposition to the sun"[44]—that is, invisible in the bright sky near the sun. Newton agrees, describing the tertiary's light as being "scarce strong enough to cause a sensible Bow,"[45] a limitation that he extends to bows caused by additional internal reflections. Our own calculations show that the primary rainbow is nearly 3.5 times brighter than the tertiary and that the secondary is almost twice as bright. Certainly the tertiary rainbow's diminished brightness does not improve our chances of seeing it in nature.

Yet however rare, observations of natural tertiary bows do occur. Before Newton and Halley, an obvious complication in making these observations was that the tertiary rainbow's true location was unknown. As a consequence, any colored arc that did not coincide with the primary or secondary stood a good chance of being mislabeled a "third rainbow."[46] Aristotle had dismissed the possibility of a third rainbow outright, saying: "Three or more rainbows are never seen, because even the second is dimmer than the first, and so the third reflection is altogether too feeble to reach the sun."[47] By implication, Aristotle places his invisible tertiary above the secondary bow, where the distance to his cloud-mirror is greater.[48]

Aristotle's rejection of the tertiary bow has the advantage of plausibility, so much so that it served as the definitive word for many Aristotelian and Scholastic commentators. Alexander of Aphrodisias dutifully records Aristotle's statement, although he does stubbornly add "certainly, though, there are some [rainbows] made at a distance beyond the second rainbow."[49] Avicenna also hedges on the tertiary, noting in his essentially Aristotelian account that "Certainly the rainbow is a phantom, and not more than two can exist simultaneously, for the second is already barely perceptible. How can still a third appear! If I say here and in similar contexts 'it cannot be,' it only means that the chance is remote, not impossible."[50] On a more positive note, Witelo reports once seeing four rainbows simultaneously at Padua. However, he curiously places these rainbows "not ten degrees distant from the sun,"[51] perhaps confusing them with the corona (and even then overestimating its distance from the sun). Theodoric apparently seizes on the two different senses of rotation in the primary and secondary rainbow rays (see Fig. 4-3) when he says "certainly beyond these two modes of radiation and reflection in generating the rainbow, it is not possible to fashion another."[52] Thus Theodoric seems to disallow even the theoretical *possibility* of a tertiary rainbow.

In later centuries, such dogmatism was replaced by genuine curiosity about the oddity of triple rainbows. Huygens's brother wrote to him in 1660 about observing a triple rainbow,[53] and in 1699 Christoph Volkamer cited Descartes as his justification for placing a tertiary bow no more than 11° above the secondary.[54] In fact, Descartes had only said rather offhandedly "I am also told that sometimes a third kind of rainbow above the two usual ones has sometimes been seen, but that it was much feebler, and approximately as much removed from the secondary one as that is from the primary."[55] As Descartes's rumor-mongering indicates, not until Halley's and Newton's work would the position of the true tertiary rainbow finally be fixed near the sun.

While the optics and mathematics developed by Descartes and Newton made possible many eighteenth-century calculations of the tertiary (and higher-order) rainbows, observations were not nearly so plentiful.[56] In fact, our best-informed and least-fanciful reports of the tertiary rainbow come from the last two centuries. An 1880 paraphrase of the German scientist Johann Heilermann's (1820–99) account is worth quoting at length, both for its historical and observational merit:

> Theory now further teaches that the color order in this third rainbow is exactly the same as in the primary rainbow, however the third rainbow does not appear on a cloud layer opposite the sun, but is located on one between the sun and eye. Therefore most observers have looked for the third rainbow in exactly the wrong place; only this can explain how from Radicke's *Optics*[57] up until now only one observation of the same [tertiary rainbow] is known, from Bergmann (Swedish physicist of the previous [eighteenth] century),[58] and that Jacob Bernoulli[59] could make the statement: "Lynxes and eagles could perhaps see it, but the weak human eye is not in this class."
>
> The speaker [Heilermann] was quite happy to obtain a sighting of this rare phenom-

enon. On 4 September 1878, traveling north from Cologne, he had his seat in the train compartment facing west and noticed initially that a thin cloud appeared before the bright sun. As the sun was still 10° above the horizon (according to later calculations), suddenly there emerged above the same on the right a circular red segment at the correct distance of about 40°, and this expanded in all directions around the sun, while afterward the remaining colors also emerged according to theory. Ultimately the edges of the circular bow extended down to near the horizon, and any doubt about whether this was the third rainbow dwindled for the observer and his similarly expert travel companions. The long duration of the phenomenon was perhaps their reason, because cloud and train traveled parallel with nearly equal speed until they finally arrived at the city of Neuss, where the rainbow's visibility ended.[60]

Heilermann is entirely believable in his wealth of detail, and he does not seem to have confused the tertiary bow with any other optical phenomenon. Had he known where to look, however, he could have read about a fairly recent encounter with a tertiary rainbow. In 1851, seminary student Charles Hartwell made detailed notes about a tertiary bow he saw in South Windsor, Connecticut, an account so believable that it passed muster with Hartwell's former professor Ebenezer Snell (1801–76). Recalling Snell's instructions, an excited Hartwell estimated the radius of his partial tertiary to be about 40°.[61] Although we can only envy Hartwell's and Heilermann's choice of window views, we need not worry that the tertiary rainbow is confined to the mists of history. Kenya of the 1980s will do just fine, as author David Pedgley (1932–) makes clear:

> Whilst in Nairobi recently I had the good fortune to see a tertiary rainbow. On 21 May 1986 at 1755 a new shower cloud had just started to rain out over my hotel in dense curtains of medium-sized drops brilliantly lit by the low sun. From the balcony of my fourth-floor room I could see not only a bright primary, accompanied by a moderate secondary, but also a weak bow in the direction of the sun, which was conveniently shielded by the side of the building. The bow was scintillating but distinct for two or three minutes. It was about the same size as the primary bow, but centred on the sun, with red on the outside and green on the inside.[62]

Pedgley's observation confirms what rainbow theorists since Newton have said: any naturally occurring tertiary rainbow will be faint, and unless we are well positioned, the sun's glare is likely to obscure it. Of course, the Holy Grail of tertiary-rainbow observations is a clear color photograph of this bow. Readers, consider yourselves challenged!

While we have no reliable reports of fourth- or higher-order natural bows, such bows can easily be seen indoors under controlled conditions. As physicist Jearl Walker demonstrates, a suspended drop of water can be our window onto myriad (or at least the first dozen) rainbow orders.[63] When a suspended drop is illuminated by a narrow pencil of light, we can observe

FIG. 9-11

Theoretically sound but practically impossible: a sky filled with the first eleven rainbow orders

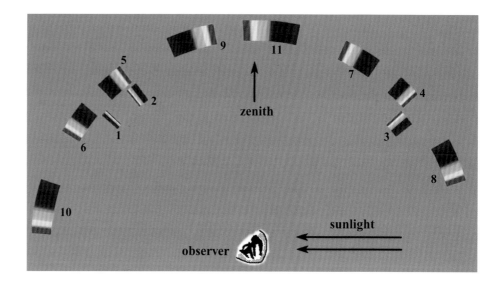

many different rainbows simply by changing our viewing angle in a horizontal plane. Glare from transmitted or reflected light complicates some of the observations, but Walker reports that patience is rewarded by the rarest of sights, rainbow colors of many different orders. (Note that you simply see each rainbow's colors, not a rainbow arc.) What would such a display look like if we could duplicate it in many drops and transplant them in the sky? Figure 9-11 shows the answer—a sky filled with rainbows.

In Fig. 9-11, we have followed Walker's lead by creating an array of rainbows that illustrates the angular position of the first several rainbow orders.[64] An observer's eye looks upward from the center of our meteorological hemisphere, on which rainbow orders 1-11 appear (to simplify Fig. 9-11's geometry, the sun is placed on the horizon). Orders 1 and 2 (the primary and secondary, respectively) appear 42° and 51° from the antisolar point, as expected. The tertiary rainbow (order 3) is, as Heilermann, Hartwell, and Pedgley observed, at about the same distance from the sun as the primary is from the antisolar point. (To avoid overlapping higher-order rainbows in Fig. 9-11, we place the first three rainbows closer to the observer.)

Bear in mind that Fig. 9-11 is an illustration of geometrical optics' theory of the rainbow, not a practical observing guide. Within any drop, the final internal reflection of each higher order is paired with a refraction that contributes to the next-lower-order rainbow. Inevitably, each higher-order rainbow is dimmer than its predecessor, meaning that Fig. 9-11's lovely array of rainbows is too faint ever to be seen outdoors in a rain shower. However, as an illustration of rainbow theory, Fig. 9-11 is still quite useful. Note that the red-to-violet color order reverses with each new order of rainbow. In other words, red is alternately on the outside and then inside of the different rainbows, a pattern of flip-flops that continues through the first eleven rainbow orders.[65] Notice too that each higher-order rainbow is slightly wider than its predecessor. The reason for this widening is simple enough: as rainbow order increases, the minimum deviation ray moves ever closer to grazing incidence (external incidence angle $i = 90°$). As the minimum-

deviation *i* approaches 90°, the rainbow spectrum is dispersed through an ever-wider range of angles. In turn, the rainbow widens with each new order. Johannes Kepler presumably would be pleased to know that the rainbow of infinite order requires a grazing incident ray, just as he had advocated for the primary rainbow![66]

Does a Zero-Order Rainbow Exist?

From the dizzying zenith of the infinite-order rainbow, we plummet to its nadir opposite: the putative zero-order rainbow. What do we mean by a zero-order rainbow? Just as the rainbow of one internal reflection (the primary) is a first-order rainbow, the zero-order bow would be the rainbow resulting from light traversing a raindrop with *no* internal reflections (that is, it is Fig. 5-3's transmitted ray). Recall that Albertus Magnus, Theodoric, and others examined the spectrum refracted from the rear of a sunlit, water-filled glass globe.[67] This spectrum is produced without any internal reflections, so can it be the cause of a zero-order rainbow?

In *Opticks*, Isaac Newton seems to suggest that a zero-order rainbow is possible: "The Light which comes through drops of Rain by two Refractions without any Reflexion, ought to appear strongest at the distance of about 26 Degrees from the Sun, and to decay gradually both ways as the distance from him increases and decreases. And the same is to be understood of Light transmitted through spherical Hail-stones. And if the Hail be a little flatted, as it often is, the Light transmitted may grow so strong at a little less distance than that of 26 Degrees, as to form a Halo about the Sun or Moon."[68]

Two centuries after Newton, similar arguments are offered by physicist Walter LeConte Stevens (1847–1927), who writes: "A bow of the kind just described [resulting from no internal reflections], though always produced, would not be perceptible in the sky, because the refracting sphere and the sun are too nearly in the same direction from the receiving eye. For a visible bow we must consider the rays emergent after one or more internal reflections."[69] Clearly Stevens is unaware of Heilermann's and Hartwell's accounts of the tertiary rainbow, which, though farther from the sun than Newton's 26° arc, is both visible and much weaker than the invisible bow he claims is "always produced"! Furthermore, by Stevens's logic, neither the corona nor the 22° halo should be visible because they too are near the sun. In fact, Stevens did not (and, based on his own equations, could not)[70] fix the angular position of this "most brilliant" of rainbows. He simply offered it as a "first approximation" among several increasingly sophisticated rainbow explanations.

Unfortunately for Stevens, the zero-order rainbow is not an approximation but an impossibility. Stevens's error seems to be his own; he does not cite Newton's passage from *Opticks*. Clearly a single raindrop projects a brilliant *spectrum* of colors after it refracts sunlight twice *sans* internal reflection (see Fig. 5-3's transmitted ray). Yet because this unreflected spectrum has no minimum deviation, a sky filled with sunlit raindrops will not yield a bright clustering of

colored rays. In other words, without a minimum deviation angle, each raindrop in the sunward part of the sky projects a different, overlapping spectrum on our eye.[71] The net result is that while raindrops can enhance the sky's brightness toward the sun, they produce only a *mixture* of spectral colors (that is, white sunlight), not a rainbow. Although Stevens's brilliant zero-order rainbow does not exist, we can console ourselves that the equally invisible higher-order rainbows (all caused by a minimum deviation) most certainly *do* exist. Among invisible rainbows, real ones are surely preferable!

But what of Newton's remarks? Does he too believe in a nonexistent zero-order rainbow? As one of us (Fraser) has shown, Newton's normally robust mathematics fails him here, and he invents a nonexistent minimum deviation angle for light refracted (but not internally reflected) by spheres of water or ice. Historian Alan Shapiro further demonstrates that Newton's aside here is actually an attempt to explain the 22° halo rather than the rainbow.[72] Newton seems to have convinced himself that he had done so, although later writers (including Thomas Young) would rightly object to his "inadmissible calculation"[73] of the zero-order minimum deviation for spheres of water and ice. In addition, Newton must fudge to make his 26° arc coincide with the 22° halo, which he does by invoking hail that is "a little flatted." Consummate optician that he is, Newton surely realizes that his convenient explanation only puts *some* twice-refracted light 22° from the sun, and it certainly will not yield a circular 22° halo.[74]

Newton sandwiches his remarks on the halo between his much longer discussion of the rainbow and his one-sentence nod toward the tertiary rainbow. This blending of several phenomena, two media (raindrops and hailstones), and one supposedly unifying mechanism (two refractions separated by zero or more reflections within a sphere) makes misinterpretation easy. In fact, Shapiro notes that Newton inexplicably substituted at the last minute his erroneous explanation of a hail-generated halo for the correct one[75] that appeared in the *Opticks* manuscript. Newton may have believed that he was tying together (falsely, as we now know) the explanation of the rainbow and halo. Yet the long history of spectra projected without internal reflections from spheres, combined with Newton's vain attempts at continuity in his text, was enough to convince Carl Boyer that Newton believed in a zero-order rainbow.[76] The irony here is double: Newton's ill-advised change to *Opticks*' discussion of the rainbow and halo not only muddied the mathematical waters, but also the historical ones. Yet while the zero-order rainbow does not exist, we can certainly admire the zero-order spectrum projected by a refracting sphere.

Rainbow Reflections and Reflection Rainbows

Readers reeling from bouts with zero-order and infinite-order rainbows can catch their breath as we examine a less exotic topic: reflection and the rainbow. As the nonexistent zero-order rainbow shows, a true rainbow requires at least *one* reflection within raindrops. Now, however, we are concerned with other kinds of reflections, namely (1) reflection of rainbow rays them-

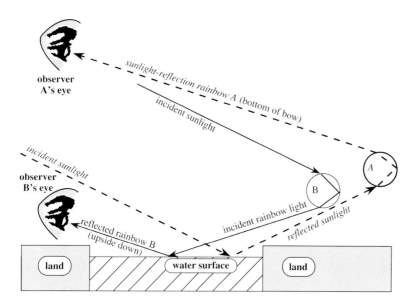

FIG. 9-12

A reflected rainbow (observer B) and a sunlight-reflection rainbow (observer A) are formed by light coming from different directions that traverses (possibly) different raindrops.

selves from standing water or (2) reflection of sunlight before it enters raindrops and produces the rainbow. For consistency, we refer to the former as *reflected rainbows* and to the latter as *sunlight-reflection rainbows*.[77] Rainbows seen directly without reflection from water bodies we call *ordinary* rainbows.

Figure 9-12 illustrates how the two types of rainbow reflections differ. In the reflected rainbow, light is refracted and reflected internally through minimum deviation in drop B. Observer B sees this light as part of an inverted rainbow that appears to lie on the water surface. This reflected bow's ordinary, upright image is visible by looking directly at Fig. 9-12's "incident rainbow light" ray. In other words, if we looked upward from the point where drop B's rainbow ray intersects the water surface, we would see the reflected rainbow's upright source, an ordinary rainbow. As noted in Chapter 4, the reflected rainbow's center is as far *above* the astronomical horizon as its ordinary companion's center is *below* that horizon. Observer B reasonably (but wrongly) assumes that the reflected rainbow is just a reflection of the ordinary rainbow that is visible from his or her location on land. (Naturally, reflected rainbows can be seen over water as well as on land.) However, the ordinary and reflected rainbows arise in *different* raindrops, since their minimum deviation rays must come from different parts of the sky. Literally, the ordinary and reflected bows are two different rainbows.

In a storm's wake, ruffled waters often destroy the mirror-like surface needed to produce a good reflected rainbow. For example, only a vestige of a reflected rainbow is visible beneath the right side of Fig. 8-8's rainbow, appearing merely as an area of enhanced color on the lake surface. However, good planning and good luck can converge to produce a clear reflected rainbow such as that reproduced in Boyer.[78] Of course, if your reflected-rainbow ambitions are more modest, a quiet mud puddle is perfectly adequate to reflect a segment of the ordinary

FIG. 9-13

Two observers (A and C) see different parts of two different sunlight-reflection rainbows. Observer C can see only the bow's elevated top, while A sees its lower half and perhaps the entire rainbow circle. For both observers, the sunlight-reflection rainbow's center is as far *above* the astronomical horizon as the ordinary rainbow's is below it.

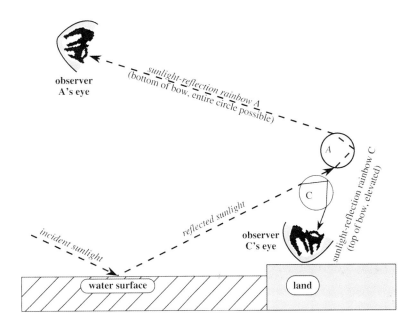

rainbow, but the resulting fragmentary arc is far less satisfying than the wide one reflected by a large water body.

Judging from published reports, the sunlight-reflection rainbow is regarded as spectacularly puzzling while the reflected rainbow is seen as unremarkable.[79] However, both kinds of bows are subtle indeed. For example, in Fig. 9-12 the sunlight-reflection rainbow A is not visible at observer B's location. To see its lower half, observer A must rise above B's location. Now incident sunlight is reflected *up* to drop A, which in turn deviates it toward A's eye. If A's and B's eyes are positioned correctly, they can receive rainbow light from the same raindrop, although this light has two different sources (reflected versus direct sunlight) and takes two different paths through the drop. Alternatively, if another observer at the surface (observer C; see Fig. 9-13) looks upward, he or she can see rainbow rays that have been deviated downward and that thus form the top of the sunlight-reflection rainbow.

Figure 9-13 certainly does not exhaust all possible sunlight-reflection rainbows. In particular, we may stand *between* the sun and the water that reflects sunlight toward the raindrops causing the sunlight-reflection rainbow, although observer C's position in Fig. 9-13 is more likely (that is, the water is to our backs). Wherever its watery mirror lies, the vivid sunlight-reflection rainbow illustrated in both Boyer and Greenler immediately shows this rainbow's power to impress.[80] In Greenler's Plate 1-9, the sunlight-reflection rainbow appears as startling vertical spikes of rainbow light that rise from the base of the ordinary primary and secondary rainbows. Sometimes the primary sunlight-reflection rainbow crosses the ordinary secondary bow. This makes sense, since both the reflected and sunlight-reflection rainbows have centers that are as far above the astronomical horizon as the ordinary rainbow's center (the antisolar point) is

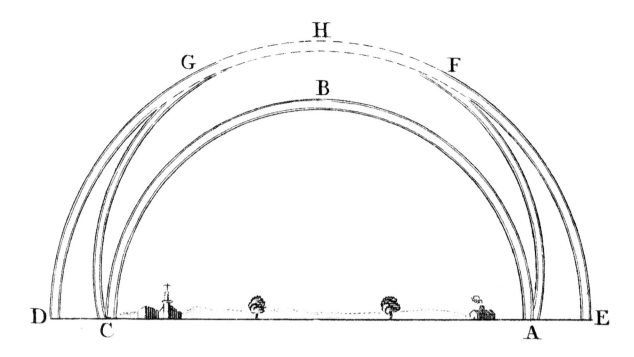

FIG. 9-14

Edmond Halley's drawing of an ordinary primary and secondary rainbow crossed by a primary sunlight-reflection bow. (From Edmond Halley, "Account of an Extraordinary Iris, or Rainbow, Seen at Chester," in *Philosophical Transactions of the Royal Society of London (abridged)* 4 [1694–1702], Plate V, Fig. 6)

below it. Literally, we overlay the elevated disk of the sunlight-reflection rainbow on the ordinary rainbow, with spectacular visual results. Note that reflected rainbows cannot appear above the astronomical horizon, although clearly the upper parts of the sunlight-reflection rainbow will.

The spectacle of sunlight-reflection rainbows has long been written about. Edmond Halley gives a clear account of one in a 1698 letter to the Royal Society:

> August 6, 1698, in the evening, between 6 and 7 o'clock, walking on the walls of Chester, I . . . observed an iris, exceedingly vivid, as to its colours . . . ; and soon after, the beams of the sun being very strong, there appeared a secondary iris, whose colours were more than ordinary bright. . . . But what appeared most remarkable was, that with these two concentric arches, there appeared a third arch, nearly as bright as the secondary iris, but coloured in the order of the primary, which took its rise from the intersection of the horizon and primary iris, and went across the space between the two, and intersected the secondary.[81]

Figure 9-14, the drawing accompanying Halley's published account, clearly shows an elevated sunlight-reflection rainbow that arcs between the ordinary primary and secondary bows. In Fig. 9-14, arc ABC is the ordinary primary rainbow and EFHGD is its accompanying secondary bow. From this simple diagram, Halley mines a wealth of observation and insight.

Chester is on the River Dee and is near its estuary, so a substantial amount of open water lies between Halley and the low sun. This is not lost on Halley, who reports "afterwards recollecting that the sun shone along the river Dee, which from thence empties itself W.N.W. where the sun then was, I concluded this secondary [that is, sunlight-reflection] arch AFHGC was produced by the beams of the sun reflected from that water, which at the time was very calm."[82] Yet Halley finds several surprises in this remarkable rainbow. He notes that arcs gradually rose from points F and G to complete the secondary's top (FHG) and that "for a great space, the secondary iris lost its colours, and appeared like a white arch at the top." Furthermore, "the upper part of the third iris was not at all visible, beyond the intersections, F, G,"[83] because the additively mixed light of the secondary and sunlight-reflection rainbows (which have opposite color orders) combine to yield near-neutral colors or white. In 1854, Ebenezer Snell would cite Halley's account to explain possible variations on a sunlight-reflection bow that yet *another* of his former students had seen from the seminary at East Windsor, Connecticut.[84] If observers ranging from seminarians to one of Newton's most illustrious contemporaries can read so much from rainbow reflections, surely today we owe it to ourselves to seek them out too!

Rainbow's End—and Fantasy's Beginning

We have come to the end of our survey of the natural rainbow's basic features, although myriad other variations and oddities are sprinkled throughout the rainbow literature.[85] As varied and marvelous as the rainbow's natural guises are, however, human imagination is far from bound by them. To no one's surprise, we can easily find manmade rainbows that have precious little to do with nature and much to do with, well, the inexplicable. A roller-coaster ride through the bizarre, bewildering, and sometimes banal world of the advertiser's rainbow is the subject of our next chapter. Let the selling begin.

We began our rainbow travels with mythology, and it seems fitting to end there—with the mythology of the modern advertiser's rainbow. Of course, the rainbow has no special claims on strange iconography in our popular culture, where all of nature is fair game. But the rainbow's ancient symbolism and varied meanings do give it unusual power to impress and persuade. When we compare the rainbow's manic exploitation in commerce with its modern theoretical complexities, at first we notice only the wide gulf separating the bow's modern artistic, commercial, and scientific images. Yet on closer inspection we see that these disparate images are all joined together by an enduring, uniquely human appreciation of the rainbow bridge's compelling natural beauty.

TEN

SELL IT WITH A RAINBOW

Whatever the other merits of Constance Cumbey's anti–New Age jeremiad *The Hidden Dangers of the Rainbow*, at least it makes one important point—the rainbow can serve almost anyone's ends. We say this because you might find *Hidden Dangers* stocked in a Christian book store whose door is adorned with the likes of Fig. 10-1. We agree with Cumbey that commercial use of the rainbow poses a danger, but the danger is of being overrun by rainbows, not of succumbing to their supposedly diabolical powers.

Practically speaking, we can only dip a cup from the ocean of proselytizing rainbows. Our goal here is to be instructive about the rainbow's use and misuse in daily life, not encyclopedic. Any initial hope that we had of compiling a Baedeker of bad rainbows has been washed away by their sheer numbers. Some of the rainbows that we found combined wit and inventive art, some were amusing to look at, and others simply

> According to the Bible, the rainbow is symbolic of God's everlasting covenant that he would never again destroy the earth by a flood. However, the New Age Movement uses rainbows to signify their building of the Rainbow Bridge (antahkarana) between man and Lucifer who, they say, is the over-soul. New Agers place small rainbow decals on their automobiles and book stores as a signal to others in the Movement. Some people, of course, use the rainbow as a decoration, unaware of the growing popular acceptance of its occult meaning and the hidden dangers.[1]
>
> Constance E. Cumbey, *The Hidden Dangers of the Rainbow* (1983)

FIG. 10-1

Dove and rainbow above door to a Christian book store in State College, Pennsylvania, 1980

FIG. 10-2

Rainbow-emblazoned trailer advertising a revival meeting, Carlisle, Ontario, 1978

FIG. 10-3

Pastel rainbow decal for Putnam City Baptist Church, Oklahoma City, Oklahoma

FIG. 10-4

Vivid rainbow decal for Pope John Paul II's 1984 visit to Manitoba

defied description. Of course, the purpose of much advertising is not to mimic nature but to persuade us by using caricatures of nature. While insisting on strict naturalism misses the point of advertising, we can nevertheless learn much about our culture's views of nature by examining the unnaturalism of advertising. With this in mind, we proceed, tongue firmly in cheek and analytic eye open wide.

A Rainbow for Every Sect and State

As the book of Genesis makes clear, the rainbow has long been favored as a Judeo-Christian emblem. However, Old Testament authors could be forgiven some confusion about the religious significance of Fig. 10-2's inverted fundamentalist rainbow. Even within the Christian mainstream, the rainbow today is assigned diverse advertising ends and, given the variety of color orders that we see, apparently gets there by diverse means (Figs. 10-3 and 10-4). Naturally, painted rainbows with red inner bands *could* be representations of the secondary rainbow, but our experience suggests otherwise.

FIG. 10-5 (ABOVE)

Peter Max, billboard with rainbow and running figure, 1980. United States–Canadian border crossing, Pembina, North Dakota

FIG. 10-6 (TOP RIGHT)

Poster for Saskatchewan's 1980 Canadian Heritage Festival

FIG. 10-7 (BOTTOM RIGHT)

Rainbow poster for Israel, November 1980

What the rainbow is asked to do in the name of God, it is also asked to do in the name of the state, as our next three examples show. As visually delightful as Peter Max's rainbow billboard is, U.S. Customs officials probably are not recommending its method of entry (Fig. 10-5). Just as we cannot take Max's rainbow literally, neither can we believe Saskatchewan's continent-spanning rainbow (Fig. 10-6). Not surprisingly, Canada and the United States see the rainbow's colors differently (compare Figs. 10-5 and 10-6), while Israel has yet a third opinion on the order of rainbow colors (Fig. 10-7).

The rainbow's duties can be truly international in scope. Although Zionists and the United Nations have seldom seen eye to eye, here at least they advocate a common cause—world peace and compassion, as heralded by inverted rainbows (Figs. 10-8 and 10-9). The U.S. Postal Service has more modest goals—simply getting you to use its ZIP code somewhere over the rainbow (Fig. 10-10). Here, as in much of rainbow advertising, the bow is just one more element in a cartoon landscape. Naturalism is as incidental as the rainbows are gratuitous.

FIG. 10-8 (TOP LEFT)
"Peace is the Zionist way" rainbow poster, 1980

FIG. 10-9 (CENTER LEFT)
UNICEF Halloween trick-or-treat poster with rainbow, 1980

FIG. 10-10 (BOTTOM LEFT)
U.S. Postal Service rainbow poster promoting ZIP code, 1980

FIG. 10-11 (TOP RIGHT)
Rainbow billboard advertisement for Dave Holt Ford-Mercury, near Minneapolis, Minnesota, 1980

Fig. 10-12 (BOTTOM RIGHT)
Rainbow Motors, near Lewisburg, Pennsylvania, 1993

The Rainbow Tour

If church and state can be joined in their use of the rainbow, can mere commercial enterprises be far behind? No business empire is too vast, no shop too tiny, to escape the rainbow's fatal attraction. Sellers of automobiles, lodging, travel, liquor, food, appliances, paint, and trinkets

FIG. 10-13 (ABOVE)

Rainbow Motel sign,
Swift Current, Saskatchewan,
1980

FIG. 10-14 (TOP RIGHT)

Rainbow billboard advertisement for
Berkshire Hilton Inn, Pittsfield,
Massachusetts, 1980

FIG. 10-15 (BOTTOM RIGHT)

Sign for Mike and Andy's Recovery
Room restaurant, Tucson, Arizona,
1980 (photo: Craig F. Bohren)

have all borrowed the rainbow's cachet to make their point, however speciously. A sprinkling of rainbow products and their purveyors follows.

With the U.S. auto industry near its quality nadir in 1980, Dave Holt Ford-Mercury of Hudson, Wisconsin, invoked two unblemished icons, the rainbow and Ford's 1955 Thunderbird coupe, to sell its cars (Fig. 10-11). Even the most jaded reader will be startled to learn from Fig. 10-11 that this car dealership apparently has "exclusive distributor" rights for the rainbow! But the rainbow is hardly a panacea for car dealers' ills, as the starkly vacant lot of Rainbow Motors near Lewisburg, Pennsylvania, indicates (Fig. 10-12). Perhaps failing to get the exclusive distributor rights was a mistake.

What could be more natural than touring in your rainbow-sanctioned automobile? When you do, rest assured that rainbow lodging is available far and wide. You can relax from Saskatchewan's Rainbow Motel (Fig. 10-13) to the Massachusetts Berkshire Hilton Inn (Fig. 10-14), even if you do have to join the Hilton staff within the rainbow. Should your room smell disagreeable, simply ask management to freshen it up with Rainbow Technology's RainbowAir Housekeeper, an ozone-generating room deodorizer.[2]

The truly lucky hotel guest will find the dinner table graced with a "rainbow glow" designed by Seattle's Gourmet Display company, which sells such props because "people taste with their eyes as well as their taste buds."[3] For the complete rainbow dining experience, insist that the hotel use as its grocer Minnesota's well-heeled Rainbow Foods, whose projected 1993 sales were $900 million.[4]

FIG. 10-16
Magazine advertisement for Alberta Pure Vodka

FIG. 10-17
Magazine advertisement for Virgin Islands White Cruzan Rum

FIG. 10-18
Sign for Great Escape Hair Fashions, Williamsburg, Virginia, 1994

FIG. 10-19
Chips Ahoy! Chocolate Chip cookie bag, with a rainbow bridge at the end of a maze

FIG. 10-20
Magazine advertisement for "pot of gold" aircraft paint from Ditzler Aircraft Finishes

FIG. 10-21
Magazine advertisement for "rainbow-fresh" YES laundry detergent

FIG. 10-22
Pillboxes with rainbows, Pegasus, and Pegasus-unicorn hybrid, State College, Pennsylvania, 1980

FIG. 10-23
Rack of rainbow stickers, State College, Pennsylvania, 1980

Fig. 10-24. Patrick Hughes, *Rubbish Rainbows*, 1979. Postcard. Courtesy Patrick Hughes and Angela Flowers Gallery, London

If travel has simply jangled your nerves, you can soothe them in establishments ranging from Rockefeller Center's elite Rainbow Room to Mike and Andy's more modest Recovery Room (Fig. 10-15). Travelers alarmed by the red cross on Mike and Andy's sign obviously are not made of stern enough stuff to drink beneath the rainbow.

Eat, Drink, and Use the Rainbow Shamelessly

If you prefer to mix your own drinks, both Alberta Pure Vodka and Virgin Islands White Cruzan Rum stand prepared to take your breath away, although whether with taste or temerity is unclear (Figs. 10-16 and 10-17). While the link between liquor and the rainbow is inexplicable, at least Alberta Vodka deserves credit for acknowledging that the rainbow's beauty *is* breathtaking. If rainbow drinking has left your hair in disarray, look no further than Great Escape Hair Fashions, where a rainbow coiffure surely awaits (Fig. 10-18).

Casual rainbow dining has never been easier. You can enjoy dessert either from California's Double Rainbow Gourmet Ice Cream company[5] or from the Chips Ahoy! Chocolate Chip Cookie Mine (Fig. 10-19). In Fig. 10-19, young adventurer Chip is about to brave a maze that leads to the entrance of an enormous chocolate chip mine. Chip knows that he has arrived at this Elysium when he encounters our old acquaintance, the rainbow bridge. Now is probably not a good time to acquaint Chip (or shoppers) with the Hawaiian meaning of going "by the path of the rainbow."[6]

Naturally, paint manufacturers have often adopted the rainbow in their advertising (Fig. 10-20). A less obvious use is recruiting the rainbow to sell laundry detergent (Fig. 10-21), although echoes of the RainbowAir Housekeeper reverberate here. The connection between the rainbow and cleanliness, however odd, might go something like this: The lightning discharges of thunderstorms can impart an ozone smell to the air,[7] a smell that is most obvious just after the storm. The lower humidity and improved visibility that often follow the storm are sometimes accompanied by a rainbow seen in the retreating storm's rain. In addition, your surroundings have just been washed by presumably pure rainwater. Thus the sight of the rainbow, the smell of ozone, and a cleaner, fresher-feeling environment can occur together. Although the logic is tenuous, the sensory association might be enough to sell detergent.

Kitsch and Sink: The Edge of the Rainbow Envelope

When all else fails, we can sell the rainbow itself. While illogic reigns in other rainbow commerce, in rainbow kitsch it is bad taste that rules. How else can we explain rainbow-encrusted pillboxes and reels of rainbow stickers (Figs. 10-22 and 10-23)? To make their philosophical stance perfectly clear, the creators of these fantasies often give the rainbow companions such as pixies and unicorns. While some of these rainbow caprices are amusing and visually elegant, their overabundance soon cloys. Graphic artist Patrick Hughes has wittily and succinctly offered a solution for disposing of the excess (Fig. 10-24).

Even meteorologists' books are not safe from ersatz rainbows (Fig. 10-25). In one edition of *The Atmosphere*, an introductory meteorology textbook, an overzealous picture editor at the last minute added an impossible rainbow to the book's front cover (sunbeams radiate from within the fictitious rainbow). Much to his consternation, one of us (Fraser) had just written a thorough, scientifically accurate description of the rainbow that now lay within *The Atmosphere*'s offending covers. Physician, heal thyself (or, in this case, thy picture editor).

Finally, we come to the category of completely inexplicable rainbow kitsch. Examples of this class are discouragingly easy to collect, but our personal favorite is Fig. 10-26. We can only hope that this postcard is done tongue-in-cheek, a bad-taste puzzler that deliberately strives for inscrutability. Otherwise, trying to think of *any* connection between the rainbow and 1980's eruption of Mount Saint Helens is an impossible task.

By now, even the most patient reader may be echoing the frustrations of the man in Fig. 10-27, who snaps at his young companion that *their* beautiful rainbow is "not advertising *anything*, damn it!" We sympathize. But beyond understandable frustration, what does the rainbow's casual use and misuse in advertising tell us?

Reading the Rainbow

First, as we have noted before, the lowest common denominator in rainbow representation is that the rainbow is a bow, usually with colored bands. Yet even this much naturalism is not guaranteed, as Fig. 10-28 indicates. The colorless rainbow in Fig. 10-28 could be a cloudbow,[8] but even we regard this as farfetched. More likely, it is simply a further abbreviation of the rainbow icon, made in the reasonable hope that the improbable association of drinking and the rainbow will survive the rainbow's bleaching

Second, as the figures above make clear, painted rainbows' colors are of secondary importance in signaling us that we are viewing a rainbow. Color order shifts seamlessly and impossibly from one figure to the next, and colors wax and wane in vividness. Given the rainbow's reputation as a color paragon, this unnatural mutability of painted rainbow colors is remarkable.

Third, occasionally we see rainbows painted obliquely (for example, Figs. 10-12 and 10-20), indicating that the rainbow is sometimes regarded as a physical object whose shape changes with our vantage point. We do not know whether most graphic designers believe in this impossibility or whether they are knowingly indulging in a subtle perspective joke. Yet as we saw in Chapter 4, the idea of moving around the rainbow maintains a powerful hold on our imaginations.

What might all these bits of unnaturalism have in common? To us, overuse and visual warping of the rainbow by commerce suggests that the bow has lost almost all portentousness. While John Keats could lament the loss of heaven's "awful rainbow" in 1820, today we would likely find the word "awe" too embarrassing to apply to our beautiful but benign rainbows. As George Landow has pointed out, once the rainbow was freed from its strictly biblical function as a sign of God's covenant, nineteenth-century painters could render the bow in new symbolic and

FIG. 10-25
Impossible rainbow added to the cover of an introductory meteorology textbook (Anthes et al., 1978)

FIG. 10-26
Postcard with kitsch rainbow and an erupting Mount St. Helens

natural contexts.⁹ But with this freedom of expression came ambiguity of interpretation. Unless the artist provides explicit clues, viewers must decide for themselves what function the rainbow serves in the image.

Today, the rainbow serves primarily as a visual shorthand for peace and natural beauty. As pleasing as these interpretations are, their very agreeableness makes them prey to trivialization. With triviality can come banality and a loss of meaning—in careless hands, the rainbow slides from visual shorthand to visual cliché. Furthermore, clichés feed on themselves, so that later generations of kitsch artists and their public learn from and value the rainbow clichés rather than the rainbow archetypes.¹⁰

Consider a similar example from archaeology: our present-day stereotype of Neanderthals as simian brutes. Archaeologist Stephanie Moser shows how early twentieth-century scientific opinion and prejudice combined with popular illustrations to create two completely different, but equally inaccurate, caricatures of these ancient humans.¹¹ In 1909, French paleontologist Marcellin Boule advised an artist for the French newspaper *L'Illustration* on the "accurate reconstruction" of a live Neanderthal, based on a newly discovered skeleton. Boule's vision of Neanderthals was truly monstrous, as evidenced by *L'Illustration*'s picture of a massive, stooped simian. Yet two years later, the *Illustrated London News* published another scientifically sanctioned image that showed a markedly human (and European) reconstruction based on the very same skeleton.¹²

Both images of the Neanderthal had more to do with the ideological agendas of their

FIG. 10-27
Charles E. Martin cartoon, "It's not advertising *anything,* damn it!" (Copyright © 1966 *The New Yorker* Collection. Charles E. Martin from cartoonbank.com. All Rights Reserved.)

"*It's not advertising anything, damn it!*"

scientific advisers than reality, yet it was Boule's brute who lived on in the public consciousness. Why? One suggestion is that Boule's early twentieth-century European public was still distinctly uncomfortable with its new Darwinian role as descendants of lower primates.[13] Just as today's public seeks unalloyed beauty in the rainbow, so Boule's public looked for unambiguous brutishness in an uncomfortably recent ancestor. Later generations exposed to Boule's stark vision of Neanderthals would likely find it more compelling than a less dramatic yet scientifically balanced image.

In fact, popular readings of the rainbow and Neanderthals nicely define polar opposites in our views of nature. Whereas Neanderthals supposedly embody our tangibly animalistic side,

the rainbow is made a proxy for our intangibly spiritual side. Both clichés have almost nothing to do with the realities of either Neanderthals or rainbows, yet they are remarkably durable. That the optimistic, spiritual rainbow cliché is nothing more than cultural parochialism is evident in the very different roles for the rainbow that we find throughout the world (see Chapter 1).

In fairness, our clichés do serve the purpose of simplifying a complex world. If every natural phenomenon we encountered in daily life demanded its own thorough, even-handed explanation, we probably would be immobilized by instruction. In addition, most of us have had the frustrating experience of having a cherished icon demystified and rationalized by the earnest explanations of others. Is that our agenda with the rainbow? No, far from it. Indulging in fantasy for its own sake is one of life's great pleasures, and rainbow fantasies are no exception. However, being *unable* to distinguish between rainbow fact and fantasy is no asset. Being able to make that distinction is our goal here.

FIG. 10-28
White rainbow sign for Wetherburn's Tavern, Colonial Williamsburg, Virginia, 1994

So where do we leave the advertiser's rainbow? Clearly one solution is Patrick Hughes's rubbish can (Fig. 10-24), but another solution is to savor rainbows from commerce and kitsch for all their delicious inconsistencies and absurdities. We can simultaneously admire their (sometimes) splendid artistic execution while smiling at their unnaturalism and silly excess.

Epilogue: The Rainbow to Today

The rainbow is clearly a workhorse of commerce, but what other roles does it play in art and science today? Let us first look at what has happened to rainbow theory in the more than 150 years since George Airy published what he called his "complete theory" of the rainbow?[14]

Airy's Rainbow Theory: The Incomplete "Complete" Answer

Not surprisingly, Airy's theory was neither complete nor the last word on rainbow optics,[15] but it did add three salient features to rainbow theory. First, Airy's theory quantified how a raindrop's size affects the resulting rainbow's radius and angular width, as well as the spacing of its supernumeraries. Thomas Young had occasionally linked specific drop sizes to specific supernumerary spacings, but he did not elaborate further on the matter.[16] Second, as is the case with many new theories, Airy's made a prediction that challenged conventional wisdom but that later would be vindicated by observation. Specifically, Airy predicted that *some* rainbow light is sent into angles between the primary and secondary bows, a region where Young, Newton, and Descartes had admitted none. Finally, Airy overcame a problem that had dogged earlier rainbow theories, all of which predicted *infinite* intensity at the minimum deviation angle.

Yet for all its mathematical elegance and power, Airy's theory was just that—a theory. Experimentalists began to test its predictive powers, using monochromatic light to generate supernumerary bows in dizzying profusion. In 1841, mineralogist William Miller (1801–80) described laboratory experiments in which he generated thirty supernumeraries inside the primary rainbow and twenty-five outside the secondary bow.[17] Despite some difficulties with his observing apparatus, he reported that "the differences between [Airy's] theory and observation are not greater than might reasonably be expected."[18]

Others remained unconvinced, among them chemist Richard Potter (1799–1886). Even though Potter favored the particle or corpuscular theory of light, he correctly insisted in 1835 that interference (nominally a wave property) must be considered in any physically realistic theory of the rainbow.[19] Just as we did in Fig. 8-7, Potter described rainbow light with a folded wave front, the outer edge of which is a series of wave cusps. The line that connects these wave cusps or folds is the minimum deviation angle, or in optical terms, the rainbow ray. Because light intensity is highest here, the wave cusps are said to form a caustic, literally a "burning curve."[20] An everyday example of a caustic is the bright arc of light seen inside a sunlit teacup.

We might then expect Airy's 1838 paper "On the Intensity of Light in the neighbourhood of a Caustic" to be a wave-theory soul mate of Potter's corpuscular theory of the rainbow. However, Potter's theory allowed no rainbow light outside the Cartesian primary bow, while Airy's theory required it. In time, personal animus appeared to tinge the two men's theoretical differences. Airy ungently corrected in print some of Potter's work on interference. Potter wrote in 1838 that his observations of the rainbow's angular radius differed from Airy's theory, and he would chide Airy's theoretical tack in 1855, saying that it "fails in so many cases when examined with impartial eyes."[21]

Within a decade, however, Potter's and Airy's scholarly bickering seemed inconsequential. In 1862, James Clerk Maxwell demonstrated that light could be explained as combined electrical and magnetic waves.[22] Eleven years later, Maxwell published a rigorously thorough mathematical explanation of his theory. This theoretical achievement cannot be minimized—Maxwell had explained light (and other electromagnetic radiation) from very fundamental physical principles. Among other phenomena, Maxwell's theory explains such seemingly unrelated things as television, x-rays, and rainbows. An extremely versatile man, Maxwell also created a predecessor of the colorimetric diagrams used in Chapters 7 and 8.[23]

The immediate significance of Maxwell's work for the rainbow was that it spurred a new round of experiments underpinned by electromagnetic theory. Ever greater mathematical insights were trained on the rainbow problem, and extrapolations of Airy's theory were compared with laboratory-generated rainbows. In 1888, two scientists separately showed that Airy's theory did not precisely predict the angular position of all the many supernumerary bows that they generated. One of the men, Boitel, concluded: "The theory of Airy appears thus to need supplementing."[24] Yet another layer of the scientific onion had been exposed. Airy's mid-century optics triumph, the "complete" theory of the rainbow, was now officially incomplete!

The Rainbow Fades

Yet for the purposes of our story, Airy's theory had not really been eclipsed. Its inadequacies were first noticed when experimenters ceased observing rainbows outdoors and began creating them in the laboratory's controlled confines. Airy's theory is clearly inadequate to explain the details of water-droplet bows created with monochromatic light. As drop size decreases, its calculations of bow brightness and angular position grow increasingly unreliable, making its predictions of monochromatic cloudbows only qualitatively correct. Although Airy's theory is still useful for analyzing the features of natural rainbows, it is unsuitable for explaining precisely the myriad details of artificial rainbows.[25]

Thus in the closing decade of the nineteenth century, the natural rainbow began to fade from the forefront of scientific research. A touchstone of optical theory and measurement for centuries, now, like Airy's theory, it seemed outdated. The natural rainbow's evanescence and variability appeared to make it an unacceptable investigative tool, and thus in many scientific circles the rainbow was deemed a problem solved. Yet if the rainbow had lost its scientific preeminence, it had not lost all its scientific friends.

Although Airy's rainbow theory was passé by 1900, it still had many contributions to make to the story of the natural rainbow. One of the theory's champions was Austrian professor Josef Pernter (1848–1908), who campaigned tirelessly for it to supplant the older Cartesian explanation of the rainbow that prevailed in secondary schools.[26] (Readers can reflect on the ultimate success of Pernter's campaign by recalling their own classroom introduction to the rainbow!) Pernter's ambitious volume on meteorological optics, completed after his death by Felix Exner (1876–1930), boosted Airy's rainbow theory while pointedly noting the deficiencies of the Cartesian model.[27]

One of Pernter's and Exner's great achievements was that they were the first to quantify rainbow colors, a Herculean calculation exercise that combined Airy's theory of the rainbow and Maxwell's theory of color perception. There is a subtle irony here: Maxwell authored the electromagnetic theory of light, which superseded Airy's wave theory of the rainbow. Yet Pernter and Exner could, with perfect scientific legitimacy, use Maxwell's color theory to analyze Airy's pre-Maxwell theory of the rainbow.

From the standpoint of Maxwell's electromagnetic theory, the rainbow was nothing more than a special case of a sphere scattering electromagnetic waves. (In electromagnetic theory, refraction and reflection are simply particular kinds of scattering.) In the year of Pernter's death, a paper by German physicist Gustav Mie (1868–1957) presented the tortuous mathematical details that described a similar problem, the scattering and absorption of light by colloidal gold sols. At first glance, the scattering of light by raindrops and by submicroscopic gold spheres may seem to be completely unrelated problems, yet Mie's theory treats both as cases of light scattering by homogenous spheres in a homogenous medium.[28]

Nearly coincident with the publication of Mie's theory, doctoral student Peter Debye (1884–

1966) independently developed a similar electromagnetic scattering theory, this time in connection with a problem in astrophysics.[29] Because Mie and Debye developed models based on fundamental electromagnetic principles, their approach (now generally called Mie theory) has endured and continues to flourish.[30] H. M. Nussenzveig, who himself has made important contributions to rainbow scattering theory, describes some recent examples of other electromagnetic scattering phenomena, including exotica such as "rainbow" scattering by atoms.[31]

Mie Theory: Can the Rainbow Be Described Too Well?

Does all this theoretical progress mean that Airy's theory of the rainbow has been left in the dust? Not quite. For all its generality and power, Mie theory exacts a considerable mathematical price. Until development of the electronic computer, applying the theory to all but the simplest problems was prohibitively time-consuming. For example, to calculate the intensity of light scattered by a 1-mm radius raindrop, a fast personal computer might require nearly 10,000 times as long to calculate Mie's solution as it does Airy's. As drop size decreases, this computational disparity decreases, but Mie calculations remain formidable.

Furthermore, as we noted in Chapter 8,[32] the natural rainbow is not generated by a solitary spherical raindrop seen *sans* background. The factors outlined in Chapter 8 conspire to make the natural rainbow anything but a neatly circumscribed theoretical problem. Ockham's razor is not an infallible scientific principle, but to blindly pile a very complicated theory such as Mie theory onto an already complicated observational problem such as the rainbow seems to be courting trouble. In fact, Airy's theory has been used recently to gain new insights on the natural rainbow.[33]

Finally, Mie theory is overkill for our purposes. It describes in minute detail the intensity of the light scattered by a raindrop, both spectrally and across deviation angle. For large drops, Mie theory's intensity wiggles and bumps, all of them real, stand in stark contrast to the smooth curves predicted by Airy's theory (for example, Fig. 9-7). This embarrassment of riches poses a practical question: Can naked-eye observers actually perceive Mie theory's myriad intensity changes in natural rainbows? To us, the answer is almost certainly no.

Mie theory's detail is invaluable in the laboratory, especially when studying scattering of monochromatic light. Unlike specialized radiometers, however, humans have only very broad-band light detectors (that is, the photoreceptors in our eyes span many wavelengths). During the daytime, three broad-band classes of retinal photoreceptors (the cones; see Fig. 7-19) provide our only brightness information about the rainbow. As Chapter 7's discussion of metamerism suggests, we cannot reliably distinguish among light sources whose spectra are more detailed than the absorption spectra of our cones' photopigments. In short, Mie theory's myriad intensity variations *do* exist in the light refracted and reflected by a single raindrop, but we are insensitive to their details.

Because computer time (and the time of scientists) is still limited, we can often forgo the

FIG. 10-29

A Mie theory map of primary rainbow colors versus drop size. Compare this map with the similar Airy theory map, Fig. 8-11. In both maps, colors have been smoothed by the sun's 0.5° angular width.

esoteric details of Mie theory when analyzing systems that do not require them. Human color perception of the natural rainbow is just such a system. Yet another practical issue needs to be considered when analyzing the natural rainbow. Additive mixing of the intensities from a rain shower's diverse drops will obscure Mie theory's single-droplet variations, which further strengthens the case for using the theory judiciously.

To demonstrate this, we show a map of Mie theory's rainbow colors in Fig. 10-29. It is arranged in the same way as Fig. 8-11's Airy theory rainbow map, yet a comparison of the two maps shows differences that are both subtle and revealing. For sizes ranging from cloud drops to the smallest raindrops (about 0.01–0.07 mm), the intricate details of Mie theory manifest themselves as an intricate marbling of its bows. While this marbling on *individual* small-drop bows is correct in theory, in practice we will not see it because a *range* of drop sizes exists in clouds and rain. In other words, the small-scale color variations evident from a single drop will be obscured by additively mixing the variations from drops of many different sizes. At drop sizes larger than about 0.07 mm, the Mie theory marbling disappears and is replaced by barely detectable color striations. These striations result when the theory's changes in rainbow brightness occur on too small a scale to be shown accurately in our Fig. 10-29 map. Furthermore, when we consider cloudbows caused by sunlight rather than monochromatic light, the deficiencies of Airy theory's cloudbow intensity pattern disappear. For naturally occurring cloudbows, Mie theory and Airy theory place the cloudbows' intensity maxima and minima at virtually the same deviation angles, even for drops with radii as small as 0.01 mm.[34]

Our point here is not that the exact Mie theory describes the natural rainbow inadequately, but rather that the approximate Airy theory can describe it quite well. Thus the supposedly outmoded Airy theory generates a more natural-looking map of real rainbow colors than Mie

FIG. 10-30

Rockwell Kent, *Entrance of the Gods into Valhalla*, 1927. Courtesy Steinway & Sons, New York

theory does, even though Airy theory makes substantial errors in describing the scattering of monochromatic light by isolated small drops. As in many hierarchies of scientific models, the virtues of a simpler theory can, under the right circumstances, outweigh its vices.

Nature, the Artist, and the Twentieth Century: Rockwell Kent and Rufino Tamayo

As little as science and art seem to have in common today, they do share one tendency: both have often turned away from the directly observable world of our senses. Of course, their goals usually differ from that point onward. Scientists try to mold theory and observation, no matter how esoteric, into a coherent whole. A scientist's creation should always acknowledge and analyze its antecedents, if only to reject them. In contrast, artists do not need to fit a given work into any theoretical framework, nor do they have to explain the work explicitly for it to be a creative success. Artistic and scientific creation are equally demanding, yet they must satisfy quite different ends.

One obvious change in Western art from George Airy's day is that naturalism is no longer

regarded as a criterion indispensable for judging a work's merit. The West's long-standing appetite for representational paintings is diminished now, perhaps satisfied in part by photography and electronic images. When artists do choose naturalism, they are likely to face an audience with very different expectations than the Victorian contemporaries of George Airy or Frederic Church. Photographic realism may appeal to some audiences, geometric abstraction is more likely to succeed with others, and still others may want paintings that combine both. Thus naturalism, Western art's nominal single standard from the Renaissance to the nineteenth century, has been supplanted by a variety of tastes in artists and their public.

With this in mind, we consider two of the many twentieth-century paintings that feature the rainbow. Both works contain naturalistic elements, yet neither is an essay in realism. In 1927, American artist Rockwell Kent (1882–1971) painted an image taken from a rainbow mother lode, *Entrance of the Gods into Valhalla* (Fig. 10-30).[35] In it, we see a scene from Richard Wagner's opera *Das Rheingold*, itself ultimately based on the thirteenth-century Icelandic tales of the *Eddas*. As we noted in Chapter 1, the Eddic rainbow is Bifrost, the bridge between earth and the Norse home of the gods, Asgard. Bifrost was built by the gods for their daily travels to the world below and is resolutely guarded by the keen-eyed Heimdall against their dread enemies: the frost and mountain giants. When Bifrost is stormed and collapses in the climactic battle with the giants, it will signal the Twilight of the Gods—and of humanity.[36]

In Fig. 10-30 we see gods traveling Bifrost on a less fateful day, with heavenly Asgard just visible in the distance. At the foot of the rainbow, Heimdall keeps vigil, aided by the perpetual rainbow fire that wards off the frost giants. Although Kent observes the rather variable convention that Heimdall stands guard at Bifrost's base, he omits Heimdall's palace at the rainbow summit.[37] Neither are the rainbow's twisted colors true to the original, but perhaps Kent means by this unnaturalism to emphasize the tremulous strength of Bifrost, which was "constructed with more art than any other work."[38] The stark, block-like forms of Kent's landscape remind us that the rainbow's environs are the forbidding precinct of the gods, beings who mete out justice and punishment.

Norse mythology was likely to be much on Kent's mind in 1927, since he was the proud new owner of a large Adirondack farm that he had named Asgaard, and within two years he would embark on the first of several artistic sojourns in Greenland.[39] Commissioned by Steinway & Sons, Fig. 10-30's severe image may seem an unusual choice to grace the headquarters of a musical instrument manufacturer. Kent often got work as an illustrator of advertisements, yet Steinway & Sons was among Kent's few commercial patrons to give him free rein to create art that was not explicitly commercial.[40]

If there is any irony in Fig. 10-30, it is that Kent, who would become a favorite of the Soviet Union (he received the Lenin Peace Prize in 1967),[41] should have painted in 1927 a scene whose subject was dear to Germany's future Nazi leadership. However, Kent's complex world view seamlessly combined a long-standing love of German culture and enthusiasm for Russian socialism.[42] Kent was moderately pro-Soviet and in 1953 was called before Joseph McCarthy's Permanent Subcommittee on Investigations for a grilling about his suspect writings.[43]

FIG. 10-31

Rufino Tamayo, *Nature and the Artist*, 1943 (detail). Smith College Museum of Art, Northampton, Massachusetts. Commissioned in honor of Mrs. Dwight W. Morrow (Elizabeth Cutter, class of 1896).

Yet Kent's international interests ranged far beyond the Soviet Union. In 1940, he wrote an introduction for a book on Brazilian painter Cândido Portinari (1903–62), who was then gaining recognition in the United States as an important South American artist.[44] Portinari's international reputation is as a muralist (his prominent *War* and *Peace* murals were installed at United Nations headquarters in 1957),[45] so it is tempting to think that Kent might eventually have seen works such as Fig. 10-31, created by Mexican muralist and painter Rufino Tamayo (1899–1991).

Tamayo, a Zapotec Indian, rejected the openly politicized art of his countryman Diego Rivera (1886–1957), choosing instead to incorporate both pre-Columbian and European imagery in his work.[46] Much of Tamayo's work in the 1940s borrows from Pablo Picasso (1881–1973), especially a series of animal paintings from 1941–43 that are strongly reminiscent of figures in Picasso's famous *Guernica*.[47] Although Fig. 10-31 is contemporary with these animal paintings and includes some Cubist echoes, no other connection with Picasso is evident.

In fact, *Nature and the Artist* stands independent, an expression of Tamayo's own interests in natural form, geometric pattern, and color. Color was central to Tamayo's later art, and here he has used it to tie together the painting's disparate elements with a familiar unifying emblem, the rainbow. The large reclining figure in Fig. 10-31 is Nature, who is held by the brown figure of Earth above her. A stream emerges from the hands of Water (lower left), and the red figure entering from the upper left is Fire. On the panel's right side, bluish Air emerges from behind the Artist at his easel.[48] In Tamayo's own description, these figures are tied together by the rainbow of Color. "The whole group is terminated by a rainbow which springs from the figures of Water and Fire, and ends by merging with the figure of Air. This motif, besides serving to give unity to the upper part of the composition, symbolizes Color, the basic element of painting."[49]

In this context, the foreshortened (and thus literally unnatural) rainbow makes pictorial sense as a three-dimensional element that gathers together the figures that the Artist tries to control. The colors of Tamayo's rainbow are vivid yet jumbled, suggesting that for Tamayo, as for

Rockwell Kent, the *idea* of rainbow colors is more important than their natural order. Although neither the rainbow nor the mural as a whole is literally naturalistic, the visual logic of Tamayo's work is as self-evident as its beauty.

Our Rainbow's End

We have come to the end of this book's rainbow road. But rather than leaving you stranded, we hope that we have instead led you to the foot of your own rainbow bridge. The natural rainbow's enduring power to inspire artists, scientists, mythmakers, and the merely curious has never ceased to amaze us. Now, equipped with your own repertoire of rainbow knowledge, you can admire the bow anew, as well as scrutinize those who use it.

Repeated generations have observed and disassembled the rainbow, each confident that it has arrived at a complete explanation (whether scientific, artistic, or mythic) of this wondrous sight. Just as predictable as this confidence is the later awareness that the rainbow has yet more secrets to reveal. Of course, like other natural phenomena, the rainbow has often been expropriated rather than examined. Whether championing the cause of religion, state, or commerce, many people have believed that the rainbow's evanescence and beauty give it powers of persuasion uniquely suited to their ends.

We feel obliged to note that academicians too have made the rainbow grist for their exceedingly fine mills. As historian Michael Cohen says: "Intellectual and political historians continually take natural objects for their battle flags or shibboleths. . . . The stars can be malignant or benign; the moon constant or inconstant, representing chastity, lunacy, or man's conquest of nature. The rainbow, too, has been a sign of very different relationships between man and what surrounds him, from the controlling suggestions of Newtonian science to the humbling ones of sublime or sacramental nature."[50] Yet in our experience, the rainbow is scarcely reserved for the makers of books. The world's peoples have made the rainbow a symbol of peace, tranquillity, divine promise, beauty, and a bridge to the gods. They have also made it a harbinger of death and disease, an ill omen from the gods, a gigantic malevolent snake, and fox's urine. Pick a world view, and probably you can find a rainbow emblem to support it.

Amid this welter of rainbow symbols, we merely ask readers to pause briefly and admire the rainbow as part of the natural world. Humanity's hard-won understanding of the rainbow's essential features and of its subtle variations need not lessen our immediate visual pleasure when we see a rainbow. If we reflect on how tenaciously our species has directed its intellectual and spiritual energies toward explaining the rainbow, we also find that it bears an indelible human stamp. Welcome to the rainbow—wonder of the natural and human worlds!

APPENDIX

A FIELD GUIDE TO THE RAINBOW

Q1: What is a rainbow?

Observationally, the rainbow is a circular arc of several colors seen in rain or spray opposite the sun and centered around the shadow of your head (Figs. 4-4 and A-1). The rainbow's colors are in concentric bands, and while they vary slightly from one bow to the next, the colors are always arranged in spectral order: red, orange, yellow, green, blue, and violet. While you are unlikely to see all of these colors in a given rainbow, their order does not change. For the inner (or primary) rainbow, red is on the outside; for the outer (or secondary) rainbow, red is on the inside.

FIG. A-1

Imaginary perspective view of an observer's rainbow (From Robert Greenler, *Rainbows, Halos, and Glories*, p. 3. Copyright © 1980 by Cambridge University Press)

Optically, the rainbow is just a distorted image of the sun. Raindrops perform this rearranging of sunlight via reflection and refraction. Think of the drops as imperfect one-way mirrors: most light passes through them, but the light forming the rainbow is reflected from their rear surfaces (Fig. 5-3). In addition, as sunlight passes from air to water (or vice versa) it is deviated from its original path, with blue light being deviated more than red (Fig. 6-6). As Fig. 5-3 indicates, this combination of refraction and reflection occurs at each air-water boundary. However, the light forming the primary rainbow is that refracted on entering the drop, reflected at its rear, and refracted a second time on exiting (Fig. 6-6).

Q2: When and where can I expect to see a rainbow?

You can see the rainbow whenever you look opposite the sun at sunlit raindrops (or spray drops). The rainbow occurs because raindrops do *not* scatter sunlight uniformly in all directions (Fig. 6-5). Consider a ray passing through the middle of the drop. It is deviated by 180°, returning in the direction that it entered (ray Q in Fig. 6-5 is closest to this ray). As rays strike the drop at ever more glancing angles, the combined refractions and reflection bend the rays through smaller and smaller angles. This does not continue indefinitely. One ray in particular is bent by 138°, the

minimum deviation (ray M in Fig. 6-5). Rays that enter the drop more obliquely are deviated by *more* than 138°. In contrast to other rays, this *minimum deviation ray* has a great many neighbors leaving the drop at nearly the same angle. It is this concentration of light 138° from the sun that forms the primary rainbow.

We translate the rainbow's geometry to a more convenient reference point, the shadow of your head. Whenever you are illuminated by sunlight, the shadow of your head is 180° from the sun. The shadow of your head thus covers the *antisolar point*, the point directly opposite the sun. So the primary bow is a 42°-radius circle (180° − 138° = 42°) centered on the antisolar point (Figs. 4-4 and A-1).[1] All rays other than the minimum deviation ray simply add to the general brightness within this 42°-radius circle. Thus the sky within the primary rainbow may look bright compared to the brightness of the surrounding sky. By the same logic, the sky *outside* an intense secondary rainbow will be relatively bright. The reason is that rays exceeding the secondary rainbow's minimum deviation are seen here (see answer to Q5). A natural corollary of this enhanced primary and secondary brightness is that the sky between bright rainbows looks dark (see answer to Q12).

Q3: What causes the rainbow's circular shape?

Many drops acting in concert cause the rainbow, and all of these must be at the same angle from the sun (that is, the same angle from the antisolar point). Thus at any instant only those drops before you that are on a 42° circle centered about the antisolar point can send you the concentrated rainbow light. These drops may be at any distance, but they must be on the 42° circle. Put another way, the rainbow is a mosaic of light sent to you by many raindrops as they fall through the surface of the imaginary cone whose tip is at your eye and whose radius is 42° (Figs. 4-4 and A-1).

Q4: What causes the rainbow's colors?

The rainbow's colors arise because the minimum deviation ray occurs at a slightly different angle for each color (Fig. 6-7). A prism's refraction of white light into a spectrum is similar to the rainbow's color separation. Because blue light at minimum deviation is bent through a greater angle than red light, the red light is closer to the sun. As a consequence, red will be on the outside of the primary bow, closest to the sun, and blue will be toward the inside. Although an indefinite number of colors is possible, their sequence across the bow is not arbitrary. From the outside to the inside of the primary bow this spectral sequence is red, orange, yellow, green, blue, and violet. (See Fig. 7-21 for an especially colorful primary rainbow.)

A single fact explains the opposite color orders of the secondary and primary rainbows: red light at minimum deviation is bent less than blue light, and thus red appears closer to the sun. However, because minimum deviation rays for the secondary are bent through more than 180° (see answer to Q5 and Figs. 4-3, 6-8), "closer to the sun" now means that red appears on the secondary rainbow's inner edge. In essence, deviating sunlight through more than 180° turns the rainbow colors inside out.

Q5: What causes double rainbows?

Figure 6-8 shows the path of a light ray (ray M) that contributes to the outer (or secondary) rainbow. This ray is reflected *twice* within the drop. Because each internal reflection is paired with a refraction of light out of the drop, less light is available to form the secondary bow, and thus it is less intense than the primary. At minimum deviation, this secondary-rainbow light is bent through an angle of about 231°, which places the secondary rainbow 51° from the antisolar point (51° = 231° − 180°). Because the secondary rainbow is inherently dimmer than the primary, it may not always be visible. However, if the primary rainbow is very bright, look for its fainter secondary companion 9° outside it (Fig. 4-3).

Q6: Why are rainbows often incomplete?

Since the raindrops are falling, their supply must be uninterrupted if the bow is to last. Because the edge of a rain shaft can pass quickly across the position where the rainbow might occur, the bow can appear or disappear rapidly. As long as you see sunlit drops at the minimum deviation (or rainbow) angle, the bow will be with you. However, if any part of the circle where the rainbow can occur is devoid of either drops or direct sunlight, that part of the bow will not form, which accounts for the partial bows we often see (Fig. 4-17). Because the rainbow's angular size and angular distance from the sun are fixed, we cannot see a rainbow in a distant shower if the sun is higher than 42° above the horizon (assuming that we are on level ground).

Q7: Can I ever see an entire rainbow circle?

Yes, any time that you can see many sunlit drops in all directions from the antisolar point, the rainbow circle will be complete. For example, you could see the rainbow circle from atop a mountain, a high hill or building, or an airplane in flight. Less ambitiously, you can see the complete circle if you fill the air before you with sunlit spray that extends 42° from the antisolar point. Note that while this spray bow *looks* smaller than one seen in a distant shower, its *angular* size is the same.

Q8: How big is the rainbow?

The primary rainbow's angular radius is about 42° and its width is about 2°. The secondary's angular radius is about 51° and its width is about 3°. Neither bow is an object, so neither has a *linear* size. However, we typically use our perception of an object's angular size and our *estimate* of its distance from us to infer its linear size. Experience and expectation combine to make these inferences fairly accurate for familiar objects. The rainbow has a fixed angular size and we plausibly (but erroneously) equate its distance with that of the rain or spray in which we see the bow. Everyday experience tells us that, for a fixed angular size, objects that appear more distant are *larger* than those nearby. Even though the rainbow is not an object, we mistakenly assume that our usual rules relating angular and linear size apply. Thus rainbows seen in a distant

shower are compellingly large, while those in a nearby spray seem small. Yet neither bow has a linear size, just a fixed angular size.

Q9: How many colors does a rainbow have?

Quite literally, as many as you think you see, whether that number is three or three hundred! For good perceptual reasons, we recognize discrete bands of color in the rainbow (Chapter 7). However, the number of rainbow colors is actually indeterminate, with each color blending smoothly into the next (Chapter 8).

Q10: Why is the sky inside the primary rainbow sometimes bright?

See answer to Q2.

Q11: Why are bright rainbows most vivid near their base?

As explained in Chapter 9, large raindrops flatten as they fall but smaller ones do not. As a result, all sizes of raindrops contribute to the rainbow near its base, and large drops make this part of the bow both bright and colorful. As we approach the top of the arch, however, only small drops contribute to the rainbow, and these yield a less intense, more pastel bow. See Fig. 7-21 for an example of this color and brightness gradation.

Q12: Why is the sky dark between the primary and secondary rainbows?

By definition, raindrops between the bows cannot send you any light that contributes to either the primary or secondary rainbow. In other words, light that has been internally reflected once (the primary) or twice (the secondary) by water drops does not reach you from this part of the sky, so the sky looks comparatively dark there. This dark band is known as *Alexander's dark band* (Chapter 4) and is most evident if the primary and secondary bows are bright (Fig. 9-2 and Minnaert 1993, Plate 13).

Q13: Why and when do red or orange rainbows occur?

Near sunrise and sunset, scattering of sunlight over long paths through the atmosphere can make direct sunlight noticeably reddish or orangish. Because direct sunlight shining on water drops causes the rainbow, the resulting rainbows will have a pronounced red or orange cast (see Greenler 1980, Plate 1-7; Minnaert 1993, Plates 11–12).

Q14: What is a cloudbow, and when can I expect to see one?

A cloudbow (Fig. 8-1) is a water-drop bow caused by the same optics that generates the rainbow. However, cloud droplets are about 10 to 100 times smaller than raindrops or spray drops. An interference theory of the rainbow explains (1) the nearly colorless appearance of bows formed by these small drops and (2) the supernumerary bows that accompany both cloudbows and

rainbows (Chapter 8). As Fig. 8-1 suggests, a cloudbow may be visible when you fly above a deck of stratus clouds and can see your airplane's shadow on them. Alternatively (and more arduously), you can see a cloudbow if you climb above a sunlit fog bank (that is, stratus near the ground) that envelops the base of a hill or mountain. There you look for the cloudbow about 40° from the shadow of your head.

Q15: Can I ever see rainbows on the ground?

Yes, if the ground is covered with sunlit dew, you may see the colorful dewbow. Like the rainbow, the dewbow's light comes from a circular set of directions that are 42° from the antisolar point. However, because we know that dew lies on the ground before us, we have the compelling sense that the dewbow is a hyperbola (or an ellipse, if the sun is high in the sky). (See Greenler 1980, p. 17, Plate 1-12; and Minnaert 1993, pp. 202–3.)

Q16: What is a lunar rainbow, and why is it white?

Like the sun, the moon can also generate rainbows. However, because moonlight is much less intense than sunlight, the lunar rainbow usually is too dim for us to see any colors in it. Recall that even under a full moon, objects that look vividly colored during the day appear only in shades of gray. Thus the lunar rainbow is white (Chapter 8; Minnaert 1993, pp. 207–8).

Q17: What are the pale green and purple arcs sometimes seen within the primary rainbow?

These are the supernumerary rainbows. Despite their superfluous-sounding name, they are an integral part of the rainbow (Figs. 8-3 and 8-8). In fact, explaining how supernumeraries occur also explains the primary and secondary rainbows (see answer to Q14).

Q18: Why does a rainbow grow brighter and darker so quickly?

See answer to Q6.

Q19: Can I touch the rainbow or reach its end?

No. Because the rainbow is an *image*, not an object, you can never reach or touch it (Chapter 4). However, in the same way that you can touch a mirror but not your image in it, you *can* touch the water drops that generate the bow. For example, if you make a rainbow in a sprinkler's sunlit spray, you can certainly touch the spray. That is quite different from the impossible feat of touching the rainbow image.

ABOUT COLOR TERMINOLOGY

Given the long and fractious history of color theory, it is not surprising that many different systems have arisen for describing color. The table below lists several common color schemes and their roughly equivalent terms. Entries in any given column may not be identical because the various systems themselves are not completely compatible. To further complicate matters, many other independent (although highly structured) color-naming systems are used in commerce and industry. For thorough reviews of color terminology, see Billmeyer and Saltzman (1981, chap. 2) and Zwimpfer's beautifully illustrated chapter titled "Color Designation and Organization" (1988, examples no. 334–408).

COLOR SYSTEM		COLOR ATTRIBUTES		
(Informal)	Color	Vividness or purity	Brightness	
CIE	Dominant wavelength	Colorimetric purity	Luminance	
Artistic tradition	Hue	Saturation or tint	Tone[2] or lightness	
Munsell System[3]	Hue	Chroma	Value	

NOTES

CHAPTER ONE

1. MacDonald 1973, p. 420.
2. Carroll 1960, p. 184.
3. Maroon and Maroon 1993, pp. 100–101.
4. Black and Green 1992, p. 89; Sandars 1964, pp. 20–21.
5. Sandars 1964, pp. 7–8.
6. Barondes 1957, p. 31.
7. Barondes 1957, p. 127.
8. Barondes 1957, p. 196. Coincidentally, an ancient literary name for Uruk is "Rainbow" (Black and Green 1992, p. 153).
9. Bloch-Smith 1994, pp. 20–23; Gates 1984, pp. 74–77.
10. Sachs and Hunger 1988, p. 45. The brackets denote missing cuneiform. For twentieth-century observations of red rainbows, see Palmer (1945, p. 204) and Greenler (1980, plate 1-7).
11. Sachs and Hunger 1988, p. 45.
12. Langer 1968, p. 34.
13. Cole and Gealt 1989, pp. 217–18. The mythic Sardanapalus is an amalgam of Šamaššumukin, Ashurbanipal, and one of Ashurbanipal's sons, Sinsharishkun (reigned c. 622–612 B.C. as the last Assyrian king). Both Šamaššumukin and Sinsharishkun supposedly burned themselves in their palaces.
14. Sandars 1964, p. 35; Gray 1969, p. 48.
15. Sandars 1964, pp. 108–9.
16. Black and Green 1992, p. 109.
17. Sandars 1964, p. 40.
18. Gray 1969, p. 50; Hastings 1905, vol. 4, p. 196.
19. Genesis 9:12–15 (King James Version).
20. Brown 1993, pp. 35–36; Adler 1906, p. 68; Hastings 1905, vol. 4, p. 196.
21. Walls 1995, p. 27.
22. Walls 1995, p. 28.
23. Walls 1995, p. 28.
24. See, for example, Sachs and Hunger (1988, pp. 45, 47, 69, 183).
25. Loon 1992, pp. 150–51.
26. Black and Green 1992, p. 142.
27. Black and Green 1992, p. 153.
28. Irwin 1982, pp. 349–50.
29. Gray 1964, vol. 4, pp. 230–31.
30. Homer 1950, p. 212 (*Iliad* 17.547–50).
31. Rusten et al. 1993, p. 325.
32. Brown 1993, p. 36; Rusten et al. 1993, p. 479 (Aeschrion, frag. 4).
33. Budge 1905, vol. 2, p. 267. Zandee (1969, p. 317) provides a more recent but essentially unchanged translation of this passage.

34. Neugebauer and Parker 1960, p. 72.
35. Watterson 1984, p. 135; Ions 1968, p. 22.
36. Piccione 1990, p. 43. Although probably unrelated, Egyptian and Indian texts both give serpent's breath unusual generative powers. While Mehen's exhalation (or his gameboard proxy) gives birth to Egyptian sovereigns in the afterlife (Piccione 1990, p. 48), a sixth-century-A.D. Indian astronomer makes serpents' exhalations the mythic cause of the rainbow (Irwin 1982, p. 349 n. 37).
37. Watterson 1984, p. 114; Ions 1968, pp. 65–66.
38. Watterson 1984, pp. 117–18; Ions 1968, pp. 51, 63.
39. Ions 1968, p. 62.
40. Ions 1968, pp. 63–65.
41. Zandee's translation has the double bows "proclaim Re in the eastern horizon of heaven." Like the natural rainbow, Zandee's bows also "tread on the vault of heaven in [Re's] retinue" (Zandee 1969, p. 317).
42. Loon 1992; Brown 1993, pp. 35–37.
43. Watterson 1984, p. 149.
44. Loon 1992.
45. For example, see Greenler (1980, plate 2-14).
46. Davies 1903, p. 30. This hieroglyph appears in the inscription that accompanies the relief (see Davies 1903, plate 22), but existing translations of the inscription shed no light on the nature of the colored arcs.
47. Griffith 1898, p. 30, fig. 37.
48. Griffith 1898, p. 30.
49. For example, see the master's thesis on Egyptian thunderstorms by El-Din (1972).
50. Bell 1975, p. 247.
51. Browne 1964, p. 455 (*Pseudodoxia epidemica* 6.8).
52. Herodotus 1960, pp. ix–x.
53. Herodotus 1960, p. 301 (*Histories* 2.22). Herodotus's geographic references are rather vague here, but he clearly implies that Egypt, Libya and Ethiopia all lack rain when he later talks of the "Nile being fed by no rain" (Herodotus 1960, p. 303 [*Histories* 2.25]).
54. Brown 1965, pp. 60–61; Herodotus 1960, p. xi.
55. Helck and Otto 1984, cols. 201–2.
56. Shennum 1977, pp. 26, 122.
57. McCoy 1970, p. 13.
58. Bell 1975, p. 247.
59. Ions 1968, pp. 67–68.
60. Budge 1969, p. 475.
61. Watterson 1984, pp. 179–80.
62. Budge 1969, p. 414.

63. Bell 1975, p. 248.
64. Newberry 1893, pp. 2, 7.
65. Parkinson 1991, p. 147. The words in brackets { } constitute a stock phrase erroneously omitted by the scribe.
66. Bell 1975, p. 247.
67. Lhote 1987.
68. Lajoux 1963, pp. 13–15, 27.
69. Lajoux 1963, p. 28.
70. Haardt 1991, p. 41.
71. Lhote 1959, pp. 80, 221.
72. Lhote 1987, p. 182. Muzzolini (1989, p. 2) describes the Round Head style's chronology as "somewhat vague," but places it later (4500–2500 B.C.) in the central Tassili than Lhote does.
73. Lhote 1959, p. 221.
74. Luckert 1977, p. 23.
75. Loon 1992, figs. 2, 20.
76. See Fig. 1–10.
77. Lhote 1959, p. 80.
78. See Loon (1992, figs. 4, 5).
79. See Sassen (1991) for other examples of banded rainbow pictographs.
80. In fact, other banded and arch-shaped rainbow serpents have been found from pre-Columbian America to ancient China (Hentze 1966).
81. Williams 1985, p. 64.
82. Cook 1940, pp. 511–12.
83. Barthell 1971, pp. 180–81. For another example of the lustful Zeus (Roman Jupiter), see Chapter 7's "Aristotelian Color Theory and the Rainbow."
84. Cook 1940, p. 512.
85. Cook 1940, p. 512 n. 1.
86. Barthell 1971, p. 7.
87. Barthell 1971, p. 12.
88. Gray 1964, vol. 1, p. 241; Oswalt 1969, p. 159.
89. Boardman 1985, pp. 230, 234.
90. Oswalt 1969, p. 159; Gladstone 1878, p. 151.
91. Barthell 1971, p. 12.
92. Banier 1976, p. 377.
93. Oswalt 1969, p. 159.
94. Hesiod 1988, p. 26.
95. Banier 1976, p. 377.
96. Virgil 1958, p. 118 (*Aeneid* 4.700–705).
97. Virgil 1958, p. 117 (*Aeneid* 4.654).
98. Ovid 1986, pp. 268–69 (*Metamorphoses* 11.616–84); Barthell 1971, p. 52.
99. Gladstone 1878, p. 146.
100. Boyer 1987, p. 23.
101. Xenophanes 1992, p. 139 (frag. 32). See Mourelatos (1989) for more on the significance of Xenophanes' treatment of the rainbow and other atmospheric phenomena.
102. Brown (1993, pp. 36–37) offers an interesting etymology of this meaning.
103. Boyer 1987, pp. 89, 111, 148.
104. Boyer 1987, p. 253; Tunstall 1809, p. 353. Tunstall's "iris" observations date from 1782.
105. Gaidoz et al. 1981, p. 111.
106. Berndt 1987, p. 205.
107. Taçon et al. 1996, pp. 103, 113–17.
108. Eliade 1973, pp. 115–16.
109. Berndt 1987, p. 206.
110. Taçon et al. 1996, pp. 104–5; see also Gray 1993.
111. Radcliffe-Brown 1926, p. 19.
112. Radcliffe-Brown 1926, p. 21. For another man-eating Aboriginal Rainbow Serpent, see Taçon et al. (1996, pp. 117–18).
113. Berndt 1987, p. 205; Poignant 1967, pp. 124, 126.
114. Eliade 1973, p. 140; Eliade 1964, p. 132.
115. Berndt 1987, p. 205; Poignant 1967, p. 126; Radcliffe-Brown 1926, p. 19.
116. Radcliffe-Brown 1926, p. 21.
117. Taylor 1990, p. 330.
118. Taylor 1990, p. 332; see also Taçon et al. 1996, p. 105.
119. Taylor 1990, p. 342.
120. Taylor 1990, p. 331.
121. Taylor 1990, p. 333.
122. Brumbaugh 1987, p. 25.
123. Brumbaugh 1987, p. 26; see also Loewenstein 1961, p. 38.
124. Brumbaugh 1987, p. 32.
125. Gray 1964, vol. 4, p. 444.
126. Métraux 1946, p. 38.
127. Parrinder 1967, p. 76.
128. Cole 1982, pp. 153, 159.
129. Cole 1982, p. 159.
130. Hastings 1957, vol. 8, p. 360.
131. Beckwith 1940, pp. 515–17.
132. Grimal 1965, p. 532; Jobes 1961, p. 55.
133. Reefe 1981, p. 76.
134. Reefe 1981, pp. 24, 76.
135. Gray 1964, vol. 10, p. 300.
136. Gray 1964, vol. 10, p. 139.
137. Weaver 1972, p. 205.
138. Gray 1964, vol. 11, pp. 67–68.
139. Loewenstein 1961, pp. 31–32; Hastings 1957, vol. 8, p. 360.
140. Poignant 1967, p. 126.
141. Gray 1964, vol. 7, p. 235; Parrinder 1967, p. 77.
142. Gray 1964, vol. 7, p. 235.
143. Bierhorst 1976, pp. 6, 93.
144. Fernandez 1982, p. 233.
145. Gray 1964, vol. 11, p. 204.
146. Taube 1993, p. 52; Weaver 1972, p. 229.
147. Jobes 1961, p. 852.
148. Boyer 1987, p. 29.
149. Erdoes and Ortiz 1984, p. 103.
150. Jobes 1961, p. 396.
151. Dumont 1976, p. 120.
152. Poignant 1967, pp. 124, 127.
153. Sayili 1939, p. 83.
154. Luckert 1977, p. 112.
155. Boyer 1987, p. 29.
156. Dömötör 1981, p. 228.
157. Gaidoz et al. 1981, p. 120; Grimm 1966, p. 733.
158. Hand et al. 1981, vol. 1, p. 232.
159. Sayili 1939, p. 82.
160. Gray 1964, vol. 10, p. 24.
161. Hastings 1957, vol. 2, p. 510.
162. Schimmel 1992, p. 211.
163. Gray 1964, vol. 11, p. 342.
164. Dömötör 1981, p. 228; Grimm 1966, p. 733.
165. Hasler 1979, p. 24.
166. Fernandez 1982, p. 211.
167. Conzemius 1932, p. 127.
168. Strachov 1988, pp. 339–40; Métraux 1946, pp. 38–39.
169. Strachov 1988, p. 341.
170. Parrinder 1967, p. 77.

171. Strachov 1988, pp. 336–37.
172. Cavendish 1983, vol. 9, p. 2335; Strachov 1988, p. 349.
173. Strachov 1988, p. 347.
174. Strachov 1988, pp. 341–42.
175. Hand et al. 1981, vol. 2, p. 1427.
176. Emrich 1972, pp. 624–25.
177. Strachov 1988, p. 345; Hand et al. 1981, vol. 2, pp. 1432, 1437.
178. Virgil 1978, p. 107 (*Georgics* 1.380–81).
179. Dömötör 1981, p. 228.
180. Gray 1964, vol. 4, pp. 443–44.
181. Hastings 1957, vol. 9, p. 275.
182. Loewenstein 1961, p. 34; Hastings 1957, vol. 10, pp. 371–72.
183. Hastings 1957, vol. 8, p. 360.
184. Gray 1964, vol. 7, p. 236; see also Loewenstein 1961, p. 35.
185. Hastings 1957, vol. 12, p. 663.
186. Radcliffe-Brown 1926, p. 20.
187. Cavendish 1983, vol. 9, p. 2333.
188. Métraux 1946, p. 38.
189. Gray 1964, vol. 7, p. 236.
190. Gray 1964, vol. 7, p. 234.
191. Irwin 1982, pp. 349–50.
192. Hand et al. 1981, vol. 2, p. 1067.
193. Gales 1968, p. 161; Boyer 1987, p. 29. See Chapter 9's "Flattened Raindrops and the Pot of Gold" for this myth's optical basis.
194. Gray 1964, vol. 7, pp. 234–35.
195. Parrinder 1967, p. 76.
196. Hastings 1957, vol. 10, p. 371; Melville 1969, p. 32.
197. Radcliffe-Brown 1926, p. 20.
198. Gray 1964, vol. 4, p. 444. Eastern Brazil's Botocudo combined rainbow, serpent, and urine by calling the rainbow "the urine of the great snake" (Loewenstein 1961, p. 35).
199. Gray 1964, vol. 4, p. 444.
200. Conzemius 1932, p. 127.
201. Hastings 1957, vol. 1, p. 383.
202. Eberhard 1965, p. 24.
203. Black and Green 1992, p. 153.
204. Dunnigan 1987, p. 204.
205. Fernandez 1982, pp. 491–92.
206. Coyne 1992, pp. 34–35.
207. Coates and Zweibel 1995; Shiono and Shikakura 1994.
208. Gray 1964, vol. 10, pp. 167–68.
209. Gray 1964, vol. 10, p. 168.
210. Beckwith 1940, p. 366.
211. Gray 1964, vol. 8, pp. 222–23; Grimal 1965, pp. 298–99.
212. Gray 1964, vol. 8, p. 378 n. 5.
213. Gray 1964, vol. 9, p. 156.
214. Fernandez 1982, p. 647.
215. Homer 1950, p. 64 (*Iliad* 5.367–69).
216. Beckwith 1940, pp. 248–49; Gray 1964, vol. 9, pp. 66–67.
217. Hastings 1957, vol. 10, p. 371.
218. Eliade 1964, pp. 131–32.
219. Eliade 1964, p. 118.
220. Nechodom 1992.
221. Cavendish 1983, vol. 9, pp. 2334–35.
222. Tyler 1964, p. 142.
223. Gray 1964, vol. 10, p. 48.
224. Gray 1964, vol. 11, p. 203.
225. Cavendish 1983, vol. 9, pp. 2333–34; Pigott 1978, p. 215; Hastings 1957, vol. 2, pp. 853–54.
226. Gray 1964, vol. 2, p. 329; Pigott 1978, p. 215.
227. Pigott 1978, p. 189.

CHAPTER TWO

1. Oresme 1968, p. 729.
2. Oresme 1968, p. 731. In fairness, we note that Oresme also wrote a prolix, if occasionally insightful, commentary on Aristotle's rainbow explanation in *Meteorologica* (Thorndike 1954, p. 152). Oresme's work closely follows that of a group of scholars at the University of Paris and thus may represent a consensus opinion rather than his own. See Boyer 1987, pp. 130–37.
3. Thomas Aquinas 1924, p. 5.
4. Lindberg 1992, p. 232; Baumer 1952, p. 23.
5. See Chapter 4's "Plato, Pythagoras, and Empirical Science" and Chapter 5's "Robert Grosseteste and the Refraction Rainbow."
6. Oresme 1968, p. 727.
7. Grant 1974, p. 27.
8. See Chapter 4's "Aristotle's Rainbow: Antiquity's Explanation of the Bow's Geometry."
9. Isidore de Seville 1960, p. 284 (*De natura rerum* 31). See Chapter 7's "Aristotelian Color Theory and the Rainbow," for Aristotle's similar analysis of rainbow colors.
10. Isidore de Seville 1960, p. 286 (*De natura rerum* 31).
11. Bartholomaeus Anglicus 1975, vol. 1, p. 582 (*De proprietatibus rerum* 11.5); Grimm 1966, p. 734.
12. Boyer 1987, p. 74.
13. Browne 1964, pp. 495–96 (*Pseudodoxia epidemica* 7.4).
14. Weitzmann 1970, pp. 81–82; Janson 1977, p. 199.
15. Weitzmann 1970, p. 82; Wellesz 1960, p. 17.
16. Wellesz 1960, p. 5.
17. Janson 1977, pp. 209–11.
18. Brubaker 1989, p. 27.
19. Jerome 1933, pp. 131–33.
20. Wellesz 1960, p. 5.
21. Hartel and Wickhoff 1895, p. 147.
22. Friedman 1989, pp. 8–10.
23. Wellesz 1960, p. 6.
24. Goes 1956, plate 5.
25. Friedman 1989, p. 5.
26. Janson 1977, pp. 194, 199.
27. Brubaker 1989, pp. 62–63.
28. Gedzelman 1991, pp. 3515–16. Weitzmann (1970, pp. 99–102) briefly discusses some Byzantine and medieval conventions for representing the clear sky.
29. Janson 1977, p. 187, color plate 17.
30. Janson 1977, p. 126.
31. Friedman 1989, p. 14.
32. Janson 1977, p. 200.
33. Hartel and Wickhoff 1895, pp. 146–47.
34. See Chapter 7's "Aristotelian Color Theory and the Rainbow."
35. James 1991, p. 70.
36. James 1991, p. 72.
37. Wellesz 1960, pp. 14–15.
38. Brubaker 1989, pp. 24–26.
39. Janson 1977, pp. 193–94.
40. Wellesz 1960, pp. 9, 14.
41. Janson 1977, p. 259; Mayr-Harting 1991, vol. 2, p. 25.

42. Mayr-Harting 1991, vol. 2, p. 25.
43. Mayr-Harting 1991, vol. 2, p. 271.
44. See Lindberg (1992, p. 185) on Charlemagne's educational reforms.
45. Janson 1977, pp. 249, 252–54.
46. Lasko 1972, p. 108.
47. Mayr-Harting 1991, vol. 1, p. 164.
48. Mayr-Harting 1991, vol. 1, p. 163.
49. Mayr-Harting 1991, vol. 1, figs. 93, 97.
50. Mayr-Harting 1991, vol. 1, p. 176.
51. Mayr-Harting 1991, vol. 1, color plate 19.
52. Janson 1977, p. 259.
53. Mayr-Harting 1991, vol. 2, p. 25.
54. Brendel 1944, p. 20; James 1991, p. 76.
55. Anzelewsky 1981, p. 140.
56. Douay Vulgate 1914, New Testament p. 282 (Apocalypse 4:2–3; Revelation 4:2–3, King James Version). The King James and Douay Vulgate English translations of the Bible date from c. 1600, so obviously their words were not known to medieval and earlier artists. However, these translations do accurately reflect the imagery found in the predominant medieval biblical texts, St. Jerome's fifth-century Latin Vulgate and its recensions. Artists unable to understand Latin would have been limited to vernacular translations, whether oral or written.
57. Orlandi 1974, p. 60 and fig. 39.
58. James 1991, p. 71.
59. On the rainbow's enhanced brightness, see Chapter 4's "Arc in the Sky: The Circular Symmetry of Rainbow Light."
60. James 1991, pp. 75–79.
61. James 1991, pp. 78–79.
62. James 1991, pp. 79–80. For an atmospheric halo interpretation of Ezekiel's vision, see Fraser (1975).
63. Brendel 1944, pp. 6, 14–19; Blum 1992, pp. 55–56.
64. See Biletskyi and Vladych 1976, plate 5.
65. Greenler 1980, pp. 25–29, 47–52, 139–42.
66. Olszewski 1982. Unfortunately, Olszewski (1982, p. 26) confuses the corona with the 22° halo and mistakenly describes the 22° halo as "rare . . . in northern latitudes." One linguistic source of his confusion may be that the Latin term for solar halo is "corona."
67. Ladis 1986, p. 591; Vasari 1963, vol. 1, p. 72. Stories that praise Giotto's skill are found in later writings that range from fiction to the (possibly) fictitious. Yet even these invented details strongly suggest that Giotto's talents were in fact admired during his lifetime.
68. Vasari 1963, vol. 1, p. 66.
69. Leonardo da Vinci 1954, pp. 902–3.
70. Hartt 1975, p. 51.
71. Janson 1977, p. 281, color plate 36.
72. Janson 1977, pp. 316–18, 326.
73. Eimerl 1967, pp. 85–86.
74. Hartt 1975, p. 52; Eimerl 1967, p. 109.
75. Ladis 1986, p. 586; Guillaud and Guillaud 1987, p. 301.
76. See Chapter 7's "How Many Colors Does the Rainbow Have?"
77. Basile 1993, p. 284.
78. Pioneering English mathematician and astronomer Edmond Halley (1656–1742) is most often associated with the comet whose orbit he calculated. As we shall see in Chapter 9 ("Tertiary Rainbows and More" and "Rainbow Reflections and Reflection Rainbows"), Halley's wide-ranging scientific interests occasionally turned to observation and analysis of the rainbow.

79. Basile 1993, pp. 121, 123.
80. Olson 1984, p. 217. Interestingly, one source of this legend may have been John of Damascus, whose ideas on the power of images we encountered above.
81. Olson 1984, pp. 216–18.
82. Olson 1984, p. 224 nn. 26, 35. Albrecht Dürer's *Melencolia I* (Fig. 2–6) is one such work.
83. See the Appendix's "A Field Guide To The Rainbow" for more on circular rainbows.
84. Hartt 1975, p. 54.
85. Hartt 1975, p. 60.
86. Douay Vulgate 1914, Old Testament p. 629 (Psalm 90:2–5; Psalms 91:2–5, King James Version).
87. Ladis 1986, p. 586.
88. Edgerton 1991, p. 84; Eimerl 1967, p. 128.
89. Compared to the Douay Vulgate, the King James Version's Revelation 6:14 is closer to the Vulgate's Latin: "And the heaven departed as a scroll when it is rolled together."
90. Hartt 1975, p. 52.
91. Guillaud and Guillaud 1987, p. 308.
92. Hartt 1975, p. 51.
93. Edgerton 1991, pp. 88–89, 108–11.
94. Lane 1991, p. 623.
95. McFarlane 1971, pp. 30–32.
96. McFarlane 1971, p. 29.
97. Lane 1991, p. 626; De Vos 1994, p. 20.
98. McFarlane 1971, pp. 29–30.
99. Janson 1977, p. 354.
100. Janson 1977, pp. 356–57. See Chapter 7's "Toward Modern Color Theory: Moving Beyond Newton" for definitions of "saturated" and other color terms.
101. Reproduced in Janson (1977, fig. 462).
102. Janson 1977, p. 358.
103. Bohren 1987, pp. 124–26.
104. Gedzelman 1991, p. 3515.
105. Fairbanks 1960, p. 5 (Philostratus the Elder, *Imagines* 1, introduction).
106. Ptolemy 1989, pp. 14, 83, 119 (*Optica* 2.9, 139; 3.64).
107. Neuberger 1970, pp. 51–54.
108. Bohren and Fraser 1985, pp. 270–71.
109. De Vos 1994, p. 82. Memling also painted many clear daytime skies that illustrate his command of airlight illusionism (for example, *Triptych of John Donne*, c. 1479–80).
110. Janson 1977, p. 354.
111. McFarlane 1971, p. 28.
112. De Vos 1994, pp. 60–72, 424; McFarlane 1971, pp. 35–38.
113. Lane 1991, pp. 623, 632–37. De Vos (1994, p. 89 n. 10) disagrees with Lane's 1991 theory that Portinari conspired to seize his predecessor's triptych.
114. Lane 1991, pp. 632–33; De Vos 1994, p. 85.
115. Lane 1991, p. 623; De Vos 1994, p. 88.
116. De Vos 1994, pp. 25–26.
117. Rogier's and Memling's *Last Judgment*s are paired as figures 50 and 51 in McFarlane (1971).
118. This brightness reduction is a different phenomenon than the occasional brightening of the rainbow's vertical base, discussed in Chapter 9's "Flattened Raindrops and the Pot of Gold." While few natural rainbows have their bases obscured by airlight (the rain responsible is usually nearby), Memling's combination of airlight and the rainbow is nonetheless possible.

119. See Chapter 9's "Vanishing Supernumeraries: A Rainbow Mystery Solved." De Vos (1994, p. 89 n. 13) attributes the narrowing of Fig. 2-4's rainbow to linear perspective. While Memling has simulated perspective narrowing at the rainbow's base, this does not explain why only *some* of the bow's colors disappear there.

120. Color reproductions appear in De Vos (1994, pp. 13, 153).

121. Janson 1977, pp. 379–80.

122. Boyer 1987, pp. 130–37. In Memling's day, few fifteenth-century scientific innovators wrote about the rainbow, and the subject was still dominated by Aristotelian interpreters (Boyer 1987, pp. 141–42).

123. Boyer 1987, pp. 102, 109, 113, 130, 134, 140. Although unanswerable, this question is still an interesting one—see Chapter 7's "How Many Colors Does the Rainbow Have?"

124. See the Appendix's "A Field Guide To The Rainbow" and Chapter 4's "The Impossibility of Seeing Rainbows Obliquely."

125. De Vos 1994, p. 85.

126. De Vos 1994, p. 393.

127. Russell 1967, pp. 48–49.

128. Koreny 1991, pp. 596–97; Anzelewsky 1981, pp. 19–23, 26, 30; Russell 1967, pp. 48, 50.

129. Anzelewsky 1981, pp. 28–30.

130. Anzelewsky 1981, pp. 8–9; Russell 1967, pp. 52–53. Dürer's immediate motivation for travel was a plague outbreak in Nuremberg (Anzelewsky 1981, p. 48).

131. Anzelewsky 1981, p. 246.

132. Anzelewsky 1981, p. 248.

133. Russell 1967, pp. 128–29; Stechow 1966, pp. 103–5.

134. Russell 1967, p. 140. Anzelewsky (1981, pp. 224–33) discusses the intertwining of Dürer's religious and artistic concerns during the early years of the Reformation.

135. Anzelewsky 1981, p. 136; Russell 1967, pp. 120–21.

136. Anzelewsky 1981, p. 140. Suffield (1994) describes recent curatorial efforts to halt the disastrous side effects of a nineteenth-century restoration of the *Adoration*.

137. Panofsky 1945, pp. 125–31.

138. Carty 1985, p. 146.

139. Carty 1985, pp. 147–53.

140. James 1991, pp. 75–79.

141. Dürer's writings as recorded in Stechow (1966, pp. 85–122) and Dürer (1958, 1913) do not mention the rainbow.

142. Russell 1967, p. 161.

143. Koreny 1991, p. 596; Russell 1967, pp. 32–33.

144. Russell 1967, p. 66.

145. Russell 1967, p. 100. The biblical text is Apocalypse/Revelation 1:12ff.

146. For example, Read (1945), Hoffmann (1978), and Manning (1983) feature alchemy, the Flood, and astronomy in their respective interpretations of *Melencolia* and its rainbow. Russell (1967, p. 13) lists several other older interpretations of the engraving.

147. Hoffmann 1978, p. 35.

148. Compare Hoffmann (1978, pp. 34–35) and Panofsky (1945, p. 162).

149. Panofsky notes the winged figure's apparent resignation, although he gives this attitude a different import (1945, p. 168).

150. For example, on the subject of the comet in *Melencolia*, Manning states flatly: "Early attempts to identify this object as a comet have been properly refuted" (1983, p. 27). He reasons that, unlike a comet, the light source within the rainbow radiates in all directions. While this is true, it does not radiate *equally* in all directions, so its well-defined "tail" could well be that of a comet. Although the light is closely encircled by the rainbow and does not lie at its center, Manning identifies it as the sun, which is even less plausible than a comet (see the Appendix's "A Field Guide To The Rainbow" on the positions of the sun and rainbow). Neither a rainbow nor a comet is literally possible here, but literal representations of nature are seldom central to symbolic images.

151. In a 1511 woodcut of the same subject (the *Seat of Mercy in the Clouds*), Dürer omits the rainbow (Wölfflin 1971, plate 69).

152. Russell 1967, pp. 157–58.

153. By this time, the thoroughly independent Müntzer found the church's faith in the pope and Luther's faith in the Scriptures equally unacceptable.

154. Graziani 1972, p. 252.

155. Graziani 1972, pp. 252–53.

156. Nashe 1966, p. 241.

157. Russell 1967, p. 61.

158. Veldman 1977, p. 12.

159. Zafran 1988, p. 96; Mander 1936, p. 163.

160. Hartt 1975, p. 422.

161. Hartt 1975, pp. 456, 574. Significantly, Michelangelo's revolutionary treatment of the subject omits the Judgment Day rainbow, despite his likely familiarity with numerous medieval Last Judgments that included it, including Giotto's Arena Chapel fresco (Hartt 1975, p. 577).

162. Reproduced in Hartt 1975, as color plates 64 and 68, and fig. 546, respectively.

163. Janson 1977, p. 439.

164. Harrison 1990, pp. 21–22.

165. Hartt 1975, p. 518.

166. Hartt 1975, pp. 482–83.

167. Hartt 1975, pp. 484–87, 510.

168. Gombrich 1991, p. 255; Hartt 1975, pp. 484–87.

169. This reaction should not be overstated, for Mannerist art also favored antique, abnormal, and sensual subject matter (Hartt 1975, p. 518; Harrison 1990, pp. 21–22). See also Bruyn (1988, pp. 94–97) for Renaissance and earlier ideas on the inevitable transience of Rome's ancient glory.

170. Clement's latter-day predicaments are typified by his futile embroilment in the marital intrigues of England's Henry VIII (1491–1547), which ultimately led to Henry's separation of the Church of England from the Roman church.

171. Harrison 1990, pp. 19–22.

172. Veldman 1977, pp. 12, 17–18; Turner 1966, p. 167; Mander 1936, p. 211.

173. Stechow 1966, p. 46. Vasari's earlier, earthier account of Heemskerck and his Roman companions also praises their industry, but it does allow that during one project, "as they had a continual supply of drink they were always drunk" (Vasari 1963, vol. 4, p. 16).

174. Harrison 1986, p. 175; Veldman 1977, p. 12.

175. Harrison 1979, pp. 92–103; Lurie 1992.

176. Among many examples, see his *Venus and Cupid* of 1545 (Veldman 1977, fig. 15) and *Apollo and the Muses* of c. 1550–60 (Veldman 1985, fig. 1).

177. Harrison 1990, Figs. 1 and 3–5. In a 1559 print design, Heemskerck enthrones the triumphant Christ on a rainbow, which itself is mounted on a lamb-drawn car (Veldman 1977,

Fig. 46). Of interest to us is that car, Christ, and rainbow are all seen in three-quarter profile (see Chapter 4's "The Impossibility of Seeing Rainbows Obliquely").

178. Mander noted that a 1546 Heemskerck altarpiece includes "various portraits of simple folk and also his own" (Stechow 1966, p. 47; reproduced in Grosshans 1980, figs. 81, 84–85). Similarly, a *Judgment of Paris* of c. 1550–55 now attributed to Heemskerck features a rather solid Juno, Minerva, and Venus (reproduced in Grosshans 1980, fig. 115).

179. Veldman 1977, pp. 15–16; Saunders 1978–79. A mere thirty years after Heemskerck's death, Mander would write: "There is no telling how many prints, after his works, were circulated" (Mander 1936, p. 215).

180. Veldman 1977, p. 16. Heemskerck also drew many print designs based on biblical subjects (Saunders 1978–79; Veldman 1977, pp. 53–93).

181. For example, see Harrison (1975) and Veldman (1980, 1985).

182. See Gombrich 1991; Bruyn 1988, pp. 94–100.

183. Zafran 1988, p. 96.

184. Harrison 1987, vol. 1, p. 307.

185. Zafran 1988, p. 98.

186. Zafran 1988, p. 96. The Venus-bearing figure is to Paris and Helen's right, and another golden statue of Venus appears before her circular temple at the water's edge. Heemskerck may have been subtle, but clearly he was not above helpful repetition.

187. King 1944–45, p. 63; Harrison 1987, vol. 1, p. 298.

188. Hamilton 1969, p. 179.

189. Harrison 1987, vol. 1, pp. 303–4; Harrison 1975, fig. 7; Turner 1966, p. 168. Heemskerck evidently had limited use for his own maxim, which Mander says "he used to [state] many times: 'A painter who wants to do things well must avoid decorative detail and architectural ornament'" (Mander 1936, p. 213).

190. Zafran 1988, pp. 96–98. One pyramid appears above Venus's temple, and another is to the right of the Colossus.

191. For example, see King (1944–45, pp. 61–63), Grosshans (1980, p. 117), Bruyn (1988, p. 94), Zafran (1988, pp. 96–98), and Spicer (1993, p. 3).

192. Zafran 1988, p. 98.

193. Although Heemskerck had a "very different notion of the appearance of these marvels" in drawings dating from 1570 (King 1944–45, p. 63 and fig. 4), the absence of these much later models from Fig. 2-7 does not rule out the Wonders' existence there.

194. Bruyn 1988, pp. 98–102.

195. Barthell (1971, pp. 347–50) recounts the inglorious details of Paris's death and Helen's reconciliation with Menelaus.

196. Ironically, Alessandro would be murdered soon after Fig. 2-7 was completed.

197. Turner 1966, p. 168. Archaeological curiosity may be explicitly depicted in Fig. 2-7, where torch-bearing men explore the underground vault behind Paris (Grosshans 1980, p. 118).

198. Gibson 1989, p. 40; Spicer 1993, p. 3.

199. Gibson 1989, pp. xx, 38–39.

200. Gibson 1989, pp. xx–xxi.

201. Gibson 1989, p. xx. Unlike world landscape, history painting that features landscape may have only a single vanishing point and seem to place the viewer within, not above, the landscape. Note that world landscape and the High Maniera share some common pictorial techniques.

202. The real Ionian island of Cythera, Venus's mythic realm, is a plausible setting for Fig. 2-7 (Zafran 1988, p. 96; Grosshans 1980, p. 118).

203. Gibson discusses the relationship between sixteenth-century maps and landscapes (1989, pp. 52–54).

204. These are *The Good Samaritan* (c. 1550) and *The Pope Watching the Excavation of a Statue of Jupiter in Front of a Panorama of Rome* (present location unknown) (Gombrich 1991, plates 68, 69; Grosshans 1980, pp. 177–80).

205. Gibson 1989, p. 7; Turner 1966, pp. 167–68.

206. Based on shadows cast by the mountains and foreground objects, the sun is on the picture's right.

207. The sky might be sunlit here if the sun were correctly positioned behind the viewer.

208. Gibson 1989, p. 42.

209. King 1944–45, p. 61. If we overeagerly make the rainbow a symbol of peace (based on King's note that the "rainbow ushers out a departing tempest"), we then have to confront Gibson's opposite reading of the storm's direction!

210. Bruyn 1988, p. 96. For Bruyn, the rainbow is ominously paired with Heemskerck's "menacing clouds."

211. Zafran 1988, p. 96.

212. Homer 1950, p. 41 (*Iliad* 3.125–28).

213. Yates 1975, p. 216.

214. Cecil 1992, p. 3; Auerbach and Adams 1971, pp. 60–61.

215. Strong 1985, p. 697 and fig. 42.

216. An eighteenth-century writer praised Fig. 2-8 as "extremely worth notice," remarking that it handsomely portrayed Elizabeth while pointing out her "turn to allegory and apt devices" (Auerbach and Adams 1971, p. 61).

217. Erler (1987, p. 370) and Strong (1977, p. 52) both suggest that a royal entertainment of December 1602 is the probable source of Fig. 2-8.

218. Strong 1977, pp. 47–50; Graziani 1972, p. 247.

219. Graziani 1972, p. 247.

220. Strong 1977, p. 50.

221. These successes include Francis Drake's (c. 1540–96) circumnavigation of the globe (1577–80) and the Spanish Armada's 1588 defeat in the English Channel.

222. For example, Elizabeth's political confrontation with and ultimate execution of the Earl of Essex, Robert Devereux (1567–1601), arose from a failed military campaign against the fractious Irish.

223. Strong 1977, pp. 14–15.

224. Yates 1975, p. 29.

225. Barthell 1971, pp. 26–27; Spenser 1977, pp. 195–97 (*Faerie Queene* 2.3.21–31). As queen of Spenser's land of Faerie, Gloriana embodies Elizabeth's public virtue as head of a just government. Belphoebe emphasizes Elizabeth's private virtue, especially her chastity (Yates 1975, pp. 69–70).

226. Barthell 1971, p. 51.

227. Yates 1975, pp. 32–33, 217.

228. Ovid 1986, p. 5 (*Metamorphoses* 1.149–50); Yates 1975, p. 30.

229. Barthell 1971, p. 63.

230. Yates 1975, pp. 30–31. Astraea is so identified in Spenser's *Faerie Queene* (1977, p. 731 [7.7.37]).

231. Strong 1977, pp. 47–48; Yates 1975, p. 32.

232. Strong 1977, p. 47; Virgil 1958, p. 37 (*Aeneid* 1.314–25).

233. Barthell 1971, pp. 26–27; Strong 1977, p. 48; Yates 1975, p. 29. Diana is also goddess of the hunt and wild animals.

234. Ovid 1986, pp. 3–4 (*Metamorphoses* 1.89–112); Yates 1975, p. 30.
235. Yates 1975, p. 33; Virgil 1978, p. 29 (*Eclogue* 4.8–10).
236. Virgil 1958, p. 171 (*Aeneid* 6.791–97).
237. Yates 1975, pp. 33–34.
238. Yates 1975, p. 66.
239. Yates 1975, pp. 34–36. Remarkably, some contemporary writers described Elizabeth as deserving of adoration as the Virgin Mary (Yates 1975, pp. 78–80).
240. Yates 1975, pp. 41–47.
241. Yates 1975, p. 41.
242. Rice 1966, p. 109.
243. Yates 1975, p. 61. The whore is Revelation's whore of Babylon (Revelation 17), an Elizabethan Protestant commonplace for the Roman Catholic Church.
244. Yates 1975, p. 62.
245. Yates 1975, p. 64.
246. See Chapter 1's "Archers' Bows and Rainbows in Egyptian Antiquity." From the Fourth Dynasty (c. 2575–c. 2465 B.C.) onward, Egyptian kings usually identified themselves as offspring of the sun god Re.
247. Far from being a marginal enthusiast, Davies was well-known at court. After Elizabeth's death, he served as attorney general for Ireland and was appointed lord chief justice shortly before his own death.
248. Strong 1977, p. 50 (*Hymnes of Astraea* 6).
249. Erler 1987, pp. 361–62.
250. According to English folklore, rain will continue for forty days if it falls on Saint Swithin's feast day, July 15.
251. Erler 1987, pp. 362–63.
252. Erler 1987, p. 363.
253. Strong 1977, p. 50; Graziani 1972, p. 259.
254. The Cecils of England are closely tied to our story. We will encounter Robert's father, William Cecil (1520–98), First Baron Burghley, in connection with Burghley House's rainbow-emblazoned Heaven Room (Fig. 3-1). William was Elizabeth's first chief minister, and after the queen's death Robert acquired Hatfield House by exchange with her successor, James I (1566–1625). Elizabeth herself spent much of her childhood at Hatfield (Cecil 1992, pp. 1–2).
255. Erler 1987, p. 365.
256. Erler 1987, pp. 365–67; Yates 1975, p. 220.
257. Yates 1975, p. 218. The emblem of the chaste moon goddess Diana is the crescent moon (Strong 1977, p. 52).
258. Erler 1987, p. 367; Strong 1977, p. 48.
259. Erler 1987, p. 367.
260. Graziani 1972, pp. 258–59.
261. Graziani 1972, p. 257.
262. Graziani 1972, pp. 252, 255–56.
263. 1 Thessalonians 1:2–9, 2:14.
264. Strong's pointed disagreement (1977, pp. 194–95 n. 64) with Graziani (1972) suggests the inherent difficulties of interpretation posed by the *Rainbow Portrait*.
265. Yates 1975, p. 217.
266. Erler 1987, p. 370; Strong 1977, p. 52.
267. Graziani 1972, p. 256. See also Matthew 13:1–23, especially vv. 16–17.
268. Yates 1975, p. 220.
269. Erler 1987, p. 365.
270. Graziani 1972, p. 254. Moses' brass serpent (Numbers 21:6–9) as a prefiguring of the Savior (John 3:14–15) had been the subject of numerous Renaissance engravings and paintings; Maarten van Heemskerck's *Brazen Serpent* (1549) is a particularly energetic example (Harrison 1990).
271. Strong 1977, p. 50; Yates 1975, p. 217. These topics do not exhaust the symbolic language of the *Rainbow Portrait*; Graziani (1972) and Yates (1975, pp. 216–19) explore some others.
272. Erler especially notes how Elizabeth exceeds Iris's modest powers in the *Rainbow Portrait* (1987, p. 363).
273. The lily had long been used as a heraldic device and a symbol of Christian purity and mercy. In the latter role, it frequently accompanied the figure of Christ in Judgment (see Fig. 2-4 and De Vos 1994, p. 82).
274. Davidson 1979, pp. 402–4.
275. Davidson 1979, p. 402.
276. Davidson 1979, pp. 403–4.
277. Erler 1987, p. 359; Yates 1975, p. 218.
278. Auerbach and Adams 1971, p. 59.
279. Yates 1975, p. 218; Auerbach and Adams 1971, p. 59.
280. Yates 1975, p. 218; Strong 1977, p. 50; Erler 1987, pp. 363, 370; and Graziani 1972, p. 252, respectively.

CHAPTER THREE

1. Thomson 1971, pp. 10–11 (*Spring*, lines 203–12).
2. Bredvold et al. 1973, p. 638.
3. Thomson 1971, pp. 439–40 (*To the Memory of Sir Isaac Newton*, lines 122–24); Abrams 1971, pp. 304–5. Nicolson (1966, p. 114) notes that Thomson prepared to write his Newton memorial by carefully reading *Opticks* or commentaries on it. See Wright (1980) and Nicolson (1966) for other literary and artistic reactions to atmospheric optical phenomena in Georgian and Victorian Britain.
4. See Chapter 6, n. 299.
5. Bredvold et al. 1973, pp. 638–39.
6. Bredvold et al. 1973, p. 638.
7. Wilkinson 1995; Charlton 1847, p. 235.
8. Haskell 1980, p. 196; Croft-Murray 1962, p. 54. Verrio featured himself as a Neapolitan, which was true in the general sense that his birthplace of Lecce was in the kingdom of Naples and that he himself had lived in Naples for a few years.
9. Croft-Murray 1962, p. 53.
10. Portier 1989, p. 402.
11. On Verrio's indiscreet lovemaking, see Croft-Murray (1962 pp. 52–53). The present inheritor of Burghley house, Lady Victoria Leatham, notes Verrio's "keen appreciation of the naked female form" and that the artist "wreaked havoc among the serving girls" while in residence at Burghley (Leatham 1992, p. 153).
12. The First Earl of Shaftesbury (1621–83) served as lord chancellor to Restoration England's Charles II (reigned 1660–85). In this office, Shaftesbury actively tried to bar from the throne Charles's Catholic brother, the Duke of York (James II, 1685–88). Shaftesbury continued this quest in later years as a leader of Parliament's Whig opposition. Following Charles's dissolution of Parliament in 1681, Shaftesbury was briefly jailed for treason, thus securing his reputation as a factious schemer.
13. Haskell 1980, p. 196. Art historian Edgar Wind notes dryly: "The mere fact that [Verrio] served to their full satisfaction four successive sovereigns of vastly different tempers—Charles II, James II, William III and Queen Anne—ought to free him from the suspicion of having been a man of principles" (Wind 1939–40, p. 128 n. 3).
14. Croft-Murray 1962, p. 53. In 1669, Montagu had been

dispatched to Versailles to persuade Louis XIV of the advantages of an Anglo-French treaty against the Netherlands. Louis needed little persuading, agreeing in 1670 to provide Charles with substantial funding for joint campaigns against the Dutch.

15. Haskell 1980, pp. 195–96. For an illustration of Verrio's *Sea Triumph*, see Millar (1963, plate vol., plate 121).

16. Millar 1963, text vol., p. 133 (catalog no. 297).

17. Croft-Murray (1962, p. 55) lists Verrio's considerable "band of assistants" at Windsor. Typically Verrio would delegate architectural painting to them (Leatham 1992, p. 192).

18. Croft-Murray 1962, p. 59.

19. A color illustration of Verrio's King's Staircase appears in Osborne (1990, p. 174). For an earlier painting that pairs Juno and Iris, see Fig. 7-2.

20. Quoted in Wind 1939–40, p. 127 n. 1.

21. Croft-Murray 1962, p. 59.

22. Wind 1939–40, p. 127.

23. Croft-Murray 1962, p. 57.

24. Wind 1939–40, p. 128. Verrio's royal appointment by James II ended before James fled England early in 1689 (Croft-Murray 1962, p. 57).

25. Julian 1969, pp. 347–67 (*The Caesars* 307–15); Wind 1939–40, pp. 128–30. Recall that Fig. 2-7 may include a similar allusion to its patron and Alexander.

26. Wind 1939–40, p. 130. Verrio's Romans may also symbolize William III's Roman Catholic opponents, including such Stuart claimants to the throne as James II (Osborne 1990, p. 142).

27. Wind 1939–40, pp. 134–35.

28. Wind 1938–39, p. 185.

29. Pestilli 1993, p. 131; Haskell 1980, pp. 198–99. Haskell notes of Shaftesbury's 1711 program for Italian artist Paolo de Matteis (1662–1728) that the earl's "elevated ideas [of art's role] and his conception of the artist as a mechanical executant were not new, but they had rarely been so stringently applied to an actual creation" (Haskell 1980, p. 198).

30. Wind 1939–40, p. 130 n. 2.

31. Leatham 1992, p. 192.

32. Leatham comes to Verrio's support, finding his figure painting to be of "staggering quality." As further evidence of his abilities, she notes that Verrio alone painted a convincing *trompe l'oeil* ceiling at Burghley from atop a sixty-foot scaffold (Leatham 1992, pp. 153, 156).

33. Leatham et al. 1989, p. 21; Croft-Murray 1962, p. 57; Charlton 1847, p. 235.

34. Recall that Fig. 2-8 is from another Cecil holding, Hatfield House of Robert Cecil, First Earl of Salisbury.

35. Brigstocke and Somerville 1995, pp. 18–19, 29–37; Leatham et al. 1989, p. 23. Verrio's fee for decorating just the Heaven Room is now the equivalent of more than $100,000 (Leatham 1992, p. 192).

36. Leatham 1992, p. 153; Croft-Murray 1962, p. 57. Another major decorative painter, Louis Laguerre (1663–1721), also worked for Exeter at Burghley. The poet Alexander Pope (1688–1744) memorably linked the two painters' names in his couplets "On painted Cielings you devoutly stare,/ Where sprawl the Saints of Verrio or Laguerre, / On gilded clouds in fair expansion lie, / And bring all Paradise before your eye" (Pope 1978, p. 319 [*Epistle to Richard Boyle, Earl of Burlington*, lines 145–48; first published 1731]).

37. Leatham 1992, p. 192.

38. Leatham 1992, pp. 153, 156, 194; Croft-Murray 1962, pp. 58–59.

39. Greek and Roman gods frequently mingle in such paintings.

40. Wilkinson (1995) has performed the Herculean labor of cataloging the Heaven Room's denizens. Faced with this profusion of divine flesh, a nineteenth-century cataloger could only wearily offer that the room featured "scenes of Gods and Goddesses disporting themselves as Gods and Goddesses are wont to do" (Leatham 1992, p. 192).

41. Croft-Murray 1962, p. 58.

42. Mount Fuji appears in Fig. 3-2's companion screen (not shown).

43. Hickman 1976, pp. 32, 38, 88. In 1603, shogun Tokugawa Ieyasu (1543–1616) headquartered his central government in Edo (modern Tokyo). An earlier shogun had also established his government center away from imperial Kyoto (Paine and Soper 1974, pp. 53, 103).

44. Hickman 1976, pp. 15–20, Rosenfield and Shimada 1970, pp. 206–7. With clearly mixed emotions, the earliest known commentator on Shōhaku says: "He relied only on his own talents, and therefore fell into heterodox ways. Nevertheless, his paintings were extraordinary in character." A slightly later account notes imperturbably: "When Shōhaku was traveling about in this province he was always drunk; he would get into a [litter] backwards, and play the *samisen* [lute] as he was being carried along, and in his drunken condition his behavior was truly a sight to be seen" (Hickman 1976, pp. 16, 18). Hickman notes that Shōhaku's drunkenness was no more than conventionally Bohemian and that later accounts of his life embellished such stories. See also Guth 1996, p. 83.

45. Rosenfield and Shimada 1970, p. 212.

46. Art historian John Rosenfield describes Shōhaku's foreshortened rainbow as one of his "startling innovations" (Rosenfield 1995). To date, we have found no other rainbows in Japanese landscape art.

47. Stanley-Baker 1984, pp. 22, 27–31; Rosenfield and Shimada 1970, pp. 9–11.

48. Paine and Soper 1974, p. 1. The Shintō deities Izanagi and Izanami came down a rainbow proxy, the Floating Bridge of Heaven, to create the world's first land mass (see Chapter 1, n. 211).

49. Rosenfield and Shimada 1970, pp. 9–10.

50. Rosenfield and Shimada 1970, p. 11.

51. Rosenfield and Shimada 1970, p. 90.

52. Rosenfield and Shimada 1970, pp. 89–91.

53. Rosenfield and Shimada 1970, p. 157.

54. Rosenfield 1988, pp. 5–7; Rosenfield and Shimada 1970, p. 159.

55. Rosenfield and Shimada 1970, p. 207.

56. Paine and Soper 1974, p. 2. For similar airlight and visibility effects in Western art, see Fig. 2-4 and Neuberger (1970, pp. 51–54).

57. Rosenfield and Shimada 1970, p. 206.

58. Hickman 1976, p. 87.

59. Hickman 1976, p. 19.

60. Hickman 1976, p. 21; Rosenfield and Shimada 1970, p. 207. Maruyama Ōkyo (1733–95) combined elements of Kanō, Chinese academic, and Western perspectivist painting into hybrids that sold well to Japanese gentry (Rosenfield 1988, pp. 14–15, 23; Stanley-Baker 1984, pp. 177–78). Although Shōhaku's comment about Ōkyo originally might have reflected only jest or self-assurance, it has since been (mis)interpreted as arrogance (Hickman 1976, p. 48; Paine and Soper 1974, p. 126).

61. Hickman 1976, p. 87; Paine and Soper 1974, p. 129; Rosenfield and Shimada 1970, p. 207.

62. Rosenfield 1988, pp. 17–21; Paine and Soper 1974, pp. 127–33. On Fig. 3-2's right, Shōhaku's ornate signature declares an invented kinship between himself and a talented monk-painter of the mid-fifteenth century, Soga Dasoku. Shōhaku embellishes Dasoku's accomplishments and imposes on the monk a given name that resembles his own (Rosenfield 1995; see also Hickman 1976, pp. 138–40).

63. Rosenfield 1995.

64. Rosenfield 1995; Rosenfield and Shimada 1970, p. 212.

65. See Chapter 4's "The Impossibility of Seeing Rainbows Obliquely."

66. Rosenfield 1988, pp. 22–23; Stanley-Baker 1984, p. 153. Portuguese and Spanish traders first appeared in Japan in the mid-sixteenth century, followed by the Dutch. European imperialism and Christian missionaries' effective proselytizing so alarmed the Tokugawa shogunate that, beginning in 1612, it issued decrees prohibiting Christianity. By 1636, foreign visitors (including Japanese living abroad too long) and travel were banned. The necessary evil of foreign trade continued with the Dutch and Chinese, but this was confined to an island in Nagasaki harbor.

67. For Descartes's oblique drawing of the rainbow, see Fig. 6-4. Newton illustrates a similar rainbow in his 1704 *Opticks* (Newton 1952, Fig. 15, p. 173). By the mid–eighteenth century, the works of both men were fixtures of the Western scientific canon, with Newton's *Opticks* being available in English, Latin, French, and Italian editions (see Chapter 6).

68. Rosenfield and Shimada 1970, p. 212.

69. Roworth 1992, p. 68.

70. Baretti 1781, p. 26.

71. Schweizer 1982a, pp. 434–35. See n. 1 above for Thomson's rainbow prism. As for the possibility that Fig. 3-3's artist adds colors to, instead of taking them from, its multihued rainbow, Schweizer notes that her palette has only one color.

72. Schweizer 1982a, p. 435.

73. Rosenthal 1992, p. 48; Hope 1967, pp. 3–4. Various editions and translations of Ripa's *Iconologia* appeared throughout the eighteenth century (Roworth 1992, p. 16).

74. Adam and Mauchline 1992. Kauffman's methods as a history painter are suggested by the fact that in 1772 she had assembled at least ten custom-bound volumes of prints and drawings. These contained copies of both Roman and European works of art (Waterhouse 1985, p. 272).

75. Ripa 1971, no. 8.

76. Okayama 1992, p. 71. Translator Edward Maser (Ripa 1971, no. 8) claims that the 1603 *Iconologia* used the camelopard or giraffe as air's emblem. This probably reflects his understandable etymological confusion of camelopard and chameleon, which had long shared the spelling "camelion" (*Oxford English Dictionary* 1971, pp. 322–23, 375).

77. Ripa 1971, no. 8; *Oxford English Dictionary* 1971, p. 375.

78. Evans 1959, p. 105. West would succeed the Royal Academy's first president, Joshua Reynolds (1723–92), in 1792. West's unabashed enthusiasm for rainbow colors is quite consistent and dates from the 1770s (Schweizer 1982a, p. 435). In advice written c. 1787, West warns a young artist always to follow Rubens's example, "Never failing to place the *brightest Red* in his pictures *joyning* the light side of the Phocus [where light enters the scene] . . . for in that point Nature has placed the most glowing colours of the Rainbow, so that any deviation from this order of colours becomes offencive, and sikens every Eye (tho ignorant of the cause)" (Forster-Hahn 1967, p. 381).

79. Roworth 1992, p. 11; Croft-Murray 1969, p. 16. Originally, *Colour* and its companion paintings were on the Council Chamber ceiling of Somerset House, the Academy's then-new home on London's Strand.

80. Schweizer 1982a, p. 435.

81. Kauffman executed two versions and several copies of this work between 1791 and 1796. A color reproduction of the *Self-Portrait* appears in Shawe-Taylor (1987, p. 21).

82. Roworth 1992, pp. 15–16. Roworth suggests that Kauffman and her biographer may have separately garnished this story's details.

83. Rosenthal 1992, p. 49. In the wake of the French Revolution, Kauffman's choice of a tricolor of red, white, and blue for the three female figures in the *Self-Portrait* may also have political overtones.

84. Opfell 1991, p. 26.

85. Roworth 1992, pp. 17–18; Janson 1977, pp. 557, 565.

86. Kauffman's penchants for history painting and Neoclassical form overlap. History painting's use of grand or ennobling scenes from the real or mythological past made it a style broad enough to accommodate several centuries of artistic fashion (for example, Fig. 2-7), including Neoclassicism. The Third Earl of Shaftesbury's tracts on art had been devoted to improving the theory and practice of history painting (Roworth 1992, pp. 21–22; Rosenthal 1992, pp. 42–43).

87. Schweizer 1982a, p. 435. Editions of Mengs' works in Italian, French, and German considerably predate this 1796 English translation.

88. Schweizer 1982a, p. 437; see also Roworth 1992, p. 14. Consistent with his reputation as an artist of the macabre and the fantastic, Fuseli oddly raises the specter of a "phantastic" economy here.

89. For Barry's views, see Chapter 7, n. 71. For a while, Kauffman was close friends with German theorist and philosopher Johann Wolfgang von Goethe (1749-1832), whose intolerance of Newton's color theory was a mainstay of his own theories of painting. However, Goethe's views were not widely available before Kauffman's death, and the two did not meet until years after Kauffman had painted Fig. 3-3. See Chapter 7, n. 87; Opfell 1991, pp. 33–35.

90. Parris et al. 1976, pp. 127–29; Thornes 1984 and 1979a. Constable not only made numerous outdoor sketches of skies in Hampstead during the early 1820s but also copied engravings of skies by artist Alexander Cozens (1717–86) (Parris et al. 1976, p. 128).

91. Boulton 1984, p. 42; Schweizer 1982a, p. 425.

92. Lucas transformed *Salisbury Cathedral* into one of numerous mezzotints for his and Constable's ambitious print series entitled "English Landscape Scenery." Each print was accompanied by Constable's explanatory letterpress, and the entire project was conceived as a way to explain and popularize Constable's unique approach to landscape. The series was a commercial failure, one that Constable took deeply personally (Parris et al. 1976, pp. 160–62).

93. Leslie 1845, p. 237. Leslie's ellipsis refers to another work of Constable's.

94. Parris et al. 1976, p. 164; Schweizer 1982a, pp. 425–26.

95. Leslie 1845, pp. 287–88. Leslie notes that the "new bow" in Lucas's mezzotint was actually one that Constable had ap-

proved of earlier (reproduced in Wilton 1979, p. 109).

96. Leslie 1845, p. 346. Constable's actual lecture is only approximated by such quotations. Writing about the first of his landscape lectures, Constable calls his notes "little more than a recollection" (Leslie 1845, p. 318). One of the Rubens rainbows that Constable alludes to is Fig. 4-12.

97. Parris et al. 1976, p. 164; Thomson 1971, p. 98 (*Summer*, lines 1229–32). Our excerpt from Thomson is shorter than Constable's excerpt. The caption's last phrase may be Constable's optimistic rewording of Thomson, who instead finds the fields "yet dropping from distress."

98. Rosenthal 1983, pp. 228–30.

99. Rosenthal 1983, pp. 7–10.

100. Rosenthal 1983, pp. 11–12.

101. Leslie 1845, p. 2.

102. Rosenthal 1983, pp. 6–7, 206–13; Constable 1962–68, vol. 3, p. 49 (1831; Constable to Leslie).

103. Rosenthal 1983, pp. 38–41, 111.

104. Rosenthal 1983, pp. 22–23; Parris et al. 1976, p. 14. Farington's published *Diary*, which covers the years 1793–1821, chronicles the Academy's high ideals and low machinations in gossipy detail.

105. Howat 1972, p. 28.

106. Constable 1962–68, vol. 2, p. 32 (29 May 1802; Constable to John Dunthorne, Sr.).

107. Romanticism is a broad label that encompasses both the picturesque and the sublime aesthetics, although the emotional connotations of "Romanticism" more closely ally it with the sublime (see n. 200 below). Classifying any given painting as picturesque, sublime, or Romantic may be a difficult (and irrelevant) exercise. All involve a rejection of Neoclassical order and formalisms. A landscape painter who subscribes to the sublime or Romantic aesthetics has direct emotional involvement with his or her nature imagery, as opposed to the picturesque painter who merely assembles pleasing natural icons.

108. Rosenthal 1983, pp. 31–35, 41.

109. Rosenthal 1983, pp. 154, 177–80.

110. Rosenthal 1983, p. 178. In characteristic picturesque language, Knight relies on "accidental mixtures" of landscape features to define his middle distances.

111. Constable 1962–68, vol. 6, p. 191 (23 January 1825; Constable to John Fisher). Two different versions of *The Leaping Horse* are reproduced in Rosenthal (1983, pp. 164–65).

112. Rosenthal 1983, pp. 227–28. Figure 3-4's most obvious borrowings are the dog taken from *The Cornfield* (1826) and the boat, wagon, and figures taken from *The Hay Wain* (1821).

113. Constable 1962–68, vol. 6, p. 190 (5 January 1825; Constable to John Fisher).

114. Thornes 1979b.

115. As Thornes notes, Forster's book was unusual in providing explanations, rather than mere descriptions, of atmospheric phenomena. Constable also seems familiar with the writings of Luke Howard (1772–1864), another influential early writer on meteorology (Thornes 1979a, pp. 697, 703). Howard also influenced Goethe's typically metaphysical views on clouds, which in turn affected the way that some contemporary German artists approached them (Novak 1980, pp. 80–83).

116. Constable wrote in 1836, "Forster's is the best book—he is far from right, still he has the merit of breaking much ground" (Thornes 1979a, p. 697). For example, Forster associated atmospheric electricity with the duration and shapes of cirrus "mares' tails" (Thornes 1979a, p. 701). In fact, however, Forster's imagined "peculiar state of the electric atmosphere" does not determine cirrus properties.

117. Thornes 1979a, p. 703. These incorrect theories claimed that electricity was a fluid that directly affected precipitation and cloud formation (Middleton 1965, pp. 111–15).

118. Thornes 1979a, p. 702.

119. Thornes 1979a, p. 702.

120. See Fig. 7-8 and Schweizer (1982a, p. 429).

121. For a recent edition of *English Landscape Scenery*, see Wilton (1979).

122. Constable 1970, pp. 21–22; see also Wright 1980, pp. 192–93. Wilton (1979, p. 11) notes Constable's blithe belief in 1832 that his letterpress would consist of "10 or 20 lines to Each" mezzotint. In fact, both letterpress and engravings would become time-consuming labors of love.

123. Leonardo had offered the rainbow as the definitive test of a painter's understanding of color. See Chapter 7, nn. 28–29.

124. Schweizer 1982a, p. 441.

125. Schweizer 1982a, pp. 430–31, 441–42.

126. See n. 142 below for one of Constable's astute rainbow observations.

127. Leslie 1845, p. 355.

128. For the cause and colors of these unusual rainbows, see Chapter 9's "Tertiary Rainbows and More."

129. Newton 1952, pp. 171–75 (*Opticks*, 1.2, prop. 9, problem 4); Halley 1700, p. 531. Both men's mathematics would have exceeded Constable's grasp, so he probably understood them via intermediate sources.

130. Schweizer 1982a, pp. 440–41; Brewster 1834. In 1831, Brewster presented his dissent on Newton's color before Edinburgh's Royal Society. This talk was not published until 1834, but Brewster presented the same color iconoclasm in his 1831 book *Treatise on Optics*. For more on Brewster's erroneous color ideas, see Chapter 7's "Some Important Departures from Colorimetry."

131. Schweizer 1982a, p. 441.

132. Constable 1962–68, vol. 2, p. 403 (22 October 1825; John to Maria Constable).

133. See n. 102 above. The version of the Reform Bill finally passed by Parliament in 1832 did not threaten the church establishment, and its electoral reforms were not very radical. From the introduction of the original bill, however, conservatives fastened on it as a threat to the established order (Schweizer 1982b, pp. 131, 136–37).

134. Boulton 1984, pp. 29, 41–42; Rosenthal 1983, p. 230; Schweizer 1982b.

135. Boulton 1984, p. 42.

136. *Salisbury Cathedral from the Bishop's Grounds* is reproduced in Rosenthal (1983, p. 144).

137. Constable 1962–68, vol. 6, p. 138 (16 October 1823; Bishop Fisher, quoted by young John Fisher to Constable).

138. Constable 1962–68, vol. 6, pp. 251, 110 (9 August 1829 and 7 February 1823, respectively; John Fisher to Constable). Fisher wrote these two letters more than six years apart, testimony to the endurance of the two men's shared image of an embattled church.

139. In fact, the kind and amount of clouds in Fig. 3-4 are inconsistent with either the lightning or the black cloud bases that Constable depicts.

140. Schweizer 1982a, p. 426. The primary rainbow is al-

ways a segment of a circle whose radius is 42°. Because the bow's center is always directly opposite the sun, if the sun is higher than 42° no part of the rainbow circle will be visible above level ground. For more on the fixed geometry of sun, rainbow, and observer, see the Appendix's "A Field Guide To The Rainbow" and Chapter 4's "Arc in the Sky: The Circular Symmetry of Rainbow Light."

141. Parris et al. 1976, pp. 164–65.

142. Leslie 1845, p. 310.

143. In a crowning irony, the *Stoke by Neyland* mezzotint itself shows an impossible rainbow riding above the horizon "in a Summer's Noon" (Constable 1970, p. 21; reproduced in Parris et al. 1976, p. 161).

144. Rosenthal 1983, p. 63.

145. Parris et al. 1976, pp. 115, 187–88.

146. Parris et al. 1976, pp. 177–79.

147. Boulton 1984, pp. 39–40. Because *The Jewish Cemetery* (c. 1660) of Jacob van Ruisdael (1628/29–1682) also juxtaposes a church, ominous sky, and rainbow in a forbidding landscape, scholars have suggested that Constable might have drawn inspiration for *Salisbury Cathedral*'s rainbow from it (Rosenthal 1983, pp. 234–35, fig. 260; Schweizer 1982a, p. 441).

148. Schweizer 1982a, p. 426. Lanier (1988, pp. 62–63) has Constable using the Golden Section to determine the size and position of Fig. 3-4's rainbow. Like many such geometric deconstructions, Lanier's would be more compelling if we had documentary evidence that it reflected Constable's ideas. For more Golden Section pitfalls, see Herbert (1991, pp. 392–93).

149. Rosenthal 1983, pp. 234–35.

150. Schweizer 1982a, p. 426.

151. Ruskin 1888, vol. 3, pp. 123–24 (*Modern Painters*, vol. 3, part 4, chap. 9). Like many of Ruskin's pronouncements, his rebuke of Claude is leavened elsewhere in *Modern Painters*. Speaking of Claude's seas, Ruskin says they "are the most beautiful in old art. For he studied tame waves, as he did tame skies, with great sincerity, and some affection; and modelled them with more care not only than any other landscape painter of his day, but even than any of the great men" (Ruskin 1888, vol. 5, p. 250 [*Modern Painters*, vol. 5, part 9, chap. 5]).

152. For Turner on the rainbow, see Chapter 7's "Toward Modern Color Theory: Moving Beyond Newton" and Chapter 8's "Turner and *The Wreck Buoy*: A Cloudbow in Disguise?"

153. Ruskin 1888, vol. 1, p. xli (*Modern Painters*, vol. 1, preface, no. 40).

154. Hilton 1971, pp. 8, 15.

155. Hilton 1971, pp. 13, 120. Swiss physicist and geologist Horace Bénédict de Saussure (1740–99) invented not only the cyanometer (1788) but also the electrometer (for measuring electrical voltage) and the hair hygrometer (1783). Color-matching problems found in instruments patterned after the cyanometer show that such instruments do not accurately measure sky color (Neuberger 1957, p. 193). Ironically for Ruskin, who championed visual description of nature, these problems are caused by the inherent subjectivity of human color vision (see Chapter 7's "Some Important Departures from Colorimetry").

156. Landow 1980, p. 112; Ruskin 1888, vol. 1, pp. 201–3 (*Modern Painters*, vol. 1, part 2, sec. 3, chap. 1); vol. 2, pp. 134–35 (*Modern Painters*, vol. 2, part 3, sec. 1, chap. 15).

157. Hilton 1971, pp. 68, 119–20. Ruskin humorously compares the resistance of painter John Brett (1831–1902) with that of an earlier victim, John W. Inchbold (1830–88): "He is much tougher and stronger than Inchbold, and takes more hammering; but I think he looks more miserable every day, and have good hope of making him more completely wretched in a day or two more" (Hilton 1971, p. 120).

158. Hilton 1971, p. 27.

159. Staley 1973, pp. 15–19; Ruskin 1851. Millais in fact asked an intermediary to enlist Ruskin's help in fending off attacks by critics against the Brotherhood. Ruskin fared less well from their friendship than Millais, who fell in love with and ultimately married Ruskin's wife Effie in 1855 (Staley 1973, pp. 48–52).

160. Millais joined the Brotherhood's instigators, Dante Gabriel Rossetti (1828–82) and William Holman Hunt (1827–1910), to form the organization in the summer of 1848. By September, four like-minded friends and enthusiasts had been admitted (Hilton 1971, pp. 28–29, 32–33).

161. Staley 1973, pp. 1–2; Hilton 1971, pp. 29, 46. Millais was elected to the Royal Academy in 1853, and his association with the Pre-Raphaelites diminished thereafter. For both personal and professional reasons, Millais also avoided contact with Ruskin (Staley 1973, p. 52).

162. Staley 1973, pp. 5, 12; Hilton 1971, pp. 47–49.

163. Hilton 1971, p. 52. A color reproduction of *Christ in the House of His Parents* appears in Hilton 1971, p. 41.

164. Hilton 1971, p. 14.

165. Ruskin 1851, p. 8 (13 May). In fact, both academicians and Pre-Raphaelites (including Millais) occasionally had trouble with linear perspective. Rossetti found this aspect of drawing particularly difficult (Hilton 1971, pp. 40–41).

166. For example, see Benjamin West's instructions in n. 78 above.

167. Ruskin 1881, p. 180 (*Lectures on Architecture and Painting*, lecture 4); Hilton 1971, p. 57.

168. Staley 1973, p. 5; Hilton 1971, pp. 56–57.

169. Hilton 1971, p. 136. Ruskin's systematic color-mosaic technique clearly anticipates Seurat's pointillism.

170. Ruskin 1908, vol. 34, pp. 150–51 ("The Three Colours of Pre-Raphaelitism," 1878); see also Millais (1899, pp. 241–42).

171. Millais 1899, p. 241.

172. A contrary opinion comes from critic Sacheverell Sitwell, who finds the blind girl "tired out with walking." In a marvelous turn of phrase, Sitwell also describes the rainbow as "that fatal temptation to the painter"! (Sitwell 1969, p. 79).

173. Codell 1991, pp. 58–63; Cooper 1986, pp. 479–81. A *Spectator* review criticized *The Blind Girl* as "crude," an epithet simultaneously impugning the painting's shabby figures and some of Millais's brushwork. Ruskin presumably would have been startled to know that the original model for the blind girl was Millais's (and Ruskin's former) wife Effie, a woman of considerable beauty (Wildman et al. 1995, p. 152; Bennett 1967, p. 39).

174. Hilton 1971, p. 118.

175. So that no one confuses the blind girl's beatific expression with contentment, Millais pins to her dress a sign reading "PITY THE BLIND" (Wildman et al. 1995, p. 152).

176. Millais 1899, p. 240.

177. For a correct explanation of the secondary rainbow, see the Appendix's "A Field Guide To The Rainbow" or Chapter 6's "René Descartes: The Rainbow Fixed in the Sky."

178. Staley 1973, p. 54.

179. This happens when we look toward the antisolar point, which corresponds to the shadow of your head and the rainbow's center. Around this point each landscape feature (for

example, the grass blades and trees in Fig. 3-5) necessarily covers up most of its own shadow. The net effect is to increase the scene's brightness near the antisolar point compared to locations farther from it. This effect is most pronounced at the right in Fig. 3-5, which is where the antisolar point is.

180. Millais 1899, p. 240.
181. Landow 1977, p. 364.
182. Landow 1980, p. 112.
183. Ruskin 1886, vol. 2, p. 146 (*The Stones of Venice II*, chap. 5). In a classic waffle on Newtonian color, Ruskin concludes that the rainbow's symbolic stature is not "it would seem, by mere arbitrary appointment, but in consequence of the foreordained and marvellous constitution of those hues into *a sevenfold, or, more strictly still, a threefold order*, typical of the Divine nature itself" (emphasis added).
184. Cohen 1982, pp. 20–23. Staley (1973, p. 54) writes: "The spectacle of rainbows and landscape, which the blind girl cannot see, provides the meaning of the picture." Wildman et al. (1995, p. 152) note both *The Blind Girl*'s natural beauty and its religious overtones.
185. Millais 1899, p. 242.
186. Adamson 1985, pp. 14–15; Adamson 1981, p. 53.
187. Adamson 1985, p. 15.
188. Huntington 1960, p. 86.
189. A typical Victorian reading of Fig. 3-6 is that it "was immediately recognized as the first satisfactory delineation by art of one of the greatest natural wonders of the western world" (Tuckerman 1966, p. 376).
190. Adamson 1985, pp. 15–18. Niagara Falls had such a hold on American artistic imagination that painters might position themselves in literally impossible vantage points. As the title of George Catlin's (1796–1872) remarkable *Both Falls: An Imagined Aerial View* (c. 1830) suggests, Catlin did *not* survey the Falls from a balloon! (Adamson 1981, p. 54).
191. Adamson 1985, p. 64.
192. Adamson 1985, p. 64.
193. Tuckerman 1966, p. 371.
194. Tuckerman 1966, p. 371. Tuckerman means here that Church's painted rainbow is a "perfect . . . optical illusion," not that the Falls' rainbows are illusory.
195. Huntington 1960, p. 86.
196. See Figs. 2-5 and 2-7 for less dramatic (and certainly less naturalistic) interrupted rainbows.
197. The sky in Fig. 3-6 is clear except for bands of altocumulus, clouds that do not produce raindrops. Although waterdrop bows can sometimes be seen against altocumulus (Fig. 5-1), that is not the case here. Thus only Horseshoe Fall can produce the required water droplets in Fig. 3-6. Strictly speaking, Church has painted a *spray bow* rather than a rainbow. Yet whatever label we give it, *Niagara*'s bow is both optically realistic and a remarkable tribute to Church's powers of observation.
198. For more on rainbow variations, see Fig. 4-17 and Chapter 4's "Arc in the Sky: The Circular Symmetry of Rainbow Light" and "The Inescapable (and Unapproachable) Bow." On a more modest scale, you can see rainbow brightness variations by waving to and fro the sunlit spray from a garden hose. While the resulting spray bow's position does not change, its brightness will waver as drop concentration changes along the bow.
199. Adamson 1985, p. 51.
200. Burke 1958, p. 39; Novak 1980, pp. 7–9.
201. Burke 1958, p. 40.
202. Forster 1872, vol. 1, pp. 404–5 (letter dated 26 April 1842). When Dickens revisited Niagara in March 1868, he found that the intervening decades had not left him jaded: "The majestic valley below the Falls, so seen through the vast cloud of spray, was made of rainbow. The high banks, the riven rocks, the forests, the bridge, the buildings, the air, the sky, were all made of rainbow. Nothing in Turner's finest watercolour drawings, done in his greatest day, is so ethereal, so imaginative, so gorgeous in colour, as what I then beheld. I seemed to be lifted from the earth and to be looking into Heaven. What I once said to you, as I witnessed the scene five and twenty years ago, all came back at this most affecting and sublime sight" (Forster 1872, vol. 3, p. 433).
203. Adamson 1985, p. 14.
204. Novak 1980, p. 7.
205. O'Sullivan 1845, p. 5.
206. Novak 1980, p. 8.
207. Adamson 1985, p. 52.
208. Kelly 1988, pp. 1–10, 22–24; Novak 1980, pp. 19–20. Church was Cole's first and only student, working with (rather than under) him during 1844–47.
209. Howat 1972, pp. 27–33. Numerous other American artists of Cole's time worked in the Hudson River style, including Washington Allston (1779–1843) and telegraph inventor Samuel F. B. Morse (1791–1872).
210. Howat 1972, p. 27.
211. Kelly 1988, p. 3.
212. Cole's *The Course of Empire* and *The Voyage of Life* are reproduced in Novak (1980, pp. 11–13, 21–22). Cole was not a topographical painter, so he often used his detailed plein air sketches of specific sites only as starting points for finished works.
213. McKinsey 1985, p. 92.
214. Adamson 1985, pp. 66–67. The "Eternal" label for Niagara's rainbows, which is from author Nathaniel Hawthorne (1804–64), aptly describes the omnipresent rainbows seen in Niagara's sunlit spray.
215. Novak 1980, p. 91.
216. Thomas 1852, p. 212. References to "seven attributes," refraction, and "distinct but blending hues" indicate that Thomas is borrowing Newton's scientific image of the bow. As stirring as Thomas's sermon sounds, his audience consisted only of two other Universalist ministers! (Thomas 1852, p. 211). The enormous ledge of Table Rock itself fell into Horseshoe Fall gorge thirteen years later (Adamson 1985, p. 78 n. 103).
217. Adamson 1985, p. 62.
218. *Crayon* 1856, p. 77.
219. For more on these aspects of the natural rainbow, see Chapter 4's "The Inescapable (and Unapproachable) Bow."
220. This study from late 1856, *Niagara Falls*, is reproduced in Adamson (1985, p. 63).
221. Victorian audiences were keen to scan such enormous landscapes with opera glasses so that they might better admire a painting's details. Church's extended format had popular precedent in traveling panoramas, which featured continuous paintings on rollers that were scrolled before an audience. Also popular were panorama exhibits consisting of 360° painted views from a fixed (but dramatic) vantage point (Avery 1986, pp. 60–62; Adamson 1985, pp. 33–34, 40–41, 58; Novak 1980, pp. 20–24, 71).
222. Adamson 1985, p. 64. Adamson reproduces Church's 1857 study here.
223. Busy repairing *Niagara* in 1886, Church remarks in a

letter: "An energetic picture cleaner removed the sky—for repairs I suppose—mopped up most of the water and added grandeur of chaos to the scene.... I repainted the sky and I think [I] have made it in some respects better than before in as much as it is more subservient to the cataract" (Upchurch 1991, p. 92).

224. Upchurch 1991, pp. 84–85.

225. Upchurch 1991, p. 84. Unlike Constable, Church appeared little concerned with publicizing his ideas on art, including his views on the rainbow. What we know about Church's rainbows comes from his letters. Upchurch 1991, p. 75.

226. Upchurch 1991, pp. 84–85, 88. As Upchurch points out, Church's opaque rainbow arcs could simply be color shorthand appropriate to a sketch. Reproduced in Stebbins 1978, p. 64.

227. Upchurch 1991, pp. 87–88. During his second South American trip, Church noted other atmospheric optical phenomena. Near Ecuador's Mount Sangay on 10 July 1857, he observed that "a slight rainstorm gathered in the east and passed to the south and on the falling mist among the mountains the sun produced a curious prismatic effect although quite common in these countries" (Novak 1980, p. 72; Huntington 1960, p. 101). Church likely is referring to the glory—concentric rings of colored light that appear around the shadow of the observer's head (the antisolar point) when that shadow is cast on the kind of clouds ("falling mist")—that he observed. Although superficially resembling some rainbows, the glory is actually a distinctly different phenomenon. See Fig. 8-1 for a photograph of a glory.

228. Henry Tuckerman makes Church's quest for authenticity sound positively dangerous. Writing about Church's study for a later Niagara portrait, Tuckerman recounts: "Church climbed a tree at the end of the arc of a circle, and found the view thence embraced the whole of the cataract; he cut away foliage to secure a free sight, clung to the top of the tree, and made his sketch. The glint of the water, the mist, the sweep, curve, dash, spray, foam, rocks, and iris, all are reproduced in faithful and vivid tints" (Tuckerman 1966, p. 386).

229. For example, see Anton Raphael Mengs' statement that red, yellow, and blue are required for a mellifluous painted rainbow (n. 87 above).

230. Volumes by Humboldt, Tyndall, Rood, and Chevreul were found in Church's library at his Hudson River estate Olana (Novak 1980, pp. 66, 282 n. 114). Agassiz and Church apparently were longtime friends (Novak 1980, p. 132). Tyndall was the first to demonstrate (rather than simply assert; see Chapter 7, n. 119) that the sky's blue is sunlight scattered by atmospheric molecules.

231. Kemp (1990, pp. 312–15) discusses Rood's pivotal book *Modern Chromatics* (1879), which made modern color theory accessible to and practical for artists. For Chevreul's influence, see Chapter 7's "Some Important Departures from Colorimetry."

232. Novak 1980, pp. 93–94.

233. Carr 1980, pp. 34–73.

234. Novak 1980, p. 132.

235. Church owned an 1849–59 five-volume English translation of *Cosmos* (Novak 1980, p. 66). Humboldt died suddenly at the age of ninety while writing the fifth *Cosmos* volume.

236. Humboldt 1870, p. 93.

237. Kelly 1988, pp. 74–75, 95–96.

238. *Cotopaxi* and *The Heart of the Andes* are reproduced in Novak (1980) as Figs. 28 and 17, respectively.

239. Contemporary writers would also describe *The Heart of the Andes*' scientific travelogue as a depiction of Eden, Paradise, and Easter Sunday salvation (Huntington 1966, pp. 51–52).

240. Kelly 1988, p. 99.

241. Kelly 1988, p. 99; Avery 1986, pp. 59–60.

242. Tuckerman 1966, p. 383.

243. Novak 1980, p. 76.

244. During the 1867 Exposition Universelle in Paris, the joint appearance of *Niagara* and *Rainy Season in the Tropics* was one of the few popular and critical successes in the American art exhibition. Henry Tuckerman valiantly championed many of the Exposition's coolly received American paintings (Troyen 1984, pp. 4–6, 10). Yet Church himself had American detractors, including James Jackson Jarves, who wrote of the Exposition: "Church's 'Niagara,' with no more sentiment, a cold hard atmosphere and metallic flow of water ... was a literal transcript of the scene" (Troyen 1984, p. 14). The words "literal transcript" were damning ones in Victorian art parlance (Czestochowski 1982, p. 110). See Huntington (1960, pp. 149–52) for other contemporary sniping at Church.

245. This rainbow feature is called Alexander's dark band (see Chapter 4's "The Transformation of Aristotle's Theory: Commentators and Corruption"). Compared to the sky inside the primary bow and outside the secondary bows, in Alexander's dark band sunlit raindrops send us almost no light, making this region relatively dark.

246. David Huntington says that Fig. 3-7's "geology suggests the Andes; the atmosphere, Jamaica. The vegetation belongs to both locales" (Huntington 1966, p. 56).

247. Ruskin 1888, vol. 1, pp. xxxii–xxxiii (*Modern Painters*, vol. 1, preface, no. 30).

248. Humboldt 1870, p. 95.

249. Church was perfectly willing to own (and presumably read) Darwin's scientific researches, yet he would have sided with Agassiz in resisting Darwin's godless, mechanistic model of the natural world (Novak 1980, pp. 66, 74–76). Both Church and Darwin shared a passion for Humboldt's work (like Humboldt, both had undertaken arduous research trips to South America), yet they would differ starkly on the ends that such knowledge should serve (Novak 1980, pp. 72–73).

250. Carr 1980, p. 13.

251. For example, see Chapter 7's "Georges Seurat, Color Theory, and *L'Arc-en-Ciel*."

CHAPTER FOUR

1. Cicero 1933, p. 335 (*De natura deorum* 3.20).

2. Gray 1969, p. 50; Hastings 1905, vol. 4, p. 196.

3. Hesiod 1988, p. 11; Barthell 1971, pp. 7, 12.

4. Hellmann 1908, p. 483; see also Rochberg-Halton 1991, p. 118.

5. Sarton 1960, p. 194.

6. Irwin 1982, p. 349 n. 37.

7. We will often use "scientist" as shorthand for the older term "natural philosopher." See Lindberg (1992, pp. 3–4), Asimov (1974, p. 338), and Lloyd (1971, preface) for more on the relationship between the two terms.

8. Lindberg 1992, pp. 23–24.

9. Lloyd 1971, pp. 8–10; Sambursky 1987, pp. 4–8. This area was first settled by Aegean peoples and ultimately traversed by those from throughout the ancient world, making it a vital crossroads for both trade and ideas. Egypt and the Orient supplied both commodities in abundance, thus diffusing Eastern mysticism into Hellenic thinking (Sarton 1960, pp. 162–64).

10. Lloyd 1971, p. 12.
11. Lloyd 1971, p. 9.
12. Lindberg 1992, p. 29; Lloyd 1971, pp. 21–22.
13. Boyer 1987, p. 34; Gilbert 1967, p. 606; see also Xenophanes 1992, p. 140.
14. Lindberg 1992, pp. 29–31.
15. Geoffrey Lloyd notes of the Athenian playwright Aristophanes (c. 450–388 B.C.): "Learned attempts to engage in measuring are already the butt of Aristophanes' humour in the famous passage in [*The Clouds*] 143ff., where he represents Socrates [470–399 B.C.] attempting to measure the length of a flea's jump. In a variety of contexts, the desire for . . . exactness or nicety was considered illiberal or ungentlemanly" (Lloyd 1987, p. 280 n. 218; see also Lloyd 1971, pp. 139–42 on Greek experimentalism).
16. Wiedemann 1988, pp. 17, 37–38. Wiedemann (1988, pp. 136–37) also offers an example from Roman Italy of the relationship between technology and slavery.
17. Garlan 1988, pp. 135–36.
18. Aristotle's selective interest in observation and physical experiment illustrates the subtleties involved. See "Aristotle's Rainbow: Antiquity's Explanation of the Bow's Geometry" below.
19. Plato 1956, pp. 179–89 (*Republic* 7.528e–530c); Lloyd 1971, pp. 67–69.
20. Lloyd 1971, pp. 69–70, 79.
21. Lloyd 1971, p. 71; Shorey 1933, p. 236.
22. Plato 1952, pp. 127–41 (*Timaeus* 53b–57d). The presumed colors of Empedocles' four elements (earth, air, water, and fire) would be used in fanciful European explanations of the rainbow. See Chapter 2's introduction and Chapter 5's "Science, Conservatism, and Aristotle's Unyielding Rainbow."
23. Lloyd 1971, p. 79.
24. Lindberg 1992, p. 40; Sarton 1960, pp. 199ff.
25. Sarton 1960, pp. 200–201.
26. Lloyd 1971, pp. 25–27.
27. Lindberg 1992, p. 41; Sambursky 1987, pp. 29–40. See Chapter 6, n. 80, for more on these regular (or Platonic) solids. Platonism shared Pythagoreanism's enthusiasm for mathematics and numerical abstraction, although not quite so unreservedly.
28. *Philosphumena* 1.2.2 (quoted in Sarton 1960, p. 214).
29. Lindberg 1992, pp. 54–55; Sarton 1960, p. 213.
30. For example, see Isidore of Seville's account of rainbow colors, in which he adopts Empedocles' four elements (Chapter 2, n. 9). See Lindberg (1992, p. 203) on twelfth-century numerological interpretations of nature and the divine.
31. Lindberg 1992, pp. 200–201.
32. Boyer 1987, p. 113. Although Fig. 2-5's Trinity rainbow does not have three distinct colors, its insertion into the Holy Trinity nonetheless suggests our point here.
33. Lindberg 1992, p. 38.
34. Lindberg 1992, p. 68.
35. Lindberg 1992, pp. 48–50; Lloyd 1971, p. 124; Sarton 1960, pp. 496–98.
36. Veatch 1974, pp. 16–19; Crombie 1962, pp. 7–8.
37. Lloyd 1971, pp. 108, 115.
38. Aristotle 1931, *Meteorologica* 377a.
39. Aristotle 1931, *Meteorologica* 373b, 375a. Actually, Aristotle describes the rainbow as "a reflection of sight to the sun," thus reversing the true flow of visual energy (see n. 54 below).
40. Boyer 1987, p. 53.

41. Aristotle 1931, *Meteorologica* 375b–377a.
42. Although Aristotle's original diagrams have not survived, reconstructions can be made based on his detailed (although occasionally inconsistent) descriptions, as well as from figures drawn by later commentators. See Boyer 1987, pp. 63, 327 n. 32.
43. See, for example, the halo diagram in Lynch (1980, p. 127).
44. For example, the Arabic scholar Alhazen relied on a reflecting concave cloud, and both it and Aristotle's meteorological sphere would surface in rainbow explanations as late as the seventeenth century (Boyer 1987, pp. 80, 194, 231–32). See also Chapter 5's "Avicenna, Alhazen, and the Rainbow in Arabic Science." Of course, the concave cloud is a human rather than a natural construct. Giving amorphous or flat-bottomed clouds a concave shape may well be related to our perception that the sky (even a cloudy sky) forms a flattened dome (Minnaert 1993, pp. 172–73).
45. See figs. 1 and 2 in Aristotle 1952, pp. 269–70 (*Meteorologica* 375b).
46. Aristotle 1952, p. 61 (*Meteorologica* 345b). This contradiction might be explained by assuming that Aristotle is switching between physical and geometric argumentation, as he does when discussing vision and light. Most readers, however, are likely to have difficulty reconciling a geometric construction that places the sun nearby with a physical one that places it beyond the moon.
47. While Aristotle speaks of "the sun's rays" once in connection with indoor water-spray rainbows (*Meteorologica* 374b), nowhere in his elaborate geometric arguments on the cloud rainbow does he mention rays (*Meteorologica* 375b–377a). Whether the sun's rays exist in Aristotle's cloud rainbow is a moot point, since his arguments there are couched in the language of visual rays (that is, extramission; see n. 54 below).
48. Aristotle 1931, *Meteorologica* 375b–377a; Sayili 1939, pp. 76–79. See also Chapter 5's "Avicenna, Alhazen, and the Rainbow in Arabic Science" for more on the optical problems of Aristotle's rainbow theory.
49. Aristotle 1931, *Meteorologica* 377a.
50. Aristotle 1976, p. 91 (*Posterior Analytics* 79a). Aristotle also may have avoided the artificiality of experiment because he wanted to observe nature as he found it (Lindberg 1992, p. 53). Yet in *Meteorologica* 358b, Aristotle refers to an experiment in which he evaporates saltwater and determines that its condensed vapor yields fresh water.
51. Aristotle's distinction between optics and physics is quite alien to modern science.
52. Boyer 1987, p. 42.
53. Aristotle 1931, *De sensu* 437b–438a. In this model of vision, Aristotle also requires a transparent medium that transmits sensation between the eye and a light source: "Colour sets in movement not the sense organ, but what is transparent, e.g. the air, and that, extending continuously from the object [to] the organ, sets the latter in movement" (Aristotle 1931, *De anima* 419a). Displaying the courage of his convictions, Aristotle next states (in paraphrase) that vision is impossible through a vacuum! In more elaborate form, this idea would resurface as the nineteenth-century theory of a luminiferous ether that was supposedly required for transmission of light waves (Boyer 1987, p. 290).
54. Sayili 1939, p. 72.
55. Aristotle 1979, p. 505 (*De generatione animalium* 781a). Here Aristotle says, "It makes no difference to this [phenomenon's

explanation] which of the two theories of sight we adopt."

56. Aristotle 1931, *De sensu* 438a.
57. Aristotle 1931, *Meteorologica* 373b. Historian David Lindberg argues that Aristotle switches to the essentially mathematical (as opposed to physiological) extramission model of vision in his rainbow model "because in [*Meteorologica*] he was dealing with the mathematics of vision" (Lindberg 1978, pp. 367–68 n. 55). That may be true for Aristotle's rainbow geometry, but it does not explain why Aristotle uses extramission to account for our sensation of rainbow colors. In short, Aristotle's rationale for his change of vision models in *Meteorologica* is unclear.
58. Sayili 1939, pp. 71–72; see also Eastwood 1967, p. 411 n. 40. The term *refraction* denotes the bending of light as it passes from one transparent medium to another. The apparent bending of a straight straw in a glass of water is an example of refraction. The fact that the degree of refractive bending depends on color is crucial to realistic explanations of the rainbow (see Chapter 6).
59. Aristotle 1931, *Meteorologica* 375b.
60. Boyer 1987, p. 55.
61. Aristotle 1931, *Meteorologica* 372a–b.
62. Aristotle 1931, *Meteorologica* 373b.
63. Aristotle 1931, *Meteorologica* 374b; Sayili 1939, pp. 70–71.
64. Aristotle 1931, *Meteorologica* 372a. See Chapter 7's "Aristotelian Color Theory and the Rainbow" for a discussion of Aristotle's later influence on artistic color theory. H. D. P. Lee's translation of this passage has "blue" rather than "purple," although Lee acknowledges that Aristotle combines blue and violet (or purple) into a single color band (Aristotle 1952, pp. 242–43). Elsewhere in *Meteorologica* Aristotle describes the primary rainbow's inner band as "purple" (Aristotle 1952, p. 267 [*Meteorologica* 375b]).
65. Here Aristotle is actually describing a different phenomenon: cloud iridescence. When we look directly at clouds near the sun, their iridescent colors may indeed be invisible to the naked eye (although not for the reason Aristotle supposes; see Greenler 1980, pp. 141–42; Bohren 1987, pp. 133–35; Humphreys 1938, p. 497).
66. Aristotle 1931, *Meteorologica* 374b. Here Aristotle uses the principle of *contraries* (that is, black and white) to frame a theory of color. The idea that color is a mixture of contrary properties would have a long and robust life in Western art and science (see Chapters 5–7).
67. Aristotle 1931, *Meteorologica* 375a–b; Sayili 1939, pp. 73–74. For example, at the rainbow's summit its interior and associated cloud are closer to the ground (and thus to the observer) than its exterior.
68. Lindberg 1978, p. 356; Aristotle 1931, *De anima* 418a–419a.
69. Aristotle 1931, *De sensu* 439b; Sayili 1939, pp. 66–67.
70. See n. 64 above.
71. Sayili 1939, pp. 67–70. Note Aristotle's parenthetical justification above for three rainbow colors: "as we find three does in most other things." Aristotle did not accept Pythagorean numerology uncritically, though, and sometimes expressed disdain for its more fantastic claims (Lloyd 1971, pp. 25–27).
72. Aristotle 1931, *Meteorologica* 375a. Aristotle accurately places the rainbow's yellow between its red and green bands, although elsewhere he chooses orange as the intermediate color (*Meteorologica* 372a). Neither orange nor yellow figures in Aristotle's theory of a tricolor rainbow.

73. Aristotle 1931, *Meteorologica* 374a.
74. Of course, neither spray nor cloud is continuous.
75. Aristotle 1952, p. 255 (*Meteorologica* 373b). In modern terms, it is water vapor in the air, *not* the gaseous air, whose condensation forms cloud droplets (but not raindrops).
76. In other words, as the sun rises, the bow sets and its radial size increases (Boyer 1987, pp. 43–44; Aristotle 1931, *Meteorologica* 371b). For all practical purposes, sun elevation has no effect on the rainbow's radius (Fraser 1983b, fig. 5; see also Chapter 9's "Does the Secondary Rainbow Have Supernumeraries?").
77. This powerful illusion is called the *moon illusion*, and attempts to explain it have provoked centuries of speculation, experiment, and debate (Hershenson 1989; Sekuler and Blake 1985, pp. 235–36).
78. Seneca 1971, pp. 33–35 (*Naturales quaestiones* 1.3.4).
79. Seneca 1971, p. 33 (*Naturales quaestiones* 1.3.3).
80. Seneca 1971, p. 35 (*Naturales quaestiones* 1.3.5).
81. Seneca 1971, pp. 41–53 (*Naturales quaestiones* 1.3.11–5.13).
82. James 1991, pp. 73–74.
83. Boyer 1987, p. 62; Lindberg 1992, p. 149.
84. Lindberg 1992, pp. 148–49.
85. Boyer 1956.
86. Boyer 1956, p. 384.
87. Alexander of Aphrodisias 1968, p. vii; Lindberg 1992, p. 77.
88. Boyer 1987, p. 62. Alexander's ancient reputation was as an Aristotelian commentator, but his fame in medieval Europe stemmed more from his own writings on the mind and the soul.
89. Alexander of Aphrodisias 1968, p. 250 (*Meteorologica* commentary 40vb).
90. Alexander of Aphrodisias 1968, p. 252 (*Meteorologica* commentary 41ra). This thirteenth-century Latin translation of Alexander's *Meteorologica* commentary is by William of Moerbeke (c. 1220–c. 1286). At points, its discussion of the rainbow is nearly unintelligible. However, whether Moerbeke or Alexander is more to blame is immaterial to us. For centuries, Moerbeke's and later translations of Alexander were the means by which European scholars understood him and his views on Aristotle. See Boyer (1987, pp. 148, 328 n. 66) on sixteenth-century editions of Alexander's *Commentary*.
91. See n. 67 above. Actually, Aristotle had concerned himself with the *total* path length between observer, rainbow, and sun (however unrealistically he defined this distance). Alexander seems to miss this nuance and instead worries only about distances between observer and cloud. Nonetheless, he catches Aristotle in a serious geometric inconsistency.
92. Börsch-Supan 1990, p. 90.
93. Börsch-Supan 1990, p. 90; Koerner 1990, p. 164.
94. See Chapter 6's "René Descartes: The Rainbow Fixed in the Sky."
95. Greenler 1980, p. 3. See the Appendix's "A Field Guide to the Rainbow" for further details on rainbow geometry.
96. See Chapter 6 for more on the secondary rainbow's geometry.
97. While we can often observe the primary's bright interior, sometimes this distinction is unclear. Several factors can cause this: a bright background, a sun partially obscured by clouds or haze, or a rain shaft of limited depth. In each case, the low brightness of the primary bow compared to its background means that only the rainbow's pattern of colors, not its

inherent brightness, is evident.

98. Constable 1970, pp. 21–22.

99. See Chapter 1's "Sex and the Single (or Double) Rainbow."

100. Leslie (1845, p. 310) describes Constable's observation of the rainbow's sunbeam radii.

101. Cook 1940, p. 37; Gabriel 1952, p. 14. Figure 4-8's white, red, and green rainbow is joined by another quasi-naturalistic touch, the exaggerated aerial perspective (that is, airlight) evident along Eros's receding right wing (Gabriel 1952, pp. 16–17).

102. Janson 1977, pp. 185–90.

103. Egerton 1990, pp. 54–55, 58–61.

104. Rosenthal 1982, pp. 62, 66. While Wright was a quite conventional (and prolific) eighteenth-century portraitist, some of his works also reveal a distinctly Romantic sensibility. As scholar Judy Egerton notes, a 1794 letter by an aging Wright shows him "to be spiritually at one with the new Romantic generation" (Egerton 1990, p. 12).

105. Abrams 1974, p. 684 (*Lamia* 2.233). See Chapter 5's epigraph and introduction for more on Keats and the rainbow.

106. Egerton 1990, p. 10; Nicolson 1968, vol. 1, pp. 39–40.

107. Hawes 1982, p. 54. See Chapter 3's "John Constable on Optics, Landscape Art, and the Rainbow" for more on Forster's and Howard's influential writings.

108. For more on Wright's scientific connections, see Egerton (1990, pp. 15–23).

109. Nicolson 1968, vol. 1, p. 93. However, decades earlier Wright had sketched and annotated cloud and sky studies for his own use, much as John Constable would later do (Egerton 1990, pp. 141–42).

110. Egerton 1990, p. 195.

111. Constable 1970, p. 21.

112. See Adamson (1981, p. 54) for an earlier imaginary view of Niagara from the air.

113. Vergara 1982, p. 2.

114. Vergara 1982, p. xii.

115. Vergara 1982, p. 99.

116. Note especially Virgil's reading of rain signs and sky colors in *Georgics* 1.373–460 (Virgil 1978, pp. 107–13).

117. Ruskin 1890, p. 129 (*The Eagle's Nest*, lecture 7, "The Relation to Art of the Sciences of Inorganic Form"). Ruskin's broader point here is that painters need not be scientifically informed in order to paint sky phenomena well. Still, his displeasure with Rubens's Fig. 4-12 rainbow is quite apparent.

118. Ingamells 1982, p. 288.

119. See Chapter 8's "Supernumerary Bows: Cloudbows' Superfluous Cousins" and Chapter 9's "Rainbow Reflections and Reflection Rainbows."

120. Rubens 1955, p. 403. Rubens's letter is dated 16 March 1636. Although this "antique landscape" existed in a contemporary collection, the painting's actual age is not specified.

121. Rubens 1955, p. 404. Rubens goes on to speculate that "notwithstanding the precise rules of optics laid down by Euclid and others, this science was not as commonly known then, or as widespread, as it is today" (Rubens 1955, p. 404).

122. Vergara 1982, p. 130. Rubens's links with the scholar Aguilonius are discussed further in Chapter 7's "Aristotelian Color Theory and the Rainbow."

123. Held 1979, p. 257.

124. Lindsay 1968, p. 2; Ellis 1994, p. 1. Martens found "petty details" absent from J. M. W. Turner's survey of his own landscape styles, the 1807–19 engraving series *Liber studiorum*.

125. Ellis 1994, pp. 6–8.

126. Ellis 1994, p. 9.

127. Ellis 1994, p. 17; Lindsay 1968, p. 3. The two men were unlikely to have been soul mates, since Darwin wrote from the *Beagle* that Martens had "rather too much of the drawing-master about him." Nonetheless, Darwin added: "We all jog along very well together" (Ellis 1994, p. 10).

128. Darwin 1933, pp. 249, 258. Darwin's entry on the salt-spray bow is dated 14 December 1834; he notes the departure of Martens in his 27 September 1834 entry. See also Ellis 1994, p. 11.

129. Ellis 1994, p. 109; Dundas 1979, p. 13.

130. Gleeson 1971, p. 110; Lindsay 1968, p. 6.

131. Lindsay 1968, pp. 7–8; Ellis 1994, pp. 50–55.

132. Ellis 1994, p. 110; Dundas 1963, pp. 162–63.

133. Ellis 1994, p. 188; Dundas 1963, p. 164. Figure 4-13's Fitzroy Falls is about sixty-five miles southwest of Sydney and was known as Quarrooilli Falls in the 1830s. Martens made a sketching tour of the area in 1836, and his pencil drawing of the Falls was the basis for four later paintings (Ellis 1994, pp. 24, 188; de Vries-Evans 1993, pp. 154–55).

134. Ellis 1994, p. 66.

135. Lindsay 1968, p. 34.

136. Lindsay 1968, p. 13; Ellis 1994, pp. 32–33.

137. Ellis 1994, p. 64.

138. Ellis 1994, pp. 74, 77. After 1834, Martens's notebooks also show his serious interest in the latest English and European ideas on color theory (Ellis 1994, pp. 98–99, 201).

139. Lindsay 1968, pp. 32–33.

140. Even Isaac Newton remarks that "it sometimes seemed in towns as if [the rainbow] were not located in the sky but in the air near us and affixed, or rather interposed, above the walls of facing buildings" (Newton 1984, p. 593 [*Optica*, part 2, lecture 16]).

141. Boyer (1987, color insert between pp. 142–43) includes a photograph of a reflected rainbow captioned "Reflected rainbow seen in a pond in Massachusetts, next to the Atlantic Ocean." For more on rainbow reflections, see Chapter 9's "Rainbow Reflections and Reflection Rainbows."

142. For example, see William Holman Hunt's 1854/55 *The Scapegoat* at Manchester, reproduced in Treuherz (1980, p. 17).

143. Boyer 1987, pp. 79, 83, 85, 91–93, 112, 119ff.

144. Truettner 1976, p. 247, fig. 18.

145. Kinsey 1992, pp. 65–66.

146. Truettner 1976, p. 249, quoting Richard Gilder, editor of *Scribner's Monthly*.

147. Truettner 1976, p. 251.

148. Hewison 1976, p. 21.

149. Truettner 1976, p. 255.

150. Hewison 1976, p. 20.

151. Hewison 1976, p. 20; Truettner 1976, p. 254; Wagner 1988.

152. Hewison 1976, p. 21.

153. Dundas 1979, pp. 14–15. With rather strained humor, Martens wrote to Darwin in 1862 about the arguments in *Origin of Species*: "I am afraid of your eloquence and I *don't* want to think that I have an origin in common with toads and tadpoles, for if there is anything in human nature that I hate it is a toady" (Ellis 1994, p. 17).

154. Truettner 1976, p. 241; Czestochowski 1982, p. 14.

155. Czestochowski 1982, p. 29; Novak 1980, pp. 298–99 n. 55.

156. Truettner 1976, p. 251.

157. Kinsey 1992, p. 15.

158. Kinsey 1992, pp. 50–51; Truettner 1976, p. 241. Cer-

tainly Moran had his business interests in mind two years later when, at the last minute, he declined a second invitation from Hayden. Assuming that Hayden was leading his 1873 expedition to Arizona's Grand Canyon, Moran had made nearly one hundred contracts to provide pictures of the Canyon region. When Hayden's destination became unclear to Moran, he promptly turned to an expedition (John Wesley Powell's) that *was* going to the Grand Canyon (Kinsey 1992, p. 104).

159. Truettner 1976, p. 243.
160. Truettner 1976, p. 243.
161. Kinsey 1992, p. 64. Wagner (1989, pp. 155–62) discusses Moran's tutoring by expedition geologists and the geological accuracy of *The Grand Cañon of the Yellowstone* and *The Chasm of the Colorado*.
162. Truettner 1976, p. 243.
163. Kinsey 1992, pp. 117–24; Truettner 1976, p. 244.
164. Novak 1980, p. 298 n. 55.
165. Czestochowski 1982, p. 110. Turner and Moran shared similar tastes for the sublime. Romanticism recast the sublime in forms that differed from its form in classical literature. One kind of modern sublime held that grandeur of form (landscape, here) evoked an ecstatic or transcendent reaction (Kinsey 1992, p. 15).
166. Like Ruskin, Moran was ambivalent about artistic mimesis; his condemnation of "literal transcripts" did not keep him from making earnest queries about the naturalism of his pictures. See n. 161 above; see also Kinsey 1992, pp. 15–16.
167. Truettner 1976, pp. 244–45.
168. Kinsey 1992, p. 104; Truettner 1976, p. 246.
169. Kinsey 1992, p. 113; Truettner 1976, p. 249.
170. Kinsey 1992, pp. 98, 119; Truettner 1976, p. 247.
171. Kinsey 1992, pp. 27–28.
172. Truettner 1976, p. 250. Despite his misgivings, Gilder concluded that *The Chasm*, like *The Grand Cañon of the Yellowstone*, "grows in power on the beholder, haunting his memory like the solemn music of a psalm" (Kinsey 1992, p. 114).
173. Kinsey 1992, p. 27.
174. Kinsey 1992, pp. 43, 95. Given Fig. 4-17's severe scenery, Kinsey speculates on why Congress would have purchased the painting so readily. Among other ideas, she plausibly suggests that for nineteenth-century viewers the rainbow's traditional symbolism of hope (and perhaps of wealth) made the painting's alien landscape seem less ominous (Kinsey 1992, p. 116).
175. Novak (1980, chap. 4) explores in detail the development of these contradictions in American landscape art.
176. Aristotle 1931, *Meteorologica* 374b; Sayili 1939, pp. 67–68.
177. Lindberg 1992, p. 50.
178. Boyer 1987, p. 42. As historian Alistair Crombie notes: "[Greek] scientific theories were simply logical or mathematical constructions erected for no other purpose than to correlate observed facts" (Crombie 1962, p. 6). This essentially deductive approach differs from the induction (that is, reasoning from particulars to the general) that characterizes much of modern science.

CHAPTER FIVE

1. Abrams 1974, pp. 684–85 (*Lamia* 2.229–38).
2. In Greek mythology, Lamia was a beautiful Libyan queen after whom Zeus lusted and whose children Hera then stole in revenge. Deranged with grief and her own revengeful thoughts, Lamia stole other women's children (Barthell 1971, p. 122). Lamia was also envisioned as a kind of man-eating succubus.
3. Abrams 1974, p. 670.
4. Abrams 1971, p. 304.
5. See the epigraph for Chapter 3.
6. Abrams 1971, p. 306.
7. Thomson 1971, p. 11 (*Spring*, lines 210–11).
8. Abrams 1971, p. 311.
9. Abrams 1971, p. 310. Significantly, before joining Keats in a toast proposing "Confusion to the memory of Newton" (or perhaps "mathematics"), Wordsworth insisted that Keats explain himself. See Chapter 7, n. 75; see also Abrams 1971, p. 309; Haydon 1926, p. 269.
10. See Chapter 1's "Iris as the iris" and Chapter 4's epigraph, respectively.
11. See Chapter 7's "Newton's Disquieting Color Ideas."
12. See Lindberg (1992, pp. 243, 365–66) on the deference of medieval revisionists toward Aristotle.
13. See Chapter 4's "The Transformation of Aristotle's Theory: Commentators and Corruption" for the shortcomings of the sixth-century commentator Olympiodorus the Younger. Alexander of Aphrodisias was somewhat more insightful in his *Meteorologica* commentary than Olympiodorus.
14. Boyer 1987, p. 65.
15. Boyer 1987, p. 85. Claiming that *no* European scholar knew *Meteorologica* before the twelfth century is implausible, but we have no evidence of such knowledge (Callus 1944, pp. 4–5).
16. Isidore de Seville 1960, p. 284.
17. One view of nature supported by Christian Neoplatonism is that the unchanging truths of mathematics and geometry literally underlie and define the ever-changing sensible world. A possible source for this belief is Plato's claim that Empedocles' material elements are reducible to geometric forms. By contrast, the Aristotelian explanation of nature does not discredit sense information, but views it as a useful complement to the completely separate (and superior) realm of mathematics and geometry (Lindberg 1982, pp. 4–7; Hackett 1980, pp. 56, 72). Medieval scientists sometimes melded these seemingly disparate viewpoints into a coherent whole.
18. Sabra 1994, chap. 1, pp. 225–26; Lindberg 1992, pp. 168–70; Boyer 1987, pp. 74–75.
19. Lindberg 1992, pp. 163–66; Job of Edessa 1935, pp. xix–xxi. The range of Job's writing is as impressive as his credentials: his other books include *On the Soul*, *On Urine*, and *On Canine Hydrophobia* (Job of Edessa 1935, p. xxii).
20. Job of Edessa 1935, p. xxiv.
21. Job of Edessa 1935, p. 208.
22. Job of Edessa 1935, pp. 208–9.
23. The clouds against which we see Fig. 5-1's rainbow merely *seem* not to produce precipitation. Drops large enough to generate colorful bows, yet too small to yield visible precipitation, fall from such altocumulus clouds (see Chapter 8's "Why Do Cloudbows and Rainbows Look So Different?"). Other rainbow segments without a cloud background include the bases of Fig. 7-20's primary and secondary bows.
24. Aristotle 1952, p. 255 (*Meteorologica* 373b).
25. Job of Edessa 1935, pp. 209–10.
26. Job of Edessa 1935, p. 210.
27. See Chapter 2's introduction for the rainbow explanations of Bede and other first-millennium Christian writers.
28. Bartholomaeus Anglicus 1975, vol. 1, p. 581 (*De proprietatibus rerum* 11.5); see also Salter 1909, pp. 143–44. We have modernized the wording of this passage.

29. Figure 7-1 may illustrate a twentieth-century version of such attitudes.

30. Latinized versions of well-known Arabic authors' names were common in medieval writing. Some modern scholars of medieval Arabic science continue this practice by occasionally using the scientists' Latin names (for example, Avicenna; see Sabra 1994, pp. vi–vii).

31. Horten and Wiedemann 1913, pp. 539–40.

32. Horten and Wiedemann 1913, p. 540. Avicenna nonetheless sides with Aristotle in believing that only reflection causes the rainbow.

33. Horten and Wiedemann 1913, pp. 540, 542. Some eight centuries before Avicenna, Alexander of Aphrodisias noted that the rainbow is inescapable (Boyer 1956, pp. 383–84).

34. Aristotle 1931, *Meteorologica* 374a; see Horten and Wiedemann 1913, p. 540. Like many of Aristotle's arguments by analogy, the fact that these color patterns vaguely resemble rainbows does not mean that the two phenomena have a common cause.

35. See Chapter 4's "Aristotle's Rainbow: Antiquity's Explanation of the Bow's Geometry."

36. Horten and Wiedemann 1913, pp. 541–42. Avicenna tartly remarks that Aristotelian explanations of rainbow colors are both "worthless" and "nonsense" (Horten and Wiedemann 1913, p. 542).

37. Horten and Wiedemann 1913, pp. 541–42. This is a variation on Alexander of Aphrodisias's complaint about Aristotle's theory of rainbow colors. As Figs. 8-18, 8-19, and 8-20 indicate, the rainbow's reds and oranges are its *darkest* colors, a feature that naked-eye observers can often see. Thus the persistent Aristotelian claim that the rainbow's red is its *brightest* color seems to represent the triumph of Aristotle's color theory over rainbow observation. See Chapter 7's "Aristotelian Color Theory and the Rainbow."

38. Horten and Wiedemann 1913, p. 542.

39. Sabra 1994, chap. 2, pp. 195–96; Winter 1954, pp. 195–206. Sabra (1994, chap. 9) discusses at length Alhazen's accurate critique of Ptolemy's theory of the moon illusion (that is, why the moon seems larger near the horizon when it actually is not).

40. Sabra 1994, chap. 2, pp. 196–97. The Latin *Optics* received an even wider circulation when a printed, rather than manuscript, version became available in 1572 (Lindberg 1967, p. 322).

41. Like Avicenna, Alhazen rejects the Aristotelian extramission theory of vision in *Meteorologica*, holding instead that light enters the eye from luminous objects in the outside world (Sabra 1994, chap. 2, pp. 192–94; Lindberg 1992, pp. 177–80; Lindberg 1967, pp. 321–27).

42. Sabra 1994, chap. 2, pp. 190–94; Crombie 1990; Lindberg 1967, pp. 322–30.

43. Sabra 1994, chap. 2, p. 194.

44. Boyer 1987, p. 61.

45. Sabra 1994, chap. 7, pp. 2–4.

46. Boyer 1987, p. 80; Winter 1954, p. 203. Alhazen's careful planning and construction of elaborate optical apparatus mark him as a pioneer of experimental optics. Ptolemy also measured angles of refraction between air and water, although his results seem to depend both on actual measurements and on arithmetic rules that approximate them (Boyer 1987, p. 61; Schramm 1965, pp. 74–76). Used with care, such mathematical approximations remain powerful scientific tools.

47. Boyer 1987, p. 112.

48. Sabra 1994, chap. 2, p. 194. This entrance angle is called the *angle of incidence*. For a sphere, the incidence angle is defined as the angle between (1) the incoming light ray and (2) the normal (that is, perpendicular) to the sphere's convex outer surface at the point where the light ray enters (see Figs. 5-2 and 5-3 for illustrations of incidence angles).

49. Winter 1954, p. 203.

50. We have drawn the incident ray thicker than either the reflected or refracted ones to indicate that the incident light's energy is divided between them. Beyond that, however, the relative thicknesses of the light rays have no significance in Fig. 5-2.

51. While Aristotle worries about the supposedly fixed ratio between the *lengths* of incident and reflected rays, he neglects their very real *angular* equality (Sayili 1939, pp. 75–77). Whatever Aristotle's knowledge of reflection, his geometry forces him to use mutually contradictory explanations of the different color orders in the primary and secondary rainbows (Sayili 1939, pp. 73–74).

52. Francis Cornford (1971, p. 154) says that Plato "knew that the angles of incidence and reflection are equal," based on Plato's remarks about mirror images in *Timaeus* (Plato 1952, pp. 103–5 [*Timaeus* 46a–46c]).

53. Note that when Fig. 5-2's refracted ray is refracted a second time from water into the air (the transmitted ray), it turns away from the surface normal slightly. In fact, after a ray exits a parallel layer of water, its path is exactly parallel to i.

54. If we designate the speed of light in a vacuum as c, then a medium's *refractive index* is the ratio of c to light's speed in the medium. A typical refractive index for water is 1.33, for glass it is 1.5, and air's refractive index is almost exactly 1.0. See Chapter 6's "René Descartes: The Rainbow Fixed in the Sky" for more on refraction and refractive indices.

55. For example, see Ptolemy's arithmetic-progression technique for approximating t from i (Boyer 1987, p. 61).

56. Naturally, real raindrops are never perfectly spherical, but this approximation is quite accurate for small drops. To see how we account for the very real effects on the rainbow of large, flattened raindrops, see Chapter 9's "Flattened Raindrops and the Pot of Gold."

57. More generally, the surface normal at any point on a raindrop (spherical or not) is defined as the normal to the plane that is tangent to the drop at that point. For a sphere, we can substitute the appropriate radius for this more cumbersome definition.

58. Alhazen 1989, vol. 1, p. 48 (*Optics* 1.3.132).

59. See Chapter 7's "Aristotelian Color Theory and the Rainbow." As we discuss later, because color perception is inherently psychophysical, *all* color stimuli that originate in our surroundings are equally "real." Colors seen in the absence of an outside visual stimulus (for example, "seeing stars" when the head is struck) we can arbitrarily label as "unreal."

60. Alhazen 1989, vol. 1, p. 48 (*Optics* 1.3.133). Alhazen's statement about reflection from opaque objects arises from his belief that only "smooth" (that is, glossy) objects reflect light; opaque, nonglossy objects instead receive "essential" light from luminous bodies and *emit* it as "accidental" light (Sabra 1994, chap. 2, p. 191). See Alhazen (1989, vol. 1, pp. 44–46 [*Optics* 1.3.113–23, esp. 121]) for further statements about opaque bodies and their accidental light.

61. See the Appendix's "A Field Guide to the Rainbow" for an overview of how rainbow colors are actually generated.

62. See Chapter 7's "Newton's Disquieting Color Ideas."

63. Alhazen 1989, vol. 2, pp. xxxiii, xlvi n. 59.

64. Sabra 1994, chap. 7, p. 4.

65. Alhazen does not explicitly mention Aristotle in his rainbow treatise, but he earlier wrote a now-lost summary of *Meteorologica* (Alhazen 1989, vol. 2, p. xlvi).

66. Alhazen 1989, vol. 2, p. xlvi. Unlike Aristotle, Alhazen correctly maintains the equality of the angles of incidence and reflection in his model.

67. Winter 1954, p. 205.

68. See Alhazen 1989, vol. 2, p. xlvii, fig. 2; Wiedemann 1914, figs. 3 and 5. Alhazen realistically places the observer closer to the rainbow cloud and the sun much farther from it than Aristotle (Alhazen 1989, vol. 2, p. xlvi).

69. Do *not* try this demonstration using direct sunlight as your light source; the intense reflections that result can irreparably damage your sight.

70. There are practical problems with seeing the central reflection. Your head shades the area immediately around the antisolar point, and the antisolar point is usually projected onto the ground in front of you, not onto a distant cloud.

71. The thirteenth-century English scholar Robert Grosseteste pointed out this deficiency of the concave-reflector model (see n. 124 below), although he is almost certainly criticizing Aristotle, not Alhazen, whose work he apparently did not know (Grant 1974, p. 390).

72. See Chapter 4's "Aristotle's Rainbow: Antiquity's Explanation of the Bow's Geometry."

73. Alhazen 1989, vol. 2, p. xlvii; Winter 1954, p. 205. In this error, Alhazen was followed by the influential Moorish philosopher Averroës (in Arabic, Abū al-Walīd Muḥammad Ibn Aḥmad Ibn Muḥammad Ibn Rushd; 1126–98), whose account of the rainbow draws on both Aristotle and Alhazen. Naturally, both Averroës and Alhazen believed their theories were fundamentally sound.

74. Crombie 1962, p. 238; see Chapter 6's "René Descartes: The Rainbow Fixed in the Sky."

75. Sabra 1994, chap. 2, pp. 196–97.

76. Boyer 1987, p. 125; Winter 1954, p. 207; Walbridge 1992, p. 173. David Lindberg notes that Alhazen's rainbow treatise was never translated into Latin (Pecham 1970, p. 270 n. 42).

77. Winter 1954, p. 207; Wiedemann 1910–11, pp. 191–92; see also Schramm 1965, pp. 81–85.

78. Boyer 1987, p. 125; Winter 1954, pp. 207–8; Wiedemann 1914.

79. Winter 1954, p. 208.

80. Walbridge 1992, p. 181; Boyer 1987, p. 125; Sarton 1931, part 2, pp. 762–63. Quṭb al-Dīn's rainbow theory appeared in his first work on astronomy, *Nihāyat al-Idrāk fī Dirāyat al-Aflāk* (The Highest Attainment in the Knowledge of the Spheres), completed in 1281.

81. Theodoric of Freiberg independently achieved a similar breakthrough in Europe a few years later (see this chapter's "Theodoric of Freiberg's Rainbow in a Raindrop"). See Boyer 1987, pp. 110–11; Winter 1954, pp. 207–8; Sarton 1931, part 2, pp. 762–63.

82. Winter 1954, pp. 207–8.

83. Crombie 1959, p. 34.

84. Lindberg 1992, pp. 204–5; Crombie 1959, pp. 41–46. A notable Latin version of Aristotle that predates the twelfth century is Boethius's translation of the *Organon*'s six treatises on logic (Lohr 1982, pp. 81–82; Ebbesen 1982, pp. 103–5).

85. Lindberg 1992, pp. 204–5; Crombie 1959, pp. 34–35.

86. Lindberg 1967, p. 330.

87. Dod 1982, p. 76.

88. Crombie 1962, p. 117 n. 4.

89. Lindberg 1967, p. 330.

90. Kenny and Pinborg 1982, pp. 11–12. See Lindberg (1992, pp. 190–97) for more on the rise of urban schools (including church schools) from the ninth century onward.

91. Kenny and Pinborg 1982, pp. 13–14. Lindberg (1992, pp. 206–13) provides an overview of the early universities.

92. See Lindberg (1992, p. 138) for the Roman origins of the trivium and quadrivium.

93. Callus 1944, p. 3. Lindberg (1992, p. 197) describes the thirteenth-century transition between the *Timaeus*' Platonic natural philosophy and its newly available Aristotelian successor.

94. Kenny and Pinborg 1982, pp. 18–19; see also Lindberg (1992, pp. 212, 218).

95. See the introduction to Chapter 2 for these men's views on the rainbow.

96. Lohr 1982, p. 80. Augustine emphatically stated that if there were philosophers who taught anything "contrary to our Scriptures, that is to Catholic faith, we may without any doubt believe it to be completely false, and we may by some means be able to show this" (Crombie 1959, p. 60).

97. Callus 1944, p. 5. Official use of Aristotle's scientific works encountered some early resistance from the church. Beginning in 1210, teaching these works at the University of Paris (but not private study of them) was proscribed for several decades (Lindberg 1992, pp. 216–18; Dod 1982, p. 71; Crombie 1959, p. 61).

98. Lohr 1982, p. 83.

99. Lindberg 1992, p. 212. Contemporary scientific ideas from Hebrew, Arabic, and Oriental sources were used, as well as those from ancient Greece (Lohr 1982, pp. 83–84).

100. Ebbesen 1982, p. 101. The third condition sometimes required that the authors be interpreted in novel (that is, insupportable) ways, "so as to make them say what they ought to have said."

101. Callus 1944, pp. 27–29.

102. Boyer 1987, p. 88. Boyer places Grosseteste in Paris c. 1210, the year that provincial ecclesiastical authorities banned Aristotle's works on natural philosophy from the University. Whether Grosseteste had any exposure to Aristotle during his earlier education at Oxford is unclear.

103. Grosseteste was professor and chancellor at Oxford, and from 1235 he served as Bishop of Lincoln (Oxford's diocese) (Crombie 1959, p. 62; Callus 1944, p. 26).

104. Lindberg 1992, p. 224; Callus 1944, pp. 27–28.

105. Pecham 1970, p. 20; Crombie 1962, pp. 104–9. Grosseteste held that "from a point of light a sphere of light of any size may be instantaneously generated" and that the rainbow involves "the reversal of light because of cloud" (Crombie 1962, pp. 106, 115). The first statement gives light infinite speed, the second gives finite speed (because reversal implies propagation over time). At first reading, these ideas seem mutually exclusive.

106. Crombie 1962, p. 105.

107. Lindberg 1967, pp. 335–41; Crombie 1962, p. 214. Extramission is closely related to this idea.

108. Crombie 1962, p. 110.

109. Crombie 1962, pp. 110, 147.

110. Lindberg 1978, p. 340; Lindberg 1967, pp. 334–35. Aristotle's belief that a transparent medium lying between ob-

ject and viewer is required to transmit color differs from Epicurus's idea of streams of vision-producing particles (Aristotle 1931, *De anima* 419a).

111. Lindberg 1978, pp. 350–52. Species' power could be transmitted or "multiplied" by neighbor-to-neighbor agitation, similar to the progress of a wave spreading across a pond. Thus power is transmitted without net flow of the medium (Crombie 1962, pp. 114, 146–47, 110 n. 1).

112. Lindberg 1967, pp. 332–41.

113. Lindberg 1978, p. 352; Lindberg 1967, pp. 334–38. Neither man was explicitly analyzing the Epicurean model; both were simply advancing their own, coincidentally related theories. Although Gerard of Cremona's Latin translation of Alhazen's *Optics* predates 1200, Grosseteste does not mention Alhazen, implying that he had not seen the *Optics* (Eastwood 1966, p. 317; Crombie 1962, p. 117).

114. In the case of Aristotle, compare *De generatione animalium* 781a (Aristotle 1979, p. 505) and *Meteorologica* 373b, where Aristotle uses extramission, with *De anima* 419a (Aristotle 1931), in which he uses intromission.

115. Lindberg 1967, p. 339; Crombie 1962, pp. 117–18. Plato proposes a two-way model of vision (that is, combined extramission and intromission) in *Timaeus* (Plato 1952, pp. 101–3 [*Timaeus* 45b–46a]; Cornford 1971, pp. 152–53).

116. Crombie 1962, p. 114. See Aristotle 1976, p. 243 (*Posterior Analytics* 98a).

117. Crombie 1962, p. 114. Grosseteste's choice of a model of vision is immaterial so long as he is concerned with the path that visual energy takes. Geometrical optics still uses the idea that, with some important exceptions, the path of a light ray will be unchanged if we reverse the light's direction. Alhazen seems to have been the first to enunciate this *reciprocal law* (Crombie 1962, p. 219).

118. Aristotle 1976, p. 243 (*Posterior Analytics* 98a).

119. Sayili (1939, p. 71) discusses the reflection-refraction ambiguity found in Aristotle's Greek. Grosseteste's rudimentary Greek at the time of his *Posterior Analytics* commentary (c. 1220–25) certainly would not have helped resolve this ambiguity (Southern 1992, pp. 132–33).

120. Eastwood 1966, p. 315. James McEvoy proposes slightly earlier dates, 1230–33 (see Southern 1992, p. 120).

121. Eastwood 1966, p. 317. Lindberg has even less patience than Eastwood, labeling Grosseteste's theory "a collection of *ad hoc* assumptions that do not begin to show how refraction can satisfactorily account for the phenomena of the rainbow" (Lindberg 1966, p. 241).

122. Grant 1974, p. 390; Crombie 1962, p. 125. Recall that Aristotle's (and Alhazen's) unrealistic model of reflection by a concave cloud-mirror *does* produce a bright ring of light some distance from the antisolar point. However, Grosseteste is merely pointing out that the exposed cloud surface itself would be sunlit.

123. See n. 23 above and Chapter 8's "Why Do Cloudbows and Rainbows Look So Different?"

124. Grosseteste writes of the "reflection of solar rays from the convexity of the mist descending from a cloud as from a convex mirror" and then onto a concave cloud opposite the observer (Grant 1974, p. 390). Because a raindrop's surface reflects most light forward (that is, away from the sun), Grosseteste can indeed use this external reflection to illuminate a concave cloud opposite the sun. But we do not know whether Grosseteste studied such external reflection patterns or merely asserted that they would occur.

125. Crombie 1962, p. 125. For other translations of this important passage, see Eastwood (1966, p. 318) and Lindberg in Grant (1974, pp. 390–91). In Lindberg's translation "reflection" is in error; it should be "refraction."

126. Seneca 1971, pp. 59–61 (*Naturales quaestiones* 1.7.1–3). In trying to explain the rainbow's large size compared to the sun, Seneca shows his jumbled understanding of reflection and refraction: "Anything seen through moisture is far larger than in reality [that is, it is magnified by refraction]. Why is it so remarkable that the image of the sun is *reflected* larger when it is seen in a moist cloud . . . ?" (Seneca 1971, p. 59 [*Naturales quaestiones* 1.6.6]; emphasis added).

127. Eastwood 1966, pp. 314–15.

128. Eastwood 1966, p. 317. In fairness, Grosseteste made several observations about the rainbow that gainsaid ancient authority (see n. 150).

129. Grant 1974, p. 390; Eastwood 1967, p. 405; Crombie 1962, p. 123.

130. Schramm 1965, pp. 74–78. Ptolemy's *Optica* was unknown to Grosseteste (Eastwood 1966, pp. 316–17).

131. Eastwood (1967, pp. 405–13) describes the likely philosophical underpinnings of Grosseteste's law of refraction.

132. Grant 1974, p. 390.

133. Grant 1974, p. 390.

134. Eastwood 1967, p. 407 (see Aristotle 1930, *De caelo* 271a).

135. Ockham's principle that "it is futile to use more entities when it is possible to use fewer" (Crombie 1962, p. 176) becomes, in modern scientific paraphrase, "among equally accurate theories, the simplest is best." Ockham's sharp and unsparing use of his principle earned it the enduring name of *Ockham's razor*.

136. A contemporary of Descartes, Fermat was one of the seventeenth-century's most influential mathematicians. *Fermat's principle* in optics can be used to explain a variety of phenomena, one of which is the equality of angles of reflection and incidence. When these angles are equal, the path between a light source, a reflector, and the eye is the shortest possible one, meaning that light traverses this path in less time than any other.

137. As noted above, the path that connects a light source, a reflecting surface, and the eye is shortest (that is, most economical) when its incidence and reflection angles are equal. In fact, bright mirror-like reflections occur *only* in the direction whose angle with the surface normal equals the incidence angle.

138. When a light ray passes into a less dense medium, the angle of refraction *is* less than the angle of incidence. Although a 1:2 ratio of these angles is possible for air and glass, it is *impossible* for air and water in the visible part of the spectrum (Fig. 7-6 illustrates the visible spectrum). Thus Grosseteste's law of refraction could never hold true for visible light and raindrops.

139. Eastwood 1966, pp. 317–18; Crombie 1962, p. 124.

140. Grant 1974, p. 390.

141. Eastwood 1966, p. 319 n. 26.

142. Eastwood characterizes Grosseteste's description of his model as "somewhat cryptic"; Lindberg calls it "far from self-evident" (Eastwood 1966, p. 318; Lindberg 1966, p. 240).

143. Grant 1974, pp. 390–91; Eastwood 1966, p. 326. As discussed below, however, Grosseteste does not elaborate on the mechanism by which we see the rainbow on this second

cloud. Eastwood has reconstructed Fig. 5-5 based on Grosseteste's description; no contemporary illustrations exist.

144. We might think of this as "four different refractive indices," yet Grosseteste's law of refraction said nothing about refractive differences among different media.

145. Eastwood 1966, pp. 318–19.

146. Eastwood 1966, p. 319.

147. Eastwood 1966, pp. 327–28.

148. Eastwood 1966, p. 323.

149. Eastwood 1966, p. 328. The Aristotelian notion that the contrary properties (usually darkness and brightness) cause color is a fixture of medieval rainbow theories. See Chapter 7's "Aristotelian Color Theory and the Rainbow" for more on Aristotle's color theory.

150. This is perhaps the earliest explicit statement that not all rainbows look the same. For this color iconoclasm alone (and the careful observation that presumably underlies it), Grosseteste deserves great credit. See Chapter 7's "How Many Colors Does the Rainbow Have?" for examples of the variability of rainbow colors.

151. Eastwood 1966, p. 328. Neither "purity" nor "impurity" is used here in its modern colorimetric sense (see Chapter 7's "Quantifying the Rainbow's Colors").

152. Grant 1974, p. 391; Eastwood 1966, pp. 328–29.

153. In yet another borrowing from Aristotle, Grosseteste claims that "it is manifest that it is not within the abilities of painters to reproduce the rainbow" (Eastwood 1966, p. 328). This passage suggests that Grosseteste made the Aristotelian distinction between tangible pigment colors and intangible rainbow colors. See Chapter 7's "Aristotelian Color Theory and the Rainbow."

154. Eastwood 1966, p. 329. Grosseteste and other medieval scholars made the Aristotelian distinction between *material* and *efficient causes*. An efficient cause is the immediate, often energetic, cause of an effect (for example, visual rays or sunlight cause the rainbow). A material cause is the object or medium on which the efficient cause acts (for example, clouds, dew, or mist cause the bow). As another example, Aristotle enumerates the material and efficient causes of meteors in *Meteorologica*'s Book 1 (Aristotle 1952, pp. 29–35 [*Meteorologica* 341b–342a]).

155. Witelo 1983, p. 49 n. 167. Writing in 1567, mathematician Francesco Maurolico suggests the defects of sixteenth-century mirrors when he says, "Again the colors of the secondary [rainbow] are weaker as if produced by light which is reflected successively from one or possibly two mirrors" (Maurolico 1940, p. 126).

156. Eastwood 1966, p. 319.

157. Lindberg 1966, p. 239; Grant 1974, p. 391.

158. Pecham 1970, p. 235; Lindberg 1966, p. 239. Pecham's own rainbow theory combines elements of Grosseteste's refraction theory and Aristotelian reflection (Pecham 1970, pp. 233–37).

159. See n. 117 above; the pairing of reflection and refraction occurs in Grosseteste's commentary on Aristotle's *Posterior Analytics* (Crombie 1962, pp. 114, 115 n. 1). Naturally, Grosseteste's ideas on the rainbow may have changed in the years between writing this commentary and *De iride*, but he does not say so explicitly (Boyer 1987, p. 92).

160. Eastwood 1966, pp. 318, 321; Crombie 1962, pp. 122, 111 n. 6. Compare Grosseteste's statement that refraction makes it "possible to read minute letters from incredible distances" (Grant 1974, p. 389) with Seneca's note that "letters, however tiny and obscure, are seen larger and clearer through a glass ball filled with water" (Seneca 1971, pp. 57–59 [*Naturales quaestiones* 1.6.5]).

161. Lindberg 1966, p. 241. This is the same question Grosseteste asks about Aristotle's reflection rainbow (Grant 1974, p. 390).

162. Figures 8-5 and 9-2 show rainbows with bright interiors. See Chapter 8's "Observed and Intrinsic Rainbow Colors" for reasons that this enhanced brightness is not always visible. Because only unusually vivid rainbows exhibit this interior brightness, it was seldom an issue in early rainbow theories. See also Minnaert 1993, pp. 197–98; Lee 1991, p. 3402; Greenler 1980, pp. 7–9.

163. Eastwood 1966, p. 331.

164. *De iride* covers not quite six small manuscript pages (Boyer 1987, p. 94).

165. Southern 1992, p. 120.

166. A fervent proponent of the cure of souls, Grosseteste was bitterly opposed to the papal practice of granting benefices to favored clerics who cared more for themselves than their flocks. In 1250, Grosseteste presented his grievances about the state of the church to Innocent IV (reigned 1243–54) in a peroration whose only visible consequence was Innocent's later suspension of Grosseteste from his episcopal duties (Southern 1992, pp. 276–91).

167. Southern 1992, p. 296.

168. Crombie 1962, pp. 135–36.

169. Boyer 1987, p. 94. See Crombie (1962, pp. 162–88) for Grosseteste's scientific influence in general.

170. A young Thomas Aquinas was one of Albertus's students at Paris; we know that the two men worked closely from 1252 onward (Lindberg 1992, p. 231).

171. Lindberg 1992, pp. 229–30; Crombie 1962, pp. 194–200. As belated (and rather odd) proof of Albertus's stature in medieval science, the church made him patron saint of scientists in 1941.

172. Thorndike 1958, p. 540. Albertus's resolve failed him when he embellished a fantastic tale of Pliny's. Pliny claimed that hunters escaped a tigress by throwing her cubs at her one at a time; Albertus changed the ruse into rolling reflecting glass spheres at her (Thorndike 1958, p. 543).

173. Boyer 1987, p. 94.

174. Thorndike 1958, pp. 546–47.

175. Thorndike 1958, p. 521. As late as the 1830s, two historians would praise Albertus's scientific works effusively (Thorndike 1958, pp. 532–33). For more on Albertus's philosophical outlook, see Lindberg (1992, pp. 228–31).

176. Crombie 1962, p. 196.

177. Albertus Magnus 1890, pp. 666–700.

178. Aristotle actually says "So we have only met with two instances of a moon rainbow in more than fifty years," a simple observation easily mistranslated as fiat (Aristotle 1931, *Meteorologica* 372a). Humphreys (1938) discusses reasons for the lunar rainbow's rarity.

179. Thorndike 1958, pp. 547–48.

180. Poseidonius's rainbow theory is essentially that of Aristotle, and Seneca variously agrees and disagrees with Poseidonius's ideas (Boyer 1987, pp. 57–59; Seneca 1971, pp. 51–53 [*Naturales quaestiones* 1.5.10–13]).

181. Crombie 1962, p. 197.

182. Boyer 1987, p. 95. We would call this borrowing without attribution plagiarism, but Albertus was simply following

common practice in ancient and medieval scholarly writing, where rivals or fellow-thinkers might or might not be mentioned by name and where detailed citations were rare.

183. Boyer 1987, pp. 95–96.

184. Albertus and his contemporaries would not have used "vapor" in the modern sense of a gas that can be compressed at constant temperature to form a liquid. Instead, medieval "vapor" seems closer to "mist"—that is, very humid air containing some droplets, possibly resembling a very thin fog. See Wallace (1959, p. 183) for another medieval definition of vapor.

185. Crombie 1962, p. 197; see also Boyer 1987, p. 96.

186. This is Fig. 5-3's transmitted ray. Note that when the internal refracted ray encounters the back of the drop, (1) most is refracted a second time and is transmitted from the drop, forming the spectrum that Albertus describes, but (2) a small fraction of it is reflected internally before being refracted to form the primary rainbow (Fig. 5-3's internally reflected ray; see also Fig. 6-5).

187. Boyer 1987, pp. 96–97; Crombie 1962, pp. 198–200.

188. Crombie 1962, pp. 197–98.

189. Bacon first wrote about the rainbow circa 1263 (Pecham 1970, p. 15). As a whole, the *Opus majus* was probably completed around 1267–68 (see n. 196 below).

190. Lindberg 1982, p. 3.

191. Bacon was educated at Oxford and the University of Paris. After receiving a degree at Paris circa 1240, he taught there before returning to Oxford in 1247, where he became a Franciscan friar around the year 1257. Grosseteste and Bacon probably never met (Lindberg 1992, pp. 224–26; Lindberg 1983, pp. xvii–xxi; Crombie 1962, p. 139 n. 4).

192. Bacon 1962, p. 126; see also Lindberg 1982, p. 20. As for Albertus Magnus, Bacon fervently attacked his view of Aristotelian science (Lindberg 1982, p. 14 n. 54; Hackett 1980, pp. 70–72).

193. Bacon 1962, pp. 124–26; Lindberg 1982, pp. 20–21. David Lindberg finds Platonic and Aristotelian elements in Bacon's view of the relationship between mathematics and nature. He notes that Bacon, like Grosseteste, advanced both the cause and the practice of mathematics in science while not offering mathematics as a panacea (Lindberg 1982, pp. 24–25).

194. In one twentieth-century edition of the *Opus majus*, the plea in Part 4 for a mathematical science consumes more than three hundred pages (Bacon 1962, pp. 116–418).

195. Lindberg 1983, p. xxii; Lindberg 1982, p. 16. Bacon and de Foulques may already have known one another when they first corresponded before 1265.

196. Lindberg 1983, pp. xxii–xxv; Lindberg 1971, p. 68; Sarton 1931, part 2, pp. 952–53. Lindberg estimates that Bacon sent the completed works to Clement in 1267 or 1268. Just how secret these writings were among Bacon's fellow Franciscans is moot (Lindberg 1971, pp. 71–72).

197. Thorndike 1958, pp. 652–53.

198. Lindberg 1983, pp. xviii–xix.

199. Lindberg 1982, pp. 16, 25.

200. Crombie 1962, pp. 162–63. Unlike Grosseteste, Bacon believed that the speed of light was finite, an opinion for which he argues persuasively (Bacon 1962, pp. 486–89).

201. Thorndike 1958, pp. 655–58. Bacon asserts that "Ethiopian sages" drive flying dragons from caves and ride them "at top speed through the air." In addition, the flesh of these dragons may be used to "prolong life and inspire the intellect beyond all estimation." See Lindberg (1992, pp. 274–80) on the background and importance of medieval astrology.

202. Hackett 1980; Sarton 1931, part 2, p. 953.

203. Bacon 1962, p. 583.

204. Bacon 1962, p. 588.

205. Bacon 1962, p. 588. Figure 7-5 illustrates how white light passing obliquely through a prism is refracted (or *dispersed*) into different colors. The amount of refractive bending is determined by the color of the refracted light.

206. Bacon 1962, pp. 588–89.

207. Bacon 1962, p. 589; Aristotle 1931, *Meteorologica* 374a.

208. Bacon 1962, p. 589; Horten and Wiedemann 1913, p. 540.

209. Bacon does add the accurate (and perhaps original) observation that a bow is visible on the ground "where the dewfall is plentiful and sufficient to take the whole circle" (Bacon 1962, p. 589). For a modern account of this *dewbow*, see Minnaert (1993, pp. 202–3).

210. Bacon 1962, p. 592. See Chapter 4 for a summary of the rainbow's position in the landscape.

211. Carl Boyer notes that Bacon's measurement "appears to be the first estimate of the size of the bow" (Boyer 1987, p. 100).

212. Bacon 1962, p. 590; Crombie 1962, p. 157. For an overview of the astrolabe itself, see Lindberg (1992, pp. 264–65).

213. Bacon 1962, p. 594. Bacon is obviously exaggerating here; although the number of raindrops in a shower is vast, it is certainly finite.

214. Bacon 1962, pp. 594–95. Recall that this size illusion is likely related to the moon illusion (see Chapter 4's "Aristotle's Rainbow: Antiquity's Explanation of the Bow's Geometry"). While the radius of the rainbow *does* depend on raindrop size, it is for all practical purposes unaffected by solar elevation. See Fraser 1983b and Chapter 8's "A Map of the Rainbow's Colors."

215. Bacon 1962, p. 595. Implicit in this claim is the correct assumption that sunlight rays are parallel. Unlike many of his predecessors, Bacon explicitly states that this is so (Bacon 1962, p. 601; see also Crombie 1962, pp. 160–61).

216. Bacon 1962, p. 601.

217. Bacon 1962, p. 608. See n. 178 above.

218. Bacon 1962, pp. 600–601. See Chapter 4's "Infinitely Distant Light: The Bow's Ambiguous Distance in the Landscape."

219. Bacon 1962, p. 602.

220. Bacon 1962, p. 602.

221. Bacon 1962, p. 602.

222. Bacon 1962, pp. 604–5. For Bacon on the multiplication of species, see Lindberg (1983, pp. liii-lxxi) and Crombie (1962, pp. 146–47).

223. Lindberg 1966, pp. 241–43. By implication, Bacon is also challenging Albertus Magnus, who used what was essentially Grosseteste's rainbow model (Crombie 1962, p. 160 n. 1).

224. Bacon 1962, p. 609. These objections include (1) If the rainbow requires a refracting cloud and a cone of moisture, why are bows visible in sunlit spray? and (2) Why should refraction produce an arc, rather than a disk, of light? In fact, the second objection is less telling than Bacon assumes; see n. 162 above.

225. Bacon says that "we must imagine a cloud suspended in the air, and rain descending from it. The vertex of the cone falls upon the earth, and the circular base touches the concave surface of the cloud" (Bacon 1962, pp. 606–7). As Fig. 5-5 indicates, Eastwood believes that Grosseteste's cone of moisture

has its base at the ground rather than at the cloud; Lindberg differs (1966, p. 240 nn. 15–16). Whatever its orientation and composition, the idea of a vertical cone of moisture apparently passed from one generation of writers to the next (that is, Grosseteste, Albertus Magnus, and Bacon).

226. Bacon 1962, p. 607.

227. In fairness, Bacon was not unthinkingly hostile to using refraction in atmospheric optics. Refraction was central to his roughly correct explanation of the 22° halo, even if he did erroneously substitute refracting water drops for ice crystals (Bacon 1962, p. 613; see also Crombie 1962, p. 161).

228. Bacon 1962, p. 610.

229. Bacon surely did not know the exact distribution of light externally reflected by transparent raindrops, but even cursory study of reflection by an array of spherical mirrors shows that they will not produce a bright arc of light 42° from the antisolar point.

230. Lindberg 1966, p. 246.

231. Bacon 1962, p. 605.

232. Bacon 1962, p. 606.

233. Bacon 1962, p. 607.

234. Bacon explains away the rainbow's nonexistent black by saying: "The color of blue termed celestial is black with a certain sweetness of luster, and is therefore reckoned under black." He offers no explanation for the absence of white (Bacon 1962, p. 612).

235. Bacon 1962, pp. 611–12.

236. Lindberg 1966, pp. 246–47.

237. Rousseau 1992.

238. Bacon 1962, p. 615.

239. Witelo 1983, pp. 14–17.

240. Witelo 1983, pp. 16–17; Witelo 1972, pp. x–xi; Lindberg 1971, p. 73.

241. Boyer 1987, p. 103; see also Witelo 1972, p. xiii; Crombie 1962, p. 213. Viterbo was an important alternative residence for the popes from about 1257 until 1309, when Clement V (reigned 1305–14) removed the papal see from Rome to Avignon.

242. Lindberg 1971, pp. 73–75; Crombie 1962, p. 213. Bacon and Witelo could have crossed paths, but this is unlikely (Lindberg 1971, p. 73). Witelo may also have drawn on the rainbow writings of Albertus Magnus in *De meteoris* (Crombie 1962, p. 214 n. 1).

243. Lindberg 1967, p. 341; Crombie 1962, pp. 215, 217; see also Lindberg 1971, p. 74.

244. Crombie 1962, p. 215. See n. 58 above for Alhazen's similar ideas on "form."

245. Crombie 1962, pp. 218–23.

246. Crombie 1962, p. 219.

247. Witelo 1972, pp. xx–xxi; Crombie 1962, pp. 223–25; Boyer 1987, p. 105. Witelo is unaware that *total internal reflection* occurs when the incidence angle in the denser medium exceeds some critical value. For i greater than this value, none of the incident light is refracted into the less dense medium, an easily demonstrable fact. The critical i for visible light refracted from water into air is about 48.6°. At larger i the incident light is totally reflected by the water-air interface, making Witelo's reported "refraction angles" there pure fiction. Witelo's measurements also belie his professed understanding of the reciprocal law (Witelo 1983, p. 47 n. 159; Crombie 1962, p. 224).

248. Boyer 1987, pp. 106–7; Witelo 1972, pp. xxi–xxv; Crombie 1962, p. 213.

249. Witelo 1972, p. 462; Lindberg 1971, p. 72. Witelo was also motivated to write by the request of a friend at Viterbo, the translator and papal confessor William of Moerbeke (Witelo 1983, p. 16 n. 20).

250. Boyer 1987, p. 103; Crombie 1962, pp. 226–28.

251. Crombie 1962, pp. 226–27. For every reflection inside and outside a raindrop, incidence and reflection angles *are* equal. In spherical raindrops, however, this fact alone does nothing to fix the rainbow's position.

252. Crombie 1962, p. 227.

253. Crombie 1962, p. 227.

254. Crombie 1962, pp. 231, 229 n. 6. Witelo's theory of rainbow colors is vintage Aristotle; see Chapter 7's "Aristotelian Color Theory and the Rainbow."

255. Witelo 1972, p. 466.

256. Boyer 1987, p. 106.

257. Crombie 1962, pp. 229–30.

258. Boyer 1987, p. 105; Crombie 1962, pp. 231–32.

259. Recall that this cone's axis is defined by the sun, eye, and center of the rainbow (the antisolar point or shadow of your head).

260. Boyer 1987, p. 103; Crombie 1962, p. 228.

261. Crombie 1962, p. 228; Witelo 1972, p. 471; see also Boyer 1987, p. 106.

262. Witelo himself admitted that his sun-elevation effect might be imperceptible (Boyer 1987, p. 106). See Fraser (1983b, fig. 5) for sun elevation's influence on the rainbow's radius, which is small for large nonspherical raindrops and nonexistent for smaller spherical ones. Practically speaking, solar elevation has no effect on rainbow radius.

263. Wallace 1959, p. 12. Although Theodoric's actual town of origin is unknown, the Freiberg attached to his name is in Saxony, as distinct from the cities of Freiburg im Breisgau (Germany) and Fribourg (Switzerland) (Wallace 1959, p. 10 n. 2).

264. Wallace 1959, p. 11.

265. Wallace 1959, p. 13. Theodoric may also have taught during this decade, which might account for some of his completed research (Wallace 1959, p. 11).

266. Wallace 1959, p. 12.

267. Wallace 1959, pp. 14–15, 174. *De iride* dealt with a wide range of celestial "impressions" other than rainbows, including comets, solar and lunar halos, and *parhelia* or *sun dogs* (on the latter, see Minnaert 1993, pp. 214–15; Greenler 1980, pp. 26–28). Recall that Quṭb al-Dīn had arrived at nearly the same rainbow model several years before Theodoric. The two men were almost certainly unaware of each other's work, instead drawing on a common Greco-Arabic optical heritage.

268. Crombie 1962, p. 237.

269. Grant 1974, p. 436 n. 5; Wallace 1959, pp. 25–26.

270. Wallace 1959, pp. 25, 42–50. In Scholastic logic, "demonstration" meant demonstration by syllogism, not physical example, and "definitions" are the syllogism's premises.

271. Crombie 1962, p. 240. See also Aristotle 1976, p. 91 (*Posterior Analytics* 79a).

272. Crombie 1962, p. 240. For an example of Aristotle's two-fold demonstration, see Aristotle 1976, pp. 85–87 (*Posterior Analytics* 78a–78b). Theodoric uses "optics" here in its classical sense of geometrical ray diagrams constructed from physical rays' observed behavior.

273. Boyer 1987, p. 113; see also Crombie 1962, p. 244.

274. Crombie 1962, p. 239.

275. Crombie 1962, p. 241.

276. Crombie 1962, p. 237.
277. Boyer 1987, p. 113; Crombie 1962, p. 242. See n. 247 for a definition of "total reflection."
278. Crombie 1962, p. 242.
279. Crombie 1962, pp. 238–39.
280. For Theodoric, the rainbow's efficient cause is "radiation from a star that is shining brightly" (for example, the sun), and its material causes are "a dewy cloud" and "a collection of falling drops released from a cloud as rain" (Grant 1974, p. 436; see also Lloyd 1971, pp. 105–6).
281. Boyer 1987, p. 113; Crombie 1962, p. 243.
282. Boyer 1987, p. 113; Crombie 1962, p. 247.
283. Boyer 1987, p. 114; Crombie 1962, p. 247.
284. Crombie 1962, pp. 244–45.
285. For transparent objects, this brightness or darkness depends on whether light passing through them gives rise to "clear translucency" or "obscure translucency" (Wallace 1959, pp. 191–93).
286. Boyer 1987, pp. 113–14; Crombie 1962, p. 245. As for the colors of opaque bodies, Theodoric hopefully lumps them together with those of transparent objects (Crombie 1962, p. 247). William Wallace explains Theodoric's observations and highly formalized theory of color in great detail (Wallace 1959, pp. 188–205).
287. Crombie 1962, pp. 246–47.
288. Crombie 1962, pp. 247–48.
289. Ironically, every time we admire a light beam from the side, we cannot be seeing the beam. By definition, we see a light beam per se only when it shines directly into our eyes. Any light seen to the side of a beam must be light *scattered out of* the beam. However, this scattered light often will be brightest near the beam itself, thus effectively defining the beam's otherwise invisible path (Bohren 1987, p. 105). The water in Theodoric's glass spheres probably contained enough scatterers (such as floating solids) to define light beams clearly.
290. Crombie 1962, p. 249; see also Boyer 1987, p. 114. Of course, Theodoric's analogy between a water-filled glass sphere and a raindrop is not perfect, since additional reflections and refractions occur at the glass-water boundaries. These are of such minor importance, however, that we can effectively treat the sphere as a model raindrop.
291. Boyer 1987, pp. 118–23; Crombie 1962, p. 251.
292. Crombie 1962, figs. 8 and 9. Whether Aristotle knew that i equals r may be moot, but there is no question that Theodoric knew this, as his diagrams usually indicate.
293. Grant 1974, pp. 437 n. 14, 438–39; see also Boyer 1987, pp. 121–22. Like Witelo, Theodoric appreciates that discrete colors first arise within the drop rather than outside it (even though his mechanism for creating colors is wrong). See Crombie 1962, p. 249.
294. Grant 1974, p. 437; see also Crombie 1962, p. 250.
295. Our use of light rays, rather than beams, in rainbow diagrams (for example, Figs. 4-3 and 6-5) is simply an illustrative convenience, not a contradiction of Theodoric.
296. Crombie 1962, p. 252; see also Boyer 1987, pp. 119, 124.
297. Boyer 1987, p. 124.
298. Grant 1974, p. 437. Theodoric reiterates this idea later in Chapter 38 of *De iride*.
299. Grant 1974, p. 440; Crombie 1962, p. 255. Theodoric writes that properly positioned sunlit raindrops can contribute to the secondary rainbow "whether the drop is elevated above the horizon on the altitude circle at the summit of the rainbow or is located to the right or to the left of the viewer" (Grant 1974, p. 440).
300. Crombie 1962, p. 252; Boyer 1987, p. 120. Theodoric does not use the term "radius," but instead refers to the rainbow's position on his altitude circle. Because he has located the sun on the horizon, his rainbow's radius and maximum altitude are the same (Grant 1974, p. 440).
301. Theodoric consistently makes angular sizes too small—he measures the angular radius of the 22° halo and reports it as 11° (Boyer 1987, p. 120; Crombie 1962, p. 259).
302. Boyer 1987, p. 116; Grant 1974, p. 438.
303. Grant 1974, pp. 438–39.
304. Grant 1974, p. 439. As we now know, white light is actually a mixture of colors (see Chapter 7's "Metamerism and the Problem of Defining White").
305. Grant 1974, pp. 440–41; Crombie 1962, pp. 255–59. Theodoric blamed extra absorption for the secondary rainbow's darker colors. In fact, the secondary's lower brightness is caused by light refracted *from* the drop at each of the first two internal reflections. That light is unavailable to the third refraction from the drop, the one causing the secondary bow.
306. Boyer 1987, p. 122; Grant 1974, p. 439. See n. 304 for Theodoric on the rainbow's white interior. Given his skewed rainbow geometry and color theory, naturally Theodoric can only account for these features in principle, not in practice.
307. Boyer 1987, p. 124.
308. Crombie 1962, p. 260.
309. Observations never exactly coincide with theory, so every time a scientist defines acceptable experimental error, he or she makes a Platonic choice about the disagreement of mathematical theory and sense impressions (including those from instruments). Similarly, we should not be sanguine about the fierce conservatism that greets many new scientific ideas. Whether this is prudent skepticism or reactionary appeal to authority (sometimes one's own) is largely in the eye of the beholder.
310. Scientific conservatism has both advantages and disadvantages, as a recent article on unconventional scientific ideas points out (Raymo 1992).

CHAPTER SIX

1. Dante 1981, p. 157 (*Paradise*, canto 12.10–21).
2. Recall Theodoric rejecting the notion that the Trinity accounts for a tricolor rainbow (Boyer 1987, p. 113). In his commentary on Alhazen's *Optics*, Kamāl al-Dīn says: "The heavenly [optical] signs are among the wonderful works of God and the remarkable signs of His power" (Wiedemann 1914, p. 40).
3. Crombie 1962, p. 233 n. 1. Many copies might once have existed, but given the faint echoes of Theodoric's *De iride* in later works, this seems unlikely.
4. Crombie 1962, pp. 260–62.
5. At least two mentions of Theodoric's *De iride* survive from the fifteenth and sixteenth centuries (Boyer 1987, pp. 141, 144; Crombie 1962, pp. 268–69).
6. Crombie 1962, p. 262; Boyer 1987, p. 138; Grant 1974, p. 827.
7. Boyer 1987, pp. 129–70. In these pages, Boyer surveys some of rainbow theory's lesser lights during the three centuries after Theodoric.
8. Boyer 1987, pp. 148–50.

9. Leonardo da Vinci 1954, p. 284. Leonardo generally was a quite independent-minded rainbow observer and certainly not a repeater of Aristotelian cant. However, Leonardo casually remarks here that while the rainbow image is not illusory, "it follows that this arch is produced by the sun and by the cloud."

10. Digges 1927b, p. v.

11. Ronan 1992; Digges 1927b, pp. v-vii. The invention of the refracting telescope is usually presumed to predate slightly its first Netherlands patent of 1608. Ronan makes a compelling case that Digges constructed and used both refracting and reflecting telescopes more than half a century earlier.

12. Ronan 1992, p. 91. Leonard's son Thomas (1546–95) not only published a posthumous version of his father's final work (Digges 1927b) but also was an early advocate of the heliocentric solar system of Polish astronomer Nicolaus Copernicus (1473–1543). Thomas Digges himself wrote on ballistics and military surveying and precociously speculated about an infinite universe (Ronan 1992, pp. 92, 94).

13. Digges 1927a, pp. 38–39, 48.

14. Digges 1927a, pp. 27–29.

15. Digges 1927a, p. 27.

16. Digges 1927a, p. 6.

17. In his table of contents, Digges advertises the rainbow among the phenomena that alter weather, promising to explain the "naturall causes of suche alteration, according to *Aristotele*" (Digges 1927a, p. v).

18. Ronan 1992, p. 91. Leonard published two other popular *Prognostications*: *A General Prognostication* in 1553 and the *Prognostication Everlasting* in 1556. When the latter work was reissued by Thomas Digges, it became "a seminal work" (Ronan 1992, p. 91).

19. Boyer 1987, p. 153.

20. See Chapter 2's "The Rainbow Portrait of Queen Elizabeth I: An Enigmatic Emblem."

21. The writing of Maurolico's work spanned decades, and his sections on the rainbow bear completion dates of 1553 and 1567 (Rosen 1957, Maurolico 1940, pp. 4, 103, 131).

22. Maurolico 1940, p. xii. Recall that Charles V's troops had sacked Rome eight years earlier, leaving behind an overturned artistic landscape in which the young Maarten van Heemskerck would flourish. See Chapter 2's "Maarten van Heemskerck and a Pagan Rainbow."

23. Maurolico 1940, pp. xiii–xiv.

24. *Photismi* was first printed in 1611, and its opening section on reflection by mirrors had earlier borne various titles as a manuscript (Boyer 1987, p. 157). Both Maurolico and his posthumous publishers gave different titles to the *Photismi*'s different versions (Rosen 1957).

25. *Catoptrics* is the branch of geometrical optics concerned with reflection and mirrors; *dioptrics* deals with lenses and refraction. Historically, *optics* meant rectilinear propagation of light (that is, light neither reflected nor refracted), of which shadow formation and the lensless camera obscura are examples (Shea 1991, p. 150). Nowadays, the term "optics" encompasses all of these older definitions.

26. Maurolico 1940, pp. 102–3.

27. Maurolico 1940, pp. 124, 130. Recall that Witelo rejected as "impossible" the idea that the rainbow's radius is always 42° (Witelo 1972, p. 471).

28. Maurolico 1940, p. 77.

29. Boyer 1987, p. 160. Translator Henry Crew parenthetically inserts Maurolico's Latin for some of these problematic reflection/refraction translations (for example, Maurolico 1940, p. 79).

30. Maurolico 1940, pp. 79, 84.

31. Maurolico 1940, p. 77. Maurolico is aware that the sun, the observer, and the center of the bow are collinear (Maurolico 1940, p. 78).

32. See Chapter 4's "The Misperception of the Bow as a Physical Object."

33. Maurolico 1940, p. 78.

34. See Chapter 5, n. 228, on Roger Bacon's mistaken attachment to this idea.

35. For convenience, we use the modern term "antisolar point," even though Maurolico, Descartes, and Newton do not. See Chapter 4's "Arc in the Sky: The Circular Symmetry of Rainbow Light" for the definition of antisolar point.

36. Maurolico 1940, p. 79.

37. Maurolico 1940, p. 79.

38. Maurolico 1940, p. 80.

39. Maurolico 1940, p. 79. See Fig. 5-3 for illustrations of i and r.

40. Here we can put Chapter 5's reciprocal law to good use (Chapter 5, n. 117). In fact, Maurolico's sunlight reflected "point to point in a circle" will appear at 0°, not 45°, from the sun (Maurolico 1940, p. 79).

41. Maurolico 1940, p. 90. This statement about reflection weakening light is part of a straw-man argument that Maurolico subsequently attacks. However, he objects only to the argument's conclusions, not to this particular piece of it. In any event, he says later that "light and color which have been several times reflected become just so much the weaker and more enfeebled" (Maurolico 1940, p. 128).

42. Maurolico 1940, pp. 126, 128.

43. Maurolico 1940, p. 92.

44. A modern reader reels at Maurolico's apparent contradictions, some of which arise from the convoluted nature of Scholastic argument and refutation. On the rainbow's angular size, however, the contradiction seems inexplicable. Maurolico says that the rainbow's size is "not exactly 45°, but a little less as ascertained by observation," followed shortly by "As to the diameter [of the bow], a matter of the highest importance, . . . no one, so far as I know, has ever observed or established it" (Maurolico 1940, pp. 93, 95). See also Maurolico (1940, p. 127), where he reaffirms that the rainbow has been measured "by observation with the [astrolabe] instrument."

45. Maurolico 1940, p. 93. In a remarkable coincidence, Maurolico accidentally anticipates twentieth-century theories in which raindrop-flattening reduces the rainbow's radius (Fraser 1983b, fig. 5).

46. Maurolico 1940, p. 88. Crew is less patient, saying: "the remainder of the demonstration of this theorem appears to be filled with *nonsequiturs*" (Maurolico 1940, p. 85).

47. Boyer 1987, p. 161.

48. Maurolico 1940, pp. 84, 86.

49. Maurolico 1940, pp. 98, 85, 87. Maurolico's accompanying graphical explanation of rainbow colors is no more plausible than his written one (Maurolico 1940, pp. 84–89).

50. Maurolico 1940, p. 100.

51. Maurolico 1940, pp. 85–86.

52. Maurolico 1940, p. 92.

53. Maurolico 1940, p. 99.

54. Maurolico 1940, p. 130. For supernumerary rainbows, see Fig. 8-3 and Chapter 8's "Supernumerary Bows: Cloudbows'

Superfluous Cousins."

55. Maurolico 1940, p. 101.
56. Maurolico 1940, p. 129.
57. Boyer 1987, p. 156.
58. Boyer 1987, p. 171. For an earlier version of this material, see Boyer (1952a). Similar descriptions of Gilbert are found in Kelly (1965, p. 9).
59. Kelly 1965, p. 12; Boyer 1987, p. 176. Boyer believes that Gilbert's *De mundo* was written sometime after 1591, years later than *De magnete*. Kelly dates *De mundo*'s books on the rainbow to the 1580s, again after *De magnete* was written (Kelly 1965, pp. 20, 56–57).
60. Boas 1951.
61. Kelly 1965, pp. 26–32, 37–39.
62. Kelly 1965, pp. 66–67. Gilbert also appears to borrow from Thomas Digges's Copernican cosmology in *De mundo* (Kelly 1965, p. 100).
63. Boyer 1987, p. 173.
64. Gilbert 1651, p. 270. While Gilbert does use the word "refracted" once, his entire argument appears to be based on reflection. From Aristotle's day to the seventeenth century, such reflection/refraction confusion (or ignorance) was not unusual (Boyer 1987, p. 173; Boyer 1952a, p. 418).
65. Horten and Wiedemann 1913, p. 540. This commonplace of older rainbow theories bears a hint of truth—if the rainbow's background is brighter or nearly as bright as the bow, the rainbow's low brightness contrast may render it invisible. (*Brightness contrast* is proportional to the brightness difference between two light sources.) Conversely, the darker the rainbow's background, the greater the rainbow's contrast (all other conditions being unchanged; see Figs. 8-16 and 8-17). Yet a dark background is hardly a prerequisite for visible rainbows, as Fig. 8-8 shows.
66. Gilbert 1651, pp. 272–73; Boyer 1987, p. 174. Gilbert does not say, but we might reasonably translate his Latin "milliaria" as the new (1593) Elizabethan mile of 5,280 feet, rather than the Roman mile of 4,840 feet.
67. Gilbert 1651, p. 273.
68. Gilbert 1651, p. 271.
69. Gilbert 1651, p. 272.
70. Gilbert 1651, p. 272; Boyer 1987, pp. 173–74.
71. Writing around A.D. 200, Alexander of Aphrodisias distinguishes this mirror-image theory from Aristotle's explanation of the secondary rainbow (Alexander of Aphrodisias 1968, p. 250 [*Meteorologica* commentary 40va]; Boyer 1987, p. 62).
72. Maurolico 1940, p. 126.
73. Gilbert 1651, pp. 273–74. See also Boyer (1987, p. 176; 1958, p. 146; 1952a, p. 418).
74. This is Carl Boyer's assessment of Gilbert's rainbow theory (Boyer 1987, p. 173).
75. Kelly 1965, p. 110.
76. Koestler 1984, pp. 107–8. The final patron of Brahe's well-heeled research life was the mentally unstable Holy Roman Emperor Rudolph II (1552–1612), who promised Brahe the remarkably large annual salary of 3,000 florins. Because this greatly exceeded all other incomes at court, savvy bureaucrats soon pruned Rudolph's largesse.
77. Straker 1970, pp. ii–iv, 304–479.
78. Kepler's first and last known comments on rainbow theory span the years c. 1599–1619 (Boyer 1950, pp. 361, 365).
79. Koestler 1984, p. 34.
80. Each of the five regular solids is a three-dimensional figure whose faces are identical. These solids are the tetrahedron (four equilateral triangles), the cube (four squares), the octahedron (eight equilateral triangles), the dodecahedron (twelve pentagons), and the icosahedron (twenty equilateral triangles). For Plato's views on the regular solids, see his *Timaeus* (Plato 1952, pp. 127–41 [53b–57d]).
81. Koestler 1984, pp. 46–47. Kepler never imagined his spheres and solids to be real; they were merely mathematical abstractions. Interestingly, Kepler and Albrecht Dürer shared an interest in the regular solids (although Dürer simply analyzed them as problems in perspective), and Kepler explicitly cites Dürer's description of the ellipse as an "egg-shaped line" (Straker 1970, pp. 259, 276).
82. Kepler 1981, p. 8.
83. Koestler 1984, pp. 52–54. Kepler was an early and persistent advocate of Copernicus's theory.
84. Koestler 1984, pp. 47–49. The different solids had to be arranged in some set order, but this problem eventually succumbed to Kepler's relentless geometric tinkering.
85. Koestler 1984, p. 68.
86. Kepler 1981, p. 149.
87. For example, see Kepler (1981, pp. 119, 121, 203–5).
88. Kepler 1981, pp. 131–33, 240. Rooted in ancient tradition, the notion of the music of the heavenly spheres had a powerful appeal for Kepler, and he devised elaborate geometric-tonal models to demonstrate its reality in his 1619 astronomical work *Harmonice mundi* (Harmonics of the World). See Walker 1967.
89. Kepler 1981, p. 133.
90. Boyer 1987, p. 179.
91. Kepler 1858–71, vol. 1, p. 200.
92. Unlike Aristotle, however, Kepler implies that the rainbow's red is darker than its yellow (because it is closer to the darkness outside the primary). While no more satisfying than Aristotle's color theory, Kepler's statement at least describes the brightness gradation of rainbow colors more realistically (see Figs. 8-18 through 8-20).
93. Boyer 1987, p. 179. Kepler's tentativeness is evident in his next sentence: "But these may be notions."
94. Kepler is quite unlikely to have seen either man's rainbow theory. Gilbert's *De mundo* existed only as a manuscript during Kepler's life, and Kepler makes no mention of Maurolico's *Photismi de lumine* (Straker 1970, p. 300).
95. Kepler had since joined Brahe in Prague for their short-lived and quarrelsome—but enormously productive—partnership in astronomy (Koestler 1984, p. 109).
96. Kepler 1976, p. 18.
97. Speaking of his rainbow's refracted interior colors, Kepler says: "In the first step of *reflection* however, green is seen, later blue, then purple, and finally utter black or darkness" (Kepler 1976, p. 18; emphasis added).
98. Kepler's voluminous and rigorous reworking of Witelo in the *Paralipomena* is one of the first truly modern treatments of geometrical optics (Straker 1970, pp. 400–424, 474).
99. Kepler 1858–71, vol. 2, p. 211; Boyer 1950, p. 362.
100. Shea 1991, p. 211 n. 49; Kepler 1858–71, vol. 2, p. 134. Descartes would also reject this Scholastic distinction (see n. 182 below). Actually, rainbow and object colors do have different causes (spectral absorption versus refraction), yet Kepler is correct that no *observational* basis exists for determining the cause of a given color.
101. Kepler 1858–71, vol. 2, p. 52. To his credit, Kepler ear-

lier notes that he once saw a circular rainbow in a cloud that "was being shaken up by a very fast wind, with no definite shape," an observation that more clearly refutes the Aristotelian cloud-mirror.

102. Kepler 1858–71, vol. 2, p. 52.

103. In his 1606 letter to Thomas Harriot (see n. 104 below), Kepler says of the subject: "I had nearly forgotten about the rainbow" (Lohne 1959, p. 115; Kepler 1858–71, vol. 2, p. 69).

104. Boyer 1987, pp. 183–85; Lohne 1959, p. 115.

105. Boyer 1950, p. 366.

106. Boyer 1950, pp. 363, 365.

107. Boyer 1987, p. 187. See Fig. 5-3, where the incident and refracted rays are i and t, respectively. Houstoun (1958, pp. 5–6) shows that Kepler's major problem in trying to devise a trigonometric law of refraction was due not to mathematical error but to reliance on Witelo's and Ptolemy's faulty measurements of refraction. See also Lohne 1959, pp. 113–14.

108. Note that 45°, the radius of Kepler's primary rainbow, is 180°–135°.

109. Kepler 1858–71, vol. 2, p. 69. Kepler distinguishes between raindrops and "our standing waters," meaning pools of water such as those found in nature and the laboratory.

110. Descartes 1965, p. 342.

111. See Straker (1970, pp. 471–79) on the significance of *Dioptrice* in the history of optics, especially its merging of refraction (dioptrics) and direct propagation of light (linear perspective).

112. Kepler 1858–71, vol. 2, p. 531.

113. Boyer 1950, p. 365.

114. Lohne 1959, pp. 116–19; Shirley 1983, pp. 381, 384–87.

115. Deviation angle is defined in n. 191 below.

116. The length of *De l'arc-en-ciel* is roughly that of a five-page illustrated magazine article (Descartes 1965, pp. 332–45). Descartes determinedly dispenses with the rainbow of mythology by substituting the prosaic French "arc in the sky" for the traditional "iris" (Boyer 1987, p. 209).

117. In 1618–19, Descartes had spent several months in the Netherlands as a gentleman volunteer in the army of the Dutch Republic. Fortunately for Descartes and posterity, the Netherlands and Spain were then observing a twelve-year truce in their Eighty Years' War (Gaukroger 1995, pp. 65–67; Shea 1991, pp. 8–9).

118. Gaukroger 1995, p. 187.

119. Gaukroger 1995, pp. 188–90; Shea 1991, pp. 127–28.

120. Shea 1991, pp. 94–95.

121. Defensive night-owl readers can take solace from the fact that Descartes's late-rising habits never affected his scholarly productivity. Indeed, mandatory 5 A.M. tutoring sessions for Sweden's Queen Christina (reigned 1644–54) in January 1650 proved exhausting, disruptive, and perhaps fatal for Descartes, who died of pneumonia after less than a month of this regimen (Gaukroger 1995, p. 416; Shea 1991, pp. 3, 339).

122. Descartes 1965, pp. xvi, 16. In fairness, Descartes may simply be following his resolve "not to teach here the method which everyone must follow in order to direct his reason correctly, but only to show the manner in which I have tried to direct mine" (Descartes 1965, p. 5). Still, the ambiguity of his undefined self-evident truths remains.

123. Descartes 1965, p. 16.

124. In practice, Descartes uses deductive analysis as the precursor to the inductive synthesis of the *Discours* (Descartes 1965, pp. xvii–xviii). A decade earlier (1627–28), Descartes had set down a similar outline of reasoning in the essay *Rules for the Direction of the Mind*, which would be published posthumously (Shea 1991, pp. 129–39).

125. On the second and fourth rules, Descartes's earlier correspondence and writings reveal his debt to the Neoplatonic writer on hermetics and mnemonics, Ramon Llull (c. 1235–1316) (Shea 1991, pp. 98–100). Perhaps most surprising to modern readers is that Descartes believed (as had Kepler) that astrology was not intrinsically groundless, but rather so profound that it surpassed human understanding. However, Kepler regarded the popular *practice* of astrology in his day as nothing more than "a dreadful superstition" (Shea 1991, p. 119; Koestler 1984, pp. 39–42).

126. Descartes 1965, pp. 77–81. While today's consensus opinion is that Descartes divined this law by himself, in the past he has been charged with plagiarizing it (see n. 156 below).

127. Shea 1991, pp. 48–60.

128. A tireless correspondent, the theologian and scientist Mersenne wrote letters that fill some 10,000 printed pages (Gaukroger 1995, p. 477). His wide-ranging scientific interests led to frequent exchanges not only with Descartes but also with Pierre de Fermat, Galileo (1564–1642) and Blaise Pascal (1623–62). The 1666 establishment of the French Academy of Sciences was an outgrowth of Mersenne's informal meetings with his scientific correspondents.

129. Shea 1991, p. 203.

130. Shea 1991, p. 204 n. 35. Descartes was only half-serious about this anonymity, because he personally distributed numerous copies of the 1637 edition of the *Discours* to those whose opinions he sought.

131. Descartes 1965, p. 332.

132. Descartes's unwarranted belittling of his valued friends scientist Isaac Beeckman (1588–1637) and optician Jean Ferrier (fl. 1620–40) is particularly unsavory (Shea 1991, pp. 79–81, 197–200).

133. Boyer 1987, p. 208; Boyer 1952b, p. 95. Gedzelman (1989) explores Descartes's possible rainbow borrowings from Kepler's *Paralipomena ad Vitellionem*.

134. Boyer 1987, pp. 188–92; Ockenden 1936, pp. 45–49. De Dominis is the only rainbow theorist known to be burned in public, but his immolation by church authorities occurred months after his death in prison and was prompted by his antipapal tracts, not his scientific ones (Shea 1991, p. 122; Boyer 1987, p. 188).

135. Shea 1991, p. 149 n. 1; Boyer 1987, pp. 202–3; Sabra 1967, pp. 99–105.

136. Descartes's version of the law of refraction probably predates 1628. Kepler's inadequate law of refraction helped frustrate his attempts to develop a realistic rainbow theory.

137. Descartes 1965, pp. 80–81.

138. For two transparent media, $\sin(i)/\sin(t) = m$, a constant for a given wavelength of light (see Chapter 7 for a definition of wavelength). In the expanded form of the refraction law, we replace the single constant m with two constants, n_i and n_t, which are *refractive indices* of the incident and refractive media, respectively. Then the law becomes $n_i \sin(i) = n_t \sin(t)$. As noted in Chapter 5, n. 54, a typical refractive index for water is 1.33, 1.5 for glass, and 1.0 for air.

139. Descartes secretively writes Mersenne in June 1632: "As to my way of measuring the refraction of light, I compare the sines of the angle of incidence and the angle of refraction, but I would be happy if this were not made known yet" (Shea 1991, p. 155).

140. Early in *La dioptrique* Descartes says that because creation of his optical apparatus "must depend on the skill of [optical] artisans, who ordinarily have not studied, I shall attempt to make myself intelligible to everyone, and to omit nothing, nor to assume anything that might have been learned in the other sciences" (Descartes 1965, p. 66). If this truly is his goal, avoiding the mathematical demands of trigonometry would be prudent.

141. Descartes's debt to Kepler for insights on refraction (and the quality of Kepler's efforts) is suggested by the striking similarity between two crucial optical-bench diagrams appearing in *La dioptrique* and in Kepler's 1611 *Dioptrice* (compare Descartes 1965, p. 162 and Kepler 1858–71, vol. 2, p. 528, fig. 2). As is usual for Descartes, Kepler's name is nowhere mentioned in *La dioptrique*, but Descartes does let the mask of originality slip slightly in a 1638 letter to Mersenne in which he simply says "Kepler was my first teacher in optics" (Shea 1991, p. 154).

142. Sabra 1967, pp. 93–99. Sabra (1967, p. 98) notes: "Practically all subsequent explanations of refraction [after Alhazen], up until the publication of Descartes' *Dioptric*, were almost entirely dependent upon Ibn al-Haytham."

143. Shea 1991, pp. 149, 157.

144. Gaukroger 1995, pp. 140–41.

145. Sabra 1967, p. 103.

146. Descartes, perhaps anticipating readers' resistance, compares light with the sensation transmitted by a blind person's walking stick: "This will prevent you from finding it strange at first that this light can extend its rays *in an instant* from the sun to us; for you know that the action with which we move one of the ends of a stick must thus be transmitted in an instant to the other end" (Descartes 1965, p. 67; emphasis added).

147. Gaukroger 1995, p. 258. Descartes once wrote that "the whole foundation of my philosophy would be overturned" if light were shown to have finite speed, although this statement is more likely bluster than conviction (Sakellariadis 1982, p. 2). In an attempt to reconcile infinite and finite speeds, Descartes distinguishes between light's virtual and actual motion, with the latter being finite (Shea 1991, pp. 210–12). However unconvincing the distinction, Descartes implies that the velocity of light is finite, yet its motion is somehow *communicated* instantaneously because light is not actual motion but merely a "tendency to motion" (Sabra 1967, pp. 48–50; Sakellariadis 1982, pp. 2–3).

148. Recall that Grosseteste created the same contradiction (Crombie 1962, pp. 106, 115). Like Descartes, Witelo and Kepler also believed that light was transmitted instantaneously (Sabra 1967, p. 47).

149. Descartes 1965, p. 78.

150. Sabra 1967, pp. 116.

151. Sabra 1967, pp. 114–15.

152. Descartes next explains why light moves faster in a denser medium, and his explanation is an inspired collection of specious analogies (Descartes 1965, p. 82).

153. Scientists and mathematicians ranging from Fermat, Christiaan Huygens, Gottfried Wilhelm Leibniz (1646–1716), and Ernst Mach (1838–1916) would all vigorously challenge the logic underlying Descartes's development of the refraction law (Sabra 1967, pp. 104–5). Fermat tartly remarked that Descartes's making light move more easily in a denser medium "seems shocking to common sense" (Sabra 1967, p. 117; see also Scott 1976, pp. 39–40).

154. In two letters to Mersenne (1630 and 1632), Descartes expresses concern about keeping the refraction law private until he publishes it (Shea 1991, p. 155).

155. Gaukroger 1995, pp. 141, 144; Shea 1991, p. 149.

156. Shea 1991, p. 149 n. 1; Scott 1976, pp. 38–39; Sabra 1967, pp. 100–103.

157. Gaukroger 1995, p. 141; Shirley 1983, p. 381; Shirley 1951; Lohne 1959, pp. 116–17.

158. Sabra 1967, pp. 102–3.

159. Gaukroger 1995, p. 141; Shea 1991, pp. 149–50; Scott 1976, pp. 38–39. The dating of Snel's now-lost manuscript on his refraction law is uncertain. However, we do know that he experimentally determined the law, probably in the 1620s.

160. Tiemersma 1988, pp. 359–62.

161. Descartes 1965, p. 332.

162. Descartes 1965, pp. 332–33.

163. Note that Descartes's compelling illustration of rainbow geometry (Fig. 6-4) necessarily involves a cheat: in fact, no one could ever see this oblique view of the rainbow. Some of our rainbow diagrams (for example, Figs. 4-3 and 6-6) also require impossible vantage points.

164. Descartes 1965, pp. 333–34.

165. Descartes is also in a position to answer an objection seldom raised before: Is a water-filled glass sphere a fair substitute for a water drop? Because the refractive indices of glass and water are so similar, he can accurately treat the sphere as if it were composed only of water.

166. Descartes 1965, p. 334.

167. Most of this light incident on the drop's rear surface is refracted out of the drop, raising the issue of whether a zero-reflection rainbow is possible. See Chapter 9's "Does a Zero-Order Rainbow Exist?"

168. Only inhomogeneities in the rain field could make the secondary bow as bright or brighter than the primary bow. Given the narrow angular separations of the two bows, it is unlikely that rain inhomogeneities will have any perceptible effect on adjacent sections of the double rainbow.

169. Descartes 1965, p. 334.

170. Shea (1991, pp. 207–8) makes the interesting point that Descartes's rather coy, backhanded introduction of the prism (whose refractive properties he certainly knew quite well) probably stems from a desire to make *De l'arc-en-ciel* a set piece of his methodology.

171. This is one of Newton's crucial observations about refraction, although Descartes merely notes it and, unlike Newton, does not draw any conclusions about the nature of colors from it.

172. Descartes 1965, pp. 335–36. In fact, a prism completely lit by sunlight does refract a spectrum.

173. The distinction Descartes makes here is subtle yet firm; it is the pressure transmitted by the spheres, not by their own movement, that causes light. As we are about to see, however, Descartes rather confusingly illustrates refraction with an example of moving spheres.

174. Descartes 1965, p. 336. Descartes's two models of light transmission by either small spheres or dimensionless rays are not fundamentally inconsistent. Just as we describe light using the language of rays or waves (see Chapter 8's "Thomas Young and the Interference Theory of the Rainbow"), so Descartes may change his light terminology to better describe the macroscopic, observable consequences of microscopic, unobservable

events. See also Tiemersma 1988, p. 357.

175. Shea 1991, p. 209.

176. Imagine moving a ball-point pen through an open door: the pen's ball-point begins to roll (and the pen to write) only when the ball contacts the door jamb (that is, the slit's edge).

177. Descartes 1965, pp. 336–37. Valid objections to Descartes's dubious color theory were raised almost immediately (Gaukroger 1995, pp. 330–31; Shea 1991, pp. 212–19).

178. Descartes 1965, pp. 338–39.

179. Even allowing that rigid spheres of air touch one another continuously (much like a baking pan brimming with ball bearings), the coordinated rotations that Descartes proposes are mechanically impossible.

180. Seventeenth-century mechanical philosophers such as Descartes believed that matter had clearly defined properties (like size, shape, and motion) and that its motion is conveyed by nerves to the brain. This is in marked contrast to the Aristotelian tradition that emphasized the innate, essential properties of objects (Newton 1984, p. 4).

181. See Chapter 7's "Aristotelian Color Theory and the Rainbow." Like students for centuries before, Descartes received an education that stressed Aristotle's works. However, Descartes's intellectual growth shows only a debt to his teachers, not his schoolbooks, except in the negative sense that he resolutely rejects Aristotelian science by demonstration (Gaukroger 1995, pp. 53–59, 112–14; Shea 1991, pp. 4–8).

182. Descartes 1965, p. 338.

183. Descartes 1965, p. 16.

184. Descartes 1965, p. 339.

185. Demonstrating that a spectrum does *not* require a shadow requires only that you hold a prism in a broad beam of sunlight. Descartes's fixation on this point is odd indeed.

186. Descartes 1965, p. 339.

187. Descartes 1965, p. 339.

188. Descartes 1965, pp. 339–40. As an added bit of realism, Descartes widens his rainbows by an amount equal to the sun's angular radius (Descartes 1965, p. 342).

189. Lohne 1959, pp. 118–19. The remains of Harriot's manuscript contain no commentary, only annotated drawings and tables of optical calculations and measurements. However, these leave little doubt that Harriot was calculating the radius of the primary rainbow. Harriot's work on the rainbow likely predates 1606, and we know that he had excellent data on air-water refraction from 1597 onward (Boyer 1987, p. 185; Lohne 1959, pp. 115–17, 120).

190. For clarity, we have drawn only rays illuminating the upper half of the cross section. We would need to add an upside-down version of the reflected and refracted rays shown in Fig. 6-5 if we illuminated the drop's lower half. In addition, we have eliminated the externally reflected rays (ray *r* in Fig. 5-3) as well as the rays refracted from the drop at each internal reflection.

191. The *deviation angle* is the angle through which sunlight is deflected or deviated by its encounter with the raindrop. If the sunlight is not deflected at all, its deviation angle is 0°. Light forming the primary rainbow has been deviated by an angle of about 138°, which places it 42° from the antisolar point, the point that is 180° from the sun (that is, 42° = 180° − 138°).

192. As for "antisolar point," "minimum deviation ray" is not a term that Descartes used, but one that he surely would have understood.

193. Earlier in *De l'arc-en-ciel*, Descartes gives only a single value for water's index of refraction (Descartes 1965, p. 340).

194. Descartes 1965, pp. 335, 342; Shea 1991, p. 208. While the refraction angle *t* depends on *i*, the order of colors in the spectrum does not, as Descartes certainly knew. Newton generated prismatic spectra with collimated sunlight, for which *i* changes very little across the sunlit prism (Westfall 1980, pp. 166–67). This effectively contradicts Descartes's insinuation that changes in *i* within divergent sunbeams produce the spectrum.

195. Descartes 1965, p. 342. Descartes is obscure on this point, saying that when we look directly at a prism's refracted colors "we will see the red toward [the prism's] thicker part." By this he must mean that the red ray emerges from the prism at a less oblique angle than the blue, as his accompanying diagram indicates. Thus, when we see red we are looking more nearly perpendicular to the prism. However confusing his words, Descartes's diagram correctly shows the red ray traversing a *thinner* portion of the prism than the blue ray (Descartes 1965, p. 335).

196. Descartes 1965, p. 342. At least this *seems* to be Descartes's reasoning for the different color orders in the two bows. His language is quite unclear here, and the relationship between cause and effect is particularly fuzzy. Descartes biographer Stephen Gaukroger simply notes that Descartes "is unable to explain the reverse order of colours in the secondary bow" (Gaukroger 1995, p. 269). Shea (1991, pp. 223–24) also finds Descartes's reasoning suspect here.

197. Shea 1991, p. 212 n. 52.

198. The secondary rainbow's color reversal is *not* caused by the second internal reflection, as a patient exercise in ray tracing reveals. In fact, the secondary rainbow's colors would look the same even if we used fiber optic cable to deviate the rainbow colors after their first internal reflection. Those colors would *still* be reversed once we bent them through more than 180°, even if we did not bend them by a second internal reflection.

199. Descartes 1965, pp. 340–41.

200. Descartes 1965, p. 343.

201. One of us (Fraser) has followed Descartes's lead by dabbling in the design of rainbow-generating fountains (Andrews 1990).

202. Descartes 1965, pp. 343–45. On sunlight-reflection rainbows, see Chapter 9's "Rainbow Reflections and Reflection Rainbows" and Humphreys (1964, pp. 498–99).

203. Shea 1991, p. 222.

204. Boyer 1987, p. 231.

205. Boyer 1987, pp. 219–32; Gaukroger 1995, p. 329.

206. Boyer 1987, p. 229; Gaukroger 1995, p. 476.

207. Shea 1991, p. 212. Ciermans's enthusiasm was not uncritical, however, for he raised several telling objections to Descartes's color theory (Gaukroger 1995, pp. 330–31; Shea 1991, pp. 213, 215–17).

208. In October 1637, Descartes confidently believed that widespread acceptance of *Les météores* would compel its use as a college text. This never happened in his lifetime (Gaukroger 1995, p. 329).

209. See, for example, Boyle (1964, p. xii).

210. See Chapter 8, n. 43 on diffraction's role in the rainbow. In an ironic counterpoint to the charges against Descartes's originality, Grimaldi's clearly Cartesian rainbow theory does not acknowledge Descartes (Boyer 1987, pp. 238–40).

211. Boyer 1987, pp. 243–45. Boyle's law says that at constant temperature the volume and pressure of a gas are inversely proportional to one another. Frenchman Mariotte dis-

covered this relationship independently of England's Robert Boyle (1627–91). While Boyle's name is nearly universally attached to this law, in France it remains Mariotte's law.

212. Boyer 1987, p. 243.
213. Huygens 1888–1910, vol. 10, p. 405.
214. See Chapter 8's "Thomas Young and the Interference Theory of the Rainbow."
215. Boyer 1987, pp. 235–37.
216. Boyer 1987, p. 239.
217. Boyer 1987, pp. 244–46.
218. Westfall 1980, p. 156.
219. Bechler 1975, pp. 102–3.
220. Westfall 1980, pp. 161–63; McGuire and Tamny 1983, pp. 267–68. Note 264 below summarizes the complex story of Newton and chromatic aberration.
221. Although the irony is surely accidental, Newton added his independent-minded *Questiones* to a notebook that he begins with careful notes on such Scholastic standards as Aristotle's *Organon* (McGuire and Tamny 1983, pp. 4–5). That Newton bore the ancients themselves no hostility seems evident from his use of a then-conventional Latin quotation: "Plato is my friend, Aristotle is my friend, but my best friend is truth" (McGuire and Tamny 1983, p. 336 [*Questiones* 1 88r]).
222. Guerlac 1983, p. 75; Newton 1984, pp. 2–5; Westfall 1980, p. 156; Boyle 1964. Newton cites both Descartes's and Boyle's works in the *Questiones*, but his intellectual debts to other writers are also clear (McGuire and Tamny 1983, pp. 6, 20–25).
223. Newton 1984, pp. 5–6.
224. McGuire and Tamny 1983, pp. 466 n. 1, 480–81.
225. Newton 1984, p. 2.
226. McGuire and Tamny 1983, pp. 385–87 (*Questiones* 34 104v–35 105r). Newton's heading is borrowed from a vast seventeenth-century survey of science and metaphysics, Walter Charleton's (1619–1707) 1654 *Physiologia*, many of whose topics Newton used in his *Questiones* (McGuire and Tamny 1983, pp. 6, 244). Charleton himself sometimes resorts to Aristotelian ideas when explaining color (Newton 1984, p. 5 n. 10).
227. McGuire and Tamny 1983, p. 389 (*Questiones* 36 105v); see also Newton 1984, pp. 4–5. Spanish white is a powdered chalk used as a pigment. Boyle is equivocal about whether colors arise by modification of white light, but he does reject the Scholastic notion that they are inherent qualities of objects (Boyle 1964, pp. 11, 90).
228. McGuire and Tamny 1983, pp. 433–35 (*Questiones* 70 122v); Newton 1984, p. 6.
229. Newton takes the atomistic tack that light is streams of invisible corpuscles, a variation on Descartes's belief that light is pressure transmitted within a medium by small, moving spheres (McGuire and Tamny 1983, pp. 243, 385 [*Questiones* 34 104v]).
230. McGuire and Tamny 1983, p. 433 (*Questiones* 70 122v); Guerlac 1983, p. 76.
231. McGuire and Tamny 1983, pp. 260–61; Sabra 1967, p. 247.
232. McGuire and Tamny 1983, p. 250.
233. Newton 1984, pp. 5–6; McGuire and Tamny 1983, pp. 12–13.
234. McGuire and Tamny 1983, p. 435 (*Questiones* 70 122v). This passage also appears in Guerlac (1983, p. 76) and Westfall (1980, p. 160).
235. Newton's skill as an experimenter became obvious when we, armed with foreknowledge of his results, ill-advisedly substituted a white background for his black one. The resulting welter of refracted colored lines made it impossible to interpret the thread's refraction correctly.
236. Newton 1952, pp. 20–23 (*Opticks*, 1.1, prop. 1, theorem 1, experiment 1).
237. Westfall 1980, pp. 161–62, 233–37; Guerlac 1983, p. 78. One type of reflecting telescope is still referred to as a Newtonian reflector.
238. Hooke 1961, pp. 47–79 (*Micrographia*, Observations 9–10). By 1665, Hooke had been a fellow of the Royal Society and served as its curator of experiments (Hooke 1961, pp. vi–vii).
239. Hooke 1961, p. 64; Westfall 1980, pp. 158–59. Hooke had been one of Boyle's undergraduate assistants at his Oxford laboratory in the late 1650s (Boyle 1964, p. ix).
240. Hooke 1961, pp. 62–64, fig. 4, schem. 6; Newton 1984, p. 9; Shapiro 1975, pp. 197–99.
241. Newton 1984, pp. 4–5; Boyle 1964, p. 90. For more on Aristotelian color theory, see Chapter 4's "Aristotle's Rainbow: Antiquity's Explanation of the Bow's Geometry" and Chapter 7's "Aristotelian Color Theory and the Rainbow."
242. McGuire and Tamny 1983, pp. 249–50.
243. Newton 1984, p. 6; Westfall 1980, p. 159. McGuire and Tamny (1983, pp. 250–51) plausibly state that at this early stage Newton is not quite prepared to make his later, revolutionary claim that white light's spectral colors are immutable and cannot be further divided or altered.
244. McGuire and Tamny 1983, p. 431 (*Questiones* 69 122r). By 1666, Newton would record another, more elaborate multiple-prism projection that also produced white by overlapping spectral colors (McGuire and Tamny 1983, pp. 478–79).
245. Newton 1984, pp. 8–9.
246. Newton could be an even more intemperate opponent than Descartes. As part of his war of words and snubs with Hooke, Newton would expunge Hooke's name from his landmark *Philosophiae naturalis principia mathematica* (Mathematical Principles of Natural Philosophy [1687]) and withhold publication of *Opticks* until Hooke's death (to avoid Hooke's presumed objections). For more on the stormy relationship between Hooke and Newton, see Westfall (1980, pp. 241–47, 272–74, 446–52, 638).
247. Westfall 1980, pp. 63–64.
248. Westfall 1980, pp. 141–44.
249. Westfall 1980, pp. 245, 267–80.
250. Westfall 1980, pp. 183–90.
251. However, as McGuire and Tamny note (1983, p. 19), Scholasticism and its more serious adherents were far from a spent force in the 1660s: "Aristotelianism, in its variety of forms, continued to provide a coherent and powerful account of human experience. As a systematic metaphysical system, it had few serious pedagogic rivals throughout the seventeenth century." Nonetheless, the deficiencies of Aristotelian science were increasingly evident.
252. Westfall 1980, pp. 190–91.
253. Westfall 1980, pp. 195–202.
254. Westfall 1980, p. 202.
255. Newton 1984, p. 14; Guerlac 1983, p. 79; Westfall 1980, pp. 222. Despite making some substantive changes in Barrow's manuscript, Newton left undisturbed his mainstream (and thoroughly muddled) color theory, which Barrow accurately described as "guesses" (Newton 1984, p. 15).
256. Westfall 1980, pp. 206–8.

257. Newton 1984, p. 16; Westfall 1980, p. 208.

258. Newton 1984, pp. xii, xv, 19; Shapiro 1984, pp. 35–36. We use Alan Shapiro's notation for distinguishing between the two manuscripts, although Newton did not actually title the *Lectiones opticae*.

259. Westfall 1980, pp. 222, 236–37. Newton had been elected to the Society a few weeks earlier based on his construction of a successful reflecting telescope (Newton 1984, p. 12 n. 34).

260. For an exception, see Newton's suggestion about mixing the projected blue and red of two prisms (McGuire and Tamny 1983, p. 431 [*Questiones* 69 122r]).

261. McGuire and Tamny 1983, pp. 468–73, 478–80.

262. Newton 1984, pp. 47–49 (*Lectiones opticae*, lecture 1, p. 1). Simple lenses whose surfaces are spherically curved cannot focus images sharply, even if the light is of a single color. This problem of *spherical aberration* is distinct from chromatic aberration. While hyperbolic cross-section lenses avoid spherical aberration, grinding them is a practical problem that vexed Descartes, Newton, and other seventeenth-century optical workers.

263. Newton 1984, p. 49 (*Lectiones opticae*, lecture 1, p. 2).

264. Bechler (1975, pp. 107–19) shows that Newton's public gainsaying of achromatic lenses was paired with a far more positive tone in his correspondence and manuscripts. Hooke was unconvinced that chromatic aberration is inescapable, telling Nwton (and the Royal Society): "The truth is, the Difficulty of Removing that inconvenience of the splitting of the Ray and consequently of the effect of colours, is very great, but yet not insuperable" (Newton 1959, p. 111). Hooke was right, although he could not back up his objection with a working lens. Drafts of Newton's 1672 correspondence with him suggest that Newton knew in principle how to design an achromatic lens (Bechler 1975, pp. 109–16). Yet publicly yielding ground to Hooke was too high a price for Newton, and his published reply says that such lenses would be both impractical and inferior (Bechler 1975, p. 110). Decades later in *Opticks*, Newton still denies that achromatic lenses are practicable for telescopes (Newton 1952, pp. 101–2 [*Opticks*, 1.1, prop. 7, theorem 6]). Newton's perhaps willful errors on this issue would later be recognized as the first cracks in the facade of his optics.

265. Newton 1984, p. 51 (*Lectiones opticae*, lecture 1, p. 2).

266. Newton 1984, p. 51 (*Lectiones opticae*, lecture 1, p. 3).

267. Newton 1984, pp. 51–53 (*Lectiones opticae*, lecture 1, p. 3).

268. Newton 1809, p. 679; Newton 1952, p. 29 (*Opticks*, 1.1, prop. 2, theorem 2).

269. Newton correctly speaks only about differential refraction of *rays* that produce a given color, not about refraction of colors. As visual sensations, colors do not have any geometrical optical qualities such as refrangibility (that is, the ability to be refracted), even though we may use the shorthand term "refracted colors" as a convenience.

270. Newton 1984, pp. 49, 53–61 (*Lectiones opticae*, lecture 1, pp. 2, 4–8).

271. Newton 1984, p. 53 n. 18; Sabra 1967, pp. 235–37. In his "New Theory," Newton did not state explicitly that his prism *was* oriented to yield minimum deviation, although in fact it was. Newton instead noted that i and t were equal (the minimum-deviation condition) for rays "tending towards the middle of the [refracted] image" (Newton 1809, p. 680). However, at least one of his critics failed to understand the significance of this statement and believed that Newton's prism was not positioned to give minimum deviation and thus, supposedly, a circular refracted image (Sabra 1967, p. 235 n. 9).

272. Newton 1984, p. 61 (*Lectiones opticae*, lecture 1, p. 8).

273. McGuire and Tamny 1983, p. 468; Westfall 1980, pp. 166–67.

274. Newton 1959, p. 137. Because Newton used a lens to magnify (and thus brighten) Venus's image, he increased the planet's apparent angular size on the prism. However, because the resulting spectrum was a line rather than an oblong, the angular size of Venus was still much less than the size of the unmagnified sun. Newton has indeed bolstered his position that parallel white light is dispersed into a range of angles.

275. Westfall 1980, p. 167; McGuire and Tamny 1983, p. 478.

276. Newton 1809, p. 681; see also Newton 1959, p. 104 n. 10; Newton 1984, pp. 29, 31; Westfall 1980, p. 167.

277. McGuire and Tamny 1983, p. 469. Newton repeats this 1665–66 experiment in all his later works on color.

278. Newton 1984, pp. 28, 31. This mixture of spectrum colors in white light is different from what Newton believes. While Newton imagines a ray of white sunlight to be a heterogeneous bundle of rays causing different colors, we understand it to be energy that can be *decomposed* into colors associated with different wavelengths, even though these colors are not *discrete* entities in the white light. See Sabra 1967, p. 282.

279. McGuire and Tamny 1983, p. 479.

280. McGuire and Tamny 1983, pp. 479–80; Westfall 1980, pp. 167–69.

281. Newton 1984, p. 31. In fact, Newton demonstrated more than he realized, since his "colored white" is also an example of exceeding the *critical flicker frequency*. This frequency is the highest rate at which a flickering light source can be perceived as such, and it helps explain the fact that a rapid succession of discrete images may look like continuous motion—the perceptual basis of motion pictures (Sekuler and Blake 1985, pp. 253–54).

282. Apparently Newton was a confusing lecturer and lured few students to his classes. In this he had plenty of company; student attendance at professors' lectures was the exception rather than the rule during Newton's years at Cambridge (Westfall 1980, p. 209).

283. In the close-knit world of seventeenth-century science, Oldenburg would have known Hooke, Boyle (one of the Royal Society's founders), and Newton.

284. Newton 1959, pp. 92–102; Newton 1809. In its original form, Newton's letter occupied only nine pages in the *Philosophical Transactions*.

285. Newton 1959, p. 212.

286. Sabra 1967, pp. 249–50, 295–97.

287. Shapiro 1980, p. 228. This "commonsense" stumbling block is one of which Newton himself was quite aware (Newton 1959, p. 385).

288. Sabra 1967, pp. 249–50, 276.

289. Westfall 1980, p. 242; Sabra 1967, pp. 264–69; Newton 1959, pp. 130–34, 206–7. For more on Newton's correspondence with Pardies, see Shapiro 1975.

290. Westfall 1980, p. 240; Shapiro 1980, pp. 223–25. See Chapter 7's "Newton's Disquieting Color Ideas" for more on Newton's disagreement with Huygens.

291. Sabra 1967, p. 251.

292. Newton 1959, pp. 110–14; Westfall 1980, p. 241; Sabra 1967, pp. 251–53.

293. Sabra 1967, p. 252. See Chapter 8's "Thomas Young and the Interference Theory of the Rainbow."

294. Hooke echoes antiquity's concern with "saving the phenomena" when he says, "I can assure Mr Newton I cannot only salve all the Phænomena of Light and colours by [this] Hypothesis . . . but by two or three other" (Newton 1959, p. 113).

295. Newton 1959, p. 172.

296. Westfall 1980, pp. 241–46, 267–80. Sabra (1967, pp. 231–50) explores in some detail the scientific reaction to Newton's "New Theory."

297. Newton 1959, pp. 161, 146–47; see also Westfall 1980, pp. 244–45.

298. Newton 1959, p. 96; see also Shapiro 1984, p. 42 n. 2.

299. Shapiro 1984, pp. 38–39.

300. Newton 1959, p. 96; Shapiro 1984, pp. 39–40.

301. Shapiro 1984, pp. 40–42; Shapiro 1980, pp. 228–34. In *Opticks*, Newton settles for saying: "it is also *evident*, that the Whiteness of the Sun's Light is compounded of all the Colours wherewith the several sorts of Rays whereof that Light consists" (Newton 1952, p. 153 [*Opticks*, 1.2, prop. 5, theorem 4, experiment 15]; emphasis added).

302. Shapiro 1980, pp. 228–29.

303. Westfall 1980, pp. 638–39.

304. Bechler 1975, pp. 122–25.

305. Westfall 1980, p. 640; see also Newton 1984, p. 24. For some, a reverence for Newtonian optics would even linger into the mid-nineteenth century (see Chapter 8's "Thomas Young and the Interference Theory of the Rainbow").

306. Bechler 1975, pp. 125–26.

307. Newton 1952, pp. 168–78 (*Opticks*, 1.2, prop. 9, problem 4); see also Newton 1809, p. 685 (prop. 10); Newton 1984, pp. 593–603 (*Optica*, part 2, lecture 16).

308. Newton 1952, p. 169 (*Opticks*, 1.2, prop. 9, problem 4).

309. Boyer 1987, pp. 189–91; Ockenden 1936, pp. 43–45. When he died, Newton had a copy of de Dominis's *De radiis et lucis* (On Rays and Light) in his library (Newton 1984, p. 593 n. 1).

310. Ockenden 1936, pp. 46–47.

311. Newton 1984, p. 593 n. 1; Ockenden 1936, pp. 47–49. In the *Opticks* manuscript, Newton had originally given Descartes more evenhanded billing on the rainbow, while in the earlier *Optica* (1670–72) Newton gave sole credit to Descartes and omitted de Dominis entirely.

312. Newton 1952, p. 169 (*Opticks*, 1.2, prop. 9, problem 4).

313. Newton 1809, p. 685 (prop. 10).

314. Newton 1952, pp. 169–71 (*Opticks*, 1.2, prop. 9, problem 4); Boyer 1987, pp. 247–48. In the 1710s, Newton and Leibniz openly waged a bitter priority dispute over the invention of differential calculus (Westfall 1980, pp. 259–67, 712–29, 760–83).

315. Newton 1952, p. 171 (*Opticks*, 1.2, prop. 9, problem 4).

316. Newton 1952, p. 178 (*Opticks*, 1.2, prop. 9, problem 4).

317. Newton 1952, pp. 171–72 (*Opticks*, 1.2, prop. 9, problem 4).

318. Newton 1952, p. 172. Newton's rainbow radii here do not include the effect of the sun's angular size, although he knows about this broadening (Newton 1952, p. 175 [*Opticks*, 1.2, prop. 9, problem 4]).

319. Newton 1952, pp. 173–74 (*Opticks*, 1.2, prop. 9, problem 4).

320. See Chapter 7's "Newton's Disquieting Color Ideas." Indigo appears in the "New Theory" (Newton 1809, p. 684 [prop. 5]) and once in the contemporaneous *Optical Lectures* (Newton 1984, p. 50 n. 10).

321. Newton 1952, pp. 174–75 (*Opticks*, 1.2, prop. 9, problem 4).

322. Newton 1952, p. 175 (*Opticks*, 1.2, prop. 9, problem 4).

323. Newton 1952, p. 175 (*Opticks*, 1.2, prop. 9, problem 4).

324. Newton 1952, pp. 193–315 (*Opticks*, Book 2). Newton's rings are examples of *interference colors*, and these can also be seen in soap bubbles and thin skims of oil. For a recent account of interference colors, see Bohren (1991, pp. 13–23).

325. See Chapter 8's "Thomas Young and the Interference Theory of the Rainbow."

CHAPTER SEVEN

1. Shelley 1977, p. 225 (*The Cloud*, lines 67–72).
2. Milton 1975, p. 262 (*Paradise Lost* 11.861–67).
3. American Bible Society 1978, p. 39.
4. Aristotle 1931, *De sensu* 439b.
5. Aristotle 1931, *De sensu* 442a; Kemp 1990, p. 264. Note that ambiguities in surviving Aristotle manuscripts, as well as differences of opinion among translators, can cause variant translations of color names (for example, "purple" may become "violet"). Ancient practice in color naming, which seems to differ from our own, also affects modern translations (James 1991, pp. 68, 73; Sayili 1939, p. 69; see also Sahlins 1977).
6. Sayili 1939, pp. 66–67. In order of decreasing brightness (whiteness), Aristotle's colors are white, yellow, red, green, blue, purple, and black.
7. See the Appendix's "About Color Terminology" for an overview of color terminology.
8. Aristotle 1931, *Meteorologica* 372a. Aristotle also admitted orange and yellow as secondary colors between the bow's bands of red and green (*Meteorologica* 372a, 375a).
9. Aristotle 1913, *De coloribus* 794b. *De coloribus* was long mistakenly ascribed to Aristotle himself (Bell 1993, p. 93; Merker 1967, p. 82).
10. Aristotle 1913, *De coloribus* 794a–b.
11. Aristotle 1913, *De coloribus* 792b.
12. The author of *De coloribus* cautions "But we must not proceed in this inquiry by blending pigments as painters do, but rather by comparing the rays reflected from the aforesaid known colours, this being the best way of investigating the true nature of colour-blends" (Aristotle 1913, *De coloribus* 792b).
13. Aristotle 1931, *Meteorologica* 372a.
14. Aristotle 1931, *Meteorologica* 375a.
15. Merker 1967.
16. Merker 1967, p. 81.
17. Aristotle 1931, *Meteorologica* 375a.
18. Gilbert 1967, p. 606; Westfall 1962, p. 342.
19. Seneca 1971, p. 41 (*Naturales quaestiones* 1.3.13). For more on the relationship of Seneca to Aristotle, see Chapter 4's "The Transformation of Aristotle's Theory: Commentators and Corruption."
20. Kemp 1990, p. 264.
21. Westfall 1962, pp. 342, 344–45; Seneca 1971, pp. 53, 57 (*Naturales quaestiones* 1.5.11–12, 1.6.3–4); Kemp 1990, p. 287. While this distinction between real and apparent colors sounds arbitrary to us, it would seem much more reasonable if you believed that the colors of objects are inherent surface properties. Recall that Kepler and Descartes objected to this color distinction (Descartes 1965, p. 338; Shea 1991, p. 211 n. 49).
22. Newton 1984, pp. 3–4. *De anima* (Aristotle 1931, 419a) describes how color formation depends on objects' surfaces and a transparent medium between object and eye.

23. Pliny 1982, p. 97.
24. Pliny 1982, p. 97. Atramentum was a dark varnish that Apelles used to finish his paintings. The legendary softening effects of Apelles' atramentum finishes were emulated by Leonardo da Vinci and his followers (Moffitt 1989).
25. Jacobs 1984, pp. 400–404. In his widely read *Lives of the Painters, Sculptors, and Architects* (1550), Vasari lavishly praised Apelles (and other Greek painters) and favorably compared the achievements of Renaissance painters with those of antiquity.
26. Gage 1969, p. 13.
27. Kemp 1990, p. 266.
28. Leonardo da Vinci 1956, p. 84.
29. Leonardo da Vinci 1956, p. xx.
30. Rubens 1955, p. 401.
31. Held 1979, p. 257; Parkhurst 1961, pp. 38–40.
32. Barthell 1971, p. 172; Parkhurst 1961, p. 37.
33. Parkhurst 1961, p. 35.
34. Held 1979, p. 257; Parkhurst 1961.
35. Parkhurst 1961, p. 37. Interestingly, one of Aguilonius's two planned (but never completed) companion volumes to his *Opticorum* was on dioptrics, and it was to include discussions of halos, parhelia, and rainbows.
36. Parkhurst 1961, p. 42; Kemp 1990, pp. 275–76. In modern usage, *primary colors* are those mixed to yield all other colors and white.
37. Parkhurst 1961, pp. 44–46.
38. Parkhurst 1961, pp. 46–48. Aguilonius himself cites *De coloribus* in developing his color theory (Parkhurst 1961, p. 44 n. 9).
39. Rubens's own lengthy *Treatise on Light and Color* apparently has not survived (Jaffé 1971, pp. 365–66).
40. Parkhurst 1961, pp. 44, 48; Kemp 1990, p. 276.
41. Bell 1993, pp. 92–95. This bluish tint is the airlight phenomenon; see Chapter 2's "Rainbow Variations in the *Last Judgment*: Giotto and Memling."
42. Kemp 1990, p. 283.
43. Descartes 1965, pp. 335–36; Hooke 1961, p. 62; Boyle 1964, pp. 192–95; Westfall 1980, p. 164; Westfall 1962, pp. 341–48.
44. Newton claimed that he performed his darkened-room prism experiments in 1666, but other contemporary evidence suggests that they occurred in 1668 or 1669 (Guerlac 1983, pp. 75, 77). However, Alan Shapiro finds Newton's 1666 date quite plausible (Newton 1984, pp. 10–11). In any event, recall that Newton's earliest writings on refraction and colors (the *Questiones*) date from 1664.
45. Newton 1809, p. 685 (prop. 7). For more on Newton, prisms, and his color theory, see Chapter 6's "Isaac Newton and the Coloring of the Cartesian Rainbow."
46. Newton 1809, pp. 683–85 (props. 1, 4, 7).
47. Boyer 1987, p. 241.
48. Newton 1809, p. 683 (props. 1, 2). Recall that "degree of refrangibility" means the amount of refractive bending.
49. Note that Newton's language, although not his logic, echoes Aguilonius's Aristotelian distinction between "simple" and "composite" colors (Kemp 1990, pp. 275–76).
50. Newton 1809, p. 684 (prop. 5).
51. According to Newton, compound colors are those "changeable into other colours," in the sense that when samples are viewed through a prism, their edges have different colors than the compound color (Newton 1959, pp. 180–81). In modern terms, we would call Newton's compound colors *impure* or *desaturated* (see this chapter's "Quantifying the Rainbow's Colors").
52. Newton 1984, p. 50 n. 10.
53. See Newton 1952, p. 128 (*Opticks*, 1.2, prop. 3, problem 1, experiment 7).
54. Newton 1952, pp. 154–55 (*Opticks*, 1.2, prop. 6, problem 2); Shapiro 1984, pp. 39–40. Recall Kepler's similar comparison of harmonious progressions in music and the rainbow's colors (Boyer 1987, p. 179).
55. Romney has changed Newton's small circular sunbeam into a broad shaft of sunlight, with consequent changes in the shape of the projected spectrum. While Newton may have had an assistant in the 1660s, he certainly did not have an admiring audience (Guerlac 1983, p. 75; Romney 1961, pp. 25–26).
56. Gage 1971, p. 375.
57. Our slide projector makes Fig. 7-4's spectrum curved.
58. See Chapter 8's "Thomas Young and the Interference Theory of the Rainbow" for more on light as a wave phenomenon and Newton's essentially corpuscular model of light.
59. Newton 1809, p. 685 (prop. 10).
60. Newton 1952, pp. 124–25 (*Opticks*, 1.2, prop. 2, theorem 2).
61. Newton 1809, pp. 684–85 (prop. 7).
62. Shapiro 1980, pp. 227–28.
63. Shapiro 1980, pp. 223–25.
64. Newton 1959, p. 291. In *Opticks*, Newton dismissed whites produced by mixing several colors (rather than an indefinite number) as "Curiosities of little or no moment to the understanding the Phænomena of Nature" (Newton 1952, p. 157 [*Opticks*, 1.2, prop. 6, problem 2]).
65. Note that Fig. 7-7 simply illustrates Huygens's proposed experiment; we cannot actually duplicate it on the printed page.
66. Newton 1959, p. 265.
67. Sekuler and Blake 1985, pp. 184–85.
68. Zwimpfer 1988, example no. 358. In fact, this strong contrast depends on the same visual processes that yield white from complementary color mixtures.
69. Westfall 1980, p. 640. Huygens and Hooke were important exceptions to Newton's favorable scientific reception (Westfall 1980, pp. 240–52; Westfall 1963, pp. 85–93).
70. Kemp 1990, p. 287.
71. Barry 1848, p. 210.
72. Barry 1848, p. 210.
73. Newton 1959, p. 113.
74. Haydon 1926, p. 269. Lamb, "in a strain of humour beyond description," chided Haydon for including Newton's likeness in a painting that overlooked their gathering.
75. Haydon 1926, p. 269.
76. Evans 1959, p. 105. West had the courage of his convictions; he made the first of these two controversial claims when discussing color theory with England's George III (1738–1820).
77. Gage 1969, p. 206.
78. Schweizer 1982a, pp. 439–40; Finley 1967, pp. 364–66.
79. Schweizer 1982a, p. 429.
80. See Schweizer (1982a, p. 429) for others.
81. Newton 1952, pp. 154–58 (*Opticks*, 1.2, prop. 6, problem 2).
82. Newton 1952, p. 155 (*Opticks*, 1.2, prop. 6, problem 2).
83. Vividness is also called *purity* or *saturation*; see the Appendix's "About Color Terminology."
84. Wasserman 1978, p. 40.
85. Kemp 1990, p. 286.

86. Newton 1952, p. 151 (*Opticks*, 1.2, prop. 5, theorem 4, experiment 15). See Newton's discussion of his mixture of orpiment (an orange to lemon-yellow pigment) and purple powders, which yielded "a pale red."

87. Goethe 1967, p. xxv (preface to 1810 edition). English scientist and political theorist Joseph Priestley (1733–1804) is recognized not only for isolating oxygen gas but also for the work that so irritated Goethe, his 1772 *History and Present State of Discoveries Relating to Vision, Light, and Colours*.

88. Goethe 1967, p. 279 (paragraph 705). Goethe lists yellow, blue, and red as the pigment primaries. For his choice of prismatic and artistic primaries, see Goethe (1967, pp. 141–42 and 224 [paragraphs 340 and 552, respectively]).

89. Churma 1994; Goethe 1967, pp. 29–37 (paragraphs 62–80). Zajonc (1976) makes a spirited defense of the care and insight with which Goethe observed color phenomena. Nevertheless, Goethe's sometimes valid objections to Newton's theory were fatally flawed by his penchant for polemic and intuitive flights of fancy.

90. Bisanz 1967, pp. 102, 129–30; Kemp 1990, pp. 295–96.

91. Bisanz 1967, pp. 125–29; see also Ratliff 1992, pp. 101–2.

92. In particular, Helmholtz provided the first correct, consistent explanation of the difference between mixing pigments and colored lights (Sherman 1981, pp. 81–92).

93. The evolution of these ideas in the twentieth century is outlined by Sekuler and Blake (1985, pp. 179–215), Boynton (1992, pp. 15–18), and Ratliff (1992, pp. 75–85).

94. Ratliff 1992, pp. 140–41.

95. Newton 1952, p. 152 (*Opticks*, 1.2, prop. 5, theorem 4, experiment 15). That Newton's four-pigment mixture appeared brighter to him than the two-pigment mixtures (see n. 86 above; Newton 1952, p. 151) suggests that he was indeed seeing *additive* color mixing in the pigment powders. His four-pigment mixture reflected a smaller fraction of the light incident on it (its *reflectance*) than did the white paper. However, the sunlit pigment mixture was illuminated much more intensely than the shaded paper and thus appeared brighter.

96. Newton's clear understanding that the rainbow is a mosaic is evident in his 1672 paper (1809, p. 685 [prop. 10]).

97. This fraction is the sample's *spectral reflectance*.

98. The vertical scale in Fig. 7-12 is logarithmic, not linear, so that moving equal distances on it results in equal multiplicative changes in reflectance. This logarithmic scale matches our perception of brightness differences more closely than a linear one does.

99. $1 - 0.06 = 0.94$, or 94% of the light is absorbed. Often we can ignore the small fraction of light that is reflected by the surface of a transparent medium (that is, the fraction *not* transmitted into the medium).

100. $0.18 \times 0.06 = 0.01$, or 1% is reflected.

101. See Billmeyer and Saltzman (1981, pp. 137–41) and Wyszecki and Stiles (1982, pp. 221–22) for more detailed accounts. Our own measurements of subtractive mixing indicate that the simple approach outlined here often underestimates subtractive mixtures' reflectances.

102. Newton 1952, p. 151 (*Opticks*, 1.2, prop. 5, theorem 4, experiment 15). If Newton had blended these dry pigments in a binder, subtractive color mixing would have generated an even darker color than the one he describes (which essentially was produced by additive color mixing).

103. Kemp 1990, p. 276. Aguilonius is even more dire, warning that a mixture of material red, yellow, and blue results in a "livid and lurid and even cadaverous" color (Parkhurst 1961, p. 44). See Ratliff (1992, pp. 136–45) for an excellent discussion of additive and subtractive color mixing and their significance for artistic practice.

104. In Fig. 7-12, the magenta is about 28 times brighter than the purple. In this and subsequent technical diagrams, the word "brightness" strictly means *luminance*, a quantitative measure that varies directly (but not linearly) with the qualitative apparent brightness. See the Appendix's "About Color Terminology" and Wyszecki and Stiles (1982, pp. 259, 494–95).

105. Billmeyer and Saltzman 1981, pp. 28–30.

106. Bennett 1969, p. 53. Robert Boyle noted similar changes: "I observ'd a manifest Difference in some Kinds of Colour'd Bodyes look'd on by Day-light, and afterwards by the light of the Moon; either falling directly upon them or Reflected upon them from a Concave Looking-glass" (Boyle 1964, p. 195). Apparently Boyle's mirror did not intensify the moonlight as much as Hunt's lens, or he too would have noticed moonlight's color shifting toward the white of sunlight.

107. Ratliff (1992, pp. 128–32) correctly observes that the necessary imprecision of common color names makes for ambiguities when describing color mixing qualitatively. In turn, these ambiguities lead to "discoveries" of false conundrums. For example, depending on our choice of blue and yellow, their mixture (whether additive or subtractive) may yield either green or a nearly achromatic color. These are not contradictory results—they are simply the consequence of mixing the many different colors that can be called "blue" and "yellow."

108. Remember that a vivid color may also be called "pure" or "saturated."

109. Practically speaking, our eyes require a finite range of wavelengths (no matter how small) to produce detectable levels of light energy.

110. A spectrum color's purity is 100 percent, while white's purity is 0 percent.

111. A short history of the CIE system and its relationship to Newton's work appears in Boynton (1992, pp. 13–19, 397–403).

112. The CIE further distinguishes between the brightness of objects that emit light and the relative *lightness* of objects that reflect light.

113. Ratliff 1992, pp. 92–95; Sekuler and Blake 1985, pp. 71–74. Ernst Mach made the first systematic analysis of these enhanced brightness differences.

114. The achromatic cousin of simultaneous color contrast is *simultaneous brightness contrast*, in which, say, a gray swatch surrounded by black appears lighter than an identical swatch surrounded by white (Ratliff 1992, pp. 43–44, 48–51). Although both types of contrast are purely subjective (and have related physiological causes), this does not alter their persuasiveness. Interestingly, Aristotle's tortuous explanation of rainbow colors also includes a quite lucid description of simultaneous color and brightness contrasts, although he couches these in different terms than we do (Aristotle 1931, *Meteorologica* 375a).

115. Boynton 1992, p. 18; Ratliff 1992, pp. 99–100; Goldstein 1980, pp. 121–27.

116. Favreau and Corballis 1986; Ratliff 1992, pp. 105–26.

117. Leonardo da Vinci 1956, p. 83.

118. McGuire and Tamny 1983, p. 445 (*Questiones* 75 125r).

119. Dorra 1994, p. 193 n. 18. Buffon's prescience is remarkable. In his mammoth encyclopedia *Histoire naturelle, générale et particulière* (1774–89), he was the first to propose the idea

of geological epochs and to suggest that a comet impact with the sun could have produced the planets. Buffon also gave the first correct qualitative explanation of sky color and airlight, noting: "it is certain that the celestial azure is nothing other than the color of air; to be sure, a substantial thickness of air is necessary for our eye to notice that element" (Dorra 1994, p. 193 n. 26). This statement anticipates by almost a century the quantitative skylight model developed by Britain's Lord Rayleigh (John W. Strutt, 1842–1919) (Bohren and Fraser 1985).

120. Newton also noted blue in daytime shadows, although this particular observation may have been caused by the afterimage of a low sun (McGuire and Tamny 1983, p. 445 [*Questiones* 76 125v]). Newton never addressed such subjective phenomena in his mature color theory, yet it is nonetheless a little ironic that Goethe included afterimages and colored shadows in the arsenal of his anti-Newtonian polemic *Farbenlehre* (Goethe 1967, pp. 29–37 [paragraphs 62–80]).

121. Dorra 1994, p. 194 n. 35.

122. Dorra 1994, p. 187.

123. Dorra 1994, p. 189.

124. Kemp 1990, p. 295; Thompson 1809, pp. 378–79.

125. See Chapter 9's "Thomas Young and the Interference Theory of the Rainbow." Drawing on his experience in physiology, Young developed a color theory in which he correctly reasoned that "each sensitive point" on the retina must respond most strongly to one of three primary colors (Young 1802, pp. 20–21; Sherman 1981, pp. 9–11).

126. Sherman 1981, pp. 20–57; Brewster 1834.

127. Chevreul 1987, pp. 71 (paragraph 160), 73. For example, note in Fig. 7-13 that a pure violet or blue is at a greater colorimetric distance from white than a pure yellow. Perceptually, this means that the purest blue will seem more vivid than the purest yellow, even if both are equally bright.

128. Chevreul 1987, p. 137 (paragraph 869).

129. Chevreul 1987, pp. 96–98 (paragraphs 335–55); Johnson 1963, pp. 63–64.

130. Chevreul 1987, p. 137 (paragraph 869).

131. Kemp 1990, p. 310.

132. Kemp 1990, p. 308; Johnson 1963, p. 72.

133. The "opposite" here refers to the conventional opposition of a color and its complement on a color wheel or other color figure (for instance, Zwimpfer 1988, example 358).

134. Kemp 1990, p. 308.

135. Johnson 1963, p. 104. Like many another accomplished artist, Delacroix disobeyed his own principle when it interfered with effective practice.

136. Kemp 1990, p. 309.

137. For example, Henri Matisse (1869–1954) insisted: "My choice of colours does not rest on any scientific theory; it is based on observation, on feeling, on the very nature of each experience. Inspired by certain pages of Delacroix, Signac is preoccupied by complementary colours, and the theoretical knowledge of them will lead him to use a certain tone in a certain place. I, on the other hand, merely try to find a colour that will fit my sensations" (Ratliff 1992, p. 191).

138. Seurat's *Une Baignade, Asnières* and *La Grande Jatte* are reproduced in Kemp (1990, plates 548, xv) and Herbert (1991, pp. 146–47, 170–71). In 1887, Seurat brought *Asnières* up-to-date with pointillist retouchings (Gage 1987, p. 452).

139. Herbert 1991, p. 382 (version D of Seurat's *Esthétique*, 1890).

140. Webster 1978, pp. 96–99. Alan Lee misleadingly claims a "significant difference between optical blending and the genuine *addition* of coloured lights" (Lee 1987, p. 209). Certainly mosaics of reflective colors (for example, pointillist paint dots, magazine halftone photographs) are often dimmer than their emitted or transmitted cousins (for example, color television, some types of color slides). Yet aside from some subtractive color mixing due to dot overlap, pointillism's additive mixing is just as genuine as, say, color television's (assuming that, as in our television example, we cannot discern individual dots). Floyd Ratliff's incisive discussion of additive and subtractive mixing also makes this point (Ratliff 1992, pp. 136–45).

141. Homer 1978, pp. 145–46. In an 1890 exposition of his technique Seurat wrote: "Given the phenomenon of the duration of the luminous impression on the retina, Synthesis is logically the result. The means of expression is the optical mixture of tones, of tints (of local color and the illuminating color: sun, oil lamp, gas, etc.), that is, of the lights and of their reactions (shadows) following the laws *of contrast*, of gradation, of irradiation" (Herbert 1991, p. 382 [version D of Seurat's *Esthétique*, 1890]).

142. An acquaintance of Seurat's said, "To hear Seurat explaining his work, confessing in front of his yearly exhibitions, was to follow a person of sincerity and to allow oneself to be won over by his persuasiveness" (Homer 1978, p. 147).

143. At some distance from a canvas, pointillism's juxtaposing of small paint dots causes retinal fusion: dots are too small to be resolved individually, so we see only their additively mixed light. Divisionism uses larger patches of color intended to be viewed close enough that they do *not* blend together. In essence, the separate color patches of divisionism exploit opponent-color phenomena (such as simultaneous color contrast), while pointillism's fused dots exploit additive color mixing. Clearly the two techniques differ by degree rather than kind, because a nominally divisionist work will become pointillist at a sufficiently large viewing distance (Ratliff 1992, pp. 35–38, 51–52, 152).

144. Herbert 1991, p. 383 (version C of Seurat's 20 June 1890 letter to Félix Fénéon); Seurat 1978, p. 16.

145. Herbert 1991, p. 383 (versions B and C of Seurat's 20 June 1890 letter to Félix Fénéon). Gage notes that Seurat's quasi-spectral palette tries to reconcile the traditional academic (and Aristotelian) palette of "white to black through yellow, red, and blue" with the Newtonian spectrum (Gage 1987, p. 451).

146. Kahn 1978, p. 22.

147. Herbert 1991, pp. 149, 383, 394–95; Ratliff 1992, pp. 23–26.

148. Herbert 1991, pp. 382, 389; Lee 1987, p. 218; Chevreul 1987, p. 96 (paragraph 332).

149. Herbert 1991, pp. 383, 388–89, 391. *Modern Chromatics* incorporated Herman von Helmholtz's discoveries on color mixing. Seurat would have been introduced to the term "optical mixture" in the 1867 *Grammar of Painting and Engraving* by French critic and aesthetician Charles Blanc (1813–82). Seurat liberally borrowed ideas and phrases from Blanc's influential book (Herbert 1991, p. 384).

150. Rood 1973, p. 163 (1879, p. 140). Rood, in turn, cites Ruskin as saying in *Modern Painters*, "Breaking one colour in small points through or over another is the most important of all processes in good modern oil and water-colour painting."

151. Fénéon 1978, pp. 37, 38.

152. Hennequin 1978, p. 42; see also Homer 1978, p. 139.

153. Fénéon 1978, p. 39.

154. Lee 1987, p. 207. Colorimetrically speaking, Lee is not justified in saying that subtractively mixed pigments can *always* match the brightness and purity of additively mixed light reflected by other pigments. With the right choice of different pigments for additive and subtractive mixing, we can easily achieve mismatches.

155. Seurat usually painted over dark grounds, so his "spectral" palette would actually brighten the surface (Herbert 1991, p. 391). Had he painted over a white ground, the *same* palette would have darkened the surface because a bright white is more reflective than most colors. Thus even a partially visible ground will affect a painting's reflectivity and apparent brightness, whether the work is done in pointillist or conventional fashion. See also Ratliff 1992, pp. 145–47.

156. Lee 1987, p. 208; Homer 1978, pp. 137, 142; Webster 1978, pp. 96–99. See Ratliff (1992, pp. 150–51) for the gamut of pigment colors available to Seurat and his contemporaries.

157. On the CIE UCS diagram (Fig. 7-14), we additively mix two colors by moving along the straight-line segment that connects them. If we mix equal amounts of a pure spectral blue and orange, the resulting color lies somewhere in the achromatic region between them.

158. Chevreul 1987, p. 96 (paragraph 332).

159. Gage 1987, p. 449.

160. Ironically, Seurat's additive mixing of light reflected by paint dots necessarily depends on those dots' having different absorption (and thus reflection) spectra. In short, identical processes of absorption and reflection are inherent in any painting technique.

161. By comparison, Seurat included horses in four other *Asnières* studies. In fact, on old maps of the Seine, *baignade* originally meant a bathing place for horses and dogs (Herbert 1991, p. 150). Thus horses would have been everyday visitors to this working-class riverbank in Paris (note smokestacks in background).

162. Quoted in Smith (1990, p. 384).

163. Homer 1978, p. 147.

164. Angrand 1978, p. 35.

165. Ratliff 1992, pp. 261–62 (Paul Signac, *D'Eugène Delacroix au Néo-Impressionnisme* [From Eugène Delacroix to Neo-Impressionism, 3rd ed., 1921], chap. 5, sec. 4).

166. See Chapter 8's "Observed and Intrinsic Rainbow Colors" and Lee (1991).

167. Churma 1994, pp. 4719–20.

168. Brou et al. 1986, pp. 86–87.

169. Sekuler and Blake 1985, pp. 185–86.

170. Naturally, white sunlight will be much brighter than light from a television.

171. Sekuler and Blake 1985, pp. 54–59, 197–201.

172. Sekuler and Blake 1985, pp. 192–97.

173. Boynton 1992, pp. 19, 399–403.

174. Lee 1991.

175. Wyszecki and Stiles 1982, p. 489; Billmeyer and Saltzman 1981, pp. 99–100.

176. The JND's size changes slightly with location on the diagram (Wyszecki and Stiles 1982, pp. 306–9).

CHAPTER EIGHT

1. Barker 1988, p. 110.

2. Perhaps surprisingly, winter's freezing temperatures do not rule out water drop formation, making wintertime rainbows or cloudbows entirely possible (Bohren 1987, pp. 180–85).

3. See Greenler (1980, pp. 143–46) and Anthes et al. (1981, p. 429) for discussions of the glory.

4. Barker 1988, p. 111. A century earlier, Descartes had also hopefully invoked "many very round and transparent grains of hail mingled among the rain" to explain reports of another kind of unusual rainbow (Descartes 1965, p. 344).

5. Boyer 1987, p. 277.

6. Lynch and Futterman 1991.

7. Wallace 1959, p. 225; Theodoric 1914, pp. 179–80.

8. Witelo 1972, p. 462.

9. Horten and Wiedemann 1913, p. 541.

10. Leonardo da Vinci 1956, p. 335. See Palmer (1945, p. 204) and Greenler (1980, plate 1-7) for twentieth-century observations of red rainbows.

11. Lynch and Futterman 1991, p. 3538.

12. Boyer 1987, p. 277. This name is ironic because Juan, not Ulloa, observed the cloudbow in 1737 and authored the scientific account of it. However, Ulloa seems to have been the abler, and thus more memorable, writer (Juan and Ulloa 1964, pp. 16–17, 112).

13. With the benefit of hindsight, we can generate different-colored rainbows even within the confines of geometrical optics.

14. Descartes 1965, p. 332.

15. Eastwood 1966, p. 328.

16. Churma 1995.

17. Boyer 1987, p. 287.

18. Botley 1970, p. 287. Smith and Vingrys (1995) discuss in some detail how the low brightness of lunar rainbows affects their colors.

19. Boyer 1987, pp. 280, 307.

20. Middleton 1965, pp. 54–57; Boyer 1987, p. 307.

21. Wallace 1959, p. 223.

22. Witelo describes his "rainbow under a rainbow" as follows: "whenever more rainbows are seen with the same placement of colors, one is under the other, as first red then green: and then purple: and again red: and again green: and finally purple." He confidently (although incorrectly) claims that "a diversity of matter in the different bands" explains these bows (Witelo 1972, pp. 464–65).

23. Boyer 1987, p. 279.

24. Langwith 1809, p. 623.

25. Boyer 1987, p. 278.

26. Langwith 1809, p. 624.

27. Fraser 1983a.

28. Boyer 1987, pp. 279–81.

29. Steffens 1977, pp. 92–101; Sabra 1967, pp. 185–230.

30. Young 1804, pp. 8, 11. In fact, the explanation of the glory involves considerably more than Young's suggestion that it is "perhaps more nearly related to the common colours of thin plates as seen by reflection" (that is, interference colors). See Anthes et al. 1981, p. 429.

31. Young 1804, p. 11.

32. Steffens 1977, pp. 111–13. Huygens believed that light waves consisted of longitudinal pulses rather than periodic transverse waves. For more about these two kinds of waves, see the text's discussion of polarization at n. 36 below.

33. Steffens 1977, pp. 128–36.

34. See Bohren (1991, pp. 25–48) for a thorough qualitative explanation of polarization; Können (1985, pp. 47–56) discusses the rainbow's polarization.

35. Boyer 1987, p. 289.
36. The vibrations of a drumhead illustrate this idea.
37. Boyer 1987, p. 290.
38. Brewster 1833, p. 361. Brewster's objection here was to some implausible optical properties of wave theory's speculative *luminiferous ether*, a supposedly omnipresent medium required for the transmission of light. Young and Fresnel separately gave this ether contradictory physical properties, and it was eventually abandoned as being both untenable and unnecessary for explaining the wave nature of light. Although Brewster's complaint was well-founded, his conclusion—that wave theory was gravely flawed—was not (Boyer 1987, pp. 290–91).
39. Young 1804, p. 9.
40. Recall that deviation angle is defined in Chapter 6, n. 191.
41. Mathematically, in any medium the speed of light v is given by: v = frequency x wavelength. Frequency is the number of wave cycles that pass a point per second. For a given v, frequency increases as wavelength decreases.
42. Young 1804, p. 9. Although Young estimated the range of drop sizes required to produce supernumeraries of a particular radius, he offered no explanation for his estimate.
43. Greenler 1980, pp. 10–12. See McDonald and Herman (1964) on the confusing and sometimes contentious use of the word "diffraction" in modern rainbow theory.
44. Maurer 1967–68, p. 374.
45. Note that Fig. 8-1 was photographed with a wide-angle lens.
46. Lynch and Futterman 1991, p. 3538.
47. McDonald 1962, p. 243.
48. Minnaert (1993, p. 203) clearly analyzes this perceptual conundrum.
49. McDonald 1962, p. 244.
50. This is Airy theory; see Chapter 10's "Airy's Rainbow Theory: The Incomplete 'Complete' Answer."
51. Note that 8° = 145°–137°.
52. See Fig. 8-23 below for estimates of the radii of Fig. 8-1's cloudbow and Fig. 8-8's rainbow.
53. Of course, bear in mind Chapter 7's color-naming pitfalls.
54. See Chapter 7's "How Many Colors Does the Rainbow Have?" for discussions of our colorimetric and image analysis techniques.
55. Lee 1991, p. 3403.
56. Bohren 1987, pp. 160–63.
57. Minnaert 1993, pp. 81–86; Bohren 1987, pp. 98–103; Greenler 1980, pp. 172–77.
58. For example, see Rösch (1968, p. 238).
59. Note that now we are looking at these curves from a different vantage point than earlier.
60. For example, see those near u' = 0.19, v' = 0.485 in Fig. 8-15.
61. Aristotle 1931, *Meteorologica* 374b. As with much of Aristotle's rainbow explanation, ambiguity lurks here. Aristotle's geometric arguments erroneously require rainbow colors to become progressively darker as we move from red to green to purple. Apparently Aristotle regards yellow as the brightest of all colors, yet red is the brightest of his rainbow colors. In an attempt to make a flawed theory agree with observation, he confuses the matter by placing the brighter yellow between red and green (*Meteorologica* 375a).
62. Modern rainbow theories realistically predict that reds on the outside of the primary rainbow are its darkest colors (see Figs. 8-11 and 10-29).
63. Uncertainties abound in measuring the angular size of amorphous features such as Fig. 8-1's cloudbow. Accordingly, this cloudbow's radius might be as much as 1°–2° smaller than that estimated in Fig. 8-23. See Minnaert (1993, p. 201) and Greenler (1980, pp. 11–12) for other estimates of cloudbow radii.
64. For a cloudbow near-miss, see Fig. 10-28.
65. Thornbury 1970, p. 105. A small segment of a secondary bow is visible in Fig. 8-24.
66. *Illustrated London News* 1849, p. 347.
67. *Spectator* 1849, p. 592.
68. Milner 1990, p. 76.
69. Landow 1977, p. 369.
70. Quoted in Schweizer (1982a, p. 439).
71. Kemp 1990, pp. 301–3.
72. Wilton 1980, pp. 35–36. A portion of this poem is quoted as Chapter 3's epigraph.
73. Thomson 1971, p. 10 (*Spring*, line 205).
74. Wilton 1980, pp. 165–66.

CHAPTER NINE

1. Shakespeare 1958, pp. 98–99.
2. Maurer 1967–68, pp. 374–75.
3. Lawrence 1976, p. 495.
4. Langwith 1809, p. 624.
5. Greenler 1980, p. 10.
6. Because a nonspherical raindrop does not have a radius as such, "radius" here is just a label that refers to a spherical drop with the same volume as the nonspherical one.
7. Note that 31° = 180° – 149°.
8. Recall from Chapter 8 ("A Map of the Rainbow's Colors") that larger drops produce brighter, as well as purer, rainbow colors.
9. Fraser 1972.
10. See Chapter 4's "The Inescapable (and Unapproachable) Bow."
11. Martin 1984, pp. 52–55.
12. For Pope himself, the rainbow is among the ephemera that fade before the *Dunciad*'s universal, anarchic darkness: "She comes! she comes! the sable Throne behold / of *Night* Primæval, and of *Chaos* old! / Before her, *Fancy*'s gilded clouds decay, / And all its varying Rain-bows die away" (Pope 1978, p. 583 [*Dunciad* 4.629–32; first published 1742]).
13. Gove 1961, vol. 2, p. 1876. Optically of course the rainbow is no more an illusion than your reflection in the mirror.
14. Walker 1950.
15. Airy 1838. See Chapter 10's "Airy's Rainbow Theory: The Incomplete 'Complete' Answer."
16. Boyer 1987, pp. 294–318.
17. See Fig. 9-8 and Ulbrich (1983).
18. Lee (1998) describes the details of this sun-width smoothing.
19. Fraser 1983a.
20. Green 1975.
21. Fraser 1983b.
22. Churma 1995, pp. 42–43.
23. Ross 1985, p. 4.
24. For Church's and Bierstadt's cloud studies, see Novak (1980, pp. 93–98).
25. Cropsey 1984, p. 82.
26. Talbot 1977, pp. 579ff.
27. Cropsey 1855; see also Owens and Peters-Campbell (1982, p. 39).

28. Cropsey 1855, p. 79.
29. Cropsey 1855, p. 80.
30. Cropsey 1855, p. 79. Cropsey also is keenly aware of both airlight and color gradations in the clear sky: "nor is it always the same monotonous blue; it is constantly varied, being more deep, cool, warm or grey—moist or dry—passing by the most imperceptible gradations from the zenith to the horizon—clear and blue through the clouds after rain—soft and hazy when the air is filled with heat, dust, and gaseous exhalations" (Cropsey 1855, p. 79).
31. *Crayon* 1860, p. 40.
32. *Crayon* 1860, p. 40.
33. *Crayon* 1860, p. 41.
34. *Crayon* 1860, pp. 40–41.
35. Wallace 1959, p. 223; Theodoric 1914, pp. 175–76.
36. Boyer 1958, p. 153.
37. Lynch and Livingston 1995, p. 114.
38. Lynch and Livingston 1995, p. 114 (also reproduced as Können 1987, fig. 5).
39. Können 1987, p. 810.
40. Fraser (1983b, fig. 5) shows this relationship between sun elevation and minimum deviation angle for the primary rainbow.
41. Können 1987, p. 810.
42. Können 1987, fig. 5.
43. Newton 1952, p. 171 (*Opticks*, 1.2, prop. 9, problem 4); Halley 1700. Newton in fact presents formulas in his 1670–72 *Optica* for calculating the position of tertiary and higher-order rainbows (Newton 1984, pp. 423–25 [*Optica*, part 1, lecture 15, prop. 36]). However, the *Optica* were not published during Newton's lifetime. (A rainbow's *order* is determined by its number of reflections within a raindrop. Thus the primary rainbow is a first-order bow and the secondary rainbow is a second-order bow.)
44. Halley 1700, p. 531.
45. Newton 1952, p. 178 (*Opticks*, 1.2, prop. 9, problem 4).
46. Boyer 1987, pp. 249–50; Corliss 1984, pp. 7–11. For examples of speculative (and wrong) positions for the tertiary, see Boyer (1958). One obvious source of "multiple" rainbows is discrete segments of an incomplete double or single rainbow.
47. Aristotle 1952, p. 267 (*Meteorologica* 375b).
48. Boyer 1987, p. 52.
49. Alexander of Aphrodisias 1968, p. 252 (*Meteorologica* commentary 41[ra]). Earlier, Alexander says of the rainbow that "sometimes it was made two-fold, as we have said, and moreover it has appeared to some to be three-fold" (Alexander of Aphrodisias 1968, p. 250 [*Meteorologica* commentary 40[va]]).
50. Horten and Wiedemann 1913, p. 542.
51. Witelo 1972, p. 464.
52. Theodoric 1914, p. 150; Boyer 1958, p. 144. Witelo uses similar arguments about formal causes to rule out a third rainbow (Witelo 1972, p. 466).
53. Huygens 1888–1910, vol. 3, p. 226 (26 January 1661; Christiaan to Lodewijk Huygens). Only Christiaan Huygens's reply to his brother Lodewijk survives, and this letter's few details do not clearly indicate what kind of "triple rainbow" Lodewijk saw. However, Christiaan does not mention the true tertiary's most remarkable feature, its position opposite the primary rainbow, implying that Lodewijk observed something else.
54. Boyer 1987, pp. 246–47.
55. Descartes 1965, p. 344. Descartes further speculated that this third bow was caused by "many very round and transparent grains of hail mingled among the rain." Newton may have Descartes's speculation in mind when he says of the feeble tertiary bow: "in those Cylinders of Ice by which *Hugenius* explains the *Parhelia*, it may perhaps be sensible" (Newton 1952, p. 178 [*Opticks*, 1.2, prop. 9, problem 4]).
56. Boyer 1958, pp. 152–53.
57. The *Handbuch der Optik* of F. W. Gustav Radicke (1810–83) was published in 1839.
58. Bergmann's remarkably closely spaced observations of tertiary rainbows (3 and 5 September 1759) were questioned (Boyer 1987, p. 271).
59. Jakob Bernoulli (1655–1705) was the eldest in a family of gifted Swiss mathematicians.
60. Heilermann 1880, p. 72.
61. Hartwell 1854.
62. Pedgley 1986.
63. Walker 1977.
64. Walker 1977, p. 144. Walker's diagram, in turn, is a transformation of the rose of rainbows first illustrated in 1868 by French scientist Félix Billet (1808–82) (Boyer 1987, fig. 66 [facing p. 310]).
65. Inevitably, the rainbow's changing position and increasing breadth complicate our simple notions of its "inside" and "outside." For example, as Walker points out, the red and violet of the twelfth-order bow wrap around the sun's position (Walker 1977, p. 141). Equally problematic are the eleventh- and twenty-fourth-order rainbows, which straddle the zenith!
66. Boyer 1987, p. 251.
67. See Chapter 5 for medieval examples of this model raindrop and its spectrum.
68. Newton 1952, pp. 177–78 (*Opticks*, 1.2, prop. 9, problem 4).
69. Stevens 1906, p. 171.
70. Bohren and Fraser 1991, p. 325.
71. Bohren and Fraser 1991.
72. Shapiro 1992.
73. Shapiro 1992, p. 749.
74. Say that Newton assumes his flattened (that is, ellipsoidal) hailstones are oriented in a particular direction as they fall, much like our ellipsoidal raindrops. Then only parts of the halo will be shifted from 26° to 22°. Alternatively, if he assumes that the hailstones are randomly oriented, refracted sunlight will be spread over a *range* of minimum deviation angles, not just 22°. This unrealistically makes the halo at least 4° wide. Finally, why assume that flattening of hailstones reduces the minimum deviation angle to 22° and no less? In short, no amount of optical gymnastics can change Newton's nonexistent 26° arc into a real 22° halo circle.
75. Newton correctly says in the *Opticks* manuscript that the 22° halo is caused by minimum deviation within hexagonal ice crystals. He crossed out this clear, essentially correct explanation and substituted for it the present confusing one (Shapiro 1992, p. 749).
76. Boyer 1987, p. 253.
77. Humphreys (1964, pp. 497–99) uses "reflection rainbow" while Greenler (1980, p. 13) uses "reflected-light rainbow" for what we call the sunlight-reflection rainbow. Reflected moonlight also could cause this kind of bow. See Minnaert (1993, pp. 203–4) for more on rainbow reflections.
78. Boyer 1987, color insert between pp. 142–43. The reflected rainbow photograph is captioned "Reflected rainbow seen in a pond in Massachusetts, next to the Atlantic Ocean."
79. For a sampling of accounts of sunlight-reflection rainbows, see Corliss (1984, pp. 7–11).

80. Boyer 1987, color insert between pp. 142–43; Greenler 1980, plate 1-9.
81. Halley 1698, p. 277.
82. Halley 1698, p. 278.
83. Halley 1698, p. 278.
84. Snell 1854, p. 21.
85. Corliss (1984, pp. 7–39) lists many of these, which range from the dubious to the bizarre, including rainbows that are not concentric with one another.

CHAPTER TEN

1. Cumbey 1983, foreword.
2. *Lodging Hospitality* 1993.
3. Macdonald 1994.
4. Weinstein 1993.
5. Long 1987.
6. See Chapter 1's "Rainbow Bridges of Every Stripe."
7. Ozone produces the familiar "electric arc" smell.
8. See Chapter 8's "Cloudbows: The 'Circle of Ulloa'."
9. Landow 1977, p. 351.
10. Dorfles 1969, pp. 154–55.
11. Shreeve 1994.
12. Shreeve 1994, pp. 17–18.
13. Shreeve 1994, p. 18.
14. Airy 1838, p. 392.
15. Recall that Airy theory's colors are illustrated in Fig. 8-11.
16. Young 1804, p. 9.
17. Miller 1841, p. 520. Recent papers by Lock (1987) and Walker (1976) show that even higher-order rainbows continue to attract scientific attention.
18. Miller 1842, p. 285.
19. Potter 1838, pp. 141–43. Potter read this paper before the Cambridge Philosophical Society in 1835; publication followed three years later.
20. Nussenzveig 1980, p. 65.
21. Boyer 1987, p. 306; Potter 1855, p. 322.
22. Boyer 1987, pp. 310–11.
23. Ratliff 1992, pp. 76–78; Sherman 1981, pp. 165–70.
24. Boitel 1888, p. 240; Boyer 1987, p. 313.
25. See Nussenzveig (1980, p. 70).
26. Boyer 1987, p. 314.
27. Pernter and Exner 1922, pp. 565–88. Hammer (1903) gives an English summary of Pernter's work on the rainbow.
28. For raindrops, the medium is air.
29. Bohren and Huffman 1983, p. 82.
30. Kerker 1969, p. 54.
31. Nussenzveig 1980, pp. 67–68.
32. See Chapter 8's "Observed and Intrinsic Rainbow Colors."
33. For example, see Volz (1961), Fraser (1983b), and Churma (1995).
34. Lee 1998.
35. Johnson 1982, pp. 44, 326.
36. Hastings 1957, vol. 2, pp. 853–54. See Chapter 1's "Rainbow Bridges of Every Stripe" for a more detailed discussion of Bifrost.
37. Guerber 1908, p. 148; Pigott 1978, p. 40; Hastings 1957, vol. 2, p. 853.
38. Hastings 1957, vol. 2, p. 853.
39. West 1985, p. 22.
40. Traxel 1980, p. 170.
41. Kahan 1979, pp. 104–5.
42. Traxel 1980, pp. 77–78, 175.
43. Traxel 1980, pp. 200, 205.
44. Bento 1980, pp. 62–63, 106–8.
45. Bento 1980, pp. 85–88.
46. Rubinstein 1994.
47. Tamayo 1979, pp. 49–53.
48. A second panel called *The Work of Art and the Observer* adjoins *Nature and the Artist* on its right.
49. Tamayo 1993, pp. 12–13. It seems oddly appropriate that Tamayo's twentieth-century rainbow painting is inhabited by antiquity's four elements. Earth, air, water, and fire are bound together by the rainbow just as they were for Saint Isidore and Bartholomaeus Anglicus. See Chapter 2, n. 9 and Chapter 5, n. 28.
50. Cohen 1982, p. 24.

APPENDIX

1. Your hands and arms provide a built-in angular measure. Extend your arm straight and splay out the fingers on that hand, keeping your palm outward. The angular distance between the tips of your outstretched thumb and little finger is about 22°, so two hand spans cover 44°, slightly more than the primary rainbow's radius. Thus, if you put your thumb over your head's shadow and measure a distance of two outstretched hand spans from it, you will be looking at the primary rainbow's position.
2. The tone of a pigment mixture increases as black is added to it (that is, lightness and tone change in opposite senses). Confusingly, "tint" is now sometimes a synonym for "hue" (Chevreul 1987, p. 70 [paragraph 148]; Herbert 1991, p. 381).
3. The Munsell System is a large collection of color samples, each of which differs from its immediate neighbor by a fixed perceptual interval of hue, chroma, or value. With its carefully measured color samples, this practical and fairly rigorous system has long had many commercial applications (Billmeyer and Saltzman 1981, pp. 28–30).

BIBLIOGRAPHY

Abrams, Meyer H. 1971. *The Mirror and the Lamp: Romantic Theory and the Critical Tradition*. London: Oxford University Press.

Abrams, Meyer H., ed. 1974. *The Norton Anthology of English Literature*. Vol. 2. Third edition. New York: W. W. Norton and Co.

Adam, Malise F., and Mary Mauchline. 1992. "*Ut pictura poesis*: Angelica Kauffmann's Literary Sources." *Apollo* 135:345–49.

Adamson, Jeremy E. 1981. "In Detail: Frederic Church and *Niagara*." *Portfolio* 3 (November/December): 53–59.

———. 1985. "Nature's Grandest Scene in Art." In *Niagara: Two Centuries of Changing Attitudes, 1697–1901*, edited by Jeremy E. Adamson, 11–81. Washington, D.C.: Corcoran Gallery of Art.

Adler, Cyrus, ed. 1906. *The Universal Jewish Encyclopedia*. Vol. 9. New York: Ktav Publishing House.

Airy, George B. 1838. "On the Intensity of Light in the neighbourhood of a Caustic." *Transactions of the Cambridge Philosophical Society* 6:379–403.

Albertus Magnus. 1890. "Tractatus IV: De Coronis et Iride Quæ Apparent in Nubibus." In *Opera omnia*, vol. 4, edited by Auguste Borgnet, 666–700. Paris: Ludovicum Vives.

Alexander of Aphrodisias. 1968. *Corpus latinum commentariorum in Aristotelem graecorum*. Vol. 4, *Commentaire sur les Météores d'Aristote*, edited by A. J. Smet. Louvain: De Wulf-Mansion-Centrum.

Alhazen. 1989. *The Optics of Ibn al-Haytham*. Books 1–3, *On Direct Vision*. Translated by Abdelhamid I. Sabra. 2 vols. London: Warburg Institute.

American Bible Society. 1978. *The Story of Noah: A Scripture Activity Book with a Story from the Good News Bible*. New York: American Bible Society.

Andrews, Edmund L. 1990. "Patents: A Fountain That Makes Real Rainbows." *New York Times*, 8 December, A34:1.

Angrand, Charles. 1978. Excerpts from letters by Charles Angrand to Gustave Coquiot. In *Seurat in Perspective*, edited by Norma Broude, 34–35. Englewood Cliffs, N.J.: Prentice-Hall.

Anthes, Richard A., John J. Cahir, Alistair B. Fraser, and Hans A. Panofsky. 1981. *The Atmosphere*. Third edition. Columbus, Ohio: Charles E. Merrill Publishing Co.

Anthes, Richard A., Hans A. Panofsky, John J. Cahir, and Albert Rango. 1978. *The Atmosphere*. Second edition. Columbus, Ohio: Charles E. Merrill Publishing Co.

Anzelewsky, Fedja. 1981. *Dürer: His Art and Life*. Translated by Heide Grieve. New York: Alpine Fine Arts Collection.

Aristotle. 1913. *The Works of Aristotle*. Vol. 6, *Opuscula*, edited by W. D. Ross. London: Oxford University Press.

———. 1930. *The Works of Aristotle*. Vol. 2, *Physica, De caelo, De generatione et corruptione*, edited by W. D. Ross. London: Oxford University Press.

———. 1931. *The Works of Aristotle*. Vol. 3, *Meteorologica, De mundo, De anima, Parva naturalia, De spiritu*, edited by W. D. Ross. London: Oxford University Press.

———. 1952. *Meteorologica*. Translated by H. D. P. Lee. Cambridge, Mass.: Harvard University Press.

———. 1976. *Aristotle in Twenty-Three Volumes*. Vol. 2, *Posterior Analytics, Topica*, edited by G. P. Goold. Cambridge, Mass.: Harvard University Press.

———. 1979. *Aristotle in Twenty-Three Volumes*. Vol. 13, *Generation of Animals*, edited by G. P. Goold. Cambridge, Mass.: Harvard University Press.

Asimov, Isaac. 1974. *Words of Science and the History Behind Them*. London: George G. Harrap and Co.

Auerbach, Erna, and Charles K. Adams. 1971. *Paintings and Sculpture at Hatfield House*. London: Constable and Co.

Avery, Kevin J. 1986. "*The Heart of the Andes* Exhibited: Frederic E. Church's Window on the Equatorial World." *American Art Journal* 18:52–72.

Bacon, Roger. 1962. *The Opus Majus of Roger Bacon*.

Translated by Robert B. Burke. 2 vols. New York: Russell and Russell.

Banier, Antoine. 1976. *The Mythology and Fables of the Ancients, Explain'd from History.* Vol. 2. 1740. Reprint, New York: Garland Publishing.

Baretti, Giuseppe [Joseph]. 1781. *A Guide Through the Royal Academy.* London: T. Cadell.

Barker, Thomas. 1988. *The Weather Journals of a Rutland Squire: Thomas Barker of Lyndon Hall*, edited by John Kington. Oakham, U.K.: Rutland Record Society, Rutland County Museum.

Barondes, Royal de Rohan. 1957. *The Garden of the Gods: Mesopotamia, 5000 B.C.* Boston: Christopher Publishing House.

Barry, James. 1848. "Lecture VI.—On Colouring." In *Lectures on Painting, by the Royal Academicians*, edited by Ralph N. Wornum, 205–36. London: Henry G. Bohn.

Barthell, Edward E., Jr. 1971. *Gods and Goddesses of Ancient Greece.* Coral Gables, Fla.: University of Miami Press.

Bartholomaeus Anglicus. 1975. *On the Properties of Things: John Trevisa's Translation of Bartholomæus Anglicus* De proprietatibus rerum: *A Critical Text*, edited by M. C. Seymour. 3 vols. London: Oxford University Press.

Basile, Giuseppe. 1993. *Giotto: The Arena Chapel Frescoes.* London: Thames and Hudson.

Baumer, Franklin Le van, ed. 1952. *Main Currents of Western Thought.* New York: Alfred A. Knopf.

Bechler, Zev. 1975. "'A Less Agreeable Matter': The Disagreeable Case of Newton and Achromatic Refraction." *British Journal for the History of Science* 8:101–26.

Beckwith, Martha. 1940. *Hawaiian Mythology.* New Haven, Conn.: Yale University Press.

Bell, Barbara. 1975. "Climate and the History of Egypt: The Middle Kingdom." *American Journal of Archaeology* 79:223–69.

Bell, Janis C. 1993. "Zaccolini's Theory of Color Perspective." *Art Bulletin* 75:91–112.

Bennett, Mary. 1967. *Millais: An Exhibition Organized by the Walker Art Gallery, Liverpool and the Royal Academy of Arts, London, January–April, 1967.* Liverpool: Walker Art Gallery.

———. 1969. *William Holman Hunt: An Exhibition Arranged by the Walker Art Gallery.* Liverpool: Walker Art Gallery.

Bento, Antonio. 1980. *Portinari.* Rio de Janeiro: Léo Christiano Editorial.

Berndt, Catherine H. 1987. "Rainbow Snake." In *Encyclopedia of Religion*, edited by Mircea Eliade. Vol. 12, 205–8. New York: Macmillan Publishing Co.

Bierhorst, John. 1976. *Black Rainbow: Legends of the Incas and Myths of Ancient Peru.* New York: Farrar, Straus and Giroux.

Biletskyi, Platon O., and Leonid V. Vladych. 1976. *Ukrainian Painting.* Leningrad: Aurora Art Publishers.

Billmeyer, Fred W., Jr., and Max Saltzman. 1981. *Principles of Color Technology.* Second edition. New York: John Wiley and Sons.

Bisanz, Rudolf M. 1967. "The Art Theory of Philipp Otto Runge." Ph.D. diss., Syracuse University.

Black, Jeremy, and Anthony Green. 1992. *Gods, Demons and Symbols of Ancient Mesopotamia: An Illustrated Dictionary.* Austin: University of Texas Press.

Bloch-Smith, Elizabeth. 1994. "'Who Is the King of Glory?' Solomon's Temple and Its Symbolism." In *Scripture and Other Artifacts*, edited by Michael D. Coogan, J. Cheryl Exum, and Lawrence E. Stager, 18-31. Louisville, Ky.: Westminster John Knox Press.

Blum, Shirley N. 1992. "Hans Memling's *Annunciation* with Angelic Attendants." *Metropolitan Museum Journal* 27:43–58.

Boardman, John. 1985. *The Parthenon and Its Sculptures.* Austin: University of Texas Press.

Boas, Marie. 1951. "Bacon and Gilbert." *Journal of the History of Ideas* 12:466–67.

Bohren, Craig F. 1987. *Clouds in a Glass of Beer: Simple Experiments in Atmospheric Physics.* New York: John Wiley and Sons.

———. 1991. *What Light Through Yonder Window Breaks? More Experiments in Atmospheric Physics.* New York: John Wiley and Sons.

Bohren, Craig F., and Alistair B. Fraser. 1985. "Colors of the Sky." *Physics Teacher* 23:267–72.

———. 1991. "Newton's Zero-Order Rainbow: Unobservable or Nonexistent?" *American Journal of Physics* 59:325–26.

Bohren, Craig F., and Donald R. Huffman. 1983. *Absorption and Scattering of Light by Small Particles.* New York: John Wiley and Sons.

Boitel. 1888. "On the Secondary Arcs Which Accompany the Rainbow." *London, Edinburgh, and Dublin Philosophical Magazine and Journal of Science* 26, 5th series (August): 239–40.

Börsch-Supan, Helmut. 1990. *Caspar David Friedrich.* Translated by Sarah Twohig and John W. Gabriel. Munich: Prestel-Verlag.

Botley, Cicely M. 1970. "Lunar Rainbow." *Weather* 25:287–88.

Boulton, Sue. 1984. "Church Under a Cloud: Constable and Salisbury." *Turner Studies* 3:29–44.

Boyer, Carl B. 1950. "Kepler's Explanation of the Rainbow." *American Journal of Physics* 18:360–66.

———. 1952a. "William Gilbert on the Rainbow." *American Journal of Physics* 20:416–21.

———. 1952b. "Descartes and the Radius of the Rainbow." *Isis* 43:95–98.

———. 1956. "Refraction and the Rainbow in Antiquity." *Isis* 47:383–86.

———. 1958. "The Tertiary Rainbow: An Historical Account." *Isis* 49:141–54.

———. 1987. *The Rainbow: From Myth to Mathematics*. 1959. Reprint, with new photographs. Princeton: Princeton University Press.

Boyle, Robert. 1964. *Experiments and Considerations Touching Colours*. 1664. Reprint, New York: Johnson Reprint Corp.

Boynton, Robert M. 1992. *Human Color Vision*. Washington, D.C.: Optical Society of America.

Bredvold, Louis I., Alan D. McKillop, and Lois Whitney, eds. 1973. *Eighteenth Century Poetry and Prose*. Third edition. New York: John Wiley and Sons.

Brendel, Otto. 1944. "Origin and Meaning of the Mandorla." *Gazette des Beaux-Arts* 25, 6th series: 5–24.

Brewster, David. 1833. "Observations on the Absorption of Specific Rays, in Reference to the Undulatory Theory of Light." *London and Edinburgh Philosophical Magazine and Journal of Science* 2, 3rd series (May): 360–63.

———. 1834. "On a New Analysis of Solar Light, Indicating Three Primary Colours, Forming Coincident Spectra of Equal Length." *Transactions of the Royal Society of Edinburgh* 12:123–36.

Brigstocke, Hugh, and John Somerville. 1995. *Italian Paintings from Burghley House*. Arlington, Va.: Art Services International.

Brou, Philippe, Thomas R. Sciascia, Lynette Linden, and Jerome Y. Lettvin. 1986. "The Colors of Things." *Scientific American* 255, no. 3 (September): 84–91.

Brown, John P. 1993. "Archery in the Ancient World: 'Its Name Is Life, Its Work Is Death.'" *Biblische Zeitschrift* 37:26–42.

Brown, Truesdell S. 1965. "Herodotus Speculates About Egypt." *American Journal of Philology* 86:60–76.

Browne, Thomas. 1964. *The Works of Sir Thomas Browne*. Vol. 2, *Pseudodoxia Epidemica*. Books 1–7, edited by Geoffrey Keynes. Chicago: University of Chicago Press.

Brubaker, Leslie. 1989. "Byzantine Art in the Ninth Century: Theory, Practice, and Culture." *Byzantine and Modern Greek Studies* 13:23–93.

Brumbaugh, Robert. 1987. "The Rainbow Serpent of the Upper Sepik." *Anthropos* 82:25–33.

Bruyn, Josua. 1988. "Old and New Elements in 16th-Century Imagery." *Oud Holland* 102:90–113.

Budge, E. A. Wallis. 1905. *The Egyptian Heaven and Hell*. 3 vols. London: Kegan Paul, Trench, Trübner and Co.

———. 1969. *The Gods of the Egyptians or Studies in Egyptian Mythology*. Vol. 1. 1904. Reprint, New York: Dover Publications.

Burke, Edmund. 1958. *A Philosophical Enquiry into the Origin of Our Ideas of the Sublime and Beautiful*, edited by J. T. Boulton. London: Routledge and Kegan Paul.

Callus, Daniel A. 1944. *Introduction of Aristotelian Learning to Oxford*. London: Humphrey Milford.

Carr, Gerald L. 1980. *Frederic Edwin Church: The Icebergs*. Dallas: Dallas Museum of Fine Arts.

Carroll, Lewis. 1960. *The Annotated Alice: Alice's Adventures in Wonderland* and *Through the Looking Glass*. New York: Clarkson N. Potter.

Carty, Carolyn M. 1985. "Albrecht Dürer's *Adoration of the Trinity*: A Reinterpretation." *Art Bulletin* 67:146–53.

Cavendish, Richard, ed. 1983. *Man, Myth, and Magic*. 12 vols. Freeport, N.Y.: Marshall Cavendish Corp.

Cecil, David. 1992. *Hatfield House*. London: St. George's Press.

Charlton, William H. 1847. *Burghley; The Life of William Cecil, Lord Burghley. . . .* Stamford, U.K.: William Langley.

Chevreul, Michel-Eugène. 1987. *The Principles of Harmony and Contrast of Colors and Their Applications to the Arts*, edited by Faber Birren. West Chester, Pa.: Schiffer Publishing.

Churma, Michael E. 1994. "Blue Shadows: Physical, Physiological, and Psychological Causes." *Applied Optics* 33:4719–22.

———. 1995. "The Modeling and Remote Sensing of the Rainbow." Master's thesis, Pennsylvania State University.

Cicero. 1933. *Cicero in Twenty-Eight Volumes*. Vol. 19, *De natura deorum, Academica*. Translated by H. Rackham. Cambridge, Mass.: Harvard University Press.

Coates, Andrew C., and Anne M. Zweibel. 1995. "Wider Ride to the Rainbow." *Civil Engineering* 65 (October): 51–53.

Codell, Julie F. 1991. "The Dilemma of the Artist in Millais's *Lorenzo and Isabella*: Phrenology, the Gaze and the Social Discourse." *Art History* 14:51–63.

Cohen, Michael. 1982. "The Rainbow in Millais' *The Blind Girl* and Other Selected Works of Art." *Journal of Pre-Raphaelite Studies* 3 (November): 16–27.

Cole, Bruce, and Adelheid Gealt. 1989. *Art of the Western World: From Ancient Greece to Post-Modernism*. New York: Summit Books.

Cole, Herbert M. 1982. *Mbari: Art and Life Among the Owerri Igbo*. Bloomington: Indiana University Press.

Constable, John. 1962–68. *John Constable's Correspondence*. 6 vols., edited by Ronald B.

Beckett. Ipswich, U.K.: Suffolk Records Society.

———. 1970. *John Constable's Discourses*, edited by Ronald B. Beckett. Ipswich, U.K.: Suffolk Records Society.

Conzemius, Eduard. 1932. *Ethnographical Survey of the Miskito and Sumu Indians of Honduras and Nicaragua*. Washington, D.C.: U.S. Government Printing Office.

Cook, Arthur B. 1940. *Zeus: A Study in Ancient Religion*. Vol. 3. London: Cambridge University Press.

Cooper, Robyn. 1986. "Millais's *The Rescue*: A Painting of a 'Dreadful Interruption of Domestic Peace.'" *Art History* 9:471–86.

Corliss, William R. 1984. *Rare Halos, Mirages, Anomalous Rainbows and Related Electromagnetic Phenomena: A Catalog of Geophysical Anomalies*. Glen Arm, Md.: The Sourcebook Project.

Cornford, Francis M. 1971. *Plato's Cosmology: The Timaeus of Plato Translated with a Running Commentary*. London: Routledge and Kegan Paul.

Coyne, Peter. 1992. "Carpenters of the Rainbow." *Archaeology* 45:32–36.

Crayon. 1856. "A Coup d'œil of Niagara Out of Season." *The Crayon* 3 (March): 76–77.

———. 1860. "A Chapter on Rainbows in Landscapes." *The Crayon* 7 (February): 40–41.

Croft-Murray, Edward. 1962. *Decorative Painting in England 1537–1837*. Vol. 1. London: Country Life.

———. 1969. "Decorative Paintings for Lord Burlington and the Royal Academy." *Apollo* 89:11–21.

Crombie, Alistair C. 1959. *Medieval and Early Modern Science*. Vol. 1, *Science in the Middle Ages: V–XIII Centuries*. Second edition. Garden City, N.Y.: Doubleday and Co.

———. 1962. *Robert Grosseteste and the Origins of Experimental Science, 1100–1700*. Oxford: Oxford University Press.

———. 1990. "Expectation, Modeling and Assent in the History of Optics: Part I. Alhazen and the Medieval Tradition." *Studies in History and Philosophy of Science* 21:605–32.

Cropsey, Jasper F. 1855. "Up Among the Clouds." *The Crayon* 2 (8 August): 79–80.

———. 1984. "'The Brushes He Painted with That Last Day Are There . . .': Jasper F. Cropsey's Letter to His Wife, Describing Thomas Cole's Home and Studio, July, 1850." *American Art Journal* 16:78–83.

Cumbey, Constance E. 1983. *The Hidden Dangers of the Rainbow: The New Age Movement and Our Coming Age of Barbarism*. Shreveport, La.: Huntington House.

Czestochowski, Joseph S. 1982. *The American Landscape Tradition, A Study and Gallery of Paintings*. New York: E. P. Dutton.

Dante. 1981. *The Comedy of Dante Alighieri the Florentine: Cantica III: Paradise*. Translated by Dorothy L. Sayers and Barbara Reynolds. New York: Penguin Books.

Darwin, Charles. 1933. *Charles Darwin's Diary of the Voyage of HMS "Beagle."* Edited by Nora Barlow. New York: Macmillan Co.

Davidson, Bernice F. 1979. "Pope Paul III's Additions to Raphael's Logge: His *Imprese* in the Logge." *Art Bulletin* 61:385–404.

Davies, Norman de Garis. 1903. *The Rock Tombs of El Amarna, Part I: The Tomb of Meryra*, edited by Francis Llewellyn Griffith. London: Egypt Exploration Fund.

De Vos, Dirk. 1994. *Hans Memling: The Complete Works*. Translated by Ted Alkins. Ghent: Ludion Press.

De Vries-Evans, Susanna. 1993. *Conrad Martens on the* Beagle *and in Australia*. Brisbane: Pandanus Press.

Descartes, René. 1897–1910. *Oeuvres de Descartes*, edited by Charles Adam and Paul Tannery. 12 vols. Paris: Léopold Cerf.

———. 1965. *Discourse on Method, Optics, Geometry, and Meteorology*. Translated by Paul J. Olscamp. Indianapolis, Ind.: Bobbs-Merrill Co.

Digges, Leonard. 1927a. *A Prognostication of right good effect, fructfully augmented contayninge playne, briefe, pleasant, chosen rules, to iudge the wether for euer, by the Sunne, Moone, Sterres, Cometes, Raynbowe, Thunder, Cloudes . . .* , edited by Robert T. Gunther. 1555. Reprint, Oxford: Old Ashmolean Reprints III.

———. 1927b. *The Theodelitus and Topographical Instrument of Leonard Digges of University College, Oxford*, edited by Robert T. Gunther. 1571. Reprint, Oxford: Old Ashmolean Reprints IV.

Dod, Bernard G. 1982. "Aristoteles latinus." In *The Cambridge History of Later Medieval Philosophy*, edited by Norman Krentzmann, Anthony Kenny, and Jan Pinborg, 45–79. Cambridge: Cambridge University Press.

Dömötör, Tekla. 1981. *Hungarian Folk Beliefs*. Bloomington: Indiana University Press.

Dorfles, Gillo, ed. 1969. *Kitsch: The World of Bad Taste*. New York: Universe Books.

Dorra, Henri. 1994. "Valenciennes's Theories: From Newton, Buffon and Diderot to Corot, Chevreul, Delacroix, Monet and Seurat." *Gazette des Beaux-Arts* 124, 6th series: 185–94.

Douay Vulgate. 1914. *The Holy Bible Translated from the Latin Vulgate*. Baltimore: John Murphy Co.

Dumont, Jean-Paul. 1976. *Under the Rainbow: Nature and Supernature Among the Panare Indians*. Austin: University of Texas Press.

Dundas, Douglas. 1963. "Conrad Martens." *Art*

Gallery of New South Wales Quarterly 5:161–65.
———. 1979. *The Art of Conrad Martens*. South Melbourne: Macmillan of Australia Pty.
Dunnigan, Ann. 1987. "Rain." In *Encyclopedia of Religion*, edited by Mircea Eliade. Vol. 12, 201–5. New York: Macmillan Publishing Co.
Dürer, Albrecht. 1913. *Records of Journeys to Venice and the Low Countries*. Translated by Rudolph Tombo, Jr. Boston: Merrymount Press.
———. 1958. *The Writings of Albrecht Dürer*. Translated by William M. Conway. New York: Philosophical Library.
Eastwood, Bruce S. 1966. "Robert Grosseteste's Theory of the Rainbow: A Chapter in the History of Non-experimental Science." *Archives Internationales d'Histoire des Sciences* 19:313–32.
———. 1967. "Grosseteste's 'Quantitative' Law of Refraction: A Chapter in the History of Non-experimental Science." *Journal of the History of Ideas* 28:403–14.
Ebbesen, Sten. 1982. "Ancient Scholastic Logic as the Source of Medieval Scholastic Logic." In *The Cambridge History of Later Medieval Philosophy*, edited by Norman Krentzmann, Anthony Kenny, and Jan Pinborg, 101–27. Cambridge: Cambridge University Press.
Eberhard, Wolfram, ed. 1965. *Folktales of China*. Chicago: University of Chicago Press.
Edgerton, Samuel Y., Jr. 1991. *The Heritage of Giotto's Geometry: Art and Science on the Eve of the Scientific Revolution*. Ithaca, N.Y.: Cornell University Press.
Egerton, Judy. 1990. *Wright of Derby*. New York: Metropolitan Museum of Art.
Eimerl, Sarel. 1967. *The World of Giotto, c. 1267–1337*. New York: Time Inc.
El-Din, Mohamed I. S. 1972. "A Further Study on Thunderstorms in Egypt." Master's thesis, Cairo University.
Eliade, Mircea. 1964. *Shamanism: Archaic Techniques of Ecstasy*. Princeton: Princeton University Press.
———. 1973. *Australian Religions: An Introduction*. Ithaca, N.Y.: Cornell University Press.
Ellis, Elizabeth. 1994. *Conrad Martens: Life and Art*. Sydney: State Library of New South Wales Press.
Emrich, Duncan. 1972. *Folklore on the American Land*. Boston: Little, Brown and Co.
Erdoes, Richard, and Alfonso Ortiz, eds. 1984. *American Indian Myths and Legends*. New York: Pantheon Books.
Erler, Mary C. 1987. "Sir John Davies and the Rainbow Portrait of Queen Elizabeth." *Modern Philology* 84:359–71.
Evans, Grose. 1959. *Benjamin West and the Taste of His Times*. Carbondale: Southern Illinois University Press.

Fairbanks, Arthur, trans. 1960. *Philostratus* Imagines; *Callistratus* Descriptions. Cambridge, Mass.: Harvard University Press.
Favreau, Olga E., and Michael C. Corballis. 1986. "Negative Aftereffects in Visual Perception." In *The Mind's Eye*, edited by Jeremy M. Wolfe, 53–59. New York: W. H. Freeman and Co.
Fénéon, Félix. 1978. Excerpts from *The Impressionists in 1886* and "Impressionism at the Tuileries." In *Seurat in Perspective*, edited by Norma Broude, 36–39. Englewood Cliffs, N.J.: Prentice-Hall.
Fernandez, James W. 1982. *Bwiti: An Ethnography of the Religious Imagination in Africa*. Princeton: Princeton University Press.
Finley, Gerald E. 1967. "Turner: An Early Experiment with Colour Theory." *Journal of the Warburg and Courtauld Institutes* 30:357–66.
Forster, John. 1872. *The Life of Charles Dickens*. 3 vols. Philadelphia: J. B. Lippincott and Co.
Forster-Hahn, Franziska. 1967. "The Sources of True Taste: Benjamin West's Instructions to a Young Painter for His Studies in Italy." *Journal of the Warburg and Courtauld Institutes* 30:367–82.
Fraser, Alistair B. 1972. "Inhomogeneities in the Color and Intensity of the Rainbow." *Journal of the Atmospheric Sciences* 29:211–12.
———. 1975. "Theological Optics." *Applied Optics* 14: A92–A93.
———. 1983a. "Chasing Rainbows: Numerous Supernumeraries Are Super." *Weatherwise* 36:280–89.
———. 1983b. "Why Can the Supernumerary Bows Be Seen in a Rain Shower?" *Journal of the Optical Society of America* 73:1626–28.
Friedman, Mira. 1989. "On the Sources of the Vienna Genesis." *Cahiers Archéologiques* 37:5–17.
Gabriel, Mabel. 1952. *Masters of Campanian Painting*. New York: H. Bittner and Co.
Gage, John. 1969. *Color in Turner: Poetry and Truth*. New York: Frederick A. Praeger, Publishers.
———. 1971. "Blake's *Newton*." *Journal of the Warburg and Courtauld Institutes* 34:372–77, plate 65.
———. 1987. "The *technique* of Seurat: A Reappraisal." *Art Bulletin* 69:448–54.
Gaidoz, Henri, Eugène Rolland, et al. 1981. "L'Arc-en-Ciel." *Quaderni di Semantica* 2:111–46.
Gales, Richard L. 1968. *Dwellers in Arcady*. 1931. Reprint, Freeport, N.Y.: Books for Libraries Press.
Garlan, Yvon. 1988. *Slavery in Ancient Greece*. Translated by Janet Lloyd. Revised edition. Ithaca, N.Y.: Cornell University Press.
Gates, Marie-Henriette. 1984. "The Palace of Zimri-Lim at Mari." *Biblical Archaeologist* 47 (June): 70–87.
Gaukroger, Stephen. 1995. *Descartes: An Intellectual Biography*. Oxford: Oxford University Press.

Gedzelman, Stanley D. 1989. "Did Kepler's *Supplement to Witelo* Inspire Descartes' Theory of the Rainbow?" *Bulletin of the American Meteorological Society* 70:750–51.

———. 1991. "Atmospheric Optics in Art." *Applied Optics* 30:3514–22.

Gibson, Walter S. 1989. *"Mirror of the Earth": The World Landscape in Sixteenth-Century Flemish Painting*. Princeton: Princeton University Press.

Gilbert, Otto. 1967. *Die Meteorologischen Theorien des Griechischen Altertums*. 1907. Reprint, Hildesheim: Georg Olms Verlagsbuchhandlung.

Gilbert, William. 1651. *Guilielmi Gilberti Colcestrensis Medici Regii, De Mundo nostro Sublunari Philosophia Nova*. Amsterdam: Ludovicum Elzevirium.

Gladstone, William E. 1878. "The Iris of Homer: And Her Relation to Genesis IX.11–17." *Contemporary Review* 32:140–52.

Gleeson, James. 1971. *Colonial Painters: 1788–1880*. Melbourne: Lansdowne.

Goes, Albrecht. 1956. *Genesis: Bilder aus der Wiener Genesis*. Hamburg: Friedrich Wittig Verlag.

Goethe, Johann Wolfgang von. 1967. *Goethe's Theory of Colours*. Translated and edited by Charles Eastlake. 1840. Reprint, with an added index, London: Frank Cass and Co.

Goldstein, E. Bruce. 1980. *Sensation and Perception*. Belmont, Calif.: Wadsworth Publishing Co.

Gombrich, Ernst H. 1991. "Archaeologists or Pharisees? Reflections on a Painting by Maarten van Heemskerck." *Journal of the Warburg and Courtauld Institutes* 54:253–56.

Gove, Philip B., ed. 1961. *Webster's Third New International Dictionary*. 3 vols. Chicago: Merriam-Webster.

Grant, Edward, ed. 1974. *A Source Book in Medieval Science*. Cambridge, Mass.: Harvard University Press.

Gray, Denis D. 1993. "Champion of Aboriginal Art." *Archaeology* 46:45–47.

Gray, John. 1969. *Near Eastern Mythology*. London: Hamlyn Publishing Group.

Gray, Louis H., ed. 1964. *The Mythology of All Races*. 13 vols. 1916–32. Reprint, New York: Cooper Square Publishers.

Graziani, René. 1972. "The 'Rainbow Portrait' of Queen Elizabeth I and Its Religious Symbolism." *Journal of the Warburg and Courtauld Institutes* 35:247–59.

Green, A. W. 1975. "An Approximation for the Shapes of Large Raindrops." *Journal of Applied Meteorology* 14:1578–83.

Greenler, Robert. 1980. *Rainbows, Halos, and Glories*. Cambridge: Cambridge University Press.

Griffith, Francis Llewellyn. 1898. *A Collection of Hieroglyphs; A Contribution to the History of Egyptian Writing*. London: Egypt Exploration Fund.

Grimal, Pierre, ed. 1965. *Larousse World Mythology*. London: Paul Hamlyn.

Grimm, Jacob. 1966. *Teutonic Mythology*. Translated by James S. Stallybrass. Vol. 2, 439–898. New York: Dover Publications.

Grosshans, Rainald. 1980. *Maerten van Heemskerck: Die Gemälde*. Berlin: Horst Boettcher Verlag.

Guerber, Helene A. 1908. *Myths of the Norsemen from the Eddas and Sagas*. London: George G. Harrap and Co.

Guerlac, Henry. 1983. "Can We Date Newton's Early Optical Experiments?" *Isis* 74:74–80.

Guillaud, Jacqueline, and Maurice Guillaud. 1987. *Giotto: Architect of Color and Form*. New York: Clarkson N. Potter.

Guth, Christine. 1996. *Japanese Art of the Edo Period*. London: Calmann and King.

Haardt, Caroline. 1991. "The Rock Art of Tassili N'Ajjer." *UNESCO Courier* 44 (July): 38–41.

Hackett, Jeremiah M. G. 1980. "The Attitude of Roger Bacon to the *Scientia* of Albertus Magnus." In *Albertus Magnus and the Sciences*, edited by James A. Weisheipl, 53–72. Toronto: Pontifical Institute of Mediaeval Studies.

Halley, Edmond. 1698. "Account of an Extraordinary Iris, or Rainbow, Seen at Chester." *Philosophical Transactions of the Royal Society of London, from their commencement, in 1665, to the year 1800; abridged, with notes and biographic illustrations* 4 (1694–1702): 277–78.

———. 1700: "To Determine the Colours and Diameter of the Rainbow, from the Given Ratio of Refraction; and the Contrary." *Philosophical Transactions of the Royal Society of London, from their commencement, in 1665, to the year 1800; abridged, with notes and biographic illustrations* 4 (1694–1702): 527–33.

Hamilton, Edith. 1969. *Mythology*. New York: New American Library.

Hammer, D. 1903. "Airy's Theory of the Rainbow." *Journal of the Franklin Institute* 156:335–49.

Hand, Wayland D., Anna Casetta, and Sondra B. Thiederman, eds. 1981. *Popular Beliefs and Superstitions: A Compendium of American Folklore*. 3 vols. Boston: G. K. Hall and Co.

Harrison, Jefferson C. 1975. "*Parnassus*—Signed and Dated 'Martinus Heemskerck f. 1565.'" *Chrysler Museum at Norfolk* 4, 10 (October).

———. 1979. "Maerten van Heemskerck and Alkmaar." In *Kennemer Contouren: Uit de geschiedenis van Alkmaar en omgeving*, 87–107. Zutphen, Netherlands: Walburg Pers.

———. 1986. "The Detroit *Christ on Calvary* and the

Cologne *Lamentation of Christ*: Two Early Haarlem Paintings by Maerten van Heemskerck." *Nederlands Kunsthistorisch Jaarboek* 37:175–94.

———. 1987. "The Paintings of Maerten van Heemskerck: A Catalogue Raissone." 4 vols. Ph.D. diss., University of Virginia.

———. 1990. "*The Brazen Serpent* by Maarten van Heemskerck: Aspects of Its Style and Meaning." *Record of the Art Museum, Princeton University* 49:16–29.

Hartel, Wilhelm R. von, and Franz Wickhoff. 1895. *Die Wiener Genesis*. Vienna: F. Tempsky.

Hartt, Frederick. 1975. *History of Italian Renaissance Art: Painting, Sculpture, Architecture*. Englewood Cliffs, N.J.: Prentice-Hall.

Hartwell, Charles. 1854. "Description of a Tertiary Rainbow." *American Journal of Science and Arts* 17, 2nd series (May): 56–57.

Haskell, Francis. 1980. *Patrons and Painters: A Study in the Relations Between Italian Art and Society in the Age of the Baroque*. Second edition. New Haven, Conn.: Yale University Press.

Hasler, Juan A. 1979. "The Nuk-Yiní·k. The Earthquake. The Rainbow: Three Chontal Texts." *Latin American Indian Literatures* 3:11–24.

Hastings, James, ed. 1905. *A Dictionary of the Bible*. 5 vols. New York: Charles Scribner's Sons.

———. 1957. *Encyclopædia of Religion and Ethics*. 13 vols. 1908–26. Facsimile, New York: Charles Scribner's Sons.

Hawes, Louis. 1982. *Presences of Nature: British Landscape 1780–1830*. New Haven, Conn.: Yale Center for British Art.

Haydon, Benjamin R. 1926. *The Autobiography and Memoirs of Benjamin Robert Haydon*, edited by Tom Taylor. Vol. 1. London: Peter Davies.

Hayley, William. 1809. *The Life of George Romney, Esq*. London: T. Payne.

Heilermann, Johann. 1880. "Ueber den dritten Regenbogen." *Zeitschrift für mathematischen und naturwissenschaftlichen Unterricht* 11:72–73.

Helck, Wolfgang, and Eberhard Otto. 1984. *Lexikon der Ägyptologie*. Vol. 5. Wiesbaden, Germany: Otto Harrassowitz.

Held, Julius. 1979. "Rubens and Aguilonius: New Points of Contact." *Art Bulletin* 61:257–64.

Hellmann, Gustav. 1908. "Die Anfänge der Meteorologie." *Meteorologische Zeitschrift* 25:481–91.

Hennequin, Émile. 1978. "Notes on Art: The Exhibition of Independent Artists." In *Seurat in Perspective*, edited by Norma Broude, 41–43. Englewood Cliffs, N.J.: Prentice-Hall.

Hentze, Carl. 1966. "Die Regenbogenschlange: Alt-China und Alt-Amerika." *Athropos* 61:258–66.

Herbert, Robert L. 1991. *Georges Seurat, 1859–1891*. New York: Metropolitan Museum of Art.

Herodotus. 1960. *Herodotus in Four Volumes*. Vol. 1: *The Histories*, Books 1 and 2. Translated by A. D. Godley. Cambridge, Mass.: Harvard University Press.

Hershenson, Maurice, ed. 1989. *The Moon Illusion*. Hillsdale, N.J.: Lawrence Erlbaum Associates.

Hesiod. 1988. *Theogony* and *Works and Days*. Translated by M. L. West. Oxford: Oxford University Press.

Hewison, Robert. 1976. *John Ruskin: The Argument of the Eye*. London: Thames and Hudson.

Hickman, Money L. 1976. "The Paintings of Soga Shōhaku (1730–1781)." Ph.D. diss., Harvard University.

Hilton, Timothy. 1971. *The Pre-Raphaelites*. New York: Harry N. Abrams.

Hoffmann, Konrad. 1978. "Dürer's 'Melencolia.'" *The Print Collector's Newsletter* 9:33–35.

Homer. 1950. *The Iliad*. Translated by W. H. D. Rouse. New York: New American Library.

Homer, William I. 1978. Extracts from *Seurat and the Science of Painting*. In *Seurat in Perspective*, edited by Norma Broude, 135–54. Englewood Cliffs, N.J.: Prentice-Hall.

Hooke, Robert. 1961. *Micrographia: or Some Physiological Descriptions of Minute Bodies Made by Magnifying Glasses with Observations and Inquiries Thereupon*. 1665. Facsimile, New York: Dover Publications.

Hope, Ann. 1967. "Cesare Ripa's *Iconology* and the Neoclassical Movement." *Apollo* 86 (supplement): 1–4.

Horten, Max, and Eilhard Wiedemann. 1913. "Avicennas Lehre vom Regenbogen nach seinem Werk al Schifâ." *Metorologische Zeitschrift* 30:533–44.

Houstoun, Robert A. 1958. "Kepler and the Law of Refraction." *Bulletin of The Institute of Physics* 9:3–6.

Howat, John K. 1972. *The Hudson River and Its Painters*. New York: Viking Press.

Humboldt, Alexander von. 1870. *Cosmos: A Sketch of a Physical Description of the Universe*. Vol. 2. New York: Harper and Brothers.

Humphreys, William J. 1938. "Why We Seldom See a Lunar Rainbow." *Science* 88:496–98.

———. 1964. *Physics of the Air*. 1940. Reprint, New York: Dover Publications.

Huntington, David C. 1960. "Frederic Edwin Church, 1826–1900: Painter of the Adamic New World Myth." Ph.D. diss., Yale University.

———. 1966. *The Landscapes of Frederic Edwin Church: Vision of an American Era*. New York: George Braziller.

Huygens, Christiaan. 1888–1910. *Œuvres Complètes*

de Christiaan Huygens. 12 vols. La Haye, Netherlands: Martinus Nijhoff.
Illustrated London News. 1849. "Exhibition of the Royal Academy of Arts, 1849." *Supplement to the Illustrated London News* 14 (26 May): 345–48.
Ingamells, John. 1982. "A Masterpiece by Rubens: *The Rainbow Landscape* Cleaned." *Apollo* 116:288–91.
Ions, Veronica. 1968. *Egyptian Mythology*. London: Hamlyn Publishing Group.
Irwin, John C. 1982. "The Sacred Anthill and the Cult of the Primordial Mound." *History of Religions* 21:339–60.
Isidore de Seville. 1960. *Traité de la Nature*, edited by Jacques Fontaine. Bordeaux: Féret et Fils.
Jacobs, Fredrika H. 1984. "Vasari's Vision of the History of Painting: Frescoes in the Casa Vasari, Florence." *Art Bulletin* 66:399–416.
Jaffé, Michael. 1971. "Rubens and Optics: Some Fresh Evidence." *Journal of the Warburg and Courtauld Institutes* 34:362–66.
James, Liz. 1991. "Colour and the Byzantine Rainbow." *Byzantine and Modern Greek Studies* 15:66–94.
Janson, Horst W. 1977. *History of Art*. Second edition. New York: Harry N. Abrams.
Jerome. 1933. *Select Letters of St. Jerome*. Translated by F. A. Wright. Cambridge, Mass.: Harvard University Press.
Job of Edessa. 1935. *Encyclopædia of Philosophical and Natural Sciences as Taught in Baghdad About* A.D. *817, or, Book of Treasures*. Translated and edited by Alphonse Mingana. Cambridge: W. Heffer and Sons.
Jobes, Gertrude. 1961. *Dictionary of Mythology, Folklore, and Symbols*. New York: Scarecrow Press.
Johnson, Fridolf. 1982. *Rockwell Kent, An Anthology of His Works*. New York: Alfred A. Knopf.
Johnson, Lee. 1963. *Delacroix*. New York: W. W. Norton and Co.
Juan, Jorge, and Antonio de Ulloa. 1964. *A Voyage to South America*. Translated by John Adams. New York: Alfred A. Knopf.
Julian. 1969. *The Works of the Emperor Julian*. Translated by Wilmer C. Wright. Vol. 2. 1913. Reprint, Cambridge, Mass.: Harvard University Press.
Kahan, Mitchell D. 1979. *Art Inc., American Paintings from Corporate Collections*. Montgomery, Ala.: Montgomery Museum of Fine Arts.
Kahn, Gustave. 1978. "Seurat." In *Seurat in Perspective*, edited by Norma Broude, 20–25. Englewood Cliffs, N.J.: Prentice-Hall.
Kelly, Franklin. 1988. *Frederic Edwin Church and the National Landscape*. Washington, D.C.: Smithsonian Institution Press.
Kelly, Suzanne. 1965. *The De Mundo of William Gilbert*. Amsterdam: Menno Hertzberger and Co.
Kemp, Martin. 1990. *The Science of Art*. New Haven, Conn.: Yale University Press.
Kenny, Anthony, and Jan Pinborg. 1982. "Medieval Philosophical Literature." In *The Cambridge History of Later Medieval Philosophy*, edited by Norman Krentzmann, Anthony Kenny, and Jan Pinborg, 11–42. Cambridge: Cambridge University Press.
Kepler, Johannes. 1858–71. *Joannis Kepleri Astronomi Opera Omnia*, edited by Christian Frisch. 8 vols. Frankfurt am Main and Erlangen: Heyder and Zimmer.
———. 1976. *Johannes Kepler's On the More Certain Fundamentals of Astrology*. Translated by Mary Ann Rossi. Appleton, Wis.: Mary Ann Rossi and J. Bruce Brackenridge.
———. 1981. *Mysterium Cosmographicum—The Secret of the Universe*. Translated by A. M. Duncan. New York: Abaris Books.
Kerker, Milton. 1969. *The Scattering of Light and Other Electromagnetic Radiation*. New York: Academic Press.
King, Edward S. 1944–45. "A New Heemskerck." *Journal of the Walters Art Gallery* 7–8:61–73.
Kinsey, Joni L. 1992. *Thomas Moran and the Surveying of the American West*. Washington, D.C.: Smithsonian Institution Press.
Koerner, Joseph L. 1990. *Caspar David Friedrich and the Subject of Landscape*. New Haven, Conn.: Yale University Press.
Koestler, Arthur. 1984. *The Watershed: A Biography of Johannes Kepler*. 1960. Reprint, Lanham, Md.: University Press of America.
Können, Günther P. 1985. *Polarized Light in Nature*. Cambridge: Cambridge University Press.
———. 1987. "Appearance of Supernumeraries of the Secondary Rainbow in Rain Showers." *Journal of the Optical Society of America A* 4:810–16.
Koreny, Fritz. 1991. "A Coloured Flower Study by Martin Schongauer and the Development of the Depiction of Nature from Van Der Weyden to Dürer." *Burlington Magazine* 133:588–97.
Ladis, Andrew. 1986. "The Legend of Giotto's Wit and the Arena Chapel." *Art Bulletin* 68:581–96.
Lajoux, Jean-Dominique. 1963. *The Rock Paintings of Tassili*. Translated by G. D. Liversage. London: Thames and Hudson.
Landow, George P. 1977. "The Rainbow: A Problematic Image." In *Nature and the Victorian Imagination*, edited by U. C. Knoepflmacher and G. B. Tennyson, 341–69. Berkeley and Los Angeles: University of California Press.
———. 1980. *Victorian Types, Victorian Shadows: Biblical Typology in Victorian Literature, Art, and Thought*. Boston: Routledge and Kegan Paul.

Lane, Barbara G. 1991. "The Patron and the Pirate: The Mystery of Memling's Gdańsk *Last Judgment*." *Art Bulletin* 73:623–40.

Langer, William L., ed. 1968. *An Encyclopedia of World History*. Fourth edition. Boston: Houghton Mifflin Co.

Langwith, Benjamin. 1809. "Concerning the Appearance of Several Arches of Colours, Contiguous to the Inner Edge of the Common Rainbow, Observed at Petworth in Sussex, by the Rev. Dr. Langwith." *Philosophical Transactions of the Royal Society of London, from their commencement, in 1665, to the year 1800; abridged, with notes and biographic illustrations* 6 (1713–23): 623–24.

Lanier, Parks, Jr. 1988. "The Rainbow Comes and Goes: Constable's *Salisbury Cathedral from the Meadows* and Wordsworth's Great Ode." *Studies in the Humanities* 15:58–67.

Lasko, Peter. 1972. *Ars Sacra: 800–1200*. Baltimore: Penguin Books.

Lawrence, David H. 1976. *The Rainbow*. New York: Penguin Books USA.

Leatham, Victoria. 1992. *Burghley: The Life of a Great House*. London: Herbert Press.

Leatham, Victoria, Jon Culverhouse, and Eric Till. 1989. *Burghley House*. Derby, U.K.: English Life Publications.

Lee, Alan. 1987. "Seurat and Science." *Art History* 10:203–26.

Lee, Raymond L., Jr. 1991. "What Are 'All the Colors of the Rainbow'?" *Applied Optics* 30:3401–7, 3545.

———. 1998. "Mie Theory, Airy Theory, and the Natural Rainbow." *Applied Optics* 37:1506–19.

Leonardo da Vinci. 1954. *The Notebooks of Leonardo da Vinci*. Translated by Edward MacCurdy. New York: George Braziller.

———. 1956. *Treatise on Painting* [Codex Urbinas Latinus 1270]. Translated by A. Philip McMahon. Vol. 1. Princeton: Princeton University Press.

Leslie, Charles R. 1845. *Memoirs of the Life of John Constable, Esq. R.A., Composed Chiefly of His Letters*. Second edition. London: Longman, Brown, Green, and Longmans.

Lhote, Henri. 1959. *The Search for the Tassili Frescoes*. Translated by Alan Houghton Brodrick. London: Hutchinson and Co.

———. 1987. "Oasis of Art in the Sahara." *National Geographic* 172 (August): 180–91.

Lindberg, David C. 1966. "Roger Bacon's Theory of the Rainbow: Progress or Regress?" *Isis* 57:235–48.

———. 1967. "Alhazen's Theory of Vision and Its Reception in the West." *Isis* 58:321–41.

———. 1971. "Lines of Influence in Thirteenth-Century Optics: Bacon, Witelo, and Pecham." *Speculum* 46:66–83.

———. 1978. "The Science of Optics." In *Science in the Middle Ages*, edited by David C. Lindberg, 338–68. Chicago: University of Chicago Press.

———. 1982. "On the Applicability of Mathematics to Nature: Roger Bacon and His Predecessors." *British Journal for the History of Science* 15:3–25.

———. 1983. *Roger Bacon's Philosophy of Nature*. Oxford: Oxford University Press.

———. 1992. *The Beginnings of Western Science: The European Scientific Tradition in Philosophical, Religious, and Institutional Context, 600 B.C. to A.D. 1450*. Chicago: University of Chicago Press.

Lindsay, Lionel. 1968. *Conrad Martens, The Man and His Art*. Revised edition. Sydney: Angus and Robertson.

Lloyd, Geoffrey E. R. 1971. *Early Greek Science: Thales to Aristotle*. New York: W. W. Norton and Co.

———. 1987. *The Revolutions of Wisdom: Studies in the Claims and Practice of Ancient Greek Science*. Berkeley and Los Angeles: University of California Press.

Lock, James A. 1987. "Theory of the Observations Made of High-Order Rainbows from a Single Water Droplet." *Applied Optics* 26:5291–98.

Lodging Hospitality. 1993. "Budgetel Hires 'The Ozonator.'" *Lodging Hospitality* 49 (February): 49.

Loewenstein, John. 1961. "Rainbow and Serpent." *Anthropos* 56:31–40.

Lohne, Johannes A. 1959. "Thomas Harriott (1560–1621): The Tycho Brahe of Optics." *Centaurus* 6:113–21.

Lohr, Charles H. 1982. "The Medieval Interpretation of Aristotle." In *The Cambridge History of Later Medieval Philosophy*, edited by Norman Krentzmann, Anthony Kenny, and Jan Pinborg, 80–98. Cambridge: Cambridge University Press.

Long, Dolores. 1987. "Double Rainbow on the Rise." *Restaurant Business* 86 (10 August): 115–17.

Loon, Maurits van. 1992. "The Rainbow in Ancient West Asian Iconography." In *Natural Phenomena: Their Meaning, Depiction and Description in the Ancient Near East*, edited by Diederik J. W. Meijer, 149–68. Amsterdam: North-Holland.

Luckert, Karl W. 1977. *Navajo Mountain and Rainbow Bridge Religion*. Flagstaff, Ariz.: Museum of Northern Arizona.

Lurie, Ann T. 1992. "Heemskerck's Portrait of Machtelt Suijs at The Cleveland Museum of Art." *Burlington Magazine* 134:698–706.

Lynch, David K. 1980. "Atmospheric Halos." In *Atmospheric Phenomena*, edited by David K. Lynch, 122–30. San Francisco: W. H. Freeman and Co.

Lynch, David K., and Susan N. Futterman. 1991. "Ulloa's Observations of the Glory, Fogbow, and an Unidentified Phenomenon." *Applied Optics* 30:3538–41.

Lynch, David K., and William Livingston. 1995. *Color and Light in Nature*. Cambridge: Cambridge University Press.

MacDonald, George. 1973. "The Golden Key." In *Beyond the Looking Glass: Extraordinary Works of Fairy Tale and Fantasy*, edited by Jonathan Cott, 395–420. New York: Stonehill Publishing Co.

Macdonald, Julie. 1994. "Appealing Presentations Promote Profitability in Foodservice." *Hotel and Motel Management* 209 (22 February): 30.

Mander, Carel van. 1936. *Dutch and Flemish Painters (Het Schilder-boeck)*. Translated by Constant van de Wall. New York: McFarlane, Warde, McFarlane.

Manning, Robert J. 1983. "Dürer's *Melencolia I*: A Copernican Interpretation." *Soundings* 66:24–33.

Maroon, Fred J., and Suzy Maroon. 1993. *The United States Capitol*. New York: Stewart, Tabori and Chang.

Martin, Peter. 1984. *Pursuing Innocent Pleasures: The Gardening World of Alexander Pope*. Hamden, Conn.: Archon Books.

Maurer, Walter H. 1967–68. "The Rainbow in Sanskrit Literature." *Adyar Library Bulletin* 31–32:360–81.

Maurolico, Francesco. 1940. *The Photismi de Lumine of Maurolycus: A Chapter in Late Medieval Optics*. Translated by Henry Crew. New York: Macmillan Co.

Mayr-Harting, Henry. 1991. *Ottonian Book Illumination: An Historical Study*. 2 vols. London: Harvey Miller Publishers.

McCoy, Raymond A., trans. and ed. 1970. *Under the Tamarisk Tree (Ancient Egyptian Poetry): Part IV. Akh-en-aton's "Hymn to the Aton" and the "Hymn to the Nile."* Menomonie, Wis.: Stout State University.

McDonald, James E. 1962. "A Gigantic Horizontal Cloudbow." *Weather* 17:243–45.

McDonald, James E., and B. M. Herman. 1964. "On a Point of Terminology in the Optics of the Rainbow." *Bulletin of the American Meteorological Society* 45:279–80.

McFarlane, Kenneth B. 1971. *Hans Memling*, edited by Edgar Wind. Oxford: Oxford University Press.

McGuire, J. E., and Martin Tamny. 1983. *Certain Philosophical Questions: Newton's Trinity Notebook*. Cambridge: Cambridge University Press.

McKinsey, Elizabeth. 1985. "An American Icon." In *Niagara: Two Centuries of Changing Attitudes, 1697–1901*, edited by Jeremy E. Adamson, 83–101. Washington, D.C.: Corcoran Gallery of Art.

Melville, Leinani. 1969. *Children of the Rainbow: Religion, Legends, and Gods of the Natives of Pre-Christian Hawaii*. Wheaton, Ill.: Theosophical Publishing House.

Merker, Gloria S. 1967. "The Rainbow Mosaic at Pergamon and Aristotelian Color Theory." *American Journal of Archaeology* 71:81–82, plate 30.

Métraux, Alfred. 1946. *Myths of the Toba and Pilagá Indians of the Gran Chaco*. Philadelphia: American Folklore Society.

Middleton, W. E. Knowles. 1965. *A History of the Theories of Rain and Other Forms of Precipitation*. London: Oldbourne Book Co.

Millais, John G. 1899. *The Life and Letters of Sir John Everett Millais, President of the Royal Academy*. Vol. 1. London: Methuen and Co.

Millar, Oliver. 1963. *The Tudor, Stuart and Early Georgian Pictures in the Collection of Her Majesty the Queen*. 2 vols. London: Phaidon Publishers.

Miller, William H. 1841. "Cambridge Philosophical Society." *London, Edinburgh, and Dublin Philosophical Magazine and Journal of Science* 18, 3rd series (June): 520–21.

———. 1842. "On Spurious Rainbows." *Transactions of the Cambridge Philosophical Society* 7:277–86.

Milner, Frank. 1990. *J. M. W. Turner: Paintings in Merseyside Collections*. Liverpool: National Museums and Galleries on Merseyside.

Milton, John. 1975. *John Milton: Paradise Lost. An Authoritative Text, Backgrounds and Sources, Criticism*, edited by Scott Elledge. New York: W. W. Norton and Co.

Minnaert, Marcel G. J. 1993. *Light and Color in the Outdoors*. Translated by Len Seymour. New York: Springer-Verlag.

Moffitt, John F. 1989. "Leonardo's 'sfumato' and Apelles's 'atramentum.'" *Paragone* 40:88–94.

Mollon, J. D., and L. T. Sharpe, eds. 1983. *Colour Vision: Physiology and Psychophysics*. New York: Academic Press.

Mourelatos, A. P. D. 1989. "'X Is Really Y': Ionian Origins of a Thought Pattern." In *Ionian Philosophy*, edited by K. J. Boudouris, 280–90. Athens: International Association for Greek Philosophy and International Center for Greek Philosophy and Culture.

Muzzolini, Alfred. 1989. "New Finds of Late Round Head Paintings in Northern Tassili and the Break of the 'Postneolithic Arid Phase.'" *Nyame Akuma* 31:2–8.

Nashe, Thomas. 1966. *The Works of Thomas Nashe*. Vol. 2, *The Unfortunate Traveller*, edited by Ronald B. McKerrow and F. P. Wilson. New York: Barnes and Noble.

Nechodom, Kerry. 1992. *The Rainbow Bridge: A Chumash Legend*. Los Osos, Calif.: Sand River Press.

Neuberger, Hans. 1957. *Introduction to Physical Meteorology*. Second edition. University Park: Pennsylvania State University.

———. 1970. "Climate in Art." *Weather* 25:46–56.

Neugebauer, Otto, and Richard A. Parker. 1960. *Egyptian Astronomical Texts: I. The Early Decans*. Providence, R.I.: Brown University Press.

Newberry, Percy E. 1893. *Beni Hasan. Part I*. London: Kegan Paul, Trench, Trübner and Co.

Newton, Isaac. 1809. "A Letter of Mr. Isaac Newton, Professor of Mathematics in the University of Cambridge; Containing His New Theory of Light and Colours: Sent by the Author to the Editor from Cambridge, Feb. 6, 1671–72; to Be Communicated to the Royal Society." *Philosophical Transactions of the Royal Society of London, from their commencement, in 1665, to the year 1800; abridged, with notes and biographic illustrations* 1 (1665–72): 678–88.

———. 1952. *Opticks, or A Treatise of the Reflections, Refractions, Inflections and Colours of Light*. New York: Dover Publications.

———. 1959. *The Correspondence of Isaac Newton*. Vol. 1, edited by H. W. Turnbull. Cambridge: Cambridge University Press.

———. 1984. *The Optical Papers of Isaac Newton*. Vol. 1, *The Optical Lectures, 1670–1672*, edited by Alan E. Shapiro. Cambridge: Cambridge University Press.

Nicolson, Benedict. 1968. *Joseph Wright of Derby: Painter of Light*. 2 vols. London: Routledge and Kegan Paul.

Nicolson, Marjorie H. 1966. *Newton Demands the Muse: Newton's* Opticks *and the Eighteenth Century Poets*. Princeton: Princeton University Press.

Novak, Barbara. 1980. *Nature and Culture: American Landscape and Painting 1825–1875*. New York: Oxford University Press.

Nussenzveig, H. Moysés. 1980. "The Theory of the Rainbow." In *Atmospheric Phenomena*, edited by David K. Lynch, 60–71. San Francisco: W. H. Freeman and Co.

Ockenden, R. E. 1936. "Marco Antonio de Dominis and His Explanation of the Rainbow." *Isis* 26:40–49.

Okayama, Yassu. 1992. *The Ripa Index: Personifications and Their Attributes in Five Editions of the Iconologia*. Doornspijk, Netherlands: Davaco Publishers.

Olson, Roberta J. M. 1984. ". . . And They Saw Stars: Renaissance Representations of Comets and Pretelescopic Astronomy." *Art Journal* 44:216–24.

Olszewski, Edward J. 1982. "Renaissance Naturalism: The Rare and the Ephemeral in Art and Nature." *Source: Notes in the History of Art* 1:23–28.

Opfell, Olga S. 1991. *Special Visions: Profiles of Fifteen Women Artists from the Renaissance to the Present Day*. Jefferson, N.C.: McFarland and Co.

Oresme, Nicole. 1968. *Le Livre du ciel et du monde*. Translated by Albert D. Menut. Madison: University of Wisconsin Press.

Orlandi, Stefano. 1974. *Historical-Artistic Guide of Santa Maria Novella and Her Monumental Cloisters*. Florence: S. Becocci.

Osborne, June. 1990. *Hampton Court Palace*. London: Her Majesty's Stationery Office.

O'Sullivan, John L. 1845. "Annexation" [unsigned]. *The United States Magazine, and Democratic Review* 17 (July/August): 5–10.

Oswalt, Sabine G. 1969. *Concise Encyclopedia of Greek and Roman Mythology*. Chicago: Follett Publishing Co.

Ovid. 1986. *Metamorphoses*. Translated by A. D. Melville. Oxford: Oxford University Press.

Owens, Gwendolyn, and John Peters-Campbell. 1982. *Golden Day, Silver Night: Perceptions of Nature in American Art 1850–1910*. Ithaca, N.Y.: Herbert F. Johnson Museum of Art.

Oxford English Dictionary. 1971. *The Compact Edition of the Oxford English Dictionary*. Oxford: Oxford University Press.

Paine, Robert T., and Alexander Soper. 1974. *The Art and Architecture of Japan*. Second edition. Baltimore: Penguin Books.

Palmer, Frederic. 1945. "Unusual Rainbows." *American Journal of Physics* 13:203–4.

Panofsky, Erwin. 1945. *Albrecht Dürer*. Vol. 1. Second edition. Princeton: Princeton University Press.

Parkhurst, Charles. 1961. "Aguilonius' Optics and Rubens' Color." *Nederlands Kunsthistorisch Jaarboek* 12:35–49.

Parkinson, R. B. 1991. *Voices from Ancient Egypt: An Anthology of Middle Kingdom Writings*. Norman: University of Oklahoma Press.

Parrinder, Geoffrey. 1967. *African Mythology*. London: Hamlyn Publishing Group.

Parris, Leslie, Ian Fleming-Williams, and Conal Shields. 1976. *Constable: Paintings, Watercolours and Drawings*. Second edition. London: Tate Gallery.

Pecham, John. 1970. *John Pecham and the Science of Optics*: Perspectiva Communis. Translated and edited by David C. Lindberg. Madison: University of Wisconsin Press.

Pedgley, David E. 1986. "A Tertiary Rainbow." *Weather* 41:401.

Pernter, Josef M., and Felix M. Exner. 1922. *Meteorologische Optik*. Second edition. Vienna:

Wilhelm Braumüller.
Pestilli, Livio. 1993. "*Ut pictura* non *poesis*: Lord Shaftesbury's 'Ridiculous Anticipation of Metamorphosis' and the Two Versions of *Diana and Actaeon* by Paolo de Matteis." *Artibus et Historiae* 14:131–39.
Piankoff, Alexandre. 1954. *The Tomb of Ramesses VI, Part I: Texts*. New York: Pantheon Books.
Piccione, Peter A. 1990. "Mehen, Mysteries, and Resurrection from the Coiled Serpent." *Journal of the American Research Center in Egypt* 27:43–52.
Pigott, Grenville. 1978. *A Manual of Scandinavian Mythology*. 1839. Reprint, New York: Arno Press.
Plato. 1952. *Plato, with an English Translation*. Vol. 7, *Timaeus, Critias, Cleitophon, Menexenus, Epistles*. Translated by R. G. Bury. Cambridge, Mass.: Harvard University Press.
———. 1956. *The Republic*. Part 2, Books VI–X. Translated by Paul Shorey. Cambridge, Mass.: Harvard University Press.
Pliny. 1982. *The Elder Pliny's Chapters on the History of Art*. Translated by K. Jex-Blake. Chicago: Ares Publishers.
Poignant, Roslyn. 1967. *Oceanic Mythology*. London: Hamlyn Publishing Group.
Pope, Alexander. 1978. *Poetical Works*, edited by Herbert Davis. Oxford: Oxford University Press.
Portier, François. 1989. "Un mécène Anglais et des artistes Italiens au début du XVIII^e siècle: Lord Shaftesbury, Antonio Verrio, et Paolo de Matteis." *Études Anglaises* 42:401–10.
Potter, Richard. 1838. "Mathematical Considerations on the Problem of the Rainbow, Shewing It to Belong to Physical Optics." *Transactions of the Cambridge Philosophical Society* 6:141–52.
———. 1855. "On the Interference of Light Near a Caustic, and the Phænomena of the Rainbow." *London, Edinburgh, and Dublin Philosophical Magazine and Journal of Science* 9, 4th series (May): 321–26.
Ptolemy. 1989. *L'Optique de Claude Ptolémée dans la version latine d'après l'arabe de l'émir Eugène de Sicile*, edited by Albert Lejeune. 1956. Reprint, Leiden: E. J. Brill.
Radcliffe-Brown, A. R. 1926. "The Rainbow-Serpent Myth of Australia." *Journal of the Royal Anthropological Institute* 56:19–25.
Ratliff, Floyd. 1992. *Paul Signac and Color in Neo-Impressionism*. New York: Rockefeller University Press.
Raymo, Chet. 1992. "Focal Point: Why Oddball Ideas Have It Tough in Science." *Sky and Telescope* 84:364.
Read, John. 1945. "Dürer's *Melencolia*: An Alchemical Interpretation." *Burlington Magazine* 87:283–84.
Reefe, Thomas Q. 1981. *The Rainbow and the Kings: A History of the Luba Empire to 1891*. Berkeley and Los Angeles: University of California Press.
Rice, George P., Jr. 1966. *The Public Speaking of Queen Elizabeth: Selections from Her Official Addresses*. 1951. Reprint, New York: AMS Press.
Ripa, Cesare. 1971. *Baroque and Rococo Pictorial Imagery: The 1758–60 Hertel Edition of Ripa's "Iconologia."* Translated by Edward A. Maser. New York: Dover Publications.
Rochberg-Halton, F. 1991. "Between Observation and Theory in Babylonian Astronomical Texts." *Journal of Near Eastern Studies* 50:107–20.
Romney, George. 1961. *George Romney, 1734–1802: Paintings and Drawings*. London: London County Council.
Ronan, Colin A. 1992. "Leonard and Thomas Digges." *Endeavour* 16:91–94.
Rood, Ogden N. 1973. *Modern Chromatics: Students' Text-Book of Color with Applications to Art and Industry*, edited by Faber Birren. 1879. Facsimile, New York: Van Nostrand Reinhold Co.
Rösch, Sigmund. 1968. "Der Regenbogen in Wissenschaft und Kunst." *Applied Optics* 7:233–39.
Rosen, Edward. 1957. "The Title of Maurolico's *Photismi*." *American Journal of Physics* 25:226–28.
Rosenfield, John M. 1988. *Extraordinary Persons: Japanese Artists (1560–1860) in the Kimiko and John Powers Collection*. Cambridge, Mass.: Harvard University Art Museums.
———. 1995. "Soga Shōhaku catalog entry #93." Personal communication.
Rosenfield, John M., and Shūjirō Shimada. 1970. *Traditions of Japanese Art: Selections from the Kimiko and John Powers Collection*. Cambridge, Mass.: Fogg Art Museum.
Rosenthal, Angela. 1992. "Angelica Kauffman Ma(s)king Claims." *Art History* 15:38–59.
Rosenthal, Michael. 1982. *British Landscape Painting*. Ithaca, N.Y.: Cornell University Press.
———. 1983. *Constable: The Painter and His Landscape*. New Haven, Conn.: Yale University Press.
Ross, Barbara T. 1985. "Nineteenth-Century American Landscape Paintings: Nine Recent Acquisitions." *Record of the Art Museum (Princeton University)* 44:4–13.
Rousseau, Denis L. 1992. "Case Studies in Pathological Science." *American Scientist* 80:54–63.
Roworth, Wendy W. 1992. "Kauffman and the Art of Painting in England." In *Angelica Kauffman: A Continental Artist in Georgian England*, edited by Wendy W. Roworth, 11–95. Brighton, U.K.: Royal Pavilion, Art Gallery and Museums.

Rubens, Peter Paul. 1955. *The Letters of Peter Paul Rubens*. Translated and edited by Ruth S. Magurn. Cambridge, Mass.: Harvard University Press.

Rubinstein, Raphael. 1994. "Rufino Tamayo at Associated American Artists." *Art in America* 82 (July): 97–98.

Ruskin, John. 1851. "The Pre-Raffaellites" and "The Pre-Raphaelite Artists." *The Times* [London], 13 May, 8–9; 30 May, 8–9.

———. 1881. *Lectures on Architecture and Painting, Delivered at Edinburgh, in November, 1853*. New York: John Wiley and Sons.

———. 1886. *The Stones of Venice*. 3 vols. Fourth edition. Orpington, U.K.: George Allen.

———. 1888. *Modern Painters*. 6 vols. Orpington, U.K.: George Allen.

———. 1890. *The Works of John Ruskin*. Vol. 4, *The Eagle's Nest*. London: George Allen.

———. 1908. *The Works of John Ruskin*, edited by Edward T. Cook and Alexander Wedderburn. 39 vols. London: George Allen.

Russell, Francis. 1967. *The World of Dürer, 1471–1528*. New York: Time Inc.

Rusten, Jeffrey, I. C. Cunningham, and A. D. Knox, trans. and eds. 1993. *Theophrastus Characters, Herodas Mimes, Cercidas and the Choliambic Poets*. Cambridge, Mass.: Harvard University Press.

Sabra, Abdelhamid I. 1967. *Theories of Light from Descartes to Newton*. London: Oldbourne Book Co.

———. 1994. *Optics, Astronomy and Logic: Studies in Arabic Science and Philosophy*. Brookfield, Vt.: Ashgate Publishing Co.

Sachs, Abraham J., and Hermann Hunger. 1988. *Astronomical Diaries and Related Texts from Babylonia*. Vol. 1, *Diaries from 652 B.C. to 262 B.C.* Vienna: Österreichischen Akademie der Wissenschaften.

Sahlins, Marshall. 1977. "Colors and Cultures." In *Symbolic Anthropology: A Reader in the Study of Symbols and Meanings*, edited by Janet L. Dolgin, David S. Kemnitzer, and David M. Schneider, 165–80. New York: Columbia University Press.

Sakellariadis, Spyros. 1982. "Descartes' Experimental Proof of the Infinite Velocity of Light and Huygens' Rejoinder." *Archive for the History of the Exact Sciences* 26:1–12.

Salter, Carle. 1909. "Mediæval Meteorology." *Symons's Meteorological Magazine* 44:141–44.

Sambursky, Samuel. 1987. *The Physical World of the Greeks*. 1956. Reprint. Princeton: Princeton University Press.

Sandars, Nancy K. 1964. *The Epic of Gilgamesh*. Baltimore: Penguin Books.

Sarton, George. 1931. *Introduction to the History of Science*. Vol. 2, parts 1–2. Washington, D.C.: Carnegie Institution of Washington.

———. 1960. *A History of Science*. Vol. 1. Cambridge, Mass.: Harvard University Press.

Sassen, Kenneth. 1991. "Rainbows in the Indian Rock Art of Desert Western America." *Applied Optics* 30:3523–37, plates 35–38.

Saunders, Eleanor A. 1978–79. "A Commentary on Iconoclasm in Several Print Series by Maarten van Heemskerck." *Simiolus* 10:59–83.

Sayili, Aydin M. 1939. "The Aristotelian Explanation of the Rainbow." *Isis* 30:65–83.

Schimmel, Annemarie. 1992. *A Two-Colored Brocade: The Imagery of Persian Poetry*. Chapel Hill: University of North Carolina Press.

Schramm, Matthias. 1965. "Steps Towards the Idea of Function: A Comparison Between Eastern and Western Science of the Middle Ages." *History of Science* 4:70–103.

Schweizer, Paul D. 1982a. "John Constable, Rainbow Science, and English Color Theory." *Art Bulletin* 64:424–45.

———. 1982b. "John Constable and the Anglican Church Establishment." *Artibus et Historiae* 3:125–39.

Scott, Joseph F. 1976. *The Scientific Work of René Descartes (1596–1650)*. 1952. Reprint, London: Taylor and Francis.

Sekuler, Robert, and Randolph Blake. 1985. *Perception*. New York: Alfred A. Knopf.

Seneca. 1971. *Seneca in Ten Volumes*. Vol. 7, *Naturales Quaestiones I*, edited by E. H. Warmington. Cambridge, Mass.: Harvard University Press.

Seurat, Georges. 1978. "Letter to Félix Fénéon." In *Seurat in Perspective*, edited by Norma Broude, 16–17. Englewood Cliffs, N.J.: Prentice-Hall.

Shakespeare, William. 1958. *The Arden Shakespeare: The Tempest*, edited by Frank Kermode. Sixth edition. New York: Methuen.

Shapiro, Alan E. 1975. "Newton's Definition of a Light Ray and the Diffusion Theories of Chromatic Dispersion." *Isis* 66:194–210.

———. 1980. "The Evolving Structure of Newton's Theory of White Light and Color." *Isis* 71:211–35.

———. 1984. "Experiment and Mathematics in Newton's Theory of Color." *Physics Today* 37 (September): 34–42.

———. 1992. "Comment on 'Newton's Zero-Order Rainbow: Unobservable or Nonexistent?'" *American Journal of Physics* 60:749–50.

Shawe-Taylor, Desmond. 1987. *Genial Company: The Theme of Genius in Eighteenth-Century British Portraiture*. Nottingham, U.K.: Nottingham University Art Gallery.

Shea, William R. 1991. *The Magic of Numbers and Motion: The Scientific Career of René Descartes*. Canton, Mass.: Science History Publications.

Shelley, Percy Bysshe. 1977. *Shelley's Poetry and Prose*, edited by Donald H. Reiman and Sharon B. Powers. New York: W. W. Norton and Co.

Shennum, David. 1977. *English-Egyptian Index of* Faulker's *Concise Dictionary of Middle Egyptian*. Malibu, Calif.: Undena Publications.

Sherman, Paul D. 1981. *Colour Vision in the Nineteenth Century: The Young-Helmholtz-Maxwell Theory*. Bristol: Adam Hilger.

Shiono, Kiyohiko, and Tomoaki Shikakura. 1994. "Rainbow Bridge Arcs over Tokyo Bay." *Lighting Design and Application* 24 (June): 18–23.

Shirley, John W. 1951. "An Early Experimental Determination of Snell's Law." *American Journal of Physics* 19:507–8.

———. 1983. *Thomas Harriot: A Biography*. Oxford: Oxford University Press.

Shorey, Paul. 1933. *What Plato Said*. Chicago: University of Chicago Press.

Shreeve, James. 1994. "Phenomena, Comment and Notes." *Smithsonian* 25 (September): 17–20.

Sitwell, Sacheverell. 1969. *Narrative Pictures: A Survey of English Genre and Its Painters*. 1936. Reprint, London: B. T. Batsford.

Smith, George, and Algis Vingrys. 1995. "Seeing Red." *New Scientist* 147 (15 July): 52–53.

Smith, Paul. 1990. "Seurat: The Natural Scientist?" *Apollo* 132:381–85.

Snell, Ebenezer S. 1854. "Account of a Rainbow Caused by Light Reflected from Water." *American Journal of Science and Arts* 18, 2nd series (November): 18–21.

Southern, Richard W. 1992: *Robert Grosseteste: The Growth of an English Mind in Medieval Europe*. Second edition. Oxford: Oxford University Press.

Spectator. 1849. "The Arts. Royal Academy: The Landscapes." *The Spectator* (23 June): 591–92.

Spenser, Edmund. 1977. *The Faerie Queene*, edited by A. C. Hamilton. Essex, U.K.: Longman Group.

Spicer, Joaneath. 1993. "Pieces of a Renaissance Puzzle: Heemskerck's 'Abduction of Helen.'" *The Walters Monthly Bulletin* (January): 2–3.

Staley, Allen. 1973. *The Pre-Raphaelite Landscape*. London: Oxford University Press.

Stanley-Baker, Joan. 1984. *Japanese Art*. London: Thames and Hudson.

Stebbins, Theodore E., Jr. 1978. *Close Observation: Selected Oil Sketches by Frederic E. Church*. Washington, D.C.: Smithsonian Institution Press.

Stechow, Wolfgang. 1966. *Northern Renaissance Art, 1400–1600: Sources and Documents*. Englewood Cliffs, N.J.: Prentice-Hall.

Steffens, Henry J. 1977. *The Development of Newtonian Optics in England*. New York: Science History Publications/USA.

Stevens, Walter LeConte. 1906. "Theory of the Rainbow." *Monthly Weather Review* 34:170–73.

Strachov, A. B. 1988. "Miscellanea Meteorologica Slavica: 'Breaking' the Rainbow in Poles'e," *Die Welt der Slaven* 33:336–53.

Straker, Stephen M. 1970. "Kepler's Optics: A Study in the Development of Seventeenth-Century Natural Philosophy." Ph.D. diss., Indiana University.

Strong, Roy. 1977. *The Cult of Elizabeth: Elizabethan Portraiture and Pageantry*. Berkeley and Los Angeles: University of California Press.

———. 1985. "The Leicester House Miniatures: Robert Sidney, 1st Earl of Leicester and His Circle." *Burlington Magazine* 127:694–701.

Suffield, Laura. 1994. "Dürer's Adoration Restored." *The Art Newspaper* 5 (July–September): 12.

Taçon, Paul S. C., Meredith Wilson, and Christopher Chippindale. 1996. "Birth of the Rainbow Serpent in Arnhem Land Rock Art and Oral History." *Archaeology in Oceania* 31:103–24.

Talbot, William S. 1977. *Jasper F. Cropsey: 1823–1900*. New York: Garland Publishing.

Tamayo, Rufino. 1979. *Rufino Tamayo: Myth and Magic*. New York: Solomon R. Guggenheim Foundation.

———. 1993. *Nature and the Artist: The Work of Art and the Observer*. Northampton, Mass.: Smith College Museum of Art.

Taube, Karl. 1993. *Aztec and Maya Myths*. Austin: University of Texas Press.

Taylor, Luke. 1990. "The Rainbow Serpent as Visual Metaphor in Western Arnhem Land." *Oceania* 60:329–44.

Theodoric. 1914. *Dietrich von Freiberg, Über den Regenbogen und die durch Strahlen erzeugten Eindrüke*, edited by Joseph Würschmidt. Münster: Aschendorffsche Verlagsbuchhandlung.

Thomas, Abel C. 1852. *Autobiography of Rev. Abel C. Thomas: Including Recollections of Persons, Incidents, and Places*. Boston: J. M. Usher.

Thomas Aquinas. 1924. *The Summa Contra Gentiles of Saint Thomas Aquinas*. Vol. 1. London: Burns Oates and Washburne.

Thompson, Benjamin. 1809. "An Account of Some Experiments on Coloured Shadows." *Philosophical Transactions of the Royal Society of London, from their commencement, in 1665, to the year 1800; abridged, with notes and biographic illustrations* 17 (1791–96): 374–80.

Thomson, James. 1971. *Poetical Works*, edited by J. Logie Robertson. 1908. Reprint, London: Oxford University Press.

Thornbury, Walter. 1970. *The Life of J. M. W. Turner, R.A.: Founded on Letters and Papers Furnished by His Friends and Fellow-Academicians*. 1877. Reprint, London: Ward Lock Reprints.

Thorndike, Lynn. 1954. "Oresme and Fourteenth

Century Commentaries on the *Meteorologica*." *Isis* 45:145–52.

———. 1958. *A History of Magic and Experimental Science*. Vol. 2. New York: Columbia University Press.

Thornes, John E. 1979a. "Constable's Clouds." *Burlington Magazine* 121:697–704.

———. 1979b. "The Weather Dating of John Constable's Cloud Studies." *Weather* 34:308–15.

———. 1984. "Luke Howard's Influence on Art and Literature in the Early Nineteenth Century." *Weather* 39:252–55.

Tiemersma, Douwe. 1988. "Methodological and Theoretical Aspects of Descartes' Treatise on the Rainbow." *Studies in History and Philosophy of Science* 19:347–64.

Traxel, David. 1980. *An American Saga: The Life and Times of Rockwell Kent*. New York: Harper and Row.

Treuherz, Julian. 1980. *Pre-Raphaelite Paintings from the Manchester City Art Gallery*. London: Lund Humphries Publishers.

Troyen, Carol. 1984. "Innocents Abroad: American Painters at the 1867 Exposition Universelle, Paris." *American Art Journal* 16 (Autumn): 2–29.

Truettner, William H. 1976. "'Scenes of Majesty and Enduring Interest': Thomas Moran Goes West." *Art Bulletin* 58:241–59.

Tuckerman, Henry T. 1966. *Book of the Artists*. 1867. Reprint, New York: James F. Carr.

Tunstall, Marmaduke. 1809. "Account of Several Lunar Rainbows." *Philosophical Transactions of the Royal Society of London, from their commencement, in 1665, to the year 1800; abridged, with notes and biographic illustrations* 15 (1781–85): 353.

Turner, A. Richard. 1966. *The Vision of Landscape in Renaissance Italy*. Princeton: Princeton University Press.

Tyler, Hamilton A. 1964. *Pueblo Gods and Myths*. Norman: University of Oklahoma Press.

Ulbrich, Carlton W. 1983. "Natural Variations in the Analytical Form of the Raindrop Size Distribution." *Journal of Climate and Applied Meteorology* 22:1764–75.

Upchurch, Diane M. 1991. "Nineteenth Century Light and Color Theory: Rainbow Science in the Art of Frederic Edwin Church." Master's thesis, University of North Texas.

Vasari, Giorgio. 1963. *The Lives of the Painters, Sculptors and Architects*, edited by William Gaunt. 4 vols. London: J. M. Dent and Sons.

Veatch, Henry. 1974. *Aristotle: A Contemporary Appreciation*. Bloomington: Indiana University Press.

Veldman, Ilja M. 1977. *Maarten van Heemskerck and Dutch Humanism in the Sixteenth Century*. Translated by Michael Hoyle. Maarssen, Netherlands: Uitgeverij Gary Schwartz.

———. 1980. "Seasons, Planets and Temperaments in the Work of Maarten van Heemskerck: Cosmo-Astrological Allegory in Sixteenth-Century Netherlandish Prints." *Simiolus* 11:149–76.

———. 1985. "The 'Concert of the Muses' in the Work of Maarten van Heemskerck." *Hoogsteder-Naumann Mercury* 1:35–41.

Vergara, Lisa. 1982. *Rubens and the Poetics of Landscape*. New Haven, Conn.: Yale University Press.

Virgil. 1958. *The Aeneid*. Translated by W. F. Jackson Knight. New York: Penguin Books.

———. 1978. *Eclogues, Georgics, Aeneid I–VI*. Vol. 1. Translated by H. Rushton Fairclough. Cambridge, Mass.: Harvard University Press.

Volz, Frederic E. 1961. "Der Regenbogen." In *Handbuch der Geophysik*. Vol. 8, edited by F. Linke and F. Möller, 943–1026. Berlin: Gebrüder Borntraeger.

Wagner, Virginia L. 1988. "John Ruskin and Artistical Geology in America." *Winterthur Portfolio* 23:151–67.

———. 1989. "Geological Time in Nineteenth-Century Landscape Paintings." *Winterthur Portfolio* 24:153–63.

Walbridge, John. 1992. *The Science of Mystic Lights: Quṭb al-Dīn Shīrāzī and the Illuminationist Tradition in Islamic Philosophy*. Cambridge, Mass.: Harvard University Press.

Walker, D. 1950. "A Rainbow and Supernumeraries with Graduated Separations." *Weather* 5:324–25.

Walker, D. P. 1967. "Kepler's Celestial Music." *Journal of the Warburg and Courtauld Institutes* 30:228–50.

Walker, Jearl D. 1976. "Multiple Rainbows from Single Drops of Water and Other Liquids." *American Journal of Physics* 44:421–33.

———. 1977. "The Amateur Scientist: How to Create and Observe a Dozen Rainbows in a Single Drop of Water." *Scientific American* 237, no. 1 (July): 138–44.

Wallace, William A. 1959. *The Scientific Methodology of Theodoric of Freiberg*. Fribourg, Switzerland: University Press.

Walls, Kathryn. 1995. "The Rainbow as Archer's Bow in the Chester Cycle's *Noah's Flood*." *Notes and Queries* n.s. 42:27–29.

Wasserman, Gerald S. 1978. *Color Vision: An Historical Introduction*. New York: John Wiley and Sons.

Waterhouse, Ellis. 1985. "Reynolds, Angelica Kauffmann and Lord Boringdon." *Apollo* 122:270–74.

Watterson, Barbara. 1984. *The Gods of Ancient Egypt*. New York: Facts on File Publications.

Weaver, Muriel P. 1972. *The Aztecs, Maya, and Their Predecessors: Archaeology of Mesoamerica*. New York: Seminar Press.

Webster, J. Carson. 1978. "The Technique of Impressionism: A Reappraisal." In *Seurat in Perspective*, edited by Norma Broude, 93–102. Englewood Cliffs, N.J.: Prentice-Hall.

Weinstein, Steve. 1993. "Rainbow's Pot of Gold." *Progressive Grocer* 72 (June): 111–14.

Weitzmann, Kurt. 1970. *Illustrations in Roll and Codex: A Study of the Origin and Method of Text Illustration*. Princeton: Princeton University Press.

Wellesz, Emmy. 1960. *The Vienna Genesis*. London: Faber and Faber.

West, Richard V. 1985. *"An Enkindled Eye": The Paintings of Rockwell Kent*. Santa Barbara, Calif.: Santa Barbara Museum of Art.

Westfall, Richard S. 1962. "The Development of Newton's Theory of Color." *Isis* 53:339–58.

———. 1963. "Newton's Reply to Hooke and the Theory of Colors." *Isis* 54:82–96.

———. 1980. *Never at Rest: A Biography of Isaac Newton*. Cambridge: Cambridge University Press.

Wiedemann, Eilhard. 1910–11. "Zu den optischen Kenntnissen von Quṭb al Dîn al Schîrâzî." *Archiv für die Geschichte der Naturwissenschaften und der Technik* 3:187–93.

———. 1914. "Theorie des Regenbogens von Ibn al Haitam." *Sitzungsberichte der Physikalisch-medizinschen Sozietät in Erlangen* 46:39–56.

Wiedemann, Thomas. 1988. *Greek and Roman Slavery*. London: Routledge.

Wildman, Stephen, Jan Marsh, and John Christian. 1995. *Visions of Love and Life: Pre-Raphaelite Art from the Birmingham Collection, England*. Alexandria, Va.: Art Services International.

Wilkinson, Kenneth. 1995. "Antonio Verrio Paintings in Burghley House: The Heaven Room." Personal communication.

Williams, Dyfri. 1985. *Greek Vases*. Cambridge, Mass.: Harvard University Press.

Wilton, Andrew. 1979. *Constable's "English Landscape Scenery."* London: British Museum Publications.

———. 1980. *Turner and the Sublime*. London: British Museum Publications.

Wind, Edgar. 1938–39. "Shaftesbury as a Patron of Art." *Journal of the Warburg and Courtauld Institutes* 2:185–88.

———. 1939–40. "Julian the Apostate at Hampton Court." *Journal of the Warburg and Courtauld Institutes* 3:127–37.

Winter, H. J. J. 1954. "The Optical Researches of Ibn al-Haitham." *Centaurus* 3:190–210.

Witelo. 1972. *Item Vitellonis Thuringopoloni Libri X (Perspectiva)* and *Opticae Thesaurus Alhazeni Arabis Libri Septem, Nuncprimum Editi*. 1572. Reprint, New York: Johnson Reprint Corp.

———. 1983. *Witelonis Perspectivae Liber Quintus: Book V of Witelo's* Perspectiva. Translated by A. Mark Smith. Wroclaw, Poland: Polish Academy of Sciences Press.

Wölfflin, Heinrich. 1971. *The Art of Albrecht Dürer*. Translated by Alastair and Heide Grieve. London: Phaidon Press.

Wright, C. J. 1980. "The 'Spectre' of Science. The Study of Optical Phenomena and the Romantic Imagination." *Journal of the Warburg and Courtauld Institutes* 43:186–200.

Wyszecki, Günter, and W. S. Stiles. 1982. *Color Science: Concepts and Methods, Quantitative Data and Formulae*. Second edition. New York: John Wiley and Sons.

Xenophanes. 1992. *Xenophanes of Colophon: Fragments: A Text and Translation with a Commentary*. Translated by James H. Lesher. Toronto: University of Toronto Press.

Yates, Frances. 1975. *Astraea: The Imperial Theme in the Sixteenth Century*. London: Routledge and Kegan Paul.

Young, Thomas. 1802. "The Bakerian Lecture. On the Theory of Light and Colours." *Philosophical Transactions of the Royal Society of London* [92], part 1:12–48.

———. 1804. "The Bakerian Lecture. Experiments and Calculations Relative to Physical Optics." *Philosophical Transactions of the Royal Society of London* [94], part 1:1–16.

Zafran, Eric M. 1988. *Fifty Old Master Paintings from The Walters Art Gallery*. Baltimore: Trustees of The Walters Art Gallery.

Zajonc, Arthur G. 1976. "Goethe's Theory of Color and Scientific Intuition." *American Journal of Physics* 44:327–33.

Zandee, J. 1969. "The Book of Gates." In *Liber Amicorum: Studies in Honour of Professor Dr. C. J. Bleeker*, 282–324. Leiden: E. J. Brill.

Zwimpfer, Moritz. 1988. *Color, Light, Sight, Sense*. West Chester, Pa.: Schiffer Publishing.

INDEX

A

aberration, chromatic, 194, 197
aberration, spherical, 357 n. 262
Aborigines, Australian, 22–24
absorption, 221–22, 230, 260
academic art, 70, 89
Académie des Sciences, France, 353 n. 128
Académie Royale, France, 70
Achilles, 8
Adrian VI (pope), 57
Aegean Sea, 18
Aeneas, 19
aerial perspective, 49, 51, 60, 128
aerodynamics, droplet, 278–79, 284–85
Aeschrion, 8
Aetion, 210
Agassiz, Louis, 97
Aguilonius, Franciscus, 211
airlight, 49–50, 60, 75, 128, 342 n. 101, 360 n. 119, 364 n. 30
Airy, George Biddell, rainbow theory, 258–60, 282, 311–16; *Fig. 8-11*
Akhenaton, 10, 13, 64; *Fig. 1-7*
Akkadia, 6
Albertus Magnus, rainbow theory, 153–55, 162
alchemy, 331 n. 146
Alcmene, 16–18; *Fig. 1-10*
Alcyone, 21
Alexander of Aphrodisias, 109–11, 291
Alexander's dark band, 110–11, 324
Alexander the Great, 72, 276
Alhazen, 142–46, 160
 rainbow model, 144–46; *Fig. 5-4*
 on refraction, 142–43
 and species, 149
Alihi, 32
Allston, Washington, 338 n. 209
Alphonso VI, 147
Amenhotep IV. *See* Akhenaton
Amphitryon, 16, 17
Anaximenes, rainbow theory, 102, 210
Andrea da Firenze, *Triumph of the Church*, 43
Andromeda (constellation), 31
angels, 46, 137
angle
 incidence, 143–44, 183, 344 n. 48
 reflection, 143–44
 refraction, 143–44, 183
angular measure, 114, 365 n. 1
ankh, 10–11
antahkarana, 301
Antenor, 16, 17
anthills, 30
antisolar point, 113, 322, 337 n. 179
Apelles, 210
Apocalypse, Book of, 43
Apollonius, 137
Archimedes, 147
Arena Chapel, Padua, 45–47
Arethas of Caesarea (bishop), 43
Aristophanes, 340 n. 15
Aristotle, 21, 50, 105–9
 cloud-mirror, 105–8, 110, 154
 color theory, 107–8, 208–10
 and empiricism, 105
 Meteorologica commentators
 ancient, 109–11, 138–39
 medieval, 139–66, 170
 Renaissance, 170–76
 Meteorologica, translations of, 147
 meteorological sphere, 105; *Fig. 4-1*
 on optics, 106–7, 149
 Pythagorean numerology, 104, 107, 134
 rainbow theory (*Meteorologica*), 40, 105–9, 290–91
Asgard, 33, 317
Ashurbanipal, 6
Assyria, 6
astrolabe, 165, 348 n. 212, 351 n. 44
astrology, 179, 348 n. 201, 353 n. 125
astronomers, 5, 10, 101
atmospheric electricity, 83
atmospheric perspective. *See* aerial perspective
atmospheric transparency. *See* airlight
atomism, 103
atramentum, 210
Atseatsine and Atseatsan, 31
August, Emil (duke), 112
Augustine, Saint, 63, 139, 148
 City of God, 52
aureole (art), 44
Averroës, 345 n. 73
Avicenna, 245, 291
 rainbow theory, 141–42, 175
Aymeric, 162

B

Babylonia, 5–6, 8, 10, 101
Bacon, Roger, 155–59
 color theory, 159
 on Grosseteste, 155, 157–58
 and mathematics, 155–56
 rainbow theory, 156–59
 reflection and rainbow, 158–59
Ball-Carrier, 32–33
Baretti, Giuseppe, 77
Barker, Thomas, 243–44
Barnfield, Richard, 64
Baroque painting, 70, 72, 79

Barrow, Isaac, 197
Barry, James, 80, 217
Bartholomaeus Anglicus, rainbow theory, 141, 159
Beaumont, George, 82
Bede, Venerable, rainbow theory, 36, 141
Beeckman, Isaac, 353 n. 132
Bernoulli, Jacob, 291
Bethlehem, star of, 46
Bierstadt, Albert, 286
Bifrost, 33, 317
Billet, Félix, 364 n. 64
bitumen, 89
Blanc, Charles, 231, 361 n. 149
Bochica, 33
Boethius, 109
Boissard, Jean-Jacques, 65–66
Boitel, 312
Book of Gates, 9
Book of the Dead, 13
Boule, Marcellin, 309–10
Bourdon, Sebastien, *Death of Dido*, Fig. 1-12
Boyle, Robert, 193–94, 355 n. 211
Brahe, Tycho, 177
Bravais, Auguste, 247
Brett, John, 337 n. 157
Brewster, David, 85, 228, 250–51
brightness (vision), 225
brightness contrast, 352 n. 65
Browne, Thomas, 12, 37
Bruges, 47–48
Brumidi, Constantino, *Apotheosis of George Washington*, Fig. 1-1
Buddhism, 74–75
Buffon, Georges-Louis Leclerc de, 227–28
Burghley House, 70, 73–74
Burghley, First Baron, 333 n. 254
Burke, Edmund, 94
Burton, Robert, 137
butterfly, 89, 91–92
Bwiti, 31
Byzantine painting, 47
 figurative style, 41
 rainbow colors, 40, 43, 53
 sky convention, 42
Byzantium, 41, 42, 109

C

Caesar Augustus, 63
calculus, 204
Callimachus, 18
Calvinism, 181
Cambridge University, 196–97
camelopard, 335 n. 76
camera obscura, 128, 142, 177, 351 n. 25
Campagna, 82
Campin, Robert, 47, 49
 Merode Altarpiece, 49
Carmina Burana, 44
Carolingian painting, 42
Carroll, Lewis, 3
cartography, 60
Castel, Louis Bertrand, 217
Catherine de Médicis, 66
Catlin, George, 338 n. 190
catoptrics, 171, 182, 203, 351 n. 25
cattle, 29, 30, 31
caustic (optics), 312
Cavallini, Pietro, 44
cave, 14, 30
Cennini, Cennino, 211
Ceyx of Trachis, 21
chameleon, 77–78
Charlemagne, 41–42, 47
Charles II (English king), 71, 333 n. 12
Charles V (Holy Roman emperor), 57, 171
Charleton, Walter, 356 n. 226
Chevreul, Michel-Eugène, 97, 228–31
Chonos (archipelago), 126
Christ
 crucified, 52; Fig. 2-5
 at Last Judgment, 45–47; Figs. 2-3, 2-4
 in Majesty, 43
 Passion, 50
 as primary rainbow, 35, 91
 as Virgil's virginal ruler, 63
Christina (Swedish queen), 353 n. 121
Church, Frederic Edwin, 92–99, 131, 133, 286
 artistic practice, 95–96
 Cotopaxi, Ecuador, 97
 Heart of the Andes, 97
 Niagara, 92–96, 123; Fig. 3-6
 Rainy Season in the Tropics, 97–99; Fig. 3-7
 in South America, 96–98
Cicero, 101
CIE (Commission Internationale de l'Eclairage)
 achromatic region, 226
 achromatic stimulus, 224
 chromaticity coordinates, 224
 chromaticity curve, 261–63
 dominant wavelength, 224
 1976 UCS diagram, 224–26, 237–40, 260–63; Figs. 7-13, 7-14
 purity, 224, 260, 262–63, 269
 spectrum locus, 224
Ciermans, Jean, 193
Cimabue, 47
Claude Lorrain, 82, 87
Clavius, Christopher, 171
Clement I (pope), 139
Clement IV (pope), 155
Clement V (pope), 349 n. 241
Clement VII (pope), 57
Clichtowe, Josse, 176
climate, 12, 14, 16, 75
cloudbow. *See* rainbow in nature
clouds, 8, 18, 36–37, 52–53, 61, 69–70, 76, 83, 97, 101–2, 157, 340 n. 44
cobra, 9
codex, 38
Cole, Thomas, 95, 132, 286
color constancy, 234–35
colorimetry. *See* CIE
colors
 additive mixing, 220–23, 231, 260, 278, 299, 315, 360 n. 95, 361 n. 140; Fig. 7-10
 afterimages, 227–28, 361 n. 120; Fig. 7-16
 apparent, 144–45, 159, 179, 187, 210–12
 brightness of, 225–26, 326
 chroma, 326
 complementary, 216, 227, 231
 desaturated, 359 n. 51
 dominant wavelength, 224, 326
 hue, 209, 326
 interference, 205, 358 n. 324, 362 n. 30
 mixing, 209, 218–23; Fig. 7-12
 naming of, 358 n. 5, 360 n. 107
 perception, 224
 pigment, 40, 48, 89, 97, 108, 209, 216, 219–23
 primary, 214, 216, 219, 359 n. 36
 purity, 224, 326, 359 n. 83
 real, 144–45, 179, 187, 210–12
 saturation, 326, 359 n. 83
 simultaneous contrast, 226, 229, 232–33, 361 n. 143; Fig. 7-15
 spectrum of, 70, 79, 85, 154,

156, 198–200, 213–16, 294–95; *Fig. 7-6*
subtractive mixing, 220–23, 231; *Fig. 7-11*
terminology, 326
tint, 326
tone, 209, 326
trichromatic, 225
value, 326
vividness, 219
and wavelength, 216; *Fig. 7-6*
coma (comet), 46
comet, 46, 55, 331 n. 150
cones (vision), 235–36, 314; *Fig. 7-19*
conservatism, scientific, 167
Constable, John, 80–87
 Church of England, 86–87
 English Landscape Scenery, 84
 Landscape with a Double Rainbow, 87
 meteorological knowledge, 83
 Mound of the City of Old Sarum, from the South, 87
 on the picturesque, 83
 on rainbow theory, 83–85, 113, 120, 218; *Fig. 7-8*
 Salisbury Cathedral from the Bishop's Grounds, 86
 Salisbury Cathedral from the Meadows, 80, 86–87; *Fig. 3-4*
 social beliefs, 85–86
 Stoke by Neyland, 84–85
 Stonehenge, 87
 View over London with Double Rainbow, 86–87, 117
Constantine the Great, 41, 63, 72, 109
Constantinople. *See* Byzantium
contrapposto, 39
contraries, 341 n. 66, 347 n. 149
Copernicus, Nicolaus, 177, 351 n. 12
corona (atmospheric), 44, 294, 330 n. 66
cosmology, 13
Coypel, Noel, 212
Cozens, Alexander, 335 n. 90
Crayon (journal), 95, 286
critical flicker frequency, 357 n. 281
Cropsey, Jasper Francis, 286–89
 Dawn of Morning, Lake George, *Figs. 9-10*
crown, 8, 12, 42
crystals, 23, 31
cuneiform, 4
cyanometer, 88
Cythera (island), 332 n. 202

D

Dante, 63, 169
Darwin, Charles, 126, 131, 310, 339 n. 249
 salt-spray bow, 126
David (Israelite king), 41
Davies, John, 64–66
de Dominis, Marcantonio, 183, 203
Debye, Peter, 313–14
Deism, 70
deities
 Adad (*see* Enlil)
 Anu, 6
 Aphrodite, 32, 59
 Apollo, 73
 Argus Panoptes, 211–12; *Fig. 7-2*
 Astraea, 63
 Athena, 8, 59
 Aton, 10, 13; *Fig. 1-7*
 Bel, 5
 Belphoebe, 63
 Castor, 73
 Ceres, 275
 Chibchachum, 33
 Chuchaviva, 26
 Cuichi Supai, 27
 Cyclopes, 73
 Cynthia, 63
 Diana, 63, 73
 Electra, 18, 101
 Enlil, 6, 7, 8
 Eos, 16
 Eros, 117; *Fig. 4-8*
 Gaea, 18, 24
 God (Judeo-Christian), 6–7, 38; *Fig. 2-5*
 Harpies, 101
 Heimdall, 33, 317
 Hera, 18, 59
 Heracles, 16–17
 Hermes, 21; *Fig. 1-11*
 Heru-behutet, 13
 Hino the Thunderer, 28
 Horus, 9; *Fig. 1-6*
 Horus Behdety, 13
 Hutash, 32
 Hyades, 17
 Indra, 8
 Io, 211
 Iris, 8, 18–22, 61, 71–74, 101, 118, 212, 275; *Figs. 1-5, 1-11, 4-8, 7-2*
 Ishtar, 5, 6
 Ix Chel, 27
 Izanagi, 31–32
 Izanami, 31–32
 Juno, 18, 19, 59, 72, 73, 211–12; *Fig. 7-2*
 Jupiter, 59, 73, 211, 275
 Loki, 33
 Mars, 73
 Mercury, 211
 Minerva, 59, 71, 73
 Morpheus, 21
 Neptune, 73
 Nike, 18
 Ninurta, 8; *Fig. 1-4*
 Oceanus, 101
 Osiris, 9
 Pluto, 19
 Re, 9
 Seth, 9; *Fig. 1-6*
 Sleep, 21
 Thaumas, 18, 101
 Thoth, 13
 Tiermes, 8
 Tlaloc, 26
 Venus, 59, 71, 73
 Vulcan, 73
 Zeus, 8, 16–18, 59, 117; *Figs. 1-10, 4-8*
Dekker, Thomas, 62
Delacroix, Eugène, 229, 230
Democritus, 103
Descartes, René, 76, 104, 181–93, 203, 291
 color theory, 187–88
 De l'arc-en-ciel, 182–92
 La dioptrique, 182–84
 rainbow theory, 182, 185–91, 246; *Fig. 6-4*
 refraction theory, 182–84, 253
Devereux, Robert, 332 n. 222
deviation angle, 181, 189–90, 255, 258, 282–85, 289, 315, 355 n. 191
devils, 46
di Cambio, Arnolfo, 44
Dickens, Charles, 88, 94
Dido, 19–21; *Fig. 1-12*
diffraction, 193, 255
Digges, Leonard, 170
Digges, Thomas, 351 n. 12
digital image, 237–38, 260–69
dioptrics, 171, 182, 203, 351 n. 25

dispersion, 161, 198–202, 253–55, 348 n. 205
divisionism, 230, 233
double rainbow, 9, 91; *Figs. 8-8, 9-2*. *See also* rainbow in nature: secondary
 as star-crossed lovers, 31
Doughty, Thomas, 95
dove, 6
Drake, Francis, 332 n. 221
Dreaming (Australian Aborigines), 22
drizzle, 256, 277, 281–82, 286
Duat, 9; *Fig. 1-6*
Dughet, Gaspard, 82
Durand, Asher B., 95
Dürer, Albrecht, 51–56
 Adoration of the Trinity, 52–55; *Fig. 2-5*
 Apocalypse, 55
 artistic practice, 55
 Melencolia I, 55–56; *Fig. 2-6*
 rainbow colors, 52
dust, 260

E

eagle, 117
earthquakes, 25, 102, 170
East Anglia, 81–82, 85
Echo (nymph), 138
echo (sound), 149
economy, principle of, 150
Eddas, 33, 317
Edo-period Japan, 74
efficient cause, 163, 347 n. 154
Egypt, 9–14
 Beni Hasan, 13
 Cairo, 10, 12
 Edfu, 13
 Giza, 14
 Qift, 13
 rain in antiquity, 12–14
 Tell el-Amarna, 10
eidola, 149
Elam, 5
Electryon of Mycenae, 16
elements in antiquity, 36, 104, 141, 175, 318
Elizabeth I, 61–67, 175
 aigrette, 66
 as Astraea, 62–64, 66
 as Belphoebe, 62–63
 as bride, 65–66
 Catholic Church, 63–64
 Church of England, 63
 as Cynthia, 62–63
 divine light, 64, 66
 divine right to rule, 63–64, 67
 divinity cult, 62, 64
 Elizabethan golden age, 63, 67
 just, virginal ruler, 64
 mask of youth, 62
 Rainbow Portrait, 66; *Fig. 2-8*
 rainbow robe, 65
 as Virgo, 66
emerald, 43, 153
Empedocles, 104
empiricism, Greek, 103
energy spectra, 234–35; *Fig. 7-18*
Epicurus, 149
Erigone (or Virgo), 63
Eucharist, 36, 37, 52
Euclid, 142
Eumenes II, 209
Eustochium, 38
Exeter, Fifth Earl of, 73
Exner, Felix, 313
experimentation, Greek, 103
extramission (vision), 106–7, 149, 157
Eyck, Jan van, 47
eyeglasses, 177
Ezekiel, 41
Ezekiel, Book of, 43

F

Farington, Joseph, 82
Fārisī, Kamāl al-Dīn al-. *See* Kamāl al-Dīn
feathers, 46
Fénéon, Félix, 230–31
Fenn, Harry, *Niagara*, 123; *Fig. 4-11*
Fermat, Pierre de, 150
Fermat's principle, 346 n. 136
Ferrier, Jean, 353 n. 132
fire, 33, 36–37, 46, 141
Fisher, John (archdeacon), 83
Fisher, John (bishop of Salisbury), 86
Fitzroy Falls, 342 n. 133
Flemish painting, 47–48
Floating Bridge of Heaven, 31–32
flood, 6, 7, 22, 33, 55
fog, 75, 83, 256–57
fogbow. *See* rainbow in nature: cloudbow
folklore
 Albania, 27
 Argentina, 25, 30
 Arnhem Land, 22, 24
 Austria, 32
 Benin, 25
 Bohemia, 27
 Brazil, 329 n. 198
 Buddhist, 30, 31
 Cambodia, 32
 Celebes Island, Indonesia, 32
 China, 27, 28, 31
 Colombia, 26, 33
 Ecuador, 27
 England, 28, 170
 Estonia, 25
 Forrest River, Australia, 32
 France, 27
 Gabon, 26, 28, 32
 Germany, 32
 Hawaii, 25, 31, 32
 Hindu, 8, 30
 Honduras, 28
 Hungary, 27, 28
 India, 30, 275
 Islamic, 30
 Japan, 31
 Judeo-Christian, 7
 Kenya, 25, 29
 Maghreb, North Africa, 28
 Malaysia, 25, 26, 29
 Mesopotamia, 8
 Mexico, 26, 28
 Natal, 26
 Native American, 26, 32
 New Mexico, 27
 New South Wales, 23
 Nicaragua, 28
 Nigeria, 25, 29
 Norse, 33, 317
 North Africa, 28
 North America, 29
 Papua New Guinea, 24
 Pennefather River, Australia, 22
 Queensland, 22
 Russia, 29
 Santa Cruz Island, California, 32
 Scandinavia, 8
 Serbia, 27
 Siberia, 29, 30, 32
 Slavic, 28
 Tanzania, 29, 30
 Tierra del Fuego, 28
 Venezuela, 27
 Washington (state), 30
 Zaire, 25
 Zambia, 28
Forster, Thomas, 83, 120
fountain, 5, 192, 211, 279
Francis I (French king), 57

Fresnel, Augustin-Jean, 251
Friedrich, Caspar David
 Christian symbolism, 112
 Mountain Landscape with Rainbow, 111–12; *Fig. 4-2*
Fuji, Mount, 75, 76
Fuseli, Henry, 79

G

Gainsborough, Thomas, 82
Galen, 139
Galileo, 353 n. 128
Gassendi, Pierre, 192
Genesis, Book of, 6–7, 38
genius (spirit), 55, 77; *Fig. 2-6*
geometrical optics, 143, 157, 182–83, 198, 247–48, 294; *Figs. 6-4 to 6-8*
George III (English king), 359 n. 76
Gerard of Cremona, 147
Gilbert, William
 magnetism theory, 175
 rainbow theory, 174–76; *Fig. 6-2*
Gilder, Richard, 133
Gilgamesh, 4–6
Gilpin, William, 82
Giotto, 44–47
 Adoration of the Magi, 46
 Last Judgment, 45–47; *Fig. 2-3*
 rainbow colors, 45, 141
glory (art), 44
glory (atmospheric), 243, 245, 248, 339 n. 227; *Fig. 8-1*
God, 6–7, 38; *Fig. 2-5*
 Mercy Seat, 52–53
 throne, 55
Goethe, Johann Wolfgang von, 219–20, 271, 335 n. 89
Golden Section, 337 n. 148
Gothic painting, 44, 47, 51
Götterdämmerung, 33
graffiti, 13
Grand Canyon, Arizona, 130, 133
green flash, 262
Greenler, Robert, 255
Grimaldi, Francesco, 193
Grosseteste, Robert, 148–53
 color theory, 152
 rainbow theory, 150–53, 174, 246; *Fig. 5-5*
 refraction theory, 149–50
Guillaume de Deguileville, 7
Gylfi of Sweden, 33

H

Habakkuk, 41
hail, 244, 294–95, 364 n. 55
Halley, Edmond, 46, 85, 290, 298–99, 330 n. 78; *Fig. 9-14*
halos (atmospheric), 11, 44, 101, 145, 154, 179, 294–95, 349 n. 227
Hanseatic League, 47
Harefield House, 65
harmony (music), 104
Harpies, 18
Harriot, Thomas, 179, 181, 184, 189
Hartwell, Charles, 292
Hatfield House, 333 n. 254
Hawthorne, Nathaniel, 338 n. 214
Hayden, Ferdinand, 132–33
Haydon, Benjamin, 217
haze, 75, 260
headdress, 9
heaven, 3, 6–7, 9, 13–14, 23, 28, 32, 35, 39, 43, 46, 52–53, 56, 63, 70, 73–74, 104, 317
Hebrew, 38, 139
Hecate, 18
Hector, 8
Heemskerck, Maarten van, 56–61
 drawings and prints, 58
 landscape colors, 60
 landscape perspective, 60
 Panoramic Landscape with the Abduction of Helen, 58–61; *Fig. 2-7*
 rainbow colors, 61
 Roman archaeology, 58–60
Heilermann, Johann, 291–92
Helen of Troy, 58–61
Helmholtz, Hermann von, 220, 361 n. 149
Hema, 32
Hennequin, Émile, 231
Henry VIII (English king), 331 n. 170
Heracles, 72
Herculaneum, 79, 117
Hering, Ewald, 227
Herodotus, 13
Hesiod, 101
hieroglyphs, 9–12
Hippocrates, 139
Hippolytus, Saint, 104
history painting, 60, 78, 332 n. 201, 335 n. 86
Hoʻokaʻakaʻaikapaka, 25

Hoamakeikekula, 25
Holy Roman Emperor, 41–42, 57
Holy Spirit, 56
Homer, 102
 Iliad, 8, 18, 21, 58
 Odyssey, 21
Hooke, Robert, 217
 color theory, 195–96
 and Newton, 196, 202–3, 248, 357 n. 264
horizon, astronomical, 129, 296–97
Housebook Master, 51
Howard, Luke, 120, 336 n. 115
Hsienpo, 31
Hudson River, 286
Hudson River School, 95, 131–32, 286
Hughes, Patrick, *Rubbish Rainbows*, 307; *Fig. 10-24*
Huguenots, 66
Humboldt, Alexander von, 96–99
Hunt, Leigh, 138
Hunt, William Holman, 223, 337 n. 160, 342 n. 142
Huygens, Christiaan, 193, 216–17, 248, 250, 291
Huygens, Lodewijk, 364 n. 53
hydria, 17

I

I Ching, 27
Iaʻtik, 27
Ibn ar-Rumi, 28
ice crystals, 364 n. 75
icebergs, 97
Iconoclastic Controversy, 38
illusionism, Western art, 47
immortals, 22
Impressionism, 230
Inana. *See* deities: Ishtar
Inchbold, John W., 337 n. 157
inductive reasoning, 155, 182
Innocent IV (pope), 347 n. 166
interference (optics), 249, 252–53, 260; *Fig. 8-6*
intromission (vision), 106–7, 149
Ionian science, 102–4
iridescence, 21, 107, 341 n. 65
Iris, 18–22
 as agent of death, 19
 caduceus, 18; *Fig. 1-11*
 as cloud, 21
 in language, 21–22, 95, 247
 as messenger, 18, 32, 61, 275; *Fig. 1-5*

Iris (cont'd)
 as rainbow, 18, 21, 138, 212;
 Figs. 4-8, 7-2
 rainbow colors, 21, 71–74
 as water bearer, 18
 wings, 18
iris (eye), 21
iris (flower), 21, 66
Isidore, Saint, rainbow theory, 36, 139
Islamic science, medieval, 139, 141–46
Izdubar of Uruk, 5

J

Jackson, William H., 133
James I (English king), 175, 333 n. 254
James II (English king), 72, 333 n. 12
Japanese painting, 74–76
 bunjin-ga, 76
 Kanō academic, 76
 suiboku-ga, 75
Jarves, James Jackson, 94–95, 339 n. 244
jasper, 43
Jerome, Saint, 38
jewels, 6, 30, 65–66
JND (just-noticeable difference), 239
Job of Edessa, rainbow theory, 139–41, 145
Job, Book of, 163
Johannes Philagathos. *See* John XVI (pope)
John of Damascus, Saint, 39
John XVI (pope), 42
John, Saint, 43, 55
 Patmos, 50, 55
Juan y Santacila, Jorge, 244–45, 257; *Fig. 8-4*
Julian the Apostate (emperor), 72

K

Kaha'i, 32
Kahn, Gustave, 230
Kamāl al-Dīn, rainbow theory, 146
Kanō Masanobu, 75
Kauffman, Angelica, 76–80, 219
 Angelica Kauffman Hesitating ... (Self-Portrait), 78–79
 Colour, 77–78; *Fig. 3-3*

Keats, John, 119, 217
 Lamia, 137–38
Kent, Rockwell, *Entrance of the Gods into Valhalla,* 317–18; *Fig. 10-30*
Kent, William, 279–80; *Fig. 9-5*
Kepler, Johannes, 177–81
 color theory, 178–79
 Pythagorean numerology, 177–79
 rainbow theory, 178–81, 294; *Fig. 6-3*
Khnumhotep II, 14
Khufu, 14
Khumbaba, 5
Knight, Richard Payne, 83
Kyoto, 74, 75

L

laborers, English, 82
Laguerre, Louis, 334 n. 36
Lamb, Charles, 217
lambs, 42
Lamia (demon), 137
Landauer, Matthäus, 52
landscape, georgic, 124–25
Langwith, Benjamin, 247–48, 277
lapis lazuli, 6
laser, 224
Last Judgment, 52
Lawrence, D. H., 275
lead (element), 175–76
Leibniz, Gottfried Wilhelm, 354 n. 153
lens, achromatic, 194, 203
lenses, 161, 183, 194–97, 223
Leo III (emperor), 38
Leo III (pope), 41
Leonardo da Vinci, 44, 57, 84, 170, 211, 227, 245
Leslie, Charles, 80
Leucippus, 103
light
 coherence, 252
 corpuscular theory, 248
 electromagnetic waves, 312–13
 frequency, 254
 interference, 252–53, 260
 metaphysics of, 148–49
 polarization, 250–51
 rectilinear propagation, 250
 speed, 143, 183–84, 195, 254, 345 n. 105, 348 n. 200
 transverse waves, 251
 wave theory, 248–52, 254
 wavelength, 194, 215

lightness (vision), 360 n. 112
lightning, 8, 17, 28, 30, 80, 286, 307
linear perspective, 47, 49, 51, 76, 88, 116
 mathematics of, 52, 53
Llull, Ramon, 353 n. 125
Lomazzo, Giovanni Paolo, 211
Louis XIII (French king), 181
Louis XIV (French king), 64, 70, 71
Lucas, David, 80
Lucifer, 301
Luke, Saint, 41–44; *Fig. 2-2*
luminance, 326, 360 n. 104
luminiferous ether, 340 n. 53, 363 n. 38
Luther, Martin, 52, 56

M

MacDonald, George, 3
Mach, Ernst, 354 n. 153
Mach bands, 225
MacNelly, Jeff, *Fig. 9-1*
Magirus, Johannes, 194
Makali'i, 31
Malanaikuaheahea, 31
Malus, Étienne-Louis, 250–51
Mander, Carel van, 58
mandorla, 43–46
Manifest Destiny, 94
Mannerism, 57–58
manuscripts, illuminated, 38
Margaret of Austria, 59
Margaret Rose, Princess (England), 246
Mariotte, Edme, 193
Martens, Conrad, 126–28, 131
 Fall of the Quarrooilli, 126–28; *Fig. 4-13*
 knowledge of optics, 127
 rainbow colors, 127
Martin, Charles E., *Fig. 10-27*
Maruyama Mondo Ōkyo, 76, 334 n. 60
material cause, 163, 347 n. 154
Matisse, Henri, 361 n. 137
Matteis, Paolo de, 334 n. 29
Maurolico, Francesco, 171–74
 color theory, 173–74
 rainbow theory, 171–74; *Fig. 6-1*
Max, Peter, *Fig. 10-5*
Maxwell, James Clerk, 220, 312–13
McCarthy, Joseph, 317–18

McDonald, James, 257–58
Medici, Alessandro de', 58–59
Medici Bank, Florence, 47, 50
Mediterranean Sea, 97
melancholy, 55
Melanthios, 210
Memling, Hans, 47–51
 Last Judgment, 47–51; *Fig. 2-4*
 patrons, 50
 rainbow colors, 51
 St. John the Evangelist on Patmos, 50
Menelaus of Sparta, 58
Mengs, Anton Raphael, 79
Mersenne, Marin, 182
Meryra, 10
Mesopotamia, 4–5, 15
metamerism, 235–36, 314
Michael, Saint, 51
Michelangelo, 57, 58
 Last Judgment, 57
Midgard, 33
Mie, Gustav, scattering theory, 313–16; *Fig. 10-29*
Milky Way, 27, 142
Millais, John Everett, 87–92
 The Blind Girl, 89–92; *Fig. 3-5*
 Christ in the House of His Parents, 88
 Pre-Raphaelite Brotherhood, 88–89
Miller, William, 312
Milton, John, 207
Minilius, Marcus, 63
mirrors, 142, 145–46, 152, 164, 175
mist, 348 n. 184
monitor, computer, 220, 261
monotheism, 10, 39
Montagu, Elizabeth, 138
Montagu, First Duke of, 71, 73
moon illusion, 142, 341 n. 77, 344 n. 39
moonlight, color of, 223
Moran, Thomas, 130–34
 Chasm of the Colorado, 130–31, 133–34; *Fig. 4-17*
 Grand Cañon of the Yellowstone, 130, 132–34
 on realism, 133
Morse, Samuel F. B., 338 n. 209
mosaic, rainbow, 40, 46, 210
Mother Earth, 18
Munsell System, 326
Müntzer, Thomas, 56
Muromachi shogunate, 75

music of the spheres, 104, 352 n. 88

N

Nahum, 41
nanometer, 215
Nao'tsiti, 27
Napoleonic Wars, 81, 85
Nashe, Thomas, 56
Near East, 11, 18
Nefertiti, 10
Neoclassicism, 79, 82, 336 n. 107
Neo-Impressionism, 230
Neoplatonism and science, 35–36, 139, 148, 153
Nestorians, 139
New Age Movement, 301
New South Wales, 126
Newton, Isaac, 69–70, 76, 79–80, 85, 96, 193–205
 artistic reaction, 137
 color theory, 194–96, 199–203, 213–19; *Figs. 6-9 to 6-11, 7-9*
 light theory, 248, 250
 "New Theory", 197, 200–202
 Optical Lectures, 197–200, 214
 Opticks, 138, 202–5, 214, 218
 rainbow theory, 198, 203–5, 246, 248, 290, 294–95
 refraction theory, 202
Niagara Falls, 26, 92–96, 123; *Figs. 3-6, 4-11*
Niagara River, 31
Nikomachos, 210
Nile River
 cataracts, 14
 floods, 13
Nilus of Rossano, Saint, 42
nimbus (art), 44
Nirvāna, 31, 75
Nkongolo, 25
Noah, 6, 7, 39, 67, 207; *Fig. 7-1*

O

O'Sullivan, John L., 94
Ockham, William of, 150
Ockham's razor, 346 n. 135
oil paint, 48, 219
Old Testament, Greek, 38
Oldenburg, Henry, 200–202
Oliver, Isaac
 miniatures, 61
 Rainbow Portrait, 61–67; *Fig. 2-8*

Olympiodorus the Younger, rainbow theory, 109
Olympus, Mount, 19, 32, 70
opponent-color theory, 227
optics, 349 n. 272, 351 n. 25
Oresme, Nicole, 35–36, 50
Otto I (German king), 42
Otto III (German king), 41–42
 Gospel Book of, 41–43; *Fig. 2-2*
Ottonian painting, 42
Ovid, 21
 Golden Age, 63
 Metamorphoses, 63
ox, 41–42
Oxford University, 148, 348 n. 191
ozone, 305, 307

P

Pambamarca, Mount, 245, 257
panoramas (art), 338 n. 221
papyrus, 38
Paradise, gates of, 46
parchment, 38
Pardies, Ignace, 202
parhelia, 262–63, 349 n. 267
Paris of Troy, 58–61
 Judgment of, 59
Paris, University of, 148, 159, 348 n. 191
Parmigianino, *Madonna with the Long Neck*, 57
Parthenon, 18
Pascal, Blaise, 353 n. 128
Patagonia, 126
Patroclus, 8
Paul III (pope), 66
Paul, Saint, 66
peacock, 212; *Fig. 7-2*
pearl, 21, 23
peasants, 56, 123
Pecham, John (archbishop of Canterbury), rainbow theory, 152
Pedgley, David, 292
Peele, George, 64
peoples
 Abnaki, 32
 Acoma, 27
 Akkadians, 31
 Aztecs, 26
 Berber, 28
 Botocudo, 329 n. 198
 Buginese, 32
 Buryats, 30, 32

peoples (cont'd)
 Catawba, 32
 Chaga, 30
 Chibcha, 26, 33
 Chumash, 32
 Dahomey, 25, 30
 Ewe, 29, 30
 Fang, 26, 28, 31
 Feranmin, 24, 25
 Guyanese, 31
 Hopi, 32
 Igbo, 25
 Ila, 28
 Iroquois, 28
 Kabi, 30
 Khmer, 32
 Kikuyu, 29
 Kirgiz, 31
 Kunwinjku, 24
 Lapps, 8
 Luba, 25
 Luhya, 25
 Makah, 30
 Makasarese, 32
 Masai, 29
 Maya, 27
 Navaho, 27, 31
 Neanderthal, 309–11
 Ostiaks, 29
 Panare, 27
 Peruvians, ancient, 26
 Pilagá, 30
 Semang, 26
 Senoi, 26
 Shoshoni, 26
 Sumu, 28, 31
 Teotihuacáns, 26
 Tlingit, 32
 Toba, 25, 30
 Toltecs, 26
 Wirajuri, 23
 Yakuts, 30
 Yámana, 28
 Yoruba, 29
 Yualai, 22
 Zulu, 26, 30
Pergamum, 40, 209
Pernter, Josef, 313
Philostratus the Lemnian, 49
photography and painting, 133
phrenology, 90
Picasso, Pablo, 318
Piccolomini, Alessandro, 170
pictographs, 14, 15, 22; *Figs. 1-8, 1-9*
picturesque, 82–83, 126, 336 n. 107

Piles, Roger de, 223
Pirckheimer, Willibald, 52
Pisano, Giovanni, 44
Pisano, Nicola, 44
Pissarro, Camille, 230
pixel, 237
plague, bubonic, 55, 196, 331 n. 130
planets, 104, 177
Plato, 36, 50, 66
 Academy, 105
 and empiricism, 103–4
 Republic, 103
 Timaeus, 104
Pliny the Elder, 210
pointillism, 230, 233
polarization (optics), 250–51
polytheism, 39
Pope, Alexander, 279–80, 334 n. 36; *Fig. 9-5*
Portinari, Cândido, 318
Portinari, Tommaso, 50
Poseidon, 102
Poseidonius, 154
Potter, Richard, rainbow theory, 312
Powell, John Wesley, 133
Pre-Raphaelite painting, 88–92, 230
Priestly, Joseph, 219, 360 n. 87
primary rainbow. *See* rainbow in nature
prism, 69, 77, 79, 85, 107, 156, 157, 160, 164, 187, 194–95, 198–200, 213, 215, 217–19, 224, 247–48, 322; *Figs. 6-9 to 6-11, 7-4, 7-5*
Ptolemy, 49, 147, 150
putti, 71, 73
pyre, 8, 17
Pythagoras, 104
Python (artist), 16, 17

Q

Queen of Heaven (Zulu), 26
Quṭb al-Dīn, rainbow theory, 146

R

Rabanus Maurus, rainbow theory, 36–37
Radicke, F. W. Gustav, 291
Ragnarök, 33
rain, 12–16, 140
 divine, 15
 life-giving, 11, 15, 17–18, 26

rainbow arch (painted), 14, 15, 17; *Figs. 1-8, 1-9*
rainbow bridge (structure), 31
Rainbow Bridge, Utah, 14
rainbow in advertising, 302–8
 automobiles, 304–5
 food and drink, 305–7, 311
 government, 280, 303–4
 kitsch, 307–9
 lodging, 305
 religion, 302
rainbow in art. *See also individual artists*
 brightness, 50, 55, 66–67, 86, 91, 93–94, 130
 cloudbow, 270–72, 308
 colors, 38, 40, 43–45, 50, 52, 77–80, 84, 86, 93, 96, 118, 127, 232, 318; *Fig. 7-1*
 foreshortened, 51, 76, 84, 120, 124, 287, 308, 318, 354 n. 163; *Figs. 4-10, 4-14 to 4-16, 7-17, 10-30, 10-31*
 geometry, 84, 86, 91, 98, 111, 128, 131–34, 232, 287; *Figs. 4-13 to 4-16*
 reflected rainbows, 125; *Figs. 4-12, 4-14*
 secondary, *Figs. 3-5, 3-7, 4-11, 9-10*
 and shadows, 46, 53, 86, 91, 98, 118, 127, 131; *Figs. 3-7, 4-7*
 sign of covenant, 91, 308; *Fig. 7-1*
 supernumeraries, 125, 287–89; *Fig. 9-10*
 as type, 91, 95
rainbow in myth
 agent of destruction, 24
 androgyny, 24
 archer's bow, 7–8; *Fig. 1-4*
 battle standard, 56
 birth, 25
 bisexual, 27
 breath, 24, 102, 327 n. 36
 bride, 28
 bridge to afterlife, 3, 21, 30, 32, 96, 112
 bridge to the divine, 18, 32, 33, 67, 301
 bullock, 29
 catfish, 24
 conception, 27
 creation, 22, 24, 27, 31
 crocodile, 24
 crown, 8

dangers of pointing at, 28
disease cure, 27
disease source, 26
drinking water, 29
eating habits, 29
emu, 24
end of (base of), 25, 275
female, 24, 25, 27, 31
fish, 24, 30
frog, 29
horse, 29
immortality, 25
infidelity, 17
kangaroo, 24
male, 24, 25, 27, 31
Mukunga Mbura, 29
ox, 25
pot of gold, 115, 275, 279–80; *Figs. 9-1, 9-6*
proxy, 10
rafters, 31
Rainbow (star), 31
raja, 25
reversed sexuality, 27
robe, 28
seat, 43, 45
serpent (*see* Rainbow Serpent)
sheep tether, 31
sign of compassion, 7
sign of covenant, 6–7, 18, 35, 38
sign of hope, 55, 270
sign of peace, 7, 67, 112
sign of power, 67
sign of promise, 6, 96, 112
thunderbird, 30
tongue, 30
transsexual powers, 27; *Fig. 4-5*
treasure at end of, 30, 115
as urine, 30, 329 n. 198
walasa aniwe, 31
walking on, 3, 32, 63, 307
water bearer, 25, 29
winged gate, *Fig. 1-3*
yolok, 31
rainbow in nature, 321–25
 Alexander's dark band, 111, 188–89, 324
 angular size, 113–14, 156, 161, 171, 185–87, 204–5, 246, 257, 269, 312–13, 323–24
 background illumination, 260, 264, 341 n. 97
 brightness, 120, 259, 263–66, 269; *Figs. 8-16, 8-17, 8-23*
 brightness gradations, 276–79, 281–86, 324
 circular symmetry, 112–14, 185, 204, 322; *Fig. 4-4*
 cloudbow, 27, 243–47, 255–58, 269–72, 315, 324–25; *Figs. 8-1, 8-9, 8-10, 8-21 to 8-23*
 and clouds, 84, 157, 257; *Fig. 5-1*
 colorimetry of, 237–40, 260–69; *Figs. 7-22 to 7-25, 8-12 to 8-15, 8-18 to 8-20*
 colors, 144, 189–91, 203–4, 236–40, 245–46, 253–58, 313; *Figs. 6-6, 6-7*
 Airy theory, 258–60; *Fig. 8-11*
 gradations of, 249, 276–79, 322
 intrinsic, 260–63
 Mie theory, 314–16; *Fig. 10-29*
 observed, 260–63
 dewbow, 163, 325, 348 n. 209
 field guide, 321–25
 futility of chasing, 114–15
 geometry, 111–22, 185–86, 189, 278; *Figs. 4-3, 8-10, 9-4*
 intangibility, 120–23, 129, 287, 308, 325; *Fig. 4-10*
 as interference phenomenon, 252–53; *Figs. 8-7, 8-9*
 lunar, 84, 112, 154, 157, 246, 325
 meteorological influences, 260
 minimum deviation ray, 189, 193, 204, 278, 289–90, 293, 312, 322; *Figs. 6-5, 6-6, 6-8, 9-4*
 as mosaic, 221
 motion of, 115, 122, 142, 157
 order of, 292–95, 364 n. 43; *Fig. 9-11*
 ordinary, 296
 partial, 93, 130, 323
 position of, 113–14, 129, 321–22
 primary, 25, 27, 84, 91, 185–87, 189, 204, 321–22; *Figs. 6-5, 6-6, 8-5, 8-8, 9-2, 9-4*
 raindrops, 154–55, 156
 red rainbows, 6, 245, 324
 reflected rainbows, 128–29, 295–99; *Figs. 9-12, 9-13*
 secondary, 25, 27, 84, 91, 186, 204, 289–90, 297–99, 321–23; *Figs. 6-8, 8-8, 9-2*
 and shadows, 113–14, 116–17; *Fig. 4-6*
 shape illusion, 257–58
 size illusion, 108–9, 142, 156
 spray bow, 14, 26, 93–94, 108, 114, 121, 126, 142, 163, 221, 244, 260, 289, 338 n. 197; *Fig. 8-2*
 sunlight-reflection rainbows, 295–99; *Figs. 9-12 to 9-14*
 supernumeraries, 174, 244, 247–49, 252–53, 259, 281–86, 289–90, 325; *Figs. 8-3, 8-7 to 8-9, 9-2, 9-7, 9-9*
 tertiary, 85, 204, 290–92
 tricolor (putative), 40, 104, 108, 140, 142, 163
 weather forecasting, 29
rainbow ray. *See* rainbow in nature: minimum deviation ray
Rainbow Room, Rockefeller Center, 307
Rainbow Serpent, 22–26; *Fig. 1-13*
 Anyiewo, 29, 30
 Australia, 22–24
 Dan Ayido Hwedo, 25
 egurugru, 25
 Mindi, 26
 Ngalyod, 24
 Niagara Falls, 26
 nkongolo, 25
 Quetzalcóatl, 26
 rubbing ice from sky, 26
 Takkan, 30
 wepal, 25
 Wosa'k, 25
 Yingarna, 24; *Fig. 1-14*
raindrop
 model of, 143–44, 154–55, 160, 164–66, 172–74, 179–80, 185, 189; *Figs. 5-3, 9-3, 9-4*
 shapes, 278–79, 284–86; *Fig. 9-3*
 sizes, 251, 252, 255–56, 258–60, 278–79, 281–86, 315; *Fig. 9-8*
rainfall, 12, 25, 27, 29, 30, 88; *Fig. 9-8*
rainmaking, 17, 23, 28, 29
Raphael, 57, 58, 66, 88
 School of Athens, 57
Rayleigh, Lord, 360 n. 119
reciprocal law, 346 n. 117, 351 n. 40
reflectance spectrum, 221–22, 360 n. 97
reflection, 51, 84, 105–7, 109, 113
 external, 158–59, 160, 172
 internal, 146, 158–59, 160, 163, 166, 172–73, 179, 186–89, 204, 252, 287, 290, 293–96, 323, 324
 law of, 143; *Figs. 5-2, 5-3*
 total internal, 163, 349 n. 247

Reformation, 52, 57
refraction, 70, 107, 109, 113, 154, 341 n. 58
 index of, 143, 202, 253–55, 344 n. 54, 353 n. 138
 law of, 143–44, 183; *Figs. 5-2, 5-3*
 minimum deviation angle, 189, 278, 289–90, 293–95, 311–12; *Figs. 6-5, 6-6, 6-8, 9-4*
 and temperature, 180
Rembrandt, 58
Remus, 72
Renaissance painting, 52, 57
Renoir, Pierre-Auguste, 230
Revelation, Book of, 43
Reynolds, Joshua, 82, 88, 128, 335 n. 78
Richelieu, Armand-Jean du Plessis (cardinal), 181
Rigveda, 8
Ripa, Cesare, 78
Rivera, Diego, 318
rock shelter, 14
Romanesque painting, 44
Romanticism, 82, 95, 119, 128, 272, 336 n. 107, 343 n. 165
Rome
 ancient ruins, 60
 artists in, 57
 sack of (1527), 57
 Sistine Chapel, 57
Romney, George, *Newton and the Prism*, 215; *Fig. 7-3*
Romulus, 72
Rood, Ogden, 97, 230–31
Rossetti, Dante Gabriel, 337 n. 160
Rosso Fiorentino, *Descent from the Cross*, 57
Round Head style, 14
Royal Academy, England, 82, 88, 217, 272
Royal Institution of Great Britain, 80
Royal Society of London, 200–202
Rubens, Peter Paul, 80, 123–26, 211–12
 Het Steen, 123
 Juno and Argus, 211–12; *Fig. 7-2*
 knowledge of optics, 125
 rainbow brightness, 124–25
 rainbow colors, 124–25
 Rainbow Landscape, 123–26; *Fig. 4-12*
Rudolph II (Holy Roman emperor), 352 n. 76
Ruisdael, Jacob van, 337 n. 147
Rumford, Count, 228
Runge, Philipp Otto, 220
Ruskin, John, 87–92, 270
 on geology, 131
 Modern Painters, 87, 99, 131, 133
 Pre-Raphaelite Brotherhood, 88–89
 on rainbows, 89–91, 93, 124–25
 on realism, 99, 131–32
 social beliefs, 90
 theological landscape, 131–33

S

Saint Helens, Mount, 308
Salisbury, First Earl of, 65
Šamaššumukin, 5–6
Samos (island), 104
Santa Maria Novella, Florence, 43
Sardanapalus. *See* Šamaššumukin
Satan, 301
Saturnalia, 72
Saussure, Horace Bénédict de, 337 n. 155
scale (music), 178, 214–15
scales (serpent), 46
scarification, 14–15
scattering, 231, 260, 313–14, 350 n. 289
Scholasticism, 148, 153, 175, 197
Schongauer, Martin, 51
Scorel, Jan van, 57
Scrovegni, Enrico, 44, 52
secondary rainbow. *See* rainbow in nature
Seneca the Younger, rainbow theory, 109, 210
serpent
 Andrénjinyi, 22
 Asura Vṛtra, 8
 brazen, 333 n. 270
 immortality, 25
 Kurreah, 23
 Magalim, 24
 Mehen, 9; *Fig. 1-6*
 mortality, 25
 rainbow (*see* Rainbow Serpent)
 rainbow iridescence, 25
 Sky Snake, 32
 spitting fire, 30
 Ungud, 23
 Wāwi, 23
Seurat, Georges, 229–33
 L'Arc-en-Ciel, 231–33; *Fig. 7-17*
 La Grande Jatte, 231
 optical mixture, 229–31
 pointillism, 230
 Une Baignade, Asnières, 231–32
Seven Wonders, 58–59
shadows, colors of, 220, 228
Shaftesbury, First Earl of, 71, 333 n. 12
Shaftesbury, Third Earl of, 70–73
Shakespeare, William, 275
shamans, 23, 32
Shelley, Percy Bysshe, 207
shield, 43–44, 46, 73
Shintō, 74, 76
shipwreck, 270–71
Shīrāzī, Qutb al-Dīn al-. *See* Qutb al-Dīn
Shōhaku. *See* Soga Shōhaku
showers, 12, 69, 80, 130, 257, 260, 277, 282–85
Sicily, 171
sickle, 29
Signac, Paul, 230, 233
simultaneous brightness contrast, 360 n. 114
sine law. *See* refraction: law of
Sinsharishkun, 327 n. 13
sky colors, 39, 46, 49, 262
slavery, 103
Sloane, Eric, *Earth Flight Environment*, *Fig. 4-7*
smallpox, 26
snake. *See* serpent
Snel, Willebrord, 184
Snell, Ebenezer, 292, 299
snow, 26
Socrates, 340 n. 15
Soga Dasoku, 335 n. 62
Soga Shōhaku, 74–76
 Miho no Matsubara, 74–76; *Fig. 3-2*
 Mount Fuji, 75
 personality, 76
solar system, 175
solids, regular, 104, 177–78
Sophonias, 41
Soviet Union, 317–18
species (metaphysics), 148–49, 157
Sprat, Thomas, 138
Stevens, Walter LeConte, 294
stippling, 15, 17
storms, 6, 9, 12, 13, 17, 29, 133
Stour Valley, England, 81, 83, 86
Styx, 18
sublime, natural, 82, 94, 119–20,

126, 132–33, 272, 287, 336 n. 107, 343 n. 165
sublunar world, 104–5
Sumer, 4, 8
sun, angular size of, 199
sunbeams, 12, 31, 86, 116–17; *Fig. 4-6*
sundogs. *See* parhelia
supernumeraries. *See* rainbow in nature
surface normal, 143–44, 163, 184, 255
Swithin, Saint, 65
Syriac, 139

T

Tamayo, Rufino, *Nature and the Artist*, 318–19; *Fig. 10-31*
Tassili National Park, Algeria, 14
Tassili-n-Ajjer, 14–16; *Fig. 1-8*
telescope
 reflecting, 170, 195
 refracting, 170, 177, 194–95; *Fig. 9-5*
television, 220, 260–61
tempera paint, 48
termite mounds, 30
Thales, 102
Themon, 170
Theodoric of Freiberg, 161–66, 245, 247, 289
 on Aristotle, 162
 color theory, 163–64
 rainbow theory, 163–66, 169–70, 291; *Fig. 5-6*
Theophanu, 42
Theophrastus, 209
Thomas Aquinas, Saint, 35–36, 75, 148
 senses and knowledge, 35–36
Thomas, Abel, 95
Thomson, James, 69–70, 80, 272
throne, 43, 52
thunder, 8, 12, 13, 29
thunderstorm, 23, 25, 86, 89, 286, 307
tides, 175, 250
Tierra del Fuego, 126
Tokugawa Ieyasu, 334 n. 43
Tokugawa shogunate, 335 n. 66
Tokyo Bay, 31
Transfiguration, 44
transubstantiation, 36
Tree of Immortality, 5
trees, sacred, 5, 6
Trinity, 52–53
Trojan War, 8, 32
Tuat. *See* Duat
Tuckerman, Henry, 93, 97
Turner, J. M. W., 87, 133, 218, 270–72
 Buttermere Lake, 271–72; *Fig. 8-25*
 Light and Colour..., 271
 Rome: The Forum with a Rainbow, 272; *Fig. 8-26*
 The Wreck Buoy, 270–72; *Fig. 8-24*
Twilight of the Gods, 33, 317
Tyndall, John, 97

U

Ukranian painting, 44
Ulloa, Antonio de, 244–45
universities, medieval Europe, 147–48
uraei, 9–10
Uruk, 6, 327 n. 8
Utnapishtim, 6

V

Vaga, Perino del, 66
Valenciennes, Pierre Henry de, 228
vapor, 154, 175, 245, 348 n. 184
Varāhamihira 102
Vasari, Giorgio, 44, 359 n. 25
vases, 17; *Fig. 1-2*
vellum, 38, 40
Venus (planet), 6, 199
Verrio, Antonio, 70–74
 Hampton Court mural, 72–73
 Heaven Room mural, 73–74; *Fig. 3-1*
 personality, 73
 political pliancy, 70–72
 rainbow colors, 74
 A Sea Triumph, 71
Victorian art, 91
Victorian social beliefs, 91
Vienna Genesis, 37–41; *Fig. 2-1*
 Jewish iconography, 39
 Near Eastern sources, 39
Villot, Frédéric, 229
Virgil
 Aeneid, 19, 63
 Eclogues, 63
 Georgics, 29, 70, 123
 golden age, 63
virgin, 63, 66, 77
Virgin Mary
 as secondary rainbow, 35
 as Virgil's virginal ruler, 63
Virgo (constellation), 63
Volkamer, Christoph, 291
Vulgate Bible, 38, 330 n. 56

W

Wagner, Richard, 317
Walker, Jearl, 292–93
Walpole, Horace, 72
waterholes, 23, 24
waterspouts (architecture), 14
West, Benjamin, 77, 78, 218
Weyden, Rogier van der, 47, 50
whales, 153
William III (English king), 70, 72–73
William of Moerbeke, 341 n. 90, 349 n. 249
Winckelmann, Johann, 79
Witelo, 159–61, 171, 179, 245, 247, 291
 rainbow theory, 160–61
 on refraction, 160
Wolgemut, Michael, 51
Wordsworth, William, 138, 217
world landscape, 60–61
Wright, Joseph, 118–20
 An Experiment on a Bird in the Air Pump, 119
 Landscape with a Rainbow, 119–20; *Fig. 4-9*
 A Philosopher giving that Lecture on the Orrery..., 118

X

Xenophanes, 21

Y

Yellowstone Canyon, 132–33
Yingt'ai, 31
Young, Thomas, 220, 248–52
 rainbow theory, 248, 258, 282, 311

Z

Zaccolini, Matteo, 212
Zen Buddhism, 75
Zimrilim of Mari, 5
zodiac, 43, 73, 178